Picasso and Braque

PIONEERING CUBISM

William Rubin

THE MUSEUM OF MODERN ART, NEW YORK

Published in conjunction with an exhibition of the
same title at The Museum of Modern Art, New York

The exhibition is sponsored by Philip Morris Companies Inc.

Additional support has been provided by the National Endowment
for the Arts. An indemnity for the exhibition has been received
from the Federal Council on the Arts and the Humanities.

Edited by James Leggio
Designed by Michael Hentges
Production by Tim McDonough

Set in type by Graphic Technology Inc., New York
Manufactured by L S Graphic Inc., New York
 Color separation by Fotolito Gammacolor, Milan
 Printed by Arti Grafiche Brugora, Milan, and Grafica Comense, Como
 Hardcover binding by Legatoria Service Beretta, Milan
 Paperback binding by Legatoria Vittoria, Bergamo

Distributed outside the United States and Canada by
 Thames and Hudson Ltd., London

The Museum of Modern Art
11 West 53 Street
New York, New York 10019

Printed in Italy

On the jacket

FRONT, LEFT:
Picasso. *"Ma Jolie" (Woman with a Zither
or Guitar)*. Paris, winter 1911–12
Oil on canvas, 39⅜ × 25¾" (100 × 65.4 cm)
Daix 430. The Museum of Modern Art, New York.
Acquired through the Lillie P. Bliss Bequest

FRONT, RIGHT:
Braque. *Le Portugais (The Emigrant)*.
Céret [and Paris], autumn 1911–early 1912
Oil on canvas, 46 × 32" (117 × 81 cm)
Romilly 80. Kunstmuseum Basel.
Gift of Raoul La Roche, 1952

BACK, ABOVE:
Picasso. *Pipe, Glass, Bottle of Rum*.
Paris, March 1914
Gesso, pasted paper, pencil, and gouache
on cardboard, 15¾ × 20¾" (40 × 52.7 cm)
Daix 663. The Museum of Modern Art, New York.
Gift of Mr. and Mrs. Daniel Saidenberg

BACK, BELOW:
Braque. *Still Life on a Table: "Gillette."*
[Paris, early 1914]
Charcoal, pasted paper, and gouache,
18⅞ × 24⅜" (48 × 62 cm)
M.-F./C. 42. Musée National d'Art Moderne,
Centre Georges Pompidou, Paris

Pablo Picasso and Georges Braque created a revolution so sweeping that today, over seventy-five years later, its influences still are felt not only in art, but also in architecture, music, and literature.

In a sense, their experiments in Cubism were artistic parallels to other pioneering events of the period such as the Wright brothers' historic breakthrough in aviation. Picasso even affectionately called Braque "Wilbourg," in admiration of Wilbur Wright, whose spectacular air demonstrations captured the imagination of the French in 1908.

Thanks to The Museum of Modern Art's initiative in assembling this exhibition, the pioneering works that Picasso and Braque produced in dialogue with each other are brought together for the first time. This offers a unique opportunity to explore their extraordinary collaboration.

Philip Morris is pleased to help present this tribute to the enduring value of creativity, experimentation, and innovation, qualities that we think are as important to business as they are to the arts. For whether the year is 1908 or 1989, in a rapidly changing world, not to take risks is the greatest risk of all.

<div style="text-align: right">

Hamish Maxwell
Chairman and Chief Executive Officer
Philip Morris Companies Inc.

</div>

Foreword

This volume is published on the occasion of the exhibition "Picasso and Braque: Pioneering Cubism." While many previous exhibitions have been devoted to Cubism, it has never before been examined solely through the work of its prime inventors, Picasso and Braque. By focusing on the core of the movement—the work that these two artists produced in dialogue with each other between 1907 and World War I—both questions and answers should emerge about an art that was to affect all that came after it. As the century draws to a close, the evolution of its most generative style seems an especially appropriate subject for examination and reappraisal. Since its founding, this museum has produced a number of exhibitions and catalogues that have proved of historical significance in altering the way we view the art of our time. We believe that this exhibition and its accompanying publications—the present volume and a subsequent publication, which will present the results of a seminar held after its participants have been able to see the exhibition—will take a distinguished place in that company.

The goodwill and collaboration of a great many individuals and institutions have been required to realize this undertaking. We are deeply grateful to these contributors, and they are specifically recognized in the extensive acknowledgments. However, the conception of this project, its plan, and in great part its accomplishment are owed to the vision and determination of one person, William Rubin, Director Emeritus of the Department of Painting and Sculpture. This exhibition and its complementary publications join a succession of prior books and exhibitions that testify to his passionate commitment to art and to the expansion of the ways in which it can be felt and understood.

A project of this scope necessarily entails high costs, and it was evident from the start that it could not be accomplished without special funding. We were very fortunate to receive generous sponsorship from Philip Morris Companies Inc., with whom we have most successfully cooperated in the past. Philip Morris has a notably distinguished record of support for the arts, both classic and contemporary, and the quality of their commitment sets a high standard for the corporate community. We are most grateful to Hamish Maxwell, Chairman and Chief Executive Officer of Philip Morris, for his interest and support. We owe particular thanks to Stephanie French, Director, Cultural and Contributions Programs for Philip Morris, with whom we first discussed this project a few years ago and who has given us continuing assistance and encouragement. We also warmly thank Karen Brosius, Manager, Cultural Affairs, for her helpful participation.

Finally, we express our deep appreciation to the National Endowment for the Arts for granting additional funds, continuing its very impressive history of support for significant exhibitions. The exhibition would not have been possible without the indemnity received from the Federal Council on the Arts and the Humanities, and we are very grateful for the assistance and advice of Alice M. Whelihan, Indemnity Administrator.

Richard E. Oldenburg
Director
The Museum of Modern Art

Contents

Preface

This exhibition was conceived during the preparation of the Picasso retrospective held at The Museum of Modern Art in 1980. While installing that show, my colleague Dominique Bozo and I engaged in a self-critique of sorts, discussing room by room what we could or should have done differently. The section on Cubism suffered from more than one weakness. With the onset of the war in Afghanistan, cultural exchanges with the Soviet Union had been halted; as a result, the bulk of the 1907–08 "primitivist" Picassos we had chosen, as well as some works of 1909 and 1910, never left Leningrad and Moscow. This almost obliterated our presentation of the evolution that immediately followed *Les Demoiselles d'Avignon*, especially the works from Picasso's stay at La Rue-des-Bois in August 1908, and deprived us of the greatest monument of the artist's early Cubism, *Three Women*. Another weakness was the relative paucity of works on paper. While there were some fine Cubist drawings in our exhibition, we had felt obliged, in order to fairly represent the range of Picasso's entire oeuvre, to choose almost all our drawings from other phases of his work, so as to illustrate ideas found uniquely in the drawings of those years. As a result, few of the many Cubist drawings, which form a kind of running commentary on Picasso's painting of this period, were to be seen.

The galleries devoted to Cubism necessarily gave a less interesting account of the formation of the movement than would have been the case in a different kind of exhibition, in which paintings and *papiers collés* by Braque could have been interspersed with the Picassos. The retrospective had naturally to leave out Braque's side of what had been a unique creative dialogue. I therefore resolved that when it became possible, the Museum should organize a much closer look at the evolution of Cubism, integrating the works in terms of that dialogue; this would also give us an opportunity to include the missing Russian-owned pictures by Picasso and do justice to his Cubist drawings. Apart from a unique chance to compare the work of Picasso and Braque in depth, it would also provide, if our efforts succeeded, a better opportunity than would ever before have been offered to see the Cubist-period Braques, which regrettably have never been adequately represented in any retrospective devoted to him (largely because of the difficulty of obtaining certain key pictures from Swiss public and private collections). Indeed,

perhaps no one outside Picasso and Braque themselves—and certainly neither the contemporaneous nor later critics of their work—could ever have had so full a view of their Cubism as such a show would provide.

Because of the risks and expenses involved in borrowing and transporting important works of art, I have rarely wanted to organize exhibitions exclusively for the sheer pleasure of looking at pictures. The justification had to go beyond that—to the opportunity to address problems of understanding and art-historical questions which could not be approached without bringing the widely dispersed objects together. The graduate seminars on Cubism I have taught at the Institute of Fine Arts every few years over the last two decades have made me keenly aware of how many open questions there are, of how little consensus exists, about Cubism's development and the respective contributions of its two principal inventors. Despite the enormous bibliography devoted to Cubism, myriad questions have been left unanswered. Not only have many specific innovations in Cubist practice been inadequately discussed, but the very dynamics of the central dialogue between Picasso and Braque remain imperfectly understood.

Far be it from me to venture answers here to the array of art-historical questions that remain, though I have a few tentative ones. But for myself, as for my colleagues, the opportunity to see the work gathered together is the *sine qua non* of critical judgment. It is a besetting problem in the preparation of exhibition catalogues that the curators and scholars involved are expected to formulate their ideas and judgments many months in advance of actually seeing assembled the body of work at issue. To have seen all these objects (and few scholars have) years and continents apart, in no particular order, is simply not the same thing—especially with so complex a subject as the step-by-step formation of Cubism. For these reasons, I have partly deferred my own contributions, and invited a number of colleagues to join me in producing a companion volume to this catalogue, to be published after the exhibition. It will contain transcripts of the proceedings of a seminar of some twenty specialists in the Cubist work of Picasso and Braque that will be held over a four-day period in November 1989, within the context of the exhibition itself.

The aim of my introductory text in the present volume is essentially to provide some additional background and several starting points for comparing the work of the two artists (during the period 1907–14), without attempting to engage prematurely those complex issues that the seminar will confront when the works themselves are before us. I do, nevertheless, attempt to unscramble the chronology of the decisive events of 1912—during the course of which the invention of constructed sculpture, collage, and *papier collé* led Picasso and Braque from Analytic into Synthetic Cubism—and to interpret these *démarches* in the light of the dialogue between the two artists, which leads me to some unsettling conclusions. I have also drawn together the scattered and partly overlooked testimony about the relation between Picasso and Braque from the handful of writers who had frequent access to them and their studios in the Cubist years, when their work was rarely visible publicly, and I comment on some of what we have been able to learn of the letters between the two artists. Extended excerpts from the correspondence, and a great deal of other relevant information, are contained in Judith Cousins's Documentary Chronology, which begins on page 335.

<div align="right">W.R.</div>

Picasso and Braque:
An Introduction

The pioneering of Cubism by Picasso and Braque is the most passionate adventure in our century's art. That is what this exhibition is about. Not since Rembrandt's has any painting so captured the elusive shading of human consciousness, the complex anatomy of thought, the paradoxical character of knowledge. Experiencing this work sequentially and in depth should help us clarify the evolving dynamic of Cubism, the concatenation of insights and discoveries from which gradually emerged nothing less than a visual dialectic for twentieth-century art. From 1910 through 1912 especially, the incremental advances in each artist's work, and the network of linkages between them, provide what may be the clearest revelation we have had of the nature of pictorial thought. This twentieth-century embodiment of Leonardo's definition of painting as *cosa mentale* was Cubism's most important bequest to subsequent generations, and the work of Duchamp is no less indebted to it than is that of Mondrian.[1]

The fact that Cubism unfolded essentially through a dialogue between two artists extending over six years makes it a phenomenon unprecedented, to my knowledge, in the history of art. Not surprisingly, much that has been said about the Cubism of Picasso and Braque turns on the comparative quality of their respective work. To the extent such argument overlooks the more readily quantifiable differences in their styles and methods, however, it seems to me something of a canard. Not that I regard the two artists as equals. Braque is one of the great modern painters, but we must go back to the most prodigious Renaissance masters for the like of Picasso. We have come to expect

more from Picasso, and in the Cubist period, under the pressure of the dialogue with Braque, we get it consistently. But the point is that what we get from Braque is not less of the same, but something different. Hence, my purpose here will be not so much to argue the relative merits of these artists as to suggest the manner in which precisely their differences, in temperament, mind, and pictorial gift, contributed to a shared vision of painting that found them both at their best when they were closest to one another—a vision which neither, I am convinced, could have realized alone.

The Picasso/Braque Dialogue

Though born only a year after Picasso, Braque was very much a "younger artist" when the two first met. Hence, some of Braque's early contributions to the language of Cubism antedate his full maturity as a painter. We sometimes forget that there is no necessary correlation between originality and pictorial quality. Thus, while Braque's Cézanne-inspired pictures of 1908—which seem to be built outward toward the viewer—provided a crucial structural model for early Cubism's simulacrum of bas-relief, they lack the weight and density of the contemporaneous Picassos. Only with the stunning and magisterial *Violin and Pitcher* (p. 149), completed in early 1910, does the quality of Braque's work fully match its inventiveness.

The friendship of Picasso and Braque may have been a classic instance of an attraction of opposites, but the nascent language they increasingly held in common served equally well their contrasting needs.

For Picasso, whose facility was demonic, and whose poorest work shows him merely coasting on it, Cubism was a kind of deliverance. It obliged him consistently to forgo the refuge of virtuosity for an art which, at least in 1908–09, any reasonably trained novice could execute—if he knew where to put the marks. This willed undercutting of his own gifts was already anticipated in some of the work of 1906, as well as in *Les Demoiselles d'Avignon* and the ensuing "African" works, though certain of the latter boast remarkable bravura passages. Thereafter, and undeviatingly until World War I, Picasso accepted as axiomatic the Cézannian commitment to conception —that is to say, invention—as the heart of painting, to the exclusion of everything related to execution. Talent was out, along with anything else that could mask or obscure the pictorial idea.

Cubism also sentenced Picasso to an emphatic focusing-down insofar as its essentially iconic nature forced him to work against the grain of one of his greatest strengths, and pleasures—that of pictorial storytelling. The Cubist years are unique in Picasso's career in being virtually devoid of overt narrative imagery. To be sure, Picasso was already able to synthesize narrative relationships entirely symbolically in such early Cubist works as *Bread and Fruit Dish on a Table* (though this was a "backdoor" solution)[2] and, once Cubism had subsumed printed words and lettering, was also able to imply anecdote wittily (or ominously) while remaining entirely within his pictorial syntax. He even writes in 1911 of working on a "large picture" showing "a stream in the middle of a town with some girls [?] swimming," as well as "a Christ." But as neither of these unlikely Cubist images was let out of the studio, or kept by the painter, who was very careful about preserving his work, it would appear that they were destroyed by Picasso himself, presumably because he found their problems insoluble. Such exceptions to Picasso's high Cubist iconography (together with the peculiar formats he used in a number of his 1910–18 paintings) represented a temporary "deformation" of the parameters of the artist's Cubism occasioned, I believe, by the demands of an ensemble of eleven

works he had agreed to execute for the library of the Brooklyn painter, critic, and collector Hamilton Easter Field. This project was considerably more ambitious than Matisse's for the Russian collector Sergei Shchukin, begun shortly before, and was no doubt intended to rival it.[3]

If Cubism forced Picasso severely to narrow the range of his subjects, it nevertheless fostered a compensatory profundity in his explorations of them. The banal yet very personal objects that are the motifs of his and Braque's Cubism constituted a studio world that gradually incorporated an iconography drawn from the more gregarious milieu of the café. The artists cultivated a profound affection for these objects, all of which were to be touched and used as well as seen; Picasso, for example, thought it "monstrous" that women should paint pipes "when they don't smoke them."[4] In their patient scrutiny of these articles, endlessly disassembled and reconceived, the two artists sought a rendering at once more economical and synoptic than sight. And this involved them in deliberations more protracted than any in which either painter would later engage. Their quest ended by making the very process of image-formation virtually the subject of their pictures, placing their enterprise at a far remove from that of other vanguard artists. "Nous étions," said Braque, "surtout très concentrés."[5] Of course Picasso had already shown, prior to meeting Braque, that he was capable of remarkable concentration for extended periods of time; but he could also be lax. Braque, however, was relentless in his pursuits. This difference was reflected in their attitudes toward Cézanne. Braque felt his profound identification with Cézanne to be as much personal as pictorial. Picasso, for all his admiration of the master of Aix, could nonetheless also find him "fatiguing."[6]

The ease with which Cubist signs could be drawn largely deprived Picasso of opportunities to exercise the "laureate" aspects of his hand, but it was appropriate to the limits of Braque's more modest draftsmanship. Like Cézanne, Braque had little conventional facility in drawing, and he rarely strayed, even later in life, beyond the Cubist draftsmanship he had shared

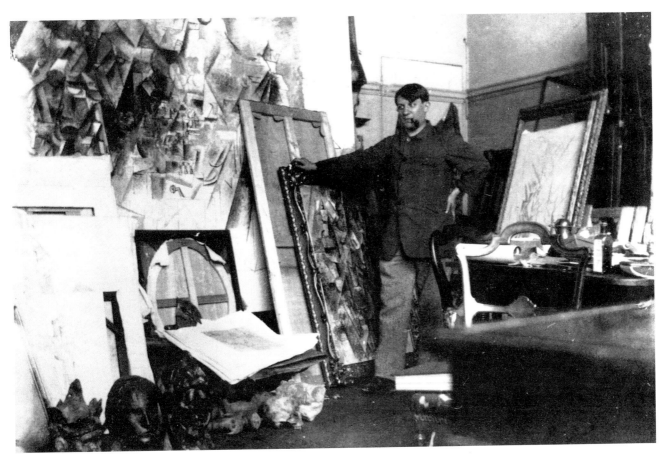

Picasso in his studio at 11, boulevard de Clichy, autumn 1911. At upper left, cut off on two sides by the camera, a monumental unfinished painting, later destroyed by the artist, which was to be the centerpiece of an ensemble of works commissioned in 1909 by Hamilton Easter Field for the library of his Brooklyn, New York, home

in forging. With sublime honesty, Braque described Cubism as a means he had created "whose purpose was above all to put painting within the reach of my own gifts."[7] Those gifts included an extraordinary sensitivity to the subtleties of light and space, a great inventiveness in the exploitation of textures and materials, a remarkable lucidity in the handling of complex pictorial ideas, and an ethical rigor rivaling Cézanne's. But they did not include a particular talent for drawing. Braque's profound personal identification with Cézanne can be understood in a multiplicity of ways, but never more immediately than in the area of "realization"; one can imagine the depth of his sympathy with Cézanne's eternal complaint, "Le contour me fuit." Braque drew relatively little with pencil, pen, or charcoal at any time in his career.

Where Picasso's rapier line cuts sculpturally into the plane of a piece of drawing paper, Braque's tends to sit passively on its surface. His line becomes fully alive only when he works against the resistance of pigment, sand, plaster, paper to be cut, or a copperplate to be incised.

Nothing if not a critic of his own gifts, Braque therefore did almost all his Cubist drawing with the paint itself (except for the charcoal drawing that links his *papier collé* cuttings, and a number of small, mostly notational sketches, the majority of which he destroyed).[8] By contrast, Picasso often tested hypotheses and found solutions for his paintings in much-developed collateral drawings. Hence, Braque's paintings tended to undergo very extended mutations, often lasting four to six months and sometimes

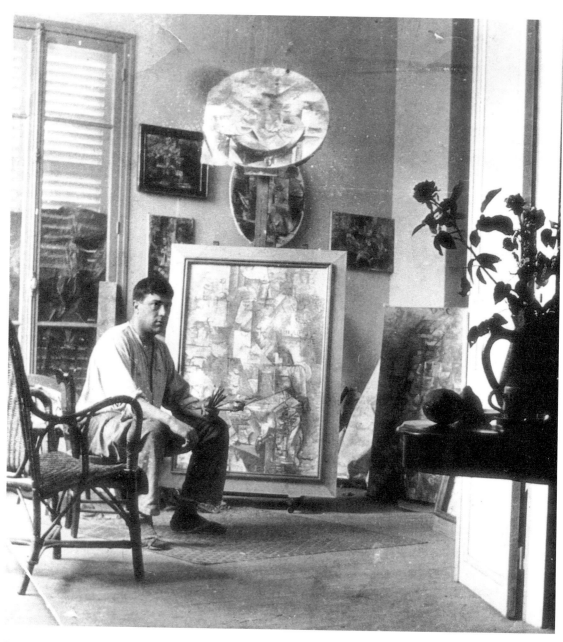

Braque in his studio at 5, impasse de Guelma, c. early 1912. On bottom of easel, *Le Portugais (The Emigrant)* (p. 211); on top of easel, *Table with Pipe* (Romilly 123); at right, *Man with a Guitar* (p. 191)

longer; indeed, Picasso himself probably never stayed so long with individual pictures as he did from 1907 to 1914. Both became adept with the turpentine-soaked rag, as they constantly effaced passages to be re-worked. Some of their letters touch on these trans-formations: Braque tells Picasso about his picture with a fireplace full of wood; in the form we know it, *Still Life with a Violin* (p. 213) has lost its logs;[9] Picasso recounts to Braque how by giving his image of a man "une geule bien du midi" and putting a banderilla in his hand, he transformed him into an *Aficionado* (p. 239).[10] Braque's slower, more pondered approach, and the more time-consuming trials on the canvas necessitated by his rejection of collateral drawing, explain in part why we have more than three times as many Cubist works by Picasso as by Braque. (The imbalance, not surprisingly, alters con-siderably with respect to *papiers collés,* a method in which the artist can rapidly test different config-urations simply by shifting the cut papers around.)[11]

The graphic simplicity of the signs that were employed in the complex structuring of 1910–14 Cubism, and the fact that they were largely shared, reflects a depersonalization of the act of painting that apparently played a role in Braque's and Picasso's thinking for several years. The decision of first Braque, and then Picasso, to give up signing their work on the front of the canvas seems to have been a function of this attitude, although they did sign on the back, or had Boischaud, D.-H. Kahnweiler's assistant, do it for them.[12] This issue has been confused by conflicting explanations. Kahnweiler argued that sig-natures on the front would have "interfered with the [formal] construction" of Analytic Cubist com-positions,[13] an explanation Picasso himself gave Brassaï late in life.[14] It would appear to be contra-dicted, however, by the willingness of both artists in later years to sign those same pictures on the front at the behest of dealers and collectors. Then we are confronted with Kahnweiler's further testimony that the suppression of signatures was "a deliberate ges-ture toward *impersonal* authorship,"[15] and, according to Françoise Gilot, Picasso also subscribed to this view. She recalls him saying that "we didn't sign our canvases" because "we felt the temptation, the hope of an anonymous art, not in its expression, but in its point of departure. We were trying to set up a new order and it had to express itself through different individuals. Nobody needed to know that it was so-and-so who had done this or that painting.... But individualism was already too strong," Picasso reflected, "and that [effort] resulted in failure...."[16] Braque clearly remembered the signature question in the same spirit: "...Picasso and I were engaged in what we felt was a search for the anonymous person-ality. We were prepared to efface our personalities in order to find originality."[17] In time, however, Braque came to feel that "without 'tics,' without recognizable traces of the individual personality, no revelation was possible."[18] By 1914, both painters had returned to signing pictures on the front, occasionally making a reflexive joke of the matter by inserting into their pictures simulated metal "museum" plaques with their names "engraved" on them in capitals (pp. 310, 313). Of the two, Picasso's wry comment on the gulf separating their painting from the museum art of the day was the more pointed, insofar as his "labels" were affixed to the trompe-l'oeil paper frames of ephemeral-looking *papiers collés.*

Along with Braque's and Picasso's depersonaliza-tion of their pictorial language went their sense of the studio as a place of "manual labor,"[19] where card-board, sand, sawdust, metal filings, Ripolin enamel, paper, wood, sheet metal, stencils, razors, house-painter's combs, and other artisanal materials and tools were increasingly employed in realizing a "pop-ular" iconography of commonplace objects. Braque, wrote André Salmon, "brilliantly developed his thoughts on how the resources of the housepainter [the craft in which he had been trained] might enrich high art."[20] Indeed, many of Braque's innovations in Cubist practice—such as using stenciled letters, charging pigment with sand, and simulating wood and marble—had genuinely artisanal origins, while others such as *papier collé,* though primarily formal in nature, nonetheless displayed a craft character. Salmon compared Picasso's and Braque's passion for the vernacular to the study that the poet François de

Malherbe had made of dockworkers' slang in order to enrich his language; and Salmon also warned of underestimating the seriousness of their interest in "the beauty of artisanal work."[21] We can measure this interest by Picasso's angry reaction when he heard that the collector-dealer Wilhelm Uhde disliked some works of 1912 in which he had used Ripolin enamel housepaint for the French flag (pp. 219, 229); "Perhaps we shall be able to disgust everyone," he wrote Kahnweiler, "and we haven't said everything yet."[22]

Not surprisingly, it was a Marxist, the early and perceptive critic of Cubism Carl Einstein, who identified the *papiers collés* in particular not only as the first entirely "synthetic" works, wholly devoid of "professional tricks," but the first which, through "total indifference to technique," definitively challenged the notion of the artist's touch as revelatory of unique genius.[23] The put-down of the traditional romantic view of the artist implied in these works was also reflected symbolically in the two artists' widely noted affectation of wearing something like a mechanic's outfit—*bleu mécano* of a very simple but very particular cut.[24] ("They arrived [at the gallery] one day cap in hand acting like laborers," Kahnweiler recalled. "Boss," they demanded, "we're here for our pay.")[25] Cubism's prophetic sense of the work of art as a pure idea, disengaged from individual artistic talent, and hence realizable by anyone—a possibility immediately seized upon by the Russian Constructivists—is embodied in a heretofore unremarked yet characteristically acute quip Picasso made to Salmon about his first sheet-metal construction, the *Guitar* of 1912. "You'll see," he said. "I'm going to hold on to the *Guitar*, but I shall sell its plan. Everyone will be able to make it himself." ("Tu vas voir. Je garde *el guitarron*, mais je vendrai *el* plan; tout le monde pourra faire la même.")[26]

Picasso's frequent recourse to drawing was not merely, of course, a function of "realization," for his drawings led him into numerous tangential experiments that both tested and expanded the limits of Cubism, resulting in varieties of Cubist painting for which there is no counterpart in Braque. Many

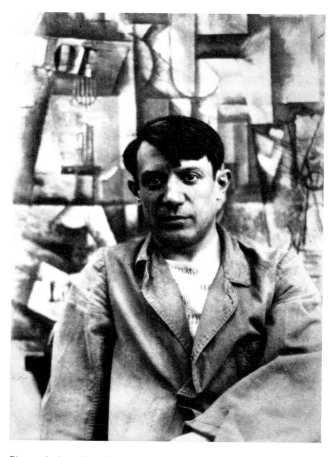

Picasso before *The Aficionado* (p. 239), summer–autumn 1912

drawings explored ways of representing motifs and body postures apparently without interest for Braque, whose Cubism, however deeply probed, remained more one-directional and more narrowly focused. The range of identifiable human emotions, like the variety of motifs, is much broader in Picasso. Although Braque's work is infused with a quiet wit that has often been overlooked,[27] his gravity, austerity, and very French discretion seem to have largely precluded such direct invocations as we see in Picasso of hilarity, discomfort, anger, and a host of other sentiments, not the least those associated with sexuality.

Since Picasso was alternately attracted by a variety of morphological, configurational, and iconographic possibilities, the main lines of Cubism's evolution are sometimes perceived more easily in Braque's work,[28] although both painters passed through periods of

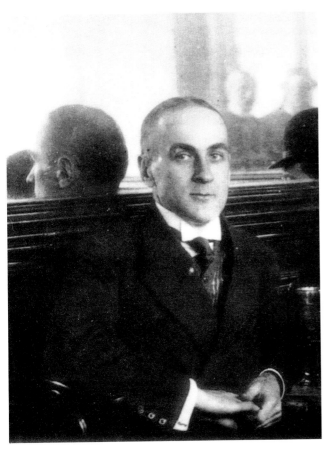

Wilhelm Uhde, February 1910

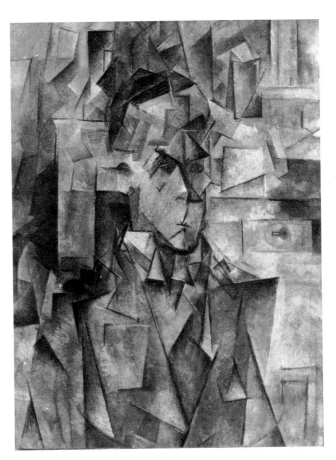

Picasso. *Portrait of Wilhelm Uhde.* Paris, spring[–autumn] 1910. (Color plate, p. 173)

confusion and of treading water. To the extent their developing enterprise may be called a style, the term is more apt for Braque than Picasso (who had a horror of the very word). And the forward motion of the style was propelled in part by technical innovations that are owed more frequently than not to Braque, though Picasso often exploited these to greater advantage. This was the case, for example, with Cubist construction sculpture, which, it is now clear, was invented by Braque.[29]

Picasso's intense interest in the particulars of the human situation led him to exploit Cubism for purposes entirely his own, as, for example, in portraiture. Indeed, figure painting played a much more central role in general for Picasso than for Braque, who was more at home with landscape, and most comfortable in the world of inanimate objects. Not until 1911, when

the subject, whether figure or object, was in any case nearly swallowed by the fragmentation resulting from its "analysis," did Braque truly inventively conceive the figure in Cubist terms.

Picasso's portraits are a perfect instance of the manner in which his extraordinary gifts (in this case, as a caricaturist) allowed him to enrich the possibilities of Cubism. The framework of fragmentary signs and marks that constitute the texture of high Analytic Cubism would seem to have allowed little room for the creation of a veritable portrait. Yet with deft accents owed to the caricaturist's eye for the telling detail—the heavy brows and the philtrum, or "cleft," in the upper lip of Wilhelm Uhde, for example— Picasso was able to make portraits that quite remarkably catch the appearance of the individuals who sat for them.

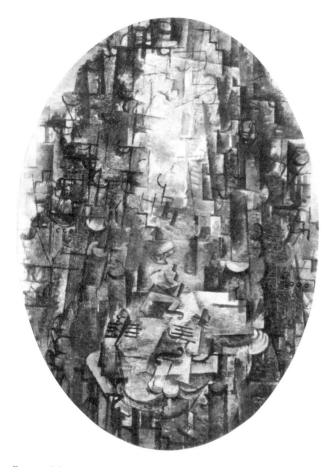

Braque. *Man with a Violin.* [Paris, spring 1912]. (Color plate, p. 223)

Braque. *Soda.* [Paris, spring 1912]. (Color plate, p. 224)

If portraiture represents a type of Analytic Cubist picture found in Picasso's oeuvre and not in Braque's, there is in the latter's work a type that is, configurationally at least, equally particular to him. I am thinking here of those extraordinary pictures of spring 1912, such as *Man with a Violin* and, in particular, *Soda,* in which Braque's anti-hierarchical distribution of increasingly fragmented compositional units foretells the character of subsequent "all-over" abstraction. Apart from a handful of pictures executed by Picasso at Cadaqués in the summer of 1910, which Kahnweiler described as unfinished (pp. 168, 169),[30] these Braques are also the most abstract of Analytic Cubist paintings.

In *Man with a Violin* and *Soda,* Braque's instinct for abstractness constitutes the other side of the coin of Picasso's will to represent very directly the human drama. It is not, of course, that Braque wishes ultimately to express human emotions any less than Picasso—all art intends that, or has no meaning whatever. Rather, Braque's reverence for the language and craft of painting distances him from his subject. Picasso has no patience with "painting" or anything else that stands between him and the most rapid and direct expression of his feelings about people and things. Given what we know of Picasso's life and personality, it is hard to imagine him putting art on a pedestal and joining Braque in saying, "I love painting above all else."[31] Picasso was involved with the plastic arts because he was born with that particular genius for self-expression, and it may be that very genius which led him often to disdain or want to go beyond

his medium. Had he lived in the Renaissance, when the artist could be an inventor because the science of the day was practical and not beyond the reach of any disciplined intelligence, he would certainly have been drawn to the kinds of extrapictorial projects in which artists such as Leonardo and Michelangelo became engaged.

Both Picasso and Braque were committed to painting as an art of representation, which is one reason why their Cubism drew back from total abstraction (that is, from non-figurative painting) in the spring and summer of 1912. But they were committed to representation in very different ways. Matisse had said, with regard to the motifs of his pictures, that the longer he worked on a picture, the less he remembered what it was he had started to paint. The image, though it carried with it the sentiments that its subject first inspired in him, developed in favor of the needs of the pictorial configuration, and thus *away* from the motif, in the direction of abstractness. This tendency, common to much twentieth-century French painting, was shared by Braque. It is, therefore, perfectly natural that the lineage of French non-figurative art of the forties and fifties—the "late Cubism" of Alfred Manessier, Pierre Soulages, and the early Nicholas de Staël—should descend primarily from Braque, whose lifelong Cubism assured the continuity of a specifically national tradition.

An historically more telling extension, however, of Braque's type of abstractness was the non-figurative painting that Mondrian evolved out of Analytic Cubism from 1913 to 1915, which, in effect, carried the dialectic progression of Analytic Cubism to conclusions that Braque and Picasso had excluded when they shifted into Synthetic Cubism. I am not suggesting, of course, that when Mondrian plugged into Cubism in Paris he was looking more at Braque than at Picasso (indeed, he admired Picasso most among other artists) but rather that his Cubism was much closer to the reductive, abstracting spirit of Braque's. Mondrian's first steps beyond what his predecessors had done—the delicate, lattice-like, all-over compositions of early 1913 from which soon issued the "plus-and-minus" configurations—are closer to such pic-

Picasso with a dog (perhaps André Derain's *Sentinelle*)

tures as Braque's *Man with a Violin* and *Soda* than to anything in Picasso.

If Braque's (and Matisse's) pictures evolved in favor of abstraction, Picasso's normally went the other way. Faced with a mark, a blot, a patch of paint, a texture or piece of material, Picasso instinctively wants to make a figure or object out of it. Where Braque may be content to let the peg of a violin dissolve from a sign into a mark, and hence into "painting," Picasso will transform it into a sign for a face or figure (p. 242), a kind of metamorphosis that becomes the procedural model for his post-Cubist method. Braque's pictorial imagination is less fired by morphological analogy, and "fantasies," as he said, "are not part of my painting."[32] Picasso delights in the ambiguous sign that permits him to develop analogies between forms, such as the female torso and the body of a violin or

Picasso. *Still Life with Liqueur Bottle.* Horta de Ebro, summer 1909. (Color plate, p. 138)

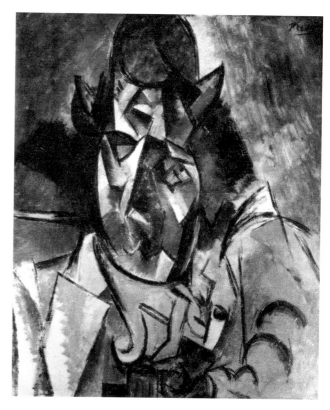

Picasso. *Man with a Hat* (also known as *Portrait of Braque*). Paris, [winter 1909–10]. (Color plate, p. 146)

guitar.[33] Braque's violin may be taken as a metaphor for a woman's body, but Picasso's signs for the instrument sometimes oblige a dualistic reading. Representation is more than a commitment for Picasso, it is an obsession, and some of the dramatic tension of his high Analytic Cubism follows from the paradoxical situation in which he finds himself as an utterly representational painter in an increasingly abstract art.

Picasso's commitment to the rendering of the particulars of his motifs notwithstanding, the reading of high Analytic Cubist pictures by both artists, those of the summer of 1911 through the following winter in particular, remains extremely problematic. Art historians who no doubt know these pictures like the backs of their hands frequently impose interpretations on them that are later shown to be utterly false through the discovery of some fact, document, or drawing.

Reading the myriad visual cues in the light of their own individual agendas, even experts have, for example, seen Picasso capturing Braque's essence in a supposed "Portrait of Braque" that was neither a portrait nor of Braque;[34] put the accordion player in Braque's *Le Portugais* inside a café, when he is "on the bridge of a boat with the harbor in the background";[35] and perceived an image of Braque wearing a bowler hat in Picasso's *Accordionist,* which the artist described as a "girl playing an accordion."[36] Even early Cubist pictures can be misread. The changing titles of The Museum of Modern Art's 1909 *Still Life with Liqueur Bottle* are a case in point. When this picture was acquired in 1951, it was known as "Still Life with Siphon," an object absent from the picture. It was retitled by the Museum "Still Life with Tube of Paint," until a Spanish visitor pointed out that the "paint tube" was actually a bottle of Anis del Mono, at

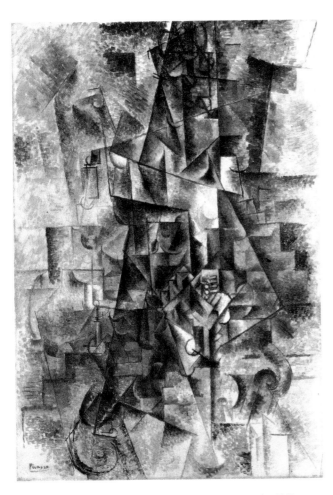

Picasso. *Accordionist.* Céret, summer 1911. (Color plate, p. 190)

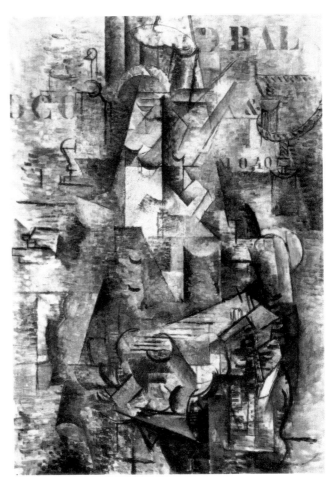

Braque. *Le Portugais (The Emigrant).* Céret [and Paris], autumn 1911–early 1912. (Color plate, p. 211)

which time the painting reverted to its present title, which had earlier been proposed by Zervos.[37] Important as is the identification of motifs in the reading of Cubist pictures, their apprehension by the viewer is far from indispensable to his or her experience of the art. However fond Picasso and Braque were of the studio paraphernalia they used for their still lifes, for example, they knew their pictures could speak eloquently even to those who could not satisfactorily decipher the images. Indeed, the poetry of high Analytic Cubism owes much to the very ambiguity of its forms. Had the viewer's recognition of figures and objects in their paintings appeared crucial to Picasso and Braque, they would surely have painted in a very different manner. "It's all the same to me," said

Braque, "whether a form represents a different thing to different people or many things at the same time." And he concluded by noting that some of his forms "have no literal meaning whatsoever."[38]

Picasso was, nevertheless, more interested in the physiognomics of his motifs than was Braque, and the two artists' contrasting degrees of commitment to those morphologies are reflected in their almost antipodal attitudes toward the picture field in which these forms were deployed. Here, we return again to Braque's profound kinship with Cézanne, whose opening-up of represented objects' contours so that they bled into contiguous areas (*passage*) made possible the first art in which the integrity of the motifs was definitively sacrificed to the autonomy and seam-

25

lessness of the composition as a whole. Cézanne was the first painter for whom the shape of the support became effectively the first four lines of the composition and, as such, remained powerful determinants of the work. Braque followed Cézanne in this, focusing almost more on the spaces, the connections between things, than on the things themselves. Braque never takes his eye off the framing edge and his composing proceeds more deductively than Picasso's. Working to synthesize individual things from a general sense of their overall relations, he is finally less interested in the thing represented than in the way it relates to the composition as a whole. Less a generalizer, Picasso is riveted by the thing itself, and its very peculiarities are his stimulus. He cares less about the continuity of space around a motif, or its relation to the shape of the support. In his drawings, this instinct for specificity generates extraordinary life and variety, though the residual white paper—in contrast to its organic role in Cézanne's drawings and watercolors—is often left to fend for itself. Picasso is confident that, in his paintings, he can adjust all his motifs to the frame, but this is not an overriding concern.

The priority that both Cézanne and Braque give the picture field expresses their allegiance to "painting," and contrasts with Picasso's primary commitment to the morphological and conceptual definition of his subjects. When Braque's paintings are weak, it is often because, in the interests of the whole, the configurations are too "set." Picasso has a horror of stability or finality, and his refusal to accept the dominance of all that spells "painting" becomes the guarantor of the perpetual challenge of his art. Rarely can he resist the instinct to put a monkey wrench in the compositional works, a joker in the iconographic deck.[39] Anarchic by instinct, Picasso resists total order, as he does the encapsulation within a style which it implies. This said, we must observe that he accepts such confinement more in the years of his dialogue with Braque than at any other time, and the work profits from the tension generated by that fact. Instead of moving from one style of imagery to another, the Cubist Picasso deepens his work by exploring sequentially the more remote implications of one evolving language.

The importance Braque attributes to the picture field, as against Picasso's stress on the physiognomic of particular forms, is also expressed in the priority he gives the spatial continuum. Picasso starts with the objects that inhabit this continuum. Braque, as he himself said, was "unable to introduce the object until I had created the space for it."[40] Braque's insistence on dissolving distinctions between figure and ground, a characteristic of his Cubism throughout, follows from this position, and also partly explains why his pictures are wont to be more painterly (*malerisch*) than Picasso's, in which the brushwork tends to produce harder, more sculptural surfaces. The radical fragmentation of objects that took place in 1910 allowed Braque further to subsume their contours in a synthesizing light and space, and he led the way in establishing the new kind of all-over painterliness that displaced the essentially sculptural illusionism of 1908–09 Cubism. The culmination of this pictorialism was the luminous space of the two artists' 1911 Céret pictures, which also marked the moment of highest coincidence between the Cubist language and Braque's individual painterly gift. While Picasso also exploited the new fusion of figure and ground to great advantage in his work of 1910–11, his real interest in the fragmentation of objects lay in the opportunity it gave for pushing their physiognomic into a world of new signs.

It is precisely in the invention of signs that the power of Picasso's imagination makes itself most manifest in Cubism. In morphological terms, Braque's art is essentially, if inventively, reductive.[41] He seeks a sign that is easily assimilated to the fabric of the picture—hence at once not overly distinguished in its individual profile, while maximally conditioned in its size, shape, and placement by the framing edge and the implicit grid structure derived from it. The signs Braque invents, such as the panels of simulated wood-graining he introduced in the winter of 1911–12, tend to be generated by the surface qualities rather than the shapes of his motifs. Picasso's signs are derived from the physiognomic of objects, and he often presses their individuation in imaginative ways until they appear, at least by the end of 1912, almost arbitrary. Although Braque invented *papier collé*,

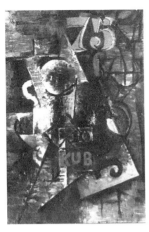

Picasso. *Bouillon Kub.* Paris, early 1912.
Oil on panel, 10⅝ × 8¼″ (27 × 21 cm).
Daix 454. Present whereabouts unknown

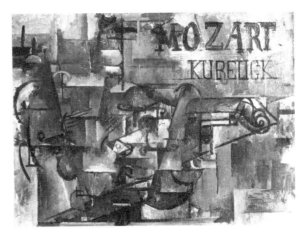

Braque. *Violin: "Mozart/Kubelick."* [Paris, early spring] 1912.
(Color plate, p. 233)

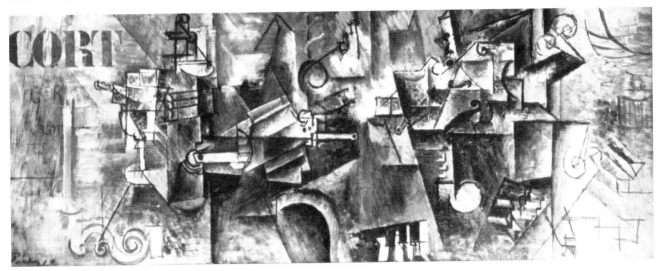

Picasso. *Still Life on a Piano.* Begun Céret, summer 1911; completed Paris, spring 1912. (Color plate, p. 215)

Picasso's ability to carry further its sign possibilities resulted in a more variegated and colorful exploitation of the medium. Synthetic Cubism was to open upon a different constellation of possibilities than the Analytic Cubism of the preceding years. And the Braque who was a full partner in the high Analytic Cubism of 1908–11, and played a crucially inventive role in the transition of 1912, was less able than Picasso to develop within the non-illusionistic sign language of the Synthetic mode of 1913.

Here and there we discover in the work of the two artists suggestions of reciprocal plays on words and other indications of a kind of friendly rivalry (which are not evidenced in the surviving letters between them). For example, among the "brand names" Picasso excerpted for his lettering was the bouillon cube KUB, a double entendre he first used early in 1912 in the now lost *Bouillon Kub.* Braque, who had introduced musical instruments into Cubism's iconography, responded characteristically, playing KUB against the name of a musician, the violinist Jan Kubelík, in his picture *Violin: "Mozart/Kubelick,"* painted shortly afterward.[42] It may well be that Picasso picked up the challenge and replied, in turn, by stenciling the first four letters of the surname of another musician, the pianist Alfred Cortot, in his *Still Life on a Piano.*[43]

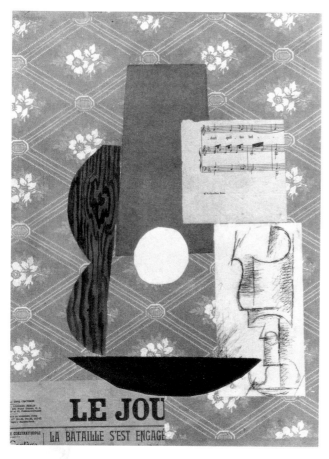

Picasso. *Guitar, Sheet Music, and Glass.* Paris, after November 18, 1912. (Color plate, p. 252)

Certainly the game of one-upmanship was a factor in the early history of the *papier collé*. John Golding long ago implied that the reason for Braque's decision to hold off making the first *papier collé* until Picasso had left Sorgues for a visit to Paris was to avoid having Picasso take up the technique before the slower-working Braque had clearly marked his precedence.[44] Thus, when Picasso returned to Sorgues, Braque was able to show him *Fruit Dish and Glass* (p. 244) and probably a few other finished *papiers collés*.[45] Picasso returned to Paris shortly thereafter, and among his first *papiers collés*—if not the very first—was *Guitar, Sheet Music, and Glass*, which contains the headline LA BATAILLE S'EST ENGAGÉ. This has been interpreted primarily as a reference to the then ongoing Balkan Wars (the literal sense of the headline), and thus a presumed example of Picasso's

political consciousness, and secondarily as an allusion to "the formal challenge represented by the unprecedented and outrageous use of the collage in art."[46] While not excluding these possible meanings, I think it would have been more in character for Picasso to have chucklingly selected that headline as a signal to Braque about the competition he was up against in the use of the new medium. This interpretation is also more consistent with the *homo ludens* sense of Picasso's segmentation of the newspaper's name into LE JOU (implying *jouer, le jeu*).

Another form of one-upmanship can be seen in the "game" of the housepainter's combs. Braque, who had been trained in the technique during his apprenticeship as a housepainter, introduced trompe-l'oeil wood-graining into Cubism in *Homage to J. S. Bach* (p. 215). He taught Picasso the technique with profes-

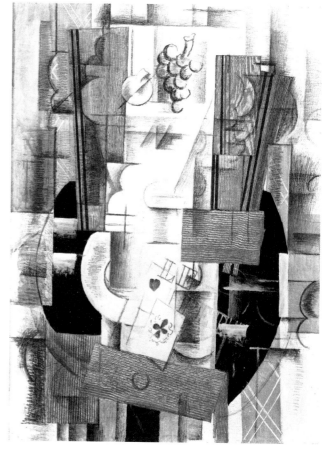

Braque. *Fruit Dish, Ace of Clubs.* [Paris, early 1913]. (Color plate, p. 277)

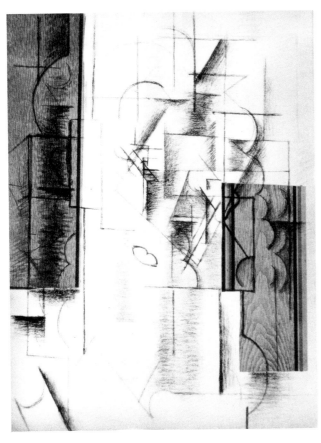

Braque. *Head of a Woman.* [Sorgues, early September] 1912. (Color plate, p. 245)

sional housepainter's combs, and after acquiring a set, Picasso was soon painting *faux bois* himself. But he did not stop there. He one-upped Braque by using the combs, in such pictures as *The Poet* (p. 236), not just for wood-graining but for hair, a *geste* that Salmon considered characteristic of Picasso's wit.[47]

The rather unusual *Hat Decorated with Grapes* seems to me a classic instance of Picasso's leg-pulling if we read it as a commentary on Braque's painting. In 1912–13, Braque introduced a cluster of grapes into his pictures so often that it became a kind of signature. We see it, for example, in the first *papier collé* (*Fruit Dish and Glass,* p. 244), in *Fruit Dish: "Quotidien du Midi"* (p. 244), and in *Fruit Dish, Ace of Clubs,* among many other works. He also had formulated a kind of reductive sign for a woman's mouth, distinguished by heart-shaped, "bee-stung" lips, which we

see in one of his first *papiers collés, Head of a Woman,* as well as in the related painting *Woman with a Guitar* (p. 297). When the two painters were together in Sorgues in 1912, Picasso had tipped his hat to Braque's invention of *faux bois* by juxtaposing it to a cluster of grapes (*Violin and Grapes,* p. 241). A year later in the *Hat Decorated with Grapes,* he parodistically disengages the grape cluster from Braque's logical association of it with a fruit dish or wineglass, and literally as well as figuratively inverts it as a decor for a woman's hat—a woman, moreover, with inverted bee-stung lips.[48]

"I often see Braque . . ." Picasso wrote Kahnweiler on July 21, 1914.[49] Less than two weeks later he accompanied his uniformed friend to the Avignon railroad station, and the dialogue they had sustained for years was over. Those who find with me that Picasso's Cubism distinguishes itself in character and quality from the rest of his work, or who go even

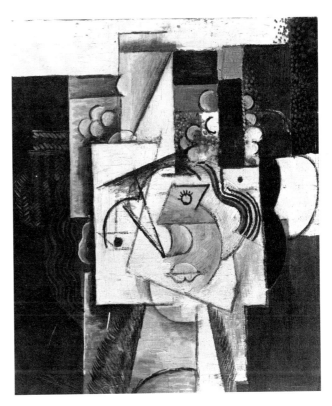

Picasso. *Hat Decorated with Grapes.* [Paris, autumn 1913]. (Color plate, p. 296)

Picasso. *Seated Man.* [Avignon or Paris, autumn 1914]. Pencil, 7⅞ × 5⅜″ (20 × 13.5 cm). Zervos II, 881. Collection Marina Picasso; Galerie Jan Krugier, Geneva

further to agree with John Berger that it was "the only period in which [he] consistently developed as an artist . . . [or in which he was] open to explanations, suggestions or arguments,"[50] will count Picasso's loss of his sole interlocutor as something of a trauma for him. It may be that in a manner more intuitive than conscious, Picasso sought a remedy by creating a dialectical "other" within the style alternatives of his own work. To be sure, Picasso's subsequent *paragone* of Cubism and classicism appears, in retrospect, a not illogical outgrowth of his history to that time. But one wonders whether it is pure chance that those curious drawings which simultaneously pit abstract and classically realist solutions against one another, and the celebrated "dual-track" pattern that quickly followed from them, should date from just after Braque's departure for the war.

The Transition of 1912:
Paper Sculpture, Collage, and *Papier Collé*

A fresh consideration of what I have been describing as the Picasso/Braque dialogue opens out into a great many related issues in the study of Cubism. Of these, I now want to examine in some detail a crucial example: the developments of 1912. The dynamics of the two artists' relationship have a particular bearing on the central innovations of that year, especially on constructed sculpture, collage, and *papier collé*. To look more closely at these three inventions as they worked themselves out through the two artists' exchanges in 1912 is in some respects to see the collaboration at its height.

A number of disparate facts and documents have come together in such a way as to establish, virtually beyond question, that Cubist construction sculpture was in fact first undertaken by Braque. And what is more, this new chronology mandates that the well-established notion that relief constructions derived from a "three-dimensionalization" of *papier collé* or collage[51] must be reversed; as can now be shown, and as Braque himself actually said, cardboard sculpture led him to the innovation of *papier collé*, rather than the other way around.[52] (Picasso's *papiers collés*, too, *followed* his earliest paper sculptures.) Braque clearly began his experiments in openwork cardboard sculpture many months and possibly as much as a year and a half before Picasso's execution of the paper version (p. 32) of his *Guitar*, identified by Picasso himself as his first constructed sculpture. Indeed, Douglas Cooper suggested as early as 1970 that Braque had anticipated Picasso in making cardboard sculptures;[53] however, he provided no documentation, and consequently his statement had no effect. What in fact mattered most about Picasso's *Guitar* was not that it was the first construction sculpture (because it turns out it was not) but that its novel cutaway structure provided a new, non-illusionistic system for declaring space. Picasso's translation of the sign language of that system into two dimensions in his *papiers collés* was to provide for them a definition of recessional space absent from the

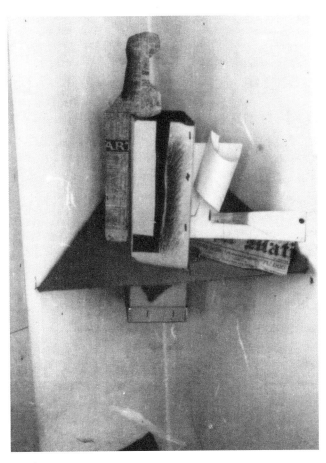

Braque's sole documented paper sculpture, photographed in his studio at the Hôtel Roma, 101, rue Caulincourt, after February 18, 1914

papiers collés of Braque which, in many other ways, had provided the model for Synthetic Cubism.

Clarifying the issue of precedence in construction sculpture requires first that we correctly situate Picasso's first paper sculpture in his work of 1912. At the time Picasso gave the metal version of his *Guitar* (p. 269) to The Museum of Modern Art, he told me that he had made it *before* beginning his collages. Although I cannot recall whether he used the term "collage" or "*papier collé*," I (mistakenly) took him to mean the collage *Still Life with Chair Caning* (p. 36), generally given to May 1912. In spite of certain reservations, I therefore placed the *Guitar* in "early 1912."[54] This caused some discussion among Picasso scholars, who felt, quite rightly as closer study proved, that not only the metal *Guitar* but its earlier cardboard model—the "original" in any case—seemed logically

to fit into Picasso's work in later 1912 or in winter 1912–13. Edward Fry, who (along with Pierre Daix) has explored more closely than anyone the precise chronology of Picasso's Cubist works, embarked on a prolonged study of this issue, the results of which were communicated to colleagues in conversations and lectures over the years and published recently in the *Art Journal*.[55] On the basis of the internal logic of Picasso's work, Fry proposes, wholly convincingly, that the cardboard *Guitar* must have been executed in October–November 1912. (It was, however, anticipated by some drawings for figure constructions made during the late summer, such as those on p. 243, which were never realized.) Quite apart from the stylistic arguments, Fry notes that the type of cardboard from which *Guitar* is constructed appears in *papiers collés* of that autumn, especially *Violin and Sheet Music* (Daix 519), in which cardboard from the top of the same box that may have been used for the *Guitar* was employed.

In a recent analysis of the *Guitar*, Yve-Alain Bois proposed—and I think he was correct—that when Picasso told me that the piece had preceded his collages (or *papiers collés*, as the case may have been), he was thinking not of *Still Life with Chair Caning*, a unique work which was not directly followed up, but of his first series of *papiers collés*, begun in autumn 1912.[56] This might effectively place the *Guitar* in early October. Indeed, since the time of my first publication on the *Guitar*, I have learned that Salmon had earlier reported the same thing Picasso told me, in Salmon's case specifically employing the term "*papiers collés*."[57]

In his discussion of the *Guitar*, Fry cites the passage from Picasso's letter of October 9, 1912, in which he tells Braque: "I am using your latest papery and powdery procedures. I'm in the process of imagining a guitar and I'm using a bit of earth against our awful [?] canvas."[58] This passage, first mentioned (fragmentarily) by Christian Zervos in 1932, then by René Huyghe, was recently disinterred and republished by Isabelle Monod-Fontaine.[59] These writers, and Fry as well, have assumed that the guitar Picasso mentions in the letter was a *papier collé* or a painting. While the

letter might refer to the oil (with sand) *Table with Guitar* (p. 255),[60] there is no proof that Picasso—who had returned from Sorgues (where he saw Braque's first *papiers collés*) only sixteen days before his letter, and who, during that time, had moved into his boulevard Raspail studio—had as yet begun to make a *papier collé* of his own. Two different *papiers collés* have traditionally been identified as his earliest essay in this technique: *Guitar and Sheet Music* and *Guitar, Sheet Music, and Glass* (p. 28). He could hardly have been executing the latter, as it contains newsprint dated November 18. (Indeed, prominent in this work is the headline, already discussed, reading LA BATAILLE S'EST ENGAGÉ, which one would like to think of as appropriate for Picasso's first essay in the medium.)

Since we know from Picasso that the cardboard *Guitar* was made before his first *papier collé*, and can be quite sure that as of this October 9 letter only one *papier collé—Guitar and Sheet Music—*could have

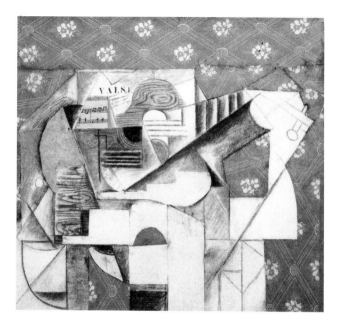

Picasso. *Guitar and Sheet Music.* Paris, [October–November] 1912. (Color plate, p. 252)

been in execution or completed, then the odds seem very good that it was indeed the cardboard *Guitar* he referred to in his letter. Hence, when Fry writes that "it is tempting to associate [Picasso's letter of October 9] with the cardboard *Guitar*," but backs away "for lack of evidence," he perhaps proves too cautious. Everything conspires to suggest that as of October 9 it was precisely the cardboard construction of the *Guitar* on which Picasso was working. The term "procede paperistique" of Picasso's letter therefore probably refers either to the cardboard *Guitar* alone or, less likely, to it *and* his first *papier collé*. Whatever may be the precise meaning of the October 9 letter, there is now a total consensus among scholars working on this issue that the cardboard *Guitar* was executed in Paris *no earlier than October 1912*. As we shall now see, this is many months after Braque had begun his cardboard sculpture.

Braque had gone to Sorgues in the summer of 1912, toward the beginning of August. He wrote Kahnweiler from there on the 24th: "I am profiting from my stay in the country by doing things one can't get done in Paris, among other things, paper sculptures, which have given me much satisfaction."[61] Eight days earlier, he had signed a letter to Kahnweiler "votre

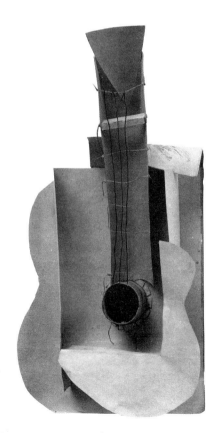

Picasso. Maquette for *Guitar.* Paris, [October] 1912. (Color plate, p. 251)

Wilb[o]urg Braque," employing the nickname (after Wilbur Wright) that both artists used for Braque. In neither of these letters, nor in any other communication, did he feel the need to explain what "paper sculptures" are, or what "Wilbourg" means. Indeed, Picasso wrote to Kahnweiler twice in August using the same nickname for Braque, also without explanation. It appears evident, therefore, that Kahnweiler was familiar *before the summer* with both the notion of paper sculpture and the nickname Wilbourg.

We do not know when Picasso began using that name for Braque. He had been reading about the Wright brothers' progress in the conquest of the air, reported almost daily in the French press. (Indeed Salmon takes note of Picasso working, in the Cubist years, in "his aviator's outfit.")[62] Wilbur Wright's name appears in juxtaposition to Braque's in the clipping, in Kahnweiler's album, of the celebrated review by Louis Vauxcelles of Braque's first Cubist paintings (the exhibition of November 1908), in which

he calls Braque "un jeune homme fort audacieux." And it is possible that Picasso got the idea for the nickname that early. Its frequent use in 1912, however, suggests that it was particularly associated with the paper sculptures Braque was doing that year. Braque had begun making them no later than in early spring, or even before. Indeed, Zervos's text of 1932, which was certainly based on conversations with Braque, dates his first paper sculptures to 1911, noting that Braque's "many inventions earned him Picasso's nickname of Wilbur Wright."[63] The relationship between the nickname Wilbourg and the paper sculptures is precised in a citation of Braque's first mentioned in an unpublished text by Jean Paulhan of 1939–45, later used as a source for his *Braque, le patron*.[64] Here Braque tells us specifically that the "scaffoldings" of his paper sculptures reminded Picasso of Wright's "biplanes." Thus, the nickname Wilbourg must already have been flourishing during the spring of 1912 when Picasso did paintings incorporating the

EXPOSITION BRAQUE

Chez Kahn Weiler, 28, rue Vignon. — M. Braque est un jeune homme fort audacieux. L'exemple déroutant de Picasso et de Derain l'a enhardi. Peut-être aussi le style de Cézanne et les ressouvenirs de l'art statique des Egyptiens l'obsèdent-ils outre mesure. Il construit des bonshommes métalliques et déformés et qui sont d'une simplification terrible. Il méprise la forme, réduit tout, sites et figures et maisons, à des schémas géométriques à des cubes. Ne le raillons point, puisqu'il est de bonne foi. Et attendons.

Louis Vauxcelles

La Conquête de l'air

AU MANS

Wilbur Wright gagne le prix de la hauteur

Le Mans, 13 novembre. — M. Wilbur Wright a couvert... à 4 heures pour le prix de hauteur de

Review of Braque's exhibition at the Kahnweiler gallery, printed in *Gil Blas*, November 14, 1908. Clipping from the Kahnweiler press albums

Wilbur Wright piloting his biplane over a racetrack near Le Mans, August 1908

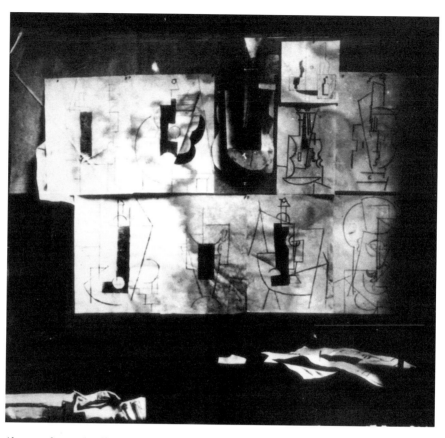

Above and opposite: Wall arrangements at Picasso's 242, boulevard Raspail studio as photographed by the artist, November–December 1912, incorporating his first construction sculpture, the cardboard *Guitar* (p. 251), at center, and various drawings and *papiers collés*

slogan NOTRE AVENIR EST DANS L'AIR (p. 229).[65] These pictures certainly refer to Wilbur Wright (who died about the time they were painted)[66] and, by extension, to Braque's paper sculptures.

None of Braque's construction sculptures now exist, though a photograph of one of them (p. 31) from the Laurens Archives was published by Nicole Worms de Romilly in 1982. The only eyewitness allusion to them followed from Kahnweiler's visit to Braque's studio in the Hôtel Roma in 1914, where the dealer noted "reliefs in wood, in paper, or in cardboard."[67] As the object in the photograph also dates from 1914, it cannot be used to infer the character of earlier constructions. Nevertheless, the few commentaries on it in the Cubist literature have completely overlooked the fact of its originality, for it is structured in a very different manner from any of Picasso's openwork sculptures. Whereas Picasso's are organized against

the plane of the wall like a bas-relief, Braque constructs his work within the literal orthogonals of the studio walls converging in a corner space. He thus anticipates, at least in that respect, the corner reliefs of Vladimir Tatlin. Indeed, as Tatlin visited Paris in 1914 and not earlier, as we know now through the researches of Fry and of Magdalena Dabrowski, and as he widely visited the studios of artists, it is not at all unlikely that the relief in the photograph, or one very like it, was a source for his corner reliefs, the earliest of which were begun later that year.[68]

What were Braque's earliest sculptures like? Almost certainly, as with Picasso's first constructions of later 1912, they were unified in medium—without such collage-like mixing of materials as we see in Picasso's 1914 *Still Life* (p. 40), in which real upholstery fringe is attached to the wood table.[69] And each probably represented only one object, as in the case of Picasso's

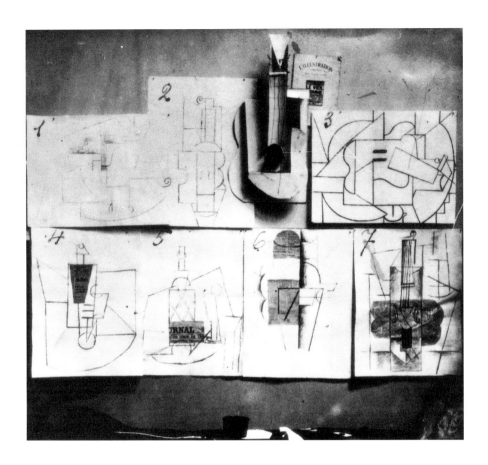

Guitar. Despite the fact that Braque's 1914 construction is partly painted and drawn upon, and that Douglas Cooper referred to his first constructions as painted, we can only regard this as certain if we interpret Braque's 1911 reference to *papiers peints* as meaning paper reliefs.[70]

Braque did nothing to preserve his cardboard constructions, whereas Picasso put his in boxes and, in the case of the cardboard *Guitar,* realized it with slight alterations in metal. Braque was evidently little interested in his paper sculpture except as an aid to painting. To the extent that he seems to have based some 1913–14 pictures directly on them, they served as a means of further distancing him from the motif. Braque did not pursue the possibilities of his constructions after August 1914 and, unlike Picasso, apparently saw no future in them. The lone Braque construction preserved in the photograph is more pictorial than Picasso's objects, and does not employ the Synthetic Cubist type of sign language for transparency that Picasso arrived at in his *Guitar* of 1912 out of his speculations on the Grebo mask he owned. Picasso's innovative use soon afterward of columns of newsprint as an almost "pointillist" equivalent of middle-value shading would seem to have derived from a translation into two dimensions of the new type of "transparency" offered by the cutaway structure of the *Guitar.* The *Guitar* provided the vocabulary for a transparency entirely indicated through flat signs, which displaced the illusioned transparency of the 1910–12 paintings. Hence, the logic of the wall arrangement in Picasso's studio in late 1912, photographed repeatedly by the artist, in which the cardboard *Guitar* is at the center of groups of newsprint *papiers collés,* alluding to its role as a generator of this idea.[71]

This revised understanding of the generative relationship between construction sculpture and *papier collé,* and the proper sorting out of the chronological developments of 1912, make it more than ever imperative that art historians cease the casual practice (of which I have been as guilty as the next) of using the terms "collage" and *"papier collé"* interchangeably. Only by insisting on the distinctions between the two can we really understand the differences between Braque's and Picasso's art as well as the nature of the give-and-take between them.

While both terms indicate etymologically a work that involves the gluing together of elements, "collage" does not imply—as does *"papier collé"*—a work governed by the classical principle of the unity of medium. To the contrary, on the purely material level, Picasso's *Still Life with Chair Caning* of May 1912, the first Cubist collage,[72] is characterized precisely by the insertion into a richly impastoed and freely brushed oil painting of an alien element, a piece of printed oilcloth—a textbook example of the anti-classical principle of the *mélange des genres.* But, more important, what is alien in this juxtaposition goes beyond

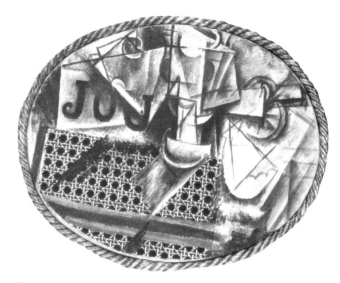

Picasso. *Still Life with Chair Caning.* Paris, [May] 1912. (Color plate, p. 229)

the oilcloth itself to the hyper-illusionism of the chair-caning pattern printed on it. And it is *this* clash—between the quasi-photographic illusionism of the chair caning and the abstract and painterly Cubist figuration of the rest of the still life—that we experience primarily. Indeed, except for this discontinuity in style—which also pits the artist's improvising hand

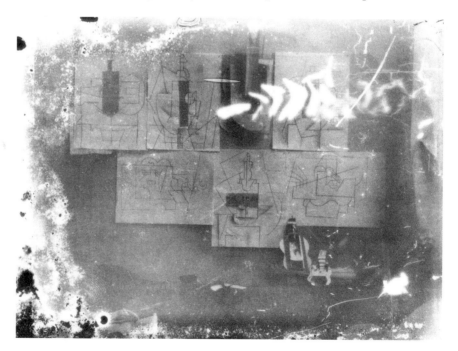

Wall arrangement at Picasso's studio as photographed by the artist, November–December 1912, incorporating his cardboard *Guitar* (p. 251), drawings, *papiers collés,* and two smaller cardboard constructions

against a mechanical and commercial method of realization—we would hardly become aware of the actual material break between the oilcloth and linen surfaces. The subversive type of displacement achieved by Picasso through the use of illusioned chair caning as a tablecloth is echoed in his unexpected employment of a custom-made endless mariner's rope as a frame, whose relief patterning reenacts the upholstery border (from which the fringe hangs) of one of Picasso's table coverings (visible in the photographs on this page) as well as the familiar carved border-molding of real tabletops (such as the one we see illusioned in *Bottle of Bass, Ace of Clubs, and Pipe,* Daix 685).[73]

Picasso's pioneering collage could really be titled "Still Life with Figured Oilcloth," insofar as what is collaged is not chair caning, which Picasso surely could have acquired and affixed to his canvas had he wished, but oilcloth *picturing* chair caning. So much for the simple-minded references to "the real" and the "reintroduction of reality" which abound in discussions of collage. If the evanescence and spatial ambiguity of reality in the high Analytic Cubism of 1911 were to Picasso "like a perfume,"[74] reality in *Still Life with Chair Caning* is a game played with smoke and mirrors. For Picasso, collage, construction, and *papier collé* were no more or less about "reality" than his work of the previous year. They were about alternate ways of *imaging* reality. Confusion on the score of the introduction of "the real" led no less an authority than Douglas Cooper to insist that Picasso's still-life objects in this picture were set on a chair,[75] and to take issue with Rosalind Krauss, who had described them rightly as resting on a table.[76]

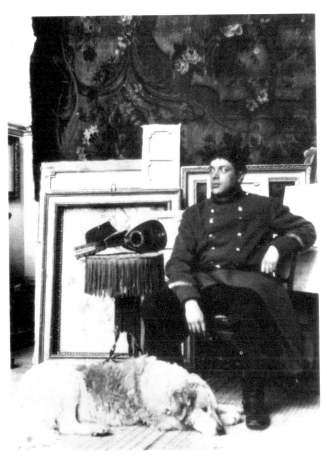

Braque wearing his military reserve uniform, in Picasso's studio at 11, boulevard de Clichy, c. 1911, photographed by Picasso

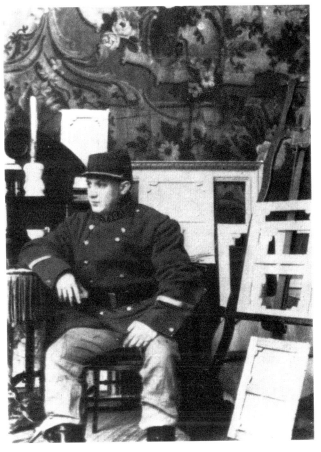

Picasso in his 11, boulevard de Clichy studio, wearing Braque's military reserve uniform, c. 1911, photographed by Braque

The essence of collage, then, is the insertion into a given context of an alien entity—not only of a different medium, but of a different style or, as the Surrealists would later insist, even of a motif drawn from a different context of experience or level of consciousness. (As Max Ernst said, "... ce n'est pas la colle qui fait le collage.")[77] The collage principle is by definition conflictual and subversive, and sorts well with Picasso's anarchic tendencies and revolutionary spirit, his personification of the *agent provocateur*. His insertion into the post-Renaissance tradition of bits and pieces of such outsider arts as the African, the Oceanic, and even the Iberian might be viewed as an essentially collage-like subversion of Western art. What one could call Picasso's "collage instinct," his particular passion for this disconcerting methodology, is not unrelated to André Chastel's notion of Picasso's aesthetic "joker"—his desire for something "outside the system"[78]—or to Leo Steinberg's postulate of Picasso's "discontinuity principle."[79]

So defined, Braque never made a collage. Its implications are foreign to his classical mind-set. If his gluing to drawing paper some wallpaper printed with *faux bois* may be likened on one level to Picasso's gluing to canvas a piece of oilcloth printed with false *chaise cannée*, what is crucial in Braque's *papiers collés*, beyond the fact that *only* paper is used, is that the sign language of the entire picture is in harmony with what is glued on, whereas just the reverse is true of the Picasso. In judging the origin and originality of Braque's innovation, it is important to remember that every element in his pioneering first *papier collé* (*Fruit Dish and Glass*) was present in one context or another in his own work, *prior* to Picasso's execution of *Still Life with Chair Caning*. The stencil-type letters that sit in the picture plane rather than in three-dimensional space, such as the BAR resumed freehand in *Fruit Dish and Glass*, were introduced into Cubism by Braque in late 1911. The wallpaper wood-graining in that same work is essentially a shortcut for the trompe-l'oeil sign for wood also introduced by Braque in 1911–12.[80] Finally, the cutting or shaping of paper, and perhaps even its coloring, were at the heart of Braque's paper sculptures. One

Braque. *Fruit Dish and Glass*. Sorgues, early September 1912. (Color plate, p. 244)

has not much more than to imagine him pinning these paper reliefs flat on a piece of drawing paper, adding his wood-grained wallpaper, imitating his stenciled letters, and linking the whole with a few linear accents in charcoal to grasp how it was that Braque saw his invention of *papier collé* in *Fruit Dish and Glass* as deriving wholly from his own 1911–12 work. Nothing in the nature of *Fruit Dish and Glass* recapitulates any aspect of Picasso's *Still Life with Chair Caning*. Braque's *papiers collés* were regularly to maintain a consistent level of figuration even as they later subsumed—following Picasso's example—newsprint and advertising imagery. Picasso's *papiers collés* also usually maintain this consistency of figuration. But sometimes, as in *Bowl with Fruit, Violin, and Wineglass*—in which the precise illusionism of the representation of fruits glued to the upper left marks a

break of the same nature with the Cubist figuration of the rest of the work as did the illusioned chair caning in Picasso's earlier picture—he effectively gives a collage dimension to a *papier collé*.

With these distinctions in mind, we can reconstruct the following sequence of exchanges during the course of 1912. In January, Braque returns to Paris from Céret with pictures that include stenciled letters (for example, *Le Portugais*, which he himself referred to as "L'Emigrant"), simulated wood-graining *(Homage to J. S. Bach)*, and very probably (as Zervos indicates) some of his early paper sculptures. Should the latter not be the case, then he makes these sculptures sometime in the following months. The paper or cardboard is shaped with scissors or razor, bent and folded, perhaps set against a ground, and possibly painted or drawn upon. That spring, at the latest, Picasso jokes that Braque's constructions look like Wright's biplanes and he nicknames Braque (or revives an old nickname) Wilbourg. We do not know how Braque's constructions were affixed. But whether pinned or glued, they did not contain, by the terms of our definition, any collage constituent. Early that May, Picasso responds with a radical *démarche* of his own, *Still Life with Chair Caning.* He does not immediately follow up on this idea, however. During the later spring and summer, collage remains in abeyance as Picasso explores the introduction of color into Cubism.

To pursue this point for a moment, let us remember that, as Kahnweiler has recounted, Picasso had been trying to insert color into Analytic Cubism since 1910, but with the exception of a single small painting, no longer extant, he had always painted it out.[81] He was, in effect, reacting to the essential incompatibility between bright, unmodulated color and the atmospheric and luminous space of 1911 Cubism. Only as he squeezed out such vestiges of illusionistic depth, during the spring and summer of 1912, did he find that the color began working to his satisfaction. It is not by accident that his first success in this regard, *Souvenir du Havre* (p. 219), executed following his trip to Le Havre with Braque in late April, should also be the first picture in which he introduced the

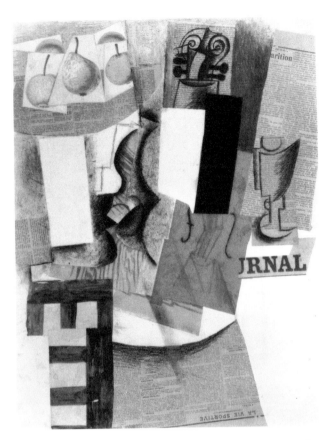

Picasso. *Bowl with Fruit, Violin, and Wineglass.* Paris, begun after December 2, 1912; completed after January 21, 1913. (Color plate, p. 270)

simulated wood-graining he had learned from his companion.[82] Like the stenciled letters Braque had introduced earlier, panels of *faux bois* tend to sit *in* the picture plane rather than behind it, and to that extent force out of the painting precisely the illusionistic space that was getting in the way of color. Picasso would drop even more of Cubism's atmospheric space, and introduce even higher-keyed color, in his unique *Landscape with Posters* (p. 235), executed largely in July. The reductive planes of this picture foreshadow the schematic flatness of Synthetic Cubism. During the late spring and summer, Braque followed up on Picasso's *Souvenir du Havre* with his own closely related *The Clarinet: "Valse"* (p. 231), but he only introduced unshaded color—never as high-keyed as Picasso's—in his *papiers collés.*[83] Here, in such works as *Still Life with Guitar* (p. 267), Braque

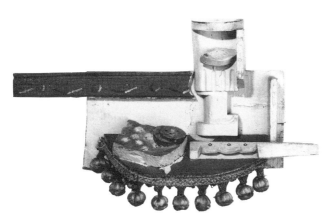

Picasso. *Still Life.* Paris, [early] 1914. (Color plate, p. 314)

turned color into an autonomous sign disengaged from the morphological depiction of an object. Now *in,* rather than behind, the picture plane, where it was freed from the need of space-denoting modulation as well as from the contouring of objects, these quantified shapes of color represented for Braque color's real "liberation."[84]

To return to the summer months: during August, in Sorgues, Braque is at work again on paper sculptures, and on pictures with *faux bois;* in addition, he now begins mixing sand in his pigment. Braque also discovers a roll of *faux bois* wallpaper in a shop in Avignon, waits for Picasso to leave for Paris before buying it, and cuts the *faux bois* paper, pinning it (and subsequently gluing it) to a sheet of drawing paper. He tells us that his paper sculptures prepared the way for these *papiers collés* (which are referred to in his letters of the time as "drawings"). Picasso returns to Sorgues for about a week in mid-September and sees Braque's *papiers collés.* ("I have to admit," said Braque, "that after having made the *papier collé* [*Fruit Dish and Glass,* p. 38], I felt a great shock, and it was an even greater shock for Picasso when I showed it to him.")[85] Going back to Paris again on or about September 27, Picasso moves into his new studio and begins to work. On October 9, Picasso writes Braque that he is using "*your* latest papery and powdery procedures" (italics added); he is "imagining" a guitar, and is using sand or earth on the canvas. What is essential to note here is that regardless of whether it is cardboard sculpture, sand painting, or indeed *papier collé* that Picasso is talking about in the October 9 letter, he does not refer back to his own exploration of collage, *Still Life with Chair Caning,* but speaks of his new works as related to Braque's "latest . . . procedures." And this is perfectly logical, for neither his cardboard *Guitar,* nor the sand painting *Small Violin* (p. 253), nor what is probably Picasso's first *papier collé (Guitar and Sheet Music,* p. 32), involves anything of the collage principle as it was defined in *Still Life with Chair Caning.* Picasso's subsequent application of that collage principle to his constructed reliefs, and even to his modeled sculpture, is illustrated by the insertion of an actual upholstery fringe in the wood *Still Life* of 1914, and the use of a real absinth spoon between the bronze sugar cube and glass of *Glass of Absinth* of the same year. In the meantime, Picasso had erected in his studio what might be considered his ultimate Cubist collage: an assemblage, known only from its photograph, which ran the gamut from an abstractly drawn and painted guitarist, through semidetached newsprint arms and hands, to a real guitar, and a bottle and pipe on a table.

To be sure, the collage principle, as we have defined it, was not entirely the property of Picasso. Kahnweiler made much in his writings of Braque's introduction into two still lifes of late 1909–early 1910 of an

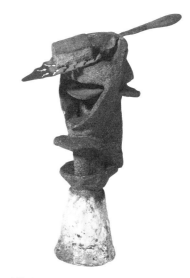

Picasso. *Glass of Absinth.* Paris, spring 1914. (Color plate, p. 323)

40

illusionistically painted nail on which Braque hung his palette (pp. 143, 149). Like many after him, he saw this as Braque's anticipation of that introduction of "reality" he attributed to Picasso's later use of the illusioned chair caning.[86] I think Kahnweiler pressed too hard here, however. It is true that insofar as Braque's nail is drawn integrally, without segmentation or distortion, and casts a "logical" shadow, its old-fashioned illusionism contradicts the schematic and abstract bas-relief illusion of the rest of his picture. But Braque's nail is discreet, to say the least, and can go virtually unnoticed in our experience of his picture. Rather than a subversive insertion of a contradictory order, his nail is a subtle artistic pun, which draws attention to the premises of his Cubist style by alluding to what it is not.

Assemblage mounted in Picasso's studio at 242, boulevard Raspail, early 1913, including figure composition in progress, newspaper, guitar, table, and still-life objects. Daix 578. No longer extant

Eyewitness Accounts

Such are the kinds of complex, intimate exchanges and transpositions between the two artists that can be deduced from some of their work of one key year. But beyond what may be intuited from the permutations of Picasso's and Braque's particular works, it is hard to imagine that the actual terms of their dialogue will ever be known. Critics and art historians who expect verbal revelations about the nature of Cubism from the Picasso/Braque correspondence are in for a disappointment. Braque foresaw the problem. Late in life he observed: "During [the Cubist] years, Picasso and I said things to one another that will never be said again . . . that no one will ever be able to understand . . . things that would be incomprehensible, but that gave us great joy. . . ." "All that," he insisted, "will end with us."[87] During the years of their dialogue, the two painters maintained an absolute public silence concerning their art; their later remarks on Cubism were rare, fragmentary, and occasionally contradictory. Braque characteristically declined publishing a statement in 1909, asserting that he hoped his ideas were "sufficiently expressed in my canvases";[88] for his part, Picasso typically eluded the problem, telling a 1911 interviewer, "il n'y a pas de cubisme," and excusing himself on account of his monkey, El Mono, who was hungry.[89] It is not surprising, therefore, that although Cubism benefits from the largest bibliography by far of any artistic movement in the twentieth century, there are still aspects of its formation about which we know little.

In part because Picasso and Braque left the field open to speculation by insisting that their work speak for itself, and in part because opportunities to view their work together throughout all the stages of prewar Cubism have been lacking, critical and art-historical discourse on their interaction in the movement's evolution has often been disputatious. Indeed, nothing could be more contradictory than the views of the handful of eyewitnesses who wrote about it. Even when limiting ourselves to eyewitness testimony actually published during the six-year period of Picasso's and Braque's closeness (1908–14),[90] we

already find this to be the case. The poets Guillaume Apollinaire and André Salmon—both familiars of Picasso's studio well before the artist met the then Fauvist Braque in the spring of 1907—largely discount the Frenchman's contributions to the language of Cubism.[91] A quite different perspective is offered, however, by Ardengo Soffici, the only painter friend of Picasso to write on Cubism at the time. (Although the painters Jean Metzinger and Albert Gleizes wrote frequently on Cubism, they were not close to either Picasso or Braque and had little access to their studios—an access that was especially important after the Indépendants of 1909, when Braque joined Picasso in not showing in the Salons. Thereafter, with rare exceptions,[92] the work of the two pioneer Cubists could be seen publicly in Paris only in very limited numbers, and sporadically at that, in the installations at Kahnweiler's little gallery in the rue Vignon.)[93]

Although Apollinaire became friendly with Braque very early on, and wrote about him favorably on a number of occasions, the basic roles he assigns Braque in the formation of Cubism are as "verifier"—which implies "the idea of a second, not to say secondary" elaboration of the style[94]—and as "teacher," the disciple who first publicly spreads the gospel of Cubism. The "inventions" of Picasso, wrote Apollinaire in 1912, "were corroborated by the good sense of Georges Braque, who as early as 1908 showed a Cubist picture in the Salon des Indépendants. . . ."[95] A year later, Apollinaire added that Braque "has verified all the new innovations in modern art. . . . He has taught both viewers and artists the aesthetic use of forms so unknown that only a few poets have been able to grasp them."[96] Braque's role, Apollinaire tells us, "was heroic" and his art "calm and splendid. . . . He is a serious craftsman, expressing a beauty full of tenderness, and the pearly luster of his pictures pleases our senses like a rainbow."[97]

While Apollinaire always published admiring (if often also florid and vague) words about Braque, he was more critical in private. In a 1911 letter to Soffici, who had described both Picasso and Braque as founders of Cubism and had championed them to the detriment of the Cubists showing in the celebrated

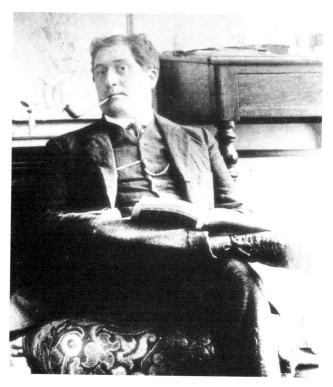

Guillaume Apollinaire, photographed by Picasso, 1910

Indépendants of that year, Apollinaire demeaned Braque's role, arguing that the Salon Cubists were comparatively more original because Braque "owes a good deal more to Picasso than they do."[98] He also gave Soffici a list of the five most important contemporary painters, which omitted Braque (though it included Raoul Dufy and Marie Laurencin). A month later, in response to Soffici's reply, Apollinaire wrote: "Don't you think that for a new artistic conception to impose itself, it is necessary that mediocre as well as sublime things be made? In this manner one can measure the breadth of their [the sublime things'] beauty. It is for that reason, and for the benefit of great artists like Picasso, for example, that I support Braque and the [other] Cubists in my writings. . . ."[99]

A not dissimilar view of Braque as the first to make public a Cubism actually invented by Picasso comes through in Salmon as well. His Braque is a "fervent disciple of Picasso"—not, however, without his own "brilliant qualities"[100]—who "if he did not invent Cubism, popularized it, after Picasso but before Metzinger."[101] In Salmon's 1912 "Anecdotal History of

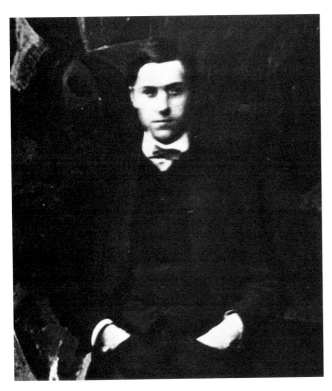

André Salmon, photographed by Picasso, winter 1907–08

Ardengo Soffici, c. 1914

Cubism," Braque is described as "borrowing directly from Picasso, even though there was occasionally room in his work for a modest expression of his [own] sensibility. Later, he was to follow [Picasso] respectfully, step by step. . . . Picasso composed a new palette of gray, black, white, and green which, adopted soon after by Braque, became that of all the Cubists."[102] Salmon's Braque does, at least, have discussions with Picasso, "to which he brought useful clarifications, full of savory details *de métier.*"[103]

The earliest description of Cubism as something of a joint venture of Picasso and Braque, Soffici's long article of 1911 in *La Voce,*[104] has been virtually overlooked in the literature.[105] And yet, though less revealing historically than Kahnweiler's subsequent essays (it was written before the invention of collage and Synthetic Cubism), its characterization of Analytic Cubism as a mysterious mental creation deeply tempered by lyricism and poetry rings truer in some ways to the Cubism of 1910–11 than does the later, more formal and philosophical reading of Kahnweiler.

Poet and critic as well as painter, and founding co-editor of *Lacerba,* the leading Futurist journal, Soffici may have met Picasso as early as 1901.[106] He maintained a studio at La Ruche from 1903 to 1906, and returned to Paris in the spring of 1907, and in 1910, 1911, 1912, and 1914 for extended stays. Soffici talked painting with both Picasso and Braque,[107] and his privileged access to Picasso's studio during the formative years of Cubism was no doubt enhanced by his fascination with *Les Demoiselles d'Avignon,* which he alone among Picasso's painter friends admired.[108] Beginning in 1909, Picasso's casual visitors could see less of his work than before. At his tiny quarters in the Bateau-Lavoir, his studio had served as his living room. Despite his turning most pictures toward the wall and covering *Les Demoiselles* with a cloth, more work could be glimpsed there than in Picasso's boulevard de Clichy apartment, where he received friends in a proper salon, only rarely letting anyone enter the studio.

In Soffici's view, Picasso and Braque found their ways into the "complex, difficult, and disconcerting"

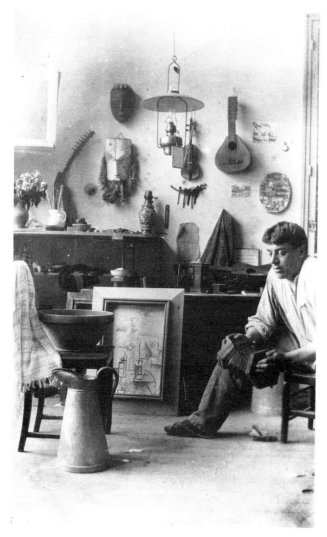

Braque in his studio at 5, impasse de Guelma, c. 1911

ineradicable, and fatal banality and academicism behind triangles and other shapes."

Soffici sketches Picasso's development from the early years of the century into the "African" period, in which "knowing how to appropriate the essential virtues" of tribal art had permitted Picasso to "excogitate them into a new pictorial manner." As Cubism evolves, Picasso presses his analysis beyond the study of volumes to the point at which it becomes "a melodious fabric of lines and tints, a music of delicate tones—lighter or darker, warmer or cooler—whose mystery increases the pleasure of the viewer." Here drawing becomes a "ductile instrument, capable of a thousand shadings of the most subtle and fugitive implications" while taking on the value of a "hieroglyph" with which Picasso "inscribes a lyrically intuited truth" in a manner that recalls "the elliptical syntax and grammatical transpositions of Stéphane Mallarmé."

Soffici is the first to emphasize the role in Cubism of Braque's L'Estaque landscapes of the summer of 1908.[110] Here, the painter's grasp of "the volumetric character" of the motif and his "preoccupation with synthesis" are, he says, already clearly affirmed. In such pictures as *Road near L'Estaque* (p. 89) and *Viaduct at L'Estaque* (p. 95), Braque "focuses his fresh eye on bare, ascetic combinations of nature and man-made forms, penetrates them, and adjusts their contours and refines their shadings" in a manner that achieves "a remarkable breadth and daring." The various motifs, "analyzed and abstracted . . . fuse in a mentally conceived homogeneity and unity."

Soffici's Braque is clearly not the prime mover in the partnership and "lacks the versatility that makes Picasso prodigious," but this is somewhat compensated by the "lovingness, acuity, and delicacy" that suffuse the "prismatic magic" of his 1910–11 pictures. As against the "mute violence" of Picasso's drama, Braque attains a sort of "musical calm, full of lightness, yet nevertheless severe." Braque's "reconstitution of reality" has a "sobriety and an orderly calm" that follow from his perception of "what is permanent and immutable—that is to say, concrete—under the endless flow of movement and light."

art of Cubism by paths that were "if not the same, then very similar," arriving at "an almost common mode of seeing and of expressing themselves." "Together, and without betraying their respective origins," the Spaniard and the Frenchman founded a movement that is "not easy to understand for the moment [1911], but is worthy and capable of a glorious future." Soffici distinguishes their work rigorously from that of the Salon Cubists, who "do not understand even one of the aesthetic concepts that guide Picasso and his colleague." These others[109] have taken up "deforming, geometrizing, and 'cubifying' randomly, without aim or purpose, perhaps in the hope of hiding their innate,

Although D.-H. Kahnweiler and Wilhelm Uhde, both early dealers of Picasso and Braque, published on the relations between the two painters only after 1914, their eyewitness accounts were based on closer day-to-day familiarity with the work and its purely pictorial problems than had been those of the earlier poet-critics.[111] More than Soffici's article, Kahnweiler's "Der Kubismus" (published in 1916 in Switzerland, where the dealer, a German national, was sitting out the war) puts the Cubist Picasso and Braque on a near equal footing. By the time of its writing, the friendship between the two artists had ended by tacit mutual consent. Braque, who had come back from the trenches wounded and trepanned, having received the Croix de Guerre and the Légion d'Honneur, was experiencing a profound mental as well as physical crisis as he tried to find his way back into painting; Picasso was now moving in the more fashionable world of Cocteau and Diaghilev and had begun his "dual-track" imagery.

Kahnweiler minces no words. Picasso and Braque are "the first and greatest Cubists." In the development of the new style, "the contributions of the two were closely intertwined," their paintings "often almost indistinguishable." Cubism is propelled forward by their "intimate [*freundbrüderlich*] conversations" about pictorial ideas that "first one, then the other, applies in his work." The painters' close friendship begins in the winter of 1908 and their "mutual and parallel mental search" is characterized by a "continuous exchange of ideas" that was "maintained in correspondence when they were separated."[112] Two quite different temperaments are nevertheless discernible: "Admittedly, Braque's art is more feminine than Picasso's brilliantly powerful [*genial-stark*] work"; in a metaphor that both poetically and diplomatically implies some primacy on the part of Picasso, the "gracious" Frenchman Braque plays the "gentle moon" to the "austere" Spaniard's "radiant sun."

Kahnweiler's essay reappeared revised and in book form four years later as *Der Weg zum Kubismus*.[113] Here, the treatment of the "founders of Cubism" is made still more even-handed. Omitted from this later

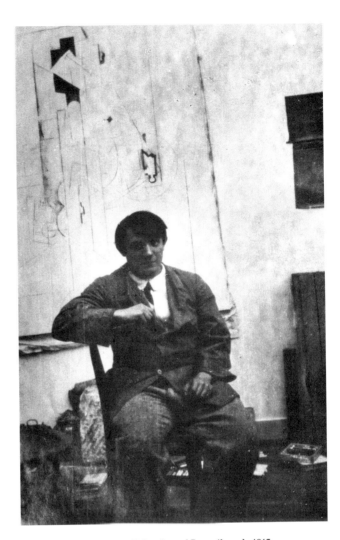

Picasso in his studio at 242, boulevard Raspail, early 1913

version is the suggestion that Braque's art is more feminine; also excised is the not unrelated image of the two as the sun and the moon. Kahnweiler adds to this text that both Picasso and Braque "deserve the credit" for Cubism. "Both are great and admirable artists, each in his particular way." Now Braque's painting is characterized as "tranquil," while Picasso's is "nervous and turbulent"; the Frenchman is "lucid" and the Spaniard "fanatically searching."

Kahnweiler's vision of Cubism as a joint effort was reinforced by Uhde's remarks on Cubism in his 1928 *Picasso et la tradition française*. Collector, critic, and dealer, Uhde had been a regular visitor to Picasso's

studio even before Kahnweiler had appeared on the scene. Indeed, it was Uhde's excited remark to Kahnweiler about a big picture of "Assyrian" nudes on which Picasso was working (*Les Demoiselles*) that first led Kahnweiler to visit the painter's studio in 1907. "Cubism," Uhde insisted, "owes much to Braque." "Hand in hand," he and Picasso "left behind the world of simple appearances and laid siege to another, which had been glimpsed earlier by Cézanne....The two friends worked toward the solution of the same problems, now one, now the other finding the means to achieve seemingly identical goals."[114] But where many saw the results as "indistinguishable," Uhde insisted that they embodied two very different and complementary spirits. For Uhde, Braque's temperament was "limpid, controlled, bourgeois," while Picasso's was "somber, excessive, and revolutionary." To their "marriage of minds" Braque brought "a great sensibility," Picasso "a great plastic gift."[115]

Uhde ultimately identified the differences between Picasso and Braque with the dual heritage of the French tradition. Picasso's Analytic Cubism—"ecstatic, sad, troubling"—is a "vertical and architectural art" that constitutes "the second great manifestation of the Gothic spirit in France."[116] From the "imprecise, atmospheric backgrounds" of Picasso's high Cubist pictures emerge scaffoldings that "come together in the foreground as Gothic structures." In Braque, "an epigone of Latin, classical art" who "continues the noblest line of the French tradition," Cubism is "horizontal and earthly." The "appropriate means" of that "horizontality" is Braque's emphasis on "the picture surface." As against Picasso's love of spatial architecture, Braque emphasizes the picture plane and labors to make it "tangible" (stenciled letters, sand, and so forth). At the same time, Braque "has a particular musicality in his blood" whose "accents were known earlier to Chardin and Corot."

The perspectives of Kahnweiler and Uhde are related in that they assimilate pioneer Cubism, not un-Germanically, into large, binding, and philosophically rooted visions of a critical and art-historical order; they differ primarily in that Kahnweiler thinks

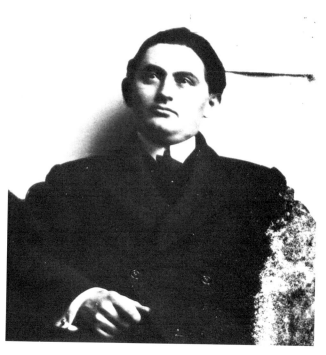

Daniel-Henry Kahnweiler, photographed by Picasso, winter 1910–11

in terms largely established by Konrad Fiedler while Uhde's ideas recall those of Wilhelm Worringer. Their views of the Picasso/Braque relationship as an essentially collaborative effort provide, together with that of Soffici, a clear alternative to the history suggested by Picasso's poet-critic friends.

Of these two groups of firsthand witnesses, art history has generally opted for the view represented by Kahnweiler, Soffici, and Uhde.[117] If Apollinaire and Salmon were discounted, it may be because their writings were widely scattered and, hence, less known (at least outside France), or because they were thought unduly swayed in their attitudes by their close friendships with Picasso in the years prior to Braque's appearance on the scene, or perhaps because it was suspected that they ultimately located Picasso's real greatness more in such Blue- and Rose-period masterpieces as *La Vie, Family of Saltimbanques,* and *Boy Leading a Horse* than in his Analytic Cubism. Certainly, most commentators believed that the two perspicacious art dealers had a more immediate and better grasp of the pictorial questions at issue in Cubism than had the two poets. Apollinaire was clearly put off by *Les Demoiselles,* and did not discuss

Picasso's Cubist work until some six years later.[118] He wrote the preface to the catalogue of Braque's November 1908 exhibition at Kahnweiler's, and although he remained friendly thereafter, he was uncomfortable with Braque's Analytic Cubism.[119] Salmon alone of Picasso's poet friends celebrated *Les Demoiselles,* but it marked the moment of his greatest closeness to the artist. Thereafter he appears to have frequented Picasso's studio less, as is suggested by his 1912 "Anecdotal History of Cubism," in which he was mistaken about the number of figures in *Les Demoiselles,* confusing the painting at one point with *Three Women,* and made uncertain and contradictory remarks about Analytic Cubism.[120]

By the time Cubism got under way in 1908, Picasso had already mastered at least five different manners and was a famous vanguard painter, whereas only some two years of Fauve painting separated Braque from his student work. Picasso already had an established market, his work selling for much higher prices than Braque's, a distinction that remained in force throughout the years of Cubism, during which Kahnweiler paid Picasso roughly four times more per picture than he paid Braque.[121] Given this context, it is not surprising that in the absence of either closeness to what the two painters were about or real understanding of the new Cubist style, Apollinaire and Salmon should assume that Picasso was virtually its sole author. However that may be, both Picasso and, needless to say, Braque were critical of Salmon's and Apollinaire's writings on Cubism. In a letter of October 31, 1912, Picasso tells Braque that Salmon's book *La Jeune Peinture française* had just appeared, and adds that "it is revoltingly unjust as far as you are concerned."[122] To Kahnweiler he would write the year following, "I have received Apollinaire's book on Cubism and am really depressed by all this chatter";[123] Braque would say of the same book, "Far from enlightening people, it succeeds in bamboozling them."[124] Picasso's view of even the favorable press on Cubism was already manifest in 1911 when, in response to a group of press clippings Kahnweiler had sent him, he expressed his "enormous amusement" at "the truly laughable ideas of our friends."[125]

The Surviving Correspondence

Braque said little, and Picasso even less, about their friendship during the years following its demise. Apart from the comment about their conversations cited above, Braque stressed the frequency of their meetings: "We saw each other every day and talked a lot";[126] "We compared our ideas, our paintings, and our techniques. What occasionally set us against each other was always quick to bear fruit for both of us. Our friendship, therefore, always turned a profit. . . . It was a union based on the independence of each."[127] But it was also based on interdependence, and Braque expressed this, as well as the precariousness of their quest, in an image of Picasso and himself as "two mountaineers roped together."[128] As far as Picasso was concerned, aside from his admittedly snide and often inadequately understood reference to Braque as "ma femme,"[129] we have just Françoise Gilot's recollection of his saying: "Almost every evening, either I went to Braque's studio or Braque came to mine. Each of us *had* to see what the other had done during the day."[130] The remarks of Braque and Picasso about the frequency of their meetings no doubt characterize more accurately the period 1910–12 than the two years previous, or the year preceding the outbreak of the war, when their dialogue was less intense. And they obviously apply only to the periods when the painters were together, in Paris or the provinces, for the two were separated geographically during thirty-two of the sixty-nine months between the beginning of their closeness in autumn 1908 and its ending with Braque's call to arms in summer 1914 (for details, see the chronological outline, pp. 336–39).

If the comments cited in the above paragraph leave any doubts as to the actuality of a meaningful dialogue between the two painters,[131] they should be dissipated by their surviving correspondence (which must be studied in tandem with their letters to Kahnweiler). Unfortunately, the bulk of the Picasso/Braque correspondence is apparently lost, although in preparing this catalogue we have been permitted limited but significant access to what remains.[132] This nevertheless provides sufficient indication of how much the

two painters prized their companionship and discussions. Although the surviving letters contain a few fascinating references to methods and techniques, they reveal nothing of the painters' intimate dialogue on art, none of those words that Braque said "no one will ever be able to understand," which were doubtless pronounced while the two discussed their pictures together after having worked separately. Indeed, in a letter of May 30, 1912, Picasso notes (in his typical telegraphic and unpunctuated manner) that he cannot write about their conversations on art: "Je ne peux pas ecrire [sur nos] discutions d'art."[133]

Nothing has been preserved of Picasso's correspondence with Braque during the earlier years of their friendship, and even the extant group of nineteen letters and one postcard in the Laurens Archives spanning the period July 16, 1911–April 23, 1913, is probably incomplete. Despite this, Picasso's concern for their friendship and his interest in their art talk come through clearly. "... and it's promised that you're coming here—don't forget. I've much to tell you," he writes Braque from Céret in 1911;[134] "Tell me when you're coming ... and give me news of [your] painting," he follows up.[135] "It's a long time since you've written. You're not sick, I hope."[136] "I await your letters and you know how pleased I am to have news of you"; a day later, "I miss you, what's happened to our walks and our exchange of feelings. ... Write me and I'll write you often";[137] two weeks later, "I'm not writing to anyone but you and K[ahnweiler] on business and I'm only taking letters from you and I'm very happy when you write me[, as] you know well"; "You'll tell me what you think above all of the largest [picture] with a violin—intentions that you've surely understood."[138] On April 23, 1913, in the last of Picasso's preserved letters, he salutes Braque's name day and complains, "It's really sad that the telephone in Paris doesn't reach Céret"; had that been the case, "what good art talk" they would have had.[139]

A similar picture of the painters' friendship emerges from the Picasso/Kahnweiler correspondence that has been preserved.[140] Picasso is "deeply touched" by a letter (now lost) from Braque, he writes Kahnweiler, "and you know how fond I am of

him. ..."[141] "Tell Braque that I've written him and that he should write and tell me when he thinks he'll come see me ...";[142] "... I've received his letter [Braque's] and he speaks very highly [of my] paintings ...";[143] Picasso apologizes to Kahnweiler for not having written, "but Braque and I have had so many walks and conversations about art that the time has passed [quickly]."[144]

What has been found of Braque's correspondence with Picasso (now in the archives of the Musée Picasso, Paris) is even more fragmentary, consisting of only five letters and fifteen postcards, some of the latter containing but a single word such as "salut" or "bonjour." References in Picasso's and Kahnweiler's letters from the period during which correspondence has been preserved identify at least ten letters of that time from Braque to Picasso that must be considered lost, though more are no doubt missing, especially from the years during which we have little or nothing. The earliest of Braque's extant communications, a postcard, "greetings to you and our friends," dates from August (or perhaps early September) 1907. The two artists had met in the spring of that year and probably exchanged studio visits then. While nothing of Picasso's correspondence to Braque prior to 1911 is preserved, a reminder in one of Picasso's spring 1907 sketchbooks—"write to Braque"—suggests that it began at that time.

Braque's extant letters are more reserved than Picasso's. He signs himself "G. Braque" or "G. B.," addressing Picasso as "Mon cher ami." The closing "Je t'embrasse" is reserved for his letter of condolence on the death of Picasso's father. In 1907–08, Picasso is "vous," which he continues to be into early 1910 (nothing remains from 1909). Picasso addresses Braque as "Mon vieux," "Mon cher Braque," "Mon cher ami," and always signs "Picasso," preceded by "bien a toi," "Je te embrasse," "vale," and "ton pard." The letter of July 10, 1912, in which he describes transforming a "bonhome" into an "aficionado ... avec sa banderille a la main ... [et] une geule bien du midi" (*The Aficionado*, p. 239), is signed "Ton Picasso, artiste peintre espagnol."

Here and there Braque's and Picasso's letters to one

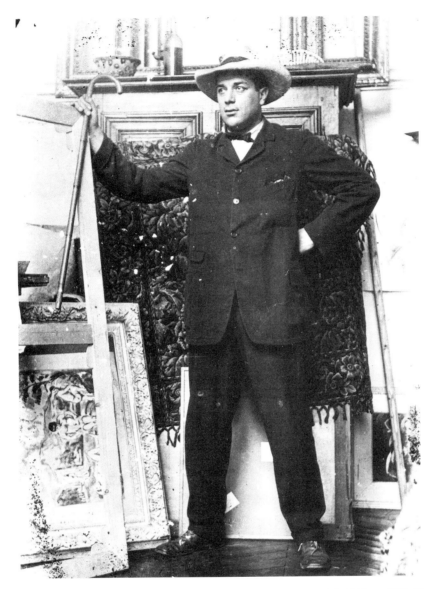

Braque, photographed by Picasso in the latter's studio at 11, boulevard de Clichy, c. 1909–10. At left, Cézanne's lithograph *Large Bathers* (Venturi 1157); at right, Picasso's *Female Nude in Profile* (Daix 165)

another and to Kahnweiler contain remarks about methods. "For the new canvas [the *Accordionist,* p. 25]," Picasso writes Braque on July 25, 1911, the procedure involves "very thinned out pigment to start with and [then] the methodical technique of the Signac type [with] scumbling only at the end."[145] In the late summer of 1912 Braque writes Kahnweiler about a large picture of a woman, now lost, "in which I began painting with sand."[146] A month or so later, as we have already seen, Picasso tells Braque, "I am using

your latest papery and powdery procedures. . . ."[147] For the most part, however, the letters of the two painters are given over to casual information about the weather, comings and goings, meetings with friends, and other day-to-day events. Neither writes reflectively. Nothing about political or social events, or about the economy, can be found in what we have seen of the extant letters.[148] The only books mentioned are Salmon's, Apollinaire's, Soffici's,[149] and that of Gleizes and Metzinger.[150]

Advance-publicity poster for French tour of Buffalo Bill Cody's "Wild West" show, 1905

Picasso's letters to Braque, and, on occasion, the two artists' letters to Kahnweiler, contain references or clues to shared interests that give something of the flavor of their friendship. ("We're doing a lot of cooking together," Braque writes Kahnweiler, humorously extolling Picasso's "white garlic.")[151] When Picasso signs himself "ton pard," short for the cowboy "pardner," he is recalling his and Braque's love of "Le Far West," in particular Buffalo Bill, whose adventure novels both read avidly. These stories almost invariably emphasized what would now be called male bonding and featured a young man Buffalo Bill called "Pard." (Such bonding, as an aspect of the artists' friendship, is also implicit in the nickname Wilbourg and their sense of being inventor-brothers.) Some of Braque's French editions of the Buffalo Bill novels (which had been ghostwritten by Ned Buntline and others and signed by Cody) are still preserved in the Laurens Archives, and it may be that the PARDO below the word COW-BOY in his *Checkerboard: "Tivoli-Cinéma"* (p. 298) is an allusion to these. Picasso's interest in Colonel Cody, whose books helped fuel the artist's lifelong curiosity about the frontier mentality of America, is reflected in his *Buffalo Bill,* one of only six portraits he painted during the seven years of prewar Cubism.[152] In a communication to Kahnweiler, Picasso mentions a letter from a young American girl whose family name he had understood as "Bill"; "es ce la fille de Bufalo Bill?," he asks.[153] While

it is possible that Picasso could have seen one of the Paris performances of Cody's "Wild West" show in Paris in 1906, it is certain that he would have known its popular posters; and it is probable that aside from inspiring the Cubist portrait, these images are at the origin of his sometimes bison-headed minotaur of the thirties.[154]

The letters of the two painters remind us, in their references to costume, of a certain dandyism, especially, as we know from other sources, on Braque's part. (He favored "suits of Roubaix cloth that were rejects from America," said Salmon in a squib describing Braque as a "dandy in his own fashion.")[155] Both artists were very particular about the outfits in blue cloth that they bought at La Belle Jardinière and nicknamed "Singapores." Shortly before Braque was to come south in the summer of 1912, Picasso wrote him asking that he pick up another of these costumes for him, giving him the size number and explaining

French edition of the dime novel *Buffalo Bill's Boy Pard,* published c. 1907–09

Picasso. *Buffalo Bill.* Paris, [spring 1911]. (Color plate, p. 185)

the necessary alterations with the aid of two sketches. Hats were a big topic. Braque had begun to wear a Kronstadt, or "melon" hat, in the fall of 1908, in honor of Cézanne, who wore them in a few self-portraits; shortly thereafter, Picasso would enshrine Braque's Kronstadt in his painting *Still Life with Hat (Cézanne's Hat)* (p. 114).[156] Picasso's *Man with a Hat* (p. 146), painted about a year later, though not intended as a portrait of Braque, was nevertheless so nicknamed by the two. When Braque sent Picasso some hats from Paris in the early summer of 1911, Picasso wrote, "I've finally received the hats and what a surprise," and told Braque how he had tried them on with Manolo, using false moustaches: "you can't imagine how much I laughed, above all in the nude. . . ."[157]

Afterwards

The war brought the Picasso/Braque intimacy to an effective end. Braque's massive head wound and protracted convalescence not surprisingly left him a changed man. Though the two got together from time to time in subsequent years, it is not difficult to understand what Picasso meant when he told Kahnweiler later in life that after seeing Braque off at the Avignon station in August 1914, he never saw him again. Picasso too had changed a great deal during 1915–16. His loneliness and unhappiness in wartime Paris, where a young man out of uniform was suspect, were compounded by the death of his companion, Marcelle Humbert (whom he called Eva, "ma jolie"), and led to a profound morosity. So far as we know, Picasso did not bestir himself to visit the ailing Braque during his convalescence in Sorgues in 1916, nor is there any evidence that Braque encouraged him to.

It was, evidently, clear to both Picasso and Braque that their dialogue, already somewhat diminished in 1913–14, could not survive the different situations in which they found themselves after the enforced separation of Braque's military service. Beyond their difference in temperament, and the fact that they no longer shared the same pictorial problems, their alienation was intensified by differing strategies vis à-vis a changed Paris art world as well as wholly different perspectives on French wartime and immediate postwar society. Braque may well have been deceived by Picasso's search for solutions outside Cubism, and seems to have believed—nor was he alone in this—that beginning in 1914 Picasso bent his work to the tastes of chic new patrons and friends. Already on the eve of the war, this critique was perhaps adumbrated in his remark to Kahnweiler, "Picasso is frequenting the cream of Avignon society."[158] In 1919, he would allude to what he considered Picasso's falling off in a letter to Kahnweiler, then still in Switzerland. "Picasso has created a new genre called 'Ingresque,'" wrote Braque of the mode Picasso was using largely for his ballet-world images and mondain portraits. "What is really constant in this artist," Braque continued coldly, "is his

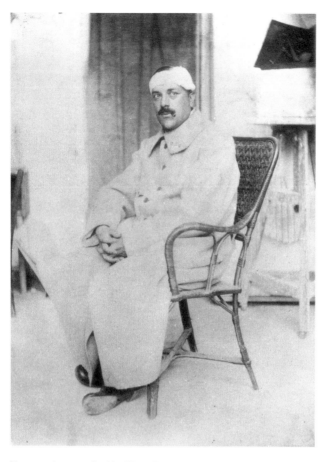

Braque, photographed by Henri Laurens in Laurens's studio, 1915

propre, it cannot have been easy to be taken so widely as the junior, indeed secondary, partner in the Cubist venture (although Picasso himself clearly did not treat him that way). Nor could it have been easy, despite Picasso's commiseration, to swallow the one-sided versions of Cubism's formation published by Salmon and Apollinaire. And no matter how much Cézanne had taught Braque about the importance of conception and invention as over and against talent, the ease and speed with which Picasso often realized his pictures—the sheer facility of his hand—could well have left the slower and more effortful Braque somewhat envious. But the alienation between the two painters also reflected, especially on Braque's side, a new and sharper sense of national differences engendered by the war. We have Braque's word that these "didn't count for anything" in his prewar friendship with Picasso. "Despite our very different temperaments, we were guided by a common idea." But "as was clear later," Braque continued ominously, "Picasso is Spanish, I am French; we know all the differences that implies."[160] That Braque may have been in the grip of something resembling xenophobia during the immediate postwar years is suggested by a note jotted down by Kahnweiler following a February 1920 visit to his studio; it concluded, "Against Picasso, virtuoso; practitioners not French."[161]

The image of Picasso that emerges from his correspondence with Braque is more sympathetic and considerably less egocentric than that of the Picasso we know from later years, and appears free of the constant sense of rivalry that marked their meetings as older painters.[162] To be sure, the epistolary Picasso is but a portion of the man, and if his letters contain none of the competitiveness, none of the witty verbal jabs he sometimes reserved for his close friends, nothing says they were absent from his relationship with Braque. Even so, it remains that Cubism is the only period in which Picasso shows more than a passing involvement with the work of another artist. And the only one in which he participates in a sustained interchange of both an emotional and a pictorial nature. It is also a period in which Picasso seems somewhat less sure of himself than he later

temperament. Picasso remains for me what he has always been, a virtuoso full of talent. . . ."[159] From an artist who profoundly identified with Cézanne, nothing could have been more damning. Braque's disenchantment was certainly not mitigated by Picasso's refusal to participate in the big Cubist exhibition in the Salon des Indépendants of 1920, which had been mounted to demonstrate the solidarity of painters whose style had been under sharp attack by conservative and jingoist critics since the beginning of the war. There Braque would show side by side not simply with Gris and Léger but with such Salon Cubists as Gleizes, Metzinger, and Auguste Herbin.

Something of Braque's bitterness may have been due to the emergence of sentiments that had had to be repressed during the years of his collaboration with Picasso. For a man of Braque's considerable *amour*

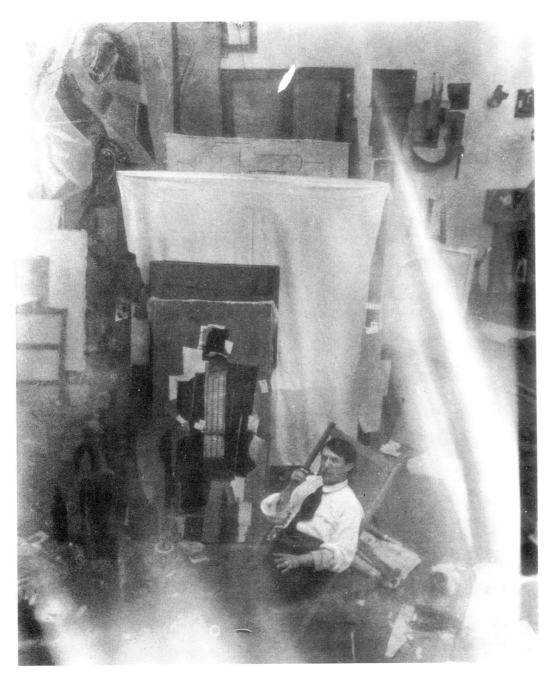

Picasso in his studio at 5 bis, rue Schoelcher, 1914–16

would, when he would only "find," and not "search." He could write of his work to Braque in July 1912 that it was "so rare that one is [even] a little sure" ("ce si rare cuant ont et un peu sur").[163] Such confidences, along with references in their correspondence to their walks and discussions, to cooking together, playing with hats, and to such incidents as Braque's waking Picasso one morning with music from a phonograph,[164] suggest that their friendship flourished in a near Eden possible only in that mood of prelapsarian optimism which characterized the vanguard in the years just preceding 1914. With the advent of World War I, that ambience, which has been compared in spirit to that of the Renaissance,[165] was to vanish.

NOTES TO THE TEXT

As in all my Museum publications of recent years, I am deeply indebted here to Judith Cousins, Curator for Research of the Department of Painting and Sculpture, for work done on my behalf.—W.R.

1. That Picasso was well aware of Leonardo's definition of painting as *cosa mentale* is indicated by his remark to Françoise Gilot: "Leonardo came nearer the truth by saying that painting is something that takes place in your mind…" (cited in Françoise Gilot and Carlton Lake, *Life with Picasso* [New York: McGraw-Hill, 1964], p. 284). Picasso goes on to say that Leonardo's definition is incomplete and, invoking Cézanne, who had characterized his own pictures of the 1860s as *couillard*, adds that a painter has also to paint "with [his] balls."

2. See William Rubin, "From Narrative to 'Iconic' in Picasso: The Buried Allegory in *Bread and Fruitdish on a Table* and the Role of *Les Demoiselles d'Avignon*," *The Art Bulletin* 65, no. 4 (December 1983), pp. 615–49.

3. The subject of the large picture with bathers is described in a letter of July 25, 1911, from Picasso in Céret to Braque in Paris; Picasso notes that it remains "to be done" (Laurens Archives; our gratitude to Claude and Denise Laurens; see below, note 132). The "Christ" is mentioned in a postcard to Kahnweiler of August 13, 1911 (Leiris Archives; our gratitude to Messrs. Michel Leiris, Maurice Jardot, and Quentin Laurens; see below, note 140).

For the relation of the "large picture" to the commission for the Field library and the various problems that the project entailed, see Appendix, p. 63.

Picasso's description of the "large picture" as "a stream in the middle of a town with some girls [?] swimming" continues: "and houses with round windows and dark transparent holes [?] full of light[,] round houses and very square houses (but what language)." In the original, the full citation reads: "Mais le grand tableau a faire[.] ce un torrent au miliu de la ville avec de filles [?] nagant et des [these two words written over another] maisons avec des fenetres rondes et des trous [?] noir transparent pleins de lumiere[,] des maison rondes et des maison tres carres (mais quelle langage)[.]"

Quel langage indeed. Given Picasso's poor French, inconsistent hand, telegraphic style, and disdain for punctuation, one cannot be sure of the reading here; therefore the text of this important passage is reproduced in facsimile on this page.

The state of Picasso's French should oblige us to reflect about such statements regarding the artist's supposed reading as have become almost commonplace in art history—suggestions that he "could have read" or "would have read" such authors as Henri Bergson, Lucien Lévy-Bruhl, Marcel Mauss, Bernhard Riemann, and Jules-Henri Poincaré, not to say Albert Einstein. (It is even permitted to wonder just what is meant when we read that Picasso "was familiar" with Mallarmé's poetry.) Picasso's French, as it stood after five to ten years of his living continuously in Paris, makes it obvious that he could *not* have read such authors. In fact, beyond the newspapers, Picasso did not read much at all—and then little but dime novels and poetry, in the latter case mostly the works of his poet friends and their Symbolist precursors. Fernande Olivier, for example, exhibited surprise that Picasso was *au courant* about literary things, since

Passage in a letter from Picasso in Céret to Braque in Paris, July 25, 1911. Laurens Archives. (See note 3)

he "never reads" (Fernande Olivier, *Souvenirs intimes* [Paris: Calman-Levy, 1988], p. 231). Gertrude Stein no doubt exaggerated when, sometime in the early thirties, she chided Picasso on his attempts at poetry writing. Making the point that one cannot write without reading, she said: "Pablo…you never read a book that was not written by a friend and then not then…" (*Everybody's Autobiography* [1937; New York: Random House, 1973], p. 37). Maurice Raynal, perhaps the least biased of our witnesses, noted in 1922 that "there were lots of books at Picasso's…. Detective novels and adventure stories were interspersed with our best poets: Sherlock Holmes and the dime novels of Nick Carter or Buffalo Bill mixed in with Verlaine, Rimbaud, and Mallarmé. Eighteenth-century French literature, which [Picasso] liked a lot, was represented by Diderot, Rousseau, or Restif de La Bretonne" (*Picasso* [Paris: Crès, 1922], pp. 52–53). Nowhere, however, can one find the least indication that Picasso read in science, history, anthropology, or any other humanities or social sciences, though he no doubt absorbed his era's studio talk—including catchwords drawn from science or philosophy (e.g., the "fourth dimension") that may be compared to the "Existentialism" and "Zen" of Abstract Expressionist studios, which Meyer Schapiro likened to "night-school metaphysics." Picasso always insisted, in any case, that Cubism had nothing to do with ideas deriving from the above-mentioned disciplines.

4. Picasso's remark is cited in Daniel-Henry Kahnweiler, *Juan Gris: His Life and Work*, trans. Douglas Cooper (New York: Abrams, 1969), p. 168.

5. The rendering of Braque's "très concentrés" (cited in Dora Vallier, "Braque, la peinture et nous," *Cahiers d'art* 29, no. 1 [October 1954], p. 14) is not easy. I should say, "We were, above all, highly focused." But also implied is that the two painters were "very together," that is, very apart from the rest of the community of artists.

6. Raynal, *Picasso*, p. 68. Cited in Guillaume Janneau, *L'Art cubiste* (Paris: Éditions d'Art Charles Moreau, 1929), p. 14.

7. "Chez les cubistes, I," *Bulletin de la vie artistique* 5, no. 21 (November 1, 1924), p. 485.

8. The fifteen Braque drawings included in the present exhibition are virtually all that remain. According to Claude Laurens (Braque's heir and the son of Braque's dear friend the sculptor Henri Laurens), the artist destroyed a large number of essentially notational sketches in very small format.

9. Letter of November 6, 1911, from Braque in Céret to Picasso in Paris (Archives of the Musée Picasso, Paris). I had originally thought the picture in question here to have been the Tate Gallery's *Clarinet and Bottle of Rum on a Mantelpiece*, but its size does not correspond to the "60 figure" Braque mentions in his letters. The only 60 figure work of that period that contains a fireplace is *Still Life with a Violin*.

Our thanks to M. Pierre Georgel of the Musée Picasso, Paris, and the heirs of the painter for access to Braque's letters to Picasso in the Musée Picasso's archives. M. Georgel will be preparing an annotated edition of the Picasso/Braque correspondence (see below, note 132).

10. Letter of July 10, 1912, from Picasso in Sorgues to Braque in Paris (Laurens Archives).

11. In 1913, for example, the first full year in which the two artists were making *papiers collés*, Picasso executed some thirty-four of them and Braque around twenty-six, a ratio of roughly four to three.

12. In his letter of July 9, 1912, from Sorgues, to Kahnweiler in Paris, Picasso says, "You did well to have Boischaud sign my recent Céret pictures" (Leiris Archives).

13. Daniel-Henry Kahnweiler, with Francis Cremieux, *Mes Galeries et mes peintres: Entretiens avec Francis Cremieux* (Paris: Éditions Gallimard, 1961), p. 58.

14. Brassaï, *Conversations avec Picasso* (Paris: Éditions Gallimard, 1964), p. 86. Picasso is cited saying of signatures on the front of Cubist canvases that they "would have disturbed the composition."

15. Kahnweiler, *Juan Gris*, p. 124. Also see Daniel-Henry Kahnweiler, "Naissance et développement du cubisme," in *Les Maîtres de la peinture française contemporaine*, ed. Maurice Jardot and Kurt Martin (Baden-Baden: Editions Woldemar Klein, 1949), p. 18: "They [Picasso and Braque] attempted, at least at that time, to eliminate all 'personal handwriting,' and sought the greatest possible anonymity in the handling of the brush. The very great resemblance between the work of Braque and Picasso dating from this period is not fortuitous."

16. Gilot and Lake, *Life with Picasso*, p. 75.

17. Georges Braque, "Against Gertrude Stein," *Transition*, no. 23 (July 1935), Supplement pp. 13–14. One of a series of critical commentaries concerning Gertrude Stein, this text by Braque was a translation from a French original that apparently no longer survives.

18. Cited in Vallier, "Braque, la peinture et nous," p. 18.

19. André Chastel, "Braque et Picasso, 1912," in *Pour Daniel-Henry Kahnweiler* (New York: George Wittenborn, 1965), pp. 80–86. Chastel states that the "workers' outfits" worn by Picasso and Braque "demonstrated their…wish to be 'manual laborers' [*d'être des 'manuels'*]. The painter declared that he was nothing more than a worker, a maker of objects, albeit of a somewhat particular type."

20. André Salmon, *Souvenirs sans fin: L'Air de la Butte* (Paris: Les Éditions de la Nouvelle France, 1945), p. 69.

21. André Salmon, *La Jeune Sculpture française* (Paris: Société des Trente, Albert Messein, 1919), pp. 13–14.

22. Letter of June 17, 1912, from Picasso in Céret to Kahnweiler in Paris (Leiris Archives): "Vous me dites que Uhde ne aime pas les tablaux derniers de moi ou il i a du Ripolin et des drapeaux peuetre nous arriverons a degouter tout le monde et nous ne avons pas tout dit…"

23. Carl Einstein, *Georges Braque* (Paris: Éditions des Chroniques du Jour, 1934), p. 101 and passim.

Except for its occasional appearance in bibliographies, Einstein's long monograph on Braque has been entirely overlooked, to the best of my knowledge, in the literature on Cubism. This is all the more surprising since—despite its occasional Marxist clichés, its disorganized character, and its repetitiousness (not to say logorrhea)—it contains some brilliant insights that one would have thought worthy of interest (especially to Marxist scholars, who often pursue a path much narrower and less interesting than Einstein's in the matter of Cubism).

It is possibly to Einstein that we owe the identification of Cubism before and after *papier collé* as "Analytic" and "Synthetic," though these terms had long been used to describe successive phases of a single creative act. Apart from a passing use of "Analytic" by Juan Gris to describe his own earlier work (see Kahnweiler, *Juan Gris*, p. 117), the earliest use I know of these two terms in their present art historical sense is found in an outline of Cubism in an issue of *Documents* (2, no. 3 [1930], pp. 180–82). The suggestion that Einstein wrote the outline was first made, to my knowledge, by Lynn Gamwell (*Cubist Criticism* [Ann Arbor: UMI Research Press, 1980], p. 106). Einstein, who was one of the regular contributors to *Documents*, and who had earlier published there his "Notes sur le cubisme" (1, no. 3 [June 1929], pp. 146–59), probably worked up that unsigned out-

line in collaboration with his close friend Kahnweiler.

24.　The *bleu mécano* costume is mentioned by André Salmon in *Souvenirs sans fin*, p. 67; Kahnweiler (*Mes Galeries et mes peintres*, p. 122) mentions Braque's "blue outfits" that were "very simple, but of an entirely special cut." These were probably the "costumes 'Singapour,'" ordered from La Belle Jardinière, one of which Picasso (in a letter from Sorgues, July 10, 1912; see Documentary Chronology under that date) asks Braque in Paris to purchase for him, giving measurements.

25.　Kahnweiler, *Mes Galeries et mes peintres*, p. 57.

26.　Salmon, *Souvenirs sans fin*, p. 82.

　　Kahnweiler (*Juan Gris*, p. 215, note 161) also reports: "Picasso did, as a matter of fact, entertain the idea in about 1911 [*sic*] that objects should be so represented in a picture that any technician could manufacture them" (in that form, presumably).

27.　For a discussion of Braque's wit, see Alvin Martin, "Georges Braque and the Origins of the Language of Synthetic Cubism," in *Braque: The Papiers Collés*, ed. Isabelle Monod-Fontaine with E. A. Carmean, Jr. (Washington, D.C.: National Gallery of Art, 1982), pp. 61–85, and Mark Roskill, *The Interpretation of Cubism* (Philadelphia: Art Alliance Press, 1985), pp. 70–77.

28.　Discussed in John Golding, *Cubism: A History and an Analysis, 1907–1914* (1959; London: Faber & Faber, 1968), pp. 47–95.

　　Despite its early date, Golding's primarily formal comparison of Picasso and Braque, the first in-depth treatment of the rapports between the two painters, contains a wealth of illuminating insights and remains an absolute *sine qua non* for all serious students of Cubism.

29.　See the next section of the text: "The Transition of 1912: Paper Sculpture, Collage, and *Papier Collé*."

30.　Daniel Henry [D.-H. Kahnweiler], *Der Weg zum Kubismus* (Munich: Delphin Verlag, 1920), p. 27.

31.　"...j'aime surtout la peinture" (statement by Braque in "Chez les cubistes, I," p. 481).

32.　"Rencontre dans l'atelier parisien," interview with Georges Braque, in André Verdet, *Entretiens, notes et écrits sur la peinture: Braque, Léger, Matisse, Picasso* (Paris: Éditions Galilée, 1978), p. 13.

33.　For further discussion of Picasso's analogy of musical instruments and human anatomies, see Rubin, *Picasso in the Collection of The Museum of Modern Art* (New York: The Museum of Modern Art, 1972), p. 82, and Werner Spies, "La Guitare anthropomorphe," *La Revue de l'art*, no. 12 (1971), pp. 89–92.

　　Picasso's art, in later 1912 and in 1913 in particular, is full of such studies as the Museum's to which I have sent the reader above, in which the artist transforms the pegs or other parts of musical instruments into *personnages*. One of the most extraordinary of such metamorphoses converts the fingerboard of the violin into a long, almost equine face. Already in the superb charcoal drawing of a violin of early spring 1912 (p. 232), the fingerboard seems to be detaching itself somewhat from the rest of the instrument, and has been truncated so that it does not terminate in a scroll. The independence of this form, here still aligned vertically with the rest of the instrument, increases in certain notebook studies of later 1912, and its shape tends to the condition of an autonomous sign, albeit of equivocal character. By early 1913, in the paper construction Picasso gave Gertrude Stein, *Guitarist with Sheet Music* (p. 282), this sign, inverted, stands for the face of the female musician, while shapes derived from the body (sound box) of the instrument— here a guitar—stand for the outer contours of her head, or her wavy hairdo. Picasso also imaginatively uses the latter form, with extraordinary economy, to represent both the shoulders and breasts of the player—as well as, of course, for the guitar itself. The form that had once been the fingerboard of the violin or guitar returns, not infrequently, as in the large, heretofore unpublished drawing of a head on newsprint (p. 287).

34.　Martin ("Georges Braque and the Origins of the Language of Synthetic Cubism," pp. 65–68) considers the "baffling image" (Picasso's *Man with a Hat*, p. 146) a "sympathetic portrait [of Braque] done in a clever spirit of caricature." Picasso told Pierre Daix, however, that this man in a bowler hat was not Braque, and had been "painted without a model." "It was later," said Picasso, "that Braque and I pretended it was his portrait. He wore a hat a little like that" (Daix, *Le Cubisme de Picasso: Catalogue raisonné de l'oeuvre, 1907–1914* [Neuchâtel: Éditions Ides & Calendes, 1979], p. 253, entry 330).

35.　Robert Rosenblum (*Cubism and Twentieth-Century Art* [New York: Abrams, 1960], p. 64) and Golding (*Cubism*, pp. 92–93) imagine—and many, including myself, have agreed with this reading—that the accordionist of Braque's *Portugais* is sitting inside a sailors' bar. But Braque described the subject as "un émigrant italien sur le pont d'un bateau avec le port comme fond..." in an undated letter, written from Céret to Kahnweiler in Paris, which can be situated in late September–early October 1911 (Leiris Archives).

36.　Patricia Leighten (*Re-Ordering the Universe: Picasso and Anarchism, 1897–1914* [Princeton, N.J.: Princeton University Press, 1989], p. 116) reads a "domed [Kronstadt] hat" into Picasso's *Accordionist*, which she believes, therefore, strongly suggests an image of Braque. But Picasso describes the *Accordionist* as "une jeune fille avec un accordeon" in his letter of July 25, 1911, from Céret, to Braque in Paris.

37.　For the various titles of Picasso's *Still Life with Liqueur Bottle*, and a sketch of the iconography of it made for this author by the artist, see Rubin, *Picasso in the Collection of The Museum of Modern Art*, pp. 62, 204.

38.　John Richardson, *Georges Braque* (London and Harmondsworth: Penguin, 1959), p. 26.

39.　See Chastel, "Braque et Picasso, 1912," p. 83. Chastel was the first, I believe, to use the image of the "joker"—a particularly apt word as regards Picasso—in describing the artist's frequent insertion of an "element outside the system."

40.　Vallier, "Braque, la peinture et nous," p. 16. Golding (*Cubism*, pp. 84–85) was the first to underline this distinction.

41.　Edward Fry in his probing comparison of Braque's and Picasso's Cubism ("Braque, Cubism and the French Tradition," in *Braque: The Papiers Collés*, pp. 45–51) goes so far as to summarize "the interaction of Braque and Picasso" as "nothing less than the confrontation of the principles of reduction and invention." As comparative terms, I would myself prefer to pair the word "reduction" with "imagination" or "fantasy" rather than "invention," inasmuch as reductiveness, when exercised in the manner of Braque—or Mondrian or Newman—involved considerable invention. Nevertheless, Fry has emphasized here, I think, an essential difference between the two artists. The solution to the "dilemma of post-classical signification," which Fry sees as the real triumph of high Cubism, "lies in the combination of the two modes." Neither "the purely reductive nor the purely inventive approach" alone would have been capable, Fry insists, of producing this Cubist solution.

42.　Roskill, *The Interpretation of Cubism*, pp. 70–71.

　　Braque may well have attended a concert given by Kubelík (whose name he misspells) at the George Petit gallery a year earlier, on the occasion of an Ingres retrospective (see Documentary Chronology, under April 23, 1911). As Kubelík played there on the violin actually owned by Ingres, Braque may well

have intended this image of the violin—perhaps his most frequent Cubist motif—to embody the pun of its being his "violon d'Ingres."

Picasso seems to be playing with a new spelling of the first syllable of "Kubelick" and of "Kub" in the KOU of his *Man with a Moustache* of spring 1912 (p. 222), and in *Man with a Guitar*, completed in 1913 (p. 67).

43. The motif of the piano may be related to the iconographic program of the Field library commission (see Appendix, p. 63). Picasso's truncation of Cortot's name is a witticism, as the root of the Spanish word for "short" or "cut off" is *cort*, which in its masculine form, *corto*, is pronounced similarly to the pianist's name. Though begun in 1911, probably in Céret, *Still Life on a Piano* was completed only in 1912, when, in addition to other changes, Picasso stenciled onto the canvas the letters CORT.

44. Actually, Golding (*Cubism*, p. 103) simply states (following a verbal communication from Braque to Douglas Cooper, to this effect) that Braque "had seen this [*faux bois*] paper for some days in a shop window and that he waited to buy it until Picasso went away." But the implication is clear.

45. The greater rapidity with which Braque produced his *papiers collés* suggests that two or three could have been produced before Picasso's return to Sorgues. I suspect that *Head of a Woman* (p. 245) was among them (see below, note 48).

46. Patricia Leighten, "Picasso's Collages and the Threat of War, 1912–13," *The Art Bulletin* 67, no. 4 (December 1985), p. 664.

47. Salmon, *La Jeune Sculpture française*, p. 15.

48. As the dates of such 1912 Picasso drawings with "bee-stung" lips as those on pp. 246–47 cannot be fixed exactly, but could fall anywhere from late summer into autumn, one cannot exclude the possibility that this motif appears in Picasso's work before it does in Braque's (in *Head of a Woman*, p. 245, probably executed in early September of that year). Inasmuch, however, as this formulation is entirely in the spirit of Braque's reductivist conceptualizing of facial features, I rather imagine that the Picasso drawings with this motif followed hard upon rather than preceded his friend's *papier collé*.

49. Letter of July 21, 1914, from Picasso in Avignon to Kahnweiler in Paris.

Picasso's entire sentence is "Je vois souvent Braque et Derain." In regard to Picasso's rapports with Derain, Salmon states: "I have always been puzzled by how little struck me [*peu d'éclat*] in the conversations between Picasso and Derain, who had a high opinion of each other. These two forces, not really opposed, but different from one another nevertheless, had nothing to say to each other" (Salmon, *Souvenirs sans fin*, p. 72).

For Derain's role in the transition just preceding Cubism, in particular the year 1907, see Rubin, "Cézannisme and the Beginnings of Cubism," in *Cézanne: The Late Work*, ed. Rubin (New York: The Museum of Modern Art, 1977).

50. John Berger, *The Success and Failure of Picasso* (1965; New York: Pantheon, 1980), pp. 35–38.

51. This commonly accepted though clearly incorrect position was "proven" by the inexorable logic of the argument in Clement Greenberg's celebrated essay "The Pasted Paper Revolution" (1958; reprinted, as "Collage," in *Art and Culture* [Boston: Beacon Press, 1961]), where construction reliefs are said to have been "extruded" out of *papiers collés* (p. 79).

52. Braque is talking to Paulhan about his paper sculptures, "which made Picasso think of airplanes...." "Then," says Braque, "I worked my sculpture into the two-dimensional surface. These were my first *papiers collés*." Cited in Jean Paulhan, *Braque, le patron* (Geneva and Paris: Trois Collines, 1946), p. 37.

There are also two indirect confirmations of the fact that Braque felt his paper sculptures led him to *papier collé*, both from writers whose works were based on conversations with the artist. Zervos, in 1932 (in "Georges Braque et le développement du cubisme," *Cahiers d'art* 7, nos. 1–2 [1932], p. 14): "Suite à ces recherches [on paper sculpture], Braque réalise en 1912 à Sorgues le 'papier collé.'" In 1949, Henry Hope (in his monograph *Georges Braque* [New York: The Museum of Modern Art, 1949], p. 62) says: "These paper sculptures seem to have suggested possible adaptations to painting which led to the making" of the first *papier collé*.

53. Douglas Cooper, *The Cubist Epoch* (London: Phaidon, 1970), p. 58.

54. Rubin, *Picasso in the Collection of The Museum of Modern Art*, p. 74.

55. Edward F. Fry, "Picasso, Cubism, and Reflexivity," *Art Journal* 47, no. 4 (Winter 1988), pp. 296–310.

56. Yve-Alain Bois, "Kahnweiler's Lesson," *Representations*, no. 18 (Spring 1987), pp. 33–68.

57. "When, before *papier collé*, Picasso hammered out the sheet metal to make his celebrated *Guitar*..." (Salmon, *Souvenirs sans fin*, p. 82). Salmon here places even the metal version of this *Guitar* prior to Picasso's *papiers collés*, but (with Fry) I believe the metal version to have been executed *after* Picasso had begun his *papiers collés*, indeed, in the winter of 1912–13 at the earliest. This confusion of Salmon's no doubt stems from the fact that Picasso told him, as he told me, that the *Guitar* came before his *papiers collés* (which, indeed, owe so much to it). But Picasso would naturally have thought of the date of his making the *Guitar* in terms of its first, cardboard version.

58. Letter of October 9, 1912, from Picasso in Paris to Braque in Sorgues (Laurens Archives). Picasso writes, "je emploies tes derniers procedes paperistiques et pusiereux[.] je suis entrain de imaginer une guitare et je emploie un peu de pusiere contre notre orrible [?] toile."

For thirty years, due to errors in Zervos, Picasso's *papiers collés* of spring 1913 were thought to have been made in the spring of 1912, thus prior to Braque's first essays in that medium. It was in Robert Rosenblum's article "Picasso and the Coronation of Alexander III: A Note on the Dating of Some *Papiers Collés*" (*The Burlington Magazine* 113 [October 1971], pp. 604–06) and Daix's Cubism catalogue of 1979 that this error was rectified.

59. The passage is published in Isabelle Monod-Fontaine, "Braque: The Slowness of Painting" in *Braque: The Papiers Collés*, p. 56, where a facsimile of the letter is reproduced.

60. I rather doubt that Picasso was referring to this work in his October 9 letter because, though executed in autumn in Paris, it was based on ideas worked out in Sorgues drawings. Since Picasso says he is "imagining" a guitar on October 9, which suggests a new conception of the instrument, the novel cardboard guitar corresponds better to that text.

61. Undated letter, on or after August 24, 1912, from Braque in Sorgues to Kahnweiler in Paris (Leiris Archives). Cited in Monod-Fontaine, "Braque: The Slowness of Painting," p. 55.

62. "Courrier des ateliers. Picasso," *Paris-Journal*, September 21, 1911.

63. Zervos, "Georges Braque et le développement du cubisme," p. 23.

If Braque actually began his paper sculptures in *early* 1911, and if, as Cooper stated (*The Cubist Epoch*, p. 58), they were painted, then an otherwise inexplicable sentence in a 1911 letter from Braque to Kahnweiler is clarified. In this undated letter, under the *en-tête* of the Grand Café de Céret, marked 1911 by

Kahnweiler, and attributable on the basis of internal evidence to August or September of that year, Braque says: "I miss the collaboration of Boischaud [Kahnweiler's assistant] in making my painted papers [*papiers peints*]." As Braque never designed wallpaper (the most common meaning of *papier peint*), that cannot be the reference here; nor can it possibly be to *papiers collés*, which Braque and Picasso began making only in September and October of 1912, respectively. On the other hand, it seems entirely possible that Braque had got the help of Boischaud (who later pasted some of his pinned *papiers collés*) in the mounting of painted paper reliefs.

64. *Jean Paulhan à travers ses peintres*, catalogue of an exhibition of unpublished documents, manuscripts, and art (Paris: Grand Palais, 1974), p. 130, entry 199. It was reformulated, without use of the word "scaffoldings," in *Braque, le patron*, p. 37.

65. The slogan "Notre avenir est dans l'air" is the title of a booklet that appears in three Picasso paintings (Daix 463, 464 [p. 229], 465) and that dealt with aerial bombing as a solution to France's military problems.

66. Wilbur Wright died on May 30, 1912.

67. Daniel-Henry Kahnweiler, "Werkstätten," *Die Freude: Blätter einer neuen Gesinnung* (Burg Lauenstein), vol. 1 (1920), pp. 153–54.

68. That Tatlin's celebrated visit to Paris took place in 1914—and not in 1913, as has always been believed—was demonstrated to me some months ago in conversation by Edward Fry, who has not yet published on this question. A similar conclusion was reached independently by Magdalena Dabrowski in "The Russian Contribution to Modernism: 'Construction' as Realization of Innovative Aesthetic Concepts of the Russian Avant-Garde" (Ph.D. diss., Institute of Fine Arts, New York University, 1989), pp. 47–50.

69. I see no reason to believe that *any* of Braque's constructions contained mixed media. Picasso's first three constructions, all guitars executed in autumn 1912 (see studio photograph, p. 36), were made out of cardboard (except, of course, for the strings). Not until 1913, in the studio assemblage of a guitarist (p. 280) did the collaging of different kinds of materials become a factor in his constructions. But even afterward, Picasso often made constructions (such as *Mandolin and Clarinet*, p. 292) that maintained a classical unity of medium.

The upholstery fringe in the Tate Gallery's *Still Life* (p. 314) alludes to the tasseled edge of one of Picasso's own tabletops (visible in the studio photographs on p. 37).

70. Cooper, *The Cubist Epoch*, p. 58. For Braque's letter, see above, note 63.

71. For the relation of Picasso's *Guitar* to the Grebo masks he owned, see Rubin, "Modernist Primitivism: An Introduction," pp. 18–20, and "Picasso," pp. 304–07, in *"Primitivism" in Twentieth Century Art: Affinity of the Tribal and The Modern*, ed. Rubin (New York: The Museum of Modern Art, 1984); Bois, "Kahnweiler's Lesson"; and Fry, "Picasso, Cubism, and Reflexivity."

Bois's very searching and enlightening article demonstrates that Kahnweiler (with some help and clarification from Bois) considered the Grebo mask important not only for Picasso's *Guitar*, but for the whole of Synthetic Cubism. He quotes Kahnweiler saying, in connection with such masks, that "the painters [presumably Picasso *and* Braque] turned away from imitation because they had discovered that the true character of painting and sculpture is that of a *script*. The products of these arts are signs, emblems, for the external world, not mirrors reflecting the external world in a more or less distorting manner. Once this was recognized, the plastic arts were freed from

the slavery inherent in illusionistic styles. The [Grebo] masks bore testimony to the conception in all its purity, that art aims at the creation of signs" (p. 40). Bois also notes Kahnweiler's statement that "the discovery of [Grebo] art coincided with the end of Analytic Cubism."

Bois summarizes Kahnweiler's position as follows: "From Grebo art, Picasso received simultaneously the principle of semiological arbitrariness and, in consequence, the non-substantial character of the sign" (p. 40). Bois may be doing himself an injustice here, as Kahnweiler says nothing (I believe) about the arbitrariness of the "sign" and usually uses that word in connection with pictures where the signs are far from arbitrary. Moreover, Kahnweiler does not say that the discovery of Grebo art produced Synthetic Cubism, only that it coincided with it. And it is indeed well that he did not, since Braque's first *papiers collés* were sign pictures and, so far as we know, they owed *no* debt to Grebo or any other tribal art. Hence, Bois's position must be supplemented by that of Fry as set forth in his remarkable "Picasso, Cubism, and Reflexivity," p. 300: "Only on the level of mental procedure," says Fry, "does [Picasso's *Guitar*] offer any suggestions for the reflexive transformation of pictorial illusionism. For Picasso, the pictorial equivalent of the Grebo mask was Braque's first *papier collé*, of September, 1912…. Whether deliberate or not, [Braque's] uncoupling of form from color and outline was the pictorial equivalent of the disassociation of mass from volume in a Grebo mask [and in *Guitar*]."

In fairness to Braque, we must remember that Picasso's *Guitar* followed—if hard upon—his experience of Braque's first *papier collé*, which was a great "shock" to him, according to Braque (see text, p. 40). As the latter is Cubism's first virtually flat, non-illusionistic sign picture, wherein space (but for a smattering of low-relief modeling) is not represented, but only *implied* (insofar as such signs as *faux bois* wallpaper identify a background wall), one can hardly credit, as sole progenitors of Synthetic Cubism, either Grebo art or the *Guitar*, or both together, as Bois sees Kahnweiler suggesting. Rather, it would appear that Picasso, grasping something from the Grebo mask that Braque had not, was able better to articulate the very sign language of *papier collé* that Braque had established by articulating a *recessional* space entirely through signs. This is precisely where I see the "middle-value" newsprint coming in, as Picasso, inspired by Grebo art to make his three-dimensional *Guitar*, then seeks a sign that will permit him to transfer its sculptural perceptions to pictorial needs. Hence, the relatively more articulated space of Picasso's, as opposed to Braque's, *papiers collés* of late 1912.

72. *Still Life with Chair Caning* has always been known as the first collage and, for all practical purposes, this is true. Two possible minor exceptions should be noted, however. Picasso adhered a real Italian postage stamp to a small painting of early 1911 called *The Letter* (Daix 451), which paraphrases cubistically an envelope addressed to the painter. This stamp, on which one can read a cancellation with the first four letters of FIRENZE, was probably taken by Picasso off the envelope in which Ardengo Soffici had sent the artist the second part of his article "Picasso e Braque," a text that had appeared in the December 7, 1911, number of *La Voce* (see note by Joan Rosselet in Daix, *Le Cubisme de Picasso*, p. 275). The letter would therefore probably date from earlier in the year 1912 than the month of May, to which *Still Life with Chair Caning* is traditionally given.

An earlier and more interesting exception is a drawing, *Bathers*, of 1908 (see *Sammlung Justin Thannhauser* [Bern:

Kunstmuseum Bern, 1978], p. 72), reproduced here. Picasso pasted to the surface of this work part of what may have been an advertisement for the Magasins au Louvre (or an entrance ticket to the museum), over which he drew a figure in a rowboat. This drawing is so isolated in the artist's work that one almost wonders whether Picasso adhered the ad to cover a hole in the paper, so he could make his study on it. (In those years Picasso drew on almost anything.) It would still be, technically speaking, the earliest *papier collé* even in that case—though an inadvertent one. Nevertheless, Picasso's segmentation of AU LOUVRE in a piece pasted on one of his own pictures is so typical of his wit that it seems to me unlikely that it could have been serendipitous.

Picasso. *Bathers*. 1908. Ink, gouache, and pasted paper, 10¼ × 16⅛″ (26 × 41 cm). Zervos II*, 66. Collection Justin Tannhauser, Bern. (See note 72)

73. This table-edge "rope" molding (also called "cable decoration"), which we see frequently in Picasso's *papiers collés* (e.g., Daix 673–75, 680, 681), is here, of course, primarily intended to represent the frame of the picture.

74. Speaking to this author, Picasso said about "reality" in high Analytic Cubism: "It's not a reality you can take in your hand. It's more like a perfume—in front of you, behind you, to the sides. The scent is everywhere but you don't quite know where it comes from" (see Rubin, *Picasso in the Collection of The Museum of Modern Art*, pp. 72, 206).

75. In his letter to the editors of *Artforum* (9, no. 9 [May 1971], p. 10), Cooper insists that the objects in *Still Life with Chair Caning* are "set on a caned chair."

76. Rosalind Krauss, "The Cubist Epoch," *Artforum* 9, no. 6 (February 1971), pp. 32–38. Krauss says of *Still Life with Chair Caning*: "…this oval can be…interpreted as a literal table top down onto which one looks at objects in plan…" (p. 33).

It is possible that the literalness here is greater than Krauss imagined—though the reverse of that which Cooper had in mind—to the extent that Picasso may very well have owned a table covering made of oilcloth imprinted with a chair-caning motif, and could well have scissored off a piece of it for his picture. Such oilcloth, imported from America, was widely used in France in the early part of the century and is still popular and available there. If this was true—and I believe Picasso probably would have wanted us to remain in the dark on such matters—then the artist's literalness is even greater than that ascribed to him by Cooper.

77. "Si ce sont les plumes qui font le plumage, ce n'est pas la colle qui fait le collage" ("If it is the plumes that make the plumage, it is not the glue that makes the gluing"). From "Beyond Painting," originally published as "Au delà de la peinture," in *Cahiers d'art* (1936); reprinted in Max Ernst, *Beyond Painting (and Other Writings by the Artist and His Friends)*, The Documents of Modern Art, ed. Robert Motherwell, trans. Dorothea Tanning (New York: Wittenborn, Schultz, 1948).

78. Chastel, "Braque et Picasso, 1912," p. 83.

79. See Leo Steinberg, "The Philosophical Brothel," originally published, in two parts, in *Art News* 71, no. 5 (September 1972), pp. 22–29 (Part One), and no. 6 (October 1972), pp. 38–47 (Part Two); republished, with revisions, in *October*, no. 44 (Spring 1988), pp. 7–74.

80. The step between Braque's trompe-l'oeil wood-graining and his use of wallpaper with a wood-graining motif was understood as a progression from an artisanal technique to one based on the appropriation of manufactured articles.

81. Kahnweiler, *Der Weg zum Kubismus*, p. 24.

82. The execution of *Violin, Wineglasses, Pipe, and Anchor* (p. 221) no doubt partially overlapped with that of *Souvenir du Havre* (p. 219). Daix places both in spring 1912, but sets the former before the latter. I rather doubt this order, for a variety of reasons, not the least of which is that the Ripolin color in *Violin, Wineglasses, Pipe, and Anchor* is more intense and daring than that of *Souvenir du Havre*.

83. Although *The Clarinet: "Valse"* (p. 231) is usually given to autumn 1912, it was no doubt worked on in August–September, when it received its sand, and was almost surely begun in late spring, hard upon Braque's seeing *Souvenir du Havre*. Much of the lettering on this picture is now almost invisible (as can be verified by comparing it to the 1912 photograph of it in the Leiris Archives) because the charcoal in which it was executed was never fixed (see Angelica Zander Rudenstine, *Peggy Guggenheim Collection, Venice* [New York: Abrams, 1985], p. 127). The tinted color in this picture may also have faded somewhat, though it was probably always paler than that of *Souvenir du Havre*.

84. Braque had always insisted that only with *papier collé* was color really freed from shading: "Le grand coup, ce fut le papier collé. Il nous restait une question primordiale à résoudre: l'introduction de la couleur. Il fallait qu'elle agisse pour son compte en toute liberté, degagée de toute forme" (Jacques Lassaigne, "Entretien avec Braque" [1961], *Les Cubistes* [Bordeaux: Delmas, 1973], pp. 16–18). "La mise au point de la couleur est arrivé avec les papiers collés" (Vallier, "Braque, la peinture et nous," p. 17).

While it is true that full dissociation of color and form came in only with *papier collé* (Picasso's collage, *Still Life with Chair Caning*, did nothing for Cubist color), the introduction of intense color into Cubism during the transitional year of 1912 took place first in Picasso's work, in *Souvenir du Havre; Violin, Wineglasses, Pipe, and Anchor;* and *The Scallop Shell: "Notre Avenir est dans l'air."* Subsequent pictures, those of summer 1912 such as *Landscape with Posters* (p. 235) and, in particular, the two paintings known simply as *Guitar* (pp. 248, 249), begun in Sorgues and completed in Paris, have much higher-keyed color than anything that would appear in Braque's *papiers collés*. It is impossible to know if the latter two predate Picasso's seeing Braque's *Fruit Dish and Glass*, with which the version on p. 248 especially shares a Synthetic Cubist flatness. Both appear, unfinished, in the photograph (p. 403) in which Picasso assembled his summer work, presumably taken just before his definitive departure for Paris in late September. These two

works are clearly the very last begun in Sorgues; the version on p. 249, in which the "raised" sound hole suggests an influence on Picasso of the cylindrical eye of his Grebo mask, was probably begun in late August, following the trip of Braque and Picasso to Marseille.

Pierre Daix was the first to realize the importance of the two paintings related to the Havre trip as constituting a turning point in regard to Analytic Cubism and color. In Severini's description of Braque's first look at these works (see Documentary Chronology, under early May 1912), which Daix discovered, we note a certain chagrin on Braque's part at Picasso's *démarche*. Braque's "mi-figue, mi-raisin" expression on seeing *Souvenir du Havre* had to result *either* from Picasso's first use there of *faux bois* or from his introduction of color. Since Braque himself taught Picasso how to do *faux bois,* his surprise can hardly be attributed to Picasso's using it, hence the reaction had to do with Picasso's color.

85. Verdet, "Rencontre dans l'atelier parisien," p. 23.
86. Braque's trompe-l'oeil nail was characterized by Kahnweiler as the first of those "real details" which would lead to collage and *papier collé.* The latter techniques were described by him as "no more than a new development of the 'real details' …with the idea of abolishing more completely tricks of brushwork and of replacing the 'hand-painted' surface by the 'readymade.' At the same time, incorporation of the actual object in the picture was intended as an act of realism" (Kahnweiler, *Juan Gris,* p. 124).
87. Vallier, "Braque, la peinture et nous," p. 14.
88. Undated letter (marked 1909 by Kahnweiler) from Braque in La Roche-Guyon to Kahnweiler in Paris (Leiris Archives).

Braque speaks here of a "letter from an Italian critic" (almost certainly Ardengo Soffici) who had evidently requested a statement for publication. "Quant à mes entendements artistiques dont celui-ci fait allusion," Braque writes, "j'espère qu'ils sont suffisament exprimés dans mes toiles…" (see Documentary Chronology, under summer 1912).
89. Interview with Picasso, *Paris-Journal,* January 1, 1912.
90. Kahnweiler describes Picasso and Braque's close friendship as beginning in the autumn of 1908, and certainly they began to see each other frequently then. Whether their dialogue was as consistent in 1908–09 as it became in 1910 is still an open question.
91. Both Apollinaire and Salmon run hot and cold on Braque, depending on circumstances and on whether they are writing for publication or not, but I think my summary of their positions is not unfair.
92. These exceptions were exhibitions of Picasso held at Uhde's gallery on the rue Notre-Dame-des-Champs in May 1910 and at Vollard's on the rue Lafitte, December 1910–January 1911 (see Documentary Chronology, under those dates).
93. There exists no record of what was shown in Kahnweiler's informal *accrochages* during the Cubist years, some of which did not include works by either Picasso or Braque. According to Maurice Jardot, who worked with Kahnweiler for many years after World War II in the Louise Leiris gallery, Kahnweiler's rue Vignon gallery was so tiny that no more than half a dozen paintings could be hung at one time. Jardot also believes that many of the most important works were never publicly exhibited, Kahnweiler keeping them hidden, to be shown selectively to his few top clients.
94. Étienne-Alain Hubert, "Georges Braque selon Guillaume Apollinaire," in *Mélanges Decaudin: L'Esprit nouveau dans tous les états, en hommage à Michel Décaudin* (Paris: Librarie Minard, 1986), pp. 265–74.

95. Guillaume Apollinaire, "Le Cubisme," *Intermédiare des chercheurs et des curieux,* October 10, 1912, pp. 474–77.
96. Guillaume Apollinaire, *Les Peintres cubistes: Méditations esthétiques* (Paris: Eugène Figuière, 1913), p. 42.
97. Ibid., p. 42.
98. Guillaume Apollinaire, letter of December 8, 1911, to Ardengo Soffici. Published by Soffici in the original French in *Rete Mediterranea* (Florence), September 1920, p. 229.
99. Letter of January 9, 1912, from Apollinaire in Paris to Soffici in Poggio a Caiano (*Rete Mediterranea* [September 1920], p. 230). Soffici's fawning letter to Apollinaire of December 12, 1911 (see Documentary Chronology, under that date), reveals unexpected clay feet as regards his position on Braque. Here, after agreeing with Apollinaire that the five names the latter had proposed in his December 8 letter (Derain, Dufy, Marie Laurencin, Matisse, Picasso) were "exactly those I would have mentioned," Soffici admits that "above all, in the light of what you wrote me" (namely, that Braque owed more to Picasso than did the Salon Cubists), he had overestimated Braque, "speaking better of him than I thought." "You see," he continues, "we could not be more in agreement. And now, my dear Apollinaire, I would like to propose a deal to you."

That Soffici did not actually change his mind about Braque is suggested by the fact that, although he excised an important paragraph in his reprinting of "Picasso e Braque," he neither eliminated nor altered the material on Braque.
100. Salmon, *Le Jeune Sculpture française,* pp. 12–13.
101. La Palette [pen name of André Salmon], "Georges Braque," *Paris-Journal,* October 13, 1911.
102. André Salmon, *La Jeune Peinture française* (Paris: Société des Trente, Albert Messein, 1912), p. 56.
103. Salmon, *La Jeune Sculpture française,* p. 13.
104. Ardengo Soffici, "Picasso e Braque," *La Voce* 3, no. 34 (August 24, 1911), pp. 635–37.
105. Beyond its occasional appearance in bibliographies on Cubism, I know of only two brief citations of this article, the first in Marianne Martin's *Futurist Art and Theory, 1909–1915* (Oxford: Clarendon Press, 1968), pp. 104–05, and a second in Jean Laude's "The Strategy of Signs," in Nicole Worms de Romilly and Jean Laude, *Braque: Cubism, 1907–1914* (Paris: Éditions Maeght, 1982), p. 53.
106. See Judith Cousins and Hélène Seckel, "Éléments pour une chronologie et de l'histoire des Demoiselles d'Avignon," in *Les Demoiselles d'Avignon,* ed. Seckel (Paris: Éditions de la Réunion des Musées Nationaux, 1988), p. 683, note 1.
107. As is clearly indicated not only by his visits to their studios, but by Picasso's letter to Soffici of November 22, 1911. There he apologizes for not writing sooner to Soffici about photographs of Soffici's work that the latter had sent, and explains that he was waiting in order also to show them to Braque. In what was for him a unique critical remark, at least to my knowledge, Picasso tells Soffici to guard himself against his pictures' becoming too "decorative" (*5 Xilografie e 4 puntesecche di Ardengo Soffici con le lettere di Picasso,* ed. Luigi Cavallo [Milan: Giorgio Upiglio and C. Edizione d'Arte Grafica Uno, 1966], pp. 55–56.
108. See Hélène Seckel, entry for Ardengo Soffici, in *Les Demoiselles d'Avignon,* pp. 682–83.
109. In the last paragraph of Soffici's article, a paragraph suppressed in later reprintings of it, Soffici names some of the painters he has in mind, namely Metzinger, Le Fauconnier, Léger, and Delaunay. It must be said, by way of explaining Soffici's inclusion of Léger, that as of spring 1911, Léger's personality was just emerging in his art, and it is probable that

Soffici had seen only those works shown in the 1911 Indépendants. The same was probably true also in the case of Delaunay. It was perhaps a change of mind as regards these two artists at least that led Soffici to suppress the final paragraph.

110. In his text, Soffici cannot recall whether the Estaque pictures he was discussing were of 1907 or 1908, but from his description of them we can identify individual works, which make it clear that Soffici is speaking of Braque's pictures of summer 1908.

111. It is worth noting that Kahnweiler's view of Apollinaire's book on Cubism—as summarized by the poet himself in a 1913 letter to the dealer (see Documentary Chronology, under end of April 1913)—was that it was "without interest."

I do not deal here with Gertrude Stein's remarks on Cubism despite the fact that she must be considered something of a firsthand witness, although she visited Picasso's studio less frequently than did the other eyewitnesses (with the probable exception of Soffici).

Stein's conviction that Cubism was a wholly Spanish art effectively eliminated any concern with Braque. Moreover, apart from the fact that her grasp of the pictorial problems of Cubism was minimal, she virtually disqualified herself by her strong personal bias against Braque, whose studio she seems never to have visited, and about whom various insulting remarks can be discerned ("Brack, Brack is the one who put up the hooks and held the things up...") in her otherwise largely unintelligible 1913 "Braque" (published in Geography and Plays [Boston: Four Seas, 1922]). Elsewhere, she had nothing to say, certainly, about the working relationship between the two artists.

Braque later returned her animosity in kind in the statement he contributed to "Against Gertrude Stein" in Transition in 1935 (see above, note 17). There he states: "Miss Stein understood nothing of what went on around her ... it is obvious that she never knew French really well, and that was always a barrier. But she has entirely misunderstood Cubism, which she sees simply in terms of personalities....Miss Stein saw everything from the outside and never the real struggle we were engaged in. For one who poses as an authority on the epoch, it is safe to say that she never went beyond the stage of the tourist."

112. Daniel Henry [D.-H. Kahnweiler], "Der Kubismus," Die weissen Blätter (Zurich and Leipzig) 3, no. 9 (September 1916); my citations are from pp. 211 and 215. The observation that the two artists' exchange of ideas was pursued in correspondence ("brieflichen Gedankenaustausch") was repeated in Der Weg zum Kubismus, though it was curiously omitted from its only English version, The Rise of Cubism, translated by Henry Aronson and published by Wittenborn, Schultz, Inc., in New York, in 1949.

113. Kahnweiler, Der Weg zum Kubismus; my quotations in this paragraph are from p. 16.

114. Wilhelm Uhde, Picasso et la tradition française (Paris: Éditions des Quatre-Chemins, 1928), p. 39.

115. Ibid.

116. Ibid., pp. 28, 35, 38.

117. As for example, Alfred H. Barr, Jr. (Cubism and Abstract Art [New York: The Museum of Modern Art, 1936], pp. 29, 31), John Golding (Cubism, p. 19 and passim), Robert Rosenblum (Cubism and Twentieth-Century Art, pp. 9–98), John Richardson (Georges Braque, p. 12 and passim), John Russell (Georges Braque [London and New York: Phaidon, 1959], pp. 17–20 and passim), Edward F. Fry (Cubism [New York: Oxford University Press, 1966], pp. 17–30), Douglas Cooper (The Cubist Epoch, p. 27 and passim), and Pierre Daix (Le Cubisme de Picasso, pp. 63ff.).

118. Guillaume Apollinaire, "Pablo Picasso," Montjoie!, March 14, 1913.

119. After writing the catalogue preface for Braque's 1908 exhibition, Apollinaire says nothing about Braque's Cubism until Les Peintres cubistes: Méditations esthetiques, and even there, fails to go beyond commonplaces.

120. "Histoire anecdotique du cubisme," in Salmon, La Jeune Peinture française.

121. See Documentary Chronology, under November 30, 1912.

122. Letter of October 31, 1912, from Picasso in Paris to Braque in Sorgues (Laurens Archives).

123. Letter of April 11, 1913, from Picasso in Céret to Kahnweiler in Paris (Leiris Archives): "Moi j'ai reçu le livre de Apollinaire sur le cubisme. Je suis bien désolé de tous ces potins."

124. Cited in John Richardson, "Metamorphosis and Mystery," in Georges Braque, 1882–1963: An American Tribute (New York: Public Education Association, 1964), n.p.

125. Letter of August 17, 1911, from Picasso in Céret to Kahnweiler in Paris (Leiris Archives): "Ce vraiment rigolo les idees des nos amis et je me amuse enorment ici de toutes les coupures que vous me envoyer."

126. Cited in Vallier, "Braque, la peinture et nous," p. 14.

127. Cited in Verdet, "Rencontre dans l'atelier parisien," p. 21.

128. Cited in Vallier, "Braque, la peinture et nous," p. 14.

129. This has usually been taken simply as a macho insult typical of the painter. But like most of Picasso's comments, it has deeper implications, for it suggests a kind of interdependence with Braque, psychologically more profound and more complementary than is suggested by the "marriage of minds" alluded to by Uhde. While it would be an oversimplification to see Braque in this pairing as the embodiment of a feminine principle (recall Kahnweiler's later suppressed remark; text, p. 45) in his quite literal love of the earth/matière, his constancy, and relative passivity, and Picasso as the more active participant, some deep unspoken duality of an implicitly sexual nature could have played an unconscious role. For speculations of this order see Mary Matthews Gedo, Picasso: Art as Autobiography (Chicago: University of Chicago Press, 1980), pp. 84–85.

130. Gilot and Lake, Life with Picasso, p. 76.

131. Leo Steinberg ("The Polemical Part," Art in America 67, no. 2 [March–April 1979], p. 117) went so far as to hold that in Picasso's quest for "absolute vision"—which Steinberg certainly intended to comprehend Cubism—he "had neither help nor companionship."

132. Through the kindness of Claude and Denise Laurens, we have been able to see those unpublished passages from Picasso's preserved letters to Braque that the Laurenses deemed pertinent to our topic. As noted earlier, we have also been able to see, through the kindness of Pierre Georgel and the Picasso heirs, the (far fewer) preserved letters from Braque to Picasso. M. Georgel's edition of the entire correspondence will be published by the Musée Picasso.

133. Here, as in some other citations in my text, I have preferred to give the text of Picasso's letter in its original form. (The English renderings of Picasso's letters, and of some of the eyewitnesses' accounts, given in the introductory text are my own.) Picasso's awkward French has an undeniable flavor which the reader will appreciate. But his telegraphic style, impatience with punctuation, and original choice of words also open his texts in many instances to more than one possible interpretation.

134. Letter of July 16, 1911, from Picasso in Céret to Braque in Paris (Laurens Archives).

135. Letter of July 25, 1911, from Picasso in Céret to Braque in Paris (Laurens Archives).

136. Letter of December 9, 1911, from Picasso in Paris to Braque in Céret (Laurens Archives).

137. Letter of May 30, 1912, from Picasso in Céret to Braque in Paris (Laurens Archives).

138. Letter of July 10, 1912, from Picasso in Sorgues to Braque in Paris (Laurens Archives). The "largest [picture] with a violin," to which Picasso refers here, would seem to be *Violin: "Jolie Eva"* in the Staatsgalerie Stuttgart (p. 234).

139. Letter of April 23, 1913, from Picasso in Céret to Braque in Paris (Laurens Archives).

140. This consists of some fifty-five letters and seven postcards for the period 1907–14.

Since the death of D.-H. Kahnweiler, these letters have been made available to a certain number of qualified scholars, and many have been published in excerpt in publications of the Musée National d'Art Moderne, Paris.

141. Letter of June 17, 1912, from Picasso in Céret to Kahnweiler in Paris (Leiris Archives).

142. Letter of July 3, 1912, from Picasso in Sorgues to Kahnweiler in Paris (Leiris Archives).

143. Letter of July 11, 1912, from Picasso in Céret to Kahnweiler in Paris (Leiris Archives).

144. Letter of August 11, 1912, from Picasso in Sorgues to Kahnweiler in Paris (Leiris Archives).

145. Letter of July 25, 1911, from Picasso in Céret to Braque in Paris (Laurens Archives): "Pour la nouvelle toile tres liquide pour comencér et facture metodique jenre Signac—des frotis que a la fin."

146. Undated letter, perhaps September 16, 1912, from Braque in Sorgues to Kahnweiler in Paris (Leiris Archives).

147. Letter of October 9, 1912, from Picasso in Paris to Braque in Sorgues (Laurens Archives).

148. There is at least one apprehensive remark, however, about the political situation in Braque's correspondence with Kahnweiler. In a letter of September 20 or 27, 1911 (Leiris Archives), he says: "There is also much talk these days of war, yet I don't believe it will happen."

149. Ardengo Soffici, *Cubismo e oltre* (Florence: La Voce, 1913).

150. Albert Gleizes and Jean Metzinger, *Du Cubisme* (Paris: Eugène Figuière, 1912).

151. Undated letter, probably August 24, 1912, from Braque in Sorgues to Kahnweiler in Paris (Leiris Archives).

152. That the remainder of these portraits are all of art dealers—Sagot, Uhde, Vollard, and Kahnweiler—with the exception of the 1909 portrait of his childhood friend the painter Pallarés, probably relates less to any financial exchanges than the fact that, as these dealers could read Picasso's Cubism, they constituted understanding and appreciative sitters for the extended numbers of séances required.

153. Letter of June 7, 1912, from Picasso in Céret to Kahnweiler in Paris (Leiris Archives).

154. The image of the minotaur that comes down to us from the ancient world is, as the etymology of the word suggests, that of a man with a bull's head. Picasso was, I believe, the only artist sometimes to use a bison's head for this figure. Most of Picasso's minotaurs have bulls' heads, a few have bisons' heads, and some have features of both. Picasso's minotaur is often imaged more bison-like when the narrative suggests pathos—which may correspond to Picasso's knowledge of the hunting down and mass slayings of these relatively docile animals by Cody's generation.

155. Salmon, "Georges Braque." See Documentary Chronology, under October 13, 1911.

156. For Braque's role as an alter ego of Cézanne in the figure wearing a Kronstadt hat in *Carnival at the Bistro*, a work conceived as a kind of symbolic memorial of the Rousseau banquet, see Rubin, "From Narrative to 'Iconic' in Picasso."

157. Letter of July 25, 1911, from Picasso at Céret to Braque in Paris (Laurens Archives).

158. Letter of July 15, 1914, from Braque in Sorgues to Kahnweiler in Paris (Leiris Archives).

159. Letter of October 8, 1919, from Braque in Sorgues to Kahnweiler in Bern (Leiris Archives): "Ce qui est vraiment constant chez l'artiste, c'est son tempérament. Or Picasso reste pour moi ce qu'il a toujours été, un virtuose plein de talent…"

160. Cited in Vallier, "Braque, la peinture et nous," p. 14.

161. From previously unpublished notes taken by Kahnweiler during a visit to Braque's studio, February 25, 1920; cited in Isabelle Monod-Fontaine, *Donation Louise et Michel Leiris: Collection Kahnweiler-Leiris* (Paris: Musée National d'Art Moderne, Centre Georges Pompidou, 1984), p. 29: "contre Picasso, virtuose. Les praticiens pas français."

162. Gilot (*Life with Picasso*, p. 317) emphasizes the sense of competitiveness—especially on Picasso's part—that existed between the two men during meetings in her presence. Neither the tone nor the content of Picasso's correspondence with Braque or Kahnweiler betrays signs of this. On the contrary, it appears frank and easygoing. No doubt, as I have suggested above, some feeling of rivalry must nevertheless have existed, as is reflected in Braque's strategy with regard to buying the *faux bois* wallpaper. Indeed, Gilot points to a logical cause when she describes the apprehensiveness of all those painters whose studios she visited with Picasso, "perhaps because Pablo often said, 'When there's anything to steal, I steal.'" "So they all felt, I think," she continues, "that if they showed him work they were doing and something caught his eye, he would take it over but do it much better, and then everyone else would think that *they* had copied it from *him*."

163. Letter of July 26, 1912, from Picasso in Sorgues to Braque in Paris (Laurens Archives).

164. Letter of April 27, 1912, from Braque in Le Havre to Marcelle Braque in Paris (Laurens Archives). "J'ai réveillé Picasso ce matin au phonographe. Ce fut charmant."

165. See John Berger, *The Success and Failure of Picasso*, pp. 47–48 and passim, and *The Moment of Cubism and Other Essays* (New York: Pantheon, 1969), p. 12.

Appendix

The Library of Hamilton Easter Field

In 1909, Picasso agreed to make a "decoration"[1] for the library of Hamilton Easter Field, a Brooklyn painter, critic, and patron of American artists. I believe that the "large picture" mentioned in Picasso's letter of July 25, 1911, must be identified as one of the principal panels of the suite of paintings he had agreed to make for Field; further, I am convinced that it is identical with the unfinished, outsize painting (otherwise unaccounted for), visible in a photograph of Picasso's boulevard de Clichy studio taken in the latter half of 1911 (p. 17), and first published in 1933 in Fernande Olivier's *Picasso et ses amis.* Moreover, it would appear that at least eight other paintings that have, in fact, come down to us—the earliest being the 1910 *Nude* (p. 65) in the National Gallery, Washington—can be identified as having been part of this intended ensemble.

Field had met Picasso in 1909, doubtless through the good offices of his cousin Frank Haviland, an American connected with the importation from France of Limoges china and a friend of the painter's; Picasso had agreed at that time to execute a suite of paintings for him. On July 12, 1910, Field wrote Picasso in care of Haviland and included sketches of the plan and elevation of his library, including the precise dimensions of the eleven wood panels on which the pictures would be hung (or, perhaps, to which they would have been adhered). Field's letter, which is in the archives of the Musée Picasso,[2] was received by Picasso in Cadaqués on August 2. The arrangement called for two very wide horizontal pictures to go on 50 × 130 cm panels over the doors, and nine other pictures to hang on wall panels that were all 185 cm in height. These ranged from an extremely narrow vertical, 185 × 30—for which Picasso, so far as I can see, decided not to execute a picture—through two less narrow verticals, 185 × 75 cm and 185 × 70 cm respectively, to a nearer square panel of 185 × 140 cm, and on to a group of horizontals. The horizontal wood panels of the library were 185 × 230 cm; 185 × 270 cm (three of these); and the largest, 185 × 300 cm. The five pictures intended for these large horizontal panels would have included one about six by ten feet (Matisse's *Dance* is eight and a half by almost thirteen) and four others almost as large, plus four verticals slightly over six feet high and two horizontals over four feet wide.

That the acceptance of this commission forced Picasso to confront a number of unusual and very knotty problems is reflected in the fact that of the nine pictures which I believe can be identified with the project, seven were either destroyed or partly (or entirely) repainted later. (Other possible candidates for the Field project—pictures no longer extant for which we have titles, but neither photographic images nor descriptions—include the mysterious "Christ," and "Poet and Peasant," both evidently destroyed.)

The particular problems Picasso faced, apart from having to formulate an overall iconographic program, were essentially of three kinds, and were interwoven. They had to do with the pictorial limitations of the normally "iconic" Cubist subjects; the peculiar proportions the library panels called for; and the vast size (particularly in relation to the characteristic *échelle* of the Analytic Cubist style) some of the pictures would have to be. This last could conceivably have entailed changes in the interior scale of Picasso's 1910–11 work in order to cover huge surfaces.[3] In the photograph, however, we can see that Picasso did *not* undertake a comparable change of scale in his "large picture,"

presumably to keep its scale consistent with that of the smaller pictures in the library. But maintenance of that "easel" scale—the scale of 1911 Cubism in general—was difficult for Picasso in a work as large as some six by ten feet without having to deploy over its surface a great deal of visual incident, which went hand in hand with the image's unusual anecdotal activity.

Picasso confronted the challenge of the uncomfortable proportions required by some of the panels in what I take to be the very first picture worked up for the project, the *Nude,* generally thought to have been executed in Cadaqués. (If Picasso's letter to Field of September 7, 1910, is entirely accurate,[4] then this picture and the next were, in fact, executed in early autumn in Paris rather than at Cadaqués; but I suspect that the artist simply avoided telling Field he had already begun to work.) I am not alone in having long felt uncomfortable with the exceeding narrowness of the *Nude*'s composition (though I realize that Picasso admirably solved the problem of accommodating to that difficult shape). Indeed, it was while musing on why Picasso would have chosen such a constraining format that it suddenly occurred to me that he might not have chosen it at all, but have had it imposed on him, and this led me to check it (and other unusual formats of 1910 and the following years) against the sizes of the Field library panels.

Picasso's second picture for the project, *Woman with a Fan,* a picture that looks to be entirely of the year 1918—in which year it was, in fact, completed—was also begun at Cadaqués, according to Picasso's statement to Pierre Daix, and it is possible to "see through" its Synthetic Cubist flatness and color to a configuration remarkably like that of the *Nude.* At slightly over six feet in height, the wood panels in Field's library obviously did not go from floor to ceiling but, as was standard in such rooms at the time, were no doubt raised above wainscoting and surrounded by framing devices. Assuming that Picasso's pictures, like Matisse's for Shchukin, were to be put on stretchers and then hung on the walls, Picasso could make his pictures smaller, but not larger, than the panels. In most cases he worked up canvases of which

one or both dimensions (as measured by their present stretchings) are very close to, if not exactly those of, the panels. *Nude* is a minor exception insofar as its height—if, indeed, it is correct in Daix—is 2.3 cm too great. But this slight discrepancy might easily have resulted from a restretching (or Daix's figure might be the result of mismeasurement). At 185 cm high, *Woman with a Fan* is exactly the height of the Field panel, though it is 2.5 cm narrower than the panel intended to support it. After Picasso's return to Paris from Cadaqués in mid-September 1910, he executed the first of the low and wide over-the-door pictures for the project, *Woman on a Divan,* whose dimensions, as given to Daix, are only one centimeter and half a centimeter, respectively, off the dimensions of the library panels.

Picasso does not appear to have worked on the project again until the following summer at Céret, when, perhaps under some prodding by Haviland, who lent Picasso a large room in his house for use as a studio,[5] Picasso began "le grand tableau" as well as two (or possibly four) other extant paintings connected with the project (*Pipes, Cup, Coffeepot, and Carafe; Still Life on a Piano; Man with a Mandolin; Man with a Guitar*), and started (then restarted) the no longer extant "Poet and Peasant."[6]

Our only image of the "grand tableau"—assuming my identification to be correct—is in the photograph from the autumn of 1911 published by Fernande Olivier. The difficulty we would have in reading any 1911 Analytic Cubist picture is here compounded by the fact that some of what we see in the photograph is in a very incipient state, while other parts of the great canvas, especially toward the lower right and along the bottom, are virtually or entirely unpainted. The picture appears to be tacked up rather than stretched, hence its bottom boundary is not entirely clear, while its top and left side are cut off by the camera. I see some evidence of the architecture that Picasso described to Braque and, with a magnifying glass, have been able to make out the heads, and parts of the bodies, of two figures, as well as fragments of such motifs as a watering can.

What seems immediately problematic about this

Picasso. *Woman on a Divan.* Paris, autumn 1910. Oil on canvas, 19¼ × 51″ (49 × 129.5 cm). Daix 365. Private collection, on loan to Kunsthaus Zürich.

Picasso, *Nude.* Cadaqués, summer 1910. Oil on canvas, 6′1¾″ × 24″ (187.3 × 61 cm). Daix 363. National Gallery of Art, Washington, D.C. Ailsa Mellon Bruce Fund, 1972

Picasso. *Woman with a Fan.* Begun Cadaqués, summer 1910; completed 1918. Oil on canvas, 6′¾″ × 28½″ (185 × 72.5 cm). Daix 364. Private collection, courtesy Gagosian Gallery, New York

painting is that it is so chock-full of visual incident that it tends to break up into localized (and sometimes rather over-busy) passages, recalling in that regard pictures by such anecdotal Cubists as Le Fauconnier. The fragmented style of Picasso's high Analytic Cubism, fashioned primarily for single-figure "iconic" pictures, did not lend itself to extension over large canvases, as it precluded the kind of continuous, binding "architectural" contours and accents such very large compositions want—and such as we, indeed, see in *Three Women* (p. 111) and *Bread and Fruit Dish on a Table* (p. 115). Those pictures of 1908 and early 1909 demonstrate the relatively easier accommodation of Picasso's early Cubist style to very large formats.

The dispersed configuration of the "grand tableau" was also a function of the anecdotal character of the motif Picasso felt compelled to choose. To be sure, he could hardly have spread Cubism's characteristic single figure across a six-by-ten-foot picture, nor even have made a still life that size, without breaking with the scale of objects represented in the smaller paintings of the series. He obviously felt he had to replace the typically "iconic" Cubist motifs with one whose anecdote could spread out to cover the lateral space— hence the variety of houses, the stream, and the swimmers. The endeavor appears to have been deemed a failure by Picasso at a certain point, and we can be quite sure he destroyed the picture, for not only was the canvas never sent to Field (nor were any of the extant library pictures, for that matter), but there is no trace of its having been sold to a dealer or collector (an unimaginable situation for Picasso's largest Cubist picture, and one of his largest ever, had it ever really left the studio). Picasso, moreover, was truly maniacal about keeping track of those pictures he retained. Of the huge number of "Picasso's Picassos," only one tiny wood panel, a study for *Les Demoiselles*, was ever lost—and that during the move from Vauvenargues to Mougins. The last we see or hear of the "large picture" is in the celebrated long business letter to Kahnweiler of June 5, 1912,[7] in which it is listed in the inventory of the unfinished, stored works at the rue Ravignan studio and (following the number

23) characterized by Picasso as "Le grand paneau pour l'America."

During that same summer of 1911 at Céret, Picasso worked on two very large vertical paintings, *Man with a Mandolin* (his largest extant Analytic Cubist painting) and *Man with a Guitar*, both of which, I am convinced, were part of the Field project, despite the fact that their heights, 158 and 155 cm respectively, are some 30 cm less than the panels. (Surely this pair was intended to be of equal height; both were found rolled, after Picasso died, and the restorers must have read their heights slightly differently when new stretchers were made.) Daix may be correct in saying these two pictures were executed in Paris soon after the artist's return from Céret, but they were probably begun in the Midi. The fact that Picasso had to seam two pieces of canvas together for *Man with a Mandolin* further suggests its commencement in Céret, where such a large piece of canvas might well have been unavailable. That Picasso executed this canvas one half at a time, the top half first (as is evident in its state in the studio photograph on p. 385), rather than bringing it along approximately equally in all areas, may be related to this seaming. In any case, the lower part remained unfinished. *Man with a Guitar* obviously dissatisfied Picasso, for he reworked it considerably in 1913 (an event not noted in Daix's catalogue, where the author uses the 1911 date Picasso gave him for its undertaking).

Picasso's decision to make these two large pictures (which were evidently intended to replace the two vertical panels painted in summer–fall 1910) somewhat lower in height than the library panels followed, I believe, from his own critique of the earlier pair, *Nude* and *Woman with a Fan*. One has only to compare the two pairs to see how much more harmonious and workable the new proportions are.

Picasso also worked in the late summer or fall of 1911 on two new panels to go over the doors, one of them also doubtless intended to replace the 1910 picture. At 50 × 130 cm, *Still Life on a Piano* (p. 215) is precisely the size of the library panels, while *Pipes, Cup, Coffeepot and Carafe* is also 50 cm high, but is two centimeters short in its horizontal dimension—

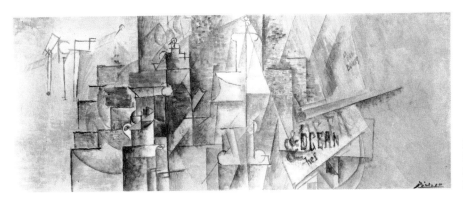

Picasso. *Pipes, Cup, Coffeepot, and Carafe.*
Céret, summer 1911. Oil on canvas,
19¾ × 50⅜″ (50 × 128 cm). Daix 417.
Private collection, New York

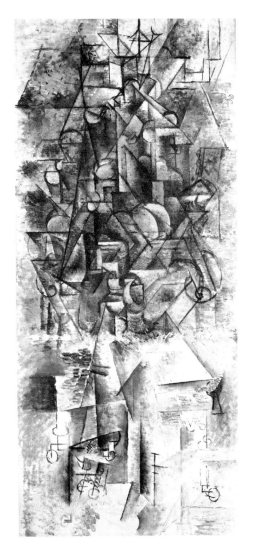

Picasso. *Man with a Mandolin.* Céret and Paris,
summer–autumn 1911. Oil on canvas, 62⅛ × 27⅞″
(158 × 71 cm). Daix 428. Musée Picasso, Paris

Picasso. *Man with a Guitar.* Céret and Paris, sum-
mer–autumn 1911; reworked 1913. Oil on canvas, 61 ×
30¼″ (155 × 77 cm). Daix 427. Musée Picasso, Paris

again certainly a question of stretching. The latter picture was never finished, while *Still Life on a Piano* was taken up again in the spring of 1912 and completed. As Picasso owned no piano, it is possible that the motif here was suggested by Field, who was an accomplished pianist and frequently held musicales in his home.

Picasso's failure to achieve even the first of the five very large horizontal pictures that Field expected he would execute suggests that, by the outbreak of the war, he had some doubts as to whether he would be able to fulfill the agreement. Nevertheless, *Woman with a Guitar* of 1915, whose format of 185 × 75 cm is precisely the size of one of the library panels, indicates that the project was still alive in Picasso's mind five years after he had begun working. (It is also possible that The Museum of Modern Art's 1915 *Harlequin*, which was painted at the same moment, and is currently stretched at 183.5 cm high, was intended for Field.) Indeed, Picasso had obviously continued to tell Field even later that he was still at work on the project, for, during a digression in a review of a Man Ray show published in the Brooklyn *Daily Eagle* for November 30, 1919, Field noted that Picasso's "decorations are not yet finished." The sculptor Robert Laurent, Field's protégé and heir, who was present when Field first met Picasso, wrote "A Personal Statement"[8] about the project in 1966, in which he recalls Picasso being "so excited" in 1909 at the prospect of decorating Field's library, which was "just the sort of commission he had been hoping for." Laurent also reports that Stieglitz had visited Picasso—no doubt his trip of autumn 1911—seen the "murals" in progress and found them "tremendous." According to Laurent, Field later heard that Picasso had sold the pictures "for a much higher price to a Russian collector." Actually, this piece of misinformation was probably the result of someone's confusing the Field commission with the sale of the monumental *Three Women* of 1908 to Shchukin in 1913. But that picture had belonged to the Steins for the four years previous and had nothing to do with the project. None of the pictures associated with the library left Picasso's studio until the 1920s.

There is no little irony in the fact that Picasso, who

Hamilton Easter Field (left) and Robert Laurent, c. 1910

would later declare, "La peinture n'est pas pour décorer les appartements," should have accepted this commission, especially in view of all the difficulties that it entailed, and given his freedom from serious financial problems at the time (although 1909 represented something of a low point in the buying of his Cubist work); shortly after he began working on the Field panels in 1910, important sales were made to Vollard and Uhde as well as Kahnweiler. But a motive for accepting the commission suggests itself. The morning I put the photograph and the nine paintings together with the Field commission in my mind, I telephoned my friend Pierre Daix to test my hypothesis on him. The instant I had formulated it, Daix saw that Picasso's motivation had to be primarily that of rivaling the commission Matisse had received earlier in 1909 to decorate the home of Shchukin. Indeed, Matisse's project must have especially galled Picasso, as Shchukin had temporarily stopped buying his work. That the Field commission would constitute a more ambitious undertaking than that of Matisse for Shchukin might have especially appealed to him.

As I discovered the identity of the Field commission

pictures shortly before the press deadline for the present volume, I have not had the time to explore many of the questions that immediately arise. Among them: To what extent can we reconstruct the iconographic program of the series? (Presumably Picasso had all his motifs roughly in mind before undertaking the large painting with bathers.) Was anything in the program (such as the piano) a concession to, or determined by, Field? What drawings, *papiers collés*, or notebook studies of 1910–15 can be associated with the commission? (Surely Daix 347 and 496 [p. 250], for example, were related to the project, and also possibly Daix 352 [p. 160] and 535). Are there any notes or inscriptions in the *carnets* of that period that, cryptic heretofore, will now make sense? Are there any references to the project buried in Picasso's letters to and from various people who knew about it? Assuming that the Musée Picasso will allow me to publish Field's letter and plans, now in its archives, and that there are no unresolvable problems with access to documentation held by the Field family, I plan to pursue these and other aspects of the commission in a fuller study.

NOTES

1. "Decoration" was Picasso's word. He wrote to Gertrude Stein, in an undated letter (probably June 16, 1910): "Next winter I have to do a decoration for America, for a cousin of Haviland's…" (see Documentary Chronology, under that date).
2. Cited, with an erroneous date, in Judith Cousins and Hélène Seckel, "Éléments pour une chronologie et de l'histoire des Demoiselles d'Avignon," in *Les Demoiselles d'Avignon*, vol. 2 (Paris: Éditions de la Réunion des Musées Nationaux, 1988), pp. 565–66.
3. In the case of Matisse, for example, it is precisely such a divergence from his easel-scale work, which he effectuated in the interior scale of his *Dance*, that makes it difficult to hang this picture alongside other, more typical Matisses of the period in the large gallery of his work at The Museum of Modern Art.
4. See Documentary Chronology, under September 7, 1910.
5. See Picasso's letter, from Céret, to Kahnweiler in Paris, July 16, 1911; Documentary Chronology, under that date.
6. Ibid. See also Picasso's letter, from Céret, to Braque in Paris, July 25, 1911; Documentary Chronology, under that date.
7. Published in *Donation Louise et Michel Leiris: Collection Kahnweiler-Leiris* (Paris: Musée National d'Art Moderne, 1985), pp. 166–68.
8. Now among the Field papers in the Archives of American Art.

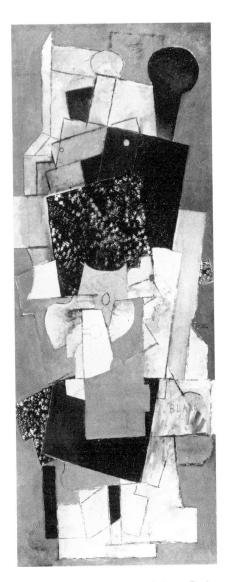

Picasso. *Woman with a Guitar*. Paris, autumn–winter 1915. Oil on canvas, 6'¾" × 29½" (185 × 75 cm). Daix 843. Private collection

Plates

In the plate captions, height precedes width, followed, in the case of sculpture, by depth. Unless otherwise specified, drawings, watercolors, prints published as illustrations in books, and *papiers collés* are works on paper, for which sheet sizes are given. For prints on single sheets of paper, plate or composition size appears. Publication information is given for prints that are part of editions, and the state is noted when more than one version of a print exists. Dates for sculptures in bronze refer to the original model. Except in the case of unpublished works, each caption includes a bibliographical reference (generally the work's entry number in the appropriate catalogue raisonné). Full titles of the sources cited can be found on page 334.

The sequence of the plates reflects the best surmise about the dates of the works, based on a synthesis of the information available at the time of publication. The information draws heavily upon Pierre Daix and Joan Rosselet's catalogue raisonné of Picasso's Cubist work; in addition, many dates have been accepted from the catalogue of Braque's Cubist work by Nicole Worms de Romilly.

The works here are generally dated by year and season. However, where there is sufficient evidence to give a more specific date, that date is given. If information is in doubt, the date or place of execution is placed in square brackets. In some cases, brackets indicate relative degrees of certitude: for example, if the year of a painting is reasonably certain, but it has been only tentatively assigned to a particular season on the basis of comparison with other works, then the season will be bracketed and the year will not.

When a work is assigned a date entirely without brackets, that date is based upon some form of documentary evidence, such as references in letters and contemporaneous accounts, or inscriptions on the work itself. When a painting depicts a particular place, it has generally been assumed that the painting was begun (if not finished) during the artist's stay there. In such cases, the assigned date corresponds to documentary evidence of when the artist was at the place in question.

The dates as a whole are provisional. The exhibition itself may well bring to light new evidence that will disprove some of the hypotheses reflected here. For this reason, an amended checklist of the exhibition, with revised dates, will be included in a companion volume to this catalogue, which will be devoted to scholarly problems, to be published after the exhibition.

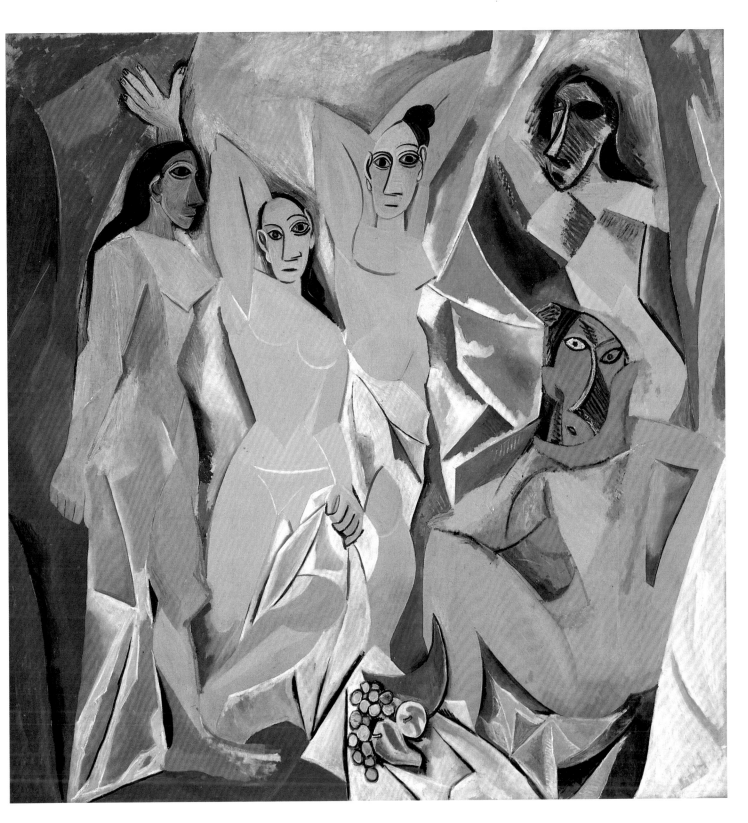

Picasso. *Les Demoiselles d'Avignon.* Paris, June–July 1907
Oil on canvas, 8′ × 7′ 8″ (243.9 × 233.7 cm)
Daix 47. The Museum of Modern Art, New York.
Acquired through the Lillie P. Bliss Bequest

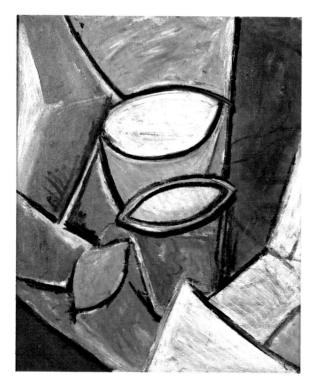

PICASSO. *Jars with Lemon.* Paris, summer 1907
Oil on canvas, 21⅜ × 18⅛″ (55 × 46 cm)
Daix 65. Collection Dr. Herbert Batliner, Vaduz, Liechtenstein

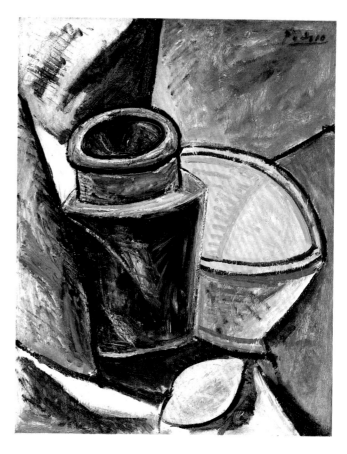

PICASSO. *Pitcher, Bowl, and Lemon.* Paris, summer 1907
Oil on panel, 24⅜ × 18⅞″ (62 × 48 cm)
Daix 66. Estate of John T. Dorrance

PICASSO. *Three Figures under a Tree.* Paris, [autumn] 1907
Oil on canvas, 39 × 39″ (99 × 99 cm)
Daix 106. Musée Picasso, Paris

BRAQUE. *Still Life with Jugs and Pipe.* La Ciotat, 1906–07
Oil on canvas, 20¾ × 25″ (52.5 × 63.5 cm)
Leymarie 6. Josefowitz Collection

BRAQUE. *Landscape at La Ciotat.* La Ciotat, summer 1907
Oil on canvas, 28¼ × 23⅜″ (71.7 × 59.4 cm)
Romilly, p. 20. The Museum of Modern Art, New York.
Acquired through the Katherine S. Dreier and Adele R. Levy Bequests

BRAQUE. *Terrace of Hôtel Mistral.* L'Estaque [and Paris], autumn 1907
Oil on canvas, 31½ × 24″ (80 × 61 cm)
Romilly, p. 28. Private collection, New York

BRAQUE. *Viaduct at L'Estaque.* L'Estaque, autumn 1907
Oil on canvas, 25⅝ × 31¾" (65.1 × 80.6 cm)
Romilly 1. The Minneapolis Institute of Arts. The John R. Van Derlip Fund,
Fiduciary Fund and gift of funds from Mr. and Mrs. Patrick Butler and various donors

BRAQUE. *Standing Nude.*
[Paris, autumn 1907]
Ink, 12¼ × 8″ (31 × 20 cm)
Romilly 4. The Douglas Cooper
Collection, Churchglade Ltd.

BRAQUE. *Standing Nude.*
[Paris, winter 1907–08].
Published Paris, Maeght, 1953
Etching, 11 × 7¾″ (27.8 × 19.6 cm)
Vallier 1. The Douglas Cooper
Collection, Churchglade Ltd.

BRAQUE. *Landscape at L'Estaque.* L'Estaque [and Paris], autumn[–winter] 1907
Oil on canvas, 21¾ × 18¼″ (55 × 46 cm)
Romilly 2. Private collection

BRAQUE. *Viaduct at L'Estaque.* [Paris, early 1908]
Oil on canvas, 28⅝ × 23¼" (72.5 × 59 cm)
Romilly 12. Musée National d'Art Moderne, Centre Georges Pompidou, Paris.
Gift of Mr. and Mrs. Claude Laurens

PICASSO. *Female Nude.* Paris, [autumn–winter 1907]
Pencil and watercolor, 24¼ × 17⅞″ (61.5 × 45.5 cm)
Daix 122. National Gallery, Prague

PICASSO. *Three Women.* Paris, [autumn–winter 1907]
Gouache, 20 × 18⅞″ (51 × 48 cm)
Daix 124. Musée National d'Art Moderne, Centre Georges
Pompidou, Paris. Gift of Mr. and Mrs. André Lefèvre

Picasso. *Bathers in a Forest.* Paris, [late 1907]
Gouache, 10¼ × 13″ (26 × 33 cm)
Daix 127. Sprengel Museum Hannover

Picasso. *Bathers in a Forest.* Paris, [late 1907]
Gouache, watercolor, and pencil, 18¾ × 22⅞″ (47.5 × 58 cm)
Daix 128. Philadelphia Museum of Art.
Samuel S. White III and Vera White Collection

PICASSO. *Nude with Raised Arms,
in Profile.* Paris, spring 1908
Oil on panel, 26⅜ × 10⅛″
(67 × 25.5 cm)
Daix 166. Private collection

PICASSO. *Standing Nude, Full Front.*
Paris, spring 1908
Oil on panel, 26⅜ × 10½″
(67 × 26.7 cm)
Daix 167. Private collection

PICASSO. *Friendship.* Paris, [winter 1907–08]
Oil on canvas, 59⅞ × 39¾″ (152 × 101 cm)
Daix 104. The Hermitage Museum, Leningrad

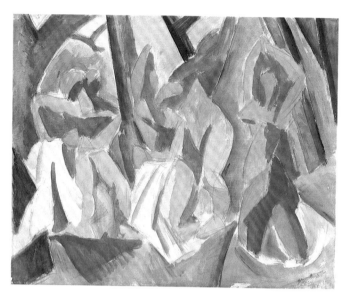

PICASSO. *Bathers in a Forest.* Paris, [spring 1908]
Watercolor and pencil on paper, mounted on canvas,
18¾ × 23⅛″ (47.5 × 58.7 cm)
Daix 126. The Museum of Modern Art, New York.
Hillman Periodicals Fund

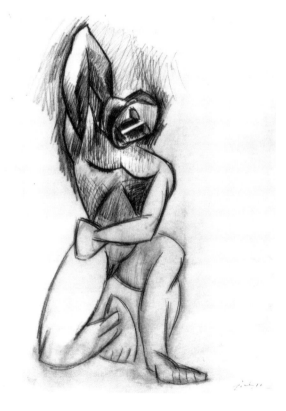

PICASSO. *Kneeling Woman.* Paris, [winter–spring 1908]
Charcoal, 25 × 18⅞″ (63.2 × 47.9 cm)
Zervos VI, 1011. The Jacques and Natasha Gelman Collection

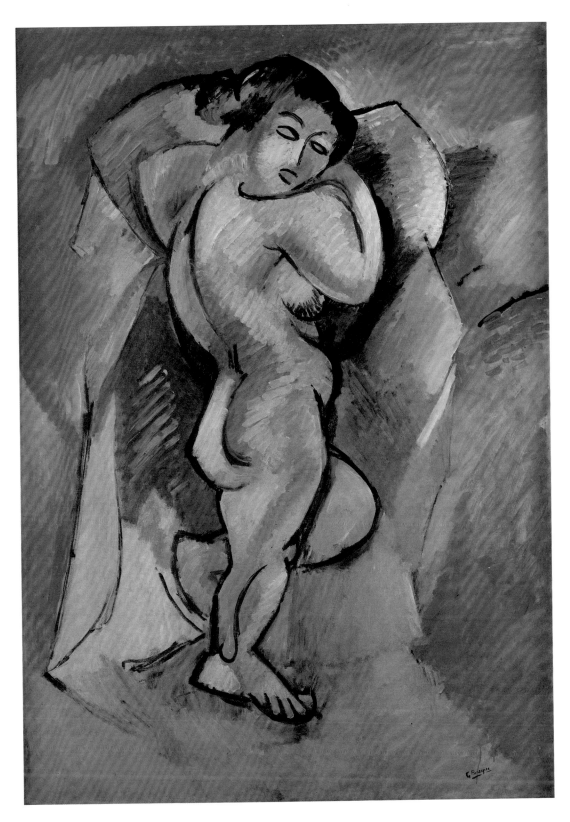

BRAQUE. *Large Nude.* Paris, spring 1908
Oil on canvas, 55¼ × 39½″ (140 × 100 cm)
Romilly 5. Collection Alex Maguy, Paris

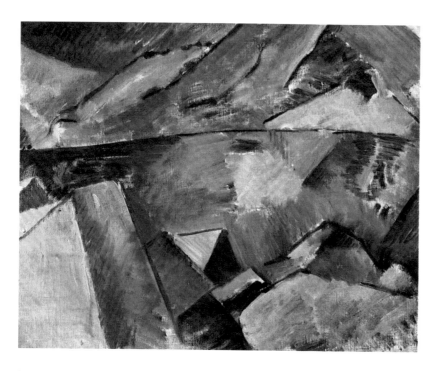

BRAQUE. *Bay at L'Estaque*. L'Estaque, [early summer 1908]
Oil on canvas, 13 × 16¼″ (33 × 41 cm)
Romilly 11. Private collection

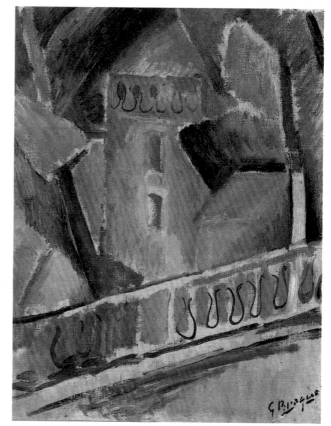

BRAQUE. *Terrace at L'Estaque.*
L'Estaque, [early summer 1908]
Oil on canvas, 16¼ × 13″ (41.5 × 33.5 cm)
Romilly 10. Musée National d'Art Moderne,
Centre Georges Pompidou, Paris.
Gift of Louise and Michel Leiris,
the donors retaining a life interest

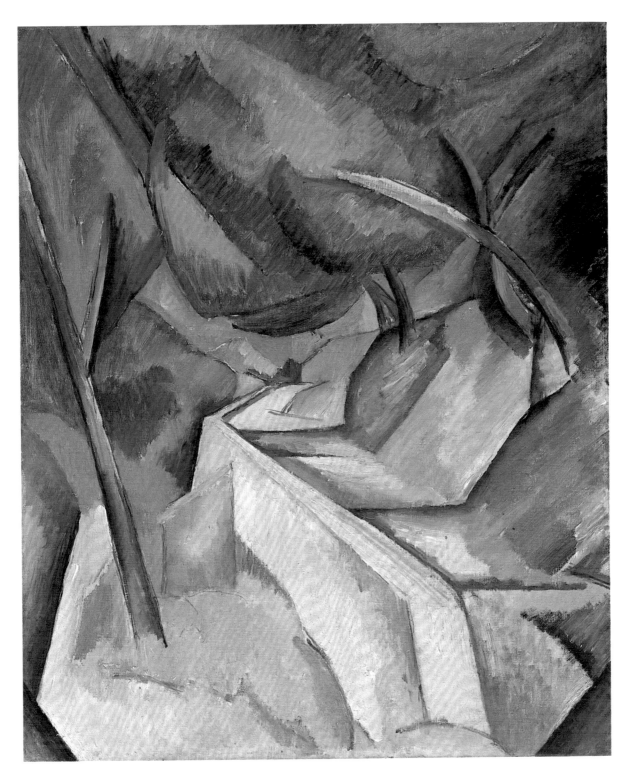

BRAQUE. *Road near L'Estaque.* L'Estaque, summer 1908
Oil on canvas, 23¾ × 19¾″ (60.3 × 50.2 cm)
Romilly 17. The Museum of Modern Art, New York.
Given anonymously (by exchange)

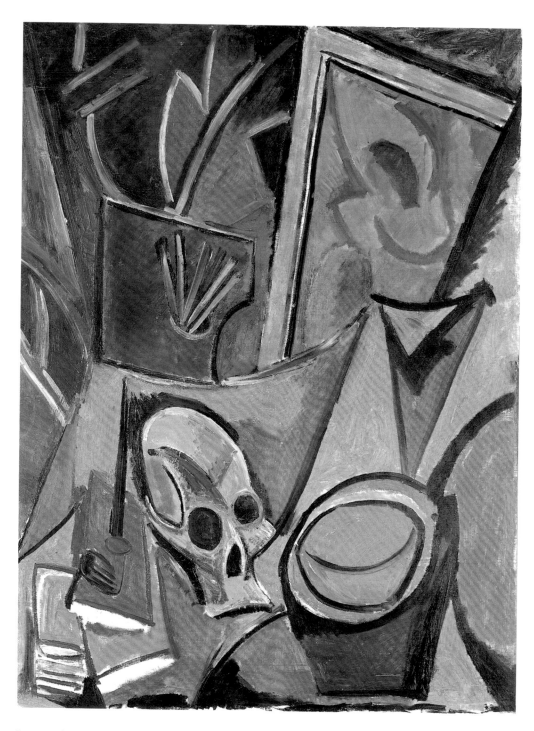

PICASSO. *Composition with Skull.* Paris, late spring 1908
Oil on canvas, 45¼ × 34⅜″ (115 × 88 cm)
Daix 172. The Hermitage Museum, Leningrad

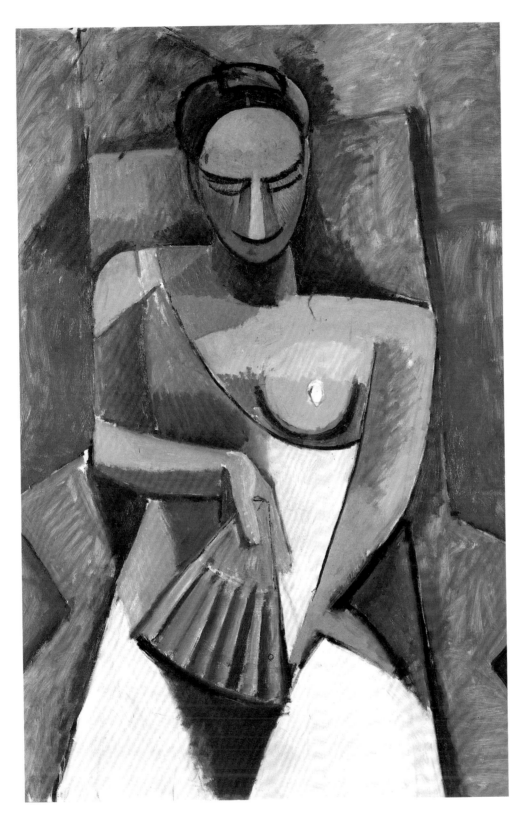

PICASSO. *Woman with a Fan.* Paris, [late spring] 1908
Oil on canvas, 59⅞ × 39¾″ (152 × 101 cm)
Daix 168. The Hermitage Museum, Leningrad

BRAQUE. *Jug and Coffeepot.* [L'Estaque, summer 1908]
Oil on canvas, 18 × 15″ (46 × 38 cm)
Romilly 8. Staatsgalerie Stuttgart

PICASSO. *Carafe and Three Bowls.* Paris, [summer] 1908
Oil on cardboard, 26 × 19¾″ (66 × 50 cm)
Daix 176. The Hermitage Museum, Leningrad

PICASSO. *Bowls and Jug.* Paris, [summer] 1908
Oil on canvas, 32¼ × 25⅞″ (81.9 × 65.7 cm)
Daix 177. Philadelphia Museum of Art.
A. E. Gallatin Collection

PICASSO. *Landscape.* La Rue-des-Bois, August 1908
Oil on canvas, 28¾ × 23⅝″ (73 × 60 cm)
Daix 192. Private collection

BRAQUE. *Viaduct at L'Estaque*. L'Estaque, summer 1908
Oil on canvas, 28¾ × 23½″ (73 × 60 cm)
Romilly 21. Mr. and Mrs. Markus Mizné, Monte Carlo

PICASSO. *Farmer's Wife*. La Rue-des-Bois, August 1908
Oil on canvas, 31⅞ × 25⅝" (81 × 65 cm)
Daix 193. The Hermitage Museum, Leningrad

PICASSO. *Vase of Flowers, Wineglass, and Spoon.* [La Rue-des-Bois, August] 1908
Oil on canvas, 31⅞ × 25⅝″ (81 × 65 cm)
Daix 196. The Hermitage Museum, Leningrad

PICASSO. *House in the Garden.* La Rue-des-Bois, August 1908
Oil on canvas, 28¾ × 23⅝″ (73 × 60 cm)
Daix 189. The Hermitage Museum, Leningrad

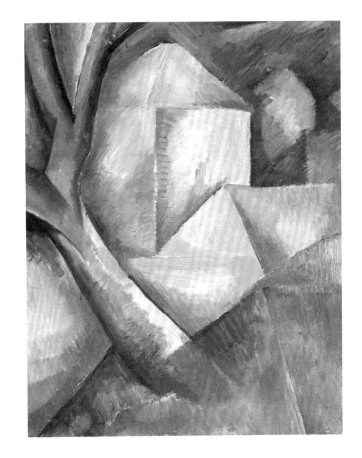

BRAQUE. *House at L'Estaque.* L'Estaque, [August] 1908
Oil on canvas, 16 × 12¾″ (40.5 × 32.5 cm)
Romilly 13. Musée d'Art Moderne, Villeneuve-d'Ascq.
Gift of Geneviève and Jean Masurel

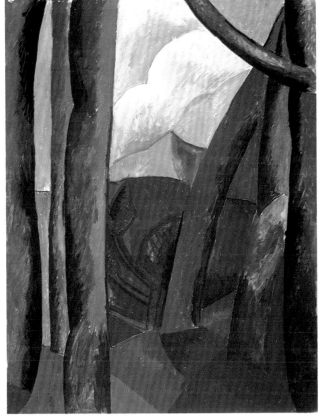

PICASSO. *Landscape.* [La Rue-des-Bois, August] 1908
Watercolor and gouache, 25¼ × 19½″ (64 × 49.5 cm)
Daix 183. Kunstmuseum Bern. Hermann and Margrit Rupf Foundation

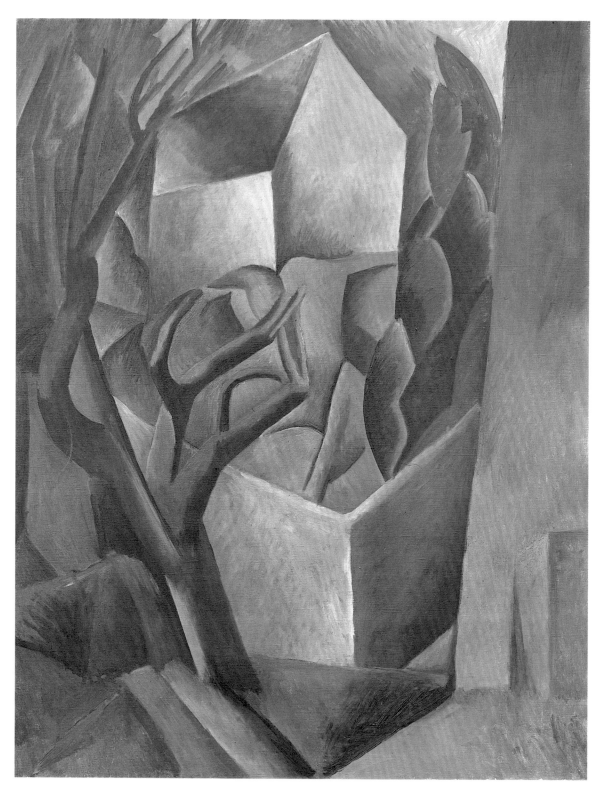

PICASSO. *Cottage and Trees.* La Rue-des-Bois, August 1908
Oil on canvas, 36¼ × 28¾″ (92 × 73 cm)
Daix 190. The Pushkin State Museum of Fine Arts, Moscow

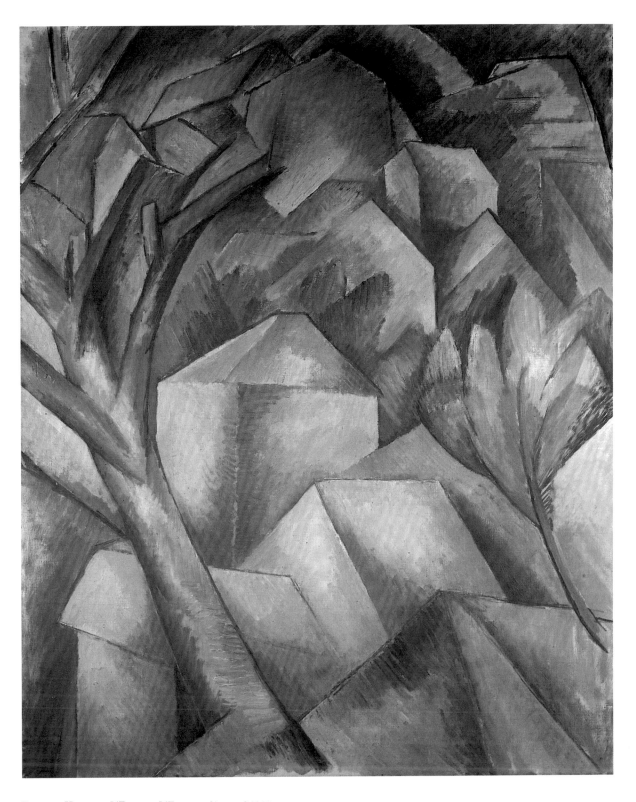

BRAQUE. *Houses at L'Estaque.* L'Estaque, [August] 1908
Oil on canvas, 28¾ × 23½″ (73 × 60 cm)
Romilly 14. Kunstmuseum Bern.
Hermann and Margrit Rupf Foundation

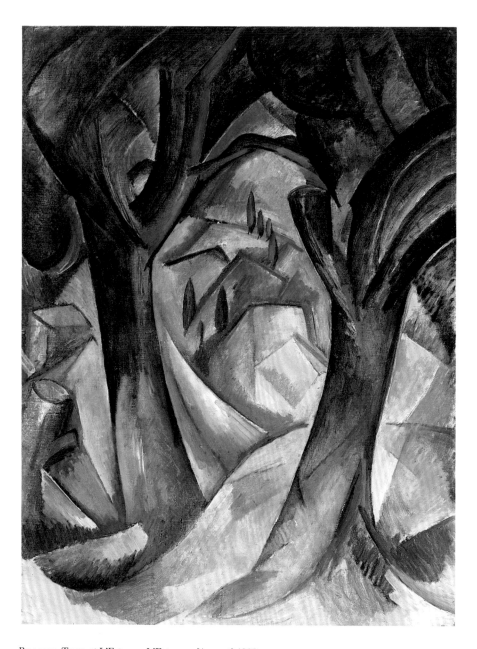

BRAQUE. *Trees at L'Estaque.* L'Estaque, [August] 1908
Oil on canvas, 31 × 23¾″ (79 × 60 cm)
Romilly 18. Private collection

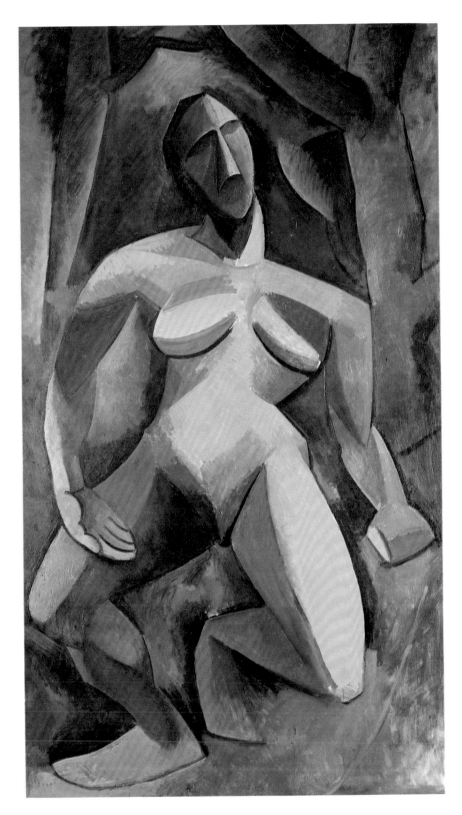

PICASSO. *The Dryad.* Paris, [spring–autumn] 1908
Oil on canvas, 72⅞ × 42½″ (185 × 108 cm)
Daix 133. The Hermitage Museum, Leningrad

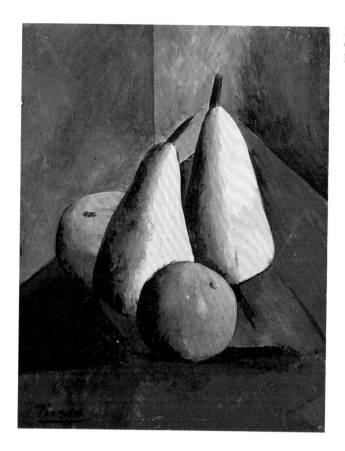

PICASSO. *Pears and Apples.* Paris, autumn 1908
Oil on panel, 10⅝ × 8¼″ (27 × 21 cm)
Daix 202. Collection Mr. and Mrs. James W. Alsdorf, Chicago

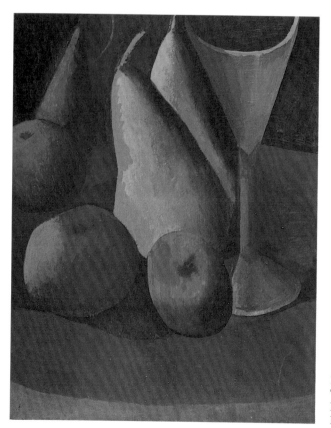

PICASSO. *Fruit Bowl with Pears and Apples.* Paris, autumn 1908
Oil wash on panel, 10⅝ × 8¼″ (27 × 21 cm)
Daix 200. Collection Heinz Berggruen, Geneva

PICASSO. *Still Life with Fruit and Glass.* Paris, autumn 1908
Tempera on panel, 10⅝ × 8⅜″ (27 × 21.1 cm)
Daix 203. The Museum of Modern Art, New York.
Estate of John Hay Whitney

Braque. *Musical Instruments.* [Paris, autumn 1908]
Oil on canvas, 19¾ × 24″ (50 × 61 cm)
Romilly 7. Private collection

PICASSO. *Bowl of Fruit.* Paris, autumn 1908
Tempera on panel, 8¼ × 10⅝″ (21 × 27 cm)
Daix 199. Kunstmuseum Basel.
Gift of Dr. H. C. Richard Doetsch-Benziger, 1960

BRAQUE. *Plate and Fruit Dish.* [Paris, autumn 1908]
Oil on canvas, 18 × 21¾″ (46 × 55 cm)
Romilly 29. Private collection

BRAQUE. *Landscape*. [Paris, autumn] 1908
Oil on canvas, 32 × 25½″ (81 × 65 cm)
Romilly 26. Kunstmuseum Basel. Gift of Raoul La Roche, 1952

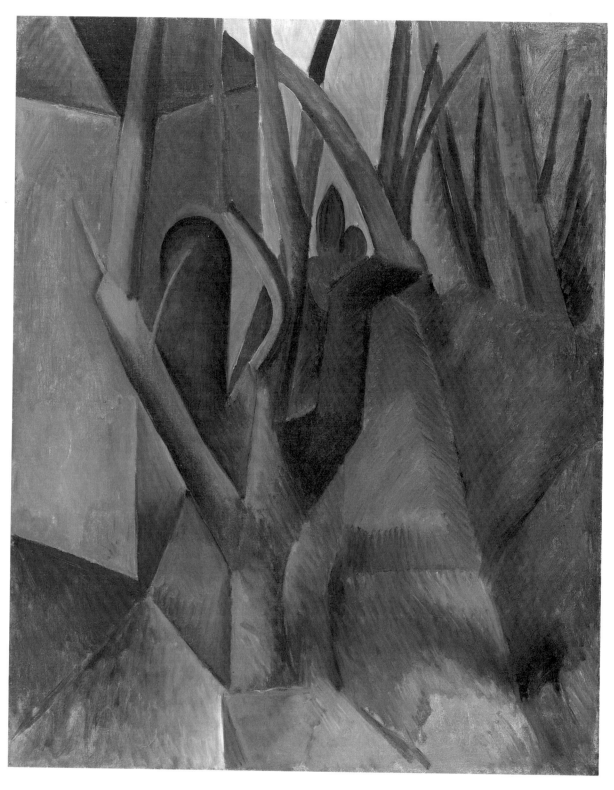

PICASSO. *Landscape.* [Paris, autumn] 1908
Oil on canvas, 39⅝ × 32″ (100.8 × 81.3 cm)
Daix 191. The Museum of Modern Art, New York.
Gift of David Rockefeller

Picasso. *Standing Nude Seen from the Back.*
[Paris, autumn] 1908
Gouache and pencil, 24⅞ × 19″ (63 × 48 cm)
Zervos XXVI, 359. Private collection

Picasso. *Landscape with Two Figures.* Paris, [late] 1908
Oil on canvas, 22⅞ × 28⅜″ (58 × 72 cm)
Daix 187. Musée Picasso, Paris

109

Picasso. *Woman with Raised Arm.* Paris, [autumn] 1908
Crayon, 24⅝ × 18⅞″ (62.5 × 48 cm)
Schiff 14. Collection Marina Picasso;
Galerie Jan Krugier, Geneva

Picasso. *Woman with Raised Arm.* Paris, [autumn] 1908
Conté crayon, 24⅝ × 18⅝″ (62.5 × 47.4 cm)
Zervos VI, 993. Private collection

PICASSO. *Three Women*. Paris, autumn 1907–late 1908
Oil on canvas, 78¾ × 70⅛″ (200 × 178 cm)
Daix 131. The Hermitage Museum, Leningrad

BRAQUE. *Landscape with Houses.* [Paris, winter 1908–09]
Oil on canvas, 25⅝ × 21¼″ (65.5 × 54 cm)
Romilly 33. Art Gallery of New South Wales, Sydney

Braque. *Harbor.* [Le Havre and Paris, autumn–winter] 1908–09
[probably reworked, 1910]
Oil on canvas, 36¼ × 28⅞″ (92.1 × 73.3 cm)
Romilly 51. The Museum of Fine Arts, Houston.
The John A. and Audrey Jones Beck Collection

Picasso. *Carnival at the Bistro.*
Paris, winter 1908–09
Watercolor and pencil,
8¼ × 8⅞" (21 × 22.5 cm)
Daix 218. Private collection

Picasso. *Carnival at the Bistro.*
Paris, winter 1908–09
Gouache and ink; sheet,
12⅜ × 19½" (32 × 49.5 cm)
Daix 219. Musée Picasso, Paris

Picasso. *Still Life with Hat (Cézanne's Hat).*
Paris, [winter] 1908–09
Oil on canvas, 23⅝ × 28¾" (60 × 73 cm)
Daix 215. Private collection

PICASSO. *Bread and Fruit Dish on a Table*. Paris, winter 1908–09
Oil on canvas, 64⅝ × 52¼″ (164 × 132.5 cm)
Daix 220. Kunstmuseum Basel

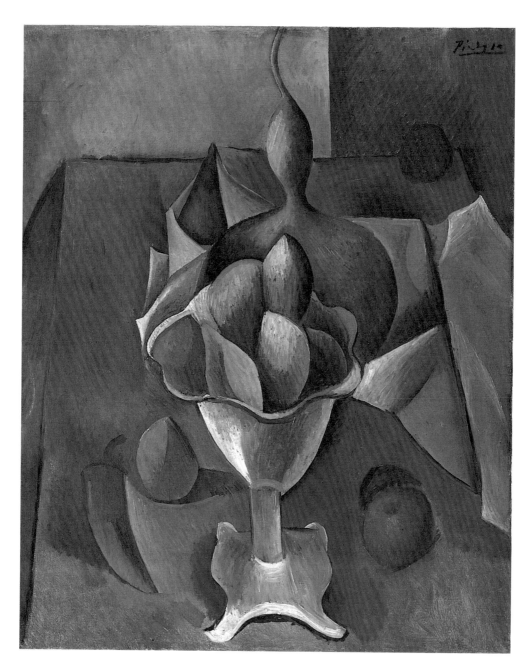

PICASSO. *Fruit Dish.* Paris, [winter] 1908–09
Oil on canvas, 29¼ × 24″ (74.3 × 61 cm)
Daix 210. The Museum of Modern Art, New York.
Acquired through the Lillie P. Bliss Bequest

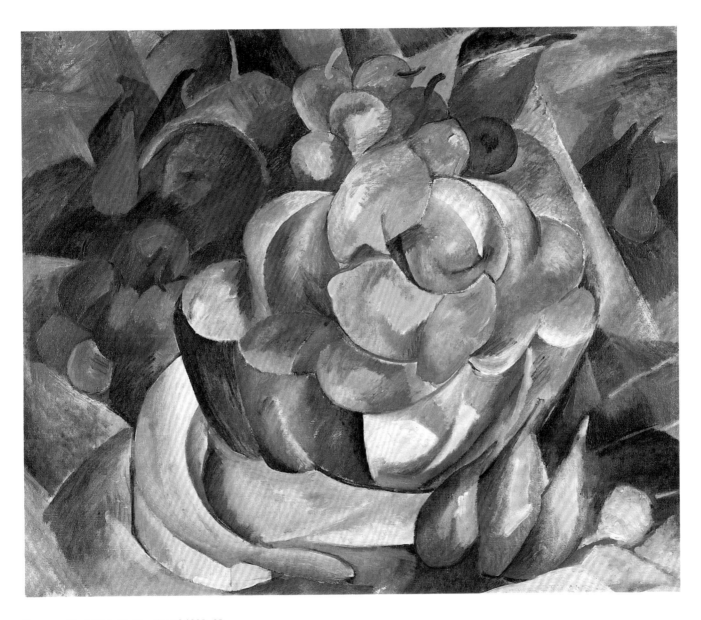

BRAQUE. *Fruit Dish.* [Paris, winter] 1908–09
Oil on canvas, 21¼ × 25½″ (54 × 65 cm)
Romilly 35. Moderna Museet, Stockholm

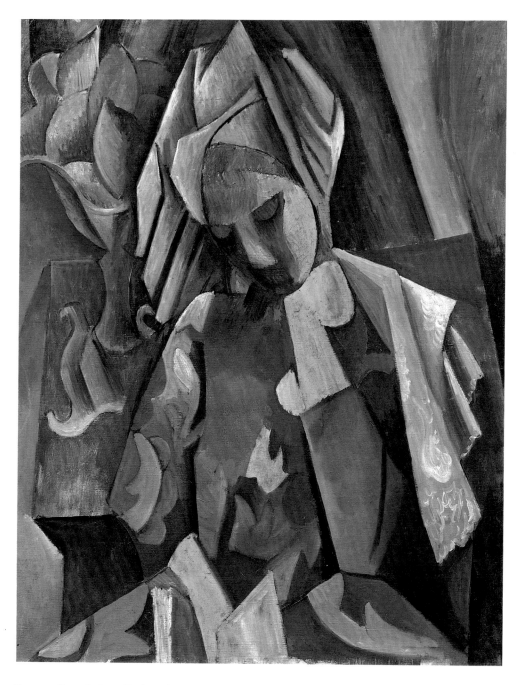

PICASSO. *Queen Isabeau.* Paris, early 1909
Oil on canvas, 36¼ × 28¾″ (92 × 73 cm)
Daix 222. The Pushkin State Museum of Fine Arts, Moscow

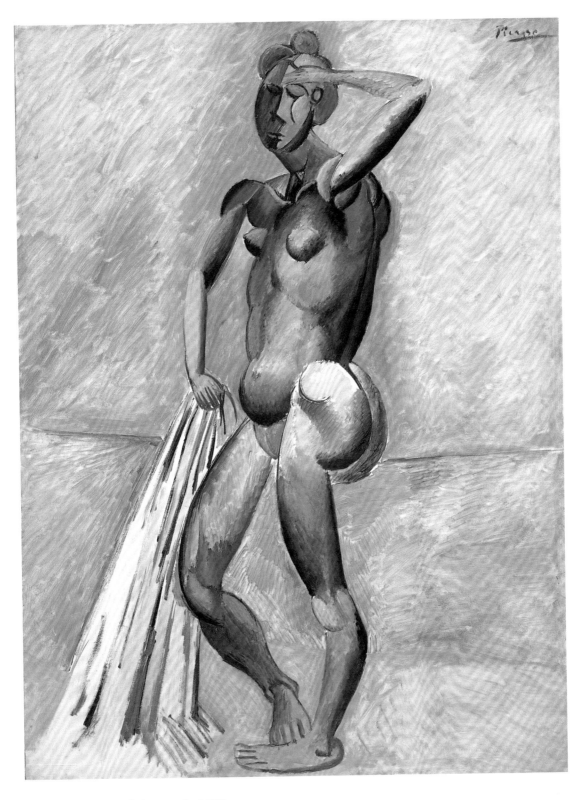

PICASSO. *Bather.* Paris, [winter–spring] 1909
Oil on canvas, 51¼ × 38⅛″ (130 × 97 cm)
Daix 239. Collection Mrs. Bertram Smith, New York

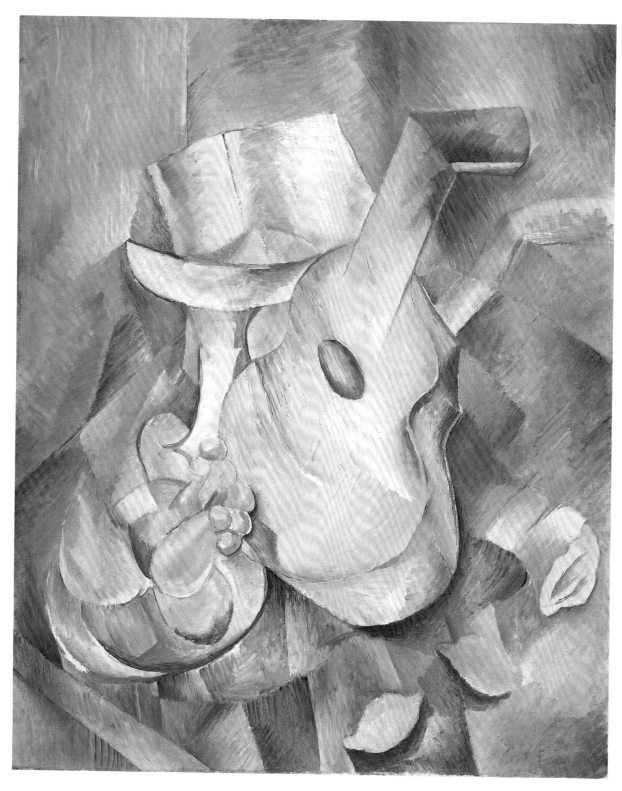

BRAQUE. *Guitar and Fruit Dish.* [Paris, winter–spring 1909]
Oil on canvas, 28¾ × 23¾″ (73 × 60 cm)
Romilly 36. Kunstmuseum Bern.
Hermann and Margrit Rupf Foundation

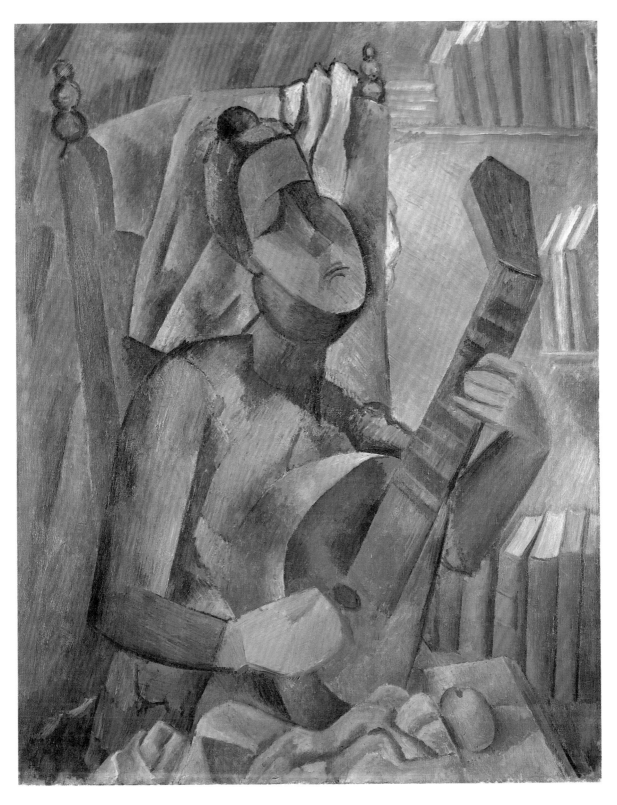

PICASSO. *Woman with a Mandolin.* Paris, [spring] 1909
Oil on canvas, 36¼ × 28¾″ (92 × 73 cm)
Daix 236. The Hermitage Museum, Leningrad

PICASSO. *St. Anthony and Harlequin.* Paris, spring 1909
Watercolor, 24⅜ × 18⅞″ (62 × 48 cm)
Daix 257. Moderna Museet, Stockholm

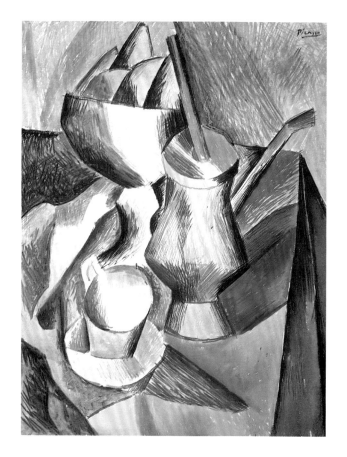

PICASSO. *The Chocolate Pot.* Paris, [spring] 1909
Watercolor, 24⅛ × 18¾″ (61.3 × 47.5 cm)
Daix 223. Private collection

Picasso. *Landscape with Bridge.* Paris, spring 1909
Oil on canvas, 31⅞ × 39⅜″ (81 × 100 cm)
Daix 273. National Gallery, Prague

PICASSO. *Woman with a Book.* Paris, spring 1909
Oil on canvas, 36¼ × 28¾″ (92 × 73 cm)
Daix 241. Private collection

PICASSO. *Two Nudes.* Paris, spring 1909
Oil on canvas, 39⅜ × 31⅞″ (100 × 81 cm)
Daix 244. Private collection

Braque. *Harbor in Normandy.* [Le Havre and Paris, May–June 1909]
Oil on canvas, 37⅞ × 37⅞″ (96.2 × 96.2 cm)
Romilly 44. The Art Institute of Chicago. Samuel A. Marx Fund

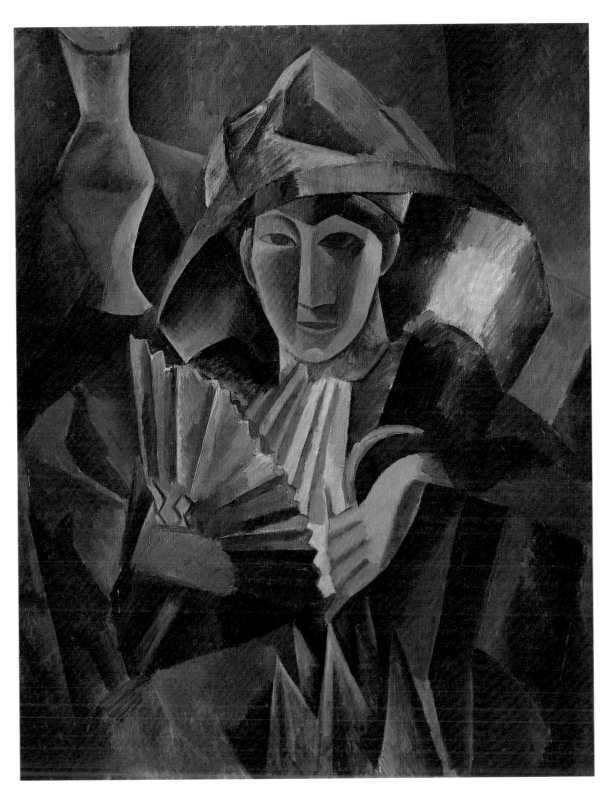

PICASSO. *Woman with a Fan.* Paris, spring 1909
Oil on canvas, 39⅜ × 31⅞″ (100 × 81 cm)
Daix 263. The Pushkin State Museum of Fine Arts, Moscow

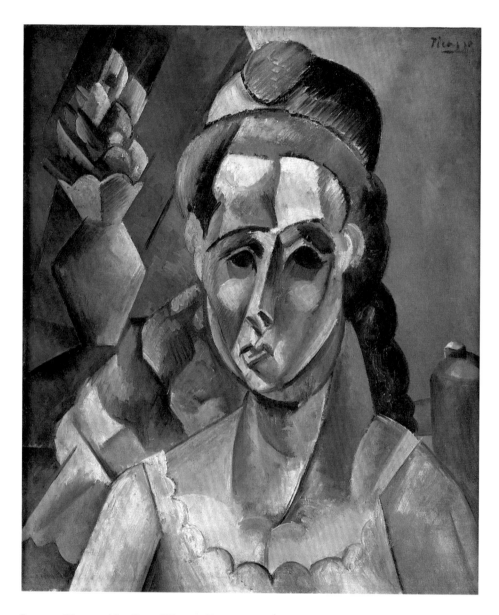

PICASSO. *Woman with a Vase of Flowers.* [Paris, spring] 1909
Oil on canvas, 23¾ × 20½″ (60.5 × 52 cm)
Daix 282. Collection Bernhard Sprengel Foundation, Hannover

Picasso. *Landscape (Mountain of Santa Bárbara).*
Horta de Ebro, late spring 1909
Oil on canvas, 15⅜ × 18⅝″ (39 × 47.3 cm)
Daix 276. Private collection

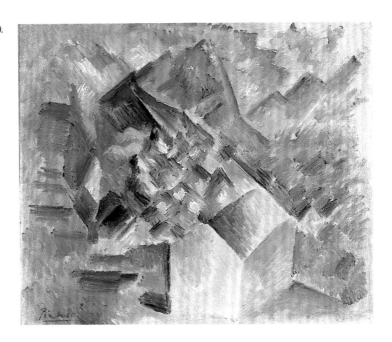

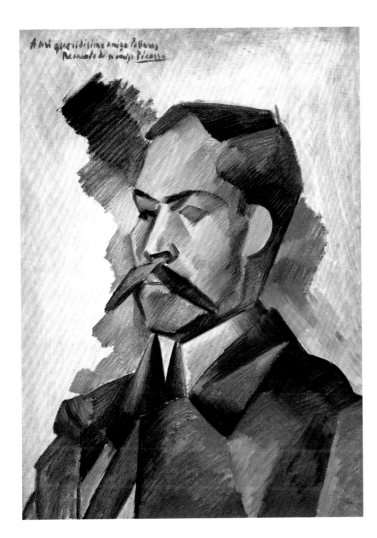

Picasso. *Portrait of Manuel Pallarés.* Barcelona, May 1909
Oil on canvas, 26¾ × 19½″ (68 × 49.5 cm)
Daix 274. The Detroit Institute of Arts. Gift of Mr. and Mrs. Henry Ford II

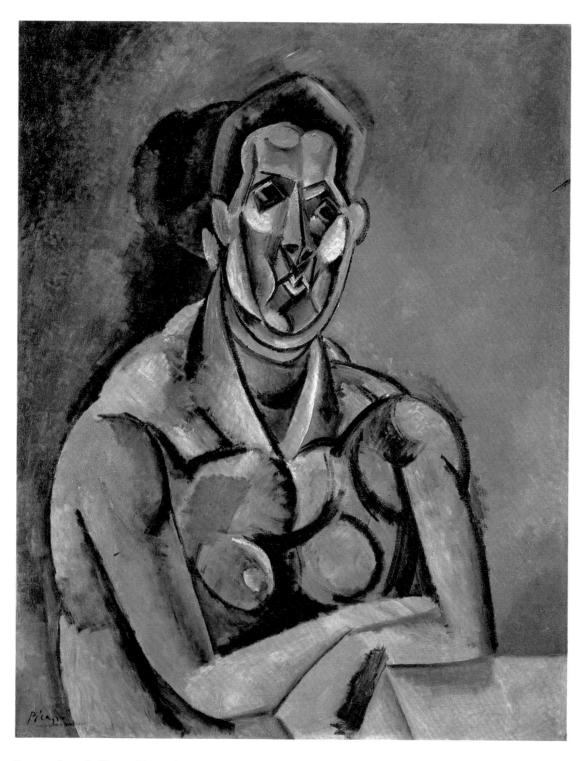

PICASSO. *Bust of a Woman (Fernande).* Horta de Ebro, summer 1909
Oil on canvas, 36⅝ × 29⅛″ (93 × 74 cm)
Daix 286. The Hiroshima Museum of Art

PICASSO. *Reservoir at Horta.* Horta de Ebro, summer 1909
Oil on canvas, 23¾ × 19¾″ (60 × 50 cm)
Daix 280. Private collection

PICASSO. *Mill at Horta.* Horta de Ebro, summer 1909
Watercolor, 9¾ × 15″ (24.8 × 38.2 cm)
Daix 281. The Museum of Modern Art, New York.
The Joan and Lester Avnet Collection

Braque. *Castle at La Roche-Guyon.* La Roche-Guyon, summer 1909
Oil on canvas, 32 × 23¾″ (81 × 60 cm)
Romilly 38. Moderna Museet, Stockholm

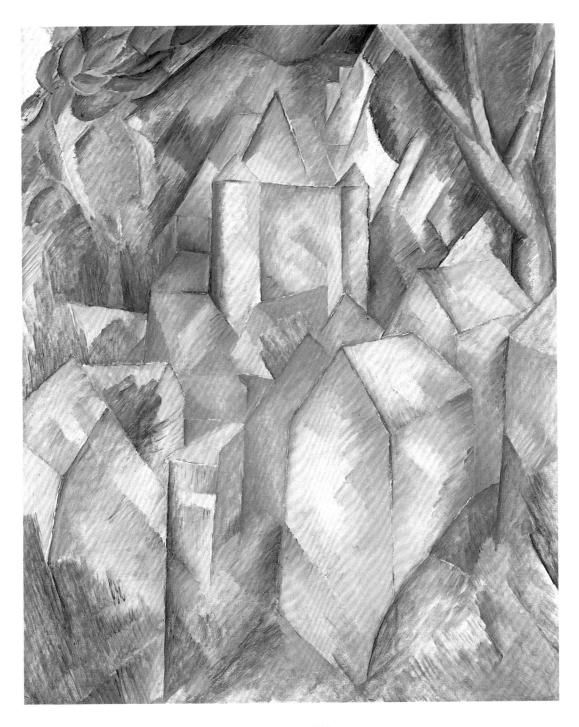

BRAQUE. *Castle at La Roche-Guyon.* La Roche-Guyon, summer 1909
Oil on canvas, 28¾ × 23¾″ (73 × 60 cm)
Romilly 39. Musée d'Art Moderne, Villeneuve-d'Ascq.
Gift of Geneviève and Jean Masurel

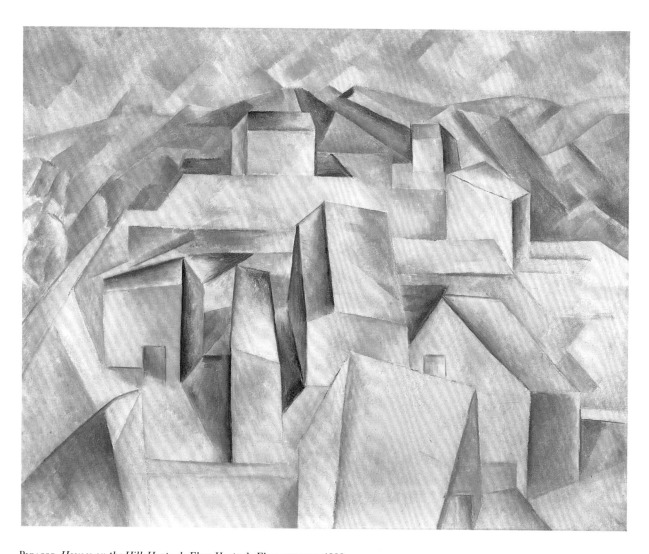

Picasso. *Houses on the Hill, Horta de Ebro.* Horta de Ebro, summer 1909
Oil on canvas, 25⅝ × 31⅞″ (65 × 81 cm)
Daix 278. The Museum of Modern Art, New York.
Nelson A. Rockefeller Bequest

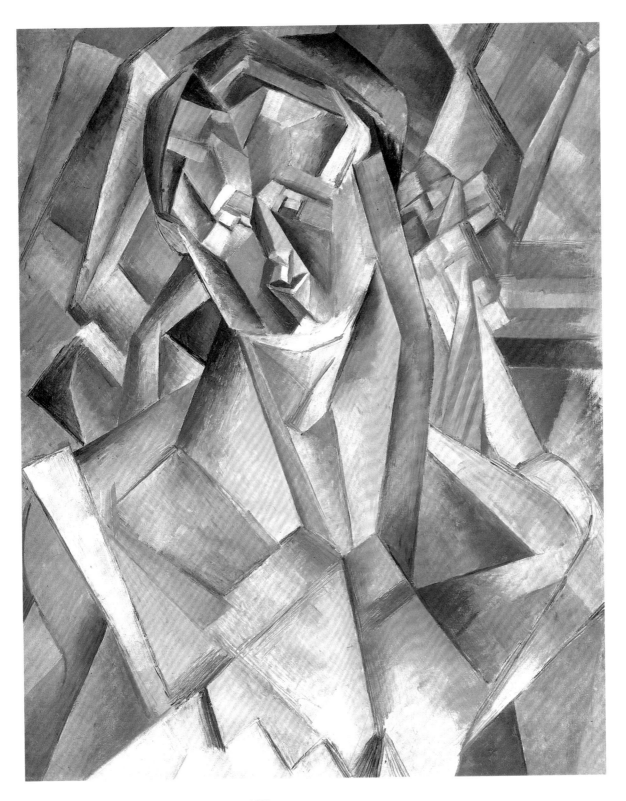

PICASSO. *Seated Woman.* Horta de Ebro, summer 1909
Oil on canvas, 31⅞ × 25⅝″ (81 × 65 cm)
Daix 292. Private collection

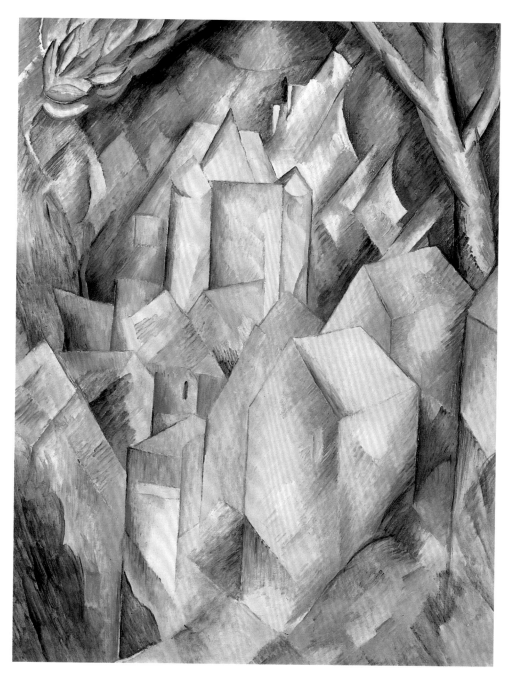

BRAQUE. *Castle at La Roche-Guyon.* La Roche-Guyon, summer 1909
Oil on canvas, 25¾ × 21¼″ (65 × 54 cm)
Romilly 41 [but reproduced as 40].
The Pushkin State Museum of Fine Arts, Moscow

BRAQUE. *Castle at La Roche-Guyon.* La Roche-Guyon, summer 1909
Oil on canvas, 36¼ × 28¾″ (92 × 73 cm)
Romilly 42. Stedelijk van Abbe Museum, Eindhoven

Picasso. *Still Life with Liqueur Bottle.* Horta de Ebro, summer 1909
Oil on canvas, 32⅛ × 25¾″ (81.6 × 65.4 cm)
Daix 299. The Museum of Modern Art, New York.
Mrs. Simon Guggenheim Fund

PICASSO. *Nude in an Armchair.* Horta de Ebro, summer 1909
Oil on canvas, 36¼ × 28¾″ (92 × 73 cm)
Daix 302. Private collection

PICASSO. *Carafe and Candlestick.* Paris, autumn 1909
Oil on canvas, 21½ × 28¾″ (54.5 × 73 cm)
Daix 316. Private collection

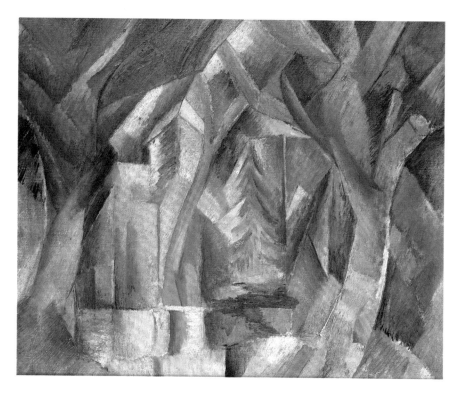

BRAQUE. *The Park at Carrières Saint-Denis.* Carrières Saint-Denis, October 1909
Oil on canvas, 15 × 18″ (38 × 46 cm)
Romilly 46. Thyssen-Bornemisza Collection, Lugano

Picasso. *Woman's Head (Fernande)*.
Horta de Ebro, summer 1909
Ink and watercolor, 13⅛ × 10⅛″ (33.3 × 25.5 cm)
Daix 289. The Art Institute of Chicago.
Alfred Stieglitz Collection

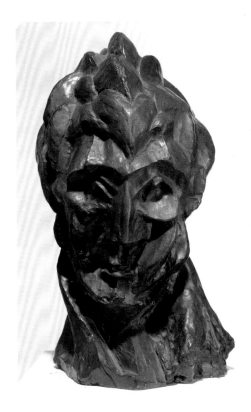

Picasso. *Woman's Head (Fernande)*. Paris, autumn 1909
Bronze, 16½ × 9¾ × 10½″ (41.3 × 24.7 × 26.6 cm)
Zervos II**, 573. Collection Stephen Hahn, New York

Picasso. *Back of a Woman's Head (Fernande)*.
Horta de Ebro, summer 1909
Charcoal and pencil, 24¾ × 18⅞″ (63 × 48 cm)
Zervos XXVI, 417. Musée Picasso, Paris

141

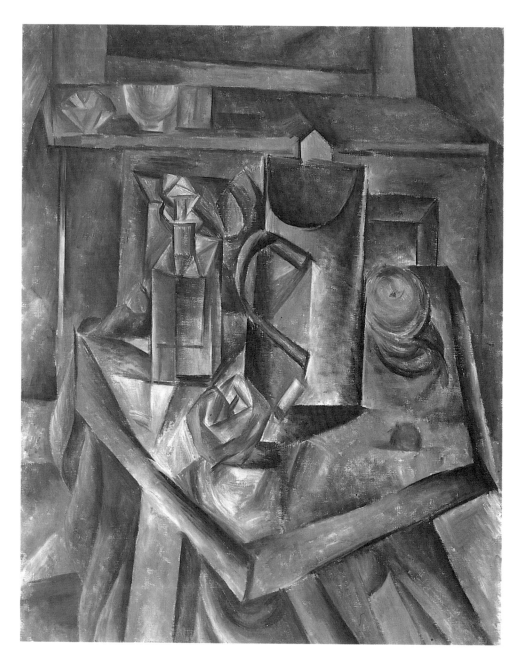

PICASSO. *Le Bock (Glass of Beer)*. Paris, autumn 1909
Oil on canvas, 31⅞ × 25⅝″ (81 × 65.6 cm)
Daix 312. Musée d'Art Moderne, Villeneuve-d'Ascq.
Gift of Geneviève and Jean Masurel

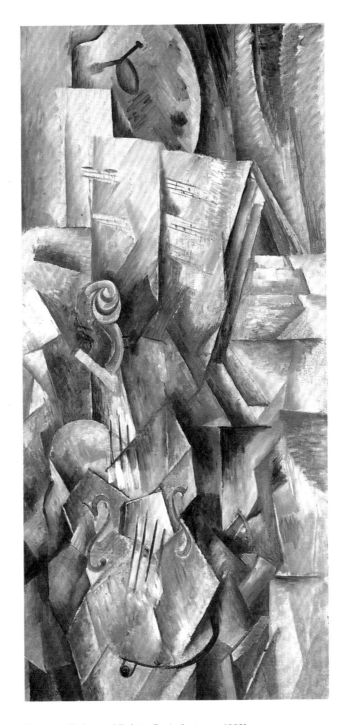

BRAQUE. *Violin and Palette.* Paris, [autumn 1909]
Oil on canvas, 36⅛ × 16⅞″ (91.7 × 42.8 cm)
Romilly 56. Solomon R. Guggenheim Museum, New York

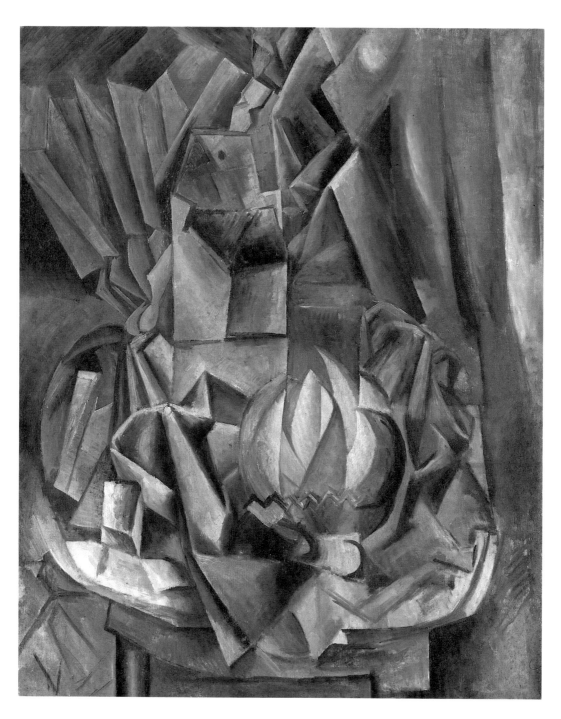

PICASSO. *Fan, Salt Box, and Melon.* Paris, autumn 1909
Oil on canvas, 32 × 25¼″ (81 × 64 cm)
Daix 314. The Cleveland Museum of Art.
Purchase, Leonard C. Hanna, Jr., Fund

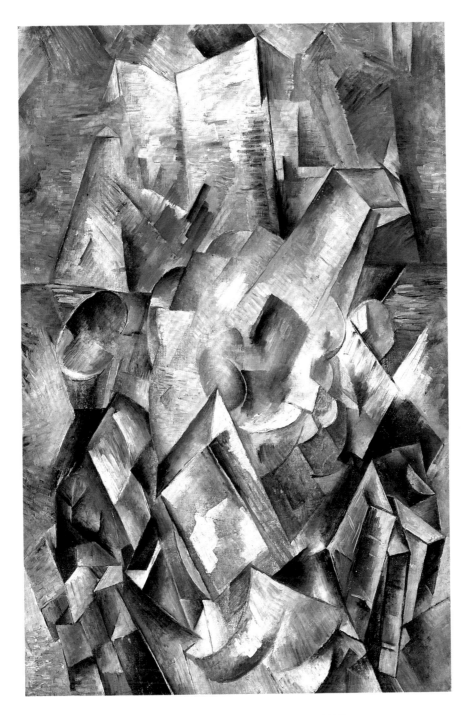

Braque. *Still Life with Mandola and Metronome.* Paris, [autumn 1909]
Oil on canvas, 32 × 21¼″ (81 × 54 cm)
Romilly 58. Private collection

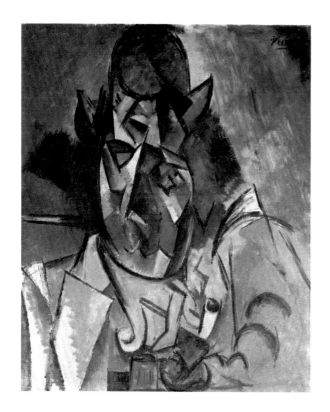

PICASSO. *Man with a Hat* (also known as *Portrait of Braque*).
Paris, [winter 1909–10]
Oil on canvas, 24 × 19⅝″ (61 × 50 cm)
Daix 330. Collection Heinz Berggruen, Geneva

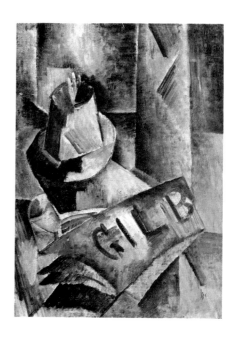

BRAQUE. *Lighter and Newspaper: "Gil Blas."*
Paris, [autumn 1909]
Oil on canvas, 13¾ × 10¾″ (35 × 27 cm)
Romilly 53. Private collection

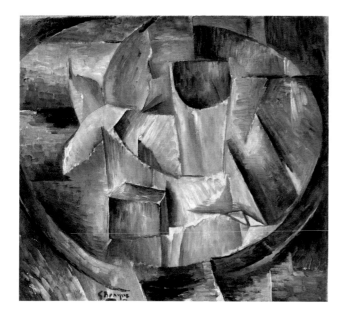

BRAQUE. *Glass on a Table.* Paris, [autumn 1909]
Oil on canvas, 13¾ × 15″ (35 × 38 cm)
Romilly 54. The Tate Gallery, London

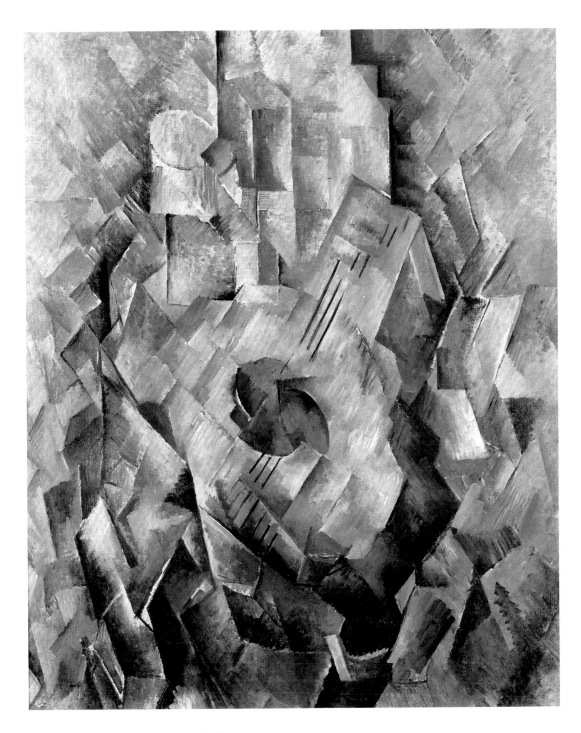

BRAQUE. *Mandola*. Paris, [winter] 1909–10
Oil on canvas, 28 × 22″ (71.1 × 55.9 cm)
Romilly 55. The Tate Gallery, London

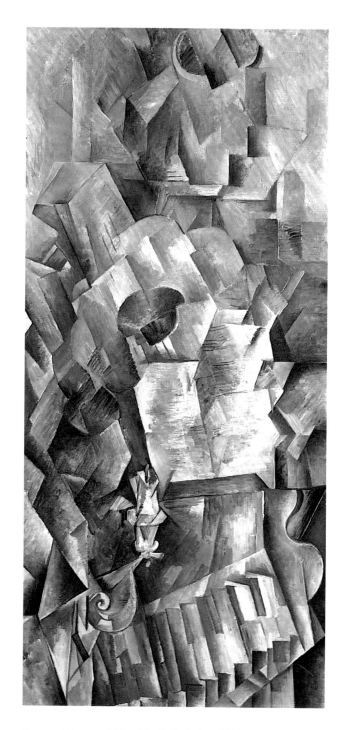

BRAQUE. *Piano and Mandola.* Paris, [winter] 1909–10
Oil on canvas, 36⅛ × 16⅞″ (91.8 × 42.9 cm)
Romilly 57. Solomon R. Guggenheim Museum, New York

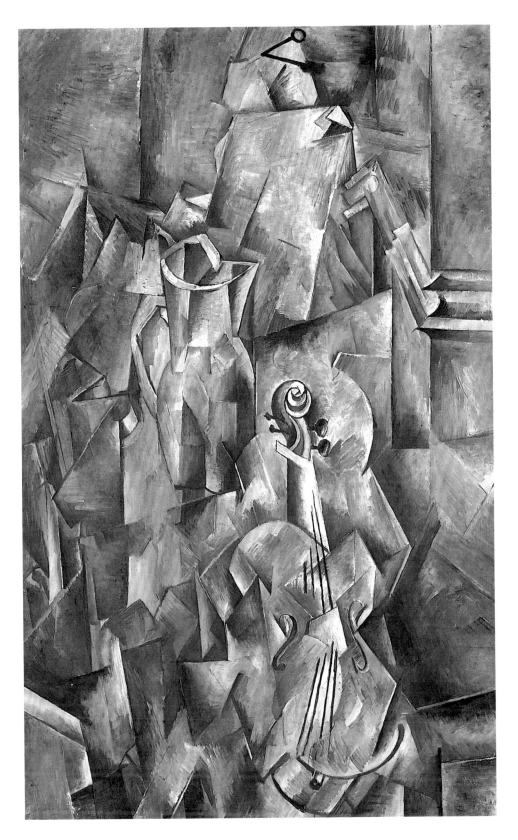

BRAQUE. *Violin and Pitcher*. Paris, [early 1910]
Oil on canvas, 46 × 28¾″ (117 × 73 cm)
Romilly 59. Kunstmuseum Basel. Gift of Raoul La Roche, 1952

Picasso. *Le Sacré-Coeur*. Paris, winter 1909–10
Oil on canvas, 36 × 25⅝″ (91.5 × 65 cm)
Daix 339. Musée Picasso, Paris

BRAQUE. *Le Sacré-Coeur*. Paris, winter 1909–10
Oil on canvas, 21¾ × 16″ (55 × 40.5 cm)
Romilly 52. Musée d'Art Moderne, Villeneuve-d'Ascq.
Gift of Geneviève and Jean Masurel

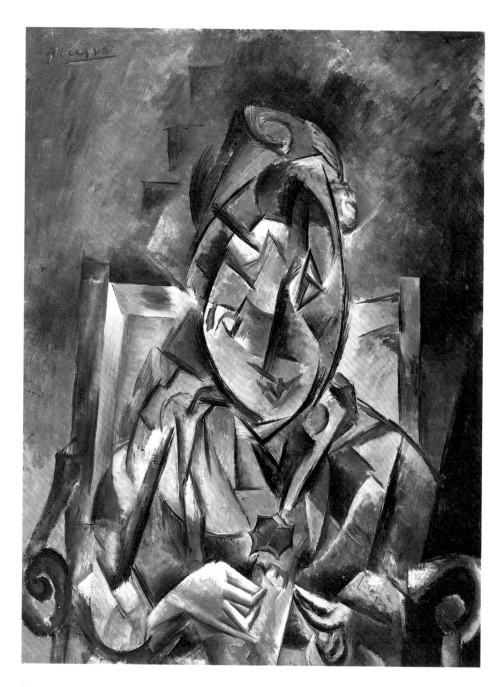

PICASSO. *Woman Sewing.* Paris, [early 1910]
Oil on canvas, 31½ × 24½″ (80 × 62.2 cm)
Daix 331. Collection Claire B. Zeisler, Chicago

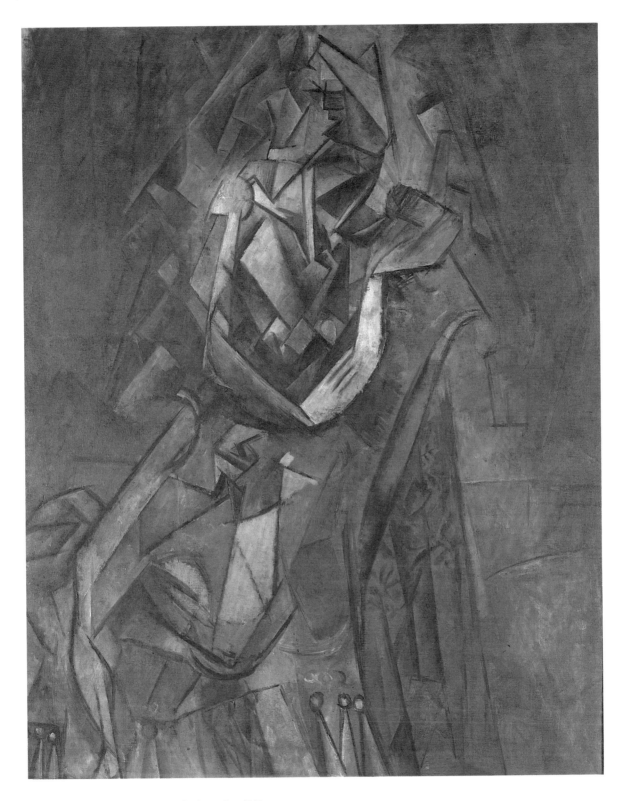

Picasso. *Woman in an Armchair.* Paris, spring 1910
Oil on canvas, 37 × 29½″ (94 × 75 cm)
Daix 344. National Gallery, Prague

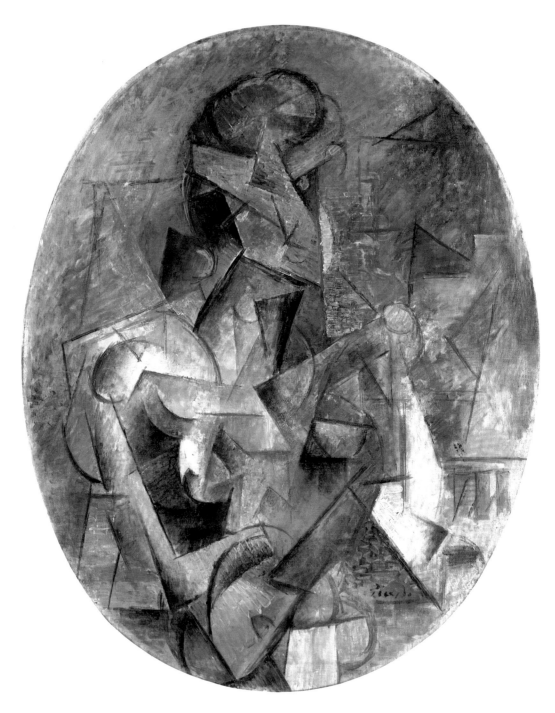

Picasso. *Woman with a Mandolin.* Paris, spring 1910
Oil on canvas (oval), 31½ × 25½″ (80 × 64 cm)
Daix 341. Private collection, Switzerland

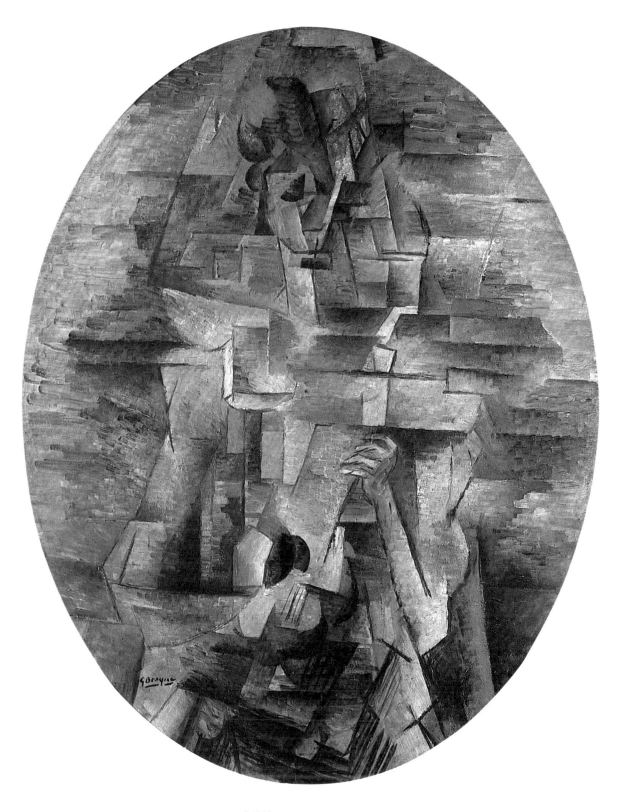

BRAQUE. *Woman with a Mandolin.* Paris, [spring] 1910
Oil on canvas (oval), 36¼ × 28¾″ (92 × 73 cm)
Romilly 71. Bayerische Staatsgemäldesammlungen, Munich

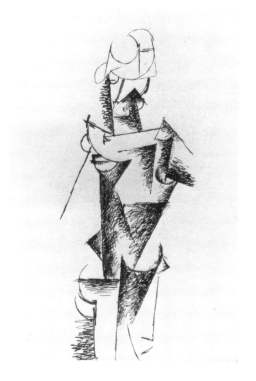

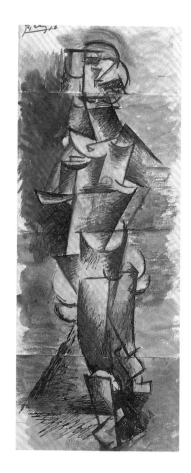

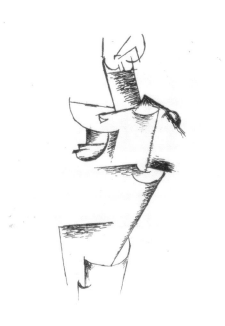

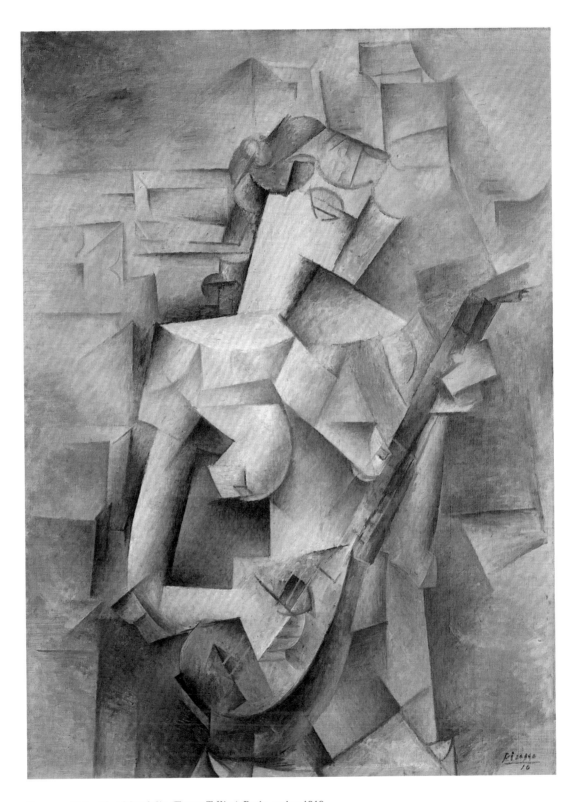

Picasso. *Girl with a Mandolin (Fanny Tellier)*. Paris, spring 1910
Oil on canvas, 39½ × 29″ (100.3 × 73.6 cm)
Daix 346. The Museum of Modern Art, New York.
Nelson A. Rockefeller Bequest

PICASSO. *Mlle Léonie.* Paris, spring 1910
Pencil and ink, 25⅝ × 19⅝″ (65 × 50 cm)
Zervos XXVIII, 2. Collection Marina Picasso;
Galerie Jan Krugier, Geneva

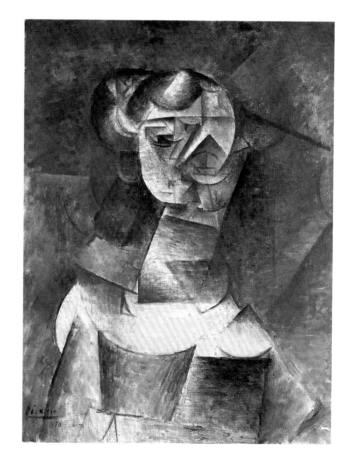

PICASSO. *Mlle Léonie.* Paris, spring 1910
Oil on canvas, 25⅝ × 19⅝″ (65 × 50 cm)
Daix 340. Private collection

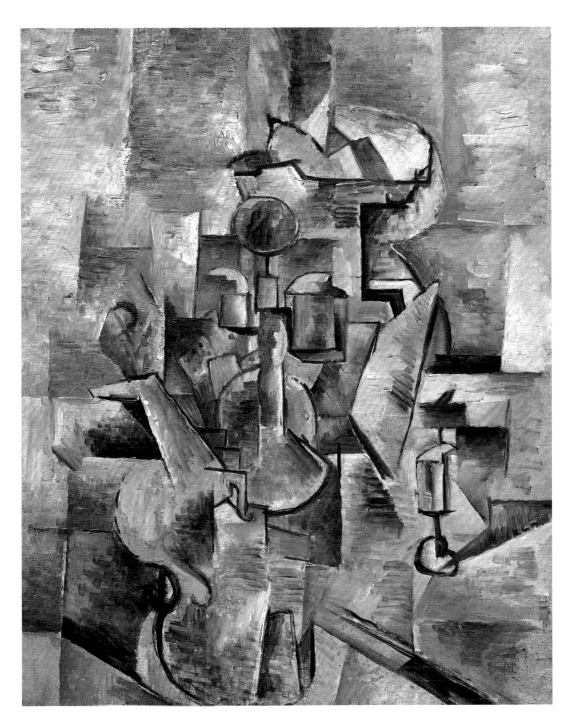

BRAQUE. *Violin and Candlestick*. Paris, [spring 1910]
Oil on canvas, 24 × 19¾″ (61 × 50 cm)
Romilly 63. San Francisco Museum of Modern Art.
Given in loving memory of her husband, Taft Schreiber,
by Rita Schreiber

PICASSO. *Nude.* Paris, [spring] 1910
Pencil and ink, 20¼ × 16⅛″ (51.5 × 41 cm)
Zervos II**, 723. National Gallery, Prague

PICASSO. *Nude.* Paris, [spring] 1910
Watercolor and ink, 29⅛ × 18¼″ (74 × 46.5 cm)
Daix 352. Private collection

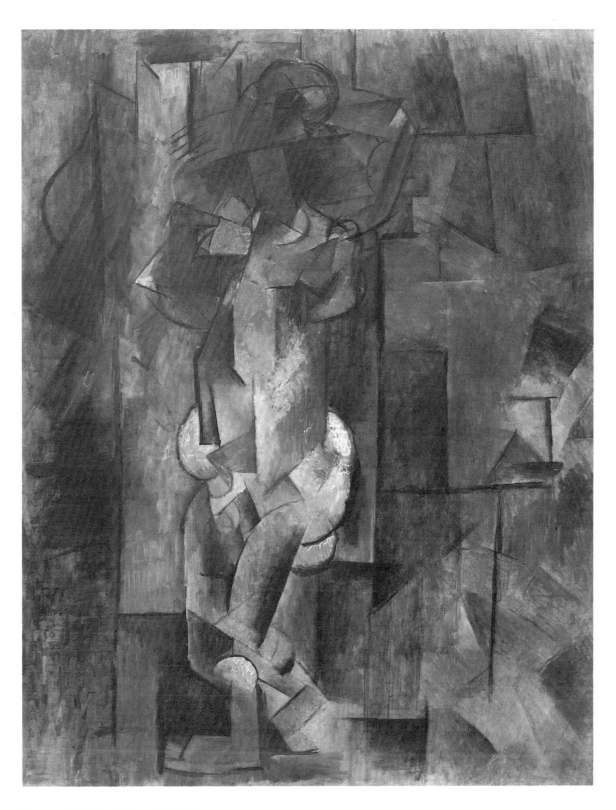

Picasso. *Nude.* [Paris, late spring] 1910
Oil on canvas, 39 × 30¾″ (99.1 × 78.1 cm)
Daix 349. Albright-Knox Art Gallery, Buffalo.
General Purchase Funds, 1954

PICASSO. *Fishing Smack at Cadaqués.*
Cadaqués, summer 1910
Ink, 8⅝ × 12⅜″ (22 × 31.5 cm)
Zervos XXVIII, 6. Private collection, Switzerland

PICASSO. *Fishing Smack at Cadaqués.*
Cadaqués, summer 1910
Ink, 8⅞ × 6⅞″ (22.5 × 17.5 cm)
Private collection

PICASSO. *Fishing Smack at Cadaqués.*
Cadaqués, summer 1910
Ink, 8⅞ × 6⅞″ (22.6 × 17.4 cm)
Richet 250. Musée Picasso, Paris

PICASSO. *Fishing Smack at Cadaqués.*
Cadaqués, summer 1910
Oil on canvas, 22 × 13⅜″ (56 × 34 cm)
Daix 359. Private collection

PICASSO. *Harbor at Cadaqués.*
Cadaqués, summer 1910
Oil on canvas, 15 × 17⅞″ (38 × 45.5 cm)
Daix 358. National Gallery, Prague

PICASSO. *The Rower.* Cadaqués, summer 1910
Oil on canvas, 28⅜ × 23½″ (72.1 × 59.7 cm)
Daix 360. The Museum of Fine Arts, Houston.
Museum purchase with funds provided by
Oveta Culp Hobby; Isaac and Agnes Cullen Arnold;
Charles E. Marsh; Mrs. William Stamps Farish;
the Robert Lee Blaffer Memorial Collection, Gift
of Sarah Campbell Blaffer, by exchange; and The
Brown Foundation Accessions Endowment Fund

PICASSO. *Figure.* [Cadaqués, summer] 1910
Ink, 12⅜ × 9⅜″ (31.5 × 24 cm)
Weisner 61. Kunstmuseum Basel, Kupferstichkabinett.
Karl August Burckhard-Koechlin Foundation

BRAQUE. *Figure.*
[L'Estaque or Paris, autumn–winter 1910]
Ink, 6¾ × 4¼″ (17 × 11 cm)
Romilly, p. 44. Private collection

BRAQUE. *Female Figure.* [L'Estaque, autumn 1910]
Oil on canvas, 36 × 24″ (91 × 61 cm)
Romilly 77. Present whereabouts unknown

PICASSO. *Mlle Léonie on a Chaise Longue*, State I.
Cadaqués, August 1910
Etching, 7¾ × 5½″ (19.8 × 14.2 cm)
Geiser 25. Collection Marina Picasso;
Galerie Jan Krugier, Geneva

PICASSO. *Mlle Léonie (Standing Figure)*, State II, from
Saint Matorel by Max Jacob. Cadaqués, August 1910.
Published Paris, Henry Kahnweiler, 1911
Etching, 7⅞ × 5½″ (20 × 14.1 cm)
Geiser 23. The Museum of Modern Art, New York.
Abby Aldrich Rockefeller Fund

PICASSO. *Mlle Léonie on a Chaise Longue*, State III, from
Saint Matorel by Max Jacob. Paris, autumn 1910.
Published Paris, Henry Kahnweiler, 1911
Etching, 7⅝ × 5⅝″ (19.8 × 14.2 cm)
Geiser 25. The Museum of Modern Art, New York.
Abby Aldrich Rockefeller Fund

PICASSO. *Standing Nude.*
[Cadaqués or Paris, summer–autumn] 1910
Charcoal, 19 × 12⅜″ (48.3 × 31.4 cm)
Zervos II*, 208. The Metropolitan Museum of Art, New York.
Alfred Stieglitz Collection, 1949

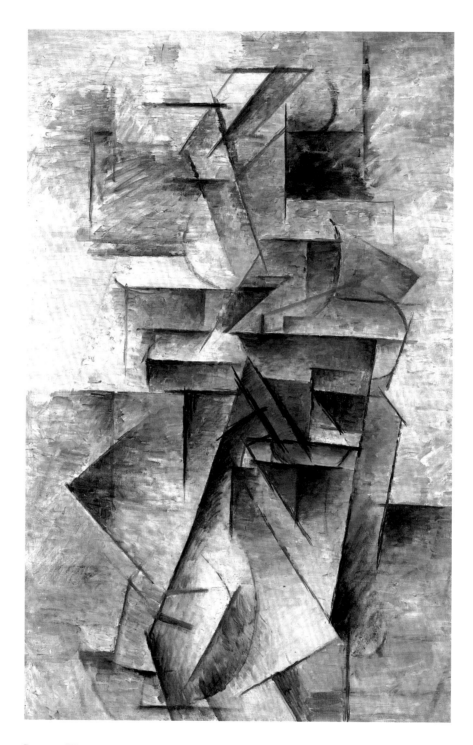

PICASSO. *Woman with a Mandolin.* Cadaqués, summer 1910
Oil on canvas, 36 × 23¼″ (91.5 × 59 cm)
Daix 361. Museum Ludwig, Cologne

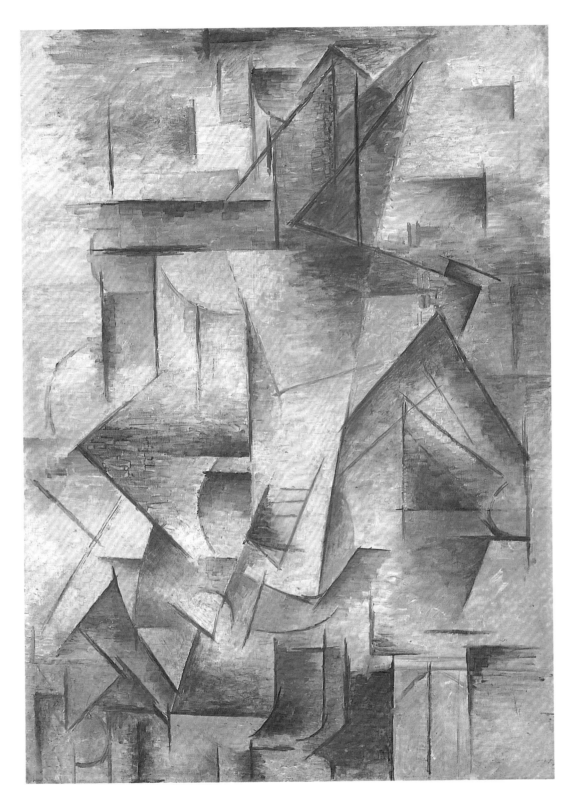

PICASSO. *Guitarist.* Cadaqués, summer 1910
Oil on canvas, 39⅜ × 28¾″ (100 × 73 cm)
Daix 362. Musée National d'Art Moderne,
Centre Georges Pompidou, Paris.
Gift of Mr. and Mrs. André Lefèvre, 1952

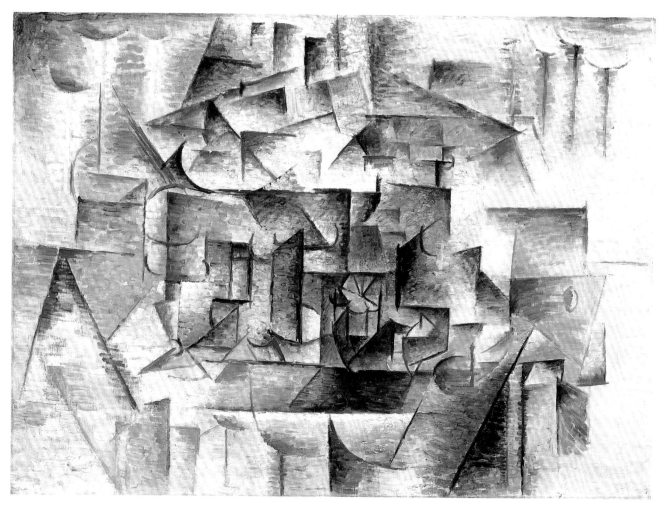

Picasso. *Still Life with Glass and Lemon.* Cadaqués, summer 1910
Oil on canvas, 28¾ × 39⅜″ (73 × 100 cm)
Daix 357. Cincinnati Art Museum

Picasso. *The Table*, from *Saint Matorel* by Max Jacob.
Cadaqués, August 1910. Published Paris, Henry Kahnweiler, 1911
Etching, 7⅞ × 5½″ (20 × 14.1 cm)
Geiser 24. Collection Hope and Abraham Melamed

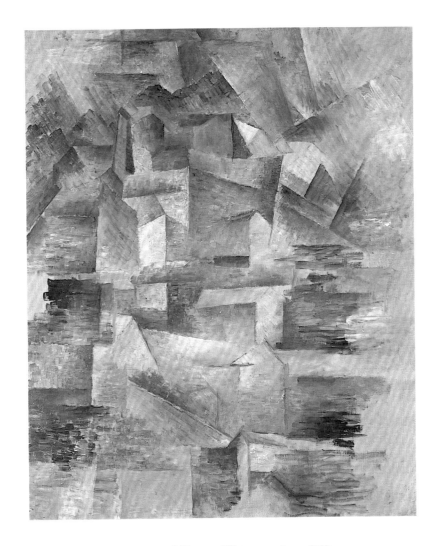

BRAQUE. *Rio Tinto Factories at L'Estaque.* L'Estaque, autumn 1910
Oil on canvas, 25¼ × 21¼″ (65 × 54 cm)
Romilly 68 [but reproduced as 69].
Musée National d'Art Moderne, Centre Georges Pompidou, Paris.
Gift of Mr. and Mrs. André Lefèvre

BRAQUE. *Checkerboard and Playing Cards*
[L'Estaque, autumn 1910]
Oil on canvas, 10¾ × 8¾″ (27 × 22 cm)
Romilly 88. Collection E. V. Thaw and Co., New York

PICASSO. *Standing Nude.*
[Paris, autumn 1910]
Ink, 12⅜ × 9″ (32 × 23 cm)
Zervos XXVIII, 20.
Staatsgalerie Stuttgart

PICASSO. *Standing Nude.*
[Paris, autumn 1910]
Ink, 12⅜ × 8½″ (31.5 × 21.5 cm)
Richet 251. Musée Picasso, Paris

PICASSO. *Standing Nude.*
[Paris, autumn 1910]
Ink, 12¼ × 8⅛″ (31.1 × 20.6 cm)
Williams 66. Private collection

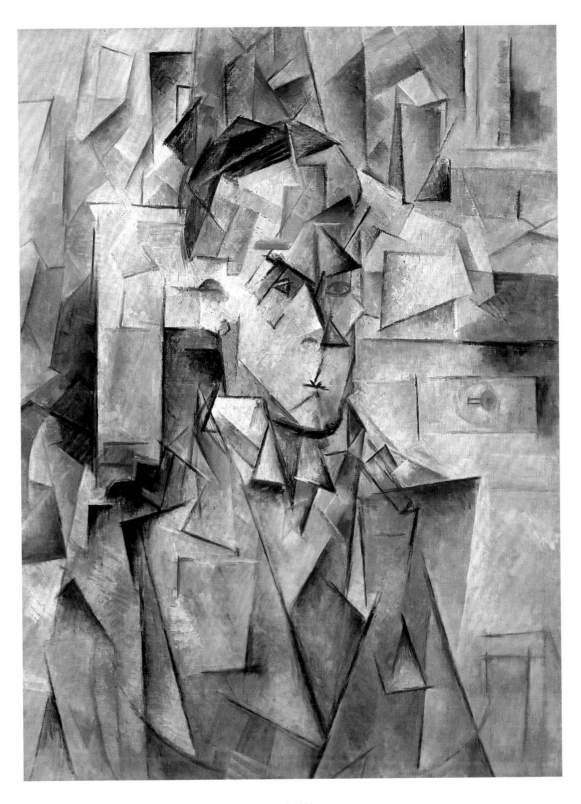

PICASSO. *Portrait of Wilhelm Uhde.* Paris, spring[–autumn] 1910
Oil on canvas, 31⅞ × 23⅝″ (81 × 60 cm)
Daix 338. Private collection

BRAQUE. *Still Life with Candlestick and Playing Cards.*
[L'Estaque, autumn 1910]
Oil on canvas (oval), 25¾ × 21¼" (65 × 54 cm)
Romilly 64. Collection Mr. and Mrs. Klaus Perls

BRAQUE. *Candlestick.* [L'Estaque, autumn 1910]
Oil on canvas, 16¼ × 11" (41 × 28 cm)
Romilly 61. Kunstmuseum Bern.
Hermann and Margrit Rupf Foundation

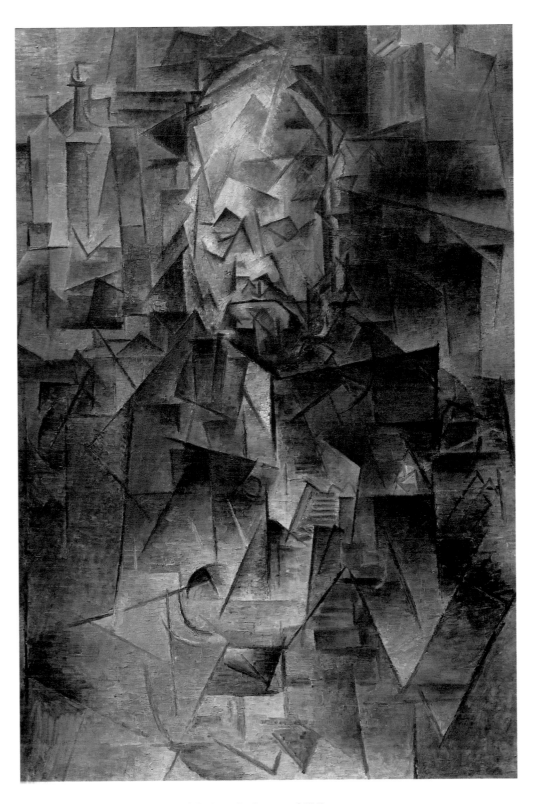

PICASSO. *Portrait of Ambroise Vollard*. Paris, spring[–autumn] 1910
Oil on canvas, 36¼ × 25⅝″ (92 × 65 cm)
Daix 337. The Pushkin State Museum of Fine Arts, Moscow

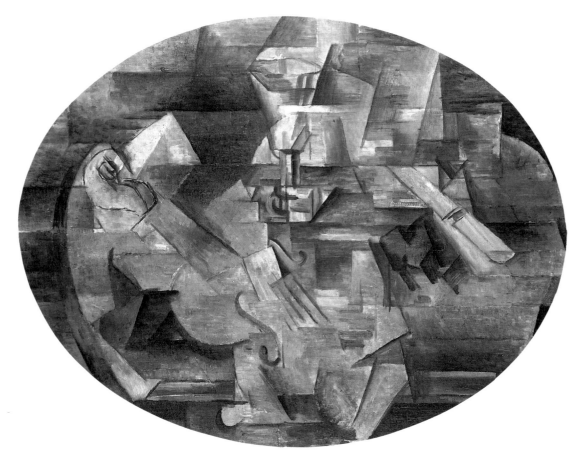

BRAQUE. *Violin, Glass, and Knife.* [L'Estaque, autumn 1910]
Oil on canvas (oval), 20 × 26¼″ (51 × 67 cm)
Romilly 65. National Gallery, Prague

BRAQUE. *Guitar on a Table.* [L'Estaque, autumn 1910].
Published Paris, Maeght, 1954
Etching with drypoint, 5⅜ × 7⅞″ (13.6 × 20 cm)
Vallier 2. Collection Hope and Abraham Melamed

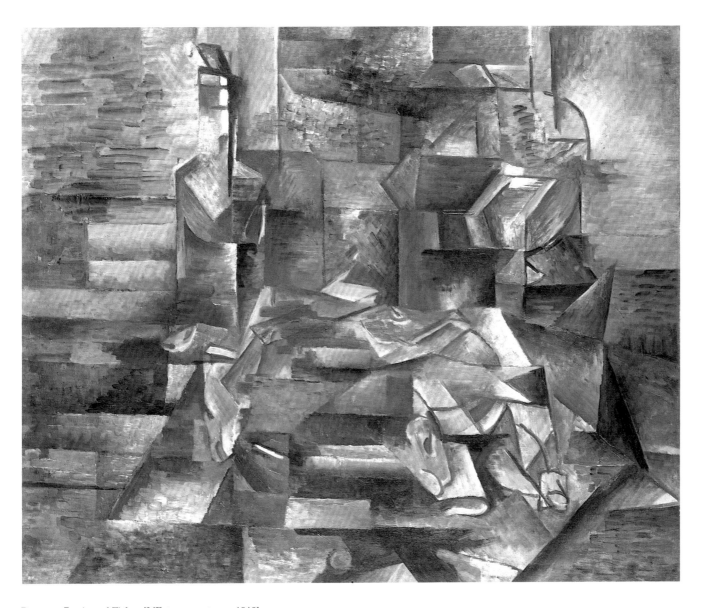

Braque. *Bottle and Fishes.* [L'Estaque, autumn 1910]
Oil on canvas, 24 × 29½″ (61 × 75 cm)
Romilly 67. The Tate Gallery, London

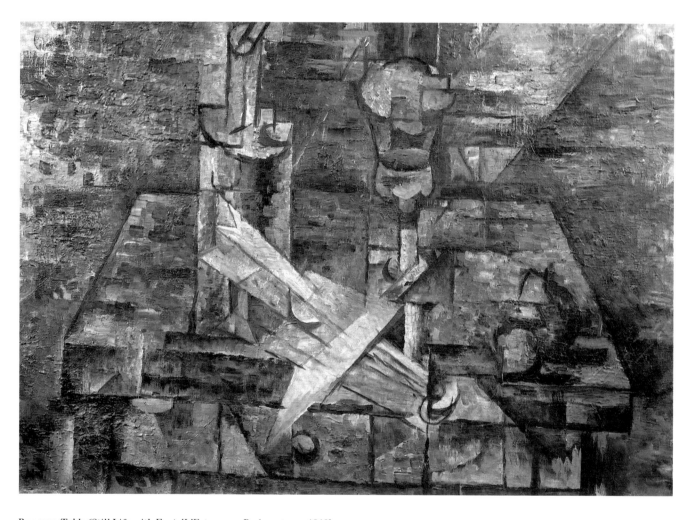

BRAQUE. *Table (Still Life with Fan).* [L'Estaque or Paris, autumn 1910]
Oil on canvas, 15 × 21½″ (38 × 55 cm)
Romilly 73. The Colin Collection, New York

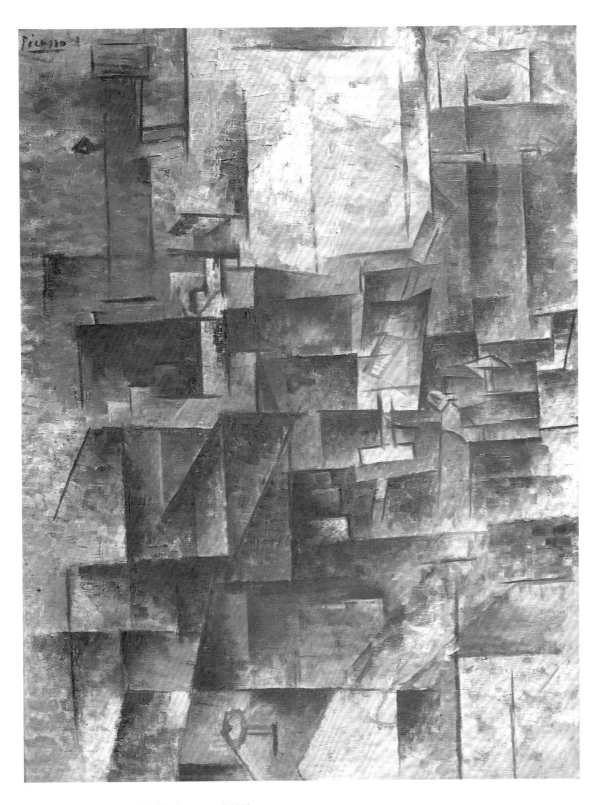

PICASSO. *The Dressing Table.* [Paris, autumn] 1910
Oil on canvas, 24 × 18⅛″ (61 × 46 cm)
Daix 356. The Colin Collection, New York

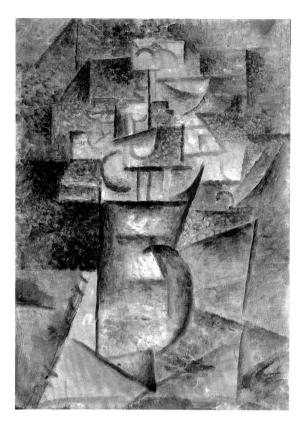

Picasso. *Vase of Flowers.* Paris, [autumn–winter 1910]
Oil on canvas, 13 × 9½″ (33 × 24 cm)
Daix 377. Collection Mr. and Mrs. James W. Alsdorf, Chicago

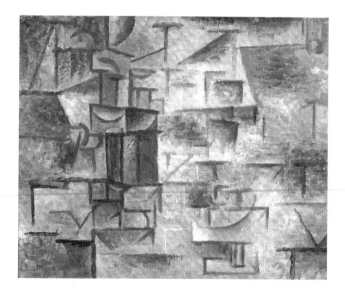

Picasso. *Field Glasses.* Paris, [autumn–winter 1910]
Oil on canvas, 8⅝ × 10⅝″ (22 × 27 cm)
Daix 375. Collection Stephen Hahn, New York

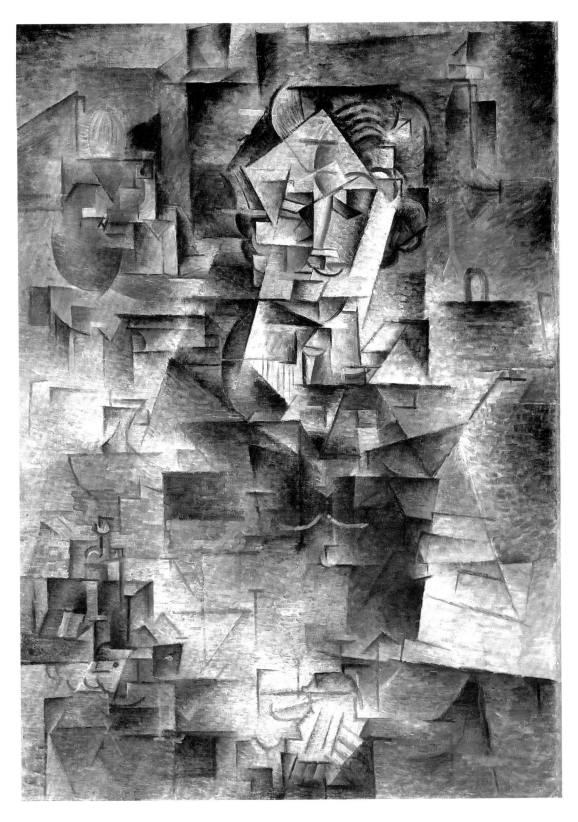

PICASSO. *Portrait of Daniel-Henry Kahnweiler.* Paris, autumn–winter 1910
Oil on canvas, 39½ × 28⅝″ (100.6 × 72.8 cm)
Daix 368. The Art Institute of Chicago.
Gift of Mrs. Gilbert W. Chapman in memory of Charles B. Goodspeed

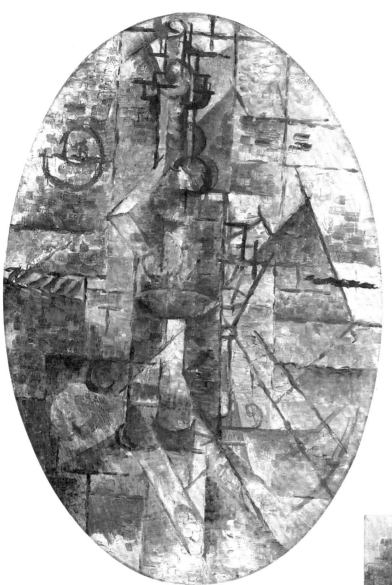

BRAQUE. *Bottle.* [Paris, winter] 1910–11
Oil on canvas (oval), 21¾ × 15″ (55 × 38 cm)
Romilly 79. Private collection

BRAQUE. *Harmonica and Flageolet.* [Paris, winter] 1910–11
Oil on canvas, 13⅛ × 16¼″ (33.3 × 41.3 cm)
Romilly 76. Philadelphia Museum of Art. A. E. Gallatin Collection

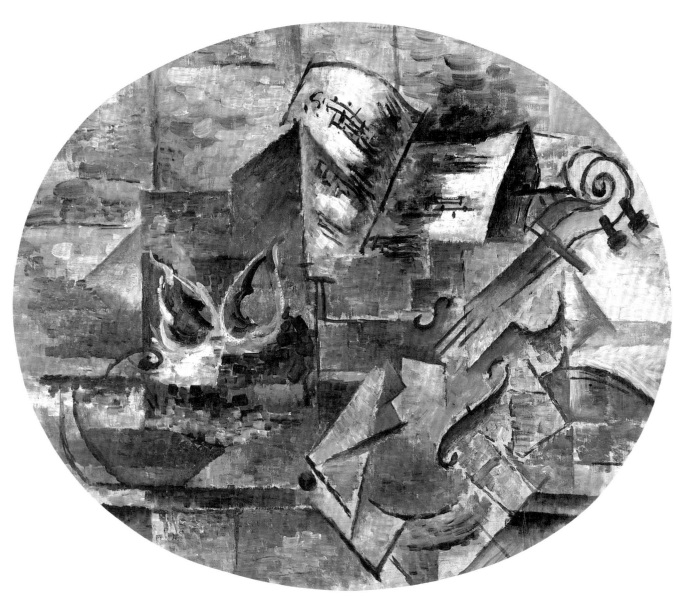

BRAQUE. *Violin and Musical Score.* [Paris, winter] 1910–11
Oil on canvas (oval), 21¼ × 25½″ (54 × 65 cm)
Romilly 75. Moderna Museet, Stockholm

BRAQUE. *Still Life on a Table: "Paris."* Paris, [early 1911]
Etching with drypoint, 7⅞ × 10¾" (19.9 × 27.3 cm)
Vallier 3. Philadelphia Museum of Art.
Louise and Walter Arensberg Collection

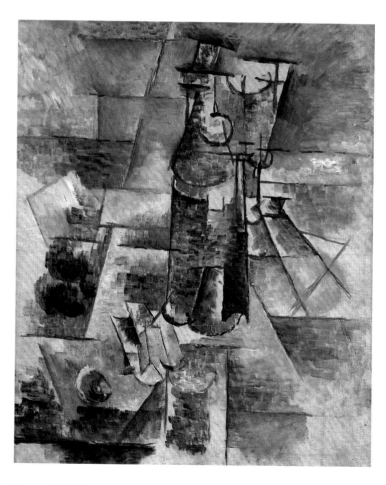

BRAQUE. *Still Life with Bottle.* [Paris, early 1911]
Oil on canvas, 21¾ × 18¼" (55 × 46 cm)
Romilly 78. Musée Picasso, Paris

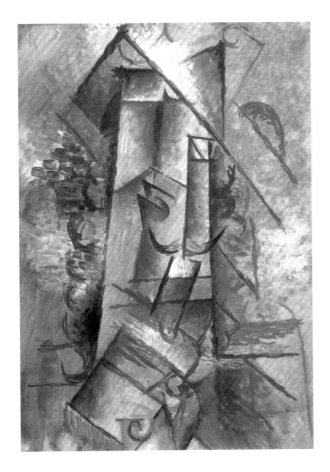

PICASSO. *Buffalo Bill*, Paris, [spring 1911]
Oil on canvas, 18⅛ × 13″ (46 × 33 cm)
Daix 396. Collection Carlos Hank

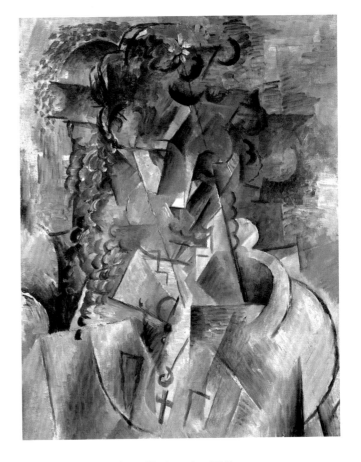

BRAQUE. *Girl with a Cross.* [Paris, spring 1911]
Oil on canvas, 21¾ × 17″ (55 × 43 cm)
Romilly 70. Kimbell Art Museum, Fort Worth

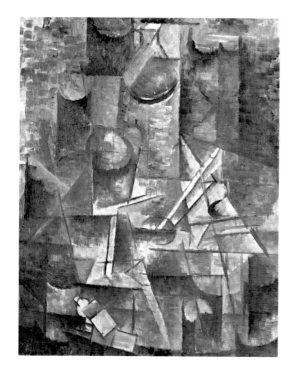

BRAQUE. *Pedestal Table.* [Paris, spring 1911]
Oil on canvas, 16 × 13″ (41 × 33 cm)
Romilly 107. Private collection, courtesy
Thomas Ammann Fine Art, Zurich

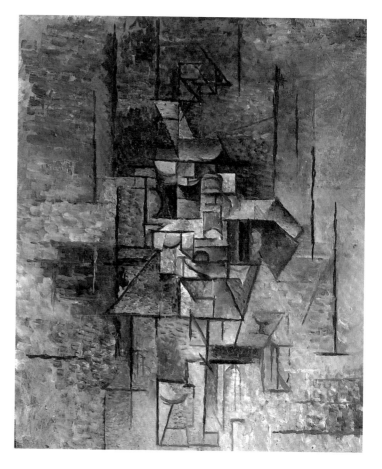

PICASSO. *Woman with a Guitar or Mandolin.* Paris, February 1911
Oil on canvas, 25⅞ × 21¼″ (65 × 54 cm)
Daix 390. National Gallery, Prague

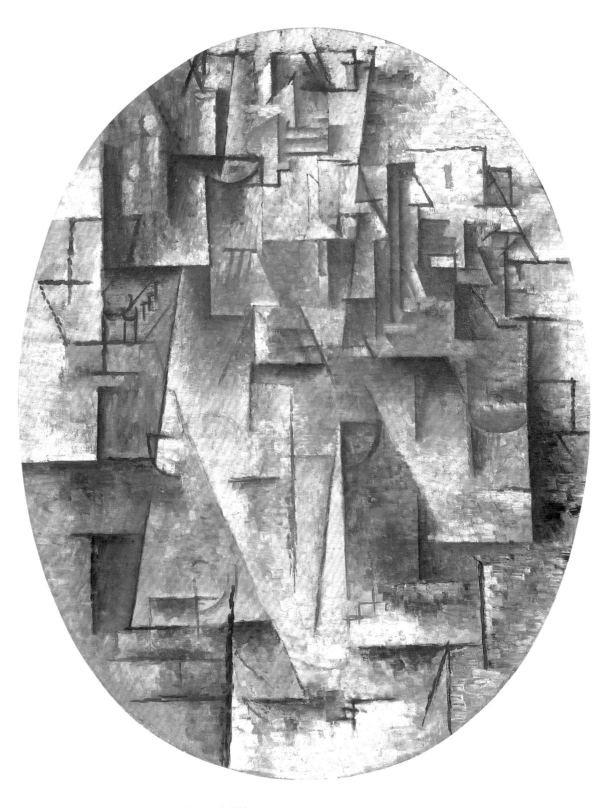

PICASSO. *La Pointe de la Cité*. Paris, [spring] 1911
Oil on canvas (oval), 35½ × 28″ (90 × 71 cm)
Daix 400. Private collection

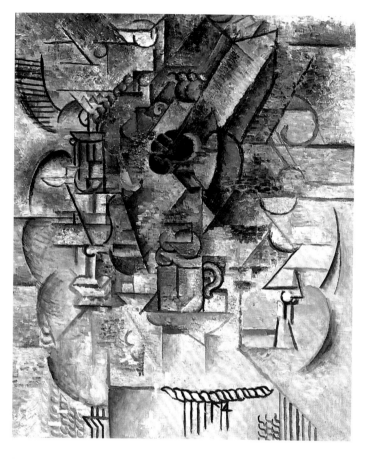

PICASSO. *Pedestal Table with Wineglasses, Cup, and Mandolin.*
Paris, [spring] 1911
Oil on canvas, 24 × 19⅝″ (61 × 50 cm)
Daix 386. Private collection

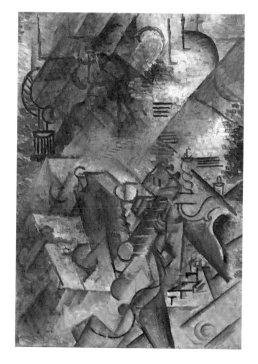

PICASSO. *Woman with a Guitar at a Piano.*
Paris, [spring] 1911
Oil on canvas, 22½ × 16⅛″ (57 × 41 cm)
Daix 388. National Gallery, Prague

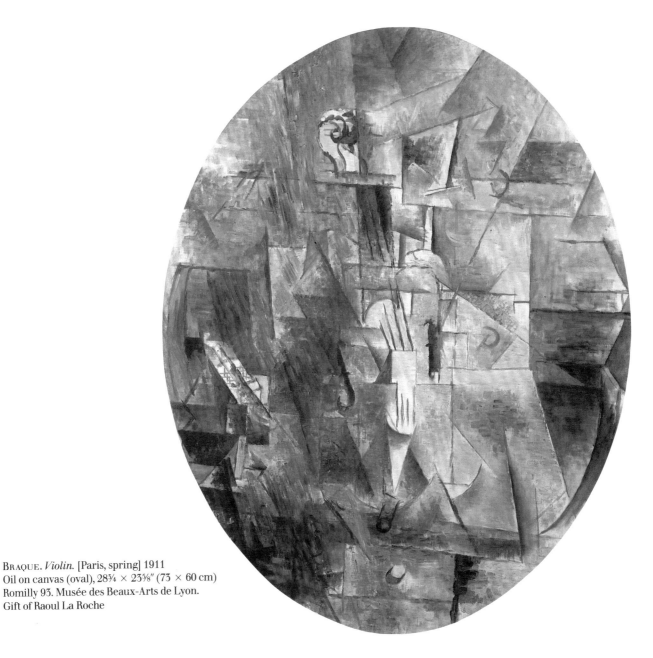

BRAQUE. *Violin.* [Paris, spring] 1911
Oil on canvas (oval), 28¾ × 23⅝" (73 × 60 cm)
Romilly 93. Musée des Beaux-Arts de Lyon.
Gift of Raoul La Roche

BRAQUE. *Job.* [Paris, spring 1911].
Published Paris, Henry Kahnweiler, 1912
Drypoint, 5⅞ × 7⅞" (14.2 × 20 cm)
Vallier 5. The Museum of Modern Art, New York.
Gift of Victor S. Riesenfeld

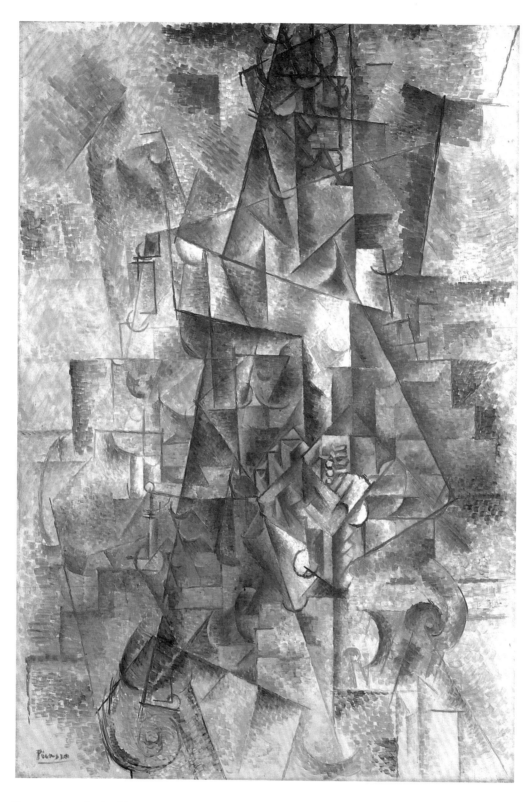

PICASSO. *Accordionist*. Céret, summer 1911
Oil on canvas, 51¼ × 35¼" (130 × 89.5 cm)
Daix 424. Solomon R. Guggenheim Museum, New York

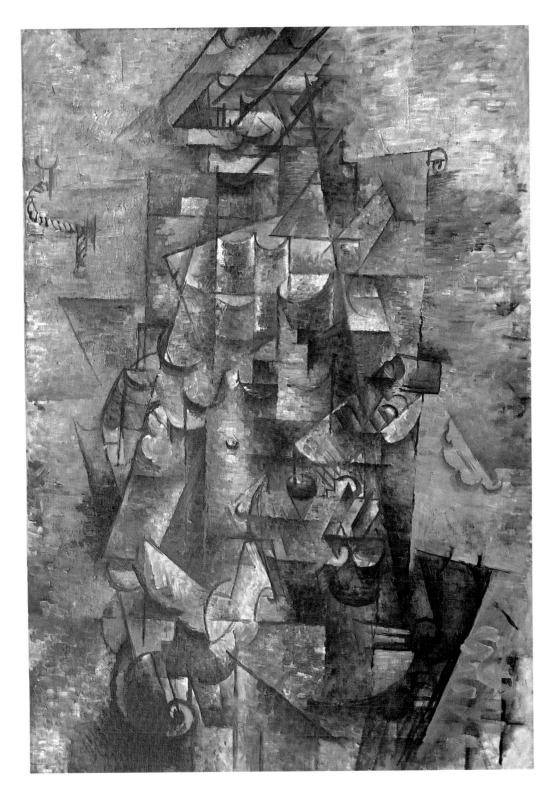

BRAQUE. *Man with a Guitar.* [Céret, summer 1911]
Oil on canvas, 45¾ × 31⅞" (116.2 × 80.9 cm)
Romilly 99. The Museum of Modern Art, New York.
Acquired through the Lillie P. Bliss Bequest

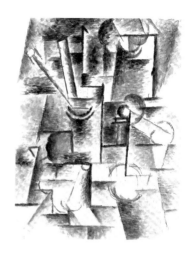

PICASSO. *Glass with Straws.*
Céret, summer 1911
Ink and watercolor,
11 × 8½″ (28 × 21.5 cm)
Daix 407. Stedelijk Museum,
Amsterdam

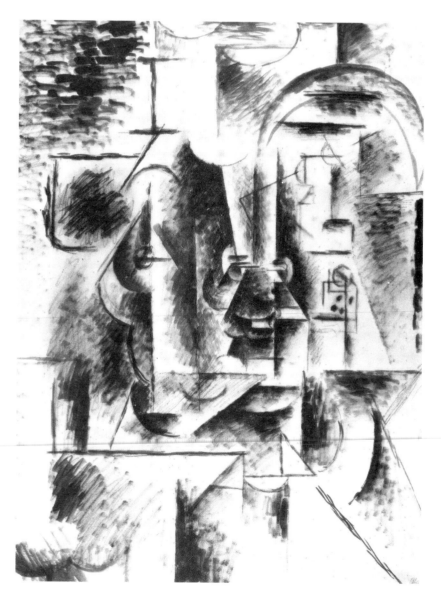

PICASSO. *Head of a Man with a Pipe.* [Céret, summer] 1911
Chalk and oil wash, 25⅜ × 18½″ (64.2 × 46.7 cm)
Daix 420. Fogg Art Museum, Harvard University,
Cambridge, Massachusetts. Purchase, Annie S. Coburn Fund

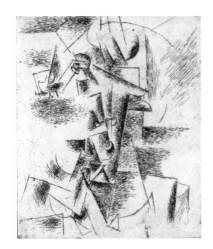

PICASSO. *Head of a Man.*
[Céret, summer 1911].
Published Paris, Henry Kahnweiler, 1912
Etching, 5⅛ × 4⅜″ (13 × 11 cm)
Geiser 32. The Museum of Modern Art,
New York. Gift of Abby Aldrich Rockefeller

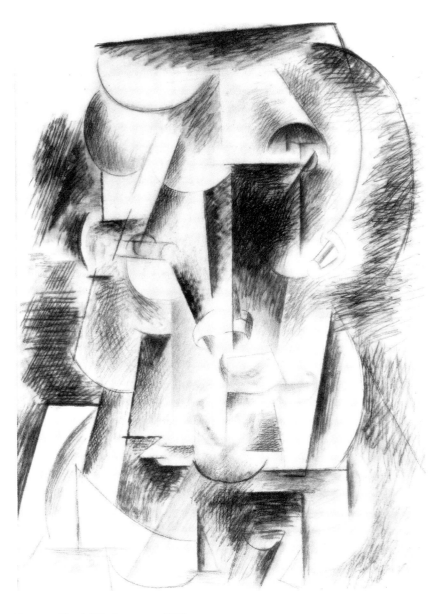

PICASSO. *Head.* [Céret, summer 1911]
Charcoal, 25¼ × 18⅞″ (64 × 48 cm)
Zervos XXVIII, 81. Collection Ernst Beyeler, Basel

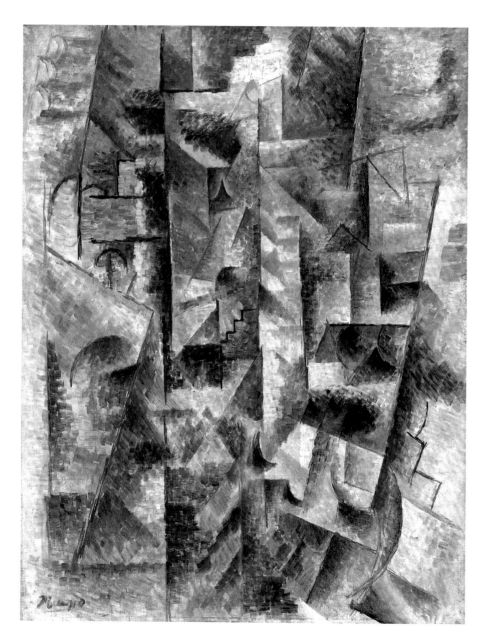

PICASSO. *Landscape at Céret*. Céret, summer 1911
Oil on canvas, 25⅝ × 19¾″ (65.1 × 50.2 cm)
Daix 419. Solomon R. Guggenheim Museum, New York

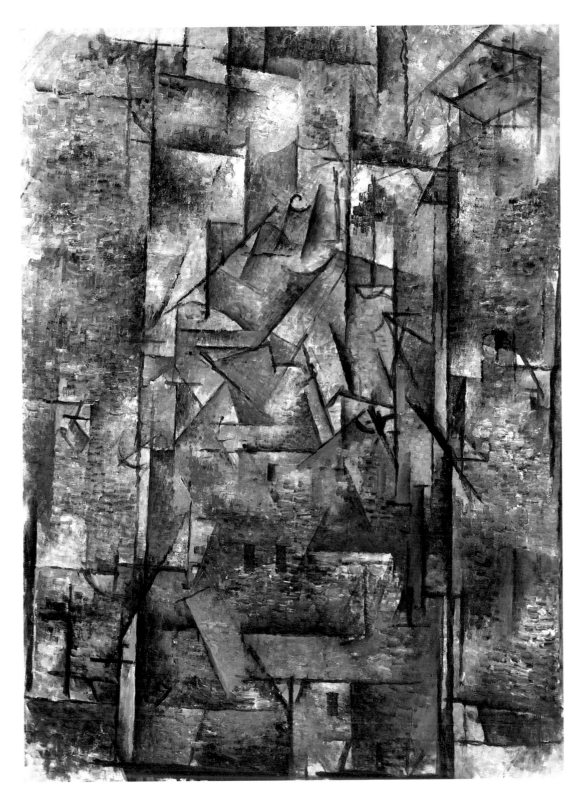

BRAQUE. *Rooftops at Céret.* Céret, [August] 1911
Oil on canvas, 34¾ × 25½″ (88.2 × 64.8 cm)
Romilly 90. Collection Mr. and Mrs. William Acquavella

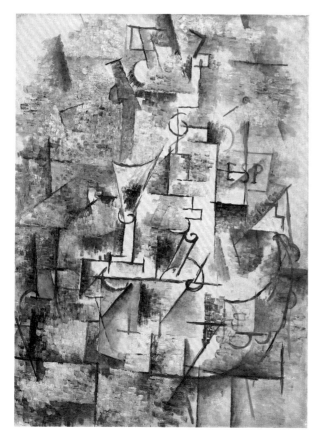

BRAQUE. *Bottle and Glass.* [Céret, late summer] 1911
Oil on canvas, 28½ × 21¼″ (72.5 × 54 cm)
Romilly 104. The Provost and Fellows of King's College,
Cambridge (Maynard Keynes Collection). On loan to the
Fitzwilliam Museum, Cambridge

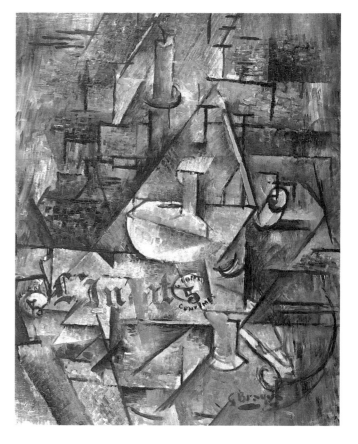

BRAQUE. *Candlestick.* Céret, [August] 1911
Oil on canvas, 18 × 15″ (46 × 38 cm)
Romilly 74. Scottish National Gallery of Modern Art, Edinburgh

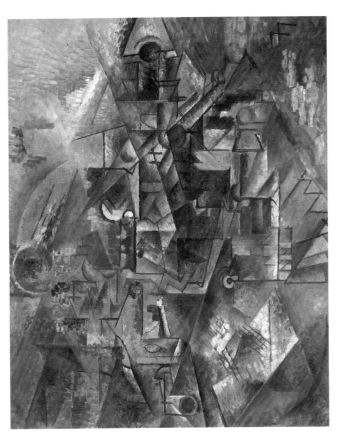

Picasso. *Clarinet*. Céret, [August] 1911
Oil on canvas, 24 × 19¾" (61 × 50 cm)
Daix 415. National Gallery, Prague

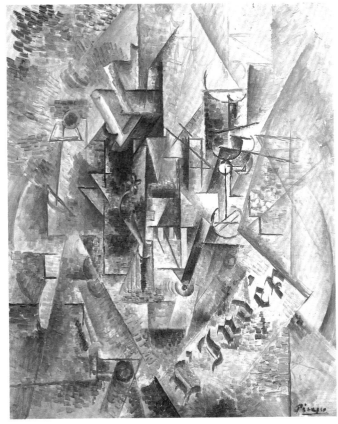

Picasso. *Still Life with Fan (L'Indépendant)*. Céret, [August] 1911
Oil on canvas, 24 × 19¾" (61 × 50 cm)
Daix 412. Private collection, Switzerland

197

BRAQUE. *Fox.* Céret, [August] 1911.
Published Paris, Henry Kahnweiler, 1912
Drypoint, 21½ × 15″ (54.8 × 38 cm)
Vallier 6. The Museum of Modern Art, New York.
Abby Aldrich Rockefeller Fund

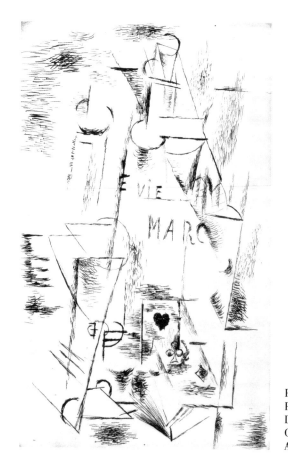

PICASSO. *Still Life with Bottle: "Vie de Marc."* [Céret, August] 1911.
Published Paris, Henry Kahnweiler, 1912
Drypoint, 19⅝ × 12″ (50 × 30.5 cm)
Geiser 33. The Museum of Modern Art, New York.
Acquired through the Lillie P. Bliss Bequest

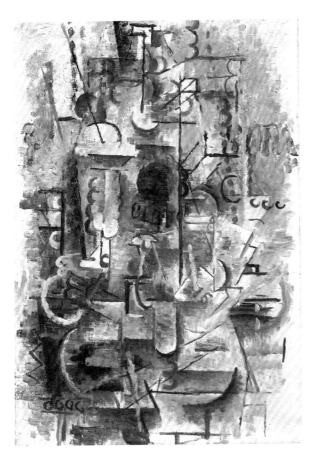

BRAQUE. *Bar Table.* [Céret, August 1911]
Oil on canvas, 21¾ × 15″ (55 × 38 cm)
Romilly 117. Kunstmuseum Bern.
Hermann and Margrit Rupf Foundation

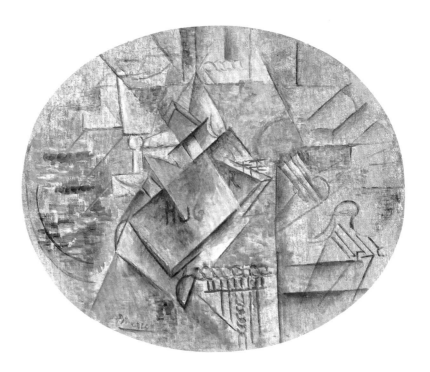

PICASSO. *Palette, Brushes, and Book by Victor Hugo.* [Céret, August 1911]
Oil on canvas (oval), 15 × 18⅛″ (38 × 46 cm)
Daix 418. Collection Mr. and Mrs. James W. Alsdorf, Chicago

199

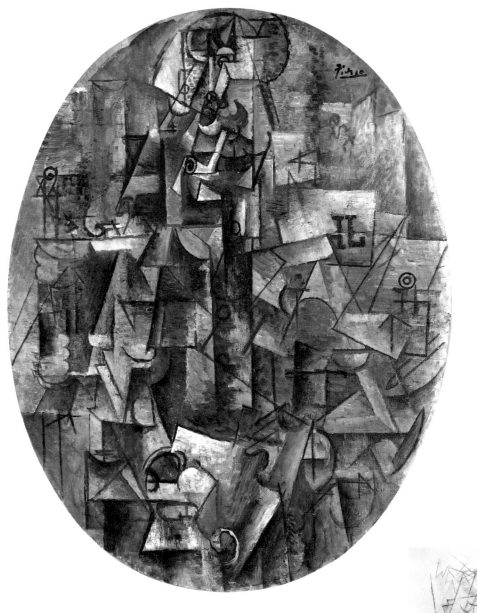

PICASSO. *Man with a Pipe.* Céret, [August] 1911
Oil on canvas (oval), 35¾ × 27⅛″ (90.7 × 71 cm)
Daix 422. Kimbell Art Museum, Fort Worth

PICASSO. *Woman with a Fan.*
Céret, [August] 1911
Ink, 7⅛ × 4⅜″ (18 × 11 cm)
Zervos XXVIII, 31.
Private collection

PICASSO. *Woman with a Fan.*
Céret, [August] 1911
Pencil, 13¾ × 9⅞″ (35 × 25 cm)
Zervos XXVIII, 25.
Collection Maya Ruiz-Picasso

PICASSO. *The Poet.* Céret, [August] 1911
Oil on canvas, 51⅝ × 35¼″ (131.2 × 89.5 cm)
Daix 423. Peggy Guggenheim Collection, Venice;
The Solomon R. Guggenheim Foundation, New York

BRAQUE. *Still Life with Banderillas.* Céret, [August] 1911
Oil on canvas, 25½ × 21¼″ (65 × 54 cm)
Romilly 91. The Jacques and Natasha Gelman Collection

BRAQUE. *Still Life.* [Céret, autumn] 1911
Ink, 11¾ × 7¾″ (30 × 20 cm)
Romilly, p. 51. Private collection

PICASSO. *Glass of Absinth.* Paris, [autumn] 1911
Oil on canvas, 15⅛ × 18¼″ (38.4 × 46.4 cm)
Daix 440. Allen Memorial Art Museum, Oberlin College, Oberlin,
Ohio. Mrs. F. F. Prentiss Fund, 1947

BRAQUE. *Bottle of Gentiane.*
[Céret, autumn 1911]
Charcoal. Romilly 115.
Present whereabouts unknown

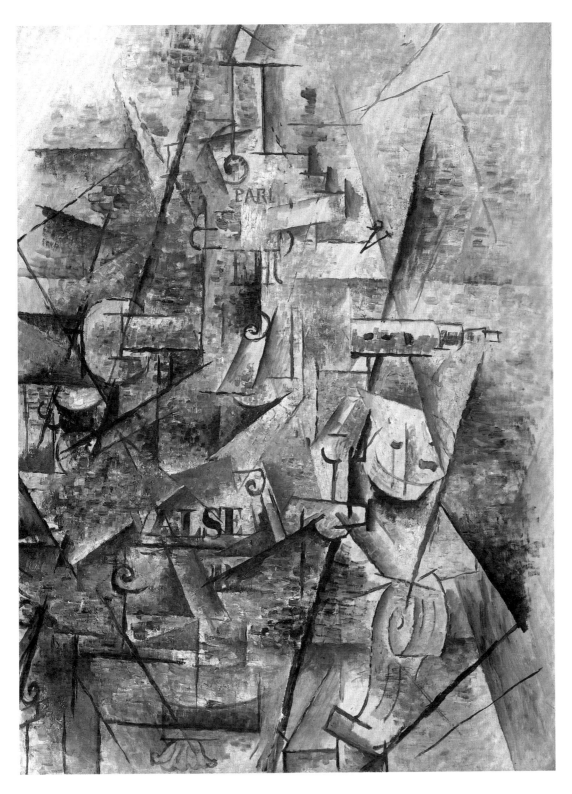

BRAQUE. *Clarinet and Bottle of Rum on a Mantelpiece.*
Céret, autumn 1911
Oil on canvas, 32 × 23½″ (81 × 60 cm)
Romilly 96. The Tate Gallery, London

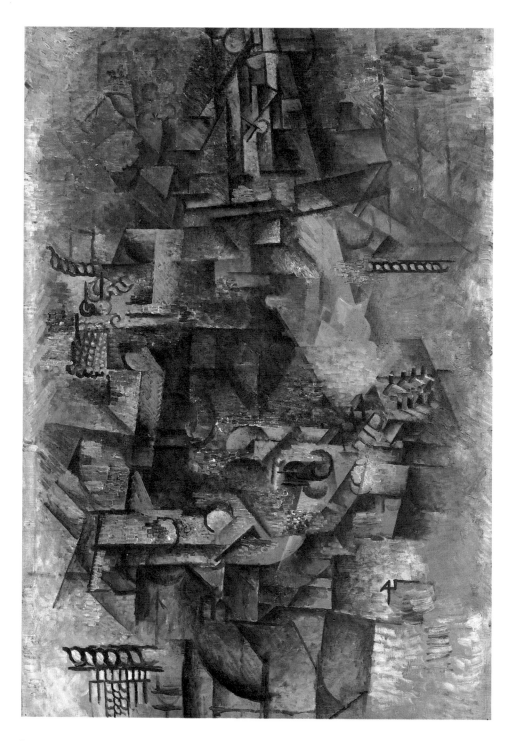

PICASSO. *Mandolin Player.* [Paris, autumn] 1911
Oil on canvas, 39⅜ × 25⅝″ (100 × 65 cm)
Daix 425. Collection Ernst Beyeler, Basel

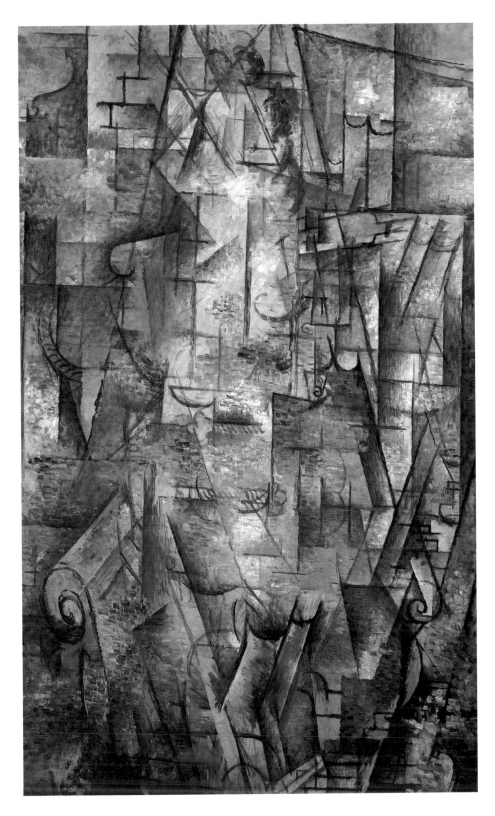

BRAQUE. *Woman Reading*. Céret, autumn 1911
Oil on canvas, 51¼ × 32″ (130 × 81 cm)
Romilly 92. Collection Ernst Beyeler, Basel

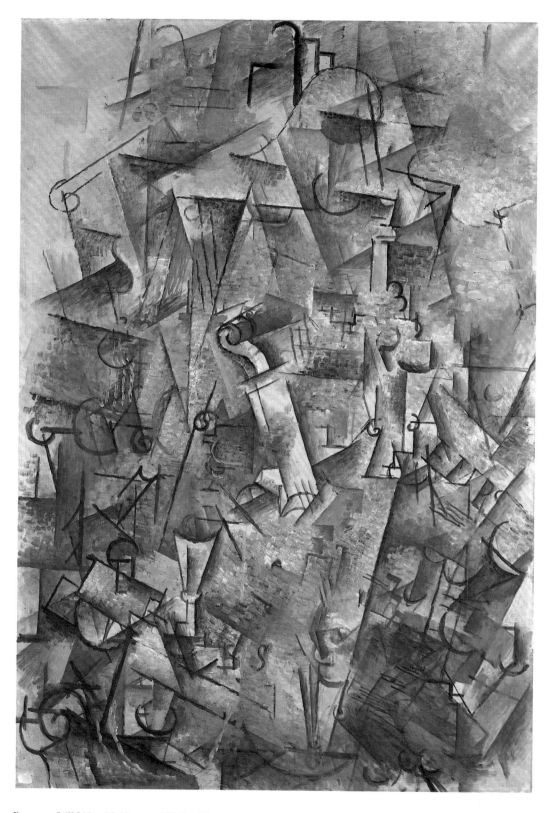

BRAQUE. *Still Life with Harp and Violin.* Céret, autumn 1911
Oil on canvas, 45¾ × 32″ (116 × 81 cm)
Romilly 95. Kunstsammlung Nordrhein-Westfalen, Düsseldorf

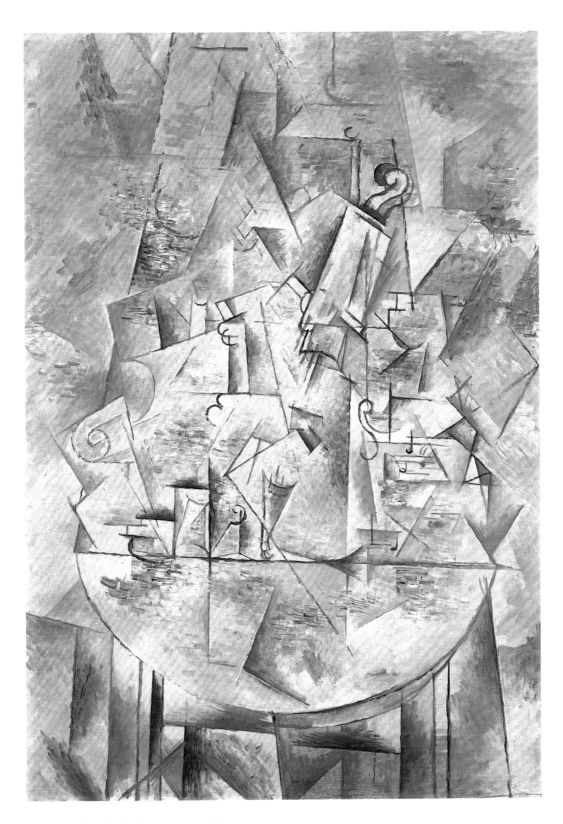

BRAQUE. *Pedestal Table.* Céret, autumn 1911
Oil on canvas, 45⅞ × 32″ (116.5 × 81.5 cm)
Romilly 98. Musée National d'Art Moderne,
Centre Georges Pompidou, Paris. Gift of
Raoul La Roche

BRAQUE. *Still Life with a Glass
(Figure with a Guitar).* [Céret, late 1911].
Published Paris, Maeght, 1950
Etching with drypoint, 13¾ × 8¼"
(34.8 × 21 cm)
Vallier 11. Collection Hope and
Abraham Melamed

BRAQUE. *Pedestal Table.* [Céret, late 1911]
Charcoal, 25 × 19" (63 × 48 cm)
Romilly 97. Kunstmuseum Basel, Kupferstichkabinett.
Gift of Raoul La Roche, 1963

BRAQUE. *Figure with a Guitar.* [Céret, late 1911].
Published Paris, Maeght, 1950
Drypoint and etching, 13¾ × 8⅝″ (35 × 21.9 cm)
Vallier 8. The Museum of Modern Art, New York.
Gift of Mr. and Mrs. Aimé Maeght

BRAQUE. *Figure with a Guitar.*
[Céret, late 1911]
Ink, 19¾ × 12½″ (50 × 32 cm)
Romilly, p. 49. Private collection

BRAQUE. *Bass.* [Céret, late 1911]. Published Paris, Maeght, 1950
Drypoint and etching, 17⅞ × 13″ (45.5 × 32.8 cm)
Vallier 7. The Museum of Modern Art, New York.
Abby Aldrich Rockefeller Fund (by exchange)

209

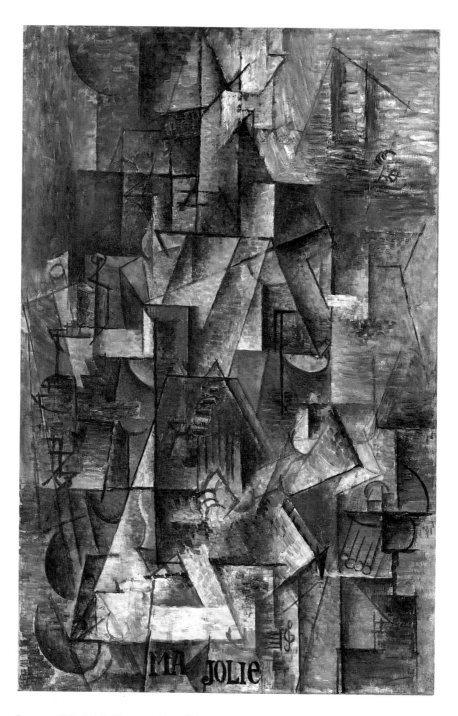

PICASSO. *"Ma Jolie" (Woman with a Zither or Guitar).*
Paris, winter 1911–12
Oil on canvas, 39⅜ × 25¾″ (100 × 65.4 cm)
Daix 430. The Museum of Modern Art, New York.
Acquired through the Lillie P. Bliss Bequest

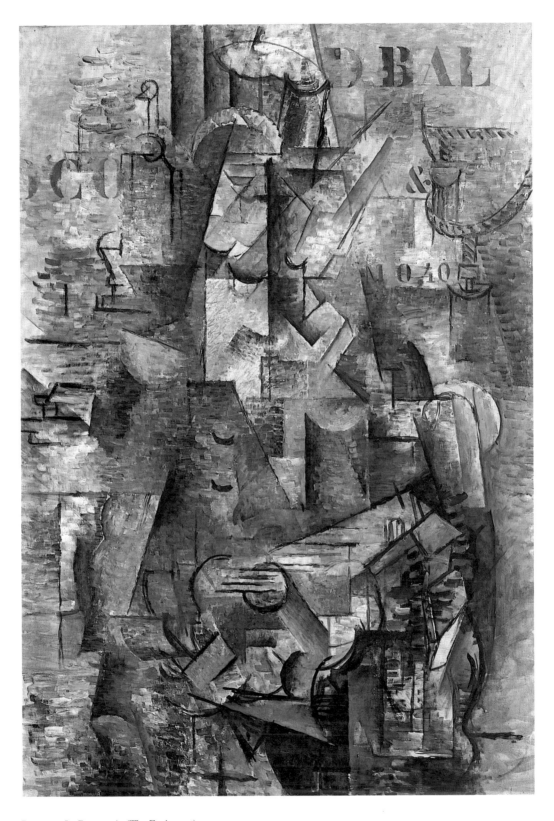

BRAQUE. *Le Portugais (The Emigrant).*
Céret [and Paris], autumn 1911–early 1912
Oil on canvas, 46 × 32″ (117 × 81 cm)
Romilly 80. Kunstmuseum Basel. Gift of Raoul La Roche, 1952

PICASSO. *The Pomegranate.* Paris, [winter] 1911–12
Oil on canvas, 8½ × 13⅝″ (21.5 × 34.6 cm)
Daix 432. Fogg Art Museum, Harvard University,
Cambridge, Massachusetts. Anonymous gift
in memory of Eric Schroeder

PICASSO. *Bottle, Glass, and Fork.* Paris, [winter] 1911–12
Oil on canvas (oval), 28¼ × 21¼″ (72 × 54 cm)
Daix 447. The Cleveland Museum of Art.
Leonard C. Hanna, Jr., Fund

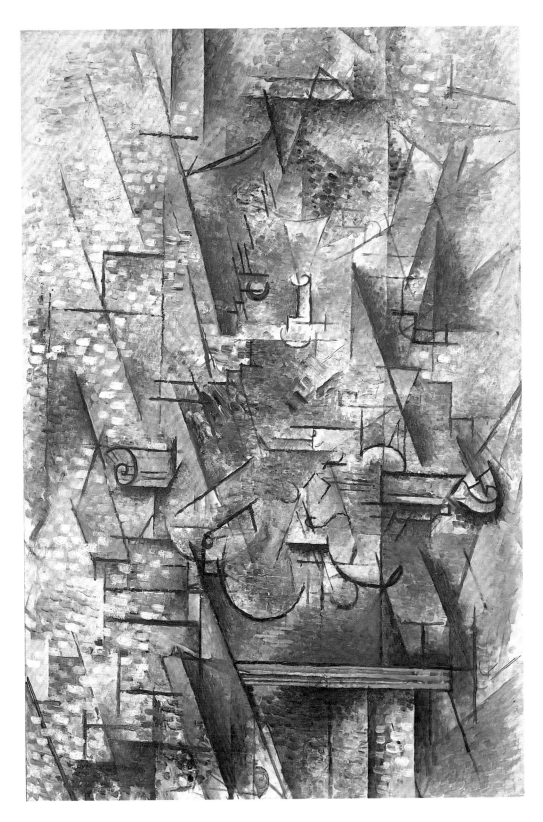

BRAQUE. *Still Life with a Violin.* [Céret, late 1911]
Oil on canvas, 51¼ × 35″ (130 × 89 cm)
Romilly 101. Musée National d'Art Moderne,
Centre Georges Pompidou, Paris.
Gift of Mrs. Georges Braque

BRAQUE. *Still Life with Dice: "Ros."* [Paris, early 1912]
Charcoal, 9⅞ × 12⅝″ (25 × 32 cm)
Romilly 130. Private collection

BRAQUE. *Bottle, Glasses, Fan, and Pipe.*
[Paris, early 1912]. Published Paris, Maeght, 1953
Drypoint and etching, 13 × 17⅞″ (32.9 × 45.5 cm)
Vallier 10. The Museum of Modern Art, New York.
Abby Aldrich Rockefeller Fund (by exchange)

BRAQUE. *Bottle of Bass and Glass on a Table: "Pal."*
[Paris, early 1912]. Published Paris, Maeght, 1954
Etching with drypoint (oval), 17⅞ × 12⅞″ (45.5 × 32.8 cm)
Vallier 9. Collection Aaron Fleischman, Washington, D.C.

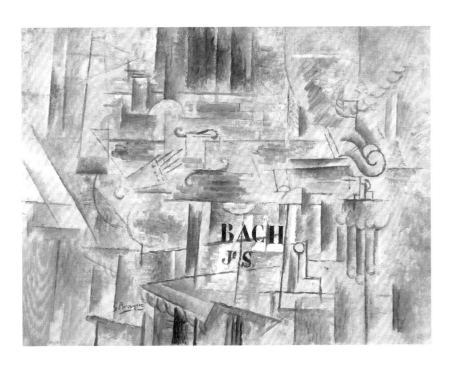

BRAQUE. *Homage to J. S. Bach.* [Céret, winter 1911–12]
Oil on canvas, 21¼ × 28¾″ (54 × 73 cm)
Romilly 122. Collection Carroll and Conrad Janis, New York

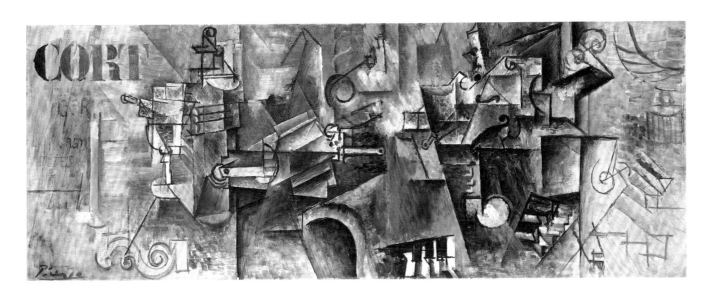

PICASSO. *Still Life on a Piano.* Begun Céret, summer 1911;
completed Paris, spring 1912
Oil on canvas, 19¾ × 51½″ (50 × 130 cm)
Daix 462. Collection Heinz Berggruen, Geneva

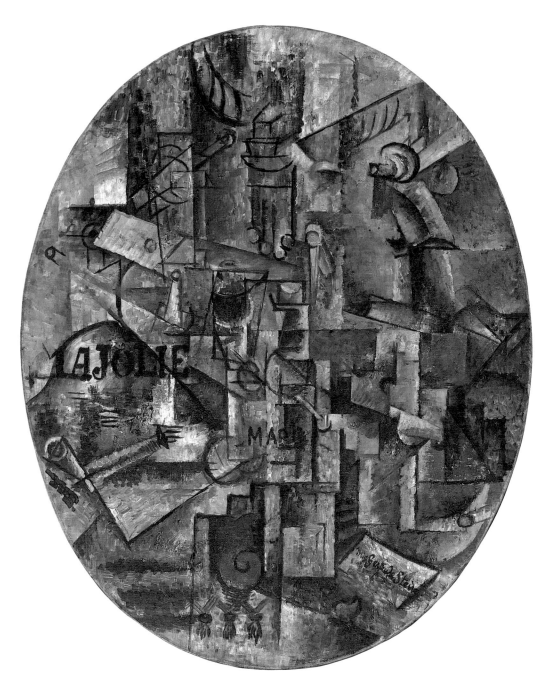

PICASSO. *The Architect's Table*. Paris, early 1912
Oil on canvas, mounted on panel (oval), 28⅝ × 23½″ (72.6 × 59.7 cm)
Daix 456. The Museum of Modern Art, New York.
Gift of William S. Paley

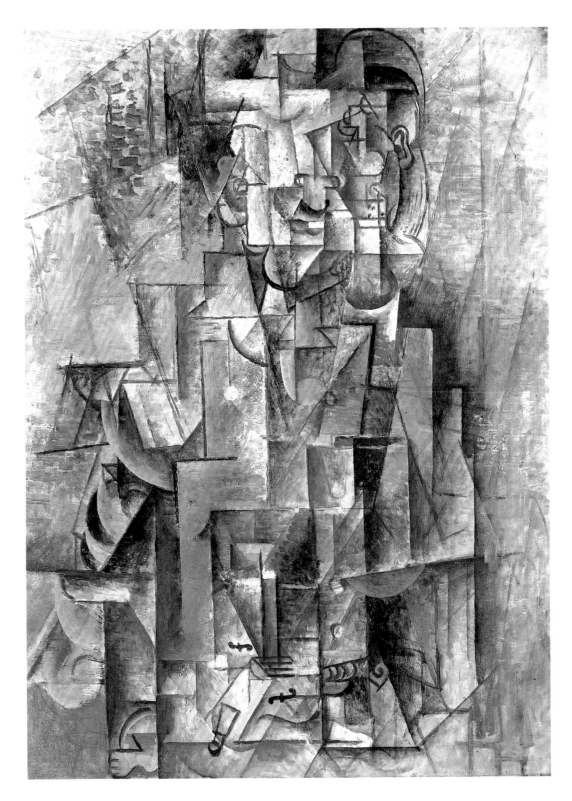

Picasso. *Man with a Violin.* Paris, [spring] 1912
Oil on canvas, 39⅜ × 28¾″ (100 × 73 cm)
Daix 470. Philadelphia Museum of Art.
Louise and Walter Arensberg Collection

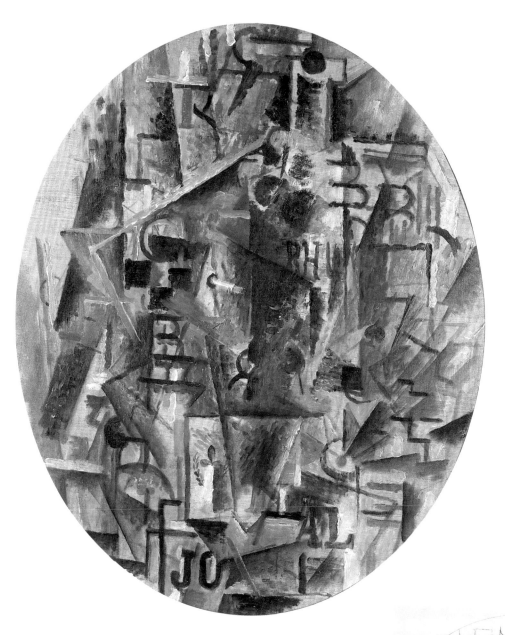

BRAQUE. *Bottle of Rum.* [Paris, spring 1912]
Oil on canvas (oval), 21¾ × 17¾″ (55 × 45 cm)
Romilly 124. Private collection, Switzerland

PICASSO. *Still Life with Bunch of Keys.*
Paris, spring 1912
Drypoint (oval), 8⅝ × 11″ (21.8 × 27.8 cm)
Geiser 30. Musée Picasso, Paris

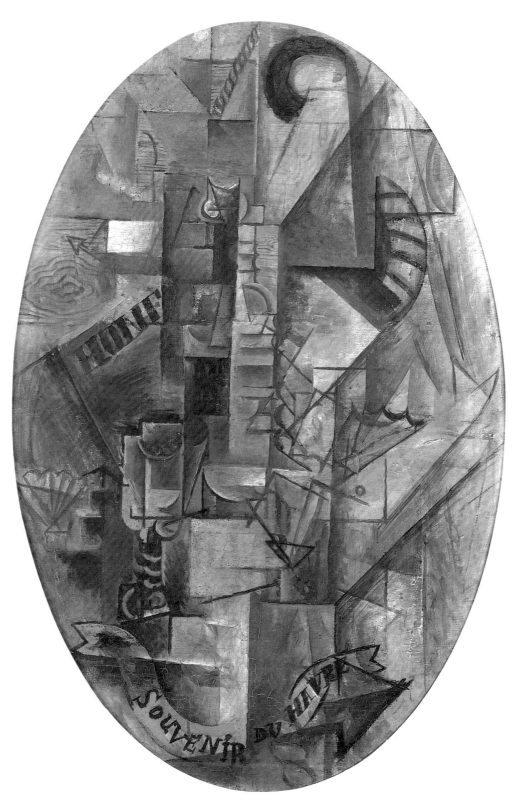

PICASSO. *Souvenir du Havre.* Paris, [May] 1912
Oil on canvas (oval), 36¼ × 25⅝″ (92 × 65 cm)
Daix 458. Private collection

Picasso. *Still Life (Souvenir du Havre).*
[Le Havre or Paris, April–May] 1912
Ink, 8¼ × 5⅜″ (21 × 13.5 cm)
Zervos XXVIII, 206. Musée National d'Art
Moderne, Centre Georges Pompidou, Paris.
Gift of Louise and Michel Leiris, the donors
retaining a life interest

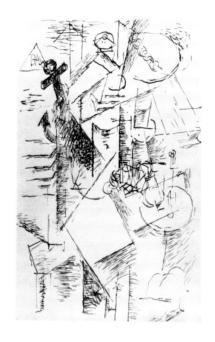

Picasso. *Accordionist (Souvenir du Havre).*
[Le Havre or Paris, April–May] 1912
Ink, 8¼ × 5⅜″ (21 × 13.5 cm)
Zervos XXVIII, 205. Musée Picasso, Paris

Picasso. *Accordionist at Le Havre.*
[Le Havre or Paris, April–May] 1912
Ink, 8¼ × 5⅜″ (21 × 13.5 cm)
Zervos XXVIII, 207. Musée Picasso, Paris

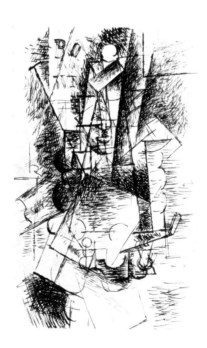

Picasso. *Guitarist at Le Havre.*
[Paris], spring 1912
Ink, 8¼ × 5⅜″ (21 × 13.5 cm)
Zervos XXVIII, 65. Musée Picasso, Paris

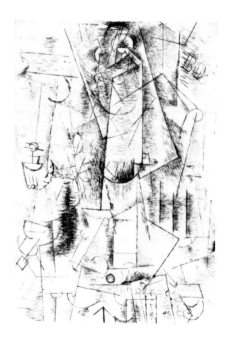

Picasso. *Guitar Player,* State V.
[Paris], spring 1912
Drypoint, 7¾ × 5½″ (19.8 × 14.1 cm)
Geiser 31. Musée Picasso, Paris

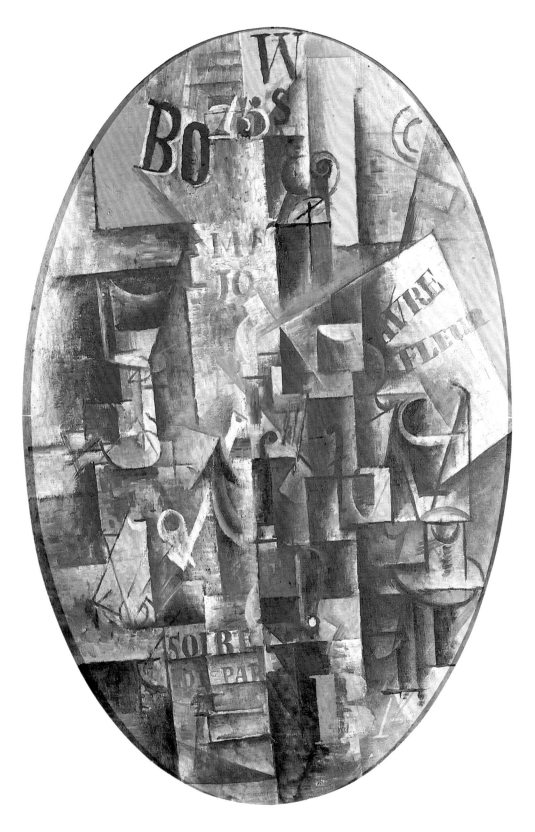

PICASSO. *Violin, Wineglasses, Pipe, and Anchor.*
Paris, [May] 1912
Oil on canvas (oval), 31⅞ × 21¼″ (81 × 54 cm)
Daix 457. National Gallery, Prague

Picasso. *Man with a Moustache.* Paris, [spring] 1912
Oil on canvas, 24 × 15″ (61 × 38 cm)
Daix 468. Musée d'Art Moderne de la Ville de Paris.
Bequest of Dr. Maurice Girardin

Picasso. *Squab with Green Peas.* Paris, [spring] 1912
Oil on canvas, 25⅝ × 21¼″ (65 × 54 cm)
Daix 453. Musée d'Art Moderne de la Ville de Paris.
Bequest of Dr. Maurice Girardin

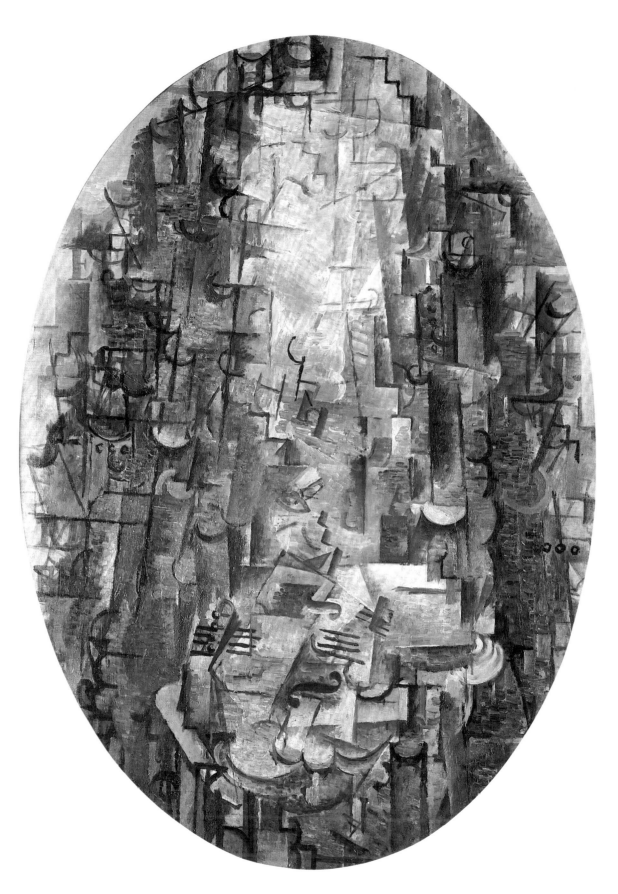

BRAQUE. *Man with a Violin.* [Paris, spring 1912]
Oil on canvas (oval), 39½ × 28¾″ (100 × 73 cm)
Romilly 125. Foundation E. G. Bührle Collection, Zurich

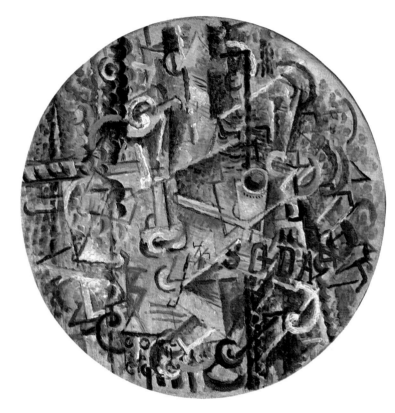

BRAQUE. *Soda*. [Paris, spring 1912]
Oil on canvas (tondo), 14¼″ (36.2 cm) diameter
Romilly 136. The Museum of Modern Art, New York.
Acquired through the Lillie P. Bliss Bequest

BRAQUE. *Bottle of Marc*. [Paris, spring 1912]
Charcoal

Romilly 116. Present whereabouts unknown

BRAQUE. *Glasses and Bottles.* [Paris, spring 1912]
Oil on canvas (oval), 29 × 21″ (73 × 54 cm)
Romilly 126. Collection Mrs. Robert Eichholz

BRAQUE. *Oboe, Sheet Music, and Bottle of Rum.* [Paris, spring 1912]
Charcoal, 19 × 24¾″ (48 × 63 cm)
Romilly 129. Kunstmuseum Basel, Kupferstichkabinett.
Gift of Raoul La Roche, 1963

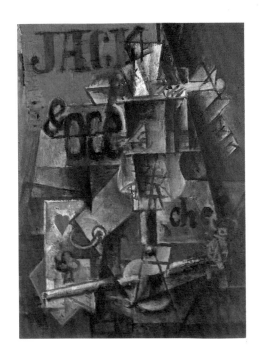

PICASSO. *Glass of Pernod and Playing Cards.*
Paris, spring 1912
Oil on canvas, 13¾ × 10⅝″ (35 × 27 cm)
Daix 459. National Gallery, Prague

BRAQUE. *Still Life: "Figaro."* [Paris, spring 1912]
Charcoal, 12¾ × 18½″ (32 × 47 cm)
Romilly 128. Musée National d'Art Moderne, Centre Georges Pompidou, Paris.
Gift of Louise and Michel Leiris, the donors retaining a life interest

226

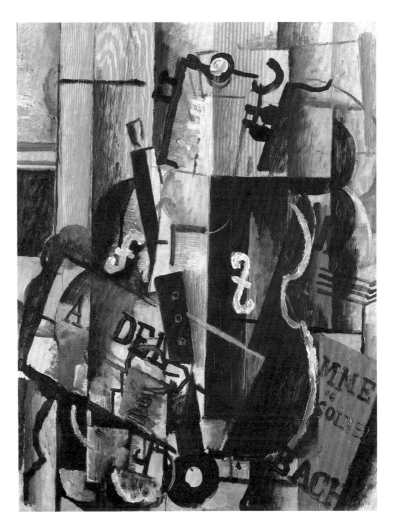

BRAQUE. *Violin and Clarinet.* [Paris, spring 1912]
Oil on canvas, 21⅝ × 17″ (55 × 43 cm)
Romilly 180. National Gallery, Prague

BRAQUE. *Bottles and Glasses.* [Paris, spring 1912]
Oil on canvas, 13 × 18″ (33 × 45.7 cm)
Romilly 135. Private collection

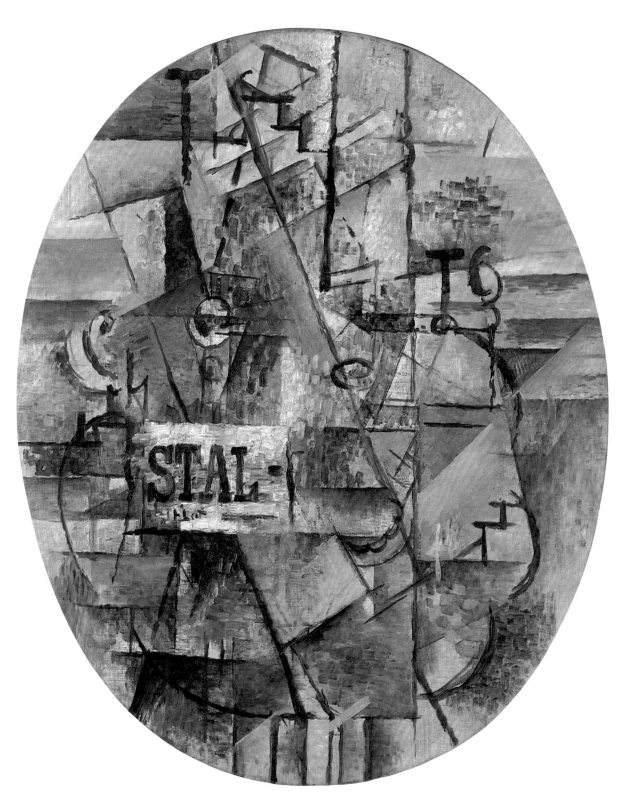

Braque. *Pedestal Table: "Stal."* [Paris, early 1912]
Oil on canvas (oval), 28¼ × 23¾″ (73 × 60 cm)
Romilly 132. Museum Folkwang, Essen

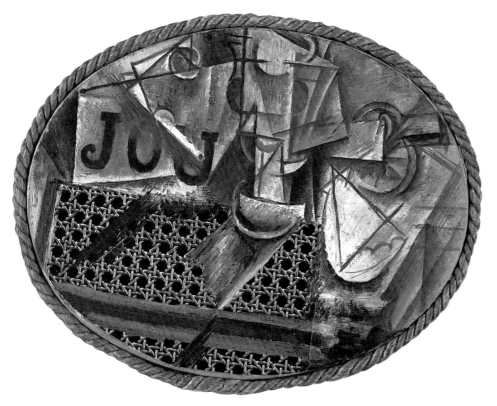

PICASSO. *Still Life with Chair Caning.* Paris, [May] 1912
Collage of oil, oilcloth, and pasted paper on canvas (oval),
surrounded by rope, 10⅝ × 13¾″ (27 × 35 cm)
Daix 466. Musée Picasso, Paris

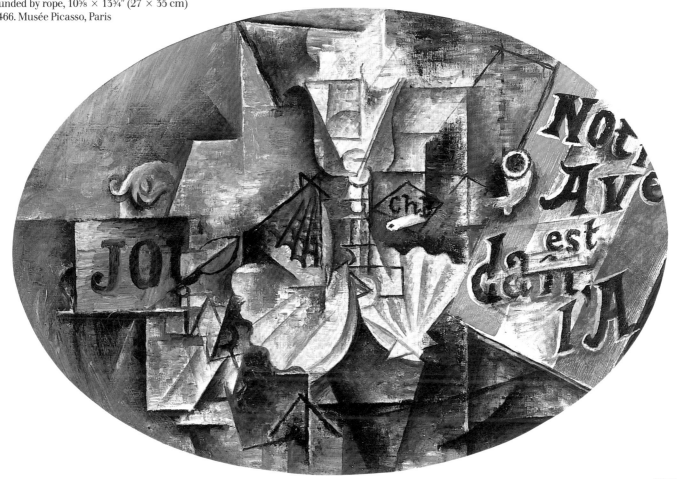

PICASSO. *The Scallop Shell: "Notre Avenir est dans l'air."*
Paris, [May] 1912
Oil on canvas (oval), 15 × 21¾″ (38 × 55.5 cm)
Daix 464. Private collection

PICASSO. *Still Life with a Bullfight Poster,
Bottle, and Fan.* [Paris, spring] 1912
Ink, 6¾ × 5″ (17.2 × 12.7 cm)
Richardson, ch. 8, 16.
Collection Mrs. Victor W. Ganz, New York

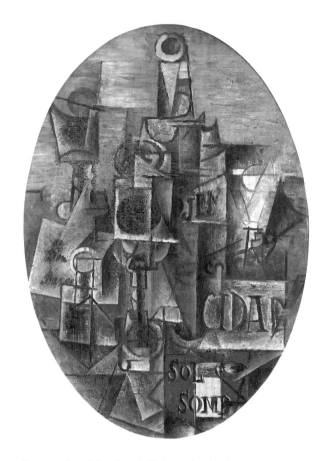

PICASSO. *Spanish Still Life.* Paris, spring 1912
Oil on canvas (oval), 18⅛ × 13″ (46 × 33 cm)
Daix 476. Musée d'Art Moderne, Villeneuve d'Ascq.
Gift of Geneviève and Jean Masurel

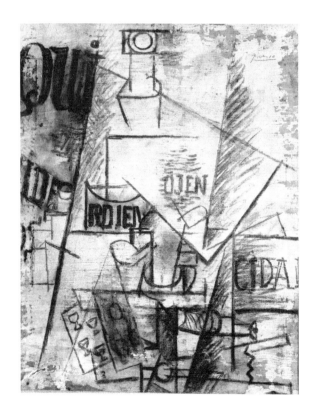

PICASSO. *Still Life: "Qui."* [Paris, spring] 1912
Oil and charcoal on canvas, 18⅛ × 15″ (46 × 38 cm)
Zervos XXVIII, 53. Musée National d'Art Moderne,
Centre Georges Pompidou, Paris. Gift of Mrs. Paul Cuttoli

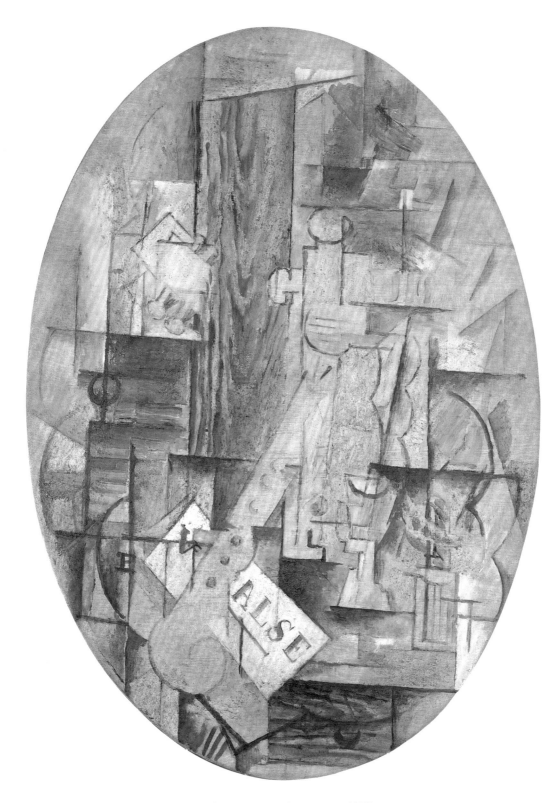

BRAQUE. *The Clarinet: "Valse."* [Paris and Sorgues, spring–late summer 1912]
Oil on canvas (oval), 35⅞ × 25⅜″ (91.3 × 64.5 cm)
Romilly 157. Peggy Guggenheim Collection, Venice;
The Solomon R. Guggenheim Foundation, New York

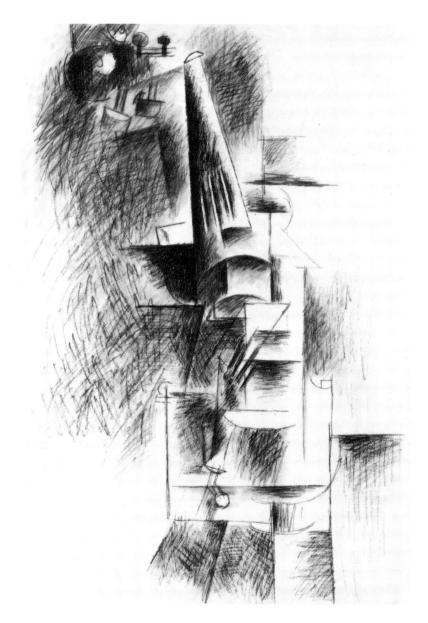

PICASSO. *Violin.* [Paris or Céret, early spring] 1912
Charcoal, 22¾ × 18″ (57.8 × 45.7 cm)
Zervos VI, 1128. Galerie Beyeler, Basel

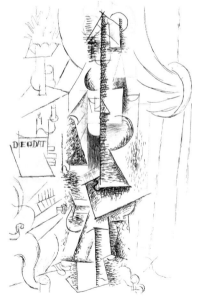

PICASSO. *Figure at the Piano
(Déodat de Séverac).*
[Céret or Sorgues, late spring] 1912
Pencil and ink, 13⅜ × 8⅝″ (34 × 22 cm)
Zervos XXVIII, 152. Musée Picasso, Paris

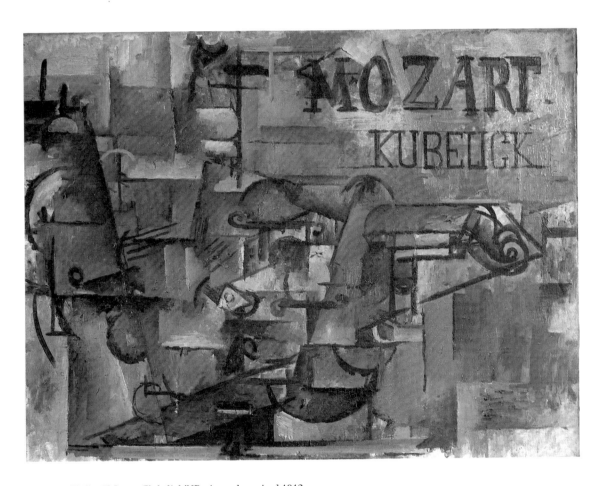

Braque. *Violin: "Mozart/Kubelick."* [Paris, early spring] 1912
Oil on canvas, 18 × 24″ (46 × 61 cm)
Romilly 121. Private collection, Switzerland

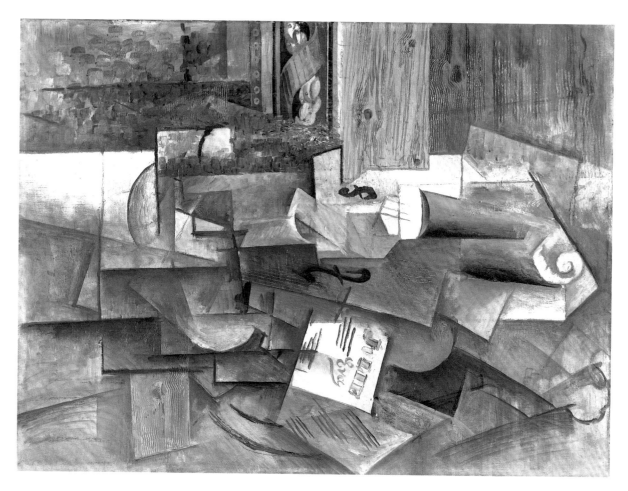

PICASSO. *Violin: "Jolie Eva."* Céret, May–June 1912
Oil on canvas, 23⅝ × 31⅞″ (60 × 81 cm)
Daix 480. Staatsgalerie Stuttgart

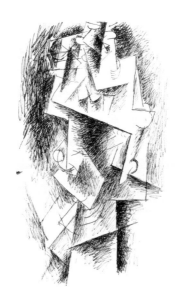

PICASSO. *Dancers.* Céret, May–June 1912
Ink, 12⅛ × 7⅝″ (30.8 × 19.5 cm)
Zervos XXVIII, 76. Musée Picasso, Paris

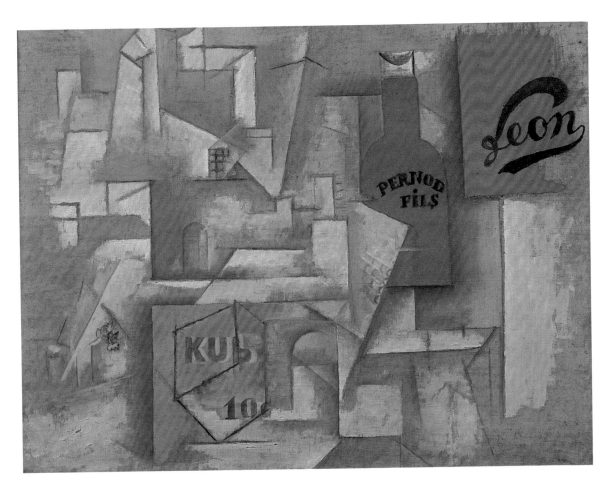

Picasso. *Landscape with Posters*. Sorgues, [July] 1912
Oil on canvas, 18⅛ × 24″ (46 × 61 cm)
Daix 501. The National Museum of Art, Osaka

Picasso. *Dancers at the Fête Nationale.*
Sorgues, July 1912
Ink and pencil, 13½ × 8½″ (34.2 × 21.7 cm)
Zervos XXVIII, 112. Musée Picasso, Paris

Picasso. *The Poet.* Sorgues, summer 1912
Oil on canvas, 23⅝ × 18⅞″ (60 × 48 cm)
Daix 499. Kunstmuseum Basel.
Gift of Maja Sacher-Stehlin, 1967

Picasso. *Head of a Man with a Moustache.* [Sorgues, summer] 1912
Charcoal, 24 × 18⅛″ (60.5 × 46 cm)
Zervos II*, 325. Collection Mr. and Mrs. Richard C. Hedreen, Seattle

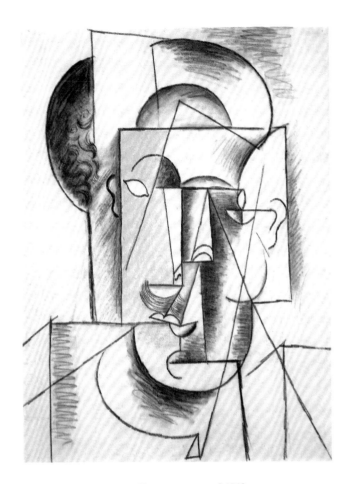

PICASSO. *Head of a Man.* [Sorgues, summer] 1912
Charcoal and pastel, 25¼ × 18½″ (64 × 47 cm)
Zervos II*, 327. Kunstmuseum Winterthur.
Bequest of C. and E. Friedrich-Jezler

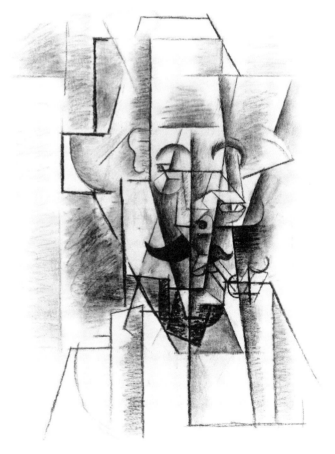

PICASSO. *Head.* [Sorgues, summer] 1912
Charcoal, 24½ × 18½″ (62.2 × 47 cm)
Zervos VI, 1144. Private collection

237

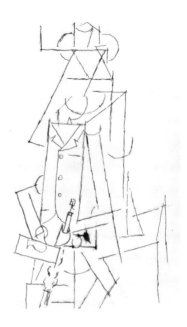

PICASSO. *Man with a Banderilla.*
Sorgues, summer 1912
Ink and pencil, 12 × 7⅝″ (30.5 × 19.5 cm)
Zervos XXVIII, 110. Private collection

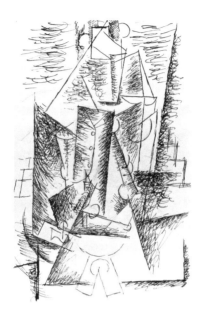

PICASSO. *Man with a Banderilla.*
Sorgues, summer 1912
Ink and pencil, 12 × 7⅝″ (30.5 × 19.5 cm)
Zervos XXVIII, 111. Musée Picasso, Paris

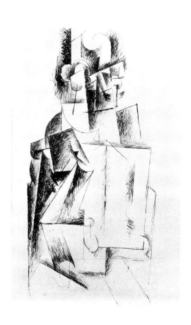

PICASSO. *Seated Man.*
Sorgues, summer 1912
Ink, 12⅛ × 7¾″ (30.8 × 19.7 cm)
Weisner 74. The Metropolitan
Museum of Art, New York.
Alfred Stieglitz Collection, 1949

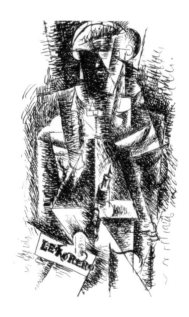

PICASSO. *The Aficionado.*
Sorgues, summer 1912
Ink, 11⅞ × 7⅝″ (30.3 × 19.2 cm)
Daix, p. 106. Present whereabouts unknown

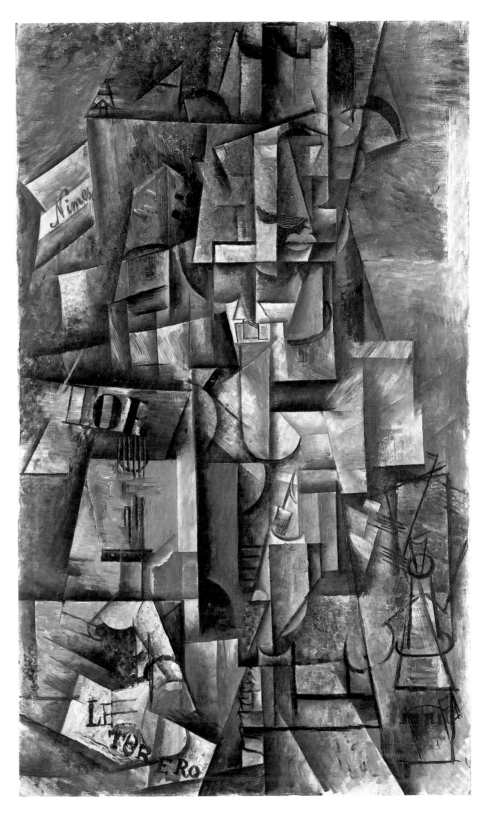

Picasso. *The Aficionado.* Sorgues, summer 1912
Oil on canvas, 53⅛ × 32¼″ (135 × 82 cm)
Daix 500. Kunstmuseum Basel.
Gift of Raoul La Roche, 1952

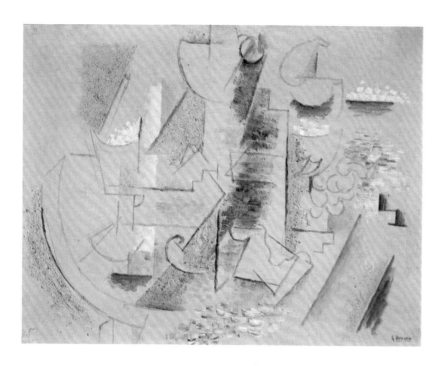

BRAQUE. *Fruit Dish and Glass.* Sorgues, [August] 1912
Oil and sand on canvas, 19¾ × 25½″ (50 × 65 cm)
Romilly 147. George L. K. and Suzy F. Morris Trust

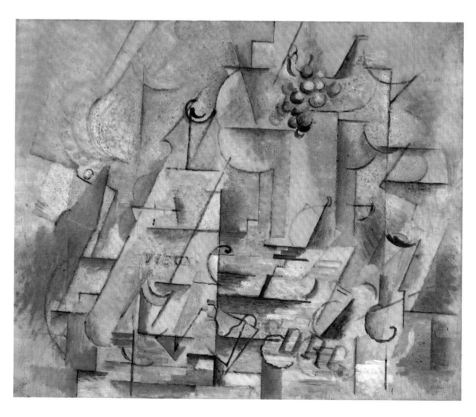

BRAQUE. *Fruit Dish, Bottle, and Glass: "Sorgues."* Sorgues, [August] 1912
Oil and sand on canvas, 23⅝ × 28¾″ (60 × 73 cm)
Romilly 144. Musée National d'Art Moderne, Centre Georges Pompidou, Paris.
Gift of Louise and Michel Leiris, the donors retaining a life interest

BRAQUE. *Woman in an Armchair: "Sorgues."*
Sorgues, [August–September 1912]
Pencil, 13½ × 8½" (34.4 × 21.6 cm)
Romilly, p. 10. Private collection

PICASSO. *Standing Nude.*
[Sorgues, summer] 1912
Ink, 12½ × 7½" (31.8 × 19 cm)
Zervos XXVIII, 38. Collection Mrs.
Bertram Smith, New York

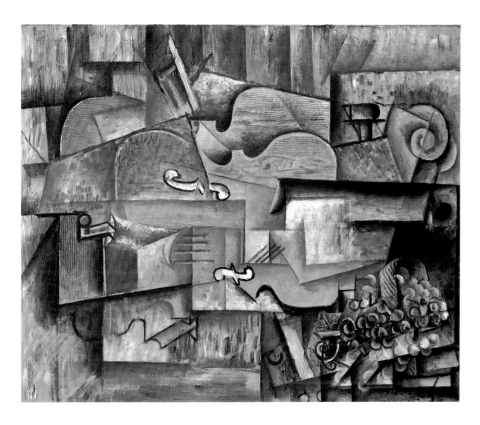

PICASSO. *Violin and Grapes.* Céret and Sorgues, spring–summer 1912
Oil on canvas, 20 × 24" (50.6 × 61 cm)
Daix 482. The Museum of Modern Art, New York.
Mrs. David M. Levy Bequest

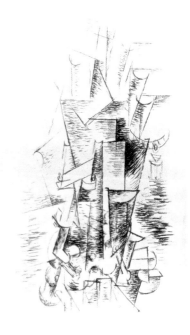

PICASSO. *Guitarist.*
[Céret or Sorgues, spring–summer] 1912
Charcoal, 19⅛ × 12⅜″ (48.5 × 31.5 cm)
Zervos XXVIII, 109. Musée Picasso, Paris

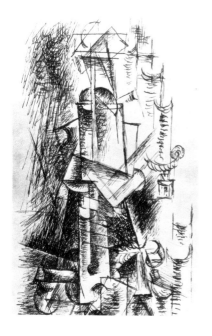

PICASSO. *Guitarist.*
[Céret or Sorgues, spring–summer] 1912
Ink, 8⅜ × 5¼″ (21.3 × 13.4 cm)
Zervos XXVIII, 115. Musée Picasso, Paris

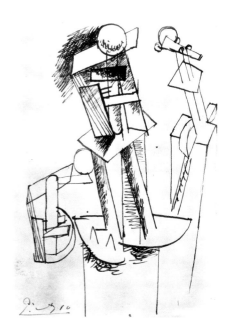

PICASSO. *Study for a Construction.*
[Sorgues, summer] 1912
Ink, 6¾ × 4⅞″ (17.2 × 12.4 cm)
Zervos XXVIII, 135; II*, 296.
The Museum of Modern Art,
New York. Purchase

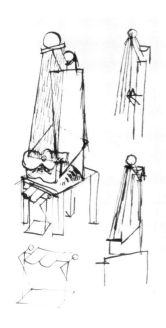

PICASSO. *Seated Figure with a Guitar.*
[Sorgues, summer] 1912
Ink, 8⅜ × 5⅛″ (21.2 × 13.2 cm)
Zervos XXVIII, 130. Musée Picasso, Paris

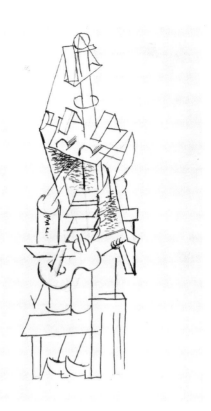

PICASSO. *Guitarist.*
[Sorgues, summer] 1912
Ink, 12¼ × 7⅞″ (31 × 20 cm)
Zervos XXVIII, 131. Musée Picasso, Paris

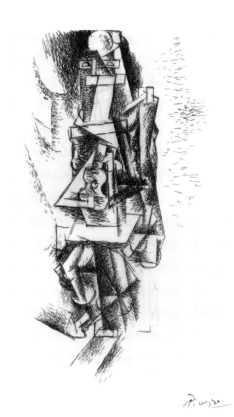

PICASSO. *Guitarist.*
[Sorgues, summer] 1912
Ink, 12 × 7¾″ (30.5 × 19.5 cm)
Zervos XXVIII, 126. Private collection

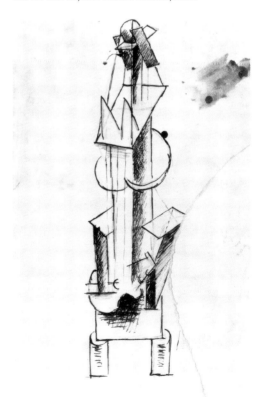

PICASSO. *Woman with a Guitar.*
[Sorgues, summer] 1912
Ink, 12¼ × 7⅞″ (31 × 20 cm)
Zervos XXVIII, 151. Collection Maya Ruiz-Picasso

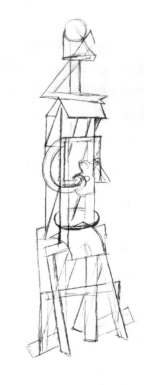

PICASSO. *Guitarist.*
[Sorgues, summer] 1912
Ink and lithographic crayon, 12¼ × 7½″ (31 × 19 cm)
Zervos XXVIII, 132. Musée Picasso, Paris

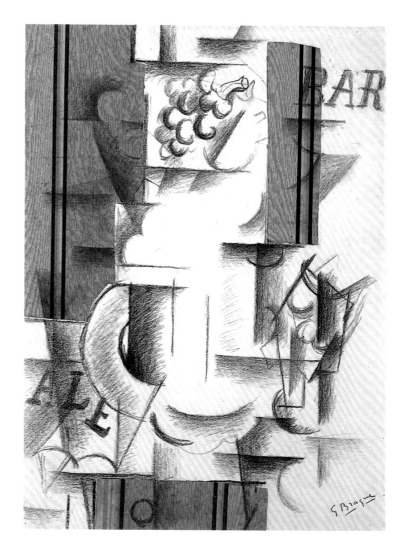

Braque. *Fruit Dish and Glass.*
Sorgues, early September 1912
Charcoal and pasted paper, 24⅜ × 17½″ (62 × 44.5 cm)
M.-F./C. 1. Private collection

Braque. *Fruit Dish, "Quotidien du Midi."*
Sorgues, August–September 1912
Oil and sand on canvas, 16 × 13″ (41 × 33 cm)
Romilly 148. Courtesy Thomas Ammann Fine Art, Zurich

BRAQUE. *Head of a Woman.*
[Sorgues, early September] 1912
Charcoal and pasted paper, 24 × 18½″ (61 × 47 cm)
M.-F./C. 7. Private collection

PICASSO. *Table and Dish of Pears.*
[Sorgues or Paris, late summer–autumn] 1912
Charcoal and pencil, 24 × 18⅛″ (61 × 46 cm)
Zervos II**, 781. The Douglas Cooper Collection,
Churchglade Ltd.

Picasso. *Head of a Man.* [Sorgues, summer] 1912
Pencil, 25⅛ × 19¼″ (64 × 49 cm)
Zervos II, 328. Musée d'Art Moderne, Villeneuve-d'Ascq.
Gift of Geneviève and Jean Masurel

Picasso. *Head.* [Sorgues or Paris, late summer–autumn] 1912
Charcoal, 24½ × 19″ (62 × 48 cm)
Weisner 73 . The Metropolitan Museum of Art, New York.
Alfred Stieglitz Collection, 1949

PICASSO. *Seated Woman with Guitar.*
[Sorgues or Paris, late summer–autumn] 1912
Pencil and ink, 24 × 18½″ (61 × 47 cm)
Zervos II**, 392. Yves Saint Laurent and
Pierre Bergé Collection

PICASSO. *Head.* [Sorgues or Paris, late summer–autumn] 1912
Charcoal, 24⅜ × 18⅞″ (61.9 × 47.8 cm)
Zervos II**, 388. The Museum of Modern Art, New York.
Alfred H. Barr, Jr., Bequest

PICASSO. *Guitar.*
Sorgues, late August–September 1912
Ink and pencil, 13⅜ × 8⅝″ (34 × 22 cm)
Zervos XXVIII, 196. Musée Picasso, Paris

PICASSO. *Guitar.* Sorgues and Paris, late summer–autumn 1912
Oil on canvas (oval), 25¼ × 19⅝″ (64 × 50 cm)
Daix 488. Private collection, Japan

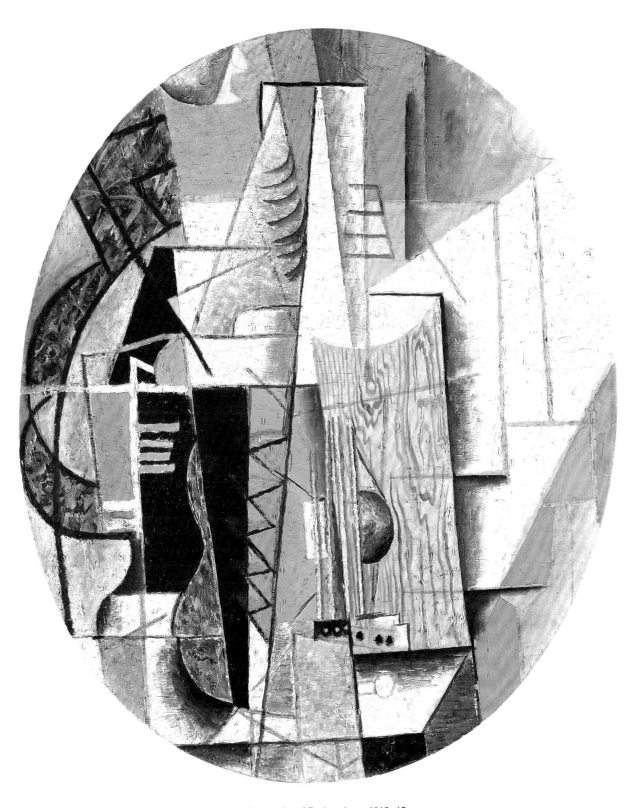

PICASSO. *Guitar.* Begun Sorgues, late summer 1912; completed Paris, winter 1912–13
Oil on canvas (oval), 28⅜ × 23⅝″ (72.5 × 60 cm)
Daix 489. Nasjonalgalleriet, Oslo

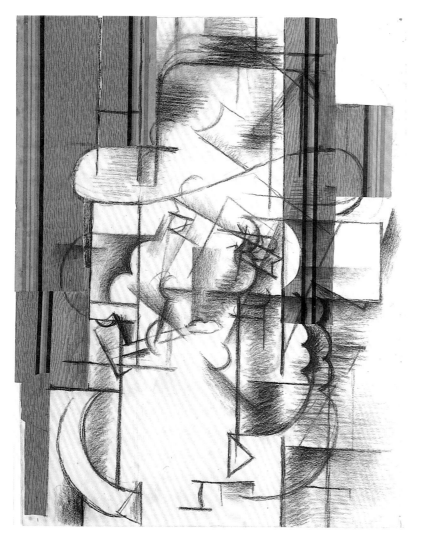

BRAQUE. *Man with a Pipe.* [Sorgues, early September 1912]
Charcoal and pasted paper, 24⅜ × 19¼″ (61.9 × 49 cm)
M. F./C. 6. Kunstmuseum Basel, Kupferstichkabinett.
Gift of Raoul La Roche, 1963

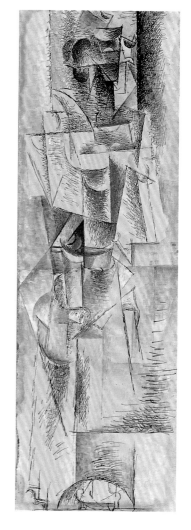

PICASSO. *L'Arlésienne.*
Sorgues, summer 1912
Gouache and ink on paper, mounted
on canvas, 26 × 9″ (66 × 23 cm)
Daix 496. The Menil Collection, Houston

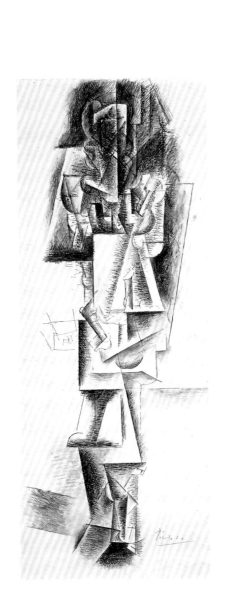

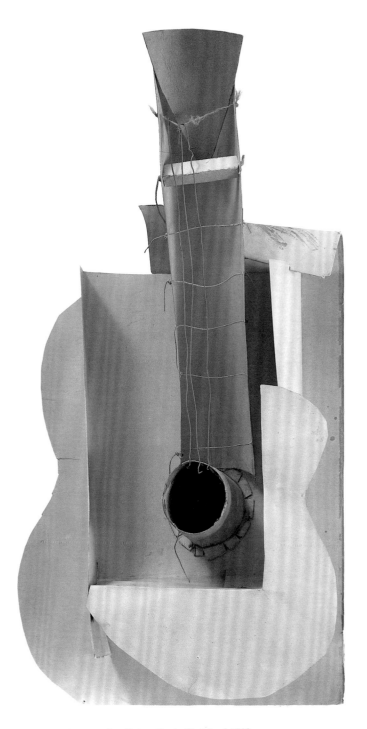

Picasso. Maquette for *Guitar*. Paris, [October] 1912
Construction of cardboard, string, and wire (restored),
25¾ × 13 × 7½″ (65.1 × 33 × 19 cm)
Daix 633. The Museum of Modern Art, New York. Gift of the artist

Picasso. *Standing Woman.*
Sorgues, summer 1912
Ink, 21⅝ × 8½″ (55 × 21.6 cm)
Zervos II**, 725. Private collection

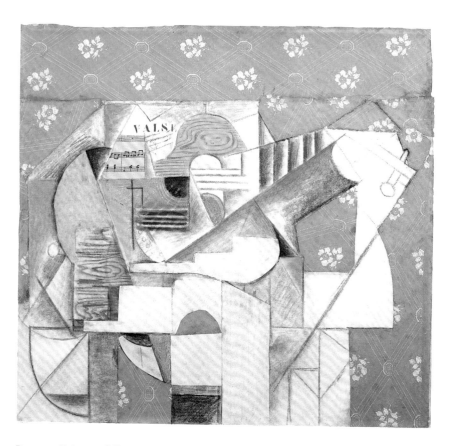

Picasso. *Guitar and Sheet Music.*
Paris, [October–November] 1912
Pasted paper, pastel, and charcoal, 22½ × 24″ (58 × 61 cm)
Daix 506. Private collection

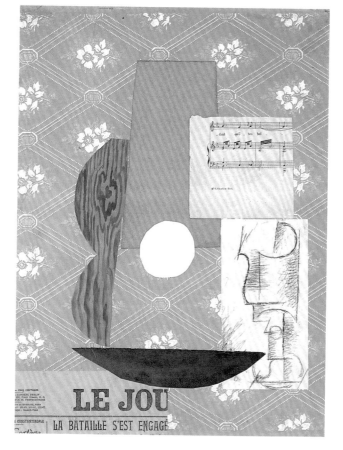

Picasso. *Guitar, Sheet Music, and Glass.* Paris, after November 18, 1912
Pasted paper, gouache, and charcoal, 18⅞ × 14¾″ (47.9 × 36.5 cm)
Daix 513. Marion Koogler McNay Art Museum, San Antonio

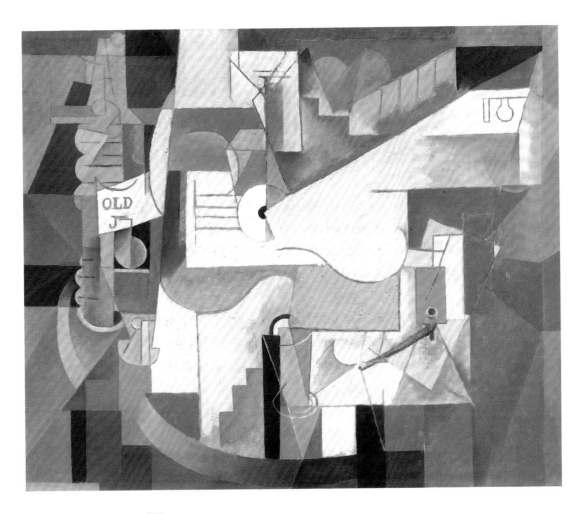

PICASSO. *Bottle, Guitar, and Pipe.*
Paris, [autumn] 1912
Oil on canvas, 23⅝ × 28¾″ (60 × 73 cm)
Daix 510. Museum Folkwang, Essen

PICASSO. *Small Violin.* Paris, autumn 1912
Oil and sand on canvas, 13¾ × 10⅝″ (35 × 27 cm)
Daix 514. Private collection

Braque. *Violin.* [Sorgues, autumn 1912]
Charcoal, 18⅞ × 24½″ (48 × 62 cm)
Romilly 160. Katz Collection, Milwaukee

Braque. *"Bal."* [Sorgues, autumn 1912]
Charcoal and pasted paper,
18¾ × 24¼″ (47.5 × 61.6 cm)
M.-F./C. 13. Private collection

Picasso. *Table with Guitar.* Paris, autumn 1912
Charcoal and pasted paper on cardboard, 18⅛ × 24″ (46 × 61 cm)
Daix 508. Collection Mr. and Mrs. Daniel Saidenberg, New York

Picasso. *Table with Guitar.* Paris, autumn 1912
Oil, sand, and charcoal on canvas, 20⅛ × 24¼″ (51.1 × 61.6 cm)
Daix 509. Hood Museum of Art, Dartmouth College, Hanover, New Hampshire.
Gift of Nelson A. Rockefeller, Class of 1930

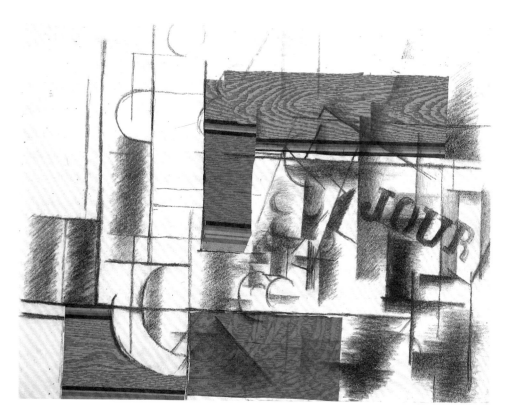

BRAQUE. *Still Life with Newspaper: "Jour."* [Sorgues, autumn 1912]
Charcoal and pasted paper, 18⅞ × 24⅜″ (48 × 62 cm)
M.-F./C. 11. Collection Ernst Beyeler, Basel

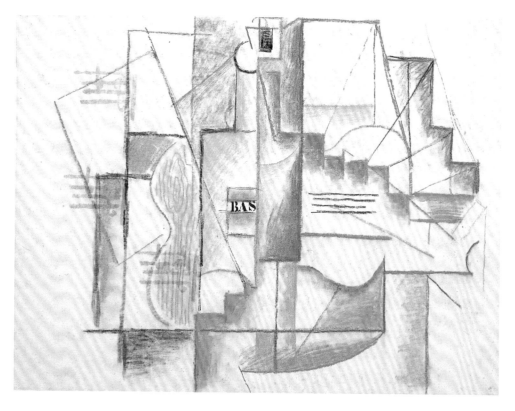

PICASSO. *Bottle of Bass and Guitar.* Paris, autumn 1912
Pastel, charcoal, and ink, 18½ × 25″ (47.7 × 63.5 cm)
Daix 511. The Douglas Cooper Collection, Churchglade Ltd.

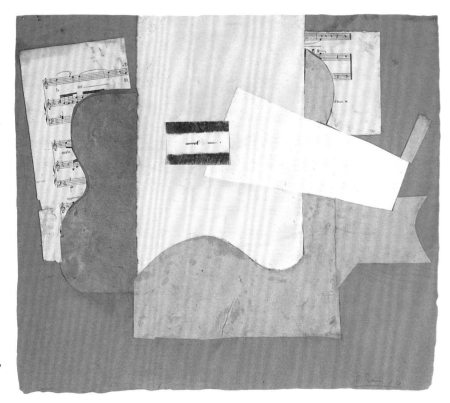

PICASSO. *Musical Score and Guitar.*
Paris, autumn 1912
Pasted and pinned paper on cardboard,
16¾ × 18⅞″ (42.5 × 48 cm)
Daix 520. Musée National d'Art Moderne,
Centre Georges Pompidou, Paris.
Bequest of Georges Salles

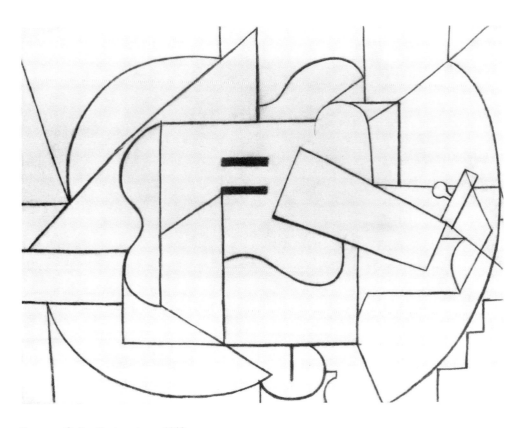

PICASSO. *Guitar.* Paris, autumn 1912
Charcoal, 18½ × 24⅛″ (47 × 62 cm)
Zervos XXVIII, 304. The Museum of Modern Art, New York.
Fractional gift of Mr. and Mrs. Donald B. Marron

257

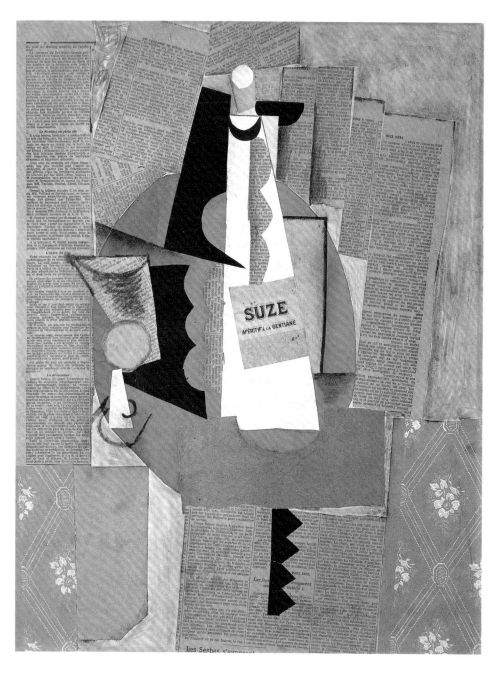

Picasso. *Glass and Bottle of Suze*. Paris, after November 18, 1912
Pasted paper, gouache, and charcoal, 25¾ × 19¾″ (65.4 × 50.2 cm)
Daix 523. Washington University Gallery of Art, St. Louis.
University Purchase, Kende Sale Fund, 1946

Braque. *Bottle of Marc.*
[Sorgues, autumn 1912]
Charcoal and conté crayon,
19 × 12¼″ (48 × 31 cm)
Romilly 155. Kunstmuseum Basel,
Kupferstichkabinett.
Gift of Raoul La Roche, 1963

BRAQUE. *Table with Pipe.* Begun Paris, early 1912;
[completed Sorgues, autumn 1912]
Oil on canvas (oval), 23¾ × 28¾″ (60 × 73 cm)
Romilly 123. Collection Rosengart, Lucerne

BRAQUE. *Newspaper and Dice: "Jou."*
[Sorgues, autumn 1912]
Charcoal, 12¼ × 9½″ (31 × 24 cm)
Romilly 152. Kunstmuseum Basel,
Kupferstichkabinett.
Gift of Raoul La Roche, 1963

BRAQUE. *Still Life with a Violin.* [Sorgues, autumn 1912]
Charcoal and pasted paper, 24½ × 18⅞″ (62.1 × 47.8 cm)
M.-F./C. 9. Yale University Art Gallery, New Haven, Connecticut.
The Leonard C. Hanna, Jr., B.A. 1913, Susan Vanderpoel Clark,
and Edith M. K. Wetmore Funds

BRAQUE. *Glass and Packet of Tobacco: "Bock."*
[Sorgues, autumn 1912]
Charcoal and pasted paper, 12¼ × 9½″ (31 × 24 cm)
M.-F./C. 17. Kunstmuseum Basel,
Kupferstichkabinett. Gift of Raoul La Roche, 1963

PICASSO. *Violin.* Paris, after December 3, 1912
Pasted paper and charcoal, 24⅜ × 18½″ (62 × 47 cm)
Daix 524. Musée National d'Art Moderne, Centre Georges
Pompidou, Paris. Gift of Henri Laugier

PICASSO. *Violin.* Paris, after December 9, 1912
Pasted paper, watercolor, and charcoal,
24⅜ × 18⅞″ (62.5 × 48 cm)
Daix 525. Collection Alsdorf Foundation, Chicago

261

PICASSO. *Bottle, Cup, and Newspaper.*
Paris, after December 4, 1912
Pasted paper, charcoal, and pencil,
24¾ × 18⅞" (63 × 48 cm)
Daix 545. Museum Folkwang, Essen

PICASSO. *Siphon, Glass, Newspaper, and Violin.*
Paris, after December 3, 1912
Pasted paper and charcoal, 18½ × 24⅝" (47 × 62.5 cm)
Daix 528. Moderna Museet, Stockholm

PICASSO. *Table with Bottle, Wineglass, and Newspaper.*
Paris, after December 4, 1912
Pasted paper, charcoal, and gouache, 24⅜ × 18⅞″ (62 × 48 cm)
Daix 542. Musée National d'Art Moderne,
Centre Georges Pompidou, Paris. Gift of Henri Laugier

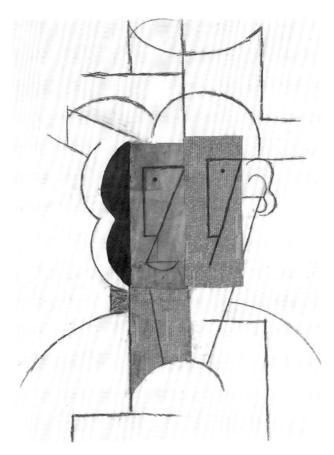

PICASSO. *Man with a Hat.* Paris, after December 3, 1912
Pasted paper, charcoal, and ink, 24½ × 18⅜″ (62.2 × 47.3 cm)
Daix 534. The Museum of Modern Art, New York. Purchase

263

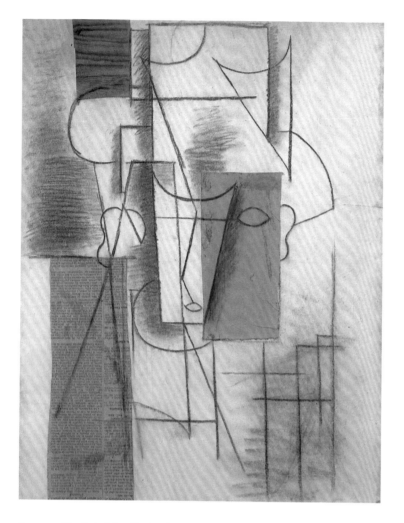

PICASSO. *Head of a Man.* Paris, after December 2, 1912
Pasted paper, watercolor, and charcoal,
24⅝ × 18½″ (62.5 × 47 cm)
Daix 532. Private collection, Switzerland

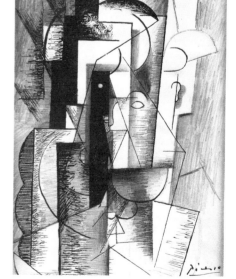

PICASSO. *Portrait of Guillaume Apollinaire.*
Paris, [early 1913]
Pencil and ink, 8¼ × 5⅞″ (21 × 15 cm)
Daix 579. Private collection

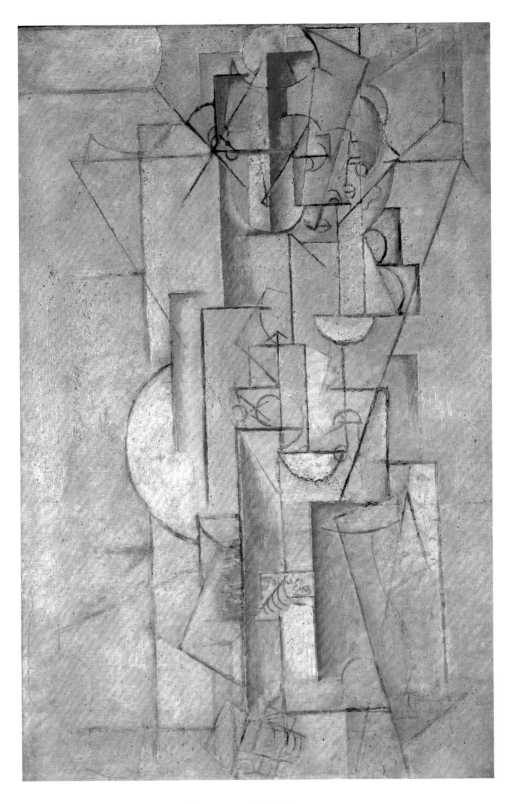

PICASSO. *Female Nude: "J'aime Eva."* Paris, winter 1912–13
Oil and sand on canvas, 29¾ × 26″ (75.6 × 66 cm)
Daix 541. Columbus Museum of Art, Ohio.
Gift of Ferdinand Howald

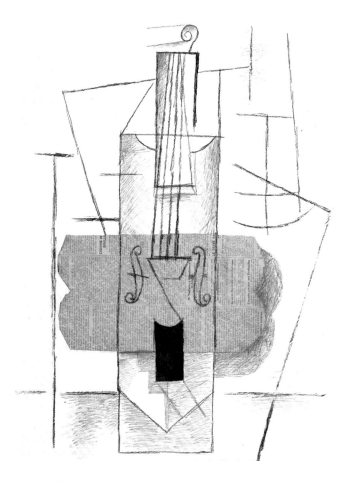

PICASSO. *Composition with a Violin*. Paris, after December 8, 1912
Pencil, charcoal, gouache, and pasted paper,
24 × 18⅜″ (61.1 × 46.5 cm)
Kosinski 59. Private collection

PICASSO. *Bottle on a Table*. Paris, after December 8, 1912
Pasted paper and charcoal, 24⅜ × 17⅜″ (62 × 44 cm)
Daix 551. Musée Picasso, Paris

BRAQUE. *Still Life with Guitar.* [Paris, December 1912]
Charcoal, pasted paper, and pencil on paper, mounted on panel,
25 × 19″ (63.5 × 48.3 cm)
M.-P./C. 23. Philadelphia Museum of Art.
Louise and Walter Arensberg Collection

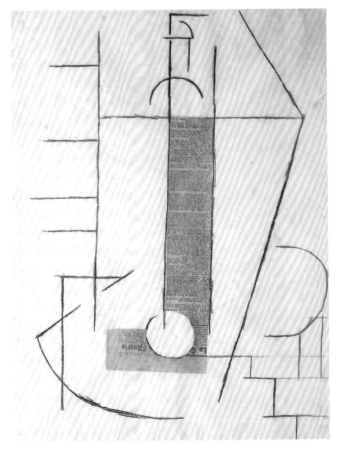

PICASSO. *Bottle on a Table.* Paris, after December 8, 1912
Pasted paper and charcoal, 23⅝ × 18⅛″ (60 × 46 cm)
Daix 552. Collection Ernst Beyeler, Basel

PICASSO. *Guitars.* Céret, spring 1913
Ink, 13¾ × 9″ (35 × 23 cm)
Zervos XXVIII, 282. Musée Picasso, Paris

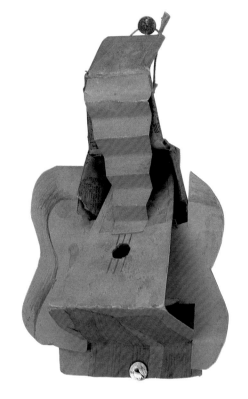

PICASSO. *Guitar.* Paris, after December 3, 1912
Paper construction, 9 × 5¼ × 2¾″
(22.8 × 14.5 × 7 cm)
Daix 556. Musée Picasso, Paris

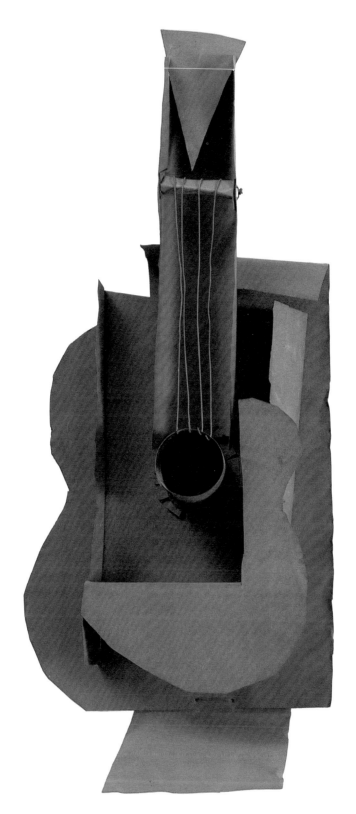

PICASSO. *Guitar*. Paris, [winter 1912–13]
Construction of sheet metal, string, and wire,
30½ × 13¾ × 7⅝″ (77.5 × 35 × 19.3 cm)
Daix 471. The Museum of Modern Art, New York.
Gift of the artist

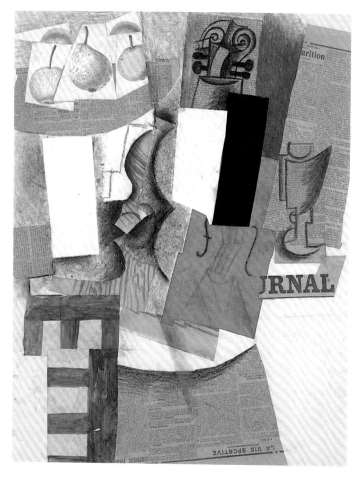

PICASSO. *Bowl with Fruit, Violin, and Wineglass.*
Paris, begun after December 2, 1912;
completed after January 21, 1913
Pasted paper, watercolor, chalk, oil, and charcoal
on cardboard, 25½ × 19⅞″ (65 × 50.5 cm)
Daix 530. Philadelphia Museum of Art.
A. E. Gallatin Collection

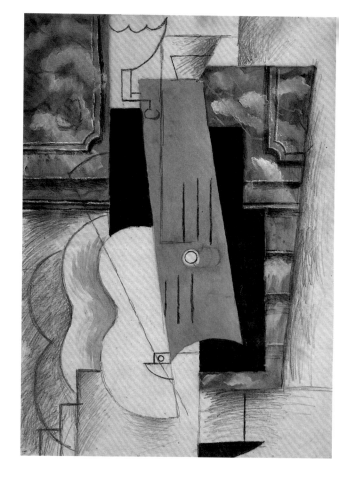

PICASSO. *Gas Jet and Guitar.* Paris, winter 1912–13
Gouache and charcoal, 24⅝ × 18¼″ (62.5 × 46.5 cm)
Daix 564. National Gallery, Prague

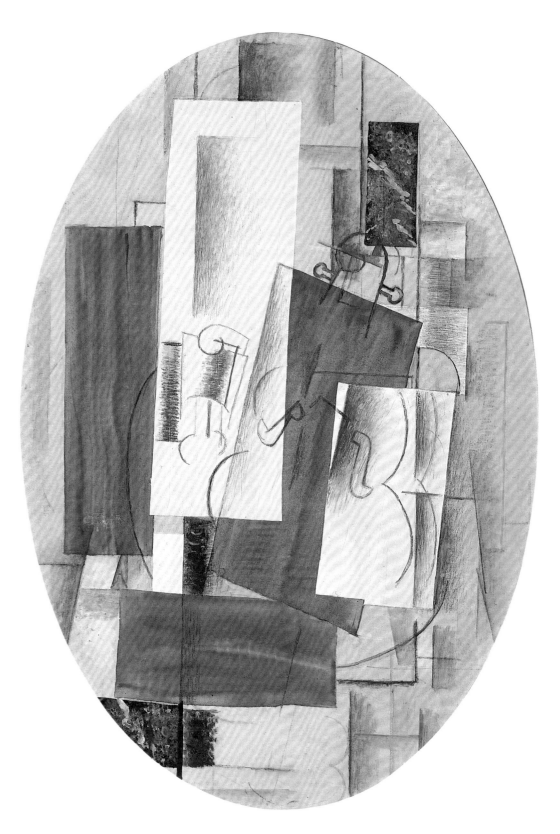

BRAQUE. *Violin and Glass.* [Paris, winter] 1912–13
Oil, charcoal, and pasted paper on canvas (oval),
45¾ × 32″ (116 × 81 cm)
Romilly 188. Kunstmuseum Basel.
Gift of Raoul La Roche, 1963

271

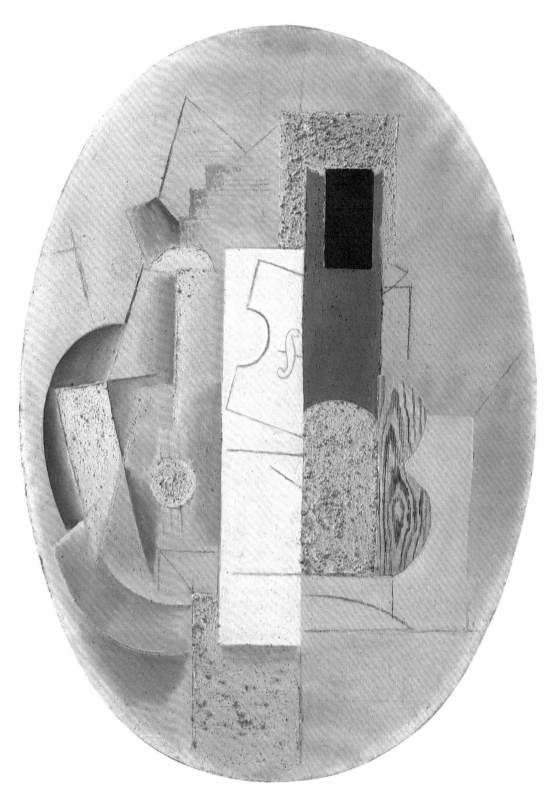

PICASSO. *Violin and Guitar.* Paris, [winter] 1912–13
Oil, pasted cloth, charcoal, and gesso on canvas (oval),
35¼ × 25¼″ (89.5 × 64.2 cm)
Daix 574. Philadelphia Museum of Art.
Louise and Walter Arensberg Collection

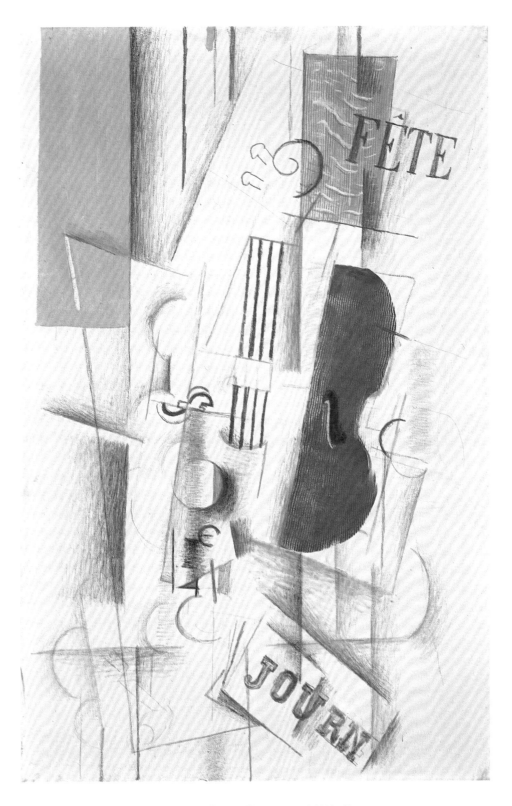

BRAQUE. *Violin and Newspaper (Musical Forms)*. [Paris, winter] 1912–13
Oil, charcoal, and pencil on canvas, 36 × 23½″ (91.5 × 59.7 cm)
Romilly 190. Philadelphia Museum of Art.
Louise and Walter Arensberg Collection

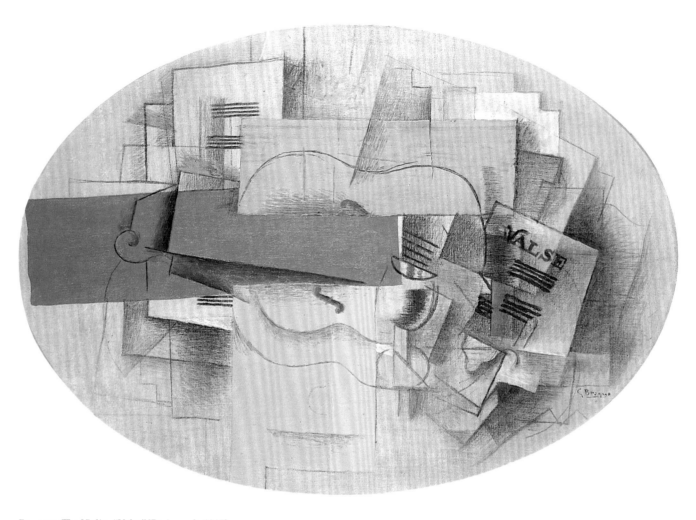

BRAQUE. *The Violin: "Valse."* [Paris, early 1913]
Oil and charcoal on canvas (oval), 25¾ × 36¼″ (65 × 92 cm)
Romilly 187. Museum Ludwig, Cologne

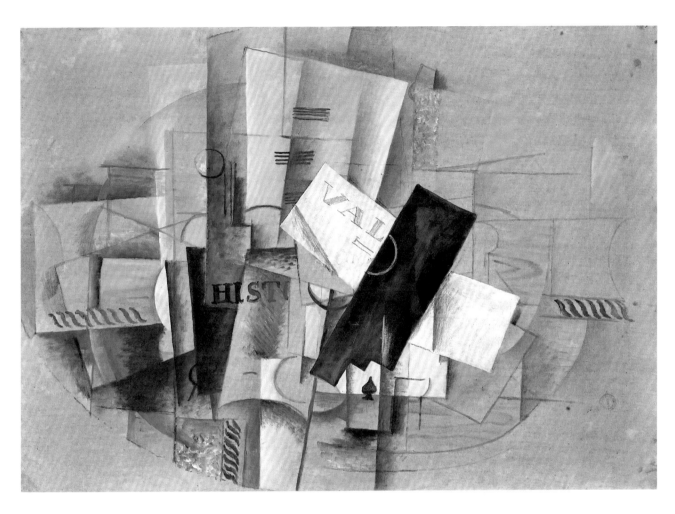

BRAQUE. *Pedestal Table.* [Paris, early 1913]
Oil and charcoal on canvas, 25¾ × 36¼″ (65 × 92 cm)
Romilly 173. Kunstmuseum Basel.
Gift of Raoul La Roche, 1952

PICASSO. *Head.* Céret, spring 1913
Pasted paper, ink, and pencil, 17 × 11⅜″ (43 × 28.8 cm)
Daix 592. The Museum of Modern Art, New York.
The Sidney and Harriet Janis Collection

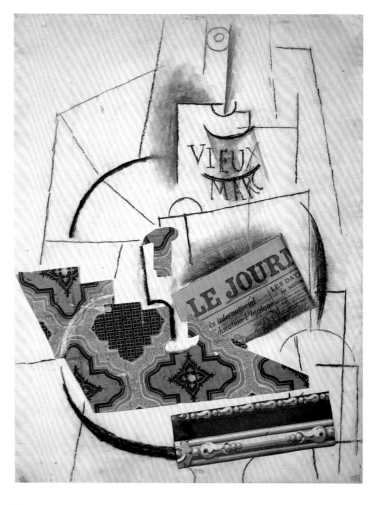

PICASSO. *Bottle of Vieux Marc, Glass, and Newspaper.*
Céret, after March 15, 1913
Charcoal and pasted and pinned paper,
24¾ × 19¼″ (63 × 49 cm)
Daix 600. Musée National d'Art Moderne,
Centre Georges Pompidou, Paris. Gift of Henri Laugier

276

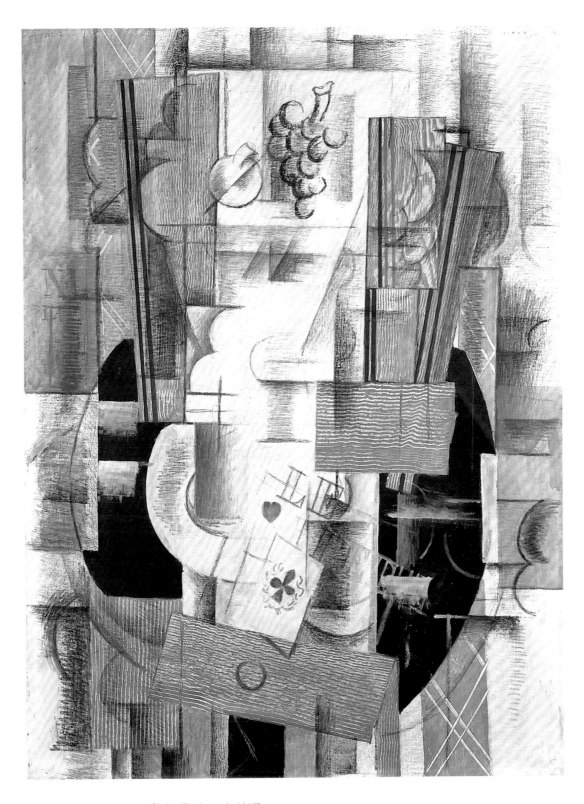

BRAQUE. *Fruit Dish, Ace of Clubs.* [Paris, early 1913]
Oil, gouache, and charcoal on canvas, 31⅞ × 23⅝″ (81 × 60 cm)
Romilly 151. Musée National d'Art Moderne, Centre Georges Pompidou, Paris.
Gift of Paul Rosenberg

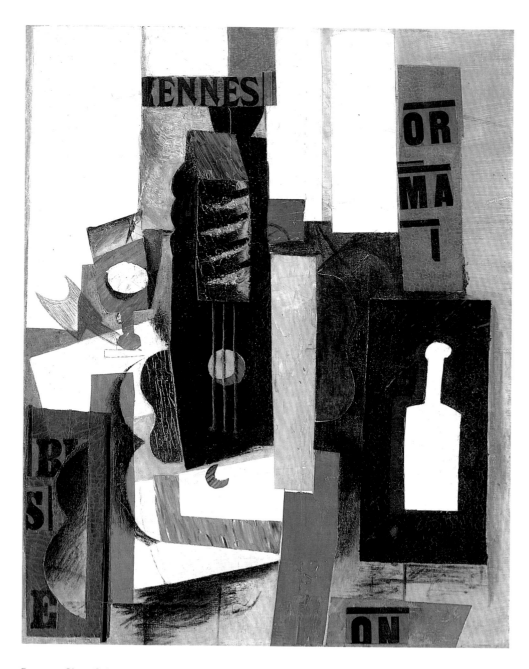

Picasso. *Glass, Guitar, and Bottle.* Paris, early 1913
Oil, pasted paper, gesso, and pencil on canvas,
25¾ × 21⅛″ (65.4 × 53.6 cm)
Daix 570. The Museum of Modern Art, New York.
The Sidney and Harriet Janis Collection

PICASSO. *"Au Bon Marché."* Paris, after January 25–26, 1913
Oil and pasted paper on cardboard, 9¼ × 12¼″ (23.5 × 31 cm)
Daix 557. Ludwig Collection, Aachen

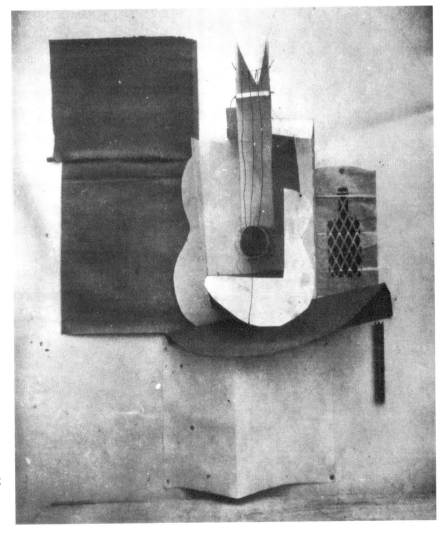

Construction mounted in Picasso's studio
at 5 bis, rue Schoelcher, early 1913, including
cardboard maquette for *Guitar* (p. 251),
photographed by the artist.
Construction no longer extant

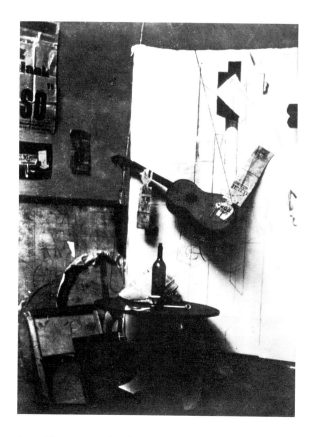

Assemblage mounted in Picasso's studio at 242, boulevard Raspail, early 1913, including figure composition in progress, newspaper, guitar, table, and still-life objects.
Daix 578. Assemblage no longer extant

PICASSO. *Head of a Girl.*
[Paris or Céret, winter–spring] 1913
Oil on canvas, 21⅝ × 15″ (55 × 38 cm)
Daix 590. Musée National d'Art Moderne,
Centre Georges Pompidou, Paris.
Gift of Henri Laugier

PICASSO. *Head of a Man.*
Paris [and Céret], winter[–spring] 1913
Oil, charcoal, ink, and pencil,
24¼ × 18¼″ (61.6 × 46.3 cm)
Daix 615. The Richard S. Zeisler Collection, New York

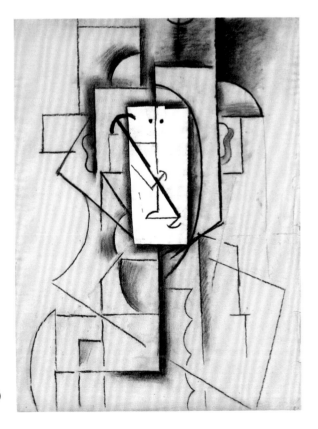

PICASSO. *Head of a Harlequin.*
[Paris or Céret, winter–spring] 1913
Charcoal and pasted paper, 24⅝ × 18½″ (62.5 × 47 cm)
Daix 617. Musée Picasso, Paris

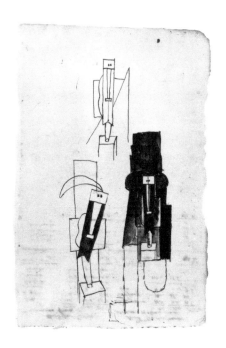

Picasso. *Three Heads.* Céret, spring 1913
Ink, 14⅛ × 9¼" (35.8 × 23.3 cm)
Zervos XXVIII, 283. Collection Maya Ruiz-Picasso

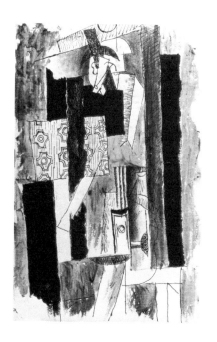

Picasso. *Guitarist with a Hat.*
Céret, spring 1913
Ink, 14 × 9⅛" (35.7 × 23.1 cm)
Zervos XXVIII, 278. Musée Picasso, Paris

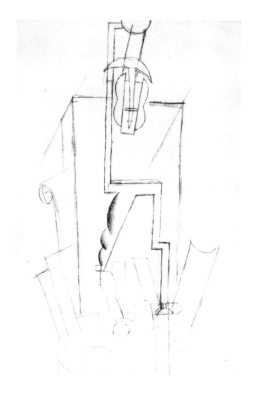

Picasso. *Guitarist.* Céret, spring 1913
Pencil, 16⅞ × 11¼" (42.5 × 28.5 cm)
Zervos XXVIII, 257. Private collection

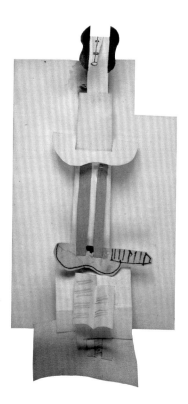

Picasso. *Guitarist with Sheet Music.*
[Céret, spring] 1913
Paper construction, 8⅝ × 4⅛"
(22 × 10.5 cm)
Daix 582. Private collection, Paris

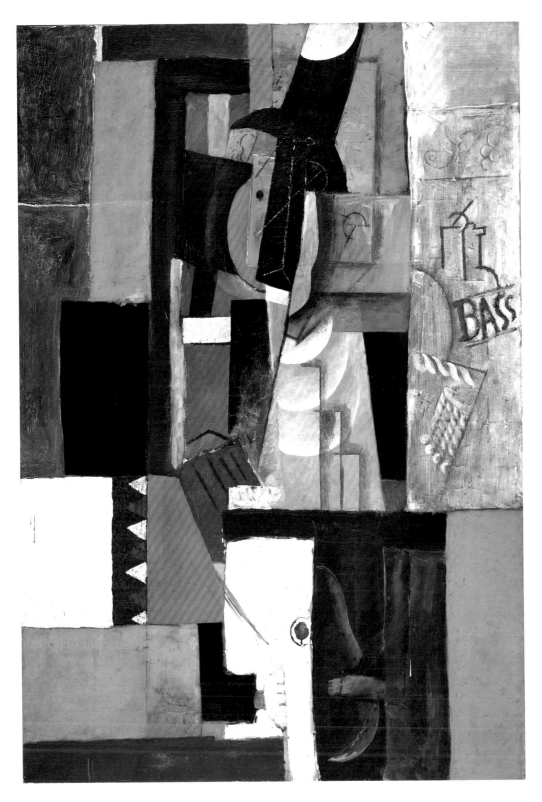

PICASSO. *Man with a Guitar*. Céret, spring 1913
Oil on canvas, 51¼ × 35″ (130.2 × 88.9 cm)
Daix 616. The Museum of Modern Art, New York.
André Meyer Bequest

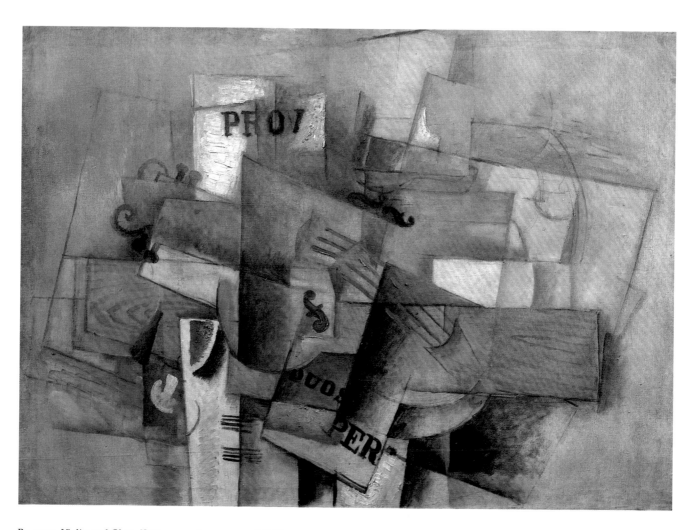

BRAQUE. *Violin and Glass.* [Sorgues, spring–summer] 1913
Oil on canvas, 25½ × 36¼″ (65 × 92 cm)
Romilly 202. Collection Mr. and Mrs. Klaus Perls, New York

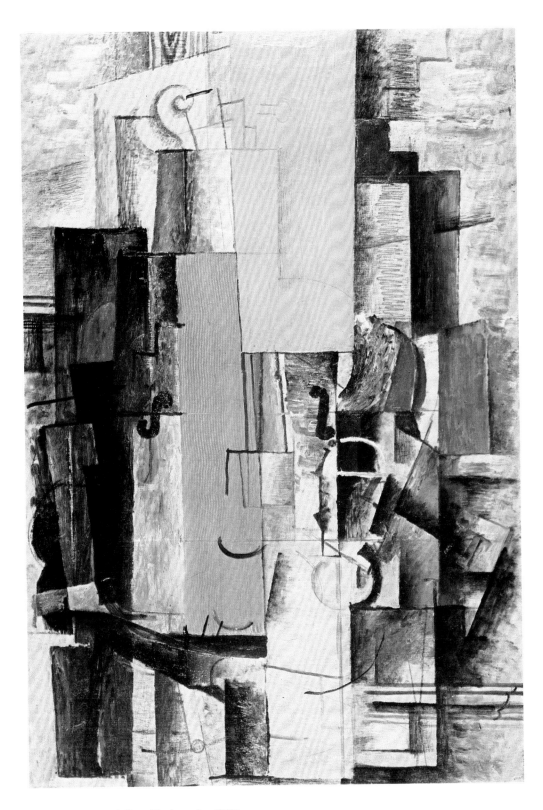

BRAQUE. *Violin and Glass.* [Paris, spring 1913]
Oil, charcoal, and pencil on canvas, 32 × 23¾" (81 × 60 cm)
Romilly 172. Private collection

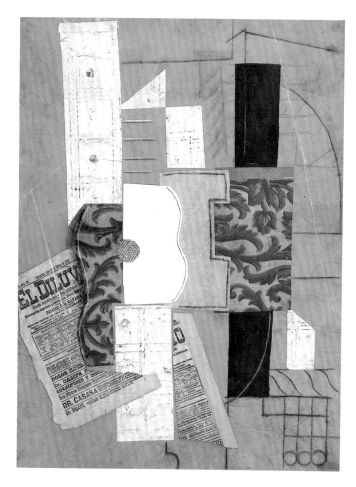

Picasso. *Guitar.* Céret, after March 31, 1913
Pasted paper, charcoal, ink, and chalk,
26⅛ × 19⅛″ (66.4 × 49.6 cm)
Daix 608. The Museum of Modern Art, New York.
Nelson A. Rockefeller Bequest

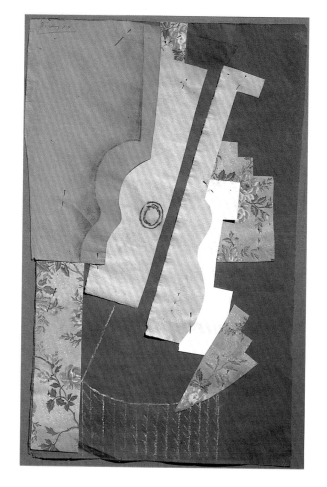

Picasso. *Bar Table with Guitar.* Céret, spring 1913
Chalk and pasted and pinned paper,
24¼ × 15½″ (61.5 × 39.5 cm)
Daix 601. Private collection

PICASSO. *Head of a Man with a Moustache.*
[Céret], after May 6, 1913
Charcoal and ink on newspaper,
21⅞ × 14¼″ (55.5 × 37.4 cm)
Private collection

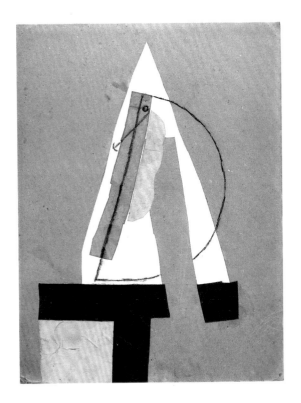

PICASSO. *Head.* [Céret, May–June] 1913
Pasted paper, charcoal, and pencil on cardboard,
17⅛ × 13″ (43.5 × 33 cm)
Daix 595. Private collection, England

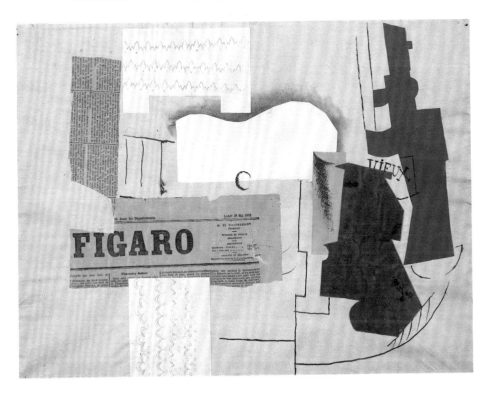

PICASSO. *Bottle of Vieux Marc, Glass, Guitar, and Newspaper.* Céret, spring 1913
Pasted paper and ink, 18⅜ × 24⅝″ (46.7 × 62.5 cm)
Daix 604. The Tate Gallery, London

Picasso. *Guitar.* [Céret, spring] 1913
Oil on canvas, mounted on panel,
34¼ × 18¾″ (87 × 47.5 cm)
Daix 597. Musée Picasso, Paris

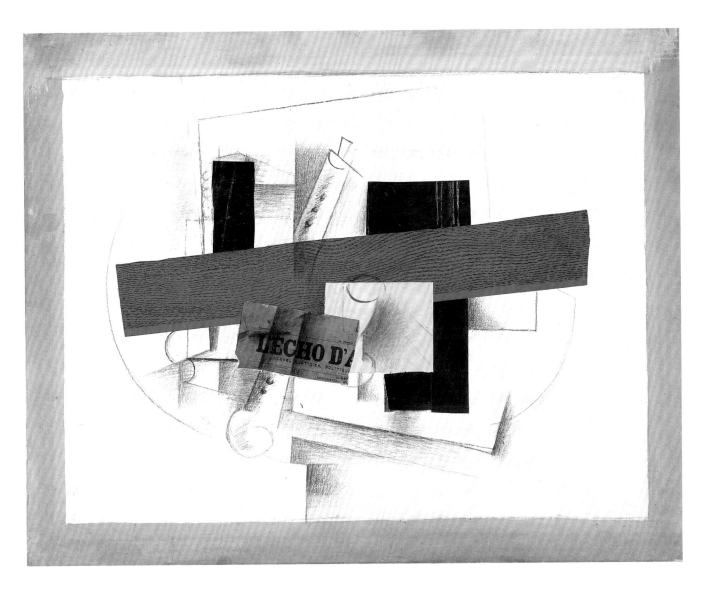

BRAQUE. *Clarinet.* [Sorgues, summer 1913]
Pasted paper, oil, charcoal, chalk, and pencil on canvas,
37½ × 47⅜″ (95.2 × 120.3 cm)
M.-F./C. 28. The Museum of Modern Art, New York.
Nelson A. Rockefeller Bequest

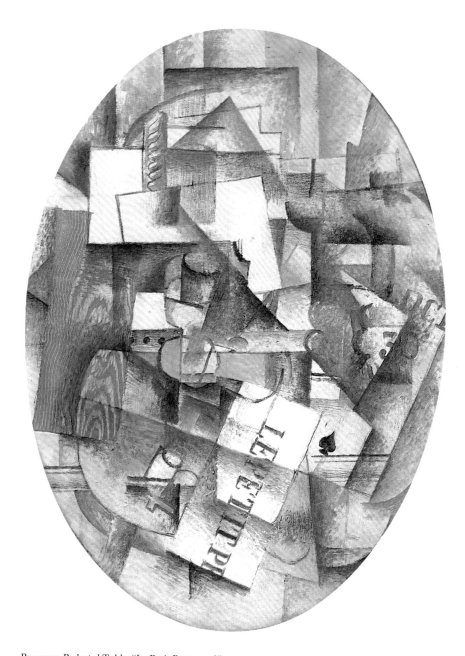

BRAQUE. *Pedestal Table: "Le Petit Provençal."*
Sorgues, [summer] 1913
Oil on canvas (oval), 28¾ × 21¼″ (73 × 54 cm)
Romilly 184. Private collection

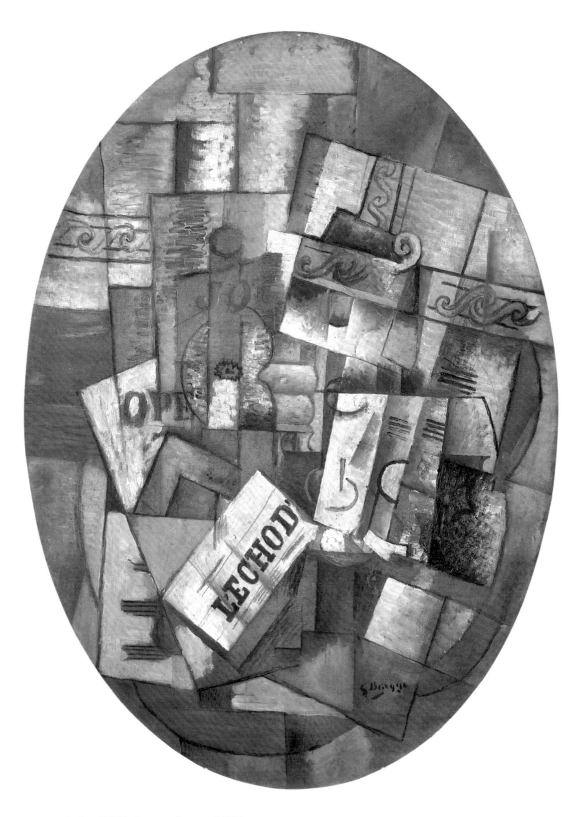

BRAQUE. *Pedestal Table*. Sorgues, [autumn] 1913
Oil on canvas (oval), 36 × 28″ (91 × 71 cm)
Romilly 182. Collection Heinz Berggruen, Geneva

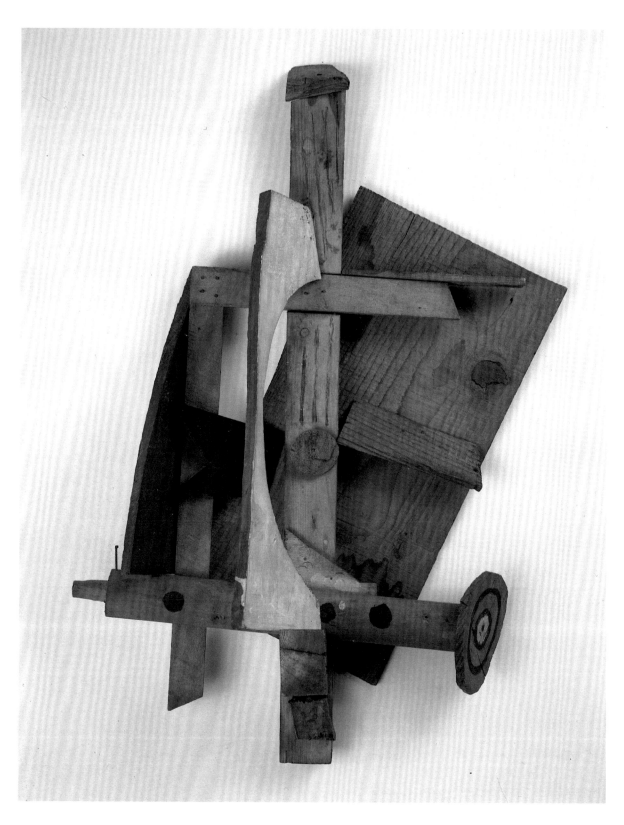

PICASSO. *Mandolin and Clarinet.* [Paris, autumn 1913]
Construction of painted wood with pencil marks,
22⅝ × 14⅛ × 9″ (58 × 36 × 23 cm)
Daix 632. Musée Picasso, Paris

PICASSO. *Standing Woman.* [Paris, autumn 1913]
Watercolor and pencil, 14¾ × 9″ (37.5 × 23 cm)
Zervos VI, 1317. Collection Maya Ruiz-Picasso

PICASSO. *Man with a Guitar and Woman.* [Paris, autumn 1913]
Watercolor and pencil, 14⅝ × 15⅛″ (37.2 × 38.5 cm)
Zervos VI, 1168. Collection Artcurial, Paris

PICASSO. *Woman on a Chaise Longue.*
[Paris, autumn 1913]
Pencil, 9 × 7½″ (23 × 19 cm)
Zervos VI, 1241. Collection Maya Ruiz-Picasso

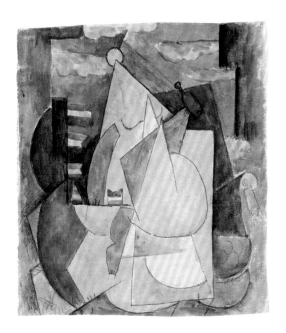

PICASSO. *Woman in an Armchair.* [Paris, autumn 1913]
Watercolor and pencil, 8¾ × 7¾″ (22.3 × 19.9 cm)
Daix 882. Musée Picasso, Paris

PICASSO. *Woman in an Armchair.*
[Paris, autumn 1913]
Etching, 3 × 2¾″ (7.8 × 6.9 cm)
Geiser 41. Collection Marina Picasso;
Galerie Jan Krugier, Geneva

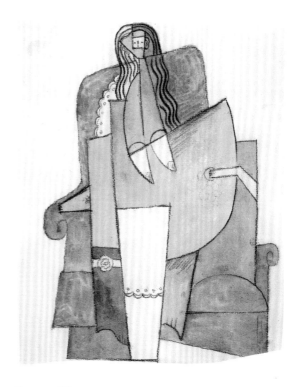

PICASSO. *Woman in an Armchair.*
[Paris, autumn 1913]
Watercolor and conté crayon,
9½ × 7½″ (24.2 × 19.3 cm)
Daix 639. Collection Mr. and Mrs.
Rafael Lopez-Cambil, New York

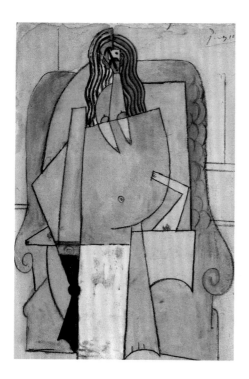

PICASSO. *Woman in an Armchair.*
[Paris, autumn 1913]
Watercolor and crayon,
10⅝ × 7½″ (27 × 19 cm)
Daix 640. Ludwig Collection, Aachen

PICASSO. *Woman in an Armchair.*
[Paris, autumn 1913]
Watercolor and conté crayon,
11¼ × 10⅞″ (28.6 × 27.8 cm)
Daix 636. Private collection

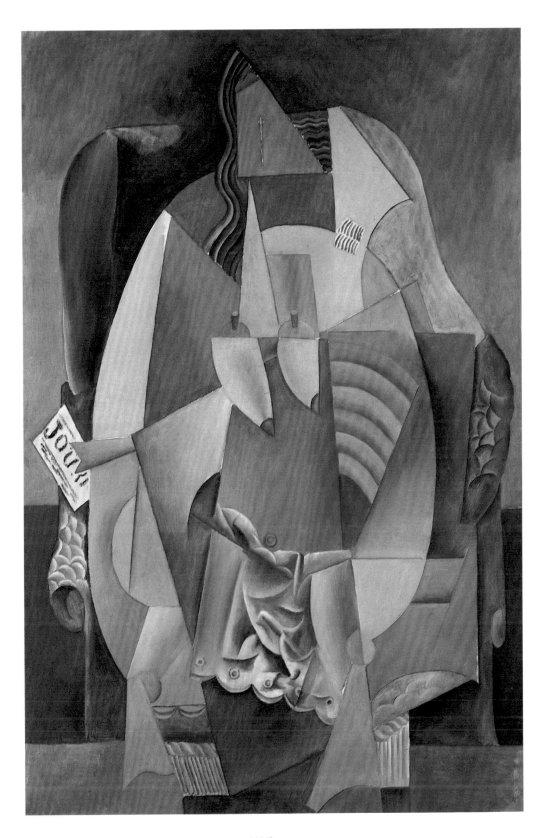

PICASSO. *Woman in an Armchair.* [Paris, autumn 1913]
Oil on canvas, 58¼ × 39″ (148 × 99 cm)
Daix 642. Collection Mrs. Victor W. Ganz, New York

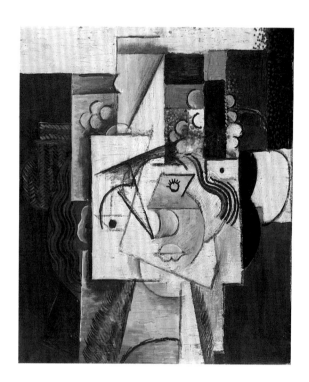

PICASSO. *Hat Decorated with Grapes.* [Paris, autumn 1913]
Oil on canvas, 21⅜ × 18⅛″ (55 × 46 cm)
Daix 648. Private collection, Japan

BRAQUE. *Guitar.* [Sorgues, autumn 1913]
Gesso, pasted paper, charcoal, pencil, and gouache on canvas,
39¼ × 25¾″ (99.7 × 65 cm)
M.-F./C. 29. The Museum of Modern Art, New York.
Acquired through the Lillie P. Bliss Bequest

BRAQUE. *Woman with a Guitar.* Sorgues, autumn 1913
Oil and charcoal on canvas, 51¼ × 28¾″ (130 × 73 cm)
Romilly 198. Musée National d'Art Moderne,
Centre Georges Pompidou, Paris. Gift of Raoul La Roche

297

BRAQUE. *Checkerboard: "Tivoli-Cinéma."* Sorgues, after October 31, 1913
Gesso, pasted paper, charcoal, and oil on paper, mounted on canvas,
25¾ × 36¼″ (65.5 × 92 cm)
M.-F./C. 31. Collection Rosengart, Lucerne

BRAQUE. *Guitar and Program: "Statue d'épouvante."* Sorgues, November 1913
Charcoal, gouache, and pasted paper, 28¾ × 39⅜" (73 × 100 cm)
M.-F./C. 34. Private collection

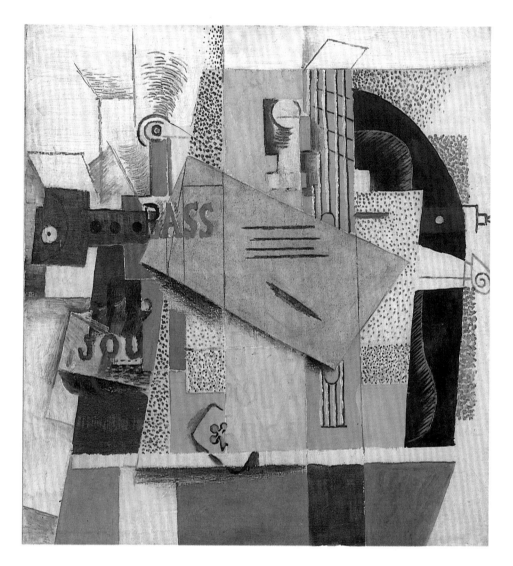

PICASSO. *Violin*. Paris, [winter] 1913–14
Oil on canvas, 31⅞ × 29½″ (81 × 75 cm)
Daix 624. Musée National d'Art Moderne,
Centre Georges Pompidou, Paris.
Gift of Raoul La Roche

PICASSO. *Woman with a Guitar*.
Paris, [winter] 1913–14
Pencil, 25 × 18¾″ (63 × 47 cm)
Zervos XXIX, 8. Solomon R. Guggenheim
Museum, New York

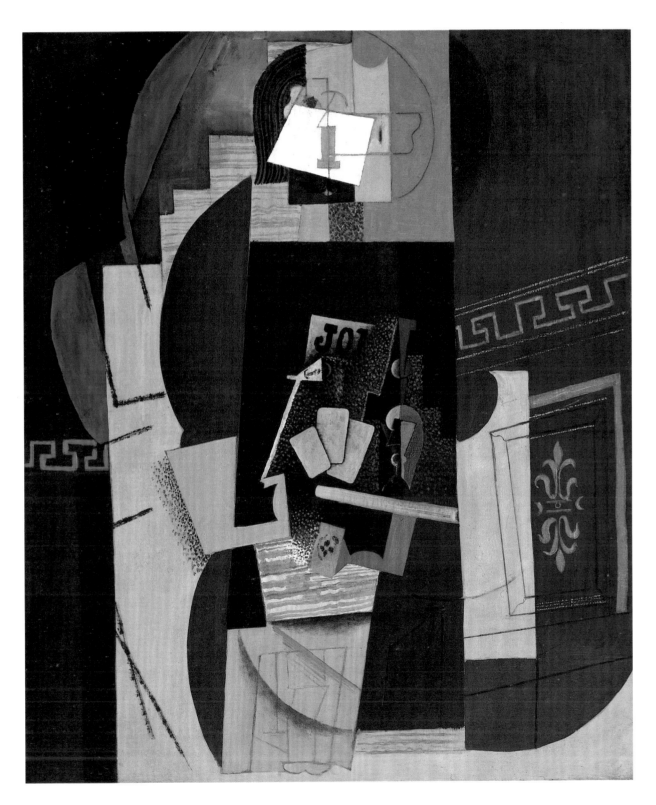

PICASSO. *Card Player.* Paris, [winter] 1913–14
Oil on canvas, 42½ × 35¼″ (108 × 89.5 cm)
Daix 650. The Museum of Modern Art, New York.
Acquired through the Lillie P. Bliss Bequest

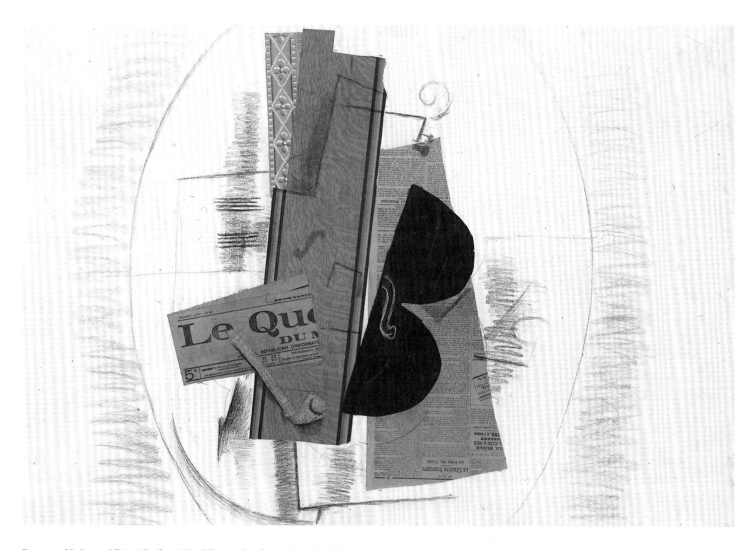

BRAQUE. *Violin and Pipe: "Le Quotidien."* Paris, after December 20, 1913
Chalk, charcoal, and pasted paper, 29⅛ × 41¾″ (74 × 106 cm)
M.-F./C. 38. Musée National d'Art Moderne, Centre Georges Pompidou, Paris.
Purchased by the Musées Nationaux

BRAQUE. *Glass and Bottle.* [Paris, winter] 1913–14
Charcoal and pasted paper, 18⅞ × 24⅜″ (48 × 62 cm)
M.-F./C. 37. Private collection

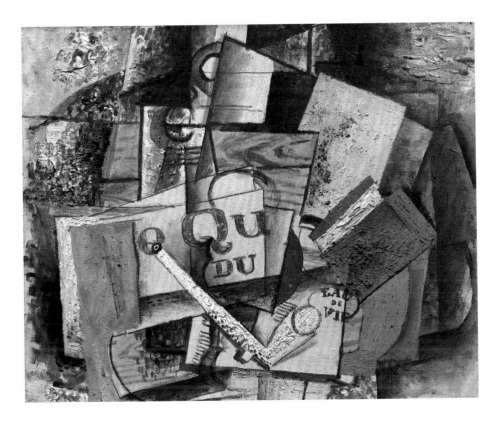

BRAQUE. *Bottle of Eau-de-Vie.* [Paris, early 1914]
Oil on canvas, 13 × 16¼″ (33 × 41 cm)
Romilly 235. Collection Heinz Berggruen, Geneva

PICASSO. *Still Life with Skull*, State II,
from *Le Siège de Jerusalem* by Max Jacob.
Paris, [late] 1913. Published Paris, Henry Kahnweiler, 1914
Etching with drypoint, 6⅛ × 4½″ (15.5 × 11.4 cm)
Geiser 36. The Museum of Modern Art, New York.
The Louis E. Stern Collection

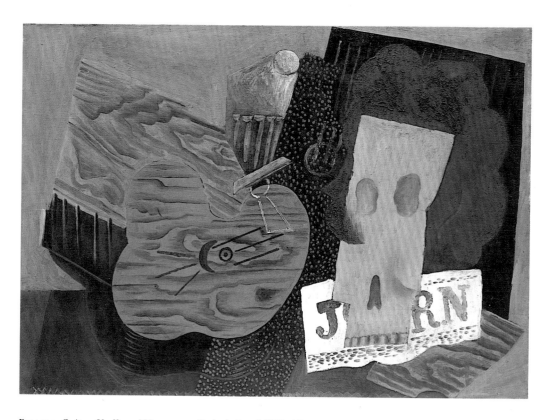

PICASSO. *Guitar, Skull, and Newspaper.* Paris, [winter] 1913–14
Oil on canvas, 17⅛ × 24″ (43.5 × 61 cm)
Daix 739. Musée d'Art Moderne, Villeneuve-d'Ascq.
Gift of Geneviève and Jean Masurel

PICASSO. *Woman with a Guitar*. Céret and Paris, 1911–early 1914
Oil on canvas, 51⅛ × 35″ (130 × 89 cm)
Daix 647. Kunstmuseum Basel. Gift of Raoul La Roche, 1952

Picasso. *Wineglass, Bottle of Bass, and Ace of Clubs.* Paris, [early] 1914
Pasted paper, pencil, and white lead, 9½ × 11⅜″ (24 × 29 cm)
Daix 695. National Gallery, Prague

Braque. *Still Life with Ace of Hearts.* Paris, [early] 1914
Pencil and pasted paper on cardboard, 11⅞ × 16⅛″ (30 × 41 cm)
M.-F./C. 50. Private collection

BRAQUE. *Glass, Bottle, and Newspaper.*
Paris, after January 15, 1914
Pasted paper, 24⅝ × 11¼″ (62.5 × 28.5 cm)
M.-F./C. 46. Private collection

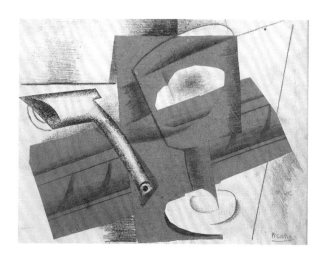

Picasso. *Pipe and Wineglass.* Paris, [early] 1914
Pasted paper and crayon, 7⅛ × 9½″ (18 × 24 cm)
Daix 665. Collection Mr. and Mrs. Eugene V. Thaw

Picasso. *Pipe and Sheet Music.* Paris, [early] 1914
Pasted paper, oil, and charcoal,
20¼ × 26½″ (51.4 × 66.6 cm)
Daix 683. The Museum of Fine Arts, Houston.
Gift of Mr. and Mrs. Maurice McAshan

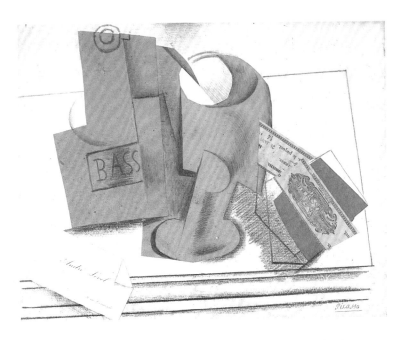

PICASSO. *Bottle of Bass, Wineglass, Packet of Tobacco, and Calling Card.*
Paris, [early] 1914
Pasted paper and pencil, 9½ × 12″ (24 × 30.5 cm)
Daix 660. Musée National d'Art Moderne, Centre Georges Pompidou, Paris.
Gift of Louise and Michel Leiris, the donors retaining a life interest

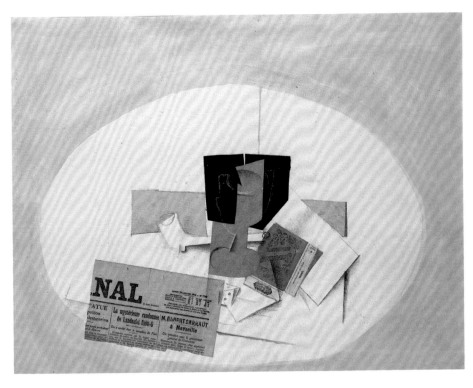

BRAQUE. *Pipe, Glass, Die, and Newspaper.* Paris, after January 26, 1914
Charcoal and pasted paper, 19⅝ × 23⅝″ (50 × 60 cm)
M.-F./C. 45. Sprengel Museum Hannover

311

BRAQUE. *Bottle of Rum.*
[Paris, spring 1914]
Pencil, 9¼ × 6⅝″ (23.5 × 17 cm)
Leymarie 94. Private collection

BRAQUE. *Still Life with Bottle.*
Paris, after January 10, 1914
Pencil, pasted paper, and gouache,
24¾ × 18½″ (63 × 47 cm)
M.-F./C. 49. Private collection

BRAQUE. *Bottle of Rum.* [Paris, spring 1914]
Gouache and pasted paper on cardboard,
25¾ × 18¼″ (65.6 × 46.5 cm)
Romilly 241. Private collection

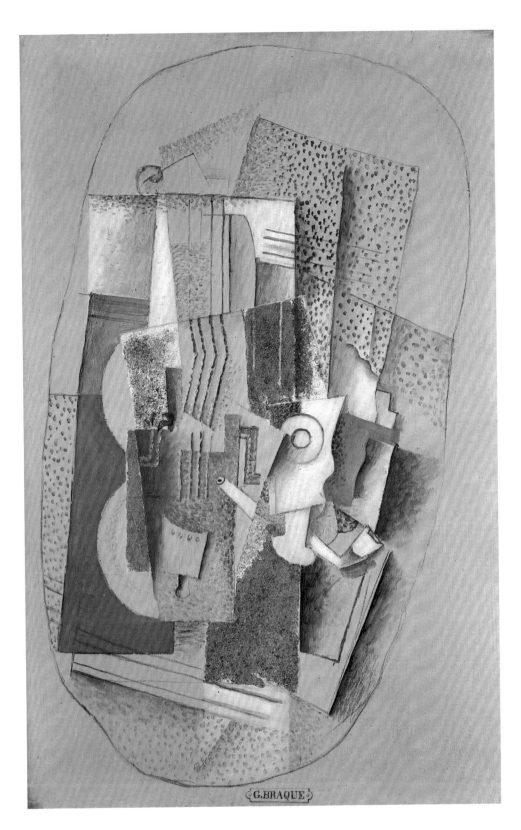

BRAQUE. *The Violin.* [Paris, early 1914]
Oil and sand on canvas,
36¼ × 23⅜″ (92.1 × 60 cm)
Romilly 232. Private collection

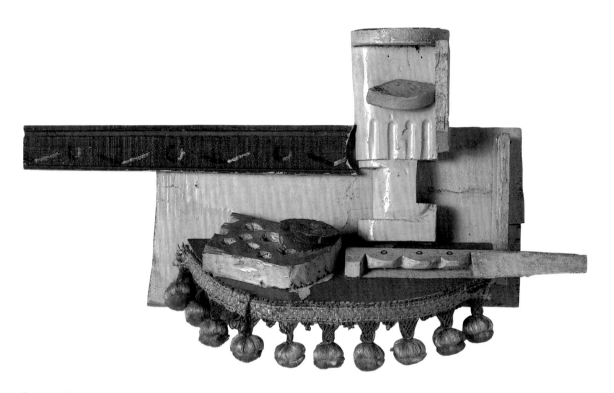

Picasso. *Still Life.* Paris, [early] 1914
Construction of painted wood with upholstery fringe,
10 × 18 × 3⅝″ (25.4 × 45.7 × 9.2 cm)
Daix 746. The Tate Gallery, London

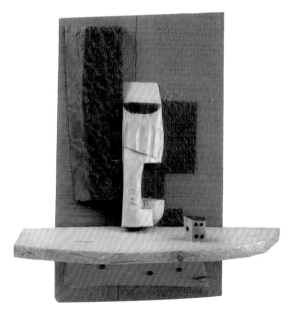

Picasso. *Glass and Dice.* Paris, [early] 1914
Construction of painted wood,
9¼ × 8⅝″ (23.5 × 22 cm)
Daix 747. Private collection

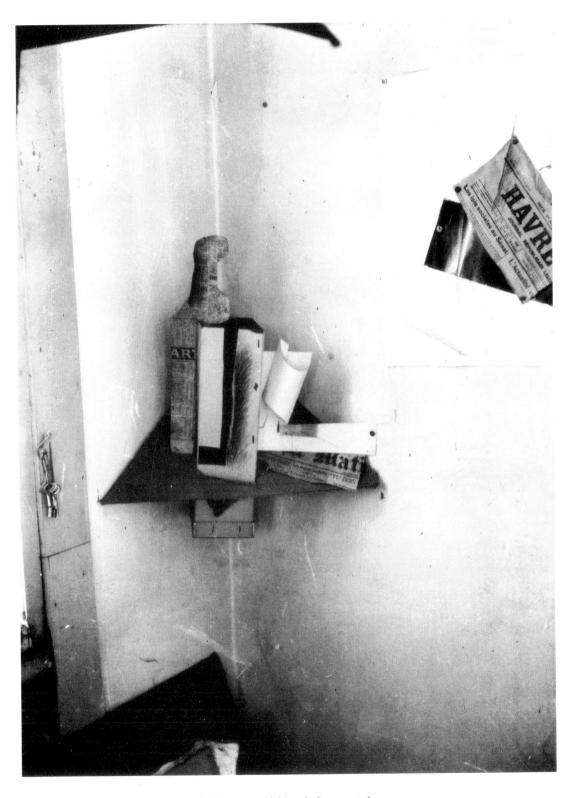

Braque's studio at Hôtel Roma, 101, rue Caulincourt, with his only documented paper sculpture, completed after February 18, 1914. Romilly, p.41. No longer extant

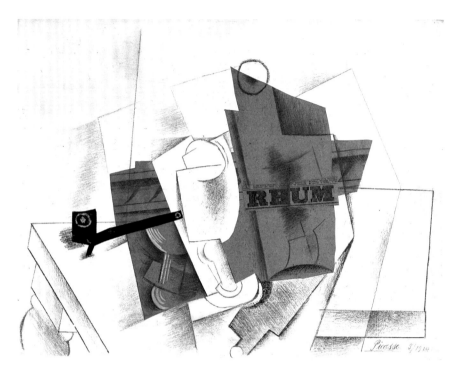

Picasso. *Pipe, Glass, and Bottle of Rum.* Paris, March 1914
Gesso, pasted paper, pencil, and gouache on cardboard, 15¾ × 20¾″ (40 × 52.7 cm)
Daix 663. The Museum of Modern Art, New York. Gift of Mr. and Mrs. Daniel Saidenberg

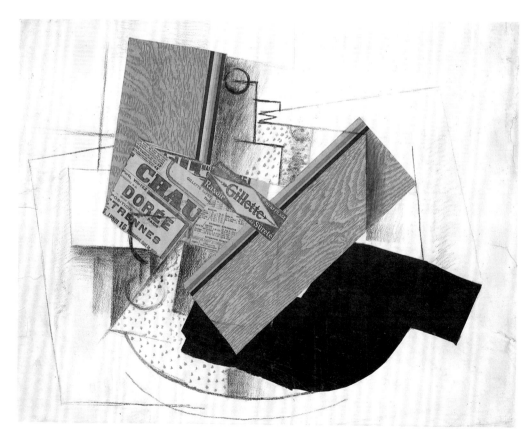

Braque. *Still Life on a Table: "Gillette."* [Paris, early 1914]
Charcoal, pasted paper, and gouache, 18⅞ × 24⅜″ (48 × 62 cm)
M.-F./C. 42. Musée National d'Art Moderne, Centre Georges Pompidou, Paris

PICASSO. *Pipe, Wineglass, Newspaper, Guitar, and Bottle of Vieux Marc: "Lacerba."*
Paris, after January 1, 1914
Pasted paper, oil, and chalk on canvas, 28¾ × 23⅜″ (73.2 × 59.4 cm)
Daix 701. Peggy Guggenheim Foundation, Venice;
The Solomon R. Guggenheim Foundation, New York

BRAQUE. *Bottle, Glass, and Pipe.* Paris, [spring] 1914
Charcoal, chalk, and pasted paper on cardboard,
18⅞ × 24¾″ (47.9 × 63 cm)
M.-F./C. 44. Private collection

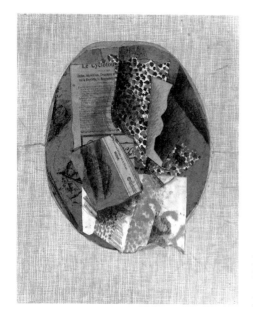

BRAQUE. *Glass and Cigarette Pack.* Paris, [spring] 1914
Pencil, charcoal, gouache, chalk, and pasted paper on cardboard,
13¾ × 10⅞″ (35 × 27.7 cm)
M.-F./C. 48. The Art Institute of Chicago. Gift of Mrs. Gilbert W. Chapman

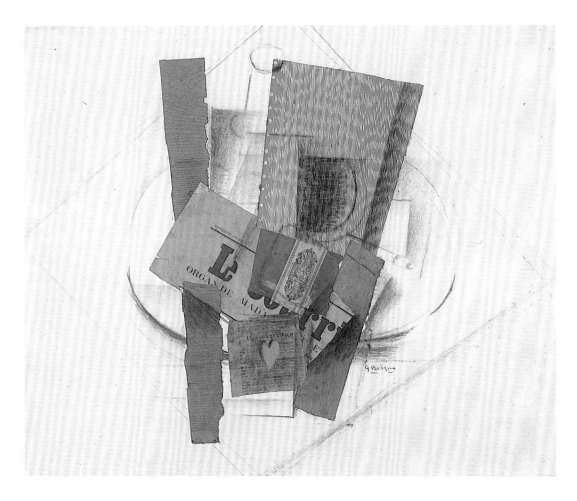

BRAQUE. *Newspaper, Bottle, Packet of Tobacco.* Paris, [spring] 1914
Charcoal, gouache, pencil, ink, and pasted paper on cardboard,
20⅝ × 23″ (52.4 × 58.6 cm)
M.-F./C. 43. Philadelphia Museum of Art.
A. E. Gallatin Collection

BRAQUE. *Still Life with Checkerboard and Pack of Cigarettes.*
Paris, [spring] 1914
Charcoal and pasted paper, 11 × 17⅜″ (28 × 44 cm)
M.-F./C. 40. Collection Mrs. Marcia Riklis Hirschfeld, New York

319

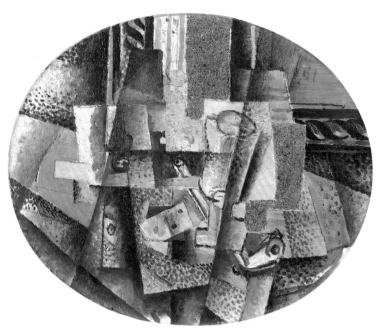

BRAQUE. *Still Life with Pipe.*
Paris, [spring] 1914
Oil on canvas (oval), 15 × 18⅛″ (38 × 46 cm)
Romilly 239. Musée d'Art Moderne de la Ville de Paris.
Bequest of Dr. Maurice Girardin

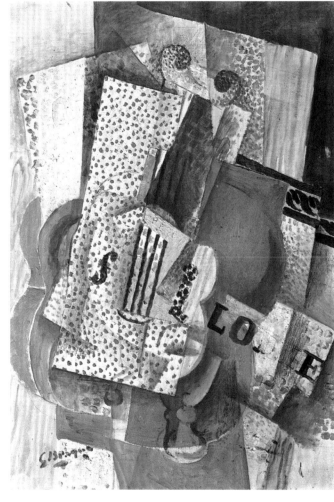

BRAQUE. *Violin: "Mélodie."* [Paris, spring 1914]
Oil on canvas, 21⅞ × 15″ (55.4 × 38.3 cm)
Romilly 238. Privately owned

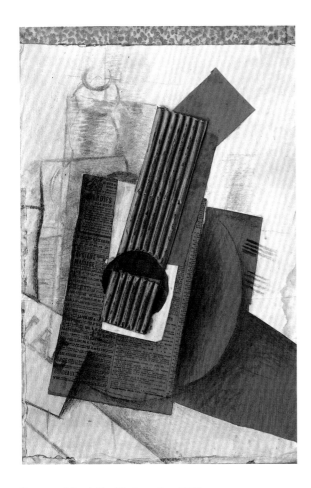

BRAQUE. *Mandolin.* [Paris, spring 1914]
Charcoal, gouache, pasted paper, and cardboard,
19 × 12½″ (48.3 × 31.8 cm)
M.-F./C. 52. Ulmer Museum, Ulm.
On extended loan from the province of Baden-Württemberg

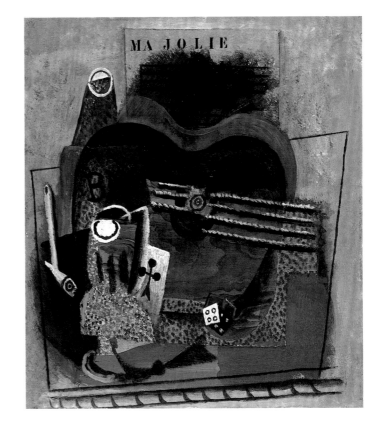

PICASSO. *Pipe, Glass, Ace of Clubs, Bottle of Bass, Guitar, and Dice: "Ma Jolie."*
[Paris, spring] 1914
Oil on canvas, 17¾ × 15¾″ (45 × 40 cm)
Daix 742. Collection Heinz Berggruen, Geneva

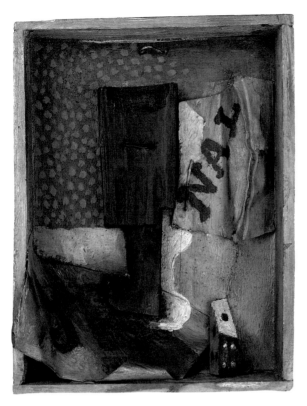

Picasso. *Glass, Newspaper, and Dice.*
Paris, [spring] 1914
Construction of painted wood and tin,
6⅞ × 5⅜ × 1⅛″ (17.4 × 13.5 × 3 cm)
Daix 749. Musée Picasso, Paris

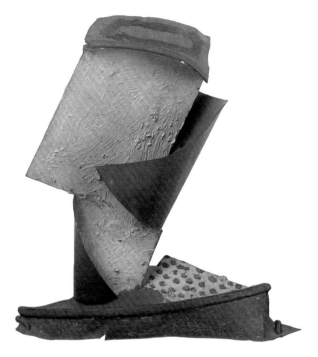

Picasso. *Glass.* Paris, [spring] 1914
Construction of painted tin,
5⅞ × 9 × 4″ (15 × 23 × 10 cm)
Daix 752. Musée Picasso, Paris

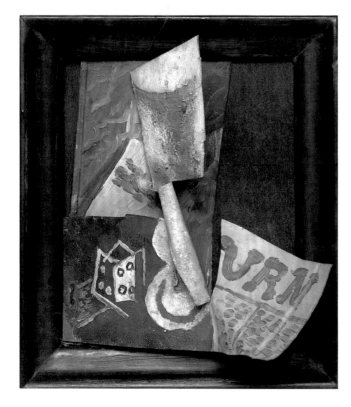

Picasso. *Glass, Dice, and Newspaper.*
Paris, [spring] 1914
Construction of painted wood and tin,
8⅛ × 7½ × 3¾″ (20.6 × 19 × 9.5 cm)
Daix 750. Musée Picasso, Paris

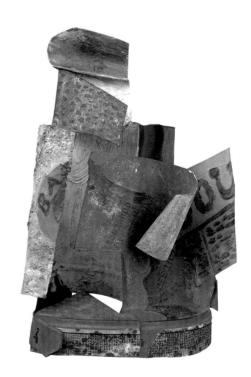

Picasso. *Bottle of Bass, Glass, and Newspaper.*
Paris, [spring] 1914
Construction of painted tin,
8 × 5⅜ × 3⅛″ (20.7 × 13.5 × 8 cm)
Daix 751. Musée Picasso, Paris

322

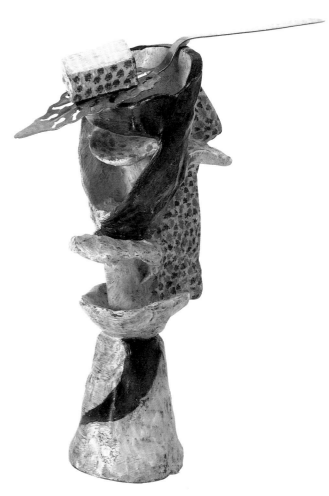

PICASSO. *Glass of Absinth.* Paris, spring 1914
Painted bronze and perforated absinth spoon,
8½ × 6½ × 3⅜″ (21.5 × 16.5 × 8.5 cm)
Daix 756. The Museum of Modern Art, New York.
Gift of Mrs. Bertram Smith

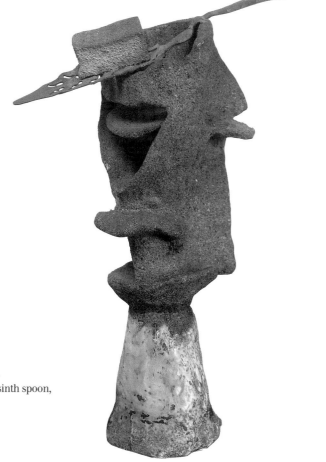

PICASSO. *Glass of Absinth.* Paris, spring 1914
Painted bronze with sand and perforated absinth spoon,
8½ × 6½ × 3⅜″ (21.5 × 16.5 × 8.5 cm)
Daix 753. Musée National d'Art Moderne,
Centre Georges Pompidou, Paris.
Gift of Louise and Michel Leiris,
the donors retaining a life interest

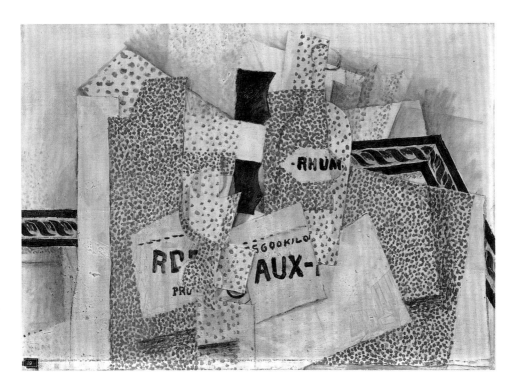

BRAQUE. *Bottle of Rum.* Paris, [spring] 1914
Oil on canvas, 18 × 21¾″ (46 × 55 cm)
Romilly 228. Private collection

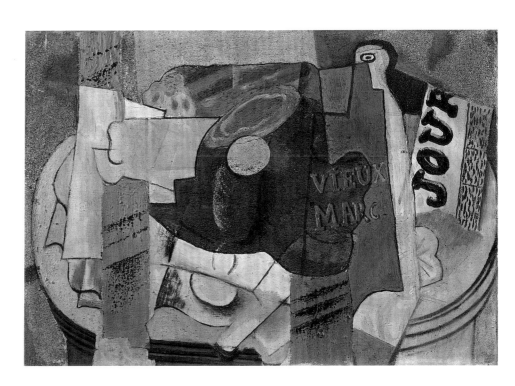

PICASSO. *Ham, Wineglass, Bottle of Vieux Marc, and Newspaper.*
[Paris, spring] 1914
Oil and sand on canvas, 15⅛ × 21⅞″ (38.5 × 55.5 cm)
Daix 705. Musée d'Art Moderne de la Ville de Paris.
Bequest of Dr. Maurice Girardin

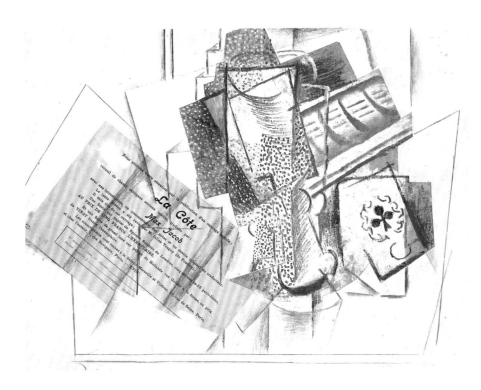

PICASSO. *Wineglass and Ace of Clubs
(Homage to Max Jacob).*
[Paris, spring] 1914
Pasted paper, gouache, and charcoal on
cardboard, 14⅛ × 18⅛" (36 × 46 cm)
Daix 696. Collection Heinz Berggruen,
Geneva

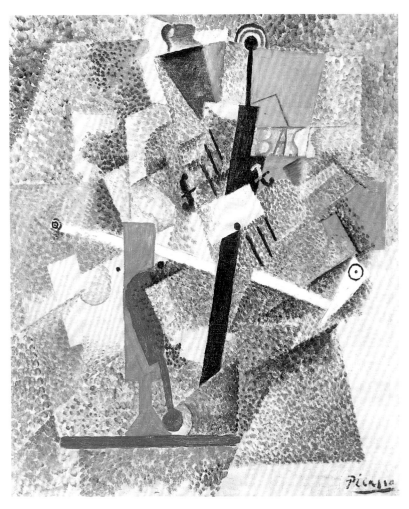

PICASSO. *Pipe, Violin, and Bottle of Bass.*
[Paris, spring] 1914
Oil on canvas, 21¾ × 18⅛" (55.2 × 46 cm)
Daix 714. Philadelphia Museum of Art.
A. E. Gallatin Collection

325

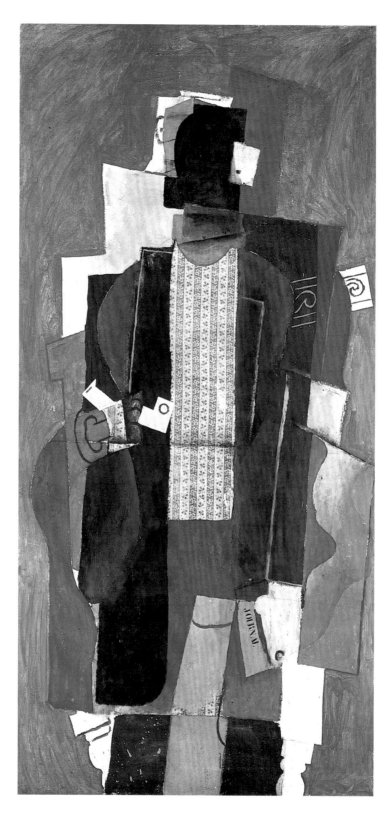

PICASSO. *Smoker.* [Paris, spring] 1914
Oil and pasted paper on canvas, 54 × 26⅛″ (138 × 66.5 cm)
Daix 760. Musée Picasso, Paris

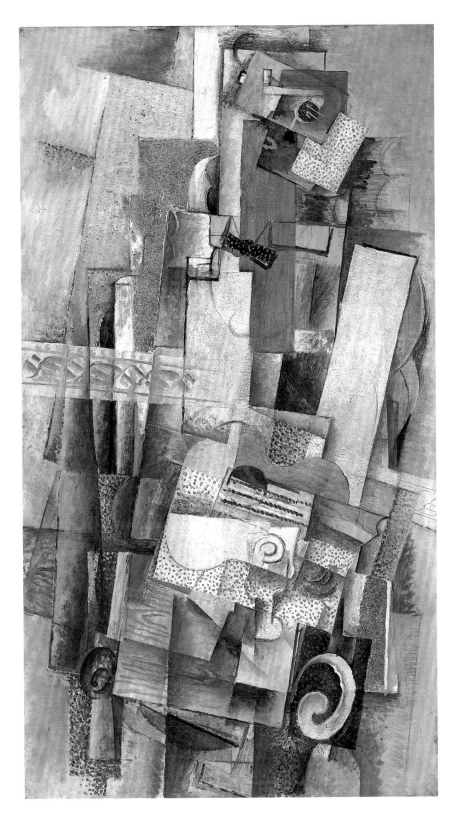

BRAQUE. *Man with a Guitar.* [Paris, spring] 1914
Oil and sand on canvas, 51⅛ × 28¾″ (130 × 72.5 cm)
Romilly 230. Musée National d'Art Moderne, Centre Georges Pompidou, Paris.
Purchased by the Centre National d'Art Contemporain with the assistance of the Scaler Foundation

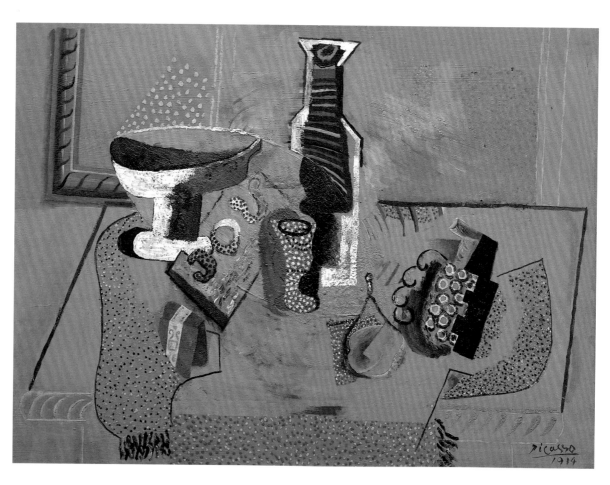

Picasso. *Green Still Life*. [Avignon, summer] 1914
Oil on canvas, 23½ × 31¼″ (59.7 × 79.4 cm)
Daix 778. The Museum of Modern Art, New York.
Lillie P. Bliss Collection

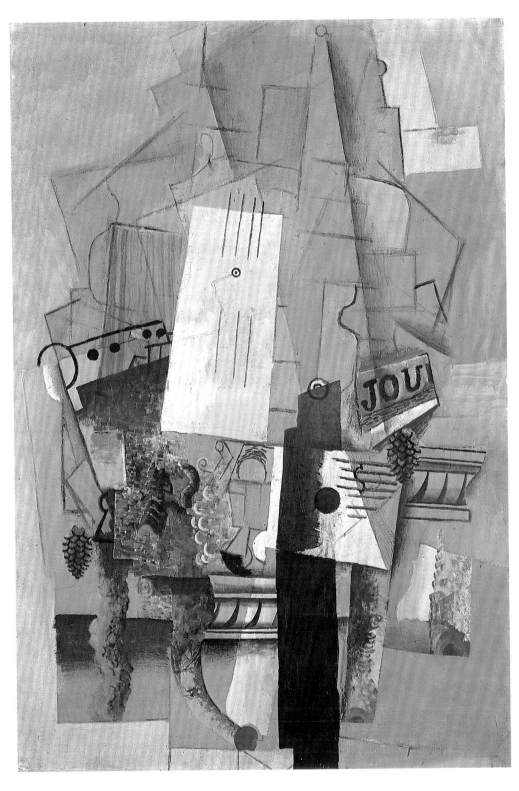

Picasso. *Bar Table.* Begun Céret, spring 1913; completed [Avignon, summer] 1914
Oil on canvas, 51⅛ × 35″ (130 × 89 cm)
Daix 764. Kunstmuseum Basel. Gift of Raoul La Roche, 1952

PICASSO. *Sailor and Figure at a Table.*
Avignon, summer 1914
Pencil, 11¾ × 7¾″ (29.8 × 19.7 cm)
Spies 98. The Metropolitan Museum of Art, New York.
Purchase, The Morse G. Dial Foundation Gift,
in memory of Morse G. and Ethelwyn Dial, 1984

PICASSO. *Seated Man at a Table.* [Avignon, summer] 1914
Crayon, 12⅛ × 9½″ (30.8 × 24 cm)
Zervos VI, 1206. Collection Maya Ruiz-Picasso

PICASSO. *Sailor and Woman.* Avignon, summer 1914
Pencil, 7⅞ × 11¾″ (20 × 29.8 cm)
Richet 355. Musée Picasso, Paris

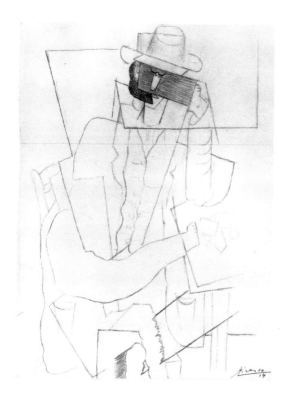

PICASSO. *Seated Man with Cards.* Avignon, summer 1914
Pencil, 12⅜ × 9⅛″ (31.5 × 23.3 cm)
Zervos II**, 507. Private collection

PICASSO. *Seated Man at a Table.* Avignon, summer 1914
Pencil, 12⅜ × 9⅜″ (31.3 × 23.8 cm)
Zervos VI, 1191. Collection Marina Picasso;
Galerie Jan Krugier, Geneva

PICASSO. *Seated Man at a Table.* Avignon, summer 1914
Ink, 12⅝ × 9⅝″ (32.2 × 24.5 cm)
Zervos VI, 1243. Collection Mr. and Mrs. Gustavo Cisneros

PICASSO. *Seated Man at a Table.* Avignon, summer 1914
Crayon, 12⅝ × 9⅝″ (32.2 × 24.4 cm)
Zervos VI, 1214. Collection Maya Ruiz-Picasso

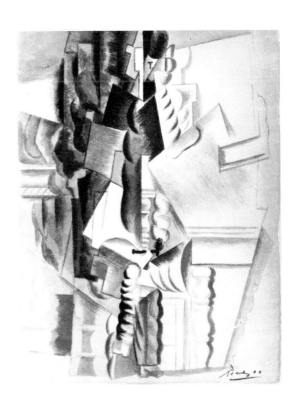

PICASSO. *Seated Man at a Table.* Avignon, summer 1914
Watercolor and ink, 13 × 9½″ (33 × 24 cm)
Daix 840. Collection Mr. and Mrs. Gustavo Cisneros

331

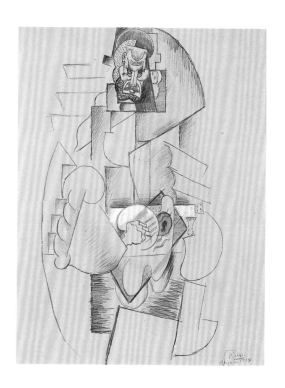

Picasso. *Man with a Mask, Playing a Guitar.*
[Avignon, summer] 1914
Pencil, 11¾ × 7⅞" (30 × 20 cm)
Daix, p. 166. Collection Marina Picasso;
Galerie Jan Krugier, Geneva

Picasso. *Bearded Man Playing a Guitar.*
Avignon, summer 1914
Pencil and gouache, 19½ × 15"
(49.7 × 38 cm)
Daix 761. Private collection

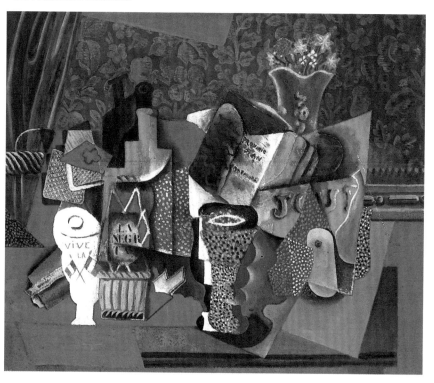

Picasso. *Still Life with Cards, Glasses, and Bottle of Rum: "Vive la France."*
Avignon, summer 1914; partially reworked, Paris, 1915
Oil and sand on canvas, 21⅜ × 25¾" (54.2 × 65.4 cm)
Daix 782. Private collection

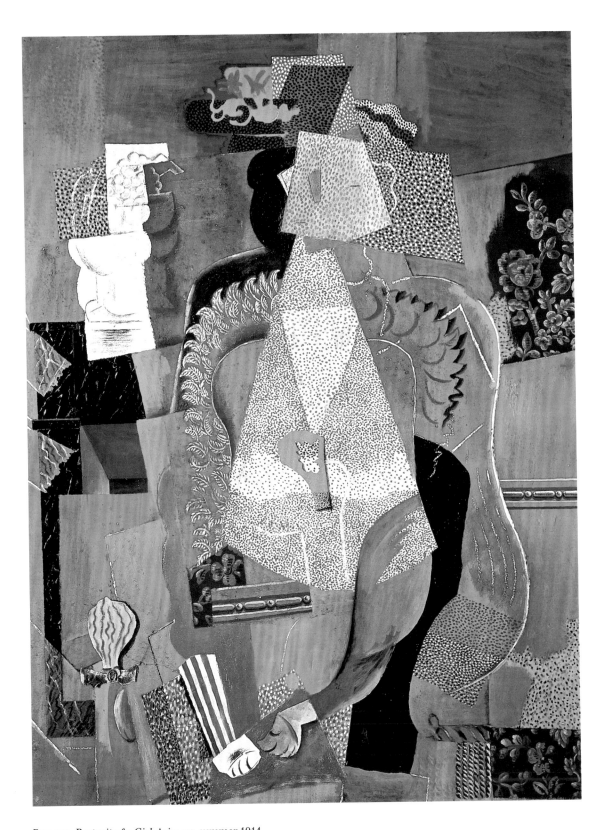

PICASSO. *Portrait of a Girl*. Avignon, summer 1914
Oil on canvas, 51⅛ × 38″ (130 × 96.5 cm)
Daix 784. Musée National d'Art Moderne, Centre Georges Pompidou, Paris.
Bequest of George Salles

REFERENCES FOR WORKS OF ART

The following books are cited, in abbreviated form, in the captions of the works reproduced in this volume. When cited in the text, they document works that are mentioned but not reproduced.

ARENSBERG *Twentieth-Century Art from the Louise and Walter Arensberg Collection.* Chicago: The Art Institute of Chicgo, 1949.

COOPER Cooper, Douglas, and Margaret Potter. *Juan Gris: Catalogue raisonné de l'oeuvre peint.* 2 vols. Paris: Berggruen, 1977.

DAIX Daix, Pierre, and Joan Rosselet. *Picasso: The Cubist Years, 1907–1916—A Catalogue Raisonné of the Paintings and Related Works.* Boston: New York Graphic Society; London: Thames and Hudson, 1979.

D./B. Daix, Pierre, and Georges Boudaille, with Joan Rosselet. *Picasso: The Blue and Rose Periods—A Catalogue Raisonné of the Paintings.* Greenwich, Conn.: New York Graphic Society, 1966.

D./R. Dorra, Henri, and John Rewald. *Seurat: L'Oeuvre peint—Biographie et catalogue critique.* Paris: Les Beaux-Arts, 1959.

ELDERFIELD Elderfield, John. *The "Wild Beasts": Fauvism and Its Affinities.* New York: The Museum of Modern Art, 1976.

FLAM Flam, Jack D. *Matisse: The Man and His Art, 1869–1918.* Ithaca, N.Y., and London: Cornell University Press, 1986.

GEISER Geiser, Bernhard. *Picasso, peintre-graveur: Catalogue raisonné de l'oeuvre gravé et lithographie, 1899–1931.* 2 vols. Vol. 1 published in Bern by the author, 1933; vol. 2 published in Bern by Kornfeld & Klipstein, 1968.

KOSINSKI Kosinski, Dorothy M. *Douglas Cooper and the Masters of Cubism.* Basel: Kunstmuseum Basel; London: The Tate Gallery, 1987.

LEYMARIE Leymarie, Jean, ed. *Georges Braque.* New York: Solomon R. Guggenheim Museum, 1988.

L./R. Lanchner, Carolyn, and William Rubin. *Henri Rousseau.* New York: The Museum of Modern Art, 1985.

M.-F./C. Monod-Fontaine, Isabelle, with E. A. Carmean, Jr. *Braque: The Papiers Collés.* Washington, D.C.: National Gallery of Art, 1982.

MOSER Moser, Joann. *Jean Metzinger in Retrospect.* Iowa City: The University of Iowa Museum of Art, 1985.

POUILLON Pouillon, Nadine, with Isabelle Monod-Fontaine. *Braque: Oeuvres de Georges Braque (1882–1963), Collections du Musée National d'Art Moderne.* Paris: Musée National d'Art Moderne, Centre Georges Pompidou, 1982.

RICHARDSON Richardson, John. *Picasso: An American Tribute.* New York: Public Education Association, 1962.

RICHET Richet, Michelle. *Musée Picasso: Catalogue sommaire des collections, II—Dessins, aquarelles, gouaches, pastels.* Paris: Ministère de la Culture et de la Communication; Éditions de la Réunion des Musées Nationaux, 1987.

ROMILLY Romilly, Nicole Worms de, and Jean Laude. *Braque: Cubism, 1907–1914.* Paris: Maeght, 1982.

ROSENBLUM Rosenblum, Robert. *Jean-Auguste-Dominique Ingres.* New York: Abrams, 1968.

SCHIFF Schiff, Gert. *Picasso at Home, at Work: Selections from the Marina Picasso Collection with Additions from the Los Angeles County Museum of Art and The Museum of Modern Art, New York.* Miami: Center for the Fine Arts, 1985.

SPIES Spies, Werner. *Pablo Picasso: Eine Ausstellung zum hundertsten Geburtstag—Werke aus der Sammlung Marina Picasso.* Munich: Prestel-Verlag, 1981.

VALLIER Vallier, Dora. *Braque: L'Oeuvre gravé—Catalogue raisonné.* Paris: Flammarion, 1982.

WEISNER Weisner, Ulrich. *Zeichnungen und Collagen des Kubismus: Picasso, Braque, Gris.* Bielefeld: Kunsthalle Bielefeld, 1979.

WILLIAMS *Second Williams College Alumni Loan Exhibition.* Williamstown, Mass.: Williams College Museum of Art; New York: Hirschl & Adler Gallery, 1976.

ZERVOS Zervos, Christian. *Pablo Picasso.* 33 vols. Paris: Éditions Cahiers d'Art, 1932–78.

Documentary Chronology

Judith Cousins

with the collaboration of Pierre Daix

This chronology, which focuses on 1907–14, is not a comprehensive narrative of those years in Picasso's and Braque's lives. Instead, it is essentially an annotated anthology of the documentary evidence, gathered during the preparation of this exhibition, that bears directly on the two artists' interaction. It is arranged in parallel chronological columns to facilitate comparison.

The documents cited include correspondence of the two artists and of those around them, as well as diaries, memoirs, catalogues and reviews of exhibitions, and archival sources. (Bibliographical data can be found in the notes, which begin on page 434.) Also included is evidence that pinpoints the movements of the two artists and the places of execution of their works; for reference, that information is summarized in the form of a chart on pages 336–39.

The titles of works of art are generally given as they appear in the documents, with the titles used in the plate section of this volume (when different) or in standard reference works also given, in parentheses. Each title is followed by a page number if the work is reproduced in the plates, or by a bibliographical reference (generally the entry number in the appropriate catalogue raisonné) if not reproduced. A list of the catalogues cited appears on page 334. For works that could not be identified or which are not extant, the catalogue number (if any) assigned at the exhibition in question is listed.

When known, the place of dispatch and/or receipt of correspondence is given, if other than Paris. In a few cases, addresses within Paris are noted when they indicate a change of residence. The dates given for correspondence are generally those inscribed by the writers. For undated correspondence, whenever possible, a date of postal dispatch is given, indicated by an asterisk (*), or a date of postal receipt, indicated by a dagger (†).

When information is in doubt, a date, a title, or the name of a location is placed within square brackets. In quoted matter, however, brackets indicate editorial interpolations and additions.

Because of restrictions imposed on the use of some documents, a number of them appear only in extract or paraphrase. With the exception of documents already published in translation (identified in the notes), all the texts have been translated into English by Pierre Adler, Sophie Hawkes, or Stephen Sartarelli.

Outline

1907

Braque	Picasso
JANUARY	
L'Estaque, since October 1906	Paris
FEBRUARY	
L'Estaque. To Paris, sometime in February	Paris
MARCH	
Paris	Paris
APRIL	
Paris	Paris
MAY	
To Le Havre. To Paris (?). To La Ciotat, end of May	Paris
JUNE	
La Ciotat	Paris
JULY	
La Ciotat	Paris
AUGUST	
La Ciotat	Paris
SEPTEMBER	
La Ciotat. To L'Estaque, by September 28	Paris
OCTOBER	
L'Estaque. To Paris (?), by October 22; returns to L'Estaque	Paris
NOVEMBER	
L'Estaque. To Paris, by November 16 (?)	Paris
DECEMBER	
Paris	Paris

1908

Braque	Picasso
JANUARY	
Paris	Paris
FEBRUARY	
Paris	Paris
MARCH	
Paris	Paris
APRIL	
Paris	Paris
MAY	
Paris. To Le Havre, after May 2	Paris
JUNE	
L'Estaque	Paris
JULY	
L'Estaque	Paris
AUGUST	
L'Estaque	Paris. To La Rue-des-Bois, by August 14
SEPTEMBER	
L'Estaque. To Paris, early September	La Rue-des-Bois. To Paris, early September
OCTOBER	
Paris	Paris
NOVEMBER	
Paris. In Le Havre, November 22; returns to Paris	Paris
DECEMBER	
Paris	Paris

1909

Braque	Picasso
	JANUARY
Paris	Paris
	FEBRUARY
Paris	Paris
	MARCH
Paris	Paris
	APRIL
Paris	Paris
	MAY
Paris. To Le Havre (?), after May 2	Paris. To Barcelona, early May; arrives May 11
	JUNE
To La Roche-Guyon	Barcelona. To Horta de Ebro, by June 5; arrives by June 10
	JULY
La Roche-Guyon	Horta de Ebro
	AUGUST
La Roche-Guyon. In Paris, August 27. En route to Le Havre, August 29	Horta de Ebro
	SEPTEMBER
In Le Havre, by September 6	Horta de Ebro. In Barcelona, September 8. To Paris; arrives by September 13
	OCTOBER
Le Havre. To Carrières Saint-Denis, after October 6. To Paris	Paris
	NOVEMBER
Paris	Paris
	DECEMBER
Paris	Paris

1910

Braque	Picasso
	JANUARY
Paris	Paris
	FEBRUARY
Paris	Paris
	MARCH
Paris	Paris
	APRIL
Paris	Paris
	MAY
In Falaise, May 17	Paris
	JUNE
In Le Havre (?)	Paris. To Cadaqués, June 26
	JULY
In Saint-Aquilin-de-Pacy, July 27	Cadaqués
	AUGUST
In Paris, by August 16. To L'Estaque, by end of August	Cadaqués. To Barcelona, August 6; returns to Cadaqués, August 12. To Paris, August 26
	SEPTEMBER
Arrives in L'Estaque, early September	Paris
	OCTOBER
L'Estaque	Paris
	NOVEMBER
Paris. In Marseille, November 3. In L'Estaque, November 20. In Le Havre, November 26	Paris
	DECEMBER
To Paris, probably December 1	Paris

1911

Braque	Picasso
JANUARY	
Paris	Paris
FEBRUARY	
Paris. In Le Havre, February 7; returns to Paris	Paris
MARCH	
Paris. In Rouen, March 27. To Saint-Mars-la-Brière, March 29	Paris
APRIL	
In Paris, April 1 or 2; returns to Saint-Mars-la-Brière. To Paris, April 12	Paris
MAY	
Paris	Paris
JUNE	
Paris	Paris
JULY	
Paris	Paris. To Céret, by July 16
AUGUST	
En route to Céret: in Orléans, August 15; in Guéret and Limoges, August 16–17; arrives in Céret by August 17	Céret
SEPTEMBER	
Céret. In Figueras, then Collioure, sometime during September; returns to Céret	Céret. To Paris, September 4
OCTOBER	
Céret	Paris
NOVEMBER	
Céret. In Perpignan, November 15; returns to Céret	Paris
DECEMBER	
Céret	Paris

1912

Braque	Picasso
JANUARY	
Céret. To Paris, January 19. In Le Havre, January 26; returns to Paris	Paris
FEBRUARY	
Paris	Paris
MARCH	
Paris	Paris
APRIL	
Paris. In Le Havre, April 26; returns to Paris, April 28	Paris. In Le Havre, April 26; returns to Paris, April 28
MAY	
Paris	Paris. To Céret, after May 18; in Céret, May 20
JUNE	
Paris. In Le Havre, June 2; returns to Paris, June 6	Céret. To Perpignan, June 21. In Avignon, June 23. In Sorgues, June 25
JULY	
Paris. To Sorgues, end of July or beginning of August	Sorgues. In Nîmes, July 7; returns to Sorgues, by July 9
AUGUST	
Sorgues. In Marseille, August 9; returns to Sorgues, by August 11	Sorgues. In Marseille, August 9; returns to Sorgues, by August 11
SEPTEMBER	
Sorgues. In Avignon, sometime between September 3 and 13. In Nîmes, September 29; returns to Sorgues	To Paris, early September. In Sorgues, September 17; returns to Paris, September 23
OCTOBER	
Sorgues	Paris
NOVEMBER	
Sorgues. In Paris (?), November 15. In Le Havre, November 25–29. To Paris, November 29	Paris. In Rouen, November 4; returns to Paris
DECEMBER	
Paris	Paris. To Céret, by December 23. To Barcelona, by December 26

1913

Braque	Picasso
JANUARY	
Paris. In Le Havre, January 22 and 25; returns to Paris	Barcelona. To Paris, about January 21
FEBRUARY	
Paris	Paris
MARCH	
Paris	Paris. To Céret, about March 10; arrives by March 12. To Barcelona, by March 29
APRIL	
Paris	Céret
MAY	
Paris	Céret. In Barcelona, by May 3; returns to Céret, May 9. In Perpignan, by May 14
JUNE	
Paris. To Sorgues, by June 15. In Avignon, June 18; returns to Sorgues, June 19	Céret. In Figueras, June 11 and 12, and Gerona, June 14; returns to Céret. To Paris, June 20
JULY	
Sorgues. To Arles, July 6, then Martigues and Marseille; returns to Sorgues, by July 10	Paris
AUGUST	
Sorgues	Paris. To Céret, by August 9; returns to Paris, by August 19
SEPTEMBER	
Sorgues	Paris
OCTOBER	
Sorgues. To Arles, October 5, then Marseille. In Nîmes, sometime later in October	Paris
NOVEMBER	
Sorgues	Paris
DECEMBER	
Sorgues. To Paris, week of December 8	Paris

1914

Braque	Picasso
JANUARY	
Paris	Paris
FEBRUARY	
Paris	Paris
MARCH	
Paris	Paris
APRIL	
Paris	Paris
MAY	
Paris	Paris
JUNE	
Paris. Begins bicycle trip to the Midi: in Sens, June 28; in Avallon, June 29; in Dijon, June 30	To Avignon, June 17, then Tarascon; returns to Avignon, by June 23
JULY	
In Mâcon and Lyon, July 2; in Loriol, July 3; in Courthézon, July 4 and 5; in Sorgues, probably July 5	Avignon
AUGUST	
Mobilized: leaves Avignon, August 2; in Lyon, August 3; in Le Havre, August 24	Avignon
SEPTEMBER	
Stationed in Le Havre	Avignon
OCTOBER	
Stationed in Le Havre. In Lyon, end of October	Avignon
NOVEMBER	
Sent to the front, by November 10 (?)	Avignon. To Paris, November 17
DECEMBER	
Participates in attack at Maricourt, December 17	Paris

Chronology

BRAQUE

PICASSO

1905

Summer
Braque is away from his studio (48, rue d'Orsel, Paris), staying at Honfleur and Le Havre with the sculptor Manolo (Manuel Martínez Hugué) and the critic Maurice Raynal, both from the "Picasso Gang."[1]

June–July
Picasso is away from Paris on a month-long trip to Holland, then returns to his studio in the Bateau-Lavoir, at 13, rue Ravignan.

September
Fernande Olivier moves into the studio at the Bateau-Lavoir with Picasso.[1]

Autumn
Probably completes the definitive version of *The Family of Saltimbanques* (D./B. XII, 35).[2]

The Bateau-Lavoir, c. 1904. Photograph inscribed by Picasso, "Windows of my studio 13 rue Ravignan"

October 18–November 25
The third Salon d'Automne. The Fauvist section makes an impression on him. Two of his friends from Le Havre, Raoul Dufy and Othon Friesz, have work on display at the Salon, although not in the Fauvists' room.

Winter
Divides his time between studio in Paris and visits to Le Havre, where he paints from nature at least three of the pictures he will submit to the upcoming Salon des Indépendants.

October 18–November 25
Salon d'Automne includes Manet and Ingres retrospectives. Is impressed with both, and above all, by Ingres's *Turkish Bath* (Rosenblum 48). Picasso's friend Ramón Pichot exhibits with the Fauvists.

Leo Stein discovers the gouache *The Acrobat's Family with a Monkey* (D./B. XII, 7) at the dealer Clovis Sagot's, buys it, and resolves to meet Picasso. Goes with his sister Gertrude to visit the artist at the Bateau-Lavoir. They purchase several paintings for a total of 900 francs. Beginning of Gertrude's eighty to ninety sitting sessions for her portrait. The Steins, who have recently bought *Woman with a Hat* (Flam 132) by Henri Matisse, urge that the two artists meet.[3]

BRAQUE

PICASSO

1906

March 20–April 30
Twenty-second Salon of the Société des Artistes Indépendants. Takes part, with seven submissions: *Town Hall, Le Havre* (no. 628 in the exhibition's catalogue), *The Coast, Le Havre* (629), *The Jetty, Honfleur* (630), *Interior* (631), *Plate and Oranges* (632), *Apples and Grapes* (633), and *Nude* (634). The paintings are later destroyed.[2]

Also represented in the Indépendants are Matisse, André Derain, Albert Marquet, and Charles Camoin, and their friends, Dufy and Friesz, with Fauvist works.

Spring
The Cercle de l'Art Moderne established at Le Havre. Braque's father, Charles, is among its nine founders. The committee on paintings consists of Friesz, Dufy, and Georges Braque.

May 26–June 30
First exhibition organized by the Cercle de l'Art Moderne in Le Havre; is represented by two works: *Anchored Three-Masted Ship* and *Interior.* The preface to the catalogue, "L'Oeil et la couleur," is written by the critic Maurice Le Sieutre (who had written the preface to the catalogue of the exhibition at the Berthe Weill gallery, October 20, 1904, which featured Picasso and Dufy).

Summer
With Friesz, leaves Le Havre for Antwerp (where Friesz had already painted in 1905). In Antwerp June 12–July 12 and August 11–September 11.[3]

March
Probable first encounter with Matisse, either during the latter's exhibition at the Druet gallery (opens March 19), where Picasso particularly remarks the lithographs in the show, or at the Salon des Indépendants, where Matisse shows *Bonheur de vivre* (Flam 143).[4]

At the Louvre, discovers an exhibition of Iberian sculptures excavated at Osuna and Cerro de los Santos which reveal to him a primitive art indigenous to his own country. (Osuna is less than fifty miles from his birthplace in Andalusia.)

Spring
Dissatisfied with his progress on Gertrude Stein's portrait, ceases working on it.[5]

Probably meets Derain, through Alice Princet.[6]

May
The dealer Ambroise Vollard buys twenty paintings for 2,000 francs. This enables Picasso and Fernande to go to Spain, first to Barcelona, then to Gósol.[7]

Beginning of "Iberian" style. Paints *The Harem* (D./B. XV, 40), which anticipates *maison close* studies that lead to *Les Demoiselles d'Avignon.*

Early or mid-August
Picasso and Fernande's visit to Gósol ends abruptly when typhoid fever breaks out in the village, causing their hurried return to Paris.

August 17
On verso of letter from Picasso to Leo Stein in Italy, Fernande writes to Gertrude Stein:
I am very much disappointed, Miss Gertrude, at not having received [the comic strip] little Jimmy at Gósol, but you must know that in Spain one never receives anything that appears useful or interesting to the postal authorities, for in such cases they confiscate everything for their own use.[8]

Fernande Olivier, Picasso, and Ramón Reventos, 1906, photographed by Juan Vidal y Ventosa in his studio, Barcelona

Leo Stein in the courtyard of the Stein residence at 27, rue de Fleurus, 1906

BRAQUE

PICASSO

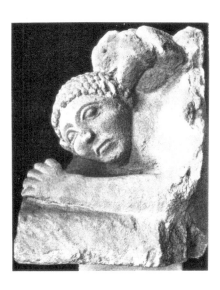

Man Attacked by a Lion. Iberian; Osuna. End of 6th–3rd century B.C. Stone (detail of a bas-relief), 16⅛″ (41 cm) high. Museo Arqueológico Nacional, Madrid

(Fernande shared Picasso's love of *The Katzenjammer Kids* and *Little Jimmy,* popular American comic strips which Leo and Gertrude were in the habit of giving them.)

Before End of August
After return to Paris, completes portrait of Gertrude Stein (D./B. XVI, 10) from memory, reducing face to masklike Iberian simplicity. The Steins return to Paris from Italy. (Matisse is back from Collioure and Derain from L'Estaque, each having acquired his first African mask.)

Autumn
After a stay in Durtal, outside Paris, with Friesz at the painter Alexis Axilette's home, returns to Paris and paints a series of canvases depicting the Canal Saint-Martin (Elderfield, p. 89).[4]

October 6–November 15
Salon d'Automne. Includes ten paintings by Cézanne, who dies October 23. Braque leaves sometime in October for L'Estaque, where he remains until February.[5] Many years later, in response to Jacques Lassaigne's question, "Was it because of Cézanne that you left for L'Estaque?," he answers:
Yes, and I already had an idea in mind. I can say that my first pictures of L'Estaque were already conceived before my departure. I nonetheless applied myself to subjecting them to the influences of the light and the atmosphere, and to the effect of the rain which brightened up the colors.[6]

October
The large Gauguin retrospective included in the Salon d'Automne makes a deep impression on him.

End of the Year
First appearance in his work of a multifigure composition on the theme of the Brothel, which will culminate in *Les Demoiselles d'Avignon.*[9]

1907

February
Returns to Paris.

February 4
Sends a postcard to Gertrude Stein at 27, rue de Fleurus; tells her of Vollard's new agreement—to buy out his studio for 2,500 francs: *Vollard came this morning. The deal is settled.*[10]

March
With the focusing of his attention on Iberian statuary in the Louvre—the stimulus of Iberian pieces would be especially relevant to the first concept, or "Iberian" state, of *Les*

BRAQUE

March 20–April 30

Exhibits six paintings at the twenty-third Salon des Indépendants.[7] The German collector Wilhelm Uhde will acquire five of Braque's paintings from the Indépendants. The sixth painting, *The Vale* (no. 724 in the exhibition's catalogue),[8] is probably bought later in the summer by Daniel-Henry Kahnweiler.

[March or April]

At an unspecified date, possibly on the occasion of a studio visit during the period of the Salon des Indépendants, Braque leaves Picasso his calling card, on which he has written: "Anticipated memories." [9]

April

Uhde leaves Braque his calling card, on which he writes that he has offered the Indépendants 120 francs for *The Olive Tree* (722).

April 10

Letter from the Société des Artistes Indépendants, twenty-third exhibition, informs him that Uhde has offered 200 francs for *Boats* (725) and *The Large Trees* (721).

April 24

Another letter from the Société des Artistes Indépendants, twenty-third exhibition:
Please note that we have payment for your paintings 721, 725, 722, 723, 726, purchased by Mr. Uhde for the sum of 505 francs.
Uhde, writing about the event twenty years later, confuses the Salon des Indépendants with the Salon d'Automne, but recalls:
I fell in love with Braque's paintings at first sight. I put out the few hundred francs I had at that time for the pictures which he had exhibited for the first time at the Salon d'Automne [sic].[10]

Although tradition has it that Braque meets Kahnweiler before meeting Picasso, Braque himself later insists, "First I got to know Picasso, and Kahnweiler only afterward." [11] Kahnweiler recalls (in 1955) that during the

PICASSO

Demoiselles d'Avignon—purchases from Géry Pieret two Iberian stone heads. Guillaume Apollinaire is instrumental in Picasso's acquisition of the two sculptures, which in August 1911 Picasso will realize have been stolen from the Louvre.[11]

At the Indépendants, discovers Matisse's *Blue Nude (Souvenir de Biskra)* (Flam 188) and Derain's large *Bathers* (Elderfield, p. 116). Is no doubt aware of Braque's submissions to the Salon, since his notebook from that time contains the entries "Write to Braque" and "Braque, FRIDAY" (suggesting that the two already know each other and have arranged to meet).[12] Before their encounter, Braque and Picasso share the friendship of Uhde, Manolo, Derain, Raynal, Apollinaire (who has known Braque at least since the show at the Salon des Indépendants), and, of course, Matisse.

Wilhelm Uhde's calling card, with a note on the back addressed to Braque, offering to buy *The Olive Tree* [1906], a painting exhibited at the twenty-third Salon des Indépendants in 1907

Two letters to Braque from the Secrétariat de la Société des Artistes Indépendants. The letter of April 10, 1907 (left), concerns Wilhelm Uhde's offer to buy two paintings by Braque; the April 24 letter confirms Uhde's purchase of five paintings, instead of two.

BRAQUE

PICASSO

run of the Indépendants "in April 1907," "I was preparing to open the small gallery that I had just rented at 28, rue de Vignon, not far from the Madeleine."[12] A few years later (in 1961) he remembers first buying paintings by Derain and Maurice de Vlaminck at the Indépendants of 1907, and immediately afterward also buying from Kees van Dongen and Braque. "So," he concludes, "I already had those four painters, and I hung their pictures."[13] Just when Kahnweiler's first purchases of Braque's work occurred is not certain, however, for he also states: "I began buying Braque's paintings in the summer of 1907. Then Braque went to the Midi, and on his return he brought the series of paintings, the L'Estaque series, which I showed in November of 1908."[14] Here he mistakes the third trip to L'Estaque (summer 1908) for the second sojourn at La Ciotat and L'Estaque (summer and autumn 1907).[15]

Spring
Probably goes to Le Havre after the Salon des Indépendants to participate in the second exhibition organized by the Cercle de l'Art Moderne, which was to open in early June.[16] Is represented in the show by two works: *Nude* (no. 3 in the exhibition's catalogue) and *Landscape at L'Estaque* (4). The catalogue's preface is written by Fernand Fleuret. The exhibition also features Friesz, Dufy, Matisse, Manguin, Marquet, Vlaminck (each represented by two paintings), reflecting his closer ties to the Fauvists.

Braque and Friesz leave, most probably from Le Havre, for the south of France. Possibly, they stop in Paris to see the exhibition of seventy-nine watercolors by Cézanne, which opens on June 17 at the Bernheim-Jeune gallery, although the date traditionally assigned to their arrival at La Ciotat (where they will remain until early September) is May.

At Cassis, the neighboring harbor to La Ciotat, Derain writes of Braque and Friesz to Vlaminck:
Their idea is young and to them seems new; they'll get over it. There are other things than that to be done.[17]

Spring
Works on studies toward what will become the painting now known as *Les Demoiselles d'Avignon*.

Except for André Salmon, most of Picasso's friends have left Paris—the Steins for Fiesole, Derain for Cassis, and Matisse for Italy.

BRAQUE

Summer

Matisse, who has been in Collioure since at least June 13, leaves on July 14 for Italy, traveling by way of Cassis, to see Derain and Girieud, and La Ciotat, to see Friesz and Braque.[18] In another letter to Vlaminck after Matisse's visit, Derain writes:

I saw Matisse a second time. On his way to Italy he passed through here with his wife. He showed the photographs of his paintings; they are quite stunning. I think that he has crossed the border of the seventh garden, that of happiness. Braque and Friesz are in a nearby region. They are more involved with the search for another goal, removed from their personalities...with neutral perfection.[19]

Late Summer

From La Ciotat, sends Picasso a postcard (September 10 or August 10; postmark not quite legible):

Greetings to you and our friends.[20]

PICASSO

June

Begins work on large canvas, *Les Demoiselles d'Avignon* (p. 73), completing first, "Iberian" state.

Visits the Musée d'Ethnographie du Trocadéro and undertakes revisions of three of the five figures in *Les Demoiselles d'Avignon*. (The present state of the painting is almost certainly completed in July.) Picasso asks Uhde to see the picture, and Uhde in turn tells Kahnweiler about it. Kahnweiler later remembers having seen the painting "in its present state in early summer."[13]

August 8

Fernande writes to Gertrude Stein, in Fiesole:[14]

Salmon right now is here with us, as is another friend.

Salmon, a frequent visitor to Picasso's studio, will write about *Les Demoiselles d'Avignon* five years later in *La Jeune Peinture française,* referring to it as "le b. philosophique."

August 24

Fernande writes to Gertrude Stein, in Fiesole, to announce that the following month she and Picasso will separate:

He is waiting for money that Vollard owes him in order to give me enough....[15]

The separation is to begin when Vollard, who, for the second time, has bought out the studio for 2,500 francs,[16] has made payment, so that they can afford to live apart.[17]

September

Alice Toklas arrives in Paris (September 7 or 8); dines for the first time with Gertrude and Leo Stein (September 28).[18] Shortly thereafter, Gertrude Stein explains to Toklas why she should take French lessons from her friend Fernande:

Because, well because she and Pablo have decided to separate forever....You know Pablo says if you love a woman you give her money. Well now it is when you want to leave a woman you have to wait until you have enough money to give her. Vollard has just bought out his atelier and so he can afford to separate from her by giving her half. She wants to install herself in a room by herself and give french lessons so that is how you come in.[19]

Picasso. *Portrait of André Salmon.* [Paris,] 1907. Charcoal, 23⅝ × 15¾" (60 × 40 cm). Private collection, France

BRAQUE

Before September 28
Goes to L'Estaque; remains until late October or early November.

September 28
From L'Estaque, Friesz sends a postcard to Kahnweiler; does not know whether his entries have been accepted for the upcoming Salon d'Automne (nor apparently does Braque, who is with him).[21] Rather than go to Paris to submit his entries, evidently has entrusted Kahnweiler with their submission.

October 1–22
Salon d'Automne. Braque probably has one work on view, *Red Rocks*.

October 12
Apollinaire's article on the Salon d'Automne in *Je dis tout* blasts the Salon president, Frantz Jourdain, for having deliberately underrepresented Cézanne and for unfairness to Matisse.[22]

PICASSO

September 19
Fernande writes to Gertrude Stein:
For two days now I've been sleeping at my place and I'm quite surprised not to find myself out of my element.[20]

[Autumn]
It is possibly during this period that Apollinaire comes to see *Les Demoiselles d'Avignon*, bringing with him the critic Félix Fénéon. Apollinaire finds the picture incomprehensible; Fénéon advises Picasso to devote himself to caricature.[21]

Late September
Makes small, curvilinear sketches for the painting *Three Women*; probably begins work on first, "African" state of the large picture.

October 1–22
Salon d'Automne. Since Fernande mentioned the Salon (in an August 8 letter to Gertrude Stein) nearly two months before its opening, it would appear to have been a topic of interest in Picasso's studio.[22] Includes a Cézanne retrospective.

October 8
Fernande writes to Gertrude Stein:
I see very little of him [Pablo], and I am not keen to see him at all, since I always feel sadder afterward.

[October 9 or 10]
Toklas makes her first visit to the Bateau-Lavoir; Stein recounts:
Against the wall there was an enormous painting, a strange mass of light and dark colors, at least that's all I can say, of a group, an enormous group, and next to it another in a sort of red brown, of three women, square and posturing, all of it rather frightening.[23]
The description corresponds to contemporaneous photographs showing *Les Demoiselles d'Avignon* more or less concealed next to early, "primitivist" states of *Three Women*.

BRAQUE

October 16
Braque's father, in Le Havre, writes to his brother-in-law that he cannot delay his trip to Paris, since the Salon d'Automne closes October 22:
I need to keep my promise of going to see Georges's show.[23]

October 19
Apollinaire writes in *Je dis tout:*
…almost all his [Braque's] submissions have been refused. He has only a single painting here, Red Rocks.[24] *But he is finding solace after these exhibition misfortunes in the south of France. The attic of the house where he is staying contains a large number of books, and at present Georges Braque is reading the good works of the sixteenth-century polygraphs.*[25]
This suggests a direct encounter and a conversation.[26] If Braque did not go to Paris to submit work, he probably did go there to recover the rejected works and saw the Salon (which includes a Cézanne retrospective) before returning to L'Estaque.

October–November
Probably returns to Paris for Friesz's exhibition at the Druet gallery, Paris (November 4–16). The exhibition catalogue's preface is written by Fernand Fleuret.

Between early October, when he goes to L'Estaque after seeing the Cézanne retrospective at the Salon d'Automne, and mid-November, when he returns to Paris, Braque paints his first conception of *Viaduct at L'Estaque* (p. 79), executed in October, and *Terrace of Hôtel Mistral* (p.78), begun in late October and known to have been completed in his Paris studio during the late fall or early winter. The two pictures belong to a group of at least four landscapes begun within a few weeks of each other, that represent Braque's transition from Fauvism into his Cézannesque or proto-Cubist style.[27] *Viaduct at L'Estaque*, in its use of a Cézannesque motif and pictorial devices, shows most clearly Braque's evolving Cézannism.[28] *Terrace of Hôtel Mistral* is significant in reflecting a change of palette into more somber, anti-Fauve colors and dark, Gauguin-inspired outlines; a motif, modeled on Cézanne, with a sharply dropping foreground; and a

PICASSO

November
Makes drawings related to the early state of *Three Women* on pages of the catalogue of Friesz's exhibition at the Druet gallery.[24] Relations between him and Braque's group from Le Havre are now fairly close.

Late November
Fernande returns to the Bateau-Lavoir and resumes living with Picasso. Picasso sends a postcard to Gertrude Stein (postmarked November 20):
We are very pleased to be coming to your

Fernande Olivier and Picasso in Montmartre, c. 1908

BRAQUE

greater degree of abstraction, due no doubt to his return to Paris, where "for the first time [he is] not working before the motif."[29]

Late November–Early December
Apollinaire accompanies Braque to Picasso's studio. This may be Braque's first visit, although it is possible that the two had exchanged studio visits in the spring, at the time of the Indépendants.

Braque has spent little time in Paris since early May; during his absence Picasso has painted the *Demoiselles* and begun *Three Women,* both of which Braque now sees. By Fernande's account, Braque's response to the *Demoiselles* is to tell Picasso, "With your paintings it's as though you wanted to make us eat tow or drink kerosene." (Similarly, Kahnweiler recalls Braque saying, "It is as if someone had drunk kerosene to spit fire.")[30] Given Fernande's account, it seems plausible that Braque's visit to Picasso's studio occurred after her return, in late November, to the Bateau-Lavoir.

December
Works on compositions with figures, which would accord with his recent visit to Picasso's studio, where he would have seen not only the *Demoiselles* but the "primitivist" state of *Three Women.*

Picasso undoubtedly visits Braque in his studio on the rue d'Orsel (a few minutes' walk from the Bateau-Lavoir) and sees the latter's post-Fauve works, marking his transition into a Cézannist early Cubism.[31]

At this time,[32] Braque makes a drawing (now lost) for the painting he called *Woman* (now lost), a Cézannist response to Picasso's primitivist version of *Three Women.*[33] Begins work on *Woman* (a single figure in three different positions),[34] in addition to beginning a Cézannist version of the viaduct at L'Estaque (p. 81).

Although he has thus far realized few figures, makes an etching of a *Standing Nude* (p. 80).[35]

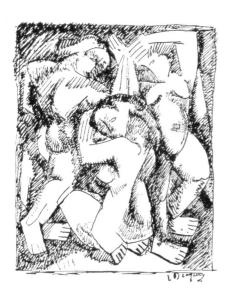

Braque. *Woman.* [Paris, early 1908.] Ink. Present whereabouts unknown. Formerly collection Gelett Burgess

PICASSO

house on Sunday and to have lunch with you. Greetings from the two of us to the two of you.

November–December
Matisse and Derain probably see *Les Demoiselles d'Avignon* at the Bateau-Lavoir. Matisse has no doubt been alerted by the Steins—Leo having found the *Demoiselles* to be a "horrible mess"—and most likely goes to the studio after the furor of the Salon d'Automne.

André Salmon writes (in 1912):
Some of his [Picasso's] painter friends were now giving him a wide berth....Picasso, somewhat deserted, found his true self in the company of the African soothsayers... and painted several formidable grimacing nudes, worthy objects of execration.[25]
In Picasso's studio late in the year are the *Demoiselles d'Avignon* (p. 73) and "primitivist" versions of *Nude with Towel* (Daix 99), *Three Women* (p. 111), and possibly *Friendship* (p. 85).[26] The rejection of the *Demoiselles* by Picasso's friends (except for Salmon and Ardengo Soffici) is confirmed by Kahnweiler, who writes (in 1961):
Derain told me that one day Picasso would be found hanging behind his big picture. ...The picture Picasso has painted seemed to everyone something mad or monstrous.[27]

Matisse and Picasso exchange paintings—Picasso's still life from the summer of 1907,[28] *Pitcher, Bowl, and Lemon* (p. 74) for Matisse's *Portrait of Marguerite* (Flam 220). Picasso's studio is a place for discussion where the debates are not only about Picasso's work, as Braque is bringing his own works there.[29]

December 15
In an article about Matisse, published in *La Phalange,* Apollinaire concludes with a remark possibly directed at Picasso:
We are not here in the presence of an extravagant or extremist undertaking: Matisse's art is eminently reasonable.[30]

December 21*
Sends Gertrude Stein a postcard with "Regards from Fernande."

BRAQUE

PICASSO

1908

Early in the Year
At work on *Woman,* which he completes in mid-March, just before the opening of the Indépendants.

Early January
Matisse opens his school, the "Académie Matisse," in a former convent (Couvent des Oiseaux) at 56, rue de Sèvres.[31] According to Gertrude Stein's later account, this marks the time when tensions increase between him and Picasso:
Derain and Braque became followers of Picasso.... The feeling between the Picasso-ites and the Matisseites became bitter.... Matisse was irritated by the growing friend-ship between Picasso and Gertrude Stein. Mademoiselle Gertrude, he explained, likes local colour and theatrical values.[32]

January
At work on preparatory sketches for *Standing Nude* (Daix 116).

February 16*
Postcard to Braque, signed with monogram LM,[36] confirms an appointment for Tuesday, 1:30 P.M., with a (deaf) female model. Use of the model, suggesting an interest in the figure, may relate to figure compositions such as *Woman*[37] and *Large Nude* (p. 87), both presumably now in progress.[38]

About this time, completes the second, proto-Cubist treatment (p. 81) of the viaduct at L'Estaque, painted from memory.[39]

Mid-March
Completes *Woman.*

March 20–May 2
Twenty-fourth Salon des Indépendants. Four works by Braque are listed in the catalogue: *Cove* (917), *Valley* (918; "which belongs to Mr. Rahnweiler [sic], rue Vignon, 28"), a drawing (919), and *Landscape* (920). It is known that Braque shows at least one picture of nudes not recorded in the catalogue, which is surely *Woman,* completed only shortly before the vernissage. That the picture in the Salon was the multifigure *Woman* accords with the plural references *(nudités)* in the review in *L'Intransigeant.* This work was formerly thought to have been the *Large Nude* but cannot have been, since the latter is now known to have remained in Braque's studio during the exhibition.

March
Gertrude Stein attends the vernissage of the Salon des Indépendants. Writing of it many years later, she emphasizes the influence of Picasso (who is not represented). She recounts (from Alice Toklas's point of view) a conversation among Toklas, herself, and a friend at the exhibition:
You have seated yourselves admirably, she [Stein] said. But why, we asked. Because right here in front of you is the whole story. We looked but we saw nothing except two big pictures that looked quite alike but not altogether alike. One is a Braque and one is a Derain, explained Gertrude Stein. They were strange pictures of strangely formed rather wooden block figures, one if I remember rightly a sort of man and women, the other three women....My friend and I sat

Catalogue of the twenty-fourth Salon des Indépendants, March 20–May 2, 1908

BRAQUE

Apollinaire writes in *La Revue des lettres et des arts* (May 1):

[Braque's work is] the most original effort of this Salon. Certainly, the evolution of this artist from his tender Valley *to his latest composition* [Woman] *is considerable. And yet these two canvases were painted at an interval of only six months. One must not dwell too much on the summary expression of this composition, but it must be recognized that Mr. Braque has unfalteringly realized his will to construct.*[40]

Apollinaire's exact reference to six months, the precise length of Braque's stay at L'Estaque, suggests that he is closely following Braque's development. Later he would state that "the first Cubist paintings that were to be seen in an exhibition were the work of Georges Braque" and that it was Braque "who exhibited a Cubist painting at the Salon des Indépendants as early as 1908," without, however, identifying these "Cubist paintings."[41]

On April 27 (five days prior to the closing of the Salon), when the American writer Gelett Burgess and Inez Haynes Irwin visit Braque's studio, they see what Irwin in her diary clearly describes as the *Large Nude:*

A bare room. One fearful picture of a woman with exposed leg muscles; a stomach like a balloon that has begun to leak and sag; one breast shaped like a water pitcher, the nipple down in the corner, the other growing up near the shoulder somewhere; square shoulders. He talks a great deal of giving volume and three dimensions to things....[42]

Burgess's description (published in 1910) is similar:

...the monster on his easel, a female with a balloon-shaped stomach.[43]

Of the Salon, *L'Intransigeant* (March 20) notes:

The most distinctive of the new tendencies are represented by Messrs. Othon Friez [sic], *Braque, Derain, van Dongen, and de Vlaminck. Though debatable, perhaps, they hold one's attention....Mr. Braque is above all impressed by the breadth of the landscape; whereas his nudes* [nudités] *show him to be preoccupied with volumes and masses. Mr. Max Jacob, in his landscapes, demonstrates a charming naiveté....In short, the Salon des Artistes Indépendants appears to be a little less overrun by charlatans.*[44]

PICASSO

without being aware of it under the two pictures which first publicly showed that Derain and Braque had become Picassoites and were definitively not Matisseites.[33]

Stein's description of the first picture does not correspond to Braque's *Large Nude* (p. 87), but her account of the second picture does correspond to Derain's *La Toilette* (now lost), known from a photograph to have been of three women and listed as such in the catalogue of the Salon.[34]

Later Fernande will remark that Picasso "was rather indignant" about Braque's reversal of direction at this time and his appropriation of Picasso's art in a "huge canvas of Cubist construction" that he showed at the Indépendants and apparently "had painted in secret," without telling anybody, not even Picasso, "his source of inspiration."[35] Gertrude Stein, writing around the same time as Fernande, will display a similar attitude:

The first time as one might say that he [Picasso] had ever shown at a public show was when Derain and Braque, completely influenced by his recent work, showed theirs.[36]

BRAQUE

Louis Vauxcelles writes in *Gil Blas* (March 20):[45]
In the presence of Mr. Braque, I am positively losing my foothold. This is savage [canaque], resolutely, aggressively unintelligible art.
He is evidently referring here to *Woman*.

Review in *L'Action* (March 21):
There is an abundance of nudes, and there are some exquisite ones...such as van Dongen's Wrestlers *[Chaumeil 64] (whose one-man show is taking place at 28, rue Vignon) in which he displays his rare gifts as a colorist. As for Derain, he is led astray, and the Egyptian look he gives to certain of his forms does not suffice to save them from being ridiculous.... Is not the painter Braque making fools of us?*[46]

In the first part of a two-installment review of the Salon, in *La Liberté* (March 20), Étienne Charles mildly commends Braque and his old friends from Le Havre:
In this first gallery one finds...more finished pieces, such as the sketches by Messrs. Othon Friesz, Georges Braque, and Dufy, in which can be discerned a true feeling for decoration.[47]
But in the second installment (March 24), without mentioning Braque or Derain by name, Charles comments:
One finds here a particularly strong position taken in favor of the deformation, the travesty and the disfigurement of women. Gallantry is not in fashion among the representatives of the new schools.[48]

Le Rire comments on the Indépendants (April 11):
It's Ubu Roi, *but in painting. I particularly recommend the painting* Hunger, Thirst, Sensuality, *in which a woman—if one may call her such—is eating her right leg, drinking her blood, and with her left hand...No, I could never tell you where her left hand is wandering, no doubt in memory of Titian.*[49]

In his chronicle (April 16) in *Mercure de France*,[50] Charles Morice challenges the young painters:
...may they listen more submissively to nature, and swiftly they will pull themselves together and renew themselves. I hope it is not too late to give the same advice to Messrs. Derain, Metzinger, and Braque, whose simplifications are disconcerting.

PICASSO

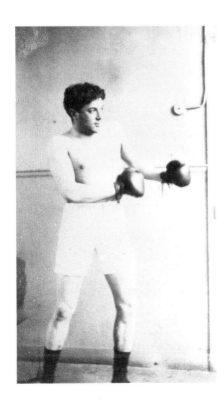

Braque, c. 1904–05

BRAQUE

PICASSO

Spring
In one of his notebooks, makes a study for the geometrization of the arm of the figure at the center of *Three Women* (p.111), which suggests he has taken up that painting again. The same notebook contains studies for *The Dryad* (p. 103) and *Woman with a Fan* (p. 91).[37]

April 18
Exhibits five of his earlier works at the first Salon de la Toison d'Or in Moscow: *Cove* (no. 6 in the exhibition's catalogue), *Cove, Gray Weather* (7), *The Poet* (8), *Mast at Antwerp* (9), and *Window* (10).

April
Gelett Burgess visits Picasso. He is researching an article on art in Paris and is visiting, among other artists, Matisse, Braque, and Derain. Completed in 1908, the article is eventually published, as "The Wild Men of Paris," in *The Architectural Record* in 1910.

April 29
Inez Haynes Irwin, a friend of Gelett Burgess's, visits Picasso for the first time, recording in her diary the presence in the studio on that occasion of "two huge pictures"—*Les Demoiselles d'Avignon* and *Three Women*—and remarking:
Shows us a mask of the Congo and some totem-pole-like hideosities that he made himself.[38]

After May 2
After the closing of the Salon des Indépendants, recovers his paintings. Sometime thereafter goes to Le Havre to help organize the upcoming show of the Cercle de l'Art Moderne, which will open in June. According to Maximilien Gauthier, this was the most important of their exhibitions to date.[51] Braque, however, shows only two early works, *Boats* and *Pine Trees*. Guillaume Apollinaire writes the preface to the catalogue, "Les Trois Vertus plastiques," a text he will use four years later for the first chapter of his *Les Peintres cubistes: Méditations esthétiques*. Among the exhibiting artists are Derain, Dufy, Friesz, Marquet, Matisse, van Dongen, and Vlaminck.

May 12*
From Le Havre, sends Picasso a postcard:
...for the exhibition bring your canvases to Friesz on the 15, 16, or 17.
Presumably refers to the Cercle de l'Art Moderne.[52] (Picasso, unmentioned in the catalogue, probably did not participate.)[53]

May 26*
Writes to the Steins, in Fiesole; says that work on *Three Women* is progressing.[39] "African" elements in his work are receding in favor of relief effects influenced by Cézanne, probably related to Braque's Cézannist reductivism in the early Cubism of *Woman*.

Before June 1
Goes to L'Estaque, where he will remain until early September. From L'Estaque, writes to Kahnweiler (postmarked at receipt, Paris, June 1):

Before May 29
Gelett Burgess pays Picasso another visit:
I photographed him again, though the joy had died out of him. It is lucky I wrote the article on my first impressions, for I didn't

Alice Toklas and Gertrude Stein in Venice, summer 1908

BRAQUE

I reached port safely after a rather good crossing and was able to set to work right away.
Braque may not have waited for the opening of the June exhibition of the Cercle de l'Art Moderne in Le Havre before returning to work.[54]

June
The verso of the *Large Nude* (p. 87) bears the date June 1908, as recorded in the catalogue of the third Kahnweiler sale, July 4, 1922 (no. 39, *Baigneuse*). The precision of this inscription, very rare for Braque, and the fact that it must have been written prior to the sequestration of Kahnweiler's holdings in 1914 suggest that Braque may have taken the painting to L'Estaque and reworked it there.

Summer
Is joined at L'Estaque by Dufy. Braque may visit Derain, who is spending the summer at Martigues,[55] twenty kilometers from the village of L'Estaque. Derain sends Braque two postcards to 48, rue d'Orsel, which are forwarded to the Hôtel Maurin, L'Estaque, where Braque is staying.[56]

Of Cézanne's influence on him during this period Braque later declares:
It was more than an influence, it was an initiation. Cézanne was the first to have broken away from erudite, mechanicized perspective....[57]

At L'Estaque, Braque executes a series of full-blown Cubist landscapes including *Houses at L'Estaque* (p. 101).

PICASSO

see any sense of humor, and had a hard time talking to him. The German, Wieghels, was here.[40]

After May 29
The German painter Wieghels commits suicide at the Bateau-Lavoir.[41] Fernande describes the circumstances of Wieghels's death as follows:
Once in a while we would go back to taking opium. We did this until a tragedy unfolded before our eyes, until, that is, our neighbor the German painter Wieghels committed suicide. After an eventful evening during which he had successively taken ether, hashish, and opium, he failed to recover his sense, and in his madness hanged himself a few days later in spite of the care with which we looked after him. This taught us a lesson, and being very shaken up, we decided never to touch drugs again.[42]
Composition with Skull (p. 90), painted in the late spring, is possibly a commemoration of Wieghels's death.[43]

June 14*
Writes to the Steins, in Fiesole:
Every day I mean to write to you. Do not hold it against me if I don't write. I have been working very hard for a while now. The large picture [Three Women] *is coming along, but with such efforts, and besides it I am doing other things....Little Wieghels, the little German who lived in my house, killed himself and I have been very worried because of that, because of Fernande who has been upset by this death. All the Indépendant painters left for the south and we are alone, Fernande and I. We see only painters from the Champs de Mars [i.e., academic painters, whereas by the Indépendant painters he means Braque and Derain].*

July 28
From London, Burgess writes to Inez Haynes Irwin of another visit to the Bateau-Lavoir:
Picasso was charming, more so than usual. ... Picasso was at work on a picture more horrible than ever, and I'll show you a picture of it [perhaps referring to one of the intermediate stages of Three Women].[44]

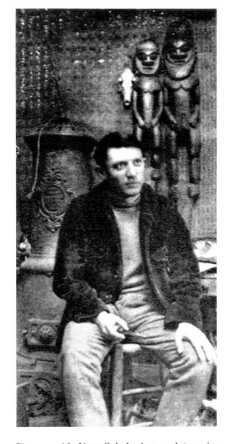

Picasso with New Caledonian sculpture in his studio at the Bateau-Lavoir, c. 1908. Photograph published in Gelett Burgess's article "The Wild Men of Paris," *The Architectural Record*, May 1910

BRAQUE

PICASSO

August

Goes to La Rue-des-Bois; remains until early September. Fernande later recounts this summer:

Picasso was tired and he decided to spend his holidays in France that year. He rented a cottage on a farm in a little village about four and a half miles from Creil: "Rue des Bois," as it was called, was on the edge of the forest of Hallatte…. Picasso was trying to get over the sort of nervous torpor which had possessed him since Wieghels's suicide. … Derain came, then Max Jacob and Apollinaire….[45]

The exact dates of the stay at La Rue-des-Bois are unknown; Burgess's letter of July 28 seems to place Picasso in Paris in late July.

August 14

Writes to Leo Stein, in Fiesole, giving as his return address "la rue des Bois-par-Creil-Verneuil-Oise." Tells Stein that he is out in the country; he has been ill and very nervous, and the doctor has recommended spending some time there:

I worked so hard in Paris this winter and last summer at the studio with all that heat that all my work has finally made me ill. I've been here several days now and feel much better already.

Early September

Probably returns to Paris, since submissions to the Salon d'Automne are required to be in September 7–9, and he intends to submit a maximum of works, staking everything on the new pieces painted at L'Estaque. Shows his work to Picasso, especially the paintings he intends to submit to the jury, and keeps him fully informed of the outcome. Matisse later recounts seeing one of these Braques (probably *Houses at L'Estaque,* p. 101) in Picasso's studio at the time, where "Picasso … discussed it with his friends."[58]

Braque submits six or seven canvases to the Salon. The jury, comprised of Matisse, Marquet, and Georges Rouault, rejects them by a majority vote that includes Matisse.[59] Louis Vauxcelles later recounts that Matisse, in 1908, had told him:

"Braque has just sent a painting made of small cubes."… In order to make himself better understood (for I was dumbfounded…), he [Matisse] took a piece of paper and in

Early September

Returns to Paris.

September

Matisse brings the Russian collector Sergei Shchukin to Picasso's studio at the Bateau-Lavoir. Upon seeing *Les Demoiselles d'Avignon,* he says, according to Gertrude Stein, "What a loss to French art!"[46] Notwithstanding, he buys two canvases, *Woman with a Fan* (p.91) and *Seated Nude* (Daix 169), both of 1908.[47] For Matisse to bring Shchukin to the studio suggests that in spite of the older painter's hostility to what will come to be called Cubism, friendly relations continue at this time between the two artists, who see each other regularly at the Steins'. In a letter to Kahnweiler (June 1912),[48] Picasso recalls another studio visit from Matisse during this period:

You are telling me that you are very fond of the Shchukin picture. I remember that when I was making it, Matisse and [Leo] Stein

BRAQUE

three seconds he drew two ascending and converging lines between which the small cubes were set, depicting an Estaque of Georges Braque, who, incidentally, withdrew it from the Grand Palais on the eve of the opening.[60]

The story of Matisse's being the first to speak of "cubes" or "Cubism" on seeing Braque's paintings submitted to the 1908 Salon d'Automne was first told by Apollinaire, in several versions, and by 1912[61] had become the standard account of the origin of the term "Cubism."[62]

Autumn

Matisse later writes of this period:

According to my recollection, it was Braque who made the first Cubist painting. He brought back from the south a Mediterranean landscape that represented a seaside village seen from above. In order to give more importance to the roofs, which were few, as they would be in a village, in order to let them stand out in the ensemble of the landscape, and at the same time develop the idea of humanity that they stood for, he had continued the signs that represented the roofs in the drawing on into the sky and had painted them throughout the sky. This is really the first picture constituting the origin of Cubism, and we considered it as something quite new, about which there were many discussions. At the same period, in Braque's atelier in rue d'Orsel, I saw a big, wide canvas that had been started in the same spirit and which represented the seated figure of a young woman.[63]

Matisse's subsequent declaration on the same subject, made in 1951 to Tériade, specifies:

Braque had come back from the Midi with a landscape of a village by the seashore, seen from above. Thus there was a large background of sea and sky into which he had continued the village roofs, giving them the colors of the sky and water. I saw the picture in the studio of Picasso, who discussed it with his friends. Back in Paris, Braque did a portrait of a woman on a chaise longue in which the drawing and values were decomposed.[64]

Before October 19

Kahnweiler and Braque decide to show a group of Braque's recent works.[65]

PICASSO

came by one day and they made no bones about laughing straight out in front of me. Stein said to me (I was telling him something in order to try to give an explanation): "But that's the fourth dimension!" and he started laughing right then and there.[49]

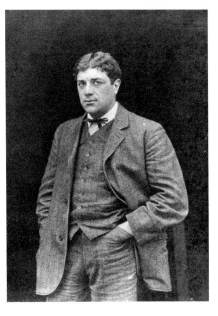

Braque, c. 1908. Photograph published in Gelett Burgess's article "The Wild Men of Paris," *The Architectural Record*, May 1910

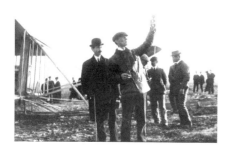

Orville Wright watching as his brother Wilbur checks the wind before a flight at Pau, France, 1909

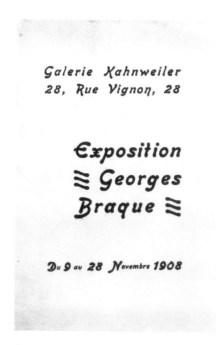

Galerie Kahnweiler
28, Rue Vignon, 28

Exposition
≋ Georges
Braque ≋

Du 9 au 28 Novembre 1908

Catalogue of Braque's exhibition at the Kahnweiler gallery, November 9–28, 1908. The Museum of Modern Art Library, New York. Gift of Joy S. Weber

BRAQUE

October 19
Apollinaire writes to Braque:
Mr. Kahnweiler has spoken to me again about the catalogue for your exhibition. I am ready to write it if you are so disposed.[66]

November 3
Wright brothers' biplane is put on view at the Salon de l'Aéronautique in the Grand Palais. This, along with an article announcing, "The Conquest of the Air, at Le Mans: Wilbur Wright Wins the Prize for Highest Flight"— which is printed (in the November 14 edition of *Gil Blas*) directly below Louis Vauxcelles's review of Braque's show—may eventually provoke Picasso's nicknaming Braque "Wilbourg," though his use of that name is undocumented prior to 1912.

November 9–28
Exhibition at the Kahnweiler gallery; features twenty-seven works, including many landscapes from L'Estaque and Braque's first Cubist still lifes, of musical instruments. Apollinaire's catalogue preface addresses itself not just to Braque but to all the innovators:
There is room now for a more noble, more measured, more orderly, and more cultivated art. The future will tell how influential in this evolution were the magnificent example of a Cézanne, the solitary and determined toil of a Picasso, the unexpected meeting between a Matisse and a Derain, following upon the meeting between a Derain and a de Vlaminck. Success has already rewarded the Picassos, the Matisses, the Derains, the de Vlamincks, the Frieszes, the Marquets, and the van Dongens. It will equally crown the works of a Marie Laurencin and a Georges Braque....[67]

November 14
In a paragraph published in *Gil Blas*, Louis Vauxcelles writes:
He [Braque] constructs deformed metallic men, terribly simplified ... despises form, reduces everything, places and figures and houses, to geometrical schemes, to cubes.[68]

PICASSO

October 25
The American painter Max Weber writes to confirm that he will visit Picasso during the week to collect a small still life Picasso has been keeping for him for three weeks. He assures Picasso that he will have the money for it before the week is over. He adds a note at the end of the letter:
I saw your landscapes and still life yesterday evening at Leo Stein's. They are truly superb.[50]
The landscapes to which Weber refers probably are two or three of the following: Daix 186, 191 (p. 108), and 192. The still life could be any one of the four owned by the Steins at this time: Daix 67, 203 (p. 104), 206, and 207.

BRAQUE

Before November 22
Goes to Le Havre; writes to Kahnweiler from there on November 22, followed by three undated letters concerning the purchase of *Wood Paths* (no. 12 in Kahnweiler's exhibition) by a collector from Le Havre.

November 28
Roger Dutilleul acquires no. 13, *House at L'Estaque* (p. 99),[69] from Braque's exhibition.

Late November–Early December
Is back in Paris. Attends the banquet for the Douanier Rousseau at the Bateau-Lavoir.

December 14
Opening of an exhibition of 107 works by Georges Seurat, at Bernheim-Jeune gallery, among which are *Baignade, Sunday at the Grande Jatte, The Poseuses, Circus Parade*, and *Circus* (D./R. 98, 139, 178, 181, 211). André Salmon later writes about this revelation of Seurat's enterprise and the "incontestable affinity" of his work to that of the first Cubists:
[Their] studios were hung with photographs of works by Ingres and Seurat, notably the Chahut *(D./R. 199), one of the great icons of the new devotion.... I am inclined to think that the wisest and most clairvoyant among the devotees of this cult were those who, like Georges Braque, were unwilling to break the nudity of the white studio wall with anything but the* Chahut, *which in itself contained the whole lesson. This lesson was not one of servile imitation, but of reasoned daring, well-founded audacity, and temerity submitted to proof in advance.*[70]

December 16
Charles Morice's review of Braque's exhibition at Kahnweiler's appears in *Mercure de France.* His attitude is less disapproving than it had been in his review of the Indépendants, earlier in the year:
The audacities of van Dongen would seem excessively "reasonable" if we compared them with those of Mr. Georges Braque. But here there is more—not worse or better—than a difference in the degree of boldness;

PICASSO

Autumn–Winter
Completes *Three Women* (p. 111). Zervos, presumably on advice of Picasso, dates the picture autumn 1908; in Kahnweiler's photographic archives it is dated winter 1908–09.

Late November–Early December
Picasso, who has bought for five francs the large *Portrait of a Woman* (L./R. 12) by the Douanier Rousseau from Père Soulier, a Montmartre secondhand dealer, organizes a banquet in Rousseau's honor at the Bateau-Lavoir to celebrate the event.[51] Braque is present, as are Apollinaire and Marie Laurencin, Salmon, Ramon Pichot, Germaine Pichot, Jacques Vaillant, Maurice Reynal, Ageros, and the Steins. (The exact date of the banquet is not known.)[52]

Winter
Close dialogue with Braque begins; increased interest in Cézanne and relationship with Braque are symbolized in *Still Life with Hat (Cézanne's Hat)* (p. 114), which

BRAQUE

there is something else. Mr. van Dongen retains taste, having regard to the accepted belief that forms should in general be "plausible"; from this last "trammel" Mr. Braque has shaken free. Visibly, he proceeds from an a priori geometry to which he subjects all his field of vision, and he aims at rendering the whole of nature by the combinations of a small number of absolute forms. Cries of horror have been uttered in front of his figures of women: "Hideous! Monstrous!" This is hasty judgment. Where we think we are justified in looking for a feminine figure, because we have read in the catalogue: Nude, the artist has seen simply the geometrical harmonies which convey to him everything in nature; to him, that feminine figure was only a pretext for enclosing them within certain lines, for bringing them into relation according to certain tonalities.... Nobody is less concerned with psychology than he is, and I think a stone moves him as much as a face. He has created an alphabet of which each letter has a universal acceptance. Before declaring his book of spells hideous, tell me whether you have managed to decipher it, whether you have understood its decorative intentions. [71]

December 21–January 15, 1909
Group show at the Notre-Dame-des-Champs gallery in Paris (a small gallery opened by Wilhelm Uhde). Braque exhibits five landscapes and a still life. Other participants include Derain, Dufy, Herbin, Metzinger, Pascin, and Sonia Terk (later Delaunay). [72]

Winter
Since the autumn, Braque has been painting freer, more rhythmic still lifes dominated by the theme of the fruit dish: *Plate and Fruit Dish* (p. 106), *Fruit Dish* (p. 117). The fruit dish, a Cézannesque emblem, is also present in Picasso's paintings—in works he makes sometime between the fall of 1908 and the beginning of 1909—a shared theme manifesting the effects of the growing closeness between the two artists.

PICASSO

shows the Kronstadt hat Braque purchased in homage to Cézanne. [53] Of the period that follows, Braque later remarks:
Before long, Picasso and I had daily exchanges; we discussed and tested each other's ideas as they came to us, and we compared our respective works. [54]
Picasso later says:
Almost every evening, either I went to Braque's studio or Braque came to mine. Each of us had to see what the other had done during the day. [55]

Studies on the theme Carnival at the Bistro (p. 114) lead to the oversize still life *Bread and Fruit Dish on a Table* (p. 115). [56]

December 21–January 15, 1909
In the group show at Notre-Dame-des-Champs, Picasso shows three early works: *Interior, The Clown,* and *Still Life.* (The first two works belonged to Berthe Weill in 1902.)

BRAQUE

PICASSO

1909

January 22–February 28

Participates in a group exhibition of paintings, watercolors, and pastels at the Berthe Weill gallery.

January 24–February 28

Shows four works,[73] probably Cubist, at the second exhibition organized by the Toison d'Or in Moscow. They are: *Bather* (no. 1 in the exhibition catalogue), *Bridge* (2), *Road* (3), *Still Life* (4). The work identified as *Bather* is in fact the *Large Nude* (p. 87), which is reproduced for the first time in an issue of the magazine *Zolotoe Runo* (2/3, 1909) published as a catalogue for the exhibition.[74] So far as can be determined from the installation photographs also reproduced in *Zolotoe Runo*, *Bridge* is perhaps *Viaduct at L'Estaque* (p.95); *Road* is perhaps *Road near L'Estaque* (p.89); and *Still Life* is perhaps *Plate and Fruit Dish* (p.106).

March 25–May 2

Participates in the twenty-fifth exhibition of the Salon des Artistes Indépendants with two canvases: *Landscape* (*Harbor*, p. 113)[75] and *Still Life* (*Still Life with Fruit Dish*). (The still life has since been destroyed.)[76] Will not exhibit in another Salon until 1920.

In *Gil Blas* (March 25) Louis Vauxcelles writes of the Salon's exhibition room XVI (which shows works by Jean Puy, Dufy, Rouault, Laprade, Matisse, Friesz, Vlaminck, Derain, Braque):
[It is an] important room, quite characteristic of the present and essential tendencies of the main artists here, the "stars"… everything, including the cubic and, I must confess, hardly intelligible oddities of Bracke [sic] (here we have someone, Pascal would have said, who abuses the geometrical turn of mind), rendering this crowded room passionately interesting.[77]

André Salmon devotes a lengthy review to the Salon des Indépendants, in two installments of *L'Intransigeant* (March 26 and 27):[78]
Although Cézanne's spirit wanders through these rooms, many of the artists who came under his influence affirm their temperament to be entirely original.…Gravity is

Beginning of the Year

The Steins buy the final state of *Three Women*. The noted Swiss collector Hermann Rupf buys some works by Picasso. Dutilleul begins his collection. (Rupf and Dutilleul are also buyers of Braque.)

March 23*

Sends a postcard to the Steins: the card shows a photographic reproduction of *Woman in an Armchair* (Daix 269); the other side is inscribed: "Regards from the author."[57]

Both sides of a picture postcard of Picasso's *Woman in an Armchair* sent by Picasso to Leo and Gertrude Stein, March 23, 1909

BRAQUE

very fitting for Mr. Georges Bracque [sic], whose mind is for the most part troubled with a concern for expressive lines; we are indebted to him for his lofty discoveries. The same preoccupation, augmented by more earthly concerns, underlies the efforts of Mr. André Derain, who is exhibiting some violent landscapes.... At a time when so many Japanese are imitating Picasso and Bracque [sic], Mr. Pierre Fauconnet has rediscovered the Japanese manner.

April 16
Article by Charles Morice appears in *Mercure de France* which contains the first known appearance of the term "Cubism" in print.[79] In it, he contrasts Georges Braque as "leader of the bold ones" with Matisse:
And at least as long as these happy folks will not laugh with me over Mr. Bonnat's "attempt," I shall not laugh with them over that of Braque. And I believe I do see that Mr. Braque is on the whole a victim—setting "Cubism" aside—of an admiration for Cézanne that is too exclusive or ill considered.

Early Spring
Probably returns to Le Havre. With Friesz and van Dongen participates in the fourth exhibition of the Cercle de l'Art Moderne at Le Havre.[80] Reviewed by "Claude Lantier" in *La Cloche illustrée* of Le Havre (June 12):
I have more trouble embracing the sort of distortion that borders on ugliness, and I shall state outright that the entries of Mr. van Dongen surprised and upset me, as did those of Mr. Braque and the large panel Summer *of Mr. Othon Friesz, who seems to me to be getting away from the unity and harmony of which he is, however, an advocate.*

Probably paints *Harbor in Normandy* (p. 126) from memory after May visit to Le Havre.

Fernande Olivier, c. 1909

PICASSO

Early May
Leaves for Barcelona with Fernande. Paints portrait of his friend Manuel Pallarés (p. 129). Makes pen-and-ink drawings from his hotel room which simplify the forms of houses, as in *Landscape with Bridge* (p. 123), painted shortly before in Paris.

May 16
From Barcelona, Fernande writes to Gertrude Stein (on letterhead "au 'Lion d'Or,' Barcelona"):
We arrived in this dreadful city of Barcelona last Thursday [May 11].
Picasso adds:
Greetings, dear friends. Spain awaits you. Pablo.

May 22*
From Barcelona, writes to Soffici, in Florence; gives his address in Barcelona as his mother's house (calle de la Merced, n. 3).[58]

BRAQUE

June
Goes to La Roche-Guyon (a picturesque site on a bend of the Seine Valley, downstream from Mantes), where Cézanne had stayed in 1885. The remnants of a medieval castle's keep engulfed by the forest fascinate him. Will paint five canvases of the castle and forest, with greens and grays predominating (Romilly 40 [but reproduced as 41] and pp. 132, 133, 136, 137).

June 23*
From La Roche-Guyon, writes to Kahnweiler:
Delighted to be here. The countryside really very beautiful.... I wish to remain as isolated as possible. I request that you do not communicate my address to anyone.

July 23
From La Roche-Guyon, writes to Kahnweiler.

Summer
From La Roche-Guyon (La Côte des Bois) writes to Kahnweiler (undated; "1909" added by Kahnweiler):
I am sending you the enclosed letter from an Italian critic that I have received in these last few days.... I am referring it to you thinking that you might perhaps find here a means to publicize your gallery. As for my artistic beliefs to which the latter alludes, I hope they are sufficiently expressed in my canvases, and that photographs ought to be their closest reflection. Therefore, I leave this matter to your appreciation. My best. G. Braque.[81]

PICASSO

May 31*
From Barcelona, Fernande writes to Alice Toklas; says she is ill, and for this reason they have been forced to remain in Barcelona longer than intended.

June 5*
Fernande writes to Alice Toklas:
...we are on our way to the country [Horta de Ebro (now Horta de San Juan)].

June 15
Fernande writes to Alice Toklas, giving their address in Horta:
We have been here ten days already.[59]

June 24
From Horta de Ebro, writes to the Steins:
I've begun two landscapes and two figures, always the same thing.
By the time he leaves Horta in early September, Picasso will have done six major landscapes, including *Reservoir at Horta* (p. 131) and *Houses on the Hill, Horta de Ebro* (p. 134), and over fifteen paintings of Fernande, including *Bust of a Woman (Fernande)* (p. 130), *Nude in an Armchair* (p. 139), and *Seated Woman* (p. 135).

July
From Horta de Ebro, writes to the Steins:
The doctor says that Fernande can make the journey to Madrid and Toledo, and Fernande also feels better. I would be very happy to go—it's been a long time that I've wanted to see Greco again in Toledo and Madrid....[60] *The countryside is splendid. I love it, and the route leading here is exactly like the Overland Route in the Far West.*[61]

The trip to Madrid is probably cancelled. From Horta de Ebro, Fernande writes to the Steins:
I've been in Spain for two months, and have not yet had an entire day to rest.... I most certainly would be better off in Paris, where I could receive treatment. But to travel now would too greatly aggravate the illness.... Life is sad. Pablo is glum and I can get no mental or physical comfort from him.... Pablo would let me die without realizing the condition I'm in. Only when I suffer does he stop for a moment [from working] to take care of me.[62]

Picasso's studio in Horta de Ebro, summer 1909. At right, *Seated Woman* (p. 135); visible behind it at center, *Carafe, Jug, and Fruit Bowl* (Daix 298); at far left, *Head of a Woman in a Mantilla* (Daix 293). At center, above, a canvas depicting three female heads; when it is later cut, half will become *Head of a Woman* (Daix 284) and the other half *Two Heads* (Daix 285).

Houses at Horta de Ebro, summer 1909, photographed by Picasso

BRAQUE

PICASSO

August

From Horta de Ebro, Fernande writes to Gertrude Stein:

We received Leo's letter this morning. You'll be back in Paris long before we will. We probably won't return before October. We'll be leaving here, Horta, in ten days or so.... Then we'll go spend a fortnight in Barcelona. Pablo's sister was married a few days ago and Pablo had little trouble avoiding the duty of taking part in the ceremony. Perhaps after we leave Barcelona, we'll go spend the end of September in Bourg-Madame, a frontier town across from Puigcerda [near Céret].... Manolo is there with Haviland.... Pablo is working. Kanweiler [sic] wants to come here and has been writing us for information, but it happens now that instead of coming September 6, as he had planned, he won't come until the 14th. We would have waited until the 6th for him, but it would be impossible to wait until the 14th. He must be disappointed.

August 24

From La Roche-Guyon, writes to Kahnweiler; says he will see him in Paris on Friday (August 27). Adds:

I will stay in Paris one or two days for I must be going to Le Havre for my 28 days [of military service].

From Horta de Ebro, Picasso writes to Kahnweiler:

I am working. Apollinaire already told me that you're publishing his L'Enchanteur pourrissant *with illustrations by Derain. That should make a very beautiful book.*[63]

[Late] August

Gives Kahnweiler directions so he can come and see him, by way of Tortosa.[64]

Picasso's studio in Horta de Ebro, summer 1909. At right, *Bust of a Woman (Fernande)* (p. 130); at left, *Head of a Woman in a Mantilla* (Daix 293)

August 27

Is in Paris to see Kahnweiler, who will show paintings by Braque, Derain, and van Dongen in his gallery during September. Emile Zavié reviews the exhibition in *Le Feu* of Marseille (September 1):

Mr. Kees van Dongen is very uneven, Mr. Derain very colorless. I like Mr. Braque very much. He is trying to express an idea, not yet fully formed, but done so well that one feels compelled to praise his efforts. What a pleasant music-hall performance he would make were he to present his own works in person.[82]

August 29*

From Caudebec-en-Caux, writes Kahnweiler; says he is on his way to Le Havre (for twenty-eight days of military service.)

August 28

From Horta de Ebro, writes to the Steins:

I am thinking of leaving here in a few days in order to spend a few days in Barcelona with my parents.... I've received the American newspapers.

[End of August]

From Horta de Ebro, Fernande writes to Gertrude Stein:

In a fortnight we shall probably join Manolo and your neighbor Mr. Haviland.

From Horta de Ebro, Picasso writes to the Steins:

Let me know if you have received the photographs of four of my paintings. One of these days I'll send you the others of the countryside and my paintings. I still don't know when I'll be back in Paris. I'm still doing

BRAQUE

PICASSO

studies, and am working fairly regularly. Kahnweiler will be here at the beginning of September. That bothers me. Maybe on my way back to Paris I'll go see Pichot at Cadaqués.

Fernande Olivier at Horta de Ebro, 1909

September 7–October 6
Period of military service. The photographs showing Braque in uniform and Picasso in Braque's uniform (both, p. 37) traditionally have been dated 1909, on account of this period of service. But since there is no evidence of communication between the two artists at this juncture, a more plausible time would be around April 1911, when Braque, during another period of military service, wrote to Picasso several times and apparently came to Paris for a weekend.

September 8
From Barcelona, writes to the Steins:
We shall probably arrive in Paris in four days.

Before September 13
Returns to Paris.

September 13*
Writes to Leo Stein; refers to the presentation, still at the Bateau-Lavoir studio, of the paintings executed at Horta de Ebro:
My dear friends. The paintings won't be hung until the day after tomorrow. You are invited to the private opening, Wednesday afternoon [September 15].

[September]
Writes to the Steins:
The pictures will not be arranged till Thursday noon, the vernissage therefore Thursday afternoon. You are invited.[65]

Mid- or Late September
Picasso and Fernande move to 11, boulevard de Clichy.

Fernande writes to Gertrude Stein (letter inscribed "Sunday"):
Henceforth my dear Gertrude, you may call on us at 11, boulevard de Clichy. We are moved in as of this morning, but unfortunately we are still a long way from feeling at home.
Picasso adds:
[Shchukin] bought my painting from Sagot, the portrait with the fan [p. 127].[66]

October
In the studio of Manolo, who is now back in Paris, Picasso works on sculptures that have surfaces broken up into facets. Sculptures are of an apple and of a head, *Woman's Head (Fernande)* (p. 141), which is derived from the canvases made in Horta de Ebro.[67]

BRAQUE

PICASSO

Gertrude Stein has landscapes from Horta de Ebro installed at 27, rue de Fleurus; buys *Houses on the Hill, Horta de Ebro* (p. 134) and *Reservoir at Horta* (p. 131). Frank Haviland acquires *Factory at Horta de Ebro* (Daix 279).

Camille Corot. *Woman Wearing a Toque.* 1850–55. Oil on canvas, 44½ × 34⅝″ (113 × 87.9 cm). Private collection. Exhibited at the Salon d'Automne of 1909

After October 6
At end of military service, joins Derain at Carrières Saint-Denis near Chatou (Derain's birthplace). From this trip he brings back four landscapes (p. 140 and Romilly 45, 47, 48). Returns to Paris before the end of October.

Autumn
Executes (through the winter) a series of large still lifes on musical themes identifiable with objects in the well-known photograph (c. 1911) of his studio (p.44): *Violin and Palette* (p.143), *Still Life with Mandola and Metronome* (p.145), *Mandola* (p.147), *Piano and Mandola* (p.148), culminating in *Violin and Pitcher* (p.149).[83] This series introduces motif of trompe-l'oeil nail which, as a foil, sets off abstract Cubist structure of the picture. Kahnweiler would later insist on this realistic detail as anticipating the reintroduction of "the real" in Picasso's *Still Life with Chair Caning* (p. 229) of spring 1912.

Also executes *Lighter and Newspaper: "Gil Blas"* (p. 146),[84] the first Cubist painting to use lettering.

October 1–November 8
Salon d'Automne features, as part of its annual series honoring a deceased master, an exhibition of twenty-four figure paintings, "Figures de Corot." The exhibition, a discovery, is admired by both Braque and Picasso.[68]

Winter
Paints *Le Sacré-Coeur* (p. 151).

Late Winter
Paints the Church of the Sacré-Coeur as he sees it from his studio on the boulevard de Clichy (p. 150).

1910

Spring
Paints *Woman with a Mandolin* (p. 155), the first oval Cubist work. Works on increasingly abstract still lifes, *Bottle and Glass* (Romilly 62), *Violin and Candlestick* (p.159).

Writes to Kahnweiler (undated; "1910" added by Kahnweiler); mentions sudden departure from Paris for Le Havre to visit his sick father:
I would like to return as soon as possible, but given my father's condition I cannot set a

Spring
Picasso's *Woman with a Mandolin* (p. 154), his first oval canvas, echos the oval format of Braque's painting of the same subject. Also paints *Girl with a Mandolin (Fanny Tellier)* (p. 157). Begins *Portrait of Wilhelm Uhde* (p. 173) and *Portrait of Ambroise Vollard* (p. 175). Works on these portraits for an extended period: the portrait of Uhde may be completed prior to his departure for Cadaqués in June; the portrait of Vollard probably is not completed until autumn. Fernande

BRAQUE

date. I often think about the canvases I have not been able to complete....Though I think I'll be able to finish them fairly soon.[85]

May 17*
From Falaise, in the Calvados region of Normandy, writes to Picasso:
Hello/G. Braque.

PICASSO

later writes:
He started making Cubist portraits. He painted that of Uhde, who traded him a small Corot for it, of which I have already spoken. Then he did Vollard's, and Kahnweiler's. He worked on these portraits for a long time, above all on that of Vollard, which dragged on for months.[69]

May
Has an exhibition at Wilhelm Uhde's Notre-Dame-des-Champs gallery.[70] The paintings in the show are lent by collectors. Those which can be identified date from 1908–09. Léon Werth observes in *La Phalange* (August):
These pictures borrow nothing from geometry, and if their sources of inspiration are diverse Mr. Picasso should not be reproached for that. Like all artists at their beginnings, he has sometimes, in seeking for himself, found others. These pleasing and ingenious works lead Mr. Picasso finally to this fruit dish and glass, which display their structure, substructure, and superstructure, and whose harmony, simplified as it is, is made up of the yellows and greens of certain Cézannes; and to this landscape of cubic roofs, cubic chimneys, and trees that are like the chimneys but decorated at the top with palms.[71]
Werth must be describing *Factory at Horta de Ebro* (Daix 279), which had been purchased by Haviland the preceding October.

[June 16]
Writes to Gertrude Stein, in Florence (undated; inscribed "Thursday"):
My dear friends: Since you left I've been working hard every day on the portrait of Vollard. I'll send you a photograph of it when it is finished.... Next winter I have to do a decoration for America, for a cousin of Haviland's, a friend of Sterne's whom you've met, in Florence I believe. We'll not leave here before the 25th of this month. We are definitely going to Cadaqués.

June 17
Fernande writes to Gertrude Stein, in Florence:
We are definitely going to Spain. I think this plan was decided upon after your departure. There are to be too many painters going to Collioure, like Marquet, Manguin,

Wilhelm Uhde in the south of France, 1913

BRAQUE

André Derain in his studio at 22, rue Tour-laque, c. 1908. Photograph published in Gelett Burgess's article "The Wild Men of Paris," *The Architectural Record*, May 1910

PICASSO

Puy, etc. So Pablo decided not to. We shall go to Cadaqués, where the Pichots go every year. We shall be there till September and then shall certainly go to Barcelona. Braque, Derain, and Alice should be coming with us to Barcelona. Our departure is set for the 26th of this month. With the Pichot family we shall be 18 or 20.

The letter also indicates that Picasso has received a copy of the article by Gelett Burgess ("The Wild Men of Paris") published in *The Architectural Record* (May). Fernande mentions the reporter who had come two years before, taken a photograph of Picasso, and made reproductions of several pictures. She adds:

The article is very long and very American, with portraits of Braque, Derain, Friesz, Herbin, Pablo, and photographs of paintings. In it is reproduced the painting, quite large, of the red Three Women *[p. 111] that you own.... Pablo is right now doing the portrait of Vollard.*[72]

[June 19]
Writes to Leo Stein:
...if you can find a copy of it, Burgess's article will give you a good laugh.[73]

June 26
Departs for Cadaqués.

Summer
Derain having declined Kahnweiler's request that he illustrate Max Jacob's *Saint Matorel*, Picasso has agreed to make etchings for it.

In the course of this summer, will further develop the style announced by *Girl with a Mandolin (Fanny Tellier)* (p. 157) in the most abstract of his Cubist paintings, such as *The Rower* (p.164), *Woman with a Mandolin* (p. 168), and *Guitarist* (p. 169).

July 12*
From Brooklyn, the painter, critic, and collector Hamilton Easter Field writes to Picasso ("in care of Mr. F. Haviland, 70 bis rue Notre Dame des Champs"); confirms a commission to decorate his library, and encloses a plan of the library and panels to be decorated. (He and Picasso have seen

BRAQUE

PICASSO

each other the previous year to discuss this project.) Field informs him of the upcoming arrival in Paris (in October) of the American painter Arthur B. Davies, who wants to see Picasso's paintings.[74]

Rubin (see Appendix, p. 63) identifies two narrow vertical pictures painted at Cadaqués as Picasso's first essays in connection with this commission.

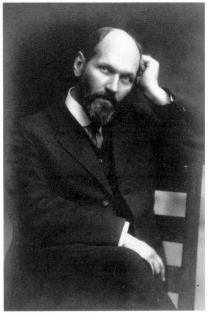

Hamilton Easter Field, c. 1915

July 14
From Cadaqués, Fernande writes to Gertrude Stein:
My dear Gertrude, I've received both your letter and the newspapers, and I thank you for them.... If I weren't afraid of offending Pichot, I would swear that I find Cadaqués very ugly.... Frika [Picasso's dog] and the maid are with us.... We may go to Barcelona for a few days.

July 27*
From Saint-Aquilin-de-Pacy (in the region of Eure, near Mantes), writes to Kahnweiler.

July 28
Writes to Kahnweiler; says he is going to start work on the etchings for Max Jacob's *Saint Matorel* "one of these days." Jacob is delighted:
Picasso's silence led me to believe that he was annoyed, that he was grumbling at both Matorels, myself and the other one.[75]
The etchings eventually published in the book include: *Mlle Léonie (Standing Figure)* (p. 166), *Mlle Léonie on a Chaise Longue* (p. 167), and *The Table* (p. 170).

August 3*
From Cadaqués, Fernande writes to Alice Toklas, in Fiesole (Casa Ricci):
I think we are going to leave for Barcelona on Saturday. We will stay one week perhaps.

August 6
Picasso and Fernande go to Barcelona; return August 12.

August 12*
From Cadaqués, Fernande writes to Alice Toklas:
Dear Alice, On our way back from Barcelona.... We stayed only five days in Barcelona. It was very hot and rained a lot. The Derains, who were with us there, left yesterday for Paris. They haven't arrived yet; they're supposed to arrive around 5 o'clock. I

BRAQUE

PICASSO

would like very much to be in their shoes. We won't be back in Paris until the 15th or 20th of September. Braque is supposed to come at the end of the month. Haviland too.
Picasso adds his greeting:
Regards to the ladies.
There is no evidence that Braque does go to Cadaqués.

August 16*
From Paris, writes to Picasso, in Cadaqués; says Derain has visited him "this morning, Sunday," and is delighted with his trip; informs Picasso he plans to leave at the end of the month, and that before going to L'Estaque, "I'll come and spend a few days with you."[86]

[Mid-August]
From Cadaqués, writes to Kahnweiler (after receiving a prospectus for the book *Saint Matorel*):
…In my opinion the margins are too large and the characters are too small. This created a little black square in the middle of the page. Frightful…. I've already moved in and have begun to work….[76]

August 20*
From Cadaqués, Fernande writes to Gertrude Stein (who has returned to Paris):
We will return to Paris next Friday 26.

About this time, Alice Toklas moves into Gertrude Stein's home at 27, rue de Fleurus.[77]

Late August–Early September
Goes to L'Estaque; remains until November.

Late August–Early September
Back in Paris. Kahnweiler later recalls:
…he returns to Paris in autumn [sic] after weeks of painful struggle, bringing back unfinished works.[78]

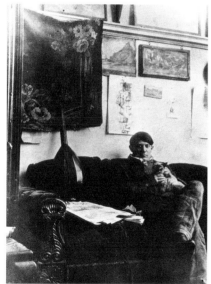

Picasso in his studio at 11, boulevard de Clichy, autumn 1910–early 1911. At lower center of wall, *Standing Nude* (p. 167)

September 1–15
For joint exhibition with Picasso at the Thannhauser gallery in Munich, four works by Braque are lent by the Kahnweiler gallery: *Bridge* (1907), *Factory* (1908), *Vale* (1908), and *Still Life* (1909).

September 1–15
For the joint exhibition with Braque in Munich, three works by Picasso are lent by the Kahnweiler gallery: *Head of a Woman* (Daix 264), *Still Life,* and *Pastel.*

September 5
André Salmon reports in his column "Courrier des arts" in *Paris-Journal:*[79]
Picasso has returned from Spain with important baggage. It has been confirmed that Vollard, this winter, will mount a general exhibition of the works of the young Andalusian master (works from 1900 to 1910).

BRAQUE

September 12
Commenting on the current Salon d'Automne in his column "Courrier des arts" (signed "La Palette") in *Paris-Journal*, André Salmon lists Braque among the "Fauves" who are not exhibiting:
Contrary to expectations, a few Fauves deserted the Salon d'Automne. At the last moment Bracque [sic] changed his mind and, bolting up his studio, left for Le Havre.
There is no other notice of Braque's supposed intent to exhibit at the Salon d'Automne, and no other evidence of a trip to Le Havre at this time.

September
Kahnweiler travels to L'Estaque and photographs the sites of Braque's paintings of 1908. A postcard from Braque (inscribed "Marseille, Cannebière, 9 o'clock, Sunday," probably September 18) to Kahnweiler at 28, rue Vignon, may mark Kahnweiler's return to Paris:
I arrived too late to shake your hand. I'm sorry I was not able to have dinner with you on Saturday, but I got home to L'Estaque at eight o'clock (I was in Marseille). I am working a little.[87]

September 27†
From L'Estaque, sends Kahnweiler a picture postcard; it has no text except the word "Bonjour," which Braque has written on the picture, in the window of the Hôtel Maurin, where is is staying.[88]

September 30
André Salmon reviews the Salon d'Automne *Paris-Journal:*
As Georges Braque is not in this show, Jean Metzinger alone is defending Cubism with a Nude [Moser 23] and a Landscape.[89]

October–November
Jean Metzinger's article "Note on Painting" appears in the journal *Pan:*[90]
Braque, joyously fashioning new plastic signs, commits not a single fault of taste...; without detracting from this painter's boldness in innovation, I can compare him to

PICASSO

September 7
Replies to Hamilton Easter Field's letter of July 12, which he received in Cadaqués in August; acknowledges receiving Field's letter; says he is back in Paris, plans to begin working on the project, and looks forward to meeting Arthur B. Davies.[80]

Autumn
Kahnweiler poses for his portrait (p. 181), which requires about twenty sittings; work on it extends into late in the year.

Autumn–Winter
Introduced by the Steins, Marius de Zayas comes to the studio and interviews Picasso. *América: Revista mensual illustrada*, a Spanish-language magazine owned by de Zayas's father, prints the interview in its May 1911 issue, the first publication in the United States of Picasso's views on his art. (A translation, published in *Camera Work* of April–July 1911, will serve as catalogue essay for the exhibition of Picasso's drawings and watercolors proposed by de Zayas, and shown by Stieglitz in his 291 gallery in New York, during March–April 1911.)[81]

October–November
Of Picasso, Metzinger writes in his "Note on Painting":
It is useless to paint where it is possible to describe. Fortified with this thought, Picasso unveils to us the very face of painting. Rejecting every ornamental, anecdotal, or sym-

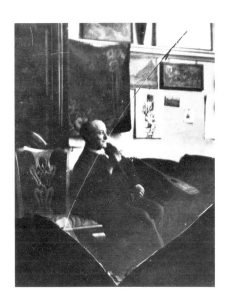

Max Jacob, photographed by Picasso in his studio at 11, boulevard de Clichy, autumn 1910–early 1911

BRAQUE

Chardin and Lancret: I can link the daring grace of his art with the genius of our race....[91]

This is the first instance of characterizing Braque as representative of a French tradition, in contradistinction to Picasso.

Autumn
Executes two paintings of the *Rio Tinto Factories at L'Estaque* (p. 171 and Romilly 69).[92]

November 3*
From Marseille, writes to Kahnweiler:
If I am ready as I think I shall be, I shall return to Paris during the first days of December.... Almost no cholera left.

November 20*
From L'Estaque, writes to Kahnweiler:
See you soon.

November 26*
From Le Havre, writes to Kahnweiler:
I am at Le Havre for a few days. I shall return in the coming days of next week.

November 29*
From Le Havre, writes to Kahnweiler:
I hope to be able to leave for Paris on Thursday [December 1]. I am beginning to miss my studio.

December 1
Probably returns to Paris.

PICASSO

bolic intention, he achieves a painterly purity hitherto unknown. I am aware of no paintings from the past, even the finest, that belong to painting as clearly as his. Picasso does not deny the object, he illuminates it with his intelligence and feeling. Cézanne showed us forms living in the reality of light, Picasso brings us a material account of their real life in the mind—he lays out a free, mobile perspective....[82]

November 8–January 15, 1911
Exhibition "Manet and the Post-Impressionists," organized by Roger Fry, at the Grafton Galleries in London; includes nine works by Picasso, from *Young Girl with a Basket of Flowers* of 1905 (D./B. XIII, 8), lent by the Steins, to *Portrait of Clovis Sagot* of 1909 (Daix 270).

December 3
Roger Fry writes in *The Nation:*
Picasso is strongly contrasted to Matisse in the vehemence and singularity of his temperament.... Of late years Picasso's style has undergone a remarkable change. He has become possessed of the strangest passion for geometric abstraction, and is carrying out hints that are already seen in Cézanne with an almost desperate consistency. Signs of this experimental attitude are apparent in the portrait of Mr. Sagot [Daix 270] but they have not gone far enough to disturb the vivid impression of reality, the humorous and searching interpretation of character.[83]

BRAQUE

PICASSO

December 20–February 1911
Has an exhibition at the Vollard gallery. No catalogue extant.

December 22
Salmon comments in *Paris-Journal* on Picasso's exhibition at Vollard's gallery:
Picasso has no disciples and we must expose the effrontery of those who publicly claim to be his disciples in manifestos liable to misguide other credulous souls....There are lovers of art capable of admiring both Picasso and Matisse. These are happy folks whom we must pity.

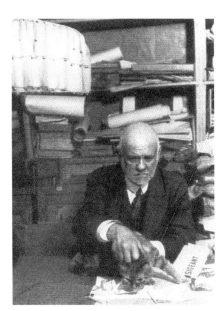

Ambroise Vollard in his gallery, photographed by Thérèse Bonney

1911

January 7
In *Hommes du jour*, Henri Guilbeaux writes:
It is said that Picasso is ready to give up the path of errors he has been treading for some time. This would be for the better since this painter is very talented. There would only remain the Cubists and sub-Cubists whom Mr. Charles Morice could gather into a cohort....[84]

January 14
Henry Bidou, "Petites Expositions—Exposition Picasso," *La Chronique des arts et de la curiosité:*[85]
There are parts of Mr. Picasso's stylizations that escape me, and it is perhaps excessively archaic to draw women in the style of pre-Mycenaean potters. But the drapery in the encounter of two women [D./B. VII, 22], in which one of them is nursing a child, is very beautiful and very noble; free and charming drawing appears in the body of the child seated on the ground near two other women.

February 7*
From Le Havre, sends Picasso a picture postcard (of Sainte-Adresse):
See you Thursday, G. Braque.

February 10
Is sent a notice requiring him to present himself at Le Havre on March 27, 1911, for a period of seventeen days of military service. (The notice is sent to 4, rue Paul-Albert, probably his Paris address prior to moving, in January 1912, to 5, impasse de Guelma, with Marcelle Lapré.) The military exercises are carried out in the town of Saint-Mars-la-Brière. Braque sends several postcards to Picasso and Kahnweiler during this

BRAQUE **PICASSO**

period. (Braque and Marcelle Lapré start living together sometime during 1911, and do not marry until many years later. In the literature she has always been referred to as Marcelle Braque.)

Guillaume Apollinaire, 1909, in the home of Eugène Montfort, director of the literary magazine *Les Marges*

February 14
Apollinaire comments in *L'Intransigeant* on Michel Puy's book *Le Dernier État de la peinture* (1910):
Michel Puy tells us what he thinks of Marquet, Manguin, de Vlaminck, Friesz, Girieud, van Dongen, and Braque…and if he does not give Derain all the credit that is his due … he is even more unjust with regard to Picasso, whose name he mentions only once…. [Nevertheless] it is an excellent summary of the state of the new painting in France today.[93]
Puy had singled out Braque, along with Metzinger, for special discussion, writing:
Braque carried things to the extremes of the most extremist theories. He reduced the universe to the simplest lines of geometry in space. He gazed at landscapes through the chemist's retort and he rendered them in such a way that if at times some greenery surrounds them, their centers are composed of a sea of crystals growing cold and their colors seem to have been studied at several hundred meters below the earth's surface, by the glimmer of a miner's lamp.[94]

March 27*
From Rouen, writes to Picasso; says he is at the Café Tortoni, waiting in uniform for Friesz, who is supposed to come with his mandolin; signs:
All the best, G. Braque.

March 27–April 12
Military service. Photographs of Braque in uniform and Picasso wearing Braque's uniform (both, p.37) may date from this period.

March 29*
From Saint-Mars-la-Brière, writes to Picasso; says he has just arrived in Saint-Mars-la-Brière and that he will try to go to Paris the following Sunday; signs:
G. Braque.

March 28–April 25
Exhibition of eighty-three drawings and watercolors by Picasso at Stieglitz's 291 gallery in New York. The exhibition is organized by Marius de Zayas, Eduard J. Steichen, Frank Haviland, and Manolo.[86] In his memoirs, Steichen mentions that "Gertrude Stein was instrumental in softening Picasso

BRAQUE

March 30*
From Saint-Mars-la-Brière, writes to Kahn-weiler.

March 31*
From Saint-Mars-la-Brière, writes to Picasso:
See you Sunday or Saturday.[95]

April
Around this time, probably begins his paper sculptures.

Before April 12
From Saint-Mars-la-Brière, writes to Picasso (postmarked April); tells his "dear friend" that he is at the camp, it is very cold, and he is going to be "liberated":
And perhaps Thursday [April 13] we'll be at the Ermitage.... See you soon.[96]

April 12
Returns to Paris from military service.

April 23
In his column, "Courrier des ateliers," *Paris-Journal,* André Salmon announces an event titled "Le Violon d'Ingres":
The great violinist Jean Kubelik will be in Paris on April 28 to grant a wish expressed by the Duchess of Rohan, president of the Committee of Women Patrons of the Ingres exhibition.[97] *This day, a gala will take place in the George Petit galleries at four o'clock sharp. Before the assembled works of the famous painter, on Ingres's violin Kubelik will play those pieces of which the*

PICASSO

for us, getting him to agree to showing at the Photo-Secession in New York."[87] Stieglitz advertises this as Picasso's "First one-man show anywhere," although he had in fact already had two such exhibitions in Paris in 1910.[88] The 291 exhibition is reviewed by Arthur Hoeber in the *Globe and Commercial Adviser* of New York (April 21):
Over at the little galleries of the Photo-Secession ... Mr. Stieglitz still holds out with his show of the work of Pablo Picasso, which, save to the extra high-browed in art, remains still an unfathomable mystery.[89]

Another review of the 291 exhibition appears, in *The Craftsman* (May 1):
The Photo-Secession Gallery... has recently had two noticeable exhibitions, one of Cézanne, who has dominated art in Paris for some years, and one of the much talked about Spanish modern worker, Pablo Picasso, who has a large following in Paris and who has certainly piqued the interest of the younger generation of artists in New York.
The reviewer goes on to cite amply Marius de Zayas's catalogue preface and adds:
Picasso does not want to see nature, but how he feels about nature.... But if Picasso is sincerely revealing in his studies the way he feels about nature, it is hard to see why he is not a raving maniac, for anything more disjointed, disconnected, unrelated, unbeautiful than his presentation of his own emotions it would be difficult to imagine.[90]

April 16
Salmon writes in his column "Courrier des ateliers," *Paris-Journal:*
On the subject of the Salon des Indépendants, Picasso makes abstentionist disciples; Friesz, Bruque [sic], and Derain, who nonetheless had prepared some beautiful things. Matisse is showing only one canvas. Van Dongen has an important exhibition.
At the Salon des Indépendants (April 21–June 13), the "Cubist" room, in which neither Braque nor Picasso is represented, creates a scandal. Although neither artist participates, their work is invoked to define Cubism; *Le Petit Parisien* (April 23):
What is a Cubist? It is a painter from the Braque-Picasso school.[91]
Alexandre Mercereau, the organizer of the exhibitions of La Toison d'Or in Moscow, who has known Matisse and Picasso since

Still-life arrangement of musical instruments on a round table, photographed by Picasso, 1911

BRAQUE

painter was particularly fond.
The words "Mozart" and "Kubelick" are paired in a painting Braque executes some twelve months later (p. 233).

May 1
Exhibits two works at the twenty-second Berliner Sezession.

Poster for a performance by Buffalo Bill Cody, 1903

July
Michel Puy, review of the Salon des Indépendants in *Les Marges:*
Cubism is, as it were, the culmination of the work of simplification undertaken by

PICASSO

1905–06, makes a similar statement in *La Rue de Paris* (April 24). Roger Allard for the first time connects Cubism with Picasso and Braque.[92]

May 1
Exhibits four works at the twenty-second Berliner Sezession.

Late Spring
Executes paintings *Buffalo Bill* (p. 185), *Woman with a Mandolin* (Daix 397), *Seated Woman* (Daix 398). In 1954, Janet Flanner will write:
[Braque] made Picasso and Apollinaire think of the Wild West. They called him "notre pard," a term they had picked up from American adventure stories they were fond of … in which Colonel Cody called a friend "my pard."[93]

June
Roger Allard, article in *Les Marches du Sud-Ouest:*
On these … artists [the Cubists] … the influence of Cézanne is manifest.…I could without injustice omit to mention Picasso and Braque in discussing influences; and I would have done so, had not Metzinger, with his delicately literary and highly impressionable nature, confessed not long ago to having looked at the pictures of these artists (who indeed are estimable) with eyes other than those of objective criticism. Picasso's violent personality is resolutely outside the French tradition, and the painters with whom I am concerned instinctively felt this.[94]

June 5*
Fernande writes to Gertrude Stein, in Fiesole; Picasso sends his regards.

About June 13
The German art historian Max Raphael visits the studio at 11, boulevard de Clichy.[95]

July 5*
Fernande writes to Gertrude Stein, in Fiesole:
Pablo is leaving for the Midi in a few days. I am staying in Paris. I may go to Holland.

BRAQUE

Cézanne and continued by Matisse, then by Derain.... It is said to have begun with the work of Mr. Picasso, but as this painter rarely exhibits his work, its evolution has been observed chiefly in Mr. Braque. Cubism seems to be a system with a scientific foundation, which enables the artist to support his effort by reliable data.[98]

July 14

André Salmon writes in *Paris-Journal:*
The other day the son of a very famous Impressionist, a painter himself and a talented one at that, and another, quite interesting painter were visiting a gallery that is a temple of Cubism. Noticing a Work by B., the son of the Impressionist master whispers, in conciliatory tone:

"On the whole, this landscape's not unpleasant."

"Fair enough," says the other, "but it's not a landscape, it's a man playing the violin."

"How do you know that?"

"B. is always painting a Man Playing the Violin."

The first painter, wanting to have the last word, takes his friend aside and shows him a painting by P., rival of B.

"Now that's a landscape."

Then a guard from the gallery intervenes saying:

"Monsieur is mistaken. That is a Woman Playing the Mandolin; *but it is a very difficult painting to understand. Indeed, I have been here only two weeks, and I still don't understand it very well."*

Those who would doubt the authenticity of this story will be convinced if they guess who the heroes are.

[July]

André Salmon will later recount[99] an anecdote about this period, illustrating Braque's penchant for hats, that has some bearing on Picasso's letter to Braque of July 25:
I remember offering...to [Braque] a book of flowery verse with this dedication: "To Georges Braque, renovator of French Dress."[100] *This was because he used to be seen on rue des Abbesses, rue Ravignan, or rue d'Orsel, dressed in blue mechanic's overalls, shod in big, bright yellow boots and wearing a magnificent gray or beige bowler hat on his head. All of us, for one season*

PICASSO

Picasso goes alone to Céret, where Manolo and his wife, Totote, have settled.

July 16

From Céret (Hôtel du Canigou), writes to Braque:
Old boy, I received your letter this morning. I'm very happy you're working well, and that you've promised to come here. Don't forget it. I have a lot of things to tell you. Kahnweiler yesterday sent me the clipping from Paris-Journal [of July 14] that you talked about in your letter. Such discretion: Mr. B., Mr. P., son of a great Impressionist painter. ... It sounds like the newspaper Max read to us the other day in Montmartre.... All the best, dear friend, Picasso.

From Céret, writes to Kahnweiler:
I'm already working. I have a rather large room at Haviland's, where it's quite cool. I've begun a painting, Poet and Peasant.[96]

André Salmon, c. 1907–12

July 25

From Céret, writes to Braque:
My dear friend Braque, I have at last received the hats. What a surprise; you can't have any idea of how much I laughed, above all in the nude.... We put them on with Manolo last night to go to the café but with false mustaches and sidewhiskers applied with cork.... I've been going to bed very late, later perhaps than in Paris, and have been working at night at Manolo's place. I'm doing watercolor drawings of little still lifes.

I'm going to begin again the Poet and Peasant; *I've abandoned the other one and am doing a young girl with an accordion*

at least, have worn such fascinating head-wear—to the envy of Second Empire book-makers, if they could have come back to the earth of the hippodromes of their belle épo-que. Braque had bought a hundred of them at twenty sous apiece at a public sale in the port of Le Havre. They were old hats, brand-new but out-of-date, antique bells pulled out of some dusty old armoire, exported to Africa, and brought back to Le Havre, the blacks no doubt finding no interest in them, as modern sailors' merchandise had already made them lose that notion of style which still remained for us to discover....

After July 25
Writes to Picasso, in Céret (letter inscribed "Thursday" [July 27?]):
Dear Friend, I have just received your letter [of July 25].
Says he is getting ready to go to Céret in about two weeks; is planning to live on the outskirts rather than in Céret proper and asks Picasso to find him a hotel. Continues:
I haven't yet touched the new canvas. I won't deflower it till I'm in the south.

I dined last night with Derain. Got a post-card from K[ahnweiler, in Corsica].
Braque says he hopes Picasso will meet him at the station with the hats, and concludes:
See you soon; be happy, G. Braque. Hello to everyone.

August 7
Writes to Picasso, in Céret (Hôtel du Cani-gou); says that he intends to be in Céret in a week's time and that Kahnweiler has returned.

[Accordionist, *p. 190]* and a still life with glass, lemon squeezer, half lemon, a little jug with spouts, and the light [Glass with Straws, *p. 192].*

But the big painting [identified by Rubin as a panel for Hamilton Easter Field; see Appendix, p. 63] remains to be done. It's a stream in the middle of town with some girls [?] swimming....Let me know when you're coming, where you're going, and give me news about painting. For the new paint-ing [Accordionist], very liquid to start and Signac-style methodical treatment—[scum-bles] only at the end.[97]

July 27*
From Céret, writes to Leo Stein, in Fiesole:
My dear friends. Here is my address. Hôtel du Canigou, Céret (Pyr. Or.), France. I've been here for two weeks.[98]
Fernande will later write:
[Picasso] had rented the second floor of a large building in the middle of an immense park. There were three or four vast rooms, one of which he used as a studio. [In the evenings he would go to a café or to] see Manolo or Haviland, both of whom had houses there.[99]

August 4
Fernande writes to Gertrude Stein, in Fiesole:
I'm in Paris. Pablo is in Céret.... I shall leave for Céret in a few days to join him.... I shall stay in Paris at least until the 15th.

August 8
From Céret, writes to Fernande:
In a letter I received from Braque this morn-ing, I see that K[ahnweiler] has arrived in Paris, so I hope that in a very few days you [Fernande and Braque] will be here too. Don't worry too much about money, we'll manage.... Work is still coming along and I'm still working on the same things.[100]

August 13*
From Céret, sends Kahnweiler a picture postcard:
I'm working on Poet and Peasant—The Pearl of Roussillon—*and a Christ right now. If I'm able, I'll send photos to you.*[101]

Both sides of a picture postcard sent by Picasso to D.-H. Kahnweiler, August 13, 1911

BRAQUE

August 15*
From Orléans, writes to Picasso, in Céret; says he is on his way to Céret; will be in Guéret tomorrow and in Limoges the following day.

Before August 17
Arrives in Céret. The following weeks see a brief but unusually intense interaction between the two artists. Braque's *Man with a Guitar* (p. 191) closely echoes the pyramidal structure of Picasso's *Accordionist* (p. 190). Both artists paint still lifes incorporating the title of the local paper, *L'Indépendant*, with its Gothic typeface, Braque in *Candlestick* (p.196), Picasso in *Still Life with Fan (L'Indépendant)* (p. 197). These paintings mark their first experiment with precisely reproducing "real" typography. It is probably during this period that they execute the pair of large etchings published by Kahnweiler in 1912, Braque's *Fox* (p. 198) and Picasso's *Still Life with Bottle: "Vie de Marc"* (p. 198). Braque's *Rooftops at Céret* (p.195) also finds a counterpart in Picasso's *Landscape at Céret* (p.194).

August 20*
From Céret (Hôtel du Canigou), writes to Kahnweiler:
The weather is ideal. I am very pleased to be here.

PICASSO

August 17
From Céret, writes to Kahnweiler:
Our friends' ideas are truly amusing and I'm enjoying myself immensely here with all the clippings you send me. Braque is here.... I would need 1,000 francs to stay here as long as I'd like to stay, to do what I want to do. I think that Braque is very happy to be here. I've already shown him the whole area and he already has a lot of ideas in mind.[102]

Paints *Still Life with Fan (L'Indépendant)* (p.197), *Bottle of Rum* (Daix 414), and *Clarinet* (p.197). It is probable that the canvases with figures, such as *Accordionist* (p. 190), *Man with a Pipe* (p. 200), and *The Poet* (p. 201), are already worked out, certain ones in fact complete.[103]

August 23
Learns from newspaper reports that the *Mona Lisa* has been stolen from the Louvre on August 21. (After the theft is discovered on August 22, the Louvre is closed for a week.)

August 24
Publication of an important essay, "Picasso and Braque," by the Florentine painter, critic, and poet Ardengo Soffici, in *La Voce* (Florence).[104] (Soffici has known Picasso since the beginning of the century—and Braque since 1909—and their friendship has grown sufficiently for him to visit Picasso's studio whenever he is in Paris; he visits Picasso in 1907 at the Bateau-Lavoir; in spring 1910, 1911, and/or 1912 at the boulevard de Clichy; and in spring 1914 at the rue Schoelcher.)[105] Soffici's essay is one of the first discussions of Picasso and Braque together, and the first article on Cubism in Italian, and is instrumental in bringing the Milanese Futurists, Boccioni, Carrà, Russolo, into contact with Cubism. Its pronouncements on Cubism, and on the art of Picasso and Braque, will be the core of Soffici's subsequent *Cubismo e oltre* (Flor-

BRAQUE

PICASSO

ence: La Voce, 1913), republished in large edition as *Cubismo e futurismo* (Florence: La Voce, 1914). In the 1914 edition, a paragraph contemptuously treating Le Fauconnier, Metzinger, Léger, and Delaunay as blind and empty followers of Cubism, masking their banality behind triangles and other figures, will be deleted (see Apollinaire's letter of December 8, 1911, to Soffici).

August 24–27
There are daily entertaining reports in *Paris-Journal* about the missing *Mona Lisa:* the newspaper offers 50,000 francs and anonymity for its return.[106]

August 28*
From Céret, writes to Ardengo Soffici, in Poggio a Caiano:
I've been here for two months. I have not received La Voce *and would be so happy to read your article. I'll be here a while longer....*[107]

August 29
The Louvre reopens. *Paris-Journal* publishes an account written by "The Thief" (Géry Pieret) relating the story of his thefts in March 1907 of two Iberian[108] statuettes that he then sells to an art lover, as well as a plaster fragment, and of another theft, of an Iberian head, on May 7, 1911, thereby demonstrating that the Louvre is not well guarded. Picasso must have learned of this affair on August 30 and immediately assessed its gravity, and its relevance to his situation as the possessor of two Iberian statuettes purchased from Géry Pieret in 1907.

August 30
Paris-Journal announces "First Restitution" (the statuette stolen on May 7, 1911, by Géry Pieret).

September 4
Probably returns to Paris.

September 5
With Apollinaire, takes the two Iberian sculptures he had bought from Géry Pieret in 1907 to the offices of *Paris-Journal,* hoping that the sculptures can be returned to the Louvre without implicating either of them.[109]

Head of a Man. Iberian; Cerro de los Santos. 5th–3rd century B.C. Stone, 8¼″ (21 cm) high. Musée des Antiquités Nationales, Saint-Germain-en-Laye. One of two sculptures bought by Picasso from Géry Pieret in March 1907

BRAQUE

PICASSO

September 6
Paris-Journal announces the anonymous return of the two Iberian heads:
Two new restitutions are made to Paris-Journal.... The stone man and the stone woman are identified by the administration.

September 8
Apollinaire is arrested on the charge of complicity in harboring a criminal (Géry Pieret) and receiving stolen goods, and Picasso is summoned by the examining magistrate. Picasso is not charged, but Apollinaire spends six days at La Santé prison.

September 9
Géry Pieret, claiming to be in Frankfurt and signing himself Baron Ignace d'Ormesan,[110] writes to *Paris-Journal,* clearing Apollinaire completely. But the police, believing Géry Pieret belongs to an international band of crooks that might have been responsible for the theft of the *Mona Lisa* and that Apollinaire possibly has knowledge of this gang, holds him for further questioning.

[September 11 or 18]
From Céret, writes to Kahnweiler (dated "Monday"; "1911" added by Kahnweiler):
Everything is under way. Work is proceeding fairly well and life is much calmer here than in Marseille. Now that Picasso has left, I have three studios at my disposal. I visited Figueras and on Sunday I am going on foot to Collioure. Thank you very much for the photographs. Don't you find them a bit dark? The fall is fully upon us [probably meaning the bad weather]. These days I have been working at home, but I am planning to go outdoors to do some landscapes.... I am continuing the Woman Reading *[p. 205], which I am executing on a canvas 60 [standard size 130 × 81 cm].... We are expecting cholera any day now.*

September 12
Writes to Soffici, in Florence:
I beg your pardon many times for not having written to you sooner, but with my travels and my return to Paris and after this business with Apollinaire that perhaps you know from the papers I haven't had time to write you. It's just now that I've found La Voce, *where I've read your article with emotion.*[111]

September 13
Paris-Journal announces the release, the previous day, of Apollinaire; the public prosecutor has realized that the charges against him were unfounded. The newspaper prints an interview with Apollinaire about the Iberian statuettes stolen from the Louvre; Picasso is not implicated.

September 14
Paris-Journal publishes "My Prisons," an article written by Apollinaire the day after his release. The same issue contains a colorful account of Géry Pieret's life history.

BRAQUE

[September 20 or 27]

From Céret, writes to Kahnweiler (on "Grand Café de Céret" letterhead, dated "Wednesday"; "1911" added by Kahnweiler): *Dear Friend, We are getting some pretty odd news from Paris down here and it's surprising to hear, out of the blue, talk of Apollinaire at an adjoining table. There's a lot of talk about war too these days, but I don't believe it.*[101]

I am working very peacefully. I have done a few still lifes and a Woman Reading, *60. I miss the collaboration of Boischaud in making my painted papers* [papiers peints].

This may be the first reference to Braque's paper sculptures (see text, p. 33, and text note 63). He continues:

I went to Collioure.... Upon arriving I ran into Matisse, who showed me his latest paintings.[102]

Henri Matisse in his studio at Issy-les-Moulineaux, 1909

[September 25 or October 2]

Writes to Kahnweiler (dated "Monday"; "1911" added by Kahnweiler): *Summer is coming to an end. I am painting a large still life and an Italian emigrant standing on the bridge of a boat with the harbor in the background* [Le Portugais (The Emigrant), *p. 211*], *and I hope that neither war nor famine will take the palette from my hands.*

Braque also informs Kahnweiler that he is in need of money, and is recovering from eight days of flu.[103]

PICASSO

September 21

Salmon publishes an article on Picasso in *Paris-Journal;* does not mention the Louvre scandal, and shows that the artist's activity has returned to normal:

[The decor of the studio on boulevard de Clichy is] picturesque and unexpected. On all the furniture strange wooden figures are grimacing, the most select pieces of African and Polynesian statuary. Long before he'll show you his work, Picasso will have you admire these primitive wonders. Affable and sly, Picasso, dressed as an aviator, equally untouched by praise or criticism, finally shows the canvases that collectors are looking for, which he has the slyness not to exhibit in any Salon. Here are the motley tramps of twelve years ago.... Over here at last are the latest works by which many find themselves less moved. All the more does he resist being called the father of Cubism, which he simply hinted at. To a young artist who asked him if one should draw feet in round or square, Picasso replied with great authority, "There are no feet in nature!" The other is still puzzling it out to the great joy of his mystifier.

In 1961, Kahnweiler will say that the person in question is Jean Metzinger.[112]

Autumn

Paints *Mandolin Player* (p. 132).

September 30

Article titled "The Cubists" published in the *Journal de Bruxelles:*

The current master is Mr. Pablo Picasso, whose work reveals the contradictory influences of Cézanne, van Gogh, and Gauguin. With an ingenious method, this disciple cuts into fragments the subjects that the great precursors invented and painted in new harmonies. As cut up and tottering as his "cubes" appear, they remain bound together by the old equilibrium. This holds up, as the art lovers say.

Advance review of the upcoming Salon d'Automne (October 1–November 8) by André Salmon appears in *Paris-Journal: Room VIII. The Cubists, once isolated skirmishers, engaged in their first pitched battle today. If it's true that Cubism was born of Picasso's speculations, Picasso himself was never Cubist. The first manifestations of Cubism, still quite indecisive (for we didn't*

BRAQUE

PICASSO

see today's fine solid cubes right away), came from Georges Braque, a few of whose examples created a sensation at the Salon des Indépendants.
Salmon refers to the Salon des Indépendants of either 1908 or 1909.

Apollinaire takes issue with Salmon's view in his report in *L'Intransigeant* (October 10), titled "The Exceptional Attention the Press Has Given Cubism Proves Its Importance." He writes:
Cubism is not, as the public generally thinks, the art of painting everything in the form of cubes. In 1908 we saw several paintings by Picasso depicting some simply and solidly drawn houses, which gave to the public the illusion of such cubes, and thus the name of our youngest school of painting was born.

Further commentary, by Henri Guilbaux, follows in *Hommes du jour* (November 11):
In L'Intransigeant, *Mr. Apollinaire extols Cubism.... To many people, and to myself in particular, Mr. Apollinaire has expressed very harsh opinions concerning Cubism. I met him before the opening of Room VIII. He was accompanied by the congenial and poker-faced Pablo Picasso, whose talent as painter, as a real painter, is undeniable. Both were sneering at the canvases in which were grouped cubes, cones, and tubes, and were expressing rather unfavorable opinions.... There are those who admire Mr. Apollinaire's talent for mystification, but I am not one of them; I do acknowledge Guillaume Apollinaire's education and hard work, but I question his right to contribute to the falsification of values.*[113]

[October 4]

From Céret, writes to Kahnweiler (dated "Wednesday"; "1911" added by Kahnweiler):
My dear friend, Received your letter and the photo. The photo came out very well. It's a good souvenir.... I've rented as a studio a very large old room. I've managed to work on a rather large painting (a nude); with God's help I think I can make something nice of it. Aside from that I've done three or four other paintings. I bought Paris-Journal *the day of the opening. That's all I know about painting in Paris. I paid a visit to the merchant of Negro art objects* [marchand de nègres]. *He told me that you had bought a head from New Caledonia. At the moment, he hasn't got anything.*

Mid-September–Early October

Alfred Stieglitz visits Picasso as well as Matisse and Rodin in their studios,[114] a "tremendous experience" that would inspire a special issue of *Camera Work* (summer 1912) devoted to Matisse and Picasso, with "word-portraits" of the two artists by Gertrude Stein.

BRAQUE **PICASSO**

[October 5 or 12]
From Céret, writes to Kahnweiler (dated "Thursday"; "1911" added by Kahnweiler):
Do all you can to send me the promised few hundred francs by the seventeenth of the month, for I will have to pay the hotel bill—besides, the season promises to be splendid! What publicity! Every day I have to contend with the inhabitants of Céret who want to see some Cubism....Work proceeds rather well and if I persist in my projects I'll stay here for a long time. I think I've already told you about a fairly large still life 50 [i.e., whose larger dimension is 116 cm].... I am continuing the Emigrant *[p. 211].*
Adds as a postscript:
I read a very profound article by E. Bernard on Impressionism in the Mercure.[104]

October 13
From Céret, writes to Marcelle Braque (on "Céret, Grand Café Michel Justafré" letterhead); says he is dining at Manolo's, and hopes she will be coming back to Céret:
I have worked again on my Woman Reading *[p. 205] and I am pleased.*

André Salmon publishes an article on Braque as part of his series of cameo portraits in *Paris-Journal:*
Is this not a black king (a giant king) come to bleach himself at the École des Beaux-Arts? Well, the bleaching wasn't enough. Georges Braque has gone to the bathhouses to wash himself clean of tradition. It is he who, if he didn't invent Cubism, is popularizing it—after Picasso, and before Metzinger. I don't think there is any painter who loves painting with a more violent love than does this good-hearted colossus, who hides a Bushman head of hair under an Ernest La Jeunesse–style Tyrolian hat. Lying down in bed at the hour of the siesta, Georges Braque, in his mind, piles up the cubes which will soon become a Man with a Violin *or a* Virgin Torso. *This practical painter willingly practices wrestling, skating, trapeze acrobatics, and each morning, before painting, he loosens up at the punching bag. A dandy in his own fashion, he buys Roubaix suits that were rejects from America by the dozen, saying that their long stay at the bottom of a ship's hold felicitously changes their fit and gives the fabric an incomparable suppleness.*

Marcelle Braque, 1911

BRAQUE

After October 13
Marcelle Braque writes to Braque, in Céret; says she intends to rejoin him there:
We could wait there for the month of January. I have not been to see the Picassos. Did you read the medallion in Paris-Journal? *[Salmon's cameo portrait of Braque appeared in* Paris-Journal, *October 13, 1911.] I am sending it to you in any case.*

[October 14]
From Céret, writes to Kahnweiler (dated "Saturday"; "1911" added by Kahnweiler):
I am perfectly well here and would like to stay as long as possible—until January. Could you send me 200 francs each month? I could send you, on the other hand, my paintings if you need them. I read the cameo about me in Paris-Journal; *it is not lacking in vividness. All that is missing is the accordion.*
Adds as a postscript:
Will you think of my rent[?] Thank you in advance.

October 17*
From Céret, writes to Kahnweiler; says he has received a letter from him.

October 31*
From Céret, writes to Kahnweiler:
My canvases were sent out yesterday.[105]

November 1
From Céret, writes to Kahnweiler (dated "Wednesday. All Souls' Day"; "1911" added by Kahnweiler):
I have discovered an imperishable white, like velvet under the brush; I am using it without restraint. While continuing work on my Woman Reading *and my* Emigrant, *I have started another still life.*[106]

November 6*
From Céret, writes to Picasso (letter with the wax-seal initial B.; dated "Sunday" [November 5]):
*Dear Friend, I've begun another still life 60 [130 × 81 cm]. There's an entire fireplace in it, with wood inside [*Still Life with a Violin, *p. 213]. I am also at present working on the pretty* Woman Reading, *of which, I believe,*

PICASSO

Late October or early November
Gino Severini takes Umberto Boccioni and Carlo Carrà to Picasso's studio.[115]

Eva Gouel (Marcelle Humbert), Paris, c. 1911

November
Probable beginnings of liaison with Eva Gouel (Marcelle Humbert), who until now has been Louis Marcoussis's companion. According to the testimony of Fernande (and Severini), the two couples meet at the Brasserie de l'Ermitage on the boulevard de Rochechouart, at the bottom of the butte Montmartre. It was there that one evening

BRAQUE

you saw the beginning. I was very happy that the large still life made a good impression on you. Sincerely yours, GB.[107]

November 13*
From Céret, writes to Kahnweiler:
The evenings are long. I miss my calls on rue Vignon [Kahnweiler's gallery].... At any rate, I hope that one day or another you will get to know Céret, now that you are in touch with Manolo. I am working on a still life 60 [possibly Still Life with a Violin, *p. 213].*

November 16
From Céret, writes to Picasso; tells "my dear friend" that he was in Perpignan the previous day; concludes:
And what are you up to? G. Braque.

[November]
Lost letter from Braque to Picasso (mentioned in Picasso's letter of November 22 to Soffici).

PICASSO

Picasso said: "One could do a very modern painting depicting Greek warriors."[116] Picasso takes a studio again at the Bateau-Lavoir, in which such pictures as *"Ma Jolie"* *(Woman with a Zither or Guitar)* (p. 210), and practically all the works done during the winter and early spring of 1912, are painted.

November 22
From 11, boulevard de Clichy, writes to Ardengo Soffici, in Poggio a Caiano; begs pardon for not having written sooner. He was waiting for Braque's return:
... in order to tell you what he thought of your paintings, as you had asked me, but he wrote to me that he'll be staying a little while longer in the south.[117]

November 23
Huntley Carter, "The Plato-Picasso Idea," in *The New Age* (London):
The New Age represents the new age. Picassoism is not of the new age, but in the new age.... As a clue to what Picassoism really is and to what little extent it is related to geometry, I may quote from a letter which Mr. Middleton Murray [sic] sent me while in Paris: "... Plato, who was a great artist and lover of art, did not turn artists out because he was a Philistine, but because he thought their form of art was superficial, 'photographic' we should call it now. There was no inward mystery of the profound meaning of the object expressed, so that the expression was merely a 'copy of a copy.' The fact is, Plato was looking for a different form of art, and that form was Picasso's art of essentials...." Thus the study... chosen for the purpose of Mr. Picasso from the Galerie Kahnweiler [Mandolin and Glass of Pernod,

BRAQUE

PICASSO

Daix 387], demonstrates that painting has arrived at the point when, by extreme concentration, the artist attains an abstraction which to him is the soul of the subject, though this subject be composed only of ordinary objects—mandolin, wine-glass and table, as in the present instance.[118]

November 24*
From Céret, writes to Kahnweiler:
These last days I have been working on my Woman Reading. *The painting is almost done. I've also done a still life…. I feel regret at the thought that in a month my stay will come to an end.*

November 30
In *The New Age*, John Middleton Murry comments on Huntley Carter's article in the previous issue:
I frankly disclaim any pretension to an understanding or even an appreciation of Picasso. I am awed by him. I do not treat him as other critics are inclined to do, as a madman. His work is not a blague…. As with Plato and Leonardo, there are some paths along which pedestrian souls cannot follow, and Picasso is impelled along one of these.

Picasso has done everything. He has painted delicate watercolors of an infinite subtlety and charm. He has made drawings with a magical line that leaves one amazed by its sheer and simple beauty—and yet he has reached a point where none have explained and none, as far as I know, have truly understood. Yet, he declares, "J'irai jusqu'au bout" ["I shall carry it through to the end"]. It is because I am convinced of the genius of the man, because I know what he has done in the past, that I stand aside, knowing too much to condemn, knowing too little to praise…. In the meanwhile, Picasso must needs wait for another Plato to understand; but the world will never have the strength to follow.[119]

Marie Laurencin, photographed by Picasso in his studio at 11, boulevard de Clichy, autumn 1911. Next to her is *Man with a Mandolin* (p.67).

December 7
Article "About Cubism" (on Braque and Picasso) by Henri Des Pruraux (a French critic living in Venice) and translated by Soffici appears in *La Voce* (Florence),[108] illustrated with two photographs of paintings by Picasso, *The Oil Mill* (Daix 277) and *Mlle Léonie* (p.158), and one of a painting by Braque, *Violin, Glass, and Knife* (p.176). This

December 8*
Apollinaire writes to Soffici, in Poggio a Caiano:
I would have gladly called attention to your article on Picasso and Braque in La France jugée à l'étranger, *but it had no appeal to those fine gentlemen from the* Mercure…. *You are unfair to the Cubists, not in the conclusions you reach, but at least in the particu-*

BRAQUE

article, together with Soffici's of August 24, would spur the newly formed Futurist group to address the French challenge in the preface to the catalogue of their introductory exhibition in Paris, in February 1912. Des Pruraux writes:

Thanks to A. Soffici, I no longer have to introduce the two masters of the new group, Picasso and Braque, nor to absolve them of any complicity with the idiots and charlatans who think they've done something very unusual and audacious whenever they break up their figures and landscapes by means of geometrical facets similar to those of carafe-plugs. I merely wish to develop a few reflections on the tendencies and possibilities of the new school on which the burlesque name of Cubism has been inflicted.

PICASSO

lar case that you make for Braque, who owes much more to Picasso than do the rest. As far as I'm concerned, here are the names of the most prominent personalities among the young new painters. I'll not write it in an article at the present time, but it's what I think. In alphabetical order: Derain, Dufy (for the little things), Marie Laurencin, Matisse, Picasso.[120]

December 9

Writes to Braque, in Céret; is worried because he has sent no news in a long time. Sends regards to Marcelle, who is with Braque. Says that he will send Braque the preface to a van Dongen exhibition catalogue (no doubt the exhibition held at the Bernheim-Jeune gallery, December 4–16, with a catalogue text by van Dongen). Picasso was probably impressed with van Dongen's comments:

For those who look with their ears, behold a naked woman. You are prudish, but let me say that the sexual organs are just as amusing as brains, and if one's sex was on one's face, in the nose's place (which might well have happened), where would modesty be then?[121]

December 12

From Poggio a Caiano, Soffici writes to Apollinaire, replying to Apollinaire's letter of December 8:

My Dear Friend. I am very happy you have enjoyed my book [on Rimbaud, of which Apollinaire has written a notice in L'Intransigeant*].... Thank you. About Cubism and painting I see we agree more than I thought because your five names are exactly the same that I would have written. You see we could not agree more. And now, my dear Apollinaire, I would like to offer you a deal.*[122]

In a postscript, Soffici adds:

I forgot to tell you that Des Pruraux exists. He is a French painter, not very talented, but very intelligent, and lives in Venice, 1038 St. Trovaso. It is true that I translated his articles and perhaps I put a bit of my style, which has misled you. I do not share all his opinions.

(See December 7, for Des Pruraux's article in *La Voce*, translated by Soffici.)

BRAQUE

PICASSO

December 21

The newspaper *Le Supplement* prints an anecdote, "Les Cheveux du peintre" (printed in three other newspapers between November 1911 and January 1912), which associates Braque with Félix Mayol.

Mayol, a popular *café-concert* singer renowned for a series of *danses chantées*, was then at the height of his celebrity as a "singer with a comic charm" and successful enough to have purchased in 1910 the Concert Parisien, a *café-concert* he renamed Concert Mayol. He had an unmistakable silhouette, widely known through billposters and photographs.[109]

The newspaper stories are all variants of the following:

Quite recently, the painter Georges Braque— a likable giant whose Cubist compositions are the subject of debate—had to fulfill an obligatory twenty-three-day period of service in the military. Upon his arrival at his company, the captain noticed his longish hair—not too long, of course—and invited him to visit the barber at once. Georges Braque, however, not too keen about the idea of returning to civilian life with too military a coif, decided to keep his hair, which pleasantly complements his overall appearance, and did not go to the barber's. The captain insisted, and ordered an immediate shearing.

But the painter heroically did not hesitate to resort to lies in order to keep his hair:

"Captain, sir," he explained, "I lied to you. I'm not a painter, but a singer. I sing songs by Mayol; my hair is my bread and butter. If I go back to Paris without it, I won't find any work. Please let me keep my hair…."

And the captain, touched, gave the painter permission to leave his hair just as it was.[110]

Cover of sheet music for Félix Mayol's song "Voilà Pourquoi!" 1911

December 27

From Céret, writes to Kahnweiler (dated "Wednesday December 27"; "1911?" added by Kahnweiler):

My stay is coming to an end. I will be in Paris on January 15 at the latest.

Says he is finishing a still life format 50 and two other ones; continues:

My Woman Reading *is also proceeding. I will have to finish the guitarist* [Le Portugais (The Emigrant), *p.211] in Paris. Anyway, you will soon see all this.[111]*

BRAQUE

PICASSO

1912

Picasso, photographed by Pablo Gargallo in Gargallo's studio at 45, rue Blomet, 1912

January 1*
From Céret, writes to Kahnweiler:
Best wishes.

January 12*
From Céret, writes to Picasso:
My dear friend, I'll be back in town next Friday. With all affection.

From Céret, writes to Kahnweiler:
I am leaving the sun next week. I expect to be in Paris on Saturday.

January 19
Returns to Paris, bringing the finished painting *Le Portugais (The Emigrant)* (p. 211), which contains the first Cubist use of stenciled *(pochoir)* letters; *Homage to J. S. Bach* (p.215), his first work using simulated woodgraining (both of these techniques having been learned in his training as a *peintre-décorateur*); and possibly some early paper construction sculptures (see text, p.33).

January 26*
From Le Havre, writes to Marcelle; they have moved to 5, impasse de Guelma.[112] Returns to Paris, January 28.

January 1
Paris-Journal presents a review of the year 1911, "un coup d'oeil en arrière. Ce que fut 1911 à travers les lettres, les arts, les sciences et la politique," consisting of opinions and statements gathered from well-known figures in literature, the arts, sciences, and politics. Under the heading "Les Arts plastiques …M. Picasso," the artist explains his views:
 "Say that everything is going very well, very well, all these gentlemen are very happy, and I too am very happy. We are all making progress. Me, I am for progress."
 "But what about Cubism?"
 "There is no Cubism."
Mr. Picasso states this just as old Ingres had proclaimed: There is no black in nature.
 "And yet, without you…"
 "Well, what about without me? I've never heard these gentlemen say anything of the sort. Excuse me, 'El Mono,' he's hungry." And Mr. Picasso shows us his favorite monkey.[123] *There are some people who will not find Mr. Picasso's remarks enigmatic.*

January 9
Apollinaire writes to Soffici:
Don't you think that for an artistic concept to be able to impose itself, it is necessary for mediocre things to appear at the same time as sublime ones? In this way one may measure the extent of the new beauty. This is why, for the sake of great artists like Picasso, I support Braque and the Cubists in my writings….[124]

Mid-January
Founding of a new review, *Les Soirées de Paris,* by a group of Apollinaire's friends, including André Billy and André Salmon.

[January–February]
Gertrude Stein and Alice Toklas go to visit Picasso in his Bateau-Lavoir studio; not finding him in, Stein leaves her calling card. Returning a few days later, they discover Picasso at work on *The Architect's Table* (p. 216), on which he has written MA JOLIE and at the lower corner painted in Stein's calling card. Gertrude purchases the picture in the spring of 1912, her first Picasso acquisition independent of her brother.[125]

BRAQUE

PICASSO

March 1
Publication of *Du Cubisme,* by Albert Gleizes and Jean Metzinger, is announced in *Revue d'Europe et d'Amérique.*[126] Its publication is announced again in *Paris-Journal* (October 26), but the book is probably not actually issued until late November or early December.

March 19
Writes to Gertrude Stein:
I've just seen Kahnweiler and don't want to give him the still life [The Architect's Table] *for less than 1,200 francs.*

Spring
Man with a Violin (p. 223) and the circular still life *Soda* (p. 224) are made around this time.

March 20–May 16
At the Salon des Indépendants, Juan Gris exhibits his *Portrait of Picasso* (Cooper 13). Vauxcelles, in *Gil Blas,* christens it "Père Ubu–Kub." Picasso later sends Kahnweiler a review of the Salon from *Le Sourire* (Thursday, April 4), which comments:
The Cubists have courageously changed weapons after having liquidated their last cube.[127]

Frank Haviland, photographed by Picasso in his studio, winter 1911–12. Right background, Picasso's *Fishing Smack at Cadaqués* (p. 163); top center, Matisse's *Marguerite* (Flam 220); mid-center, behind Haviland, Picasso's *Shells on a Piano* (Daix 461) in progress

Before April 25
Accompanies Braque to Le Havre; returns to Paris, April 28.

April 15
In an interview by Jacques des Gachons with Kahnweiler published in *Je sais tout,* Picasso's *Clarinet* (p. 197) is reproduced next to Braque's *Pedestal Table: "Stal"* (p. 228).[113]

April 25
Interview with Picasso by Max Pechstein published (in German) in *Pan,* titled: "What Is Picasso Up To?"[128]

April 26[*]
From Le Havre, writes to Marcelle:
Written before we [he and Picasso] go to sleep. We shall return Sunday evening. In Rouen we tried to pay a visit to Vlaminck, but we did not find him.[114]

April 27*
From Le Havre (Café de la Poste), writes to Marcelle:
Our stay ends tomorrow night. We'll be back at 11:50 P.M. Picasso and Fernande agreed to meet at the Fox.... Tomorrow we are going to Honfleur. This morning, I awoke Picasso with the sound of the phonograph. It was charming. I am thinking of the month of June, when we'll be here together.

April 30
Writes to Gertrude Stein (on "Taverne de l'Ermitage" letterhead); tries to arrange a day for her to come and see him; tells her:
Monsieur Kramar saw your still life Ma Jolie [The Architect's Table]. *He loves it.*[129]

[April]
Writes to Gertrude Stein:
I have received your letter. I had told you that we would be having dinner Thursday at Haviland's. I told Braque that we are not going to your place on Wednesday. So when, then?

BRAQUE

The engraver Gonon and Braque in Braque's
studio at 5, impasse de Guelma, 1912

PICASSO

Early May
About this time, completes *Still Life on a
Piano* (p. 215), begun the previous summer
at Céret, adding the letters CORT by the sten-
ciling technique *(pochoir)* that Braque had
taught him early in the year after having
introduced such letters in some of the pic-
tures he brought back with him from Céret
in January.

Paints two oval canvases full of allusions to
his trip to Le Havre with Braque—*Violin,
Wineglasses, Pipe, and Anchor* (p. 221) (in
which he also alludes to *Les Soirées de
Paris*) and *Souvenir du Havre* (p. 219). In the
latter he paints the French flag in Ripolin
enamel. These paintings carry on a dialogue
with Braque, not only in that they evoke the
trip the two took together, but also because
in *Souvenir du Havre* Picasso first uses sim-
ulated wood *(faux bois)*, employing a steel
comb, a method Braque had instructed him
in.[130] Severini was in the Bateau-Lavoir
studio when Braque first saw these works;
according to him, Braque was astonished
(probably by the high coloring Picasso had
introduced into his painting), then retorted,
in a tone that was half sour, half sweet: "The
weapons have been changed." Picasso said
nothing, however, continuing to fill his pipe,
with a typical smile that might have meant,
"A fine joke, eh?"[131]

Makes the first collage, *Still Life with Chair
Caning* (p. 229).

May 9
In an open letter in *Pan,* Max Raphael replies
to Max Pechstein's article of April 25 and
comments on the return of pure color in
Picasso's painting; concludes:
*It is my firm conviction that Picasso's art
must have as its consequence a new aesthet-
ics and new attitude to life.*[132]

May 18
Writes to Braque:
*Fernande ditched me for a Futurist [identi-
fied as "U.O." (Ubaldo Oppi) by Severini].*[133]
What am I going to do with the dog?
Says he's going to be away from Paris a while
and asks Braque to take care of the dog Frika
for a few days; concludes:
Best regards to Marcelle.

BRAQUE

PICASSO

May 20
From Céret (Grand Café), writes to Kahnweiler:
Concerning the dogs, I've asked Braque to send Frika to me. As for the other animals— the monkey, the cats—Madame Pichot will take them, she told me. You'll have to make a package of the canvas rolled up at rue Ravignan and the panels, and send them here to me (at Manolo's address). The canvases at rue Ravignan, which are only drawn in charcoal (the violin too) you should have fixed by Juan Gris.... As for the other paintings I have to give you, I'll write to you about that. I have to think about it.... Manolo is working hard, as Déodat de Séverac says. He has a splendid house with a metal gate like the one at the Ministry of the Interior...and he also has an operating table and a whole lot of surgical instruments.... For the time being, do not give my address to anyone.[134]

May 21
From Céret, writes to Braque:
Don't tell anyone I am here.
The letter is mostly about having Braque ship the dog Frika to Céret, to Manolo's house.

May 22
From Céret (Grand Café), writes to Kahnweiler:
The other paintings that have only been sketched in can be left at rue Ravignan. We [he and Eva Gouel] are indeed together, and I am quite happy. But say nothing to anyone.[135]

May 24
From Céret, writes to Kahnweiler:
I received your letter and Braque's letter yesterday.... You must also send me the paintbrushes that are at rue Ravignan, the dirty as well as the clean ones, and the stretchers that are there....The palette from rue Ravignan too, you must send me. It's dirty. You should wrap it in paper together with the stretchers, the [stencils for] letters and numbers and the [metal] combs for making faux bois.
As for the paints, you must send those from rue Ravignan and those from boulevard de Clichy. I shall tell you where they are, and shall give you the list (actually, I'm embar-

BRAQUE

PICASSO

rassed to have to trouble you so). In the large armoire and on the workshop table, there are the paints. Send me the tubes of white, ivory black [noir d'ivoire], burnt sienna, emerald green, Verona green, ultramarine blue, ocher, umber, vermilion, cadmium dark or rather cadmium yellow [cadmium citron]. I also have blue, Peruvian ocher [ocre de Perou].… I prefer to have all my paints here; I may also use the white, but I need them all at my side.

The last etching is in the studio. You must have already seen it. I'm still thinking of having a name engraved on a calling card. But you should send me one of the two proofs so I can draw for you the exact place where you should have the letters engraved by a professional engraver, by an engraver of calling cards.

Send me only three or four tubes of each of the colors, but send me all the white, and do not forget to send me a bottle of siccative and a packet of charcoal crayons (to Manolo's address, of course). I am still at the…hotel, but I've rented the house that Braque and I had last year.[136]

D.-H. Kahnweiler in his apartment, rue George-Sand, 1912

May 25
From Céret, writes to Kahnweiler:
I need sheets, pillows, bolsters, blankets, my linen, and my yellow kimono with flowers. I'm not sure what you'll have to do to arrange all this, but I've more faith in you than in myself.…[137]

From Céret, writes to Braque; says Frika has finally arrived:
She's the talk of the town.

May 29
From Céret, writes to Braque:
I await your letters. You know how pleased I am to hear from you.
Has taken the things (such as old stretchers) Braque left last year at Haviland's studio; Kahnweiler is taking care of Picasso's business in Paris.

BRAQUE

May 30
Wilbur Wright dies, in Dayton, Ohio. Wright's given name, transformed into "Wilbourg," was used by Picasso as a nickname for Braque, while Braque occasionally signed himself "Wilburg." See August 11, 15, and 16, 1912.

June 2
From Le Havre, writes to "M. Picasso (Peintre)," in Céret:
I'll be here for a few days. All the best.
Is in Le Havre for the First Communion of his nephew.

PICASSO

May 30
From Céret, writes to Braque:
My dear friend, I've just received your letter containing the opinions of those gentlemen and there are some really good ones. Juan Gris's is admirable and I can imagine what the others must have thought.
Goes on to recount how he thought that one of the *Notre Avenir est dans l'air* paintings (Daix 465) had been lost, but it was found hanging on the wall in the spot where he had left it; continues:
But I miss you. What's happened to our walks and our [exchanges of] feelings? I can't write [about] our discussions [on] art.

May 31
From Céret, writes to Kahnweiler:
Braque tells me that Markus [Marcoussis] has given you, or rather, should have given you, a receipt for the storage of Marcelle's [Eva Gouel's] things, and if that is the case, please be so kind as to send it to me. Give my regards to Max [Jacob].

June 1
From Céret, writes to Kahnweiler:
I really need my painting things. Manolo has given me some paints, but I've been working only with green made out of cobalt blue, vine black, mummy brown [brun mommie], and cadmium light, and I have no palette. Terrus has lent me an easel.... In spite of everything, I'm working....[138]

June 5†
From Céret, writes to Braque, in Le Havre:
My kindest regards to your family and best to you.

Long business letter to Kahnweiler (which crosses with a letter from Kahnweiler of June 6, asking Picasso to identify which works he considers finished, so that Kahnweiler may have them at his disposal).[139] Picasso enumerates the paintings left in his studios at boulevard de Clichy and rue Ravignan that he can release for sale to Kahnweiler, with indications of prices; the other paintings mentioned by Picasso (without prices) are "not presentable yet" and evidently not to be removed.[140]

BRAQUE

June 6
Returns to Paris from Le Havre.

Before June 12
Lost letter from Braque to Picasso (mentioned in Picasso's letters of June 12, to Kahnweiler, and June 14, to Braque).

PICASSO

June 6
From Céret, writes to Kahnweiler:
I've been working and it's not going badly at the moment. Braque is at Le Havre, as you know. I've received a few postcards from him. He has to dance with sailors at the Scandinavie Bar and at St. Joseph. I believe he went for the First Communion of his little nephew.

June 7
From Céret, writes to Kahnweiler (with "Maison Delcros" letterhead drawn in ink by Picasso):
I think that someday soon you'll have to send me a large copperplate. I'm thinking of doing a man I saw playing the bagpipes on Sunday, but none of this is really settled yet. … My studio has already gotten some character. It's already becoming my own, and I've got plenty of room. The letter I received from you yesterday was from an American girl who would like to see me before going back to America, because her father is doing criticism on the art of painting. Her [last] name is Bill. Is she the daughter of Buffalo Bill?

June 10 or 11
From Céret, writes to Kahnweiler:
I received my jerseys and the print. I don't think it's very well done.
Is alarmed because he has heard that the Barcelona newspapers
… have said that I'm here. And that jackass Pichot wrote to someone here to find out if I was in Céret. A useless effort, since no one will write back to him.

June 12
From Céret, writes to Kahnweiler:
I have bad news from Paris. Braque wrote to me yesterday and tells me he met Pichot at Wepler's [a large café in place Clichy] and that he [Pichot] told him that he, his wife, and Fernande were thinking of going … to Céret to spend the summer there, and that he was going to write to someone here to find out if I was here (as I already told you). I am very annoyed by all this, first of all because I do not want my great love for Marcelle to be disturbed in any way by the trouble they might cause me, and neither do I want her to be bothered in any way; and finally, I must have peace in order to work. I've needed it for

BRAQUE

PICASSO

a long time. Marcelle is very sweet, I love her very much and I will write this in my paintings. Apart from all that, I've been working hard. I've done quite a few drawings and have already begun eight paintings. I believe my painting has been gaining in robustness and clarity.... With all these complications, I may need to have—in case I need suddenly to leave, one never knows what might happen —a reserve of 1,000 or 2,000 francs. I should not want to be prevented from leaving for a matter of a few sous.... And if you should see Fernande, you can tell her that she can expect nothing from me, and I should be quite happy never to see her again.... And do tell me if the book on painting by Metzinger and Gleizes has come out yet.

Also tells the story of the Shchukin painting and the "fourth dimension" (see September 1908).

June 14
From Céret, writes to Braque:
You'd be very kind to keep me up on the news [in Paris] that might interest me. I'm writing no one except you and K[ahnweiler] for my business, and I get no letters except from you, and I'm very happy when you write me, as you well know.
Closes:
Keep being discreet.

June 15
From Céret, writes to Kahnweiler:
I'm working and the paintings are progressing. If I had my camera, I'd soon send you photographs of their different stages.... Inside [the camera], there are still a few plates to be developed, which I took of myself in front of the mirror.

June 17
From Céret, writes to Kahnweiler:
I've written to Braque that I'm not at all disturbed by his letter; on the contrary I'm very touched that he warned me [about Pichot], and you know how much I like him. You tell me that Uhde does not like my recent paintings where I use Ripolin and flags. Perhaps we shall succeed in disgusting everyone, and we haven't said everything yet....

BRAQUE

PICASSO

June 19
From Céret, writes to Kahnweiler:
I've learned from reliable sources that Fernande will come here with the Pichots and it goes without saying that I need some peace. I even have a right to it. And I'm going to leave here. I have a lot of different places in mind. I'm very bothered to have to leave this place; it's been good to be in a large house where I've had space, and I've liked the countryside. …And my painting is going well. I have two or three things that are finished or almost finished (if I see that they are done I'll send them to you) and I've begun others that I'll continue wherever I go.

June 20
From Céret, writes to Kahnweiler:
Tomorrow I shall leave here for Perpignan, but don't tell ANYONE, ANYONE AT ALL *where I shall be.… I shall definitely send you the paintings.… I think they're not bad. Tell me if you like them. There are three of them. The largest one is a resting* [couché] *violin with the inscription* JOLIE EVA *on a score [p. 234].*[141] *And then there's a still life from the hotel manager Duerda's place, with some letters, mazagran, armagnac, and coffee on a round table, a bowl of pears, a knife, and a glass [Daix 475]. The other still life: Pernod on a round wooden table, a bowl of pears, a knife, and a glass with grill and sugar and a bottle with Pernod Fils written on it against a background of posters: Mazagran, Café, Armagnac 50 [Daix 460]. Haviland and Manolo will take care of sending them.… I have just received the photographs and I'm very happy with them. They are beautiful and prove me right. The Ripolin enamel paintings, or Ripolin-like paintings, are the best ones. Truly, some of these paintings aren't bad at all. And now that I see the ones I'm going to send you, I think they're not bad.…*[142]

June 21*
Writes to Picasso, in Céret (forwarded to Kahnweiler at 28, rue Vignon, Picasso having already left); tells a joke about Puvis de Chavannes.

[June 21 or 23]
Writes to Kahnweiler while on trip to Perpignan and Avignon, going as far as Sorgues, in the northern suburb of Avignon.

June 23
From Avignon, writes to Kahnweiler (on "Rick Tavern" letterhead):
I have found a house with a small garden

BRAQUE

PICASSO

and an upholsterer has sold me furniture. On Tuesday I shall begin to move in at last....
This evening I'll go to the theater to see Sarah Bernhardt in La Dame aux Camélias.

June 25
From Sorgues (Hôtel du Midi), writes to Kahnweiler; says he has encountered a friend from Montmartre on the staircase of a hotel in Avignon:
I never knew his name; he was delighted to see me and wanted to introduce me to everyone. And yesterday in a restaurant I saw Girieud and Dufrenois come in, and later Séverac and everyone else we know....
I promised everyone to go to Marseille with Braque soon.

June 26
From Sorgues (Villa des Clochettes), writes to Kahnweiler:
Tell Braque that I'm writing to him, BUT DO NOT GIVE MY ADDRESS TO ANYONE. *Here in Avignon I've told everyone that I'm leaving for the town of Carcassonne.*

June 27
From Sorgues (Villa des Clochettes), writes to Braque; says he thought it was just as well to leave Céret, has again changed locality, has been in Sorgues for several days, and has rented a little house:
You will see when you come.
Continues that he plans to go to Nîmes on July 7 to see a bullfight. Explains how bothered he is by having to leave all his canvases unfinished, as it is so difficult to resume work on them after arriving in another place. Intends to begin other canvases and to go back to those he started in Céret when he is more accustomed to the region. Is counting on Braque's letters and on his visit. In an allusion to Buffalo Bill, he signs:
Your pard, Picasso.

June 29
From Sorgues, writes to Kahnweiler:
Did the paintings from Céret arrive? If not, I'm going to yell at Manolo.... It would not have been bad if you could have shown them to Kramar. As for me, I'm already working and you know my way of working. I've already begun three paintings. An Arlé-

BRAQUE

June–July

An avid Futurist interest in Braque and Picasso appears to exist; Boccioni, in Milan, writes to Severini, in Paris:

Get all possible indications on Braque and on Picasso.... Go to Kahnweiler's and if he has photos of recent works (done after my departure) buy one or two of them. Bring us all the information possible.[115]

D.-H. Kahnweiler and his wife, Lucie, in their apartment, rue George-Sand, c. 1912–13

PICASSO

sienne *[Daix 497], a still life, a landscape with posters [p. 235]. Tell Braque that I've written to him and to write me to tell me when he thinks we'll see each other.*[143]

July 3

From Sorgues, writes to Braque; says that he has received Braque's letter with the joke about Puvis de Chavannes; there follows a series of word plays on the name of (Vincenc) Kramář, who is in Paris at the time and has gone to see Kahnweiler; concludes:

All my best to Marcelle. How is your work going? As for me, I am working.

From Sorgues, writes to Kahnweiler:

As to the furnishings from rue Ravignan, I mean the easel I'm very attached to, I've had it for a long time and I'm used to it, and the sculptor's turntable—if you don't think it wise to put them in the boulevard de Clichy house [since Fernande may want to reoccupy the apartment], then yes, put them into storage, or if Braque would be so kind as to keep them for me, then they can be brought to his place.... Tell me if Kramar has taken the recent Ripolin paintings; I imagine he might have. I am curious to know which ones (and it's not a bad idea still to keep the Poet *[p. 201])....*[144]

July 4

From Sorgues, writes to Kahnweiler:

Let's hope that Manolo doesn't leave my letter lying about and that Germaine Pichot can't figure out my whereabouts. I need peace. I need to work, I shall not write to Manolo anymore, but you must tell him to be careful. I'm working. As I've told you, I've begun new things. I must leave off working on the Céret paintings and did well to send you the other ones that I probably would have ruined had I continued them right away. Here I've begun a still life and done a fair amount of work on a landscape with a factory, houses, billboards [p. 235] and the head of an Arlésienne *[Daix 497], and a canvas of about 60 marine of a man [p. 239]. The light is beautiful and I can still work in the garden.... Write to me, for I need to get letters from friends.... Tell Max Jacob that I love him very much and not to worry if I don't write to him.*[145]

BRAQUE

PICASSO

July 6
From Sorgues, writes to Kahnweiler (who has acknowledged receipt of the Céret paintings):
So, you like them. I would have worked them further, but I was afraid that in moving I'd ruin them. Yes, tomorrow I plan to go to Nîmes to see a bullfight and like you I think I'll have a good time. Don't put black frames on these paintings, they must have gold.... Braque will tell me how the paintings I sent you look in Paris. It's always astonishing to see them when we've come back....[146]

July 9
From Sorgues, writes to Kahnweiler:
I was in Nîmes and saw the bullfight. It's so rare to find an art that is intelligent about itself. Only Mazantinito did anything of note, but in spite of it all the fight was pleasant and the day beautiful. I love Nîmes.... You did well to have my recent Céret paintings signed by Boischaud. I forgot to do it before I left. Here the weather is fine and the fig tree in the garden gives excellent figs.[147]

July 10
Writes to Picasso, in Sorgues; tells his "dear friend" that he has seen Picasso's paintings at Kahnweiler's; finds them very handsome, especially *Violin: "Jolie Eva"* (p.234), which seemed to him outstanding; hopes to find much more of the same in Sorgues; concludes:
I helped Max [Jacob] move out—Best regards, G. Braque.

July 10
From Sorgues, writes to Braque; tells him about the bullfight at Nîmes on July 7 and that he's been spending time with bullfighters:
I'm already waiting for you, and I hope I shall soon have the pleasure of seeing you. Kahnweiler told me you've seen my paintings from Céret. You must tell me what you think of them, especially of the biggest one, the one with the violin [p. 234], whose intentions I'm sure you've understood.... I have transformed an already begun painting of a man into an aficionado [p. 239]; I think he would look good with his banderilla in hand, and I am trying to give him a real southern face. Write to me and work hard to finish your paintings. Regards to Marcelle and best to you. Your Picasso, Spanish artiste-peintre.
In a postscript, asks Braque to buy him a blue suit similar to the ones they had bought together. Gives the size number and other measurements, accompanied by two sketches. (See Salmon's cameo portrait of Braque, October 13, 1911.) Braque is in the habit of buying ready-made blue cotton suits

BRAQUE

PICASSO

at La Belle Jardinière which he and Picasso referred to as "Singapore" suits. These costumes have an American style, which they like.[148]

July 11
From Sorgues, writes to Kahnweiler; says nothing is new, and that he's continuing to work, doing violins that now are white, sometimes with a black border. He is continuing two still lifes that he had begun in Céret. Braque has written; Picasso received his letter this morning:
…he speaks most favorably of the paintings that I sent you from Céret….[149]

July 12
From Paris, Kahnweiler writes to Picasso:
Shchukin is in Paris. As you know, he didn't want to buy the painting.[[150]] *He insisted on buying the other, the one I didn't want to sell. And so—the flesh is weak—I let myself be tempted. Did I do the right thing? Was it a mistake? As far as business is concerned I don't think I could have acted otherwise. I sold it for 10,000 francs.*[151]

July 15
From Sorgues, writes to Kahnweiler:
… It's a good price, but I'm not so sure that it was all that good to sell it… but I realize that you couldn't have done otherwise. I would be very happy to see the photographs of the Céret things and the others… I imagine that you showed Shchukin the other things. What must he think of Ripolin and the lettering?

July 17
From Sorgues, writes to Braque:
I have told Kahnweiler that if you felt like it you could bring along my "photography machine" when you come to Sorgues.

From Sorgues, writes to Kahnweiler:
If you go to boulevard de Clichy one of these days, please get my camera, in the back room, and have Morlin develop some of the plates inside it, and send it to me as soon as possible or Braque should bring it to me.

BRAQUE

PICASSO

July 25
From Sorgues, writes to Kahnweiler; says he went to the cinema in Avignon on Sunday afternoon and saw the Carpentier-Klaus fight.[152]

July 26
From Sorgues, writes to Braque:
My dear friend. This morning I received your letter and the song by Bernard Emile.... You are satisfied with your work and that makes me happy. It's so rare that one is a little sure of oneself.... I am counting on your coming soon to visit. All the best to Marcelle, and all the best to you, dear friend. I shake your hand. Picasso.[153]

July 29
From Sorgues, writes to Braque:
... I am waiting for your visit and I am working.

Late July–Early August
Braque and Marcelle arrive in Sorgues. Braque goes with Picasso to Marseille, August 9.

In Sorgues, Braque will make more paper sculptures which, he will later say, led him to the invention of *papier collé* (see text, p. 30).

Late July–Early August
Due perhaps to the presence of Marcelle Braque, begins to call his companion, Marcelle Humbert, by the name Eva.

August 9
Goes with Braque to Marseille; commemorates the visit with a drawing inscribed "souvenir de marseille 9 aout 1912" (Zervos II, 754). During the trip, probably acquires an Ivory Coast "Wobé" (now known as Grebo) mask (private collection); it is one of two Grebo masks he owned, the other one (Musée Picasso, Paris) probably acquired earlier.[154]

Braque, Marcelle Braque, and their dog Turc (a gift from Picasso), Sorgues, summer 1912

August 11†
From Marseille, writes to Kahnweiler, in Arolla, Switzerland:
After buying all the African sculptures and showing Picasso the city, I am returning to Sorgues where I will be settling down. I am eager to work.

August 11
From Sorgues, writes to Kahnweiler (letter inscribed "Sorgues, Sunday the 11th of August of the year A.D. 1912"):
My dear friend, I have not written you for many days, but Braque and I have taken so many walks and talked so much about art that time has passed quickly. We spent two days in Marseille. Wilbourg Braque wanted to look for a house in L'Estaque, or in another place near Marseille, but he came back to Sorgues and rented a house. We bought Negro art in Marseille and I bought a

BRAQUE

PICASSO

fine mask, a woman with huge breasts and a young boy. Here I am now, once again at the work that I had forsaken for at least a week, full of new vitality.... One of these days I shall send you photographs of the Negro art I bought.[155]

August 15
From Sorgues, writes to Kahnweiler:
I'm making progress on all the paintings I've begun, and I'm drawing. Wilbourg Braque has already settled in. He is living on the Japanese farm. And painting? You must let me know if you're working. Nothing else is new, except that I'm parting my hair in the middle. I bought the toothbrushes that I told you about. I recommend them to you. If you were a smoker, I would also recommend the pipes from Marseille.[156]

[August] 16
Writes to Kahnweiler (dated "Friday 16"; "1912" added by Kahnweiler):
I have settled in here now after looking around Marseille, although not much, I admit. I returned to Sorgues. It is in Provence and that is sufficient for me. I live in a Japanese farm with good old whitewashed walls like in France. Picasso and I are spending pleasant evenings by the fire. All that is missing is Prince Borghese. We bought some African sculptures in Marseille. You will see, they are not bad. I have begun working, and I have done so with joy, for I had not touched a brush in ten days. I have started a figure and a still life, but allow me to be discreet (as Massenet used to say). And you are painting; isn't it difficult? Your Wilburg Braque. Villa Bel-Air, Route d'Entraigues, Sorgues. Vaucluse.[116]

[August 18]
Writes to Kahnweiler (dated "Sunday"; "1912" added by Kahnweiler):
I had written to you last Sunday, but I had forgotten to write Arolla on the envelope. As a result, the letter came back to me.
Continues that prior to his departure he brought to the gallery the small canvases and drawings,
...along with the large oval canvas which was unframed.... I am very happy to be in Provence. During the first days here, we had some very heavy thunderstorms and Picasso had to sleep in his bed with an open umbrella.

August 21
From Sorgues, writes to Kahnweiler:
It's vacation time and I've noticed you don't write often. This winter I plan to go work in Céret if the house that I had there is still for rent; but before that I think I should try to take care of business at boulevard de Clichy, to be done with it, since you have taken a lease and I don't know what to do to be rid of the rent. Therefore I think I'll be in Paris at the beginning of next month (don't you think it's high time I put my affairs into a little order?). Aside from all this, my work is progressing. I've even tried my hand at fresco on one of the walls of the house, and now I'm quite bothered that I'll have to leave it here unless I cut down the wall [Daix 486].[157]

On or After August 24
From Sorgues, writes to Kahnweiler (dated "Saturday"; "1912" added by Kahnweiler):
Not much that is new in Sorgues. We are having a most complete calm. Picasso and I do a lot of cooking. The other night we had ajo blanco, a Spanish dish, as its name indicates. We very much regretted your not being

BRAQUE

here to share this dessert-like soup with us. …We have not had good weather, but I do not feel so bad when I think about what you are having in Paris. I am working well and taking advantage of my stay in the country to do things that cannot be done in Paris, such as paper sculpture, something that has given me much satisfaction.…The ajo blanco is a powerful insecticide; it is used successfully against flies.…[117]

September 3–13

Makes *Fruit Dish and Glass* (p. 244), the first *papier collé*. Later recounts that while he was walking around Avignon, his eye was caught by a roll of paper printed as *faux bois* (imitation oak-grain) displayed in the window of a wallpaper shop, and he thought how it could be useful to him. Having waited until Picasso left for Paris (to organize his move to a new studio), Braque bought some of the paper and completed *Fruit Dish and Glass*, and probably one or two other *papiers collés*, before Picasso's return.[118]

September 11*

From Sorgues, writes to Kahnweiler:
Wholeheartedly with you.

[September 16]

From Sorgues, writes to Kahnweiler (dated "Monday"; "1912?" added by Kahnweiler):
Since my arrival I have been working on a rather large canvas (160 cm) of a woman [now lost], on which I introduced painting with sand. I also made a violin and another woman with a violin, some small still lifes, and have begun some others.[[119]*] Picasso told me about his trip to Paris and his encounters. Everything seems to have gone very well and I am quite happy for him.… For the exhibition in Amsterdam,[*[120]*] I sent something before I left. I knew that you did not want to show there, but why be sulky with people who only wish us well and who are giving me a place of honor?… They asked me for ten canvases. I sent one; moreover, it is a canvas that you did not want, the landscape of Carrières Saint-Denis.*

PICASSO

Early September

Goes to Paris to put his affairs in order. Returns to Sorgues; writes to Kahnweiler (September 17):
…ask the concierge if all is ready for me to move immediately [from the apartment on boulevard de Clichy]. Then I shall come to Paris and will look again and will inevitably find something, for I can't last much longer. Nothing else is new except my cold.[158]

September 18

From Sorgues, writes to Gertrude Stein:
My dear Gertrude. I've received your book, which unfortunately I'm unable to read, but in Paris I'll have someone translate it. In any case, the reproductions are very beautiful. I thank you for all that, and for your dedication.

I'm not sure I won't be forced, because of the moving, to return to Paris before the Nîmes race. In any case, I'll write you beforehand.

The day of my departure, at Kahnweiler's, I met Mr. Shchukin, who bought another large picture, much like the large, red-style painting at your place. He doesn't understand the more recent things.[159]

Paintings by Picasso arranged in front of the Villa des Clochettes, Sorgues, summer–early autumn 1912. Top, left to right: *Guitar* (p. 248), *The Poet* (p. 236), *Guitar* (p. 249). Bottom, left to right: *The Aficionado* (p. 239), *Man with a Guitar* (Daix 495), *Artist's Model* (Daix 498)

BRAQUE

[September 19 or 26]
Writes to Kahnweiler (dated "Thursday"; "1912?" added by Kahnweiler):
Your amazement seems exaggerated to me. I must tell you, however, that mine has not been any less when you told me that the price of one hundred francs nauseated you. Now, you are asking me not to do any business without your involvement. And thereby you deprive me of the means to recoup somewhat for the rather modest prices you give me. You do not really compensate for your demands. …You must understand that even with respect to this exhibition the reasons of your abstention are not as foreign to me as you seem to believe.….Apollinaire tells me that he would be happy to speak about me in a new journal (Cubist-oriented) and to add three or four photographs to his article. I think that things could work out. Give me your advice on this matter and I will write him. In the same mail I am writing to Amsterdam to tell them that this canvas belongs to you. We have been having nice weather these days. I can work outdoors and I am pleased. Although my studio is very pretty, it is somewhat small for the canvas on which I am working.[121]

Autumn
Sometime during his stay at Sorgues, Braque executes *Large Composition with Bass* on a wall,[122] presumably painting *a secco* as Picasso had earlier.

[September 27]
From Sorgues, writes to Kahnweiler (dated "Friday"; "1912?" added by Kahnweiler):
We are having good weather again and I am working outdoors all day. I am pleased. I have some canvases on which work is proceeding well and sand painting gives me some satisfaction. I am therefore thinking of extending my stay here by a good month. Provençe is definitely a region that I like a lot. Picasso's departure has created a vacuum among us. No more ajo blanco! I got a letter from him this morning telling me that Frika was done for. He really does not have much luck. But he has a house now. I hope this marks the start of a period of tranquility for him. Sunday, I am going to Nîmes to see Vicente Pastor and Cocherito de Bilbao. I think it will be great. What do you think of

PICASSO

September 23
Sends a telegram to Kahnweiler:
Leaving tonight Avignon 9.57. Regards, Picasso.[160]
This must be the date Picasso and Eva leave for Paris, where they will install themselves at 242, boulevard Raspail. The photograph Picasso has made of his works assembled in front of his Sorgues studio[161] shows that he has finished *The Aficionado* (p. 239), *Man with a Guitar* (Daix 495), *Artist's Model* (Daix 498), *The Poet* (p. 236), and two oval guitars (pp. 248, 249), as well as whichever works have been brought to Paris early in September for Kahnweiler.

Autumn
On a plaster wall (whose wallpaper he had torn away) of the Villa des Clochettes, Picasso leaves the large still life he had painted *a secco*, dedicated to "ma jolie" (Daix 486; see Picasso's August 21 letter). A receipt[162] indicates that Braque has paid 15 francs, "a compensation agreed upon with …Picasso for the deterioration of the paper in the living room at Sorgues, November 1, 1912" (see Picasso's letter to Braque, of October 31). On March 8, 1913, *Gil Blas* will report:
… last year Picasso left Céret for Avignon. On one of the walls of his villa he painted a "fresco." When it was time to go back, he regretted having to abandon the fruit of these labors, and the robust Georges Braque took care of taking down the wall. Dispatched to Paris, the work is now in a gallery near la Madeleine. As Picasso is often imitated, landlords may now hope to find a new way to get rid of their real estate.[163]

BRAQUE

my choice of photographs for Apollinaire? I think it's not bad. That way, there will be things from each period. The dates could perhaps even be added….The day before yesterday, I received another letter from Amsterdam further insisting that I send work, but I hope they will be satisfied with what you gave them. Nonetheless, we will have to talk about all this in Paris…. All days are alike here, and yet they go by so quickly.[123]

[September] 29*
From Nîmes, sends Kahnweiler a picture postcard (representing the bullfighter Vicente Pastor):
The weather is dreadful. It's two o'clock. All the cafés are lit as though it were nighttime, and the bullfight is off.

September 30
Apollinaire writes in *L'Intransigeant:*
The opening of the Salon d'Automne will take place tomorrow, Monday. This year's Salon does not have the battle-scarred look it had in 1907, 1908, and last year. Henri Matisse, van Dongen, and Friesz, accepted by the public, occupy the places of honor in their respective rooms.[124]

Olivier-Hourcade, in *Paris-Journal,* writing about the Salon, observes:
Those whom certain ignorant journalists, for no clear reason, have named "Cubists," no longer arouse either indignation or mockery. One is beginning to see in the persistent effort of these painters a logical evolution.[125]

October 5*
From Sorgues, sends Kahnweiler a picture postcard (representing the bullfighter Algabeno):
The real mistral from Avignon is blowing. Impossible to work outdoors. The trees have already lost their leaves. That's a summer that went by quickly.

October 5–December 12
Second Post-Impressionist Exhibition, at Grafton Galleries, in London. Four works by Braque are shown: *Kubelik (Violin: Mozart/Kubelick)* (p. 233); *Calanque; Antwerp;* and *Forest,* all but the last lent by Kahnweiler.

PICASSO

Both sides of a picture postcard of the bullfighter Vicente Pastor; sent by Braque to Kahnweiler, September 29, 1912

October 5–December 12
The Second Post-Impressionist Exhibition, at Grafton Galleries, in London. Includes thirteen paintings and three drawings by Picasso, among them: *Composition (Young Girl and Blind Flower Seller with Oxen)* of

BRAQUE

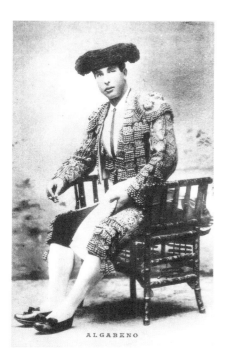

ALGABENO

Both sides of a picture postcard of the bull-fighter Algabeno; sent by Braque to Kahn-weiler, October 5, 1912

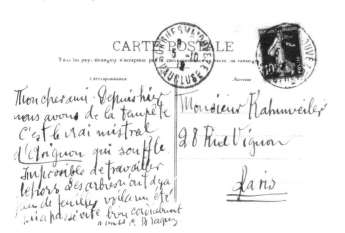

PICASSO

1906 (D./B. XV, 62), lent by Vollard; *Still Life with Bananas* of 1907 (Daix 68), lent by Kahnweiler; *Green Bowl and Black Bottle* of 1908 (Daix 173), lent by Leo Stein; *Landscape (Two Trees)* of 1908 (Daix 179), lent by Kahn-weiler; *Head of a Woman* of 1909 (Daix 266), lent by Kahnweiler; *Woman and Mustard Pot* of 1910 (Daix 324), lent by Kahnweiler; *Buffalo Bill* (p.185), lent by Kahnweiler; *Man with a Moustache* of 1912 (p. 222), lent by Kahnweiler; *Bouillon Cube* of 1912 (p. 27), lent by Kahnweiler.

R. R. M. Sée in *Gil Blas* (October 4):[164]
Messrs. Roger Fry, Robert Dell and other apostles of ultra-modern painting have just organized a second exhibition called "Post Impressionism" in London....There are some truly beautiful paintings by Cézanne. ...Henri Matisse is well represented....But to get to the other giants Pabla [sic] Picasso, the putative father of Cubism, has thirteen paintings (a fateful number) and three drawings. Here we find the Portrait de Mme Soler *[D./B. IX, 24], the* Femme au pot de moutarde *[Woman and Mustard Pot, Daix 324],* Buffalo Bill *[p. 185]—and other compositions so dear to Vollard.*[165]

Roger Fry writes of the Grafton exhibition:
But most of the art here seen is neither naïve nor primitive. It is the work of highly civilised and modern men trying to find a pictorial language appropriate to the sensibilities of the modern outlook....They do not seek to imitate form, but to create form; not to imitate life, but to find an equivalent for life....In fact, they aim not at illusion but at reality....The logical extreme of such a method would undoubtedly be the attempt to give up all resemblance to natural form, and to create a purely abstract language of form —a visual music; and the later works of Picasso show this clearly enough....No such extreme abstraction marks the work of Matisse....But here, too, it is an equivalence, not a likeness, of nature that is sought.... Between these two extremes we may find ranged almost all the remaining artists.... With the exception of Braque none of them push their attempts at abstraction of form so far as Picasso.[166]

James Huneker in the *New York Times* (November 11):
DECADE OF THE NEW ART, BIG CHANGES. What does Braque mean by his Kubelick-Mozart *picture? Or Picasso's* Buffalo Bill? *The*

BRAQUE

PICASSO

Woman and the Mustard Pot is emotional enough, for the unhappy creature is weeping, no doubt because of the mustard in her eyes; certainly because of the mustard smeared over her dress. A pungent design, indeed.[167]

October 6

Opening of the Moderne Kunst Kring 2 exhibition in Amsterdam (see letter to Kahnweiler, September 16). Braque is represented by six works.

Gil Blas writes (October 21):
The exposition at the Circle of Modern Art of Amsterdam ... is a great success for the French artists of the Salon d'Automne.... Picasso, Braque, Léger... Derain have the satisfaction of seeing art lovers give concrete proof of their admiration. Our most heartfelt congratulations.[126]

October 6

At the Moderne Kunst Kring 2 exhibition in Amsterdam, Picasso is represented by twelve works.[168]

October 7

From 242, boulevard Raspail, writes to Gertrude Stein:
My dear Gertrude ... Kahnweiler translated your portrait for me, and I thank you. But we'll talk about all that when you return, which I hope will be soon.
Is referring to her 1909 word-portrait "Picasso," first published in *Camera Work* (August 1912).

[October 9 or 16]

From Sorgues, writes to Kahnweiler (dated "Wednesday"; "1912" added by Kahnweiler):
I'm working and I already regret the thought of having to go back. I expect nevertheless to remain here until the end of the month, but time passes so fast. Le Matin keeps me abreast of events in the arts. I noticed that the Salon d'Automne is a real scandal. Mr. Lampué seems very determined. How will it all end? Diou bibant! It will all work out.
Braque undoubtedly refers to the open letter from municipal councilman Pierre Lampué to Léon Bérard, Undersecretary of State for the Fine Arts, which was first reported in the press and then published in full in *Mercure de France* (October 16). Lampué, outraged at the Salon d'Automne's Cubist room, questioned the use of a public monument by "a band of renegades who behave in the art world as Apaches do in everyday life."

October 9

Writes to Braque:
I've been using your latest papery and powdery [pusiereux] procedures. I'm in the process of imagining a guitar and I'm using a bit of earth on our dreadful canvas. I'm very pleased that you're happy in your Bel-Air villa. As you can see, I've begun working a little.[169]
The references to powder and earth indicate that Picasso has begun the first works in which he mixes sand in his paint, such as *Table with Guitar* (p. 255) and *Small Violin* (p. 253). It is about this same time that Picasso executes a guitar in cardboard, his first open-form construction (p. 251). The term "papery" refers either to the cardboard *Guitar* or to it and Picasso's first *papier collé*—if indeed *Guitar and Sheet Music* (p. 252) was begun that early. (See text, pp. 31–32). In the same letter, he mentions:
... on the walls of our dining room I have hung all the paintings from my collection, and I await your return in order to have the frame for your still life which still is unframed.
This picture in all likelihood is *Still Life with Bottle* (p. 184), which is one of the most fully developed works of 1911. It is possible, though not certain, that Picasso acquired the still life in an exchange with Braque.[170]

BRAQUE

PICASSO

October 10
Opening of the Salon de la Section d'Or, Galerie la Boétie, in Paris. It will be characterized by Maurice Raynal as:
The first such complete gathering of all the artists who inaugurated the twentieth century with works clearly representative of the tastes, tendencies, and ideas that set them apart from everyone else.[171]
Braque and Picasso do not take part in this show.

Vauxcelles writes in *Gil Blas* (October 12):
The Cubists believe they are inspired by nature, and wish this to be so, and hence do not go beyond the reproduction of material forms. The two men who concocted this idea, Picasso and Derain, have definitively abandoned it.[172]

October 15
Kahnweiler writes to Braque, in Sorgues:
The rent is due today. You didn't tell me if I was supposed to pay your rent for impasse de Guelma. Write to me about it. And the painting with the sand [peinture à la terre]? When are you coming back? I'll be away from Paris the week of November 10–17 (wedding in the family).... Picasso tells me the bullfight was beautiful.

Paris-Journal (October 15):[127]
According to the month ... the God of RENT. Today the rent is due—the long-term rents— and this is why we're not hearing from Mr. Cochon; "Saint Polycarp's Ruckus" only works, in fact, for short-term rents [quarter rents], and Mr. Cochon plays his kind of tricks on the landlords only on January 8, April 8, July 8, and October 8; he is indifferent to the 15th of each of these months; the rich people who pay rents of 1,000 francs mean nothing to him—the rent crisis is at its height.

[October 17]
From Sorgues, writes to Kahnweiler:
My dear friend.... Thank you very much for the rent [probably the payment of the rent for the studio in Paris, which had to be made by October 15]. I told the landlord that I would pay when I got back, which won't be long now. I will therefore see you before de-

October 14
Gil Blas announces the publication of André Salmon's book *La Jeune Peinture française*, which contains the "Anecdotal History of Cubism."[173]

In an article in *Le Temps*, "Les Commencements du cubisme," Apollinaire writes:
That year [1905], André Derain met Henri Matisse, and from this encounter was born the famous Fauve school.... The following year, he [Derain] joined up with Picasso and their association, almost at once, gave rise to Cubism, which was the art of painting new groups of subjects with elements borrowed not from the reality of sight, but from the reality of conception.... The Cubist paintings of Picasso, Braque, Metzinger, Gleizes, Léger, Jean [sic] Gris, etc., inspired the wit of Henri Matisse, who, greatly struck by the geometrical aspect of these paintings...first uttered the burlesque word "Cubism," which was so quickly to make its way into the world.[174]

BRAQUE

parture. Boischaud is already preparing the sign. It'll be just right: "Closed on Account of Marriage." I see from the newspapers that Cubism has made even more noise than Saint Polycarp's Ruckus. They're even talking about it in Sorgues, though I haven't yet been discovered. Nothing new since yesterday's letter. I am going to set to work on affixing drawings [i.e., papiers collés] and that's quite an undertaking in itself. I will have to buy a large portfolio to carry them in, they are so fragile.

Braque is alluding to more than the scandal of the 1912 Salon d'Automne. For the greater part of 1912, Georges Cochon, founder and president of the National Federation of Renters, attracts much publicity through "shoot the moon" operations he instigates on behalf of dispossessed tenants. The culminating event, staged by Cochon, was reported in *Paris-Journal* of October 14, under the headline "Encore un tour de M. Cochon—La Fanfare de la 'Cloche de Bois' donne une aubade, rue de Miromesnil" ("Mr. Cochon Strikes Again—The 'Shoot the Moon' Brass Band Gives a Rowdy Morning Concert on rue de Miromesnil"):

Yesterday morning a considerable crowd gathered in front of 99, rue de Miromesnil. Over 300 people invaded the building while 15 bugles, 10 drums, and 12 clarinets made a deafening din in front of the concierge's quarters.... Finally, policemen were able to force their way through the onlookers...and demanded an explanation for this morning concert. The bandleader explained, before the amused crowd, that he and his companions belonged to the brass band "Saint Polycarp's Ruckus," of which Mr. Cochon was the president....[128]

October 26

In *Paris-Journal,* Olivier-Hourcade announces publication of book by Gleizes and Metzinger, *Du Cubisme.*[129]

PICASSO

October 21

Vauxcelles writes in an article for *Gil Blas,* "Young French Painting":

I am too much André Salmon's friend to devote a "pal's" article to his book. One owes the truth to those whom one holds in esteem. Being an intimate friend of one of the innovators, of the enigmatic Pablo Picasso, who has stirred up so many ingenuous brains, Salmon witnessed the birth, the rise of a movement. Shall I say that he was the godfather to the new idol?... The question is not to know which language the Cubists speak, but whether they struck a reef. Alas, I fear it. Their doctrine is within the reach of children.... Salmon's book is interesting and useful.... He then writes "Anecdotal History of Cubism." He renders unto Caesar what belongs to him. Caesar is Picasso, a sincere seeker, who came from Greco and Lautrec.... Salmon, who is usually sparing of hyperbole, weaves a polyhedric crown "sublime, full of pathos, even Neronian ...Picasso is the first artist of his time, etc." I am afraid that the mystery in which Picasso shrouds himself feeds his own legend. Why doesn't he have a show, quite simply, and we shall judge him. Salmon compares him to Goethe. That is very serious.... Let's sum up and conclude: there is too much benevolence toward those who ratiocinate vacuously, what we need are some very subtle studies about diverse serious artists, what we need are more monographs than general ideas....[175]

October 26

In *Hommes du jour* Max Goth (Maximilien Gauthier) replies to Vauxcelles's article of October 12:

As for Picasso, he abandoned Cubism only in order to devote himself to higher speculations which continue its course.[176]

October 28

Lends *Portrait of a Woman* (L./R. 12) to the Henri Rousseau exhibition at the Bernheim-Jeune gallery, organized by Wilhelm Uhde.

BRAQUE

October 30*
From Sorgues, writes to Kahnweiler:
I meant to see you before your departure. Now I think I will only come back at the same time as you—on the fifteenth [of November]. That's exactly the time I will need to complete what I have already under way.

Both sides of a picture postcard of Le Havre; sent by Braque to Kahnweiler, November 27, 1912

November 15
May return to Paris (see October 30).

November 21
From Céret, Totote and Manolo write to Braque and Marcelle, in Sorgues (Villa Bel-Air); they are hoping that the Braques will come with the Picassos to pay them a visit in March 1913. Totote wonders if they are still in Sorgues, as Eva has written "the last few days saying that you were going to return to Paris."

November 25*
From Le Havre, writes to Marcelle, at 5, impasse de Guelma, Paris; says that he has just left Paris and is pleased with his trip; thinks he'll stay a week. Found his mother feeling much better. She was delighted with her gift.

PICASSO

October 31
Writes to Braque, in Sorgues:
My dear friend.… This morning I received the fresco [Daix 486] in good condition, and am amazed at the results of the operation and the packaging. I thank you again.…It seems that the book by Metzinger and Gleizes [Du Cubisme] *has already come out, and Apollinaire's will be out in a few days. Salmon has also published a book on painting* [La Jeune Peinture française]. *He is revoltingly unjust to you. My regards to Marcelle and you. See you soon, your friend, Picasso.*
Published in late November or early December, Albert Gleizes and Jean Metzinger's *Du Cubisme* is the first book devoted wholly to Cubism. It immediately receives attention in France, and is reviewed in *L'Opinion* (Paris), December 7, 1912.[177] As early as 1913, an English edition is published in London, and two Russian editions appear in Moscow. Excerpts are published in *Poème et drame* (Paris), March 1913, and in *Volné Smery* (Prague), 1913.

November 4*
From Rouen, Picasso and Eva write to Gertrude Stein and Alice Toklas:
Greetings from Rouen.[178]

November 18
Uses a newspaper clipping (*Le Journal*) in one of his first *papiers collés, Guitar, Sheet Music, and Glass* (p. 252), created in response to Braque's work in this medium; against a background of painted paper, glues a fragment of the title of the newspaper *Le Journal,* together with a headline of which he preserves the words "La bataille s'est engagé[e]" ("The battle is joined").[179]

BRAQUE

November 26*
From Le Havre, writes to Marcelle:
I'm thinking of my return, which will be on Friday, and of the pleasant moments this winter has in store for us.

November 27
From Le Havre, writes to Marcelle:
I am very happy to have received your letter and that the Picassos are being good to you.

[November] 27*
Sends Kahnweiler a picture postcard with "Regards." The image, called "Souvenir du Havre," is of an easel (festooned with rose branches) on which is resting a framed panoramic photograph of Le Havre's pont du Commerce and Bourse.

November 28
From Le Havre, writes to Marcelle:
Tomorrow I'll be in Paris.

November 29
Returns to Paris.

November 30
Agrees to contract with Kahnweiler after a prior exchange of correspondence. The contract is for the duration of one year (it is to last until November 15, 1913). In it, a special mention is made of "drawings with wood-paper, marble, or any other accessory."[130] Kahnweiler agrees to pay 40 francs for drawings, 75 or 50 francs for "drawings with wood-paper, marble, or any other accessories," and 250 francs for canvases, exactly a fourth of what he offers Picasso at the same time.

PICASSO

November 27*
Eva writes to Marcelle Braque; she and Picasso have invited her to dinner and, not having received any reply, are worried.

November 29
L'Intransigeant prints a review by Apollinaire of Salmon's *La Jeune Peinture française*. Although the tone of the article is detached, it is known Apollinaire was hurt by the fact that Salmon nowhere mentions him:
André Salmon has just published a charming book titled La Jeune Peinture française, *in the Collection des Trente series. This witty, well-written book contains a great deal of useful information for those who would like to know about the evolution of the young artists in France. Since a certain number of the ideas expressed here are my own, I can say that I fully appreciate this book. Salmon's ideas on contemporary women painters, for example, are expressed in terms almost exactly identical to mine. A number of amusing anecdotes enhance the interest of this volume, whose typography is as attractive as its style.*[180]
In a letter to Salmon at the beginning of 1913, Apollinaire will write:
In your book, you constantly avoid me—I do not hold it against you, because I like you very much, because we are old friends, I believe, and because I have never caused you any harm.[181]

BRAQUE

Marcelle Braque and the dog Turc, c. 1912

PICASSO

Late November–Early December
Three photographs of the boulevard Raspail studio show drawings and *papiers collés* at various stages of elaboration arranged around the cardboard construction *Guitar* (pp. 34–36).[182]

December 3
Debate over Cubism at the Chamber of Deputies. The Socialist deputy Jules-Louis Breton protests against the "artistic scandal" occasioned by the recent Salon d'Automne:
… these jokes in the worst possible taste … these displays which run the risk of compromising our magnificent artistic heritage. And this is all the worse since it is mostly foreigners who in our national galleries wittingly or unwittingly bring our French art into disrepute.… In fact, gentlemen, it is inadmissible that our national galleries should be used for displays of such a radically anti-artistic and anti-national character.
Another Socialist deputy, Marcel Sembat, a friend of Matisse, replies:
My dear sir, when a picture displeases you, you have one undeniable right: and that is not to look at it, and go and look at others. But you don't call out the police.[183]

December 18
Letter-contract for three years with Kahnweiler. Unlike Braque's contract, this one does not place *papiers collés* under a separate heading. Picasso pointedly notes: "I shall moreover reserve the right to keep as many drawings as I deem necessary for my work." Also notes: "You will allow me to decide when a painting is finished." While the mean value of a drawing is 100 francs, the value of a size 25 painting (81 × 65 cm) is 1,000 francs, and a size 60 (130 × 97 cm) is 3,000 francs.[184]

Before December 23
Goes to Céret.

December 23*
From Céret, writes to Gertrude Stein, in Paris:
My dear Gertrude, you will be the glory of America.[185]

From Céret, Eva writes to Alice Toklas:
Best regards. See you soon.
Also signed by Pablo, Totote, Manolo.[186]

BRAQUE

PICASSO

Before December 26
Goes to Barcelona.

December 26*
From Barcelona, Eva writes to Gertrude Stein and Alice Toklas.[187]

1913

Early in the Year
Gertrude Stein writes a word-portrait titled "Braque" (not published until 1922, in her *Geography and Plays*).[131]

January
Apollinaire gives a lecture in Berlin on the occasion of an exhibition of Robert Delaunay at the Der Sturm gallery. The text of his lecture, subsequently published as "Die moderne Malerei" in *Der Sturm*,[188] contains one of the earliest references to the radically new mediums of *papier collé* and collage that Braque and Picasso had developed in 1912 using a wide range of materials.

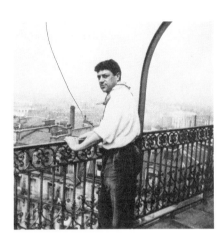

Braque, photographed by Kahnweiler at the Hôtel Roma, 1913

January 22*
From Rouen (perhaps on his way to Le Havre), writes to Marcelle, at impasse de Guelma:
We [he and Derain] had a fine trip.

From Le Havre, writes to Kahnweiler (postcard signed by Braque and Derain; postmarked).

January 21
Probably returns from Barcelona.[189]

January 25*
From Le Havre, writes to Kahnweiler; sends "regards." Returns to Paris. Perhaps around this time, moves his studio to Hôtel Roma, at 101, rue Caulincourt.[132]

February 4
Leo Stein writes to Mabel Foote Weeks:
As for Picasso's late work it is for me utter abomination. Somebody asked me whether I didn't think it mad. I said sadly, "No, it isn't as interesting as that; it's only stupid."[190]

February 17–March 15
International Exhibition of Modern Art (the Armory Show) in New York, at the 69th Regiment Armory; later travels to Chicago and Boston. Includes three works by Braque: *Port of Antwerp* (Elderfield, p. 65) of 1906; *The Forest, L'Estaque* of 1908; *Violin: "Mozart/Kubelick"* (p.233), all lent by Kahnweiler.

At the Armory Show, *Violin: "Mozart/Kubelick"* gives rise to puns about Braque being the one who put the "cube in Kubelik" and the "art in Mozart."[133] The painting also is the object of a caricature in

February 17–March 15
At the Armory Show, eight works by Picasso are shown: the bronze sculpture *Bust of a Woman (Fernande)* (p.141), lent by Stieglitz, which does not travel to Chicago or Boston; three paintings and a gouache, all lent by Kahnweiler, including *Woman and Mustard Pot* of winter 1909–10 (Daix 324); and two still lifes lent by Leo Stein, one of which is *Vase, Gourds, and Fruit on a Table* of early 1909 (Daix 211).

At the Armory Show, critical evaluation of Picasso is not devoid of sarcasm, as in "The International Exhibition of Modern Art," an

BRAQUE

The World (February 17) captioned "This Post-Impression Portrait of Kubelik, Playing Mozartian Rag-Time IMPRESSED US MOST."[134]

The journal *Musical America* (March 22) devotes an article to *Violin: "Mozart/ Kubelick"* titled "Seeing a Violin Concerto Through a Cubist's Glasses" and accompanied by a reproduction captioned " 'The Violin,' a Post-Impressionistic Painting by Braque." The author, believing Braque to have been inspired by hearing Jan Kubelík play a Mozart violin concerto, reprimands the artist for misspelling the violinist's name.[135]

PICASSO

article signed "Aloysius P. Levy, DDS, KGLPDFRCY (secretary, Royal Mexican Veterinary Society)," in the *New York American* (February 22):
Paul Picasso has two wonderful Futurist creations on exhibition. One is entitled Nature Morte No. 1 *and the other* Nature Morte No. 2. *The first one shows nature going through the death struggle. The other shows how Paul felt when he made a clean job of it.*[191]

Late February
In Munich, at the Moderne Galerie Heinrich Thannhauser, the first Picasso retrospective in Germany is held, featuring seventy-six paintings and thirty-seven watercolors from 1901 to 1912. Thannhauser writes in his catalogue preface:
It is widely believed that Picasso's work stands at the origin of the whole Expressionist, Cubist, and Futurist movements. In fact, Picasso has nothing to do with any of these, except that he did provide the initial artistic impulse; nor does he want to have anything more to do with them. What distinguishes him from all these movements, even at first sight, is that unlike them he has never expressed his artistic intentions in programs, manifestos, or similar pronouncements; and he has never sought to explain his own new departures either psychologically or psychologistically: he has simply painted.[192]

About March 10
Eva and Picasso leave for Céret.

March 12
From Céret, Eva writes to Gertrude Stein:
The weather is marvelous and we've settled in.
She also sends a postcard to Alice Toklas.

Mid-March
Begins a new series of *papiers collés*. Some, like *Bottle of Vieux Marc, Glass, and Newspaper* (p. 276), use contemporary newspapers from either Paris or Céret. Several, such as *Head* (p. 276) and *Bottle of Vieux Marc, Glass, Guitar, and Newspaper* (p.287),

BRAQUE

PICASSO

include fragments of an 1883 issue of *Le Figaro*. Also does a number of drawings on the back of sheets of a French Revolution–era tax register from Arles-sur-Tech (near Céret), including *Guitars* (p. 268), *Three Heads* (p. 282), and *Guitarist with a Hat* (p. 282).

From Céret, sends Kahnweiler a picture postcard (representing the "Grand Café de Céret").[193]

March 14
Apollinaire publishes in *Montjoie!*[194] a text titled "Pablo Picasso"; also printed in his *Les Peintres cubistes: Méditations esthétiques*, it will there constitute the second half of his essay on Picasso. The text, dating from mid-1912 with revisions made in the fall of 1912, comments on the most recent innovations of Cubism, among them the development of collage, and describes Picasso's first collage, *Still Life with Chair Caning* of May 1912 (p.229). Also refers to "ce fameux retour du Havre," an allusion to *Souvenir du Havre* (p. 219), painted following Picasso's visit to Le Havre in April 1912 with Braque.

March 17
Apollinaire publishes a volume of essays on Cubism and Cubists, titled *Les Peintres cubistes: Méditations esthétiques*. It is a patchwork of previously published articles, presented in no strict order.[195]

From Céret, Eva writes to Gertrude Stein (on the feast day of Saint Gertrude):
Happy name day.

March 21
From Céret, writes to Kahnweiler (letter inscribed "Good Friday"):
Yesterday I received the photos, which are good and please me as usual, since they surprise me. I see my paintings differently from how they are.... I think that the paintings are still not all photographed yet, for I didn't find the one of the young girl from Sorgues [L'Arlésienne, *Daix 497] and the one from Paris this winter with colors, card in hand* [Female Nude: "J'aime Eva," *p. 265] and the gouaches. I'm very curious to see what they are like.*[196]

BRAQUE

Maison Delcros, a house in Céret occupied by both Braque and Picasso in 1911 and by Picasso in 1912 and 1913

PICASSO

March 29
From Barcelona, writes to Kahnweiler:
I've been here for a few days now and I think I'll return to Céret on Monday [March 31].

His *papier collé* titled *Guitar* (p. 286) includes fragments from the March 31 issue of a Barcelona newspaper.

April 11
From Céret, writes to Kahnweiler:
I'm behaving very badly towards all my friends. I'm not writing to anyone, but I'm working; I'm working on projects and I'm not forgetting anyone or you. Max [Jacob] will be coming to Céret. Would you be kind enough to give him the money for the trip and also some pocket money for his expenses? Put it on my account. I don't need to tell you that I'm still waiting impatiently for the photos of the latest things that Deletang is supposed to have taken.... The news you've given me about the discussions of painting is sad indeed. As for me, I've received Apollinaire's book on Cubism. I'm quite disappointed with all this chatter."[197]

[April 12 or 19]
From Céret, writes to Kahnweiler:
Yesterday I received the photos and the book by Soffici, Cubismo e oltre.... *I am working but not doing many paintings. I'm doing projects, which in the trade we call gouaches.*[198]...*Max is here and likes it.... In the photos the gouaches look like paintings. I'm waiting for the others impatiently. And [the photo of] the fresco?*[199]

April 23
From Céret (Maison Delcros), writes to Braque:
My dear friend, It's your name day today. I wish you a good and happy one for many years to come. It's really too bad the phone in your place doesn't reach Céret. Such good conversations about art....
 Don't be upset if I don't write you more often; I've been very worried about my father's illness. He's not doing very well. In spite of all that, I'm working. Best wishes to Marcelle, and to you too, dear friend.

BRAQUE

PICASSO

End of April

Publication of Apollinaire's *Alcools*. The frontispiece is his portrait done by Picasso. (Picasso had written him in mid-Lent to protest the suggestion of printing it in blue.) Apollinaire writes to Kahnweiler:

Thank you for your subscription to my book.—On the other hand, I've heard that you think that what I have to say about painting is without interest, which from you I find odd.—As a writer I alone have supported painters whom you championed only after I did [i.e. Picasso]. And do you think that it's good to try to destroy someone who, when all is said and done, is the only one who was able to lay the foundations for future artistic understanding? In these cases he who seeks to destroy shall be destroyed, for the movement that I support has not stopped; it can't be stopped and all that one does against me can only fall back on the movement itself. Let this be the simple warning of a poet who knows what must be said, and knows what he is and what others are in matters of art.[200]

Beginning of May

Max Jacob writes Kahnweiler:

I shall not depict either the sites that you know or our life that you imagine. My day begins at six o'clock. A prose poem gets me going. At eight, Mr. Picasso in a dark blue or simple twill robe has just brought me a phospho-chocolate and a heavy and tender croissant.... The windows of my huge white room would like to see the Canigou (alas, rain).... Each day I learn to admire the greatness of spirit of Mr. Picasso, the true originality of his tastes, the delicacy of his senses ... and his truly Christian modesty. Eva is admirably devoted to her humble household chores. She loves to write and laughs easily. She is even-tempered and directs her attention toward satisfying a guest who is dirty and phlegmatic by nature when he's not ridiculously mad or idiotic.[201]

Sudden departure for Barcelona because of the illness of his father, who dies May 3. From Barcelona, he sends word of this to Gertrude Stein; writes to Kahnweiler: *You can imagine the state I'm in.*[202]

BRAQUE

May 10
Writes to Picasso, in Céret (Maison Delcros), addressing him as "my dear friend," and sending him condolences on the death of his father; signs:
With much affection, G. Braque.

PICASSO

May 9
From Céret, writes to Kahnweiler:
I received some kind of German Assiette au beurre *with reproductions of my work and I don't understand. I don't think that you would have given the authorization to reproduce them in such a place. I'm beginning to get used to it and this consoles me; in spite of everything one should avoid this kind of publicity as much as possible.*

May 14
From Céret, Eva writes to Gertrude Stein:
The month of May will have spared us not a thing. Frika is hopeless. We went to Perpignan to consult the veterinarian … she won't last a year.… We're nursing her, but the day when there's nothing left to do we'll have to put her to sleep, and this causes me much pain. Pablo too. This news is not so cheerful, and I hope Pablo resumes working soon, for that's the only thing that enables him to forget his troubles a little.… Did you know that Max is with us here in Céret?

May 29
Kahnweiler sends Gertrude Stein an appraisal of the works she owns—among the most important of which are *Three Women* (p.111), 20,000 francs; *Boy Leading a Horse* (D./B. XIV, 7), 12,000 francs; and *Portrait of Gertrude Stein* (D./B. XVI, 10), 6,000 francs. The appraisal of the collection is related to her estrangement from her brother Leo.[203]

June 3,* 4,* 11*
From Céret, Eva writes to Gertrude Stein and Alice Toklas.

June 10
From Céret, writes to Kahnweiler:
I've carefully read all that you wrote to me concerning the etchings for Max's book [Le Siège de Jérusalem] *and I'll do two or three the way you'd like them, for the price we agreed upon of 860 or 1,290 francs.… It's been a long time since I've heard from Braque. If you see him tell him to write to me. I imagine he must still be in Paris.*[204]

BRAQUE

PICASSO

From Céret, writes to Gertrude Stein (postmarked); invites her to come for Saint Paul's Day (June 29), telling her that there will be a bullfight in Céret that day.[205]

June 11
Leaves for a corrida in Figueras. Writes to Apollinaire; Eva and Max Jacob also sign.[206]

June 12
From Figueras, writes to Kahnweiler; also signed by Max Jacob.[207]

June 15*
From Sorgues, writes to Kahnweiler:
I left Paris only on Saturday. I wanted to say good-bye, but at the last minute there is always too much to do. The weather is superb.

June 14
Goes to Gerona.

June 17*
From Lyon, Derain writes to Kahnweiler:
128 kilometers in one day, what do you say about that?
Derain is stopping in Lyon on his way to visit Braque; makes the trip to the south (to Martigues) on bicycle.

June 18*
From Avignon, writes to Kahnweiler:
Friendly greetings.

[June 19]
From Sorgues, writes to Kahnweiler (undated; "1913" added by Kahnweiler):
I am back in Sorgues of which I am still as fond as ever. I am at Bel-Air again, but I found a peasant house nearby which I have rented for the year. I am going to have a window enlarged in my room in order to fix myself a pretty good studio. I have not started working yet. In the meantime I am doing some gardening....Say hello to Mr. Kramar if he is still in Paris.... P.S. I am expecting Derain, who is cycling down the Rhone Valley.

June 19
From Céret, writes to Gertrude Stein; says he will leave for Paris the next day:
...we shall see you on the same day of our arrival, but we shall stop in Toulouse and Montauban for a day.[208]

June 22 *
Eva writes to Gertrude Stein and Alice Toklas:
Till tomorrow.

BRAQUE

[June 26]
From Avignon, writes to Kahnweiler (postmark unclear; either June 26 or August 26): *My vacation is over, for my studio is finally completed. I am happy about it. I started working a bit. Derain paid me a visit and we took some beautiful walks in the surrounding countryside.... Before going to Martigues, Derain won Sorgues's game of bowls.... Because of the fixing up of my studio, I need some money. Could you send me four hundred francs in the next days?*

June 28
Kahnweiler writes to Braque, in Sorgues: *I am delighted by the good news you sent me. Enclosed are the requested 400 francs. The weather is hardly fair here. I feel like being down there.*

July 2
From Sorgues, writes to Kahnweiler (postmarked): *I received your letter and thank you much. My studio is ready and I am working.*

July 10
From Sorgues, writes to Kahnweiler: *We went to Arles on Sunday to see a bullfight, which turned out to be pretty bad. We then went to the Villa Paradis and to Marseille. There we found some African sculptures. I hadn't had any news from Picasso since his return to Paris. I did not know he was ill. I think that it cannot amount to much, since you say that he is already feeling better. ...P.S. Can you send me 300 francs?*

July 11
From Martigues, Derain writes to Kahnweiler: *I am as usual at Villa Paradis.... Braque came by and took photographs of the villa and its inhabitants [Vlaminck is visiting]. If they are successful, they will be quite entertaining.*

PICASSO

July 10, 14, 18
Eva writes a series of letters to Gertrude Stein and Alice Toklas, keeping them informed of the course of an illness Picasso is suffering, which she calls the "little typhoid fever."

July 15
Article in *Gil Blas*:
Our friend the painter Pablo Picasso is confined to his bed with a serious illness.... He has only recently returned from Céret, where he had passed the spring.[209]

BRAQUE

PICASSO

July 16
L'Homme libre writes:
The health of painter Pablo Picasso improved yesterday.[210]

July 22
In *Gil Blas*:
Picasso is well on the way to recovery. He has just begun his convalescence and was able to receive some close friends.[211]

Eva writes to Gertrude Stein:
Pablo is almost entirely well. He gets up every day in the afternoon. Mr. Matisse has come often to ask for news about him. And today he has brought Pablo some flowers and spent practically the afternoon with us. He is very agreeable. We shall probably leave around mid-August for Céret, then we'll go to Barcelona, unless of course Pablo changes his mind.[212]

July 27
From Sorgues, writes to Kahnweiler:
Right now I am working. I started a few canvases, two of which are fairly large.... I wrote to Picasso. I thought he had recovered. At any rate, I think that he can get up again. Now it will only be a matter of two or three days.... P.S. If you could send me 500 francs before your departure, that would allow me to wait for your return.

August 9
L'Indépendant of Perpignan writes:
In Le Figaro *one finds the following comical note: "The little town of Céret is jubilant. The Cubist master has arrived to take a well-deserved rest." "The Cubist" to whom* Le Figaro *is referring is the likable artist Pablo Picasso. Presently gathered around him at Céret are the painters Herbin, Braque* [actually in Sorgues, not Céret], *Kissling* [sic], *Ascher, Pichot, Jean* [sic] *Gris, and the sculptor Davidson.*[213]

August 10*
From Sorgues, writes to Kahnweiler, in Rome (Hotel Eden):
I have received your card from Siena. I meant to answer sooner, but I have done a lot of work these last days.[136]

August 19
Writes to Kahnweiler:
We had some disputes and preferred to come back to Paris to find some peace. We've found a studio with apartment, very large and full of sunlight ... 5 bis, rue Schoelcher. I've also bought a Rousseau [L./R. 35]. And that's all that's new.[214]

Eva writes to Gertrude Stein, in Granada:
We're back to Paris and have found a very nice studio with an apartment, rue Schoelcher, boulevard Raspail.

BRAQUE

August 22*
From Sorgues, writes to Kahnweiler, in Rome (Hotel Eden):
I am very pleased with my sojourn; the shorter days are coming upon us too fast.

September 1
From Sorgues, writes to Kahnweiler (letter sent to Paris; forwarded by Kahnweiler's gallery to Perugia, September 4):
…You seem to me to be quite pleased with your trip and I am happy about that.… I am working. Anyway, you will see that upon your return. I intend to send you the work when you go back.… P.S. Can't find your address in Perugia. My studio is full of papers that I do not dare to stir up and your letter is buried underneath.

September 2
In *Gil Blas*:
At Sorgues, near Avignon, the gentle giant Georges Braque is painting cubes after cubes and teaching boxing to the children of the region.… André Derain is completing early canvases at Martigues … Henri Matisse is at Cassis.[137]

September 18
From Sorgues, writes to Kahnweiler:
I have received your letter and the 400 francs.… Terrible weather during the last four days. Nothing new to say about Sorgues, which I haven't left in two months. Soon I am going to Marseille for a couple of days. That will be somewhat of a change.

October 2*
Writes to Kahnweiler (postmarked from Marseille):
It's our turn to have the sunshine of Paris.… Sunday [October 5] I am going to Marseille for two days and I'll stop at Arles to see a bullfight, although with this weather I may have to delay my trip. Before my departure I am sending you the canvases that I have completed. In Paris, I too would like to see them framed and on a wall, for here I have only paper frames and that isn't quite satisfactory. It's been so long since I have heard from Picasso. I guess his move must be worrying him a great deal.
The paintings Braque sends are listed as six still lifes.

PICASSO

August 29*
Writes to Gertrude Stein, in Granada:
…We take horseback rides with Matisse through the forest of Clamart.

September 2
In *Gil Blas*:
Our Fauves are moving about.… At Céret, they're all fighting for a place at the guest table.… Understandably disgusted, the great artist Picasso fled this charming little spot he had discovered.

September 20
Invites Apollinaire to lunch at boulevard Raspail.[215] (In early September, Apollinaire, in association with Serge Férat and his sister the Baroness Hélène d'Oettingen, has taken over the directorship of *Les Soirées de Paris* from André Billy.)[216]

[October]
A number of assemblages on which Picasso has been working are photographed by Kahnweiler for publication in the first issue of *Les Soirées de Paris* under its new director, Apollinaire (November 15). Reproduced will be a construction (p. 279) from which only the cardboard *Guitar* survives, *Guitar and Bottle of Bass* (Daix 630), *Bottle and Guitar* (Daix 631) and *Construction with Cardboard Violin* (Daix 629).[217]

BRAQUE

[October]
From Sorgues, writes to Kahnweiler (dated "Thursday"; "1913" added by Kahnweiler):
...Your opinion about my paintings caused me great pleasure, and I was all the more sensitive to it as it is the only one I have gotten here where isolation leads to a loss of all critical sense.... The weather is fine again and my trip to Marseille took place under fair weather....P.S. It would seem that Haviland is going to get married (confidential).

Autumn
From Sorgues, writes to Kahnweiler (dated "Tuesday"; "1913" added by Kahnweiler); tells about a very successful bullfight seen the Sunday just past in Nîmes, with superb weather, the city decked out entirely with Spanish colors, and the aficionados very fine; ends:
I am working fairly well right now. I am drawing [i.e., making papiers collés] *a lot and already would like to see how it will look in Paris.*

Writes to Kahnweiler (dated "Thursday"; "1912? 1913?" added by Kahnweiler):
My departure for Paris is drawing near. I would like to come back in about three weeks. Consequently, I won't start anything else, for I must finish the canvases and the drawings [papiers collés], and then do some pasting.[138]

November 12*
From Sorgues, writes to Kahnweiler:
... I am working a fair amount. I am doing some large drawings [papiers collés] with which I am pleased, and, for the moment, I set painting aside. For a few days now, the weather has been gray, as in Paris. So I resolved to work at night. I am very much at ease in a barn where I have installed all the lamps I need.
Since Braque habitually calls his *papiers collés* "drawings," he is probably referring here to a series of oversize *papiers collés* created in autumn 1913 including *Guitar* (p. 296); *Checkerboard: "Tivoli-Cinéma"* (pasted on canvas; p. 298), incorporating a poster for the first film shown at the Tivoli theater, which opens in Sorgues on October 31, 1913; and *Guitar and Program: "Statue d'épouvante"* (p. 299), incorporating another program from the Tivoli.

PICASSO

October 17
Kahnweiler buys three of Picasso's early paintings from Gertrude Stein. In exchange, she is given 20,000 francs and a recent picture, *Man with a Guitar* (p. 211), painted at Céret in the spring. She and Leo Stein now appear to have settled the division of their possessions.[218]

Baroness Hélène d'Oettingen, co-director, with Serge Férat and Guillaume Apollinaire, of the magazine *Les Soirées de Paris,* 1913

BRAQUE

Endpapers of a copy of Guillaume Apollinaire's book *Chronique des grands siècles de la France: Pages d'histoire* (published 1912), inscribed by the author with a dedication to Braque (above) and a "diploma," early 1914

[December] 5
From Sorgues, writes to Kahnweiler:
I am finishing my canvases and expect to be in Paris at the beginning of next week. Cordially yours and see you soon.
As December 5 is a Friday, Braque is probably back in Paris the week of December 8.

Early in the Year
In *Glass, Bottle, and Newspaper* (p. 309), uses a fragment of a page from the January 15 edition of the Italian review *Lacerba*.

Guillaume Apollinaire presents Braque with a copy of his *Chronique des grands siècles de la France: Pages d'histoire*. On the endpapers of the book Apollinaire inscribes: "To Georges Braque, his friend Guillaume Apollinaire," and draws a diploma awarding Braque first prize in imitation wood:
Kahnweiler Institution/Artistic year 1913–1914/First Prize in faux-BOIS/Class of 1902/awarded to the pupil Georges Braque/The Principal/Guillaume Apollinaire/examined and approved per pro/BOIS-CHAUD.
At the lower left, an imitation seal bears the inscribed words:
tribulation / irectes / 13–1914 / [clover emblem]/FERLA.[139]

PICASSO

November 15
Publication of No. 18, first issue of the new series of *Les Soirées de Paris* under the direction of Apollinaire and Jean Cerusse (Ces Russes, i.e., "These Russians", a pseudonym used by Serge Férat and the Baroness Hélène d'Oettingen). The majority of former subscribers to the review cancel their subscriptions in protest against the reproductions of Picasso's work.[219]

1914

Early in the Year
In two *papiers collés—Pipe, Wineglass, Newspaper, Guitar, and Bottle of Vieux Marc: "Lacerba"* (p. 317) and *Wineglass, Bottle of Wine, Newspaper, Plate, and Knife: "Purgativo"* (Daix 702)—makes use of clippings from *Lacerba* of January 1.[220]

January 14
Kahnweiler publishes *Le Siège de Jérusalem* by Max Jacob, with etchings by Picasso (one, p. 306).

February 2
The *Sun* (New York) announces:
Paris. January 31. One of the world's finest collections of four living French masters, Cézanne [sic]*, Picasso, Matisse and Renoir, will be disintegrated with the departure from Paris of Leo Stein.*[221]
Gertrude remains at rue de Fleurus while Leo goes, in April 1914, to live in Settignano. They divide their collection.

BRAQUE

February 12
In the *Berliner Zeitung:*
Yesterday evening, in the Cassirer gallery's "Oberlichtsaal," where Meier-Graefe formerly preached his gospel against modern art, Wilhelm Uhde spoke from the contrary point of view on the most recent painting in Paris, namely that of Braque, Picasso, Rousseau le Douanier, Marie Laurencin.... [140]

February 18
Uses news clipping from *Le Matin* of this date on his paper sculpture (no longer extant), known only through a photograph in the Laurens Archives (p. 315). The *papier collé* on the adjacent wall visible in the photograph bears a news clipping from *Havre-Eclair* of January 11, 1913.

April 12
Apollinaire writes to "my dear friend" Braque, inviting him to lunch:
You should also bring me the titles of your paintings. I am lacking the titles and I ask you, please, do not leave us in a jam. [141]

PICASSO

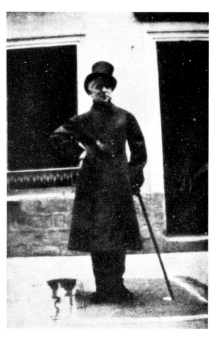

Max Jacob at 17, rue Gabrielle in Montmartre, where he took up residence in 1914

March 2
The collection of La Peau de l'Ours, [222] numbering 150 paintings and drawings, is sold at auction at the Hôtel Drouot in Paris. Thannhauser's purchase of Picasso's *Family of Saltimbanques* (D./B. XII, 35) for 11,500 francs causes a scandal. Salmon speaks of a "Hernani of painting" (an allusion to the famous battle between opposing factions of romantics and classicists set off by the first performance of Victor Hugo's drama *Hernani*, in 1830). [223] In *Gil Blas*, Thannhauser is quoted as saying he would have "willingly paid twice as much." [224] An anti-German campaign is launched in the press. Maurice Delcourt writes in *Paris-Midi:*
Before the Invasion. "Big prices" have been fetched by vile, grotesque artworks by undesirable foreigners, and it was the Germans who sent the prices so high, and paid them! Their plan is becoming clear. Naive young painters will not fail to fall into the trap. They will imitate the imitator Picasso who, after making pastiches of everything and finding nothing more to imitate, perished in his own Cubist bluff.
In his memoirs, published posthumously in 1959, André Level notes the principal lacunae in the Peau de l'Ours collection:
... no Rousseau ... finally and above all: no Braque and only three Cubist pictures, hardly Cubist, at that.... [225]

April 2–15
Vladimir Tatlin [226] visits Picasso in his studio at 5 bis, rue Schoelcher; Jacques Lipchitz apparently serves as interpreter. It is probable that Tatlin visits Braque's studio as well, where he could have seen his paper and cardboard constructions.

BRAQUE

April 15

Issue no. 23 of *Les Soirées de Paris* reproduces eight of Braque's works: *Woman with a Guitar* (p.297); *Glasses and Bottles* (p.225); *Checkerboard* (Romilly 197); *Bottles and Glasses* (p.227); *Pedestal Table* (p.291); *Violin and Candlestick* (p.159); *Pedestal Table* (p. 275); *Fruit Dish, Bottle, and Glass: "Sorgues"* (p.240).

May 5

Apollinaire in *Paris-Journal*, in the column "Echoes of Art," refers to the April 15 issue of *Les Soirées de Paris:*

The last number of Soirées de Paris *contains eight reproductions of pictures by Georges Braque, who, with Picasso, is one of the initiators of Cubism. Georges Braque is one of the most interesting French painters today and one of the least known. To date he has exhibited his work as a group only once, at the Kahnweiler gallery in November 1908, and it is also from then on that he stopped showing at the Salon d'Automne and at the Indépendants. It is the first time that a French magazine publishes reproductions of his work.*[142]

May 26

Apollinaire in *Paris-Journal*, in the column "Echoes of Art," writes the following notice about Braque entitled "Roma Hotel":

Mr. Georges Braque has his studio on the top floor of the Roma Hotel, on rue Caulincourt. Recently a Czech painter, Mr. Filla, who ... happens to be an interesting painter, came to visit the French innovator in his studio. The visit was rapid and polite, but Mr. Braque was astonished to find Mr. Filla in front of the hotel the next day, and saw him again two or three times that day. He congratulated himself on rousing the curiosity of the Czech painter, when he learned that Mr. Filla, seduced by this Roma Hotel in which there were Cubist studios, lived there and that soon all the Czech painters would come there as well. Georges Braque ... made the suggestion to the hotel owner that he put an enamel plaque above the door with the following inscription: "Cubists on every floor."[143]

When Kahnweiler describes this studio in 1920,[144] he dates his description from the year 1914:

Braque: rue Caulincourt, 1914. Braque's stu-

PICASSO

Spring

Picasso makes six bronzes of *Absinth Glass*. Adds a real, slotted absinth spoon and a bronze piece of imitation sugar. Treats each of the six versions differently using paint and sand (p. 323 and Daix 754, 755, 757, 758).

BRAQUE

*dio is located in a hotel in Montmartre—
endless steps—women in their slips fetching
hot water—at the very top of the studio. A
glass cage—a beacon. A luminous bright-
ness, all about a balcony that looks out on all
of Paris. A great many artworks: painted
and pasted ones, reliefs in wood, in paper, or
in cardboard. Many little objects on the walls
and on the tables. Braque sings as he works,
like a housepainter. With the help of bin-
oculars (he spent his childhood in Le Havre)
he points out for visitors the town of Argen-
teuil, cradle of his family, sitting on the
slopes of the hills in the distance.*

Before May 29

Braque and Marcelle move from 5, impasse
de Guelma, to 10, rue de l'Abreuvoir pro-
longée (which shortly thereafter becomes
rue Simon-Dereure.

PICASSO

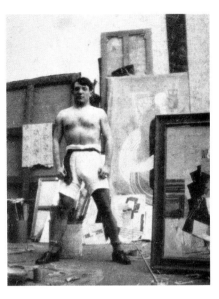

Picasso in his studio at 5 bis, rue Schoelcher,
c. 1914. At back, right, *Seated Man with a
Glass* (Daix 783); before it, on floor, *Man
with a Moustache* (Daix 759); partly visible,
at extreme right, initial state of *Harlequin
Playing the Guitar* (Daix 762)

Mid-June

Goes to Avignon.

June 12

From Avignon, Derain writes to Kahnweiler,
(on "Grand Café Moderne, Avignon,"
letterhead):
*… I arrived in Avignon two days ago.…
I don't know if Picasso has already left. I am
going to write him by the same mail. I think
he will find some very nice things either
around here or farther along.… The politi-
cal situation seems very strange to me.…*

June 17

From Avignon, Derain writes to Kahnweiler:
*The Picassos spent the day with us and then
left for Tarascon.*

June 18*

From Tarascon, writes to Soffici, in Poggio a
Caiano:
*Write to me, if you have the time, at the fol-
lowing address for the time being: Grand
Hôtel des Empereurs, Tarascon.*[227]

Writes to Gertrude Stein in Paris:
*We're still at the hotel. We've come right at
the time of the local festivals.*

BRAQUE

PICASSO

Braque in Sens, June 28 or 29, 1914, on a bicycle trip from Paris to Sorgues

June 28*
From Sens, writes to Marcelle, at 10, rue Simon-Dereure; is making a trip to Sorgues by bicycle; a friend called Harmand accompanies him as far as Sens.

From Sens, writes to Kahnweiler:
I am on the road. The first stage went really well, without fatigue. Tomorrow, I am leaving for Avallon.
Sends series of postcards to Kahnweiler at various stages of his bicycle trip.

June 29
From Autun à Avallon, writes to Kahnweiler:
I am past Avallon by a few kilometers.

From Avallon, writes to Picasso (addressed to Hôtel des Empereurs, Tarascon; forwarded by the hotel to the Grand Nouvel Hôtel, Avignon; postmarked):
See you soon. GB.

June 30*
From Dijon, writes to Picasso (addressed to Hôtel des Empereurs, Tarascon; forwarded to the Grand Nouvel Hôtel, Avignon):
I expect to find you moved in upon my arrival in Sorgues, probably on Saturday. GB.

From Dijon, writes to Marcelle; is continuing his bicycle trip.

June 21
From Montfavet (near Avignon), Derain writes to Kahnweiler:
I'm wonderfully at home here.... I see Picasso often, and he may soon become my neighbor.... When you write back to me, please be so good as to let me know if Braque has left....

June 23
Eva writes to Gertrude Stein:
We were unable to stay in Tarascon; there was nothing to rent. And so now we're in Avignon. This morning Pablo found a somewhat Spanish house in the city proper.... After all, it's about time we found a place where we could feel a little at home; this bohemian-style hotel life does us no good.

June 28
Eva writes to Gertrude Stein and Alice Toklas:
We'll be moving into our new house today, 14, rue Saint-Bernard, Avignon.
Picasso adds a sketch of a dog and the inscription: "Gertrude's and Alice's dog called 'Saucisson.'"

BRAQUE

Marcelle writes to Braque, in Lyon (dated "Tuesday" [June 30]; received July 2); mentions that there is no news from Picasso:
Write to me. Tell me everything you are doing; at the exhibition in Lyon will you go see the pictures by Picasso?

July 2*
From Mâcon, writes to Marcelle:
Hello from Mâcon. Saturday I'll be in Sorgues. All is fine, not even a flat tire.
The same day, writes to Marcelle from Lyon, acknowledging her letter of June 30, and tells her he has seen the exhibition there.

July 3
From Loriol (Drôme), writes to Kahnweiler:
Tomorrow morning, I will be in Sorgues. …Yesterday I was in Lyon … I visited the exhibition.

July 4
From Couthézon, on his way to Sorgues, writes to Marcelle (twice); says he is expecting her on Tuesday morning (July 7). He is probably in Sorgues by July 5.

July 15
From Sorgues, writes to Kahnweiler:
I have not written to you since my arrival in Sorgues. However, ever since I got here I've had to busy myself with the reconditioning of my new house and it is no small task running after the masons and the painters. You know, people here are hardly in a hurry. At last I think that all this will be done tomorrow or the day after. I would like to work, for I am getting somewhat bored. I have had a very pleasant journey, without the least amount of fatigue. I visited the exhibition in Lyon.…The paintings are displayed with much taste. De La Fresnaye has been given pride of place. I saw Derain. He is very happy to be here and is looking forward to having a good season. Picasso is frequenting the cream of Avignon society. We spent Saturday together. I intend to write to you a bit more often now that I am going to have some peace. P.S. I forgot to tell you before I left that Sergent had sold the book by Salmon with Picasso's engraving before receiving my letter, which I had, however, sent him that very day.

PICASSO

July 1*
From Avignon, writes to Soffici, in Poggio a Caiano:
Here's my address in Avignon: 14, rue Saint Bernard.[228]

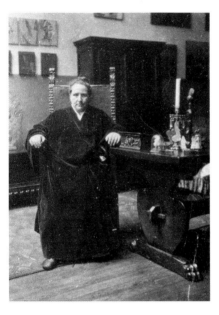

Gertrude Stein in her home at 27, rue de Fleurus, 1914

Eva Gouel in Avignon with Sentinelle, André Derain's dog, summer 1914

BRAQUE

The exhibition Braque refers to is the "Exposition internationale 1914: Beaux-Arts," shown at the Musée des Beaux-Arts, Palais St. Pierre, at Lyon (May 1–November 1). According to the exhibition catalogue, three paintings by Roger de La Fresnaye are included: *Portrait* (no. 237 in the catalogue), *Marie Ressort* (238), and *Still Life* (239). For Picasso, whose address is given as 5, rue Schoelcher, Paris, the catalogue lists two works: *La Toilette* (333; reproduced as pl. 51 in the catalogue; D./B. XIV, 20); and *Accordionist* (334; p. 190).[145]

From Montfavet, Derain writes to Kahnweiler:
I have seen Braque. Very happy with his trip.

[July 25]
From Sorgues, writes to Kahnweiler (undated; "1914" added by Kahnweiler):
I am very happy to have rented this house and that my place is finally done. The studio is very pretty.... Picasso paid me a visit. He is still fond of Sorgues. He would like to find something here.... Picasso tells me that you were supposed to leave Paris on the twenty-fifth of July. I take it then that you made up your mind about the country of your choice.

August 1
From Sorgues, writes to Kahnweiler, in Rome (Hotel Eden):
Now that you are on the road, it remains only for me to wish you a good journey. I am working, quite content to be finally settled in my own place. As a result, I hardly leave the house.

It is probable, given the detached tone of this card, that news of Austria's declaration of war on Serbia, on July 28, has not yet reached him. Writing to Braque from Bern, Switzerland (postmarked May 31, 1916), Kahnweiler would remark:
It's from Sorgues that I had news from you for the last time, in a card written two days before the war. It reached me August 10 in Rome....

PICASSO

July 21
From Avignon, writes to Kahnweiler:
I've received a few more photos and am waiting for the others. They're not bad. Deletang lately has had a good hand. But the little plates are truly bad, it's hard to understand anything from them. I've been doing only large canvases, or rather have only been thinking of doing them. I've begun one that's already fairly well along. It was very difficult for me to get used to working in a dark attic, but things are moving and I hope the Good Lord does not want them to stop.... I often see Braque and Derain.[229]

August 2
Sees Braque and Derain off at the Avignon railroad station. The two have been called up to join their military units.

BRAQUE

August 3
From Lyon, writes to Marcelle that he and Derain left Avignon the day before. They have learned only in Lyon that war has been declared. He adds:
Write to me in Le Havre.

From Avignon, Marcelle writes to Braque in Lyon:
Since your departure yesterday, we—Picasso, Alice [Derain], and her sister—have been wandering about like lost souls....[146]

August 24
Braque, mobilized, is in Le Havre waiting to ship out. Will be assigned to the 224th infantry regiment, with the rank of sergeant.

PICASSO

August 8
From Avignon, writes to Gertrude Stein, in London (Knightsbridge Hotel):
I have just received your letter. We're in Avignon and are thinking of staying here for the time being. Braque and Derain are off to war.... A few days ago, before the mobilization, we were in Paris for a few hours, just long enough to get my things a bit in order.

August 24
From Avignon, Eva writes to Gertrude Stein and Alice Toklas in London:
It is said that Guillaume Apollinaire has joined up. J'apostrophe [Serge Férat] too. We have news from Braque; he's in Le Havre, waiting to leave in turn. Of Derain we know nothing; he left us his dog Sentinelle. As for us, we're staying here for a moment, for one never knows what will happen with all these sorrows.[230]

September 11
From Collioure, Juan Gris writes to Kahnweiler:
Picasso wrote me a few days ago. He too seems to have no news of Braque, Derain, and Vlaminck.... Matisse arrived here yesterday. He tells me that Apollinaire and Galanis have enlisted.[231]

From Avignon, Picasso writes to Gertrude Stein, in London:
We're thinking of staying here till the end of the war. We're not bad off here, and I'm even working a little, but I feel very worried when I think of Paris, my house there, and all our things.
Eva writes:
Derain and Braque left some time ago, and we've had no news from them for several days.... Braque must have been made a second lieutenant. Juan Gris is at Collioure and has no money, I don't know how he's going to get by. Alice Derain is in Sorgues with Marcelle Braque, and we see them from time to time.

Picasso. *Guillaume Apollinaire as an Artilleryman.* [Avignon or Paris,] 1914. Ink and watercolor, 9⅛ × 5″ (23 × 12.5 cm). Private collection, Paris

Exhibition of works by Picasso and Braque at the 291 gallery, New York, 1914. Photograph by Alfred Stieglitz; The Museum of Modern Art, New York, gift of Charles Sheeler. At left, Picasso's *Bar Table with Bottle and Wineglass* (Daix 548); at right, Picasso's *Violin* (Arensberg 173)

Marius de Zayas at the 291 gallery, New York, 1913; the photograph may be by Alfred Stieglitz.

BRAQUE

September 22
Is still in Le Havre.

End of October
In Lyon, as a cadet machine gunner.

PICASSO

September 22
Max Jacob writes to Kahnweiler:
… Boischaud … has become a concierge, rue Francoeur.… I learned from him that our friend Braque is a sergeant at Le Havre … Our friend Picasso is living at 14, rue Saint-Bernard and people say he's doing the most beautiful things he's ever done.
Also tells Kahnweiler that Apollinaire is in the Foreign Legion at Orléans with Serge Férat and Galanis.[232]

October 19
From Avignon, Eva writes to Gertrude Stein:
We received your cards; we're very pleased that you're happy in Paris.…Alice Derain left yesterday for Paris, and we accompanied her to the train station. Marcelle Braque is thinking of leaving for Lyon in ten days … to meet up with Braque, who will be there as a cadet machine gunner. We don't know what's become of Guillaume, nor of J'apostrophe, and would very much like to have news of them.

October 30
From Collioure, Juan Gris writes to Kahnweiler:
Matisse writes from Paris that … Derain is in the front line; that Vlaminck's painting for the army at Le Havre, and that Picasso withdrew a large sum—they say 100,000 francs—from a bank in Paris at the outbreak of the war.… I have no news from Braque, the one person who interests me most.[233]

November 11
From Avignon, Eva writes to Gertrude Stein:
Marcelle Braque has returned to Paris, and we've never heard from her. Do write us again before we return, and see you soon.

November 14
From Avignon, writes to Gertrude Stein:
We plan to leave next Tuesday at 6:30 in the evening, and we hope to be in Paris the following morning around 7.… We'll come to see you the very same day. I've already begun to take down my paintings and to put my brushes and paints in order. And that's all.

BRAQUE

December 9–January 11, 1915
Exhibition of work by Braque and Picasso at Stieglitz's 291 gallery. About twenty works by Braque and Picasso are selected by Marius de Zayas for the exhibition, from the collection of Gabrielle and Francis Picabia. Picabia had assembled an important collection of modern and primitive art that included by 1913 "major works by Picasso, Braque and Duchamp, African sculpture and probably a still life painting attributed to Cézanne (Montreal Museum of Fine Arts)."[147]

In a manuscript text from the late 1940s, "How, When, and Why Modern Art Came to New York," prepared at the request of Alfred H. Barr, Jr., then Director of Museum Collections of The Museum of Modern Art, de Zayas declares:

An unpardonable sin committed by both the Photo-Secession and the Modern Gallery was not to have a one-man exhibition of the work of Braque. His contribution to modern art was, and is, one of the most valuable. When his work was first exhibited in New York at the Photo-Secession (1914–1915) it was in the company of Picasso. The same thing happened at the Modern Gallery. Braque's work was always shown with Picasso's or with other painters.[148]

December 17
Photograph, taken of Braque in uniform, standing in a trench, is inscribed: "Souvenir of the attack of December 17, 1914, Maricourt, Somme."[149]

December
Promoted to lieutenant.[150]

PICASSO

December 9–January 11, 1915
The joint exhibition with Braque at the 291 gallery in New York had originally been planned to present only the work of Picasso. However, when de Zayas, charged with assembling the exhibition, found that Kahnweiler had made an exclusive arrangement with Coady's gallery for a New York showing, he obtained a group of paintings by both Picasso and Braque from Gabrielle and Francis Picabia.[234]

December 31
Letter sent from Picasso, Eva, Max Jacob, and Serge Férat to Apollinaire; Picasso writes:

My dear friend Guillaume: I've received your letters. I'm very happy to know you're in good health.... I've given your address to all, have sent you those of Serge and Braque, and have told you what I know of Derain.... This morning Salmon came to see me; he's leaving soon to join up.... As you can imagine, my life's not too cheerful.... All my love, your Picasso.[235]

Marcelle Braque with Turc, October 19, 1914

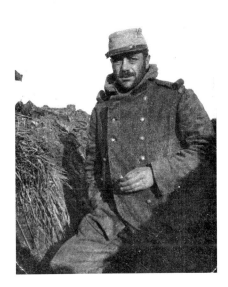

Braque at the front, December 17, 1914

NOTES TO THE DOCUMENTARY CHRONOLOGY

Unless otherwise indicated, primary materials in the Documentary Chronology come from the following sources. All correspondence to Pablo Picasso is drawn from the Picasso Archives, Musée Picasso, Paris. (Excerpts from the Braque correspondence to Picasso in the Picasso Archives were provided by Pierre Georgel, who is preparing the forthcoming critical edition, *Georges Braque et Pablo Picasso: Correspondance inédite.*) All correspondence to Georges Braque, and correspondence between Georges Braque and Marcelle Braque, is from the Laurens Archives. All correspondence to Daniel-Henry Kahnweiler is from the Galerie Louise Leiris Archives, Paris. All correspondence to Gertrude Stein, Leo Stein, and Alice B. Toklas is from the Gertrude Stein Archives, Collection of American Literature, Beinecke Rare Book and Manuscript Library, Yale University, New Haven, Connecticut. The papers of Inez Haynes Irwin are in the Collection of American Literature, Beinecke Rare Book and Manuscript Library; Inez Haynes Irwin's diary of March 27–May 3, 1908, is in the Arthur and Elizabeth Schlesinger Library on the History of Women in America, Radcliffe College, Cambridge, Massachusetts. The Hamilton Easter Field papers are in the Archives of American Art, Smithsonian Institution, Washington, D.C.

Documents from secondary sources are cited in abbreviated form. The full bibliographic references begin on page 445.

The notes to the Picasso entries in the Documentary Chronology begin on page 439.

BRAQUE

1. Leymarie 1973, p. xv.
2. Zurcher 1988, p. 284.
3. In his reminiscences (Friesz 1929), Friesz mentions that Braque had accompanied him to Antwerp in 1905 and 1906. There is no documentary evidence of a trip by Braque to Antwerp in 1905. However, on the basis of hotel receipts found in the Laurens Archives, we may establish that the stay in Antwerp in 1906 was much longer than had been thought by Pouillon (1982, p. 18). These bills show that Braque paid for lodging at the Lusthof Frascati, Vlaamsch-Hoofd bij Antwerpen, and at the Pénsion Rosalie van der Auwera, St. Anna Vlaamsch-Hoofd, June 12–July 12 and August 11–September 11, respectively.
4. Kim 1980, pp. 139, 147, note 22.
5. Pouillon 1982, p. 20.
6. Lassaigne 1973, p. xvi. Interview conducted in 1961. Braque, according to Pouillon (1982, p. 18), had seen the Cézanne retrospectives at the Salons d'Automne of 1904 and 1905.
7. Entries 721 to 726: *The Large Trees* (721), *The Olive Tree* (722), *The Port of Antwerp* (723), *The Vale* (724), *Boats* (725; now in the Musée National d'Art Moderne, Centre Georges Pompidou, Paris, and titled *Landing Stage, L'Estaque* [Pouillon 4]), *The Scheldt* (726).
8. Martin 1979, p. 120.
9. Two of Braque's calling cards (undated) were left at Picasso's studio; both are in the Picasso Archives, Musée Picasso, Paris. The second card is inscribed "Regards."
10. Uhde 1928, p. 38.
11. Lassaigne 1973, p. xvi.
12. Kahnweiler, Introduction to Stein 1955, p. ix.
13. Kahnweiler 1972, pp. 35–36.
14. Ibid., p. 43.
15. Kahnweiler also bought a drawing by Matisse (no. 1242, Salon des Indépendants) and works by Signac, Camoin, and Friesz. See Monod-Fontaine 1984b, p. 95.
16. Martin 1979, p. 122.
17. Derain 1955, p. 152.
18. Elderfield 1978, p. 184, note 1.
19. Derain 1955, pp. 149–50.
20. Quoted in Cousins/Seckel 1988, p. 558.
21. Kahnweiler and Braque may have met earlier in 1907, during the Salon des Indépendants, but "it is in all likelihood only at the time of the Salon d'Automne, after the painter's stay [in September 1907] at L'Estaque, that his first purchase of Braque's works took place" (Monod-Fontaine 1984a, p. 24). See notes 8, 12, 13, and 14, above.
22. Reprinted in Apollinaire 1972, pp. 23, 27–28.
23. The last day of the Salon was October 22. Charles Braque used the term *bâcler* to signify that the Salon would be "locked up" on October 23.
24. According to Martin (1986, p. 92, note 9), Braque's painting was probably *The Cove, La Ciotat* (now private collection, Paris), "or a work quite similar to it." Martin believes there is no other surviving Fauve work by Braque that fits the title *Red Rocks.*
25. Reprinted in English translation in Apollinaire 1972, p. 34.
26. Martin 1979, p. 140.

The first part of Apollinaire's article in *Je dis tout,* October 12, 1907 (Apollinaire 1972, p. 28), informs us that Friesz's paintings would have been rejected had it not been for Desvallières's intervention. Indirect evidence of Braque's return to Paris at the time of the Salon d'Automne is to be found in the effect of the Cézanne retrospective (fifty-six paintings) on his work. The exhibition provided the first opportunity for Braque to see a sizable group of works by the master of Aix, and this decisively led him out of Fauvism and toward his own Cézannism.
27. Rubin 1977, pp. 159 ff.
28. According to the chronology proposed by Alvin Martin (1986, pp. 83–88), *Viaduct at L'Estaque* is "an homage to the deceased master [Cézanne] and a springboard for further development"; and "ultimately his first Cézannesque model, *Viaduct,* became the pictorial source from which the new style was resolved during the winter 1907–08."
29. Rubin 1977, p. 161.
30. Daix 1987, pp. 91–92; Daix 1988a, p. 147. See also Leighten (1989, p. 91), who translates Braque's statement as meaning "to light the fuses" ("mettre le feu aux étoupes"), a common phrase referring to an anarchist bomb.
31. These experiments have been brought to light not only by

William Rubin (1977), but also in Braque's own reflections on his attachment to Cézanne, recorded in his notebooks, or in remarks reported by Russell (1959, p. 9), Richardson (1959, pp. 6–7), Verdet (1962, n.p.), Leymarie (1961, p. 11), Lassaigne (1961, pp. xvi–xvii), Verdet (1978, pp. 14, 18, 19). See also Martin 1986 and Daix 1988a.

32. And not during February and March, if not later, as stated in Rubin (1977, p. 171).

33. Daix 1988a, p. 148. *Woman,* which was exhibited at the Salon des Indépendants of 1908, is now lost or destroyed. It is not identical with the *Large Nude,* as believed heretofore. Martin (1979, pp. 200–01) was apparently the first to suggest the likelihood that it was not the *Large Nude* but a composition with several figures that was shown at the Salon des Indépendants of 1908. It is not known whether Picasso was immediately aware of Braque's response through drawings and paintings to *Demoiselles,* or whether he learned of it only at the time of the Indépendants show of 1908.

34. Reproduced in Burgess (1910, p. 405; written in 1908) with the title "Woman (La Femme)."

35. Rubin 1977, p. 170: "If Braque was, in fact, inspired to return to the figure as a result of his contact with Picasso, this rather timid work—which makes as yet no attempt to assimilate the Spanish artist's style—may be the first stage of that effort."

36. There are several communications to Braque, in the Laurens Archives, from LM, whose identity is not known.

37. Burgess 1910, p. 405.

38. It may be observed that Burgess also attributed the title "Woman (La Femme)" to Picasso's *Three Women,* reproduced on p. 407 of his article "The Wild Men of Paris" (Burgess 1910).

39. Rubin 1977, p. 160.

40. Guillaume Apollinaire, "Le Salon des Indépendants," *La Revue des lettres et des arts,* May 1, 1908; in Apollinaire 1972, p. 43.

Alvin Martin (1986, p. 91) observes, however: "Most likely the 'composition' which Apollinaire refers to is a landscape, possibly the one of that title in the catalogue. It is improbable that he would compare a landscape to a nude."

41. For Apollinaire's later comments on Braque's Cubist paintings, see below, note 62.

42. Inez Haynes Irwin, typescript of diary, April 27, 1908, pp. 129–32. As Irwin leaves Paris on May 3, there cannot be any mistake concerning the date. She also records her personal impressions of both Braque and Picasso (for the latter, see Picasso, note 46): "Braque ... is a big, broad-shouldered, husky-looking Frenchman, with regular features and beautiful eyes, who boxes. He speaks a little English. Very shabby of course.... Blushes and grows charmingly confused when Gelett suggests taking picture...."

43. Burgess's description (Burgess 1910) assuredly fits the *Large Nude.* In the article (p. 405), when he says "[Braque] gave me a sketch for his painting entitled 'Woman' in the Salon des Indépendants [*sic*]," one may assume that he is referring to the drawing he published, also on p. 405. Burgess had been to the Indépendants and must have seen Braque's submission. That it included a composition with several figures would seem to find its confirmation in Burgess's initial description of the artist as "the originator of architectural nudes with square feet, as square as boxes, with right-angled shoulders" (p. 405). See also Martin 1979, pp. 200–01.

Although completed by May 22, 1908 (Cousins/Seckel 1988,

p. 560)—based on interviews with Matisse, Braque, Derain, and Picasso, and supplemented by photographs taken both by a hired photographer and by Burgess himself—the article was not published until two years later. Information on Burgess's research, including his visits to the artists' studios and to the Steins, can be found in several letters from Burgess to Inez Haynes Irwin (who accompanied Burgess on his visits), as well as in her diary.

44. Fry 1966a, p. 70, note 13. Fry was the first to cite this review.

45. Vauxcelles 1908a, p. 2.

46. Page 2 of issue. This review was first cited in Fry 1966a, p. 70, note 13.

47. Charles 1908, part I, p. 2.

48. Ibid., part II, p. 2.

49. Page 3 of issue. This review was brought to my attention by Étienne-Alain Hubert.

50. Morice 1908, p. 732.

51. Gauthier 1957, pp. 51–53.

52. Even though the ties with Picasso are closer, Braque still addresses Picasso with the formal "vous"—"portez-vous toiles"; the more familiar "tu" evidently was used later.

53. I thank Gilbert Boudar for kindly checking this information.

54. At an early stage in the preparation of this chronology, Pierre Daix suggested that Braque must have taken a boat from Le Havre to Marseille, since he speaks of "crossing," which would mean that he had gone around Spain through the Strait of Gibraltar and had spent several days at sea. There is no documentary evidence in the Laurens Archives of such a trip.

According to Kahnweiler's recollection (cited in Rubin 1977, p. 172), Braque left on his bicycle and sent his belongings through the mail. Kahnweiler seems to have been mistaken, however. His recollection refers, in all probability, to Braque's trip to Sorgues early in the summer of 1914.

55. Leymarie 1977, p. 149.

56. Two postcards from Othon Friesz dated June 20 and July 15, 1908, respectively, and addressed to Braque at the Hôtel Maurin, furnish additional evidence of Braque's sojourn at L'Estaque during the summer of 1908.

57. Lassaigne 1973, p. xvi.

58. Tériade 1952, p. 50; reprinted in Flam 1973, p. 134.

59. "Matisse would not join the other ex-fauves and Picasso in their youthful, somewhat belated and at times naive discovery of Cézanne" (Barr 1951, p. 87).

60. Vauxcelles 1934, n.p.

61. Fry 1966a, p. 51.

62. The story of Matisse's first speaking of "cubes" or "Cubism," on seeing Braque's paintings submitted for inclusion in the Salon d'Automne of 1908, which by 1912 had become, as Edward Fry pointed out (1966a, p. 51), the "accepted version of the origin of the term Cubism," underwent several mutations, via the pen of Guillaume Apollinaire. In the first versions, written in 1911, Apollinaire explained that "in 1908, Picasso showed a few paintings in which there were some simply and firmly drawn houses that gave the public the illusion of...cubes, whence the name of our youngest school of painting" (*L'Intransigeant,* October 10, 1911; reprinted in English translation in Apollinaire 1972, p. 183); and that "the name of Cubism was found by the painter Henri Matisse, who pronounced it in connection with a painting by Picasso. The first Cubist paintings that were to be seen in an exhibition were the work of Georges Braque" (*Mercure de France,* October 16, 1911, reprinted in

Apollinaire 1955, p.47). The following year, the element of derision had entered Apollinaire's accounts: "The name Cubism, which this new school has adopted, was applied to it in derision by Henri Matisse, after he had seen a painting representing some houses whose cube-like appearance struck him greatly. This school … had as its founders Pablo Picasso and Georges Braque. Picasso's discoveries were corroborated by the good sense of Braque, who exhibited a Cubist painting at the Salon des Indépendants as early as 1908" ("Le Cubisme," in *Intermédiaire des chercheurs et des curieux*, October 10, 1912; reprinted in English translation in Apollinaire 1972, p.257); and "The Cubist paintings of Picasso, Braque, Metzinger, Gleizes, Léger, Jean [sic] Gris, etc. provoked a lively reaction from Henri Matisse; profoundly struck by the geometric aspect of these paintings…Matisse uttered the mocking word 'Cubism,' which was quickly taken up by everyone" (*Le Temps*, October 14, 1912, reprinted in Apollinaire 1972, p. 261). The version from *Intermédiaire des chercheurs et des curieux* was incorporated into chapter 7 of *Les Peintres cubistes*, published in March 1913.

Alvin Martin (1986, p.91) invokes the version of the origin of the term Cubism formulated by Apollinaire, in *Intermédiaire des chercheurs et des curieux* of 1912, as testimony of the fact that it was at the Salon des Indépendants of 1908, "not at the Kahnweiler show of the following autumn, that the first cubist paintings were shown." Salmon's recollections, in 1911, on the other hand, would seem to place this occurrence at the Salon des Indépendants of 1909. Wilhelm Uhde, for his part, remembers, in 1928, Max Jacob's observation made some twenty years earlier to Picasso while they were standing in front of a small landscape by Braque: "Haven't you noticed how Braque for some time has been introducing little cubes into his painting?" (Uhde 1928, p. 39).

Yet another view is that of Marcel Duchamp, who conflates Matisse's and Apollinaire's stories concerning Braque and the first Cubist painting in a statement of 1943 accompanying works by Braque (Yale 1950, p. 110): "As early as 1908 he [Braque] showed at the Paris Indépendants his famous view of a Mediterranean town which is considered the arrow pointing toward the new road."

63. Matisse 1935, p. 6. Matisse is here commenting on the statements published by Gertrude Stein in 1933 (Stein 1961, pp. 62, 64): "—And now once more to return…to Picasso becoming head of a movement that was later to be known as the cubists.…In these early days when he [Picasso] created cubism.…"

64. Tériade 1952; interview conducted in July 1951 and extant only in English translation. Reprinted in Flam 1973, p.134.

Alessandro De Stefani (1988) proposes to identify as Braque's *Large Nude* the canvas representing the "seated figure of a young woman" that Matisse (1935) speaks of having seen in Braque's rue d'Orsel studio—and later described to Tériade (Tériade 1952) as a "portrait of a woman on a chaise longue in which the drawing and values were decomposed." Thus it is probable, according to De Stefani, that the *Large Nude* was completed around September 1908, upon the artist's return to Paris from L'Estaque. It is De Stefani's contention, moreover, that the *Large Nude* does not represent Braque's response to a confrontation with *Les Demoiselles d'Avignon*, but rather is a consolidation and development of a prototype established by Matisse in his bronze sculpture *Reclining Nude* of 1906–07, then transposed into his *Blue Nude* (*Souvenir de Biskra*) of 1907. And

it is from these works that pictorial devices of Cubism came into being, before the meeting of Braque and Picasso in 1907.

I am indebted to Alessandro De Stefani for bringing to my attention his painstaking study of Matisse as the progenitor of Braque's *Large Nude*.

65. Monod-Fontaine 1984b, p.24: "Organized in a few days, the exhibition upset the schedule of the gallery, which planned a show of Girieud's paintings and Paco Durio's ceramics for the period 25 October to 14 November."

66. Apollinaire wrote the preface to the catalogue of Braque's November 9–28 show at Kahnweiler's gallery.

67. Apollinaire, "Georges Braque," reprinted in English translation in Apollinaire 1972, p. 51. The American painter Max Weber most likely visited Braque's exhibition. He owned a copy of the exhibition catalogue, which his daughter, Joy S. Weber, presented to The Museum of Modern Art Library in 1986.

68. "Exposition Braque chez Kahnweiler," *Gil Blas*, November 14, 1908; reprinted in translation in Fry 1966b, p.50.

Monod-Fontaine (1984a, p.24, note 1) states that fifteen paintings entered Kahnweiler's gallery in 1908 and wonders if these pictures could have been shown in the exhibition.

69. For the Kahnweiler gallery invoice documenting this acquisition, see the exhibition catalogue *Le Bateau-Lavoir* (Paris: Musée Jacquemart-André, 1975), entry 290.

70. Salmon 1920, pp.115–22; incorporated into "La Révélation de Seurat," in Salmon 1922, pp.41–56. In Salmon 1926 (p.525) he will say that Seurat's *Chahut* (D./R. 199) is among the "most perfectly pure materials comprised in the foundations of the Cubist edifice being mapped out in 1906 between the studios of the rue Ravignan (Picasso) and the rue d'Orsel." Salmon's advocacy of Seurat reflects the postwar shift to a revisionist view of recent art history. In the midst of France's reconstruction period, Seurat's art was seen as genuinely classical and as opening the way to the true tradition.

I am indebted to Beth Gersh-Nešić for bringing Salmon's two articles on Seurat to my attention.

71. Morice 1908, pp.736–37; cited in English translation in Fry 1966b, p.52. Hope (1949, p.33) and Monod-Fontaine (1984b, p.24) mistakenly believe the review was written by Apollinaire.

72. Exhibition catalogue for the Notre-Dame-des-Champs gallery, December 21, 1908–January 15, 1909, in Delaunay press album.

73. Martin 1982, p. 62.

74. Douglas 1979, p.185, note 3.

75. This painting was listed as no. 215 in the Indépendants catalogue, with the title "Landscape." It is reproduced as "Small Harbor in Normandy" ("Petit port normand") and described as painted from nature, in Des Gachons 1912, p. 350. Hope (1949, pp.36–37) referred to the picture as "Port in Normandy."

76. According to Hope (1949, p. 37).

77. Kahnweiler misquotes Vauxcelles, writing about the "origin" of the term Cubism: "From Matisse's word 'cube' Vauxcelles then invented the meaningless 'Cubism,' which he used for the first time in an article on the 1909 Salon des Indépendants, in connection with two…paintings by Braque, a still life and a landscape. Strangely enough he (later) added to this term the adjective 'Peruvian' and spoke of 'Peruvian' Cubism and 'Peruvian' Cubists, which made the designation even more meaningless. This adjective soon disappeared, but the name 'Cubism' endured and entered colloquial language, since Braque and Picasso, the painters originally so designated, cared very little whether they were called that or something else." See

436

Kahnweiler 1920a, pp. 15–16 (Aronson trans., 1949, p. 6). This definition was repeated by Barr (1946, p.259; note to p.63), who cited Kahnweiler (1920a) as his source. Barr seems not to have been aware that Kahnweiler was in error. Vauxcelles's article was written in connection with the Salon d'Automne of 1909, from which Braque was altogether absent. Martin (1982, p.62) and Daix (1987, p.102) have shown that Charles Morice (1909, p.729) was the first critic to give currency in print to the word Cubism in 1909.

78. Several critics, Salmon included, comment on the fact that the number of works submitted by artists to the Salon des Indépendants of 1909 was limited from six, allowed each artist in the past, to two, as a result of the Indépendants' considerably reduced exhibition space.

I am very much indebted to Étienne-Alain Hubert for bringing to my attention various articles discussing the reduced numbers of submissions, as for instance, Andrée Myra's review of the Salon (Myra 1909), in which she commented favorably on the fact that the Salon of 1909 had shrunk from 4,000 to 1,700 works because of the relocation of the Salon to "baraquements" erected in the Tuileries following the destruction of the Serres de la Ville de Paris, where it had always been held in the past.

79. Martin 1982, pp.62, 74, note 19; Daix 1987, p.102. See above, note 62.

80. Martin 1982, pp.44–45.

81. Braque indicates his address as care of Mme Veuve Petit, Côte des Bois, La Roche-Guyon (Seine et Oise). The Italian critic to whom he refers is most probably Ardengo Soffici.

82. Kahnweiler press album I; cited by Martin 1982, p.62.

83. Alvin Martin (1982, p.64) wrote that the inclusion of wit and humor in the form of visual or verbal puns is an integral part of Synthetic Cubism. "The basis for many of these puns," he stated, "may be found in Braque's *Violin and Pitcher,* which is a landmark in the development not only of Cubism's form, but also its iconography."

84. *Lighter and Newspaper: "Gil Blas"* is dated 1909 by Romilly (1982), the beginning of 1910 by Leymarie (1973, p. viii), and 1910 by Martin (1982, p.69).

85. The dialogue between Picasso and Braque is especially difficult to establish during this spring, as each artist often worked on individual paintings over an extended period.

86. Picasso Archives. In the original French text, Braque employs the "vous" mode of address, which may denote either formality or the fact that he is referring to both Picasso and Fernande.

87. One of Kahnweiler's photographs showing Braque at L'Estaque confirms that they had met before. See Monod-Fontaine 1984a, p.25.

According to Hope (1949, p.49), Kahnweiler visited Braque at L'Estaque in September, and "the artist pointed out the sites from which he had painted some of his landscapes in 1908, such as the *Houses at L'Estaque* (p.101). Kahnweiler was astonished at their fidelity to natural details in the landscape. However, by 1910, Braque, like Picasso, was painting entirely from invention and imagination." Several photographs he took of the sites, including one of Braque at L'Estaque, record Kahnweiler's visit (Leiris Archives; reproduced in Monod-Fontaine 1984a, p. 25, and Monod-Fontaine 1984b, p.104).

88. Reproduced in Monod-Fontaine 1984b, p.103.

89. Salmon 1910, p. 5. Salmon describes Metzinger's *Nude* as deserving special mention. "The *Nude* is alive, if one may say so, in a set of Louis-Philippe furniture....In the background a round wall clock shows ten past four."

90. Metzinger 1910, p. 403.

91. Quoted in English translation in Fry 1966b, p. 60.

92. The development begun in 1908 is brought to completion in these works, for the decomposition into facets unifies the buildings and the spatial container. There is, however, space between the edges for transitions, the contrasts of volumes or lighting being indicated by small brushstrokes, tending to the monochrome. The divergence from Picasso is manifest. Whereas the latter seeks new formal constructions, which are often brutal, Braque especially works the whole of the painted surface, finely modulating the articulations. Similar problems are discernible in two oval still lifes (pp.174, 176), of which it is not known whether they date from the stay at L'Estaque or from the return to Paris.

93. Reprinted in Apollinaire 1972, pp. 135, 136.

94. Puy 1910, pp. 44–45. Originally published in *Mercure de France,* July 16, 1910, pp. 243–66; the cited passage appears on p. 257.

95. Two undated photographs, one showing Braque in his army uniform, photographed by Picasso, the other showing Picasso in Braque's uniform, photographed by Braque, were taken in Picasso's studio at 11, boulevard de Clichy, on either a journey to or back from a period of military exercises; see Sabartés 1954, pp. 313–14. The photographs, traditionally assigned to 1909, could conceivably date from the period of Braque's military exercises that took place from September 7 to October 6, 1909, following his stay at La Roche-Guyon. Picasso and Fernande had just moved into 11, boulevard de Clichy; however, there is no documented evidence of contacts between Braque and Picasso at that time. A more likely date would seem to be the period of military exercises from March 27 to April 12, 1911, for by that time their friendship was sufficiently well established for Braque to have sent Picasso several postcards (from Le Havre, Rouen, and Saint-Mars-la-Brière); we know of at least five during this period.

96. The Ermitage was a café on the boulevard Rochechouart patronized by artists c. 1910–12. Fernande Olivier (1965, pp.171–73) devoted several pages to describing its atmosphere.

97. There exist, in fact, two extraordinary photographs of Kubelík with violin, taken between April 25 and May 1, 1911 (Collection "Monde et Caméra," Bibliothèque Nationale, Cabinet des Estampes et Photographies). The opening of the Ingres exhibition was Wednesday, April 26.

98. Fry 1966b, p. 65.

99. Salmon 1945, p. 67.

100. André Salmon's use of the expression "renovator of French dress" is reminiscent of Apollinaire, who utilized "reformer of dress" to describe Braque, in an article about Paul Birault (who printed Apollinaire's preface to Braque's 1908 exhibition) in "La Vie anecdotique," *Mercure de France,* no. 400, February 16, 1914 (included in *Le Flâneur des deux rives,* Paris: Éditions de la Sirène, 1918; reprinted in Apollinaire 1966, pp. 59–60): Apollinaire's description of Braque reads in part: "...famous Cubist, illustrious accordion player, reformer of dress long before the Delaunay family...."

101. Because of an incident in Agadir, on September 13, the French government had rejected German peace overtures.

102. Monod-Fontaine 1984a, pp. 25–26, cited in part. Matisse sends a landscape and a still life (both catalogued as "esquisses décoratives" [decorative sketches]; Barr 1951, p.143) to the Salon d'Automne. It is likely that he left Collioure for Paris in order to

attend the opening, on October 1, 1911.

103. The crisis with Germany subsides only at the beginning of November. In Monod-Fontaine 1984a, p.25 (partially cited).

104. Bernard 1911, pp. 255–74. I am indebted to Theodore Reff for identifying this article for me.

105. Daix suggests that these might be the two landscapes *The Window, Céret* (Romilly 89), still rendered in the blue colors Braque used in Paris, and *Rooftops at Céret* (p.195).

106. Monod-Fontaine 1984a, p.26; 1984b, p.106.

107. Marcelle is with Braque at this time. Her whereabouts are known from a letter of November 11, 1911, addressed to her at the Maison Delcros, Céret, from a friend, the engraver Ganon.

108. Des Pruraux 1911, pp. 703–04. Soffici originally had selected these illustrations for his article "Picasso e Braque" of August 24, in *La Voce*, which appeared without them, because of the indignant incomprehension manifested by the director of the magazine, Giuseppe Prezzolini. The reproductions were utilized to illustrate Des Pruraux's article instead. On this subject see Rodriguez 1984–85, p.34, note 15. I am most grateful to Jean-François Rodriguez for his invaluable help in matters related to Soffici.

109. *Dictionnaire* 1968, p.160.

110. "Echos," *Le Supplément*, December 21, 1911, p.1. All news clippings are in Kahnweiler press album I.

111. Braque generally referred to *Le Portugais* as *The Emigrant*.

112. Severini gives the impression in his autobiography (Severini 1946, p. 78) that Braque and his wife (as he called Marcelle) had moved into the same building (impasse de Guelma, where they rented two studios on the floor above his studio) in the same year he did (1910). In actuality, they did not move to impasse de Guelma most likely until January 1912. Marianne Martin (1968, p. 77, note 3) noted Severini's inaccuracy but added that the Braques moved there in 1911, without any supporting evidence, however. A similar assumption is made by Billy Klüver (in an unpublished lecture, "Severini and Paris, 1906–1916," delivered at Palazzo Grassi, Venice, October 27, 1986; typescript p.10), who places the move by Severini and the Braques to impasse de Guelma within a few weeks of each other, before spring 1911. I am indebted to Billy Klüver for information on Severini's Paris domiciles and the unpublished text of his lecture.

113. Reprinted in Monod-Fontaine 1984b, pp. 28–29.

114. Laurens Archives. There is no evidence of Braque and Picasso having made a trip to Le Havre in February 1912 (as stated in Daix 1987, pp. 120, 411, note 6), for the purpose of introducing Marcelle Lapré (mistakenly called Dupré by Daix) to Braque's parents.

115. Roche-Pézard 1983, pp.173–74.

116. Monod-Fontaine 1984a, p. 26, cited in part.

117. Ibid., pp. 26–27, cited in part.

118. Cooper 1982, pp.18, 19.

119. He does not mention his first *papier collé* to Kahnweiler. Logic would require that the still lifes with sand, *Glass, Pipe, and Grapes* (Romilly 143), *Fruit Dish, Bottle, and Glass: "Sorgues"* (p.240), *Fruit Dish and Glass* (p.240), and especially *Fruit Dish: "Quotidien du Midi"* (p.244) were done prior to, or at the same time as, this first *papier collé* (Daix 1987, pp.127, 411.)

120. Braque refers to the Moderne Kunstkring exhibition, which opened at the Stedelijk Museum on October 6, 1912. His letter suggests that the twelve Picassos shown in the exhibition may have come from private collections; see the letter of Sep-tember 27.

121. There is no trace of this article by Apollinaire, unless it is in *Les Soirées de Paris*.

122. On June 20, 1988, at Paris–Drouot Richelieu, this work (no. 47), transposed onto canvas, was sold. This indicates that the dialogue between the two artists encompassed "fresco" (*a secco* wall painting) as well as numerous other media and concerns. The fresco was exhibited for the first time apparently in "Kubismus," Josef-Haubrich-Kunsthalle, Cologne, May 26–July 25, 1982; no. 7.

123. Monod-Fontaine 1984a, p. 27; cited in part.

124. Reprinted in English translation in Apollinaire 1972, p. 247.

125. Reprinted in Apollinaire 1980, p.228.

126. Kahnweiler press album I.

127. Page 1 of issue.

128. André Salmon pays tribute to Cochon (1956, pp.82–83) in a chapter titled "Le Raffut de Saint Polycarpe" (Saint Polycarp's Ruckus).

129. Gamwell 1980, p. 167, note 15. Although its publication was announced in March 1912 and on October 26, 1912, Gleizes and Metzinger's book was not published until late November or early December of that year.

130. Reproduced in Monod-Fontaine 1982, p.57, figures 41 and 42, and quoted in English translation, p.58; reproduced also in Monod-Fontaine 1984a, p. 27.

131. "There is still need to figure out the apparent, possible, or hidden references in this difficult portrait that no one has reviewed, in part because everyone concentrated on Gertrude and Pablo and not on anything else, and in part because the Braque was never reprinted" (letter from Dr. Ulla Dydo to Judith Cousins, December 13, 1988).

132. See Kahnweiler's description of the studio, under May 26, 1914.

133. Brown 1988, p.139.

134. Seckel 1977, p.276. According to Seckel, the picture was reproduced in postcard form.

135. Kahnweiler press album II.

136. If the correction of the date is right, this card invalidates the claim that he made a trip to Céret (Leymarie 1973, p. xv; Trinkett Clark [in M.-F./C. 1982, p. 152]; Daix 1987, p. 139).

137. Kahnweiler press album II.

138. The "large drawings" mentioned in the letter of November 12 can only be *Guitar* (M.-F./C. 27), *Guitar* (p. 296), *Clarinet* (p. 289), *Checkerboard: "Tivoli-Cinéma"* (p.298), *Checkerboard* (M.-F./C. 30), and *Guitar and Program: "Statue d'épouvante"* (p. 299). Two, *Checkerboard: "Tivoli-Cinéma"* and *Guitar and Program: "Statue d'épouvante,"* can be dated by the use of the programs of the Tivoli movie theater, which opened its doors in Sorgues on October 31.

Guitar and Program: "Statue d'épouvante," which contains another program, is thus at least a week later. "It is the only collage by Braque that Picasso owned....Did Picasso appreciate the anticipatory Surrealist flavor of the title *La Statue d'Epouvante*? That is at any rate the work which André Breton selected for inclusion in *Le Surréalisme et la peinture* in 1928" (M.-F./C. 1982, p.122).

139. Collection Laurens; intended as a book for children, it was published in 1912 (Vincennes: Les Arts Graphiques). See Monod-Fontaine 1984a, p.28.

140. Kahnweiler press album II.

141. It is uncertain whether Apollinaire's request for titles

BRAQUE

relates to the forthcoming issue of *Les Soirées de Paris* (see April 15), in which eight works by Braque were to be reproduced.

142. Reprinted in Apollinaire 1966.

143. News clipping in Laurens Archives.

144. Kahnweiler 1920b, p. 154. Cited in French translation in Monod-Fontaine 1984a, p. 28.

A photograph from 1914 of Braque's studio showing a cardboard-and-paper construction and a *papier collé*—with news clippings from *Le Matin* of February 18, 1914 (for the construction), and from *Havre-Eclair* of January 11, 1913 (for the *papier collé*)—is apparently the only remaining evidence of Braque's experiments with reliefs in paper (p. 315). As such, the construction has never received serious attention; Monod-Fontaine (1982, p. 55) pronounced Braque's paper reliefs "...ephemeral construction games, in which Picasso surely participated." (There is no evidence of this.) Yet, as suggested in the text (p. 34), in its formulation as an object anchored to the wall, like a corner relief, Braque's construction shows a remarkable likeness to the counter-reliefs that Vladimir Tatlin began to make, it has generally been thought, following the shock of the constructions he saw in Picasso's studio. Rubin demonstrates that Cubist construction sculpture was innovated by Braque, who had probably begun to fabricate paper sculpture as early as 1911, and certainly no later than the early spring of 1912.

145. I am very much indebted to Mme Valérie Duret for information about the exhibition and works shown by la Fresnaye and Picasso.

146. Laurens Archives. In answer to Francis Crémieux's question whether he had seen the beginning of the fraternal friendship between Braque and Picasso, Kahnweiler replied, "Yes, I saw it begin, I saw it continue, and it ended, as did everything else, in 1914. Picasso told me many years later, 'On August 2, 1914, I took Braque and Derain to the Gare d'Avignon. I never saw them again.'" This, according to Kahnweiler, "was a meta-phor of course. He [Picasso] did see them again, but by this he meant that it was never the same" (Kahnweiler 1972, p. 46).

It is therefore surprising to find the undocumented citation in Hope (1949, p. 74), "They [Braque and Picasso] had a personal quarrel just before the war, and have remained somewhat distant ever since," taken up more recently by Angelica Rudenstine (1988, p. 596—with no source given), who declares, "Picasso and Braque had a quarrel shortly before the war, and after Braque returned to Paris in the fall of 1917 they had no personal contact...." To E. A. Carmean, Jr. (M.-F./C. 1982, p. 85, note 1), "Picasso's comment has a double edge, suggesting that Braque was not a major artist after the war. The two had argued early in 1914, and thus their prewar relationship had already grown cold." (This in reference to Picasso's comment to Kahnweiler that he never saw them again.) In Patricia Leighten's version of the story (1989, p. 144), we are told: "It is quite possible that the argument he [Picasso] and Braque reportedly had on the platform of the train station in Avignon on August 2, 1914, as Braque and Derain went off to join their military units—Picasso later claimed, 'We never saw each other again'—may well have concerned Picasso's pacifism, or, in any case, his refusal to join the war." This is by no means borne out by Kahnweiler's testimony, cited above, or by Marcelle's letter of August 3 to Braque or even by Braque's letters of July 3 and 25, to Kahnweiler, in which he speaks of having spent a Saturday with Picasso, and of Picasso's paying him a visit and still hoping to find a place in Sorgues. Braque, moreover, writing to Marcelle during the war, until he was wounded in 1915, always asked to be remembered to Picasso, and similar messages from Picasso would be transmitted by Marcelle to Braque (information from Mme Claude Laurens, in conversation, April 5, 1989).

147. Camfield 1979, p. 15.

148. De Zayas 1980, p. 105.

149. Laurens Archives. Braque sent the photograph to Marcelle.

150. Hope 1949, p. 72.

PICASSO

1. Olivier 1988, p. 188. An event she associated with the inauguration of the monument to the Chevalier de la Barre across from the Sacré-Coeur, which occurred on this date (Hausser 1968, p. 204).

2. Monod-Fontaine 1982, p. 72; Daix 1987, p. 58.

3. Stein 1961, pp. 53, 64.

4. The date of their first encounter has not been established with absolute certainty. Picasso confirmed to Pierre Daix (Daix 1987, p. 68) that he met Matisse at the time of the Indépendants, which opened on March 20 and closed on April 30. Matisse was in Paris to open his second one-man show at the Druet gallery on March 19, the day before the opening of the Salon des Indépendants. Just after the two shows had opened, he made his first trip to North Africa, spending two weeks at Biskra, in Algeria. It is possible that the meeting—the two artists were introduced by Gertrude Stein—took place shortly after Matisse's return from North Africa, assuming he came back to Paris, as believed by Flam (1986, p. 174) and Daix (1987, p. 68). Barr (1951, pp. 82, 86), however, believed that Matisse went from Biskra directly to Collioure, where he spent the spring and summer of 1906, and that he and Picasso met for the first time only in the autumn at rue de Fleurus, when the two of them had returned from Collioure and Gósol, respectively. Prior to 1951, in his monograph on Picasso (Barr 1946, pp. 43, 254), Barr dated their encounter to 1905 on the basis of Picasso's "recollection": "Picasso says he met Matisse in 1905 (questionnaire, October 1945). Gertrude Stein says the two artists first met in the fall of 1906 after Picasso's return from Gósol [Stein 1961, p. 22]. The memory of neither is dependable."

5. According to Gertrude Stein (1961, p. 53), "Spring was coming and the sittings were coming to an end. All of a sudden one day Picasso painted out the whole head. I can't see you any longer when I look, he said irritably. And so the picture was left like that."

6. Daix 1987, p. 53.

7. Olivier 1988, p. 212.

8. Leo and Gertrude Stein used to receive the Sunday comic supplements of the American newspapers, which they would pass on to Picasso and Fernande (Stein 1961, pp. 23, 25–26).

9. Daix 1988b, pp. 497 ff.

10. In her letters of August 24, 1907, and September 2, 1907 (Stein Archives; not quoted here) to Gertrude Stein, Fernande refers to the fact that Vollard has not yet paid the money he owes Picasso. On December 5, 1907, Picasso writes Gertrude (Stein Archives) that Vollard has given assurance of coming the next day to pick up his canvases.

11. Picasso and Apollinaire apparently did not realize that Géry Pieret, a Belgian adventurer with a gift for extravagant stories, whom Apollinaire employed as one of his secretaries in 1906, had stolen the two heads—originally excavated at Cerro de los Santos and bought as a pair for the Louvre by the archaeologist Pierre Paris in 1903—from the Salle des Antiquités Ibériques. They had been displayed there in the basement, with some twenty other heads (the important series of reliefs from Osuna were shown on the ground floor). Géry Pieret offered the heads to Apollinaire, who suggested that Picasso might be interested in them. Picasso bought them for a small sum. He told Zervos in the spring of 1939 that at the time he was painting *Les Demoiselles d'Avignon*, his "attention had been centered on Iberian sculpture in the Louvre" (Golding 1988, p. 40). Golding (pp. 42–43) discounts the possibility of Picasso's having focused his attention on the two heads from Cerro de los Santos in the Louvre—"and this is unlikely since they were not shown on the ground floor like the Osuna reliefs…but in a small room in the basement." Leighten (1989, p. 80), on the other hand, believes that "Picasso almost certainly knew they were stolen, since he kept them hidden in his house while he owned them and knew where to return them…. Could these have been 'commissioned' thefts? It seems an otherwise extraordinary coincidence that Apollinaire's friend would have stolen such obscure works and then fortuitously discovered that Picasso would buy them, during the period of the *Demoiselles'* first phase…." For various accounts of "l'affaire des statues," as the incident came to be known, see Olivier 1965, pp. 146–50; Penrose 1973, pp. 181–83; Golding 1988, p. 42.

12. Sketchbook 4, March–April 1907 (private collection), is described by Leal (1988, pp. 168–69, reproduced p. 175). The inside front cover is inscribed "Salle 11 …" (which may be a reference to the Salon des Indépendants); sheet 20v is inscribed: "Write to Braque/Stein will be at home all of next week with the exception of Monday and Tuesday"; the inside back cover is inscribed: "Braque/Friday." There is no mention of Braque's address, as erroneously indicated by Leighten (1989, p. 91). This same sketchbook, moreover, contained a group of twenty-three black-and-white photographs (possibly taken by Picasso), studio views that show paintings, sculptures, drawings, and *papiers collés* executed by Picasso between 1906 and 1913.

Rosenblum (1986, p. 59) considers the possibility of the two artists' having first met at this time. This concurs with Kahnweiler's statement that Apollinaire introduced Braque to Picasso during the spring of 1907 (Kahnweiler 1949, p. 16).

13. In what is probably his most accurate published reference to *Les Demoiselles d'Avignon,* an account of a conversation with Picasso of December 2, 1933, Kahnweiler (1952, p. 24) spoke of having seen the picture, in early summer 1907, after the com-pletion of the present version. In subsequent accounts, however, Kahnweiler would report that he visited Picasso's Bateau-Lavoir studio to see the *Demoiselles* after Wilhelm Uhde, who had seen the painting during March 1907.

14. Cousins/Seckel 1988, p. 557, cited in part.

15. Ibid., cited in part.

16. See Picasso to Gertrude Stein, February 4, 1907.

17. Stein 1961, p. 19. Gertrude incorrectly makes this event coincident with the Salon des Indépendants of 1908.

18. On the dates of Alice Toklas's arrival in France, and her first meeting with Gertrude Stein, see Cousins/Seckel 1988, pp. 557–58.

19. Stein 1961, pp. 18–19.

20. Fernande had found lodgings at 2, impasse Girardon (Cousins/Seckel 1988, p. 557). Her calling card, printed with the name "Fernande Belvallée" (which she used while separated from Picasso) and that address is in the Stein Archives.

21. Penrose 1973, p. 134; Cousins/Seckel 1988, p. 648.

In Daix's view (1988a, p. 148), Apollinaire gave expression to his dislike of the *Demoiselles* in his remarks about Matisse published in *La Phalange,* December 15, 1907 (reprinted in translation in Apollinaire 1972, p. 39): "We are not here in the presence of an extravagant or extremist undertaking; Matisse's art is eminently reasonable."

22. Cousins/Seckel 1988, p. 557.

23. Stein 1961, p. 22.

24. Daix 1988a, p. 146, described erroneously as an invitation. It is a small catalogue with an introduction by Fernand Fleuret, two reproductions of drawings, and a list of the works exhibited.

25. Salmon 1912, p. 51.

26. The earliest was probably the primitivist version of *Three Women,* shown in a photograph with André Salmon (Daix 1988a, p. 145).

27. Kahnweiler 1971, p. 38.

28. Daix 1979, p. 203.

29. See March–April 1907.

30. Reprinted in Apollinaire 1972, p. 39.

31. Barr 1951, p. 116.

32. Stein 1961, pp. 63, 64–65. A letter from André Level of January 24 dates the purchase of *Family of Saltimbanques* (D./B. XII, 35) by the organization La Peau de l'Ours. The photograph of the studio at the Bateau-Lavoir, which was probably taken by Picasso, and which shows one of the sketches preparatory to *Standing Nude,* dates from this period (Cousins/Seckel 1988, ill. 3).

33. Stein 1961, pp. 18, 64. Stein first mistakes this opening for that of the last Salon d'Automne (p. 18) and then corrects herself (p. 64).

The French rendition of the description of the first picture differs from the American text as follows: whereas the French text says "une sorte d'homme ou de femme [a sort of man or woman]" (Stein 1934, p. 25), the American edition, published by Harcourt, Brace, New York, August 1933, reads "a sort of man and women." In the British edition, however, published by the Bodley Head, London, also in 1933 but subsequent to the American edition, the passage reads "a sort of man and woman." This corresponds to the original manuscript, typed by Alice Toklas and preserved at Yale (manuscript kindly verified for me by Dr. Ulla Dydo).

34. Several cross-checkings confirm Gertrude Stein's testimony concerning Matisse. Alfred Barr emphasizes that for

Matisse "the years 1908–10 were marked...by a further decline in his position of leadership among young French painters" (Barr 1951, p. 103). This is confirmed by Charles Morice in his review of the Salon des Indépendants of 1909: "The uncompromising, the absolutely devoted ones, who formerly accepted the tyranny of Matisse, have rejected it. Today, in effect, if not by his own admission and theirs, the head of the bold ones is Mr. Georges Braque" (Morice 1909, p. 729).

35. Olivier 1965, pp. 97–98: "He had not spoken of it to anybody, not even to Picasso, his source of inspiration. Was he hoping to be the first to exploit this new formula?...Picasso, who had barely discussed or shown his new paintings to even his closest friends, was rather indignant."

36. Stein 1961, p. 64.

37. Daix 1988a, p. 147. This notebook (no. 16) was discovered during research for the exhibition "Les Demoiselles d'Avignon" at the Musée Picasso, Paris, 1988. It dates from spring 1908.

For the study related to *Three Women*, see Seckel 1988, vol. 1, p. 306, illustration 45R.

38. Inez Haynes Irwin, typescript of diary, April 29, 1908, p. 139. Cited in part in Cousins/Seckel 1988, p. 560. In the description of her visit to Picasso's studio (pp. 138, 139–40), Irwin includes a portrait of Picasso and Fernande: "From Czobel's we go to see Picasso.... Meet Braque—the big, boxer Fauve. Picasso turns out to be a darling; young, olive, with bright, frank eyes, each with a devil in it, straight black hair; in an overcoat and in a blue sweater that Stein brought him from San Francisco... Girl comes into Picasso's with a dog—big, tall with white skin, black hair, gray eyes and huge rings in her ears—overpoweringly, gypsyishly picturesque. 'I waited for you at the restaurant. I am very angry,' the girl says. 'You see I am engaged,' explains Picasso. She smiled and went out, leaving a big, woolly, sheep-like white dog to play with a little, puppyish, woolly brown one, already there. I talk with Picasso whom I find most adorable, boyish, enthusiastic, lighting up like a torch at any talk of his work, but always with a sense of humor in it."

I am indebted to Dr. Stanley K. Jernow for making available excerpts from Irwin's diary.

39. Quoted in Daix 1988a, p. 151.

40. Quoted by Cousins/Seckel 1988, pp. 560–61.

41. Daix 1977, p. 95.

42. Olivier 1988, p. 228.

43. Daix 1987, pp. 95, 131, refers to *Composition with Skull* (p. 90) as a remembrance of Wieghels's death, which would explain, according to Daix, Picasso's later reluctance to sell the painting. It was sold by Kahnweiler to Shchukin in 1912, for a considerable price (see July 12, 1912).

44. Cited in Cousins/Seckel 1988, p. 562.

45. Olivier 1965, p. 122.

46. Stein 1939.

47. The visit could scarcely have taken place earlier, Matisse having spent the summer at Cavalière, near Toulon, and the works dating doubtless from June–July.

48. Cited in Monod-Fontaine 1984a, p. 168.

49. This canvas, having been bought by Vincenc Kramář (see below, note 129), must be *Bust of a Woman* (Daix 134), which is close to the paintings purchased by Shchukin in 1908 and has to be dated from the spring of 1908, and not from the beginning of 1908 as Daix and Rosselet have it (Daix 1979, p. 216).

50. Cited in Cousins/Seckel 1988, p. 562.

51. Olivier 1965, pp. 68–71; Stein 1961, pp. 103–07.

52. In her study of Henri Rousseau and his friendship with the American painter Max Weber, Sandra Leonard (1970) states that the banquet took place some time after November 10, 1908, and before December 4—corresponding to the date of Picasso's first encounter with Rousseau, and the date of a thank-you note from Rousseau to Apollinaire, respectively. She believes that it was "probably held on a Saturday, either November 21 or November 28." Since Braque was present, November 28 might be the more likely date, as he was in Le Havre around November 22. Rubin (1983) relates Picasso's series of works on the theme of the Carnival at the Bistro (p. 114 and Daix 217) to this banquet.

53. Richardson 1980, pp. 19–20.

54. Lassaigne 1973, p. xvii.

55. Gilot/Lake 1964, p. 74.

56. See Rubin 1983 and Geelhaar 1970.

57. This document is unusual in that the artist has adopted the conventional postcard medium for the purpose of transmitting a "photo-souvenir" of his own work.

See Seckel 1977, p. 276, on Braque's *Violin: "Mozart/Kubelick"* (p. 233) being reproduced in postcard form.

58. Cavallo 1966, p. 47.

59. In a postcard postmarked June 10, Picasso informs Leo Stein that he and Fernande are in Horta de Ebro.

60. McCully 1982, p. 65, cited in part.

61. The last passage, omitted by McCully, evokes the land of Buffalo Bill.

62. Olivier 1988, pp. 234–36.

63. Transcript from Edward F. Fry.

64. Ibid.

65. This letter is dated September 1908 in the Stein Archives at Yale, but its substance suggests a follow-up to Picasso's letter dated September 13, 1909.

66. Olivier 1988, pp. 237–38. The painting in question is *Woman with a Fan* (p. 127) of spring 1909. According to Richardson (1980, p. 19, note 2), it is a portrait of Etta Cone. That Shchukin bought it from Sagot would indicate that Kahnweiler did not yet have exclusive rights over Picasso's production.

67. Spies 1983, p. 47.

68. Leymarie 1973, p. vii.

69. Olivier 1988, pp. 244–45.

70. For reference to Uhde's association with the Notre-Dame-des-Champs gallery, see Robbins 1985, p. 12.

71. What we know of the exhibition, otherwise largely undocumented, comes almost entirely from Werth's article in *La Phalange;* quoted in translation in Fry 1966b, pp. 57–58.

72. Cousins/Seckel 1988, pp. 564–65, cited in part.

73. McCully 1982, p. 67, cited in part.

74. Letter mentioned in Cousins/Seckel 1988, pp. 565–66, with erroneous date, July 31, 1910. The letter was sent on to Picasso in Limoges, Haute Vienne, on July 31 and then forwarded to general delivery, Céret, on August 2.

Field's letter to Picasso includes precise dimensions and plan and elevation drawings of his library. The room was 7 × 3 meters, lit by a single window. The project called for eleven panels to be painted, the largest one of which was to measure 185 cm high × 300 cm wide. At night, all the panels were to be artificially lit (Picasso Archives).

Doreen Bolger, who has made an extensive study of Hamilton Easter Field (and to whom I am most indebted for her generosity in making available to me the documentation she gathered in connection with her master's thesis on Hamilton Easter Field [see Bolger 1973], as well as advance proofs of her 1988 article on Field published in the *American Art Journal*), appears to

believe that the project, "most likely a large easel painting," either was never completed (as suggested by Field himself in an article written in 1919 in which he stated "the decorations are not yet finished") or "was sold to a Russian collector, probably a more lucrative arrangement for its creator" (as reported in 1966 by Field's protégé and heir, the sculptor Robert Laurent). See Bolger 1988, pp. 87, 105, notes 34, 35.

75. Monod-Fontaine 1984b, p. 103; this letter was written prior to August 5, since on that date he hears from "everyone in Cadaqués."

76. Cited in Monod-Fontaine 1984a, p. 165.

77. The evidence is given in Potter 1970, p. 73, note 4. Alice previously was said to have moved into Gertrude's home in the fall of 1909.

78. Kahnweiler 1963, p. 29.

79. Page 4 of issue.

80. The present location of Picasso's letter is unknown. There is only a fragmentary transcription, kindly made available to me by Doreen Bolger.

81. Homer 1977, p. 62. Naumann, in de Zayas 1980, pp. 102–03, 126, notes 9, 16.

82. Metzinger 1910, p. 650; English translation in Fry 1966b, pp. 59–60.

83. McCully 1982, p. 79.

84. Apollinaire 1980, p. 192.

85. Number 2, p. 11.

86. At that time Steichen spelled his first name Eduard. He permanently changed the spelling to Edward during World War I.

87. Steichen 1963, chapter 4, n.p. Stieglitz's gallery, The Little Galleries of the Photo-Secession, had come to be known as the "291" gallery, for its address on Fifth Avenue.

88. On the exhibition, see Homer 1977, pp. 62, 66, 274, note 26.

89. McCully 1982, p. 79.

90. Ibid., p. 80.

91. Delaunay press album.

92. Fry 1966b, pp. 62, 195.

93. Flanner 1957, p. 132.

94. Allard 1911, pp. 57–64; Fry 1966b, pp. 63–64.

95. Cousins/Seckel 1988, pp. 566–67. Max Raphael had written Picasso on the recommendation of Wilhelm Uhde.

96. Monod-Fontaine 1984b, p. 106, and Monod-Fontaine 1984a, p. 165; cited in part.

97. It is hard to decipher the subject matter in Picasso's description of the "large picture," for several key words are virtually illegible. I am indebted to Edward F. Fry for identifying one of these as "filles" ("girls").

98. Partially cited in Daix 1979, p. 266.

99. Olivier 1965, p. 164.

100. The earlier French edition (1933) of Olivier 1965 includes a facsimile of the letter, pp. 207–08.

101. The recto shows Mignon, a figure from a popular song, holding a mandolin.

102. Monod-Fontaine 1984a, p. 165, cited in part; transcript from Edward F. Fry.

103. Something new in the execution of pyramidal structures in these works probably struck Braque.

104. Soffici 1911, pp. 636–37.

105. Soffici's visits to Paris after spring 1907 occurred in 1910 (February 8–April 11); 1911 (March 11–May 31); 1912 (March 18–June [before June 13]); 1914 (first half of March to before April 12; and beginning of May [before May 5] to June 14).

106. The *Mona Lisa* was not found until December 13, 1913, in Florence. The thief, Vincenzo Perugia, had worked at the Louvre as a framer-glazer. After being exhibited for one week in Florence, the painting was returned to Paris, January 1, 1914.

107. Cavallo 1966, p. 49; see also Cavallo 1986, p. 129.

108. Géry Pieret refers incorrectly to the statuettes as Phoenician; *Paris-Journal* utilizes this designation until September 6, but from then on properly identifies them as Iberian.

109. For a comprehensive account of "l'affaire des statues," as it has come to be known, with numerous citations from *Paris-Journal* in English translation, see Steegmuller 1963, pp. 182–226. Other accounts, more succinct but manifesting variants, are to be found in Olivier 1965, pp. 146–50; Penrose 1973, pp. 181–83; and Golding 1988, p. 42, notes 1, 2.

110. The name under which Apollinaire had portrayed him in *L'Hérésiarque et cie* (1910).

111. Cavallo 1986, p. 130; Cavallo 1966, pp. 50–51.

112. A similar anecdote appeared in *Annales politiques et littéraires,* March 15, 1914, but there the story was associated with Braque.

113. "Falsification of values" obviously is not directed at Apollinaire's assertion of Picasso's anteriority to Braque, but at his opinion of Cubism. Guilbeaux, an intelligent, well-informed critic, had perhaps sought his information from Kahnweiler, who often became infuriated by Apollinaire's equivocations.

114. Lowe 1983, pp. 142, 153.

115. A couple of days before October 15—the date is inferred from an unpublished letter of October 15, 1911, from Boccioni to Vico Baer (The Museum of Modern Art Archives; cited in Martin 1968, p. 110)—the Milanese artists Boccioni and Carrà visited Paris to see at first hand the most recent innovations in the visual arts, and to make contact with the Parisian art world in preparation for the Futurists' exhibition to be held at the Bernheim-Jeune gallery in Paris in February 1912. Severini, who had moved to Paris in 1906 and was well acquainted with avant-garde circles, served as their guide. (Severini [1946, p. 125] wrote of having brought them to see Picasso; Olivier [1965, p. 169] mentioned a visit of Severini and Boccioni, describing them as "impassioned prophets, dreaming of a Futurism that would oust Cubism.") Their stay in Paris lasted about fifteen days (Severini 1946, p. 125). Severini and Boccioni called on Apollinaire, who gave an account of this meeting in his column "La Vie anecdotique" (in *Mercure de France,* November 16, 1911).

116. Severini 1946, p. 139.

117. Cavallo 1966, pp. 55–56; the letter is reproduced in facsimile.

118. McCully 1982, pp. 81–82.

119. Ibid., pp. 82–84.

120. Apollinaire 1966, IV, p. 57. Originally published in Soffici 1920, pp. 229–30.

121. Van Dongen 1911, n.p.

122. This letter reveals a surprising about-face on the part of Soffici, inspired perhaps by his need at that moment to curry favor with Apollinaire. Soffici's acquiescence in the face of Apollinaire's injunction did not prevent him, it should be noted, from incorporating his text "Picasso e Braque" into subsequent publications: in *Cubismo e oltre* (published in 1913 by Edizioni della Libreria della Voce), where it appears with some variants along with articles by Soffici from *Lacerba*; in *Cubismo e Futurismo* (publication announced April 1, 1914, published by Libreria della Voce), the first part of which is comprised of

PICASSO

Cubismo e Oltre. In *Trenta artisti moderni italiani e stranieri* (Florence: Vallecchi, 1950), "Picasso e Braque" appears as two separate texts, with minor variants, one devoted to each artist. It is reprinted in the first volume, edited by Soffici himself, of his *Opere* (Florence: Vallecchi, 1959) as part of a section entitled "Cubismo e Futurismo."

I am extremely indebted to Sergio Zoppi for providing a copy of Soffici's letter and for allowing me to quote from it. The letter will appear in its entirety in *Apollinaire e l'Italia: Carteggio*, edited by Lucia Bonato and Sergio Zoppi, to be published by Bulzoni, Rome.

123. This is probably the monkey, Monina, Picasso owned at the time he and Fernande were living at boulevard de Clichy.

124. Apollinaire 1966, p. 758. Originally published in Soffici 1920, p. 230.

125. The visit is described by Stein 1961, p. 111. Further information relating to the title of the picture and its purchase by Gertrude Stein is found in Potter 1970, p. 171, and Rubin 1972, p. 206.

126. Page 383 of issue. See Fry 1966b, pp. 111, 196.

127. Kahnweiler press album I; reproduced in Monod-Fontaine 1984b, p. 109.

128. McCully 1982, p. 91.

129. Vincenc Kramář was a Czech art historian who in 1919 would be named Director of the Pinacotheca of the Society of Patriot Friends of Art, later the National Gallery of Prague. Between 1911 and 1913 he came to Paris several times, buying art from Sagot, Kahnweiler, and Vollard. He assembled a remarkable collection notable for its Picassos and Braques, most of which he donated to the National Gallery.

130. See Hope 1949, p. 14, for a description of Braque's early training as a *peintre-décorateur.*

131. Severini 1983, p. 107; Daix 1987, pp. 120 and 411, note 6.

132. McCully 1982, pp. 92–93. We know that Max Raphael visited Picasso at the 11, boulevard de Clichy studio around June 13, 1911, as well as at another studio, possibly the Bateau-Lavoir, where Picasso began to work again in the fall of 1911 (Cousins/Seckel 1988, pp. 566–67).

133. Severini 1946, p. 151.

134. Monod-Fontaine 1984a, p. 165, cited in part.

135. Ibid., cited in part.

136. Ibid., pp. 165–66, cited and reproduced.

He must be referring to the etching *Still Life with Bunch of Keys* (p. 218; Geiser speaks of another copy, since lost).

137. Monod-Fontaine 1984b, p. 110, cited in part.

138. Monod-Fontaine 1984a, p. 166, cited in part.

139. Ibid., cited in part.

140. Ibid., pp. 166–67.

141. This painting has often been mistakenly reproduced vertically.

142. Monod-Fontaine 1984a, pp. 168–69, letter cited in part.

143. Monod-Fontaine 1984a, p. 169, and Monod-Fontaine 1984b, p. 110, letter cited in part.

144. Monod-Fontaine 1984a, p. 169, cited in part.

145. Ibid., cited in part.

146. Ibid., cited in part.

147. Ibid., cited in part. Boischaud, who is also mentioned in Braque's letters, was a factotum at Kahnweiler's gallery.

148. According to Mr. and Mrs. Claude Laurens, in conversation with Judith Cousins, autumn 1988. Claude Laurens mentioned the "Singapore" suits in "Hommage à Georges Braque" (Laurens 1964, p. 66).

149. Transcript from Edward F. Fry.

150. Apparently we are missing at least one letter in which Kahnweiler discusses the possible sale. Letter of July 12, cited in part in Monod-Fontaine 1984a.

151. Daix 1987, p. 131. The painting acquired by Shchukin was an important early work, possibly *Composition with Skull*, 1908 (p. 90), as suggested by Monod-Fontaine (1984b, pp. 111–12). According to Daix (1987, p. 131), *Composition with Skull* is a remembrance of Wieghels's suicide.

152. Transcript from Edward F. Fry. Picasso may have seen a newsreel of the famous boxing match between the Frenchman Georges Carpentier and the American Frank Klaus. Carpentier, champion of Europe, was defeated in Dieppe on June 27, 1912.

153. As in the summer of 1911, it is Picasso who extends the invitation.

154. Rubin 1984, p. 305.

For an analysis of the role of the Grebo mask in the invention of Picasso's constructed sculpture, see Rubin 1972, pp. 74, 207–08; Rubin 1983, p. 647; and Rubin 1984, pp. 18–20, 76–77, notes 56–63.

For a discussion of Picasso's response to the Grebo mask, and a useful summary of the history of the Grebo mask and its relation to Picasso's Cubism, see Fry 1988, pp. 299–300, 304–05, notes 19–23. See also Yve-Alain Bois 1987, pp. 33–68, for an interpretation of Picasso's response to the Grebo mask.

155. Monod-Fontaine 1984a, p. 169, letter cited in part. This may be the object Kahnweiler calls "the Wobé Mask." See Fry in Rubin 1984, p. 305, in reference to Picasso's drawing done in Marseille on August 9.

156. Monod-Fontaine 1984a, p. 169, cited in part.

157. Reproduced in Monod-Fontaine, 1984b, p. 112. See autumn 1912.

158. This dates Kahnweiler's finding the apartment on boulevard Raspail to after early September 1912.

159. The book that Picasso refers to is almost undoubtedly *Camera Work;* see Picasso's letter to Gertrude Stein, October 7.

160. Transcript from Edward F. Fry.

161. Daix 1979, p. 357.

162. Reproduced in M.-F./C. 1982, p. 181.

163. Kahnweiler press album II.

164. Page 3 of issue.

165. I thank Lynn Gamwell and Beth Gersh-Nešić for bringing this review to my attention.

166. Roger Fry, "The French Group," one of three prefaces to the exhibition catalogue (the other two being "The English Group" by Clive Bell, and "The Russian Group" by Boris Anisfeld) *Second Post-Impressionist Exhibition* (London: Grafton Galleries, 1912), pp. 14–15; the text is reprinted in part in McCully 1982, pp. 85–86.

167. Kahnweiler press album II.

168. The Moderne Kunstkring, or "Modern Art Circle," was founded in 1910 by Conrad Kikkert, Jan Sluyters, and Piet Mondrian, with Jan Tooroop acting as chairman. It was the group's intention to mount annual exhibitions of work by the most progressive artists, in emulation of the Paris Salon d'Automne. The first of these exhibitions was held in 1911, and they continued to be held until 1915, after which the group split up.

169. The letter is reproduced in part in M.-F./C. 1982, p. 56, and also quoted in part in English, p. 58. The letter is cited (as Monod-Fontaine points out) for the first time in Zervos 1932, p. 13, with the erroneous date October 7, prior to its purported

first citation in *Histoire de l'art contemporain*, ed. René Huyghe (Paris, 1935, p.535) mentioned by Fry (1988, p.305, note 24).

170. The painting bears a Kahnweiler gallery label (28, rue Vignon; stamped with a number, possibly 52). I am most grateful to Hélène Seckel and Yves Sangiovanni, of the Musée Picasso, for enabling me to examine the label, which is affixed to the stretcher.

171. "L'Exposition de La Section d'or," in *La Section d'or*, October 9, 1912, Pierre Reverdy, ed., pp.2–5. Reprinted in translation in Fry 1966b, p.97.

172. Reprinted in Apollinaire 1980, p.228.

173. Notice discovered by Fry and reported in Fry 1966a, p.195, text 18, note 1.

174. Reprinted in Apollinaire 1972, p.261.

175. Kahnweiler press album I.

176. Partially cited in Apollinaire 1980, p.228.

177. Fry 1966b, pp.11, 196 (note 4 to text 23).

178. First referred to by Fry 1988, p.305, note 24.

179. The correct date of the newspaper fragment as November 18 has been established by Fry (1988, p.305, note 24, and p.310), instead of November 10, as indicated by Daix (1979, p.287).

180. Apollinaire 1972, p.261.

181. Apollinaire 1966, IV, p.958. I am grateful to Beth Gersh-Nešić for calling my attention to this letter.

182. Daix 1979, p.358. Fry (1988, p.305, note 24) has proposed a date of "about December 1912" for these two photographs (to which should be added a third photograph showing a similar view of the boulevard Raspail studio first published by Fry [fig. 8, p.303]) on the basis of the dates (December 2 to 9, 1912) of the news clippings contained in all of the *papiers collés* and the presence of two smaller cardboard guitars (Daix 555, 556) which Fry has dated to early December 1912.

183. Daix 1979, p.285; account from *Journal officiel* of December 3, 1912, cited in part.

184. Fry (1988, p.306, note 30) has pointed out that the date of the contract "represents the last documented moment for Picasso's presence in Paris during 1912." The contract, first published in Jardot 1955, pp.50–52, is reproduced in Daix (1979, p.359) and Rubin (1980, p.152).

185. First referred to in Fry 1988, p.306, note 30.

186. Ibid.

187. Eva's postcard to Alice Toklas first referred to in Fry (1988, p.306, note 30). The trip to Barcelona, and another one in March 1913, may have been prompted by Picasso's concerns over the health of his father, but this is a hypothesis that will remain unverifiable as long as Picasso's correspondence with his parents remains inaccessible.

188. The text of Apollinaire's lecture was subsequently published as "Die moderne Malerei" in *Der Sturm* (no. 148–49, Berlin, February 1913); reprinted in English translation in Apollinaire 1972, pp.267–71.

189. This is the date proposed by Fry (1988, p.306, note 30), on the basis of a news clipping from the January 21, 1913, issue of the Paris newspaper *Le Matin*, in the upper right portion of the *papier collé* Daix 530.

190. Stein 1950, p.49; cited in Mellow 1974, p.201.

191. Farrelly scrapbook.

192. Heinrich Thannhauser, 1913, quoted in translation in McCully 1982, p.98.

193. Transcript from Edward F. Fry.

194. *Montjoie!*, no. 3, March 14, 1913, p.6.

195. At the instigation of the publisher (apparently against Apollinaire's wishes), preeminence is given to the subtitle so that when printed the title appeared as *Méditations esthétiques: LES PEINTRES CUBISTES*. It has been so reprinted ever since, or even published with title and subtitle transposed. The section on Picasso is based on an article of 1905, published in *La Plume* (May 15, 1905), followed by a section written in 1912. The chapter on Braque is adapted from an essay published in the *Revue indépendante* (no. 3, August 1911), which is a variant of Apollinaire's preface to the 1908 exhibition at Kahnweiler's gallery.

196. Monod-Fontaine 1984a, p.170, cited in part.

197. Ibid., cited in part.

198. This would indicate that the Daix 558–563 sequence must not have been executed in Paris, but in Céret.

199. Monod-Fontaine 1984a, p.170; Leiris Archives, transcript from Edward F. Fry. Picasso is probably referring to the fresco from Sorgues; see letter of October 31, 1912.

200. Monod-Fontaine 1984b, p.118, cited in part.

201. Ibid.

202. Monod-Fontaine 1984a, p.170, cited in part.

203. Ibid.

204. Ibid.

205. Daix 1979, p.300.

206. Ibid.

207. Monod-Fontaine 1984b, p.100, erroneously dated 1909.

208. Daix 1979, p.300, cited in part.

209. Kahnweiler press album II.

210. Ibid.

211. Ibid.

212. Daix 1979, p.300, cited in part.

213. Kahnweiler press album II.

214. Monod-Fontaine 1984a, p.170, cited in part.

215. Letter referred to in Daix 1977, p.135.

216. Adéma 1968, p.231.

217. It should be noted that the idea of a corner of wall, used by Picasso in the construction (p.279) incorporating the cardboard *Guitar*, reappears in the paper construction by Braque (first reproduced in Romilly 1982, p.41) on p.315. The news clipping in Braque's construction dates from February 18, 1914. The lost or transformed *papier collé* hanging on the wall contains a news clipping dated January 11, 1913. See Braque, note 144.

218. Monod-Fontaine 1984b, p.119.

Kahnweiler's letter to Gertrude Stein of October 17, 1913, confirms the transaction: "I have the honor of confirming our conversation of yesterday. You are selling me three of your Picassos, to wit: the young girl standing on the ball, the large composition in pink, and the woman with the linen. For these pictures I am paying you 20,000 francs in cash plus the new Picasso called *The Man in Black* [*Man with a Guitar*, p.283]. I enclose herewith, as agreed, a check for 20,000 francs payable January 15, 1914. I should be grateful if you would let me know that you have received it" (Gallop 1953, pp.86–87).

219. Adéma 1968, p.232.

The reproduction of four Cubist constructions by Picasso in number 18 of *Les Soirées de Paris* "caused such disapproval among its forty subscribers that all but one of them cancelled their subscriptions" (Penrose 1973, p.195). However, according to Adéma, those who did not cancel their subscriptions included Jean Sève, Raoul Dufy, Sonia Delaunay, Stuart Merrill, and Vollard.

220. The dating for this series should be winter 1914, and not spring as in Daix 1979.

221. Kahnweiler press album III.

222. La Peau de l'Ours was a society organized by a group of young collectors in 1904, under the direction of André Level, collector and writer on modern art. Its predetermined goal was to acquire a collection of works of art, primarily by young painters, that would be sold at auction in ten years' time, with the proceeds divided among the members. The collection thus was formed over a decade, its most famous acquisition being Picasso's *Family of Saltimbanques,* purchased by Level directly from the artist in 1909. Kahnweiler (1972, p.102) considered the auction at the Hôtel Drouot as "primarily…a way of speculating on the paintings, because it was a question of reselling them at a certain point and sharing the profit." Level, however, writing about the Peau de l'Ours auction in his memoirs (Level 1959, pp.32–33), points to the fact that it set a precedent by allocating twenty percent of the profit to the artists.

According to James Neil Goodman (1989, n.p.), the members of this society "chose the name Peau de l'Ours in the spirit of 18th-century French Colonials in the New World. A rough equivalent in English would be 'The Bear-Skin Trading Company.'"

223. Salmon 1956, p.259.

224. Seymour de Ricci, "La Peau de l'Ours," *Gil Blas,* March 3, 1914, p.4.

225. Level 1959, p.27.

226. Research carried out in 1986 by Magdalena Dabrowski for a doctoral dissertation (Dabrowski 1989, chapter 2, pp.47–50). According to her findings, the currently accepted date of spring 1913 for Tatlin's trip is invalid for these reasons: Tatlin's travel document indicates he was given permission to travel abroad between February 22 and the beginning of April 1914 (old Russian calendar, i.e., twelve days behind the Western calendar); the exhibition he is supposed to have accompanied to Berlin (of Russian folk art) took place March–April 1914; the year 1913 marked the 300th anniversary of the House of the Romanovs, hence no exhibitions were released to travel outside Russia throughout the entire year. During 1913, the only time Tatlin could have seen Picasso in Paris would have been between June 20 and July 22, yet there is no evidence of Tatlin's actually being there between those dates. In 1914, Picasso was in Paris until June, a period of time that would have been available for visits. Tatlin later, probably around 1917, reminisced to his fellow artist Georgii Yakoulov that he saw a "guitar" hanging on Picasso's studio wall. This quite possibly is the guitar hanging on the back wall in the photograph of Picasso seated in his studio at 5 bis, rue Schoelcher, dated 1914–16 (p.53).

I am considerably indebted to Magdalena Dabrowski for providing me with the invaluable results of her investigations into Tatlin's sojourn in Paris.

227. Cavallo 1966, p.58.

228. Ibid.

229. Monod-Fontaine 1984a, p.171, cited in part.

230. "J'apostrophe" was Picasso's nickname for Serge Férat, whose real name was Jastrebzoff.

231. Cooper 1956, p.9.

232. Garnier 1953, pp.96–99.

233. Cooper 1956, pp.14–15.

234. Homer 1977, p.199.

235. Musée Picasso, gift of W. A. McCarty-Cooper, 1985. The text of this letter was graciously communicated by Hélène Seckel.

WORKS CITED IN THE NOTES

ADÉMA 1968 Adéma, Marcel. *Apollinaire.* Paris: Éditions de la Table Ronde, 1968.

ALLARD 1966 Allard, Roger. "Sur quelques peintres." *Les Marches du Sud-Ouest,* June 1911, pp.57–64. Reprinted in Fry 1966b, pp.63–64.

APOLLINAIRE 1928 Apollinaire, Guillaume. *Le Flâneur des deux rives.* Paris: Éditions Gallimard, 1928. Originally published 1918.

APOLLINAIRE 1955 Apollinaire, Guillaume. *Anecdotiques.* Preface by Marcel Adéma. Paris: Éditions Gallimard, 1955.

APOLLINAIRE 1966 Apollinaire, Guillaume. *Oeuvres complètes de Guillaume Apollinaire.* Edited by Michel Décaudin, II, IV. Paris: André Balland et Jacques Lecat, 1966.

APOLLINAIRE 1972 Apollinaire, Guillaume. *Apollinaire on Art: Essays and Reviews, 1902–1918.* Edited by L. C. Breunig. Translated by Susan Suleiman. New York: The Viking Press, 1972. Translation of *Guillaume Apollinaire, Chroniques d'art (1902–1918).* Edited by Breunig. Paris: Éditions Gallimard, 1960.

APOLLINAIRE 1980 Apollinaire, Guillaume. *Les Peintres cubistes: Méditations esthétiques.* Edited by L. C. Breunig and J.-Cl. Chevalier. Paris: Hermann, 1980 (this edition first published 1965). Originally published 1913.

BARR 1946 Barr, Alfred H., Jr *Picasso: Fifty Years of His Art.* New York: The Museum of Modern Art, 1946.

BARR 1951 Barr, Alfred H., Jr. *Matisse: His Art and His Public.* New York: The Museum of Modern Art, 1951.

BERNARD 1911 Bernard, E. "Réputation de l'impression-nisme." *Mercure de France* 93 (September 16, 1911), pp. 255–74.

BIDOU 1911 Bidou, Henry. "Petites-Expositions Picasso [Vollard]." *La Chronique des arts et de la curiosité,* no. 2 (January 14, 1911), p. 11.

BOIS 1987 Bois, Yve-Alain. "Kahnweiler's Lesson." *Representations,* no. 18 (Spring 1987), pp. 33–68.

BOLGER 1973 Bolger, Doreen. "Hamilton Easter Field and the Rise of Modern Art in America." Master's thesis, University of Delaware, 1973.

BOLGER 1988 Bolger, Doreen. "Hamilton Easter Field and His Contribution to American Modernism." *American Art Journal* 20, no. 2 (1988), pp. 78–107.

BROWN 1988 Brown, Milton W. *The Story of the Armory Show.* New York: The Joseph H. Hirshhorn Foundation; Abbeville Press, 1988.

BURGESS 1910 Burgess, Gelett. "The Wild Men of Paris." *The Architectural Record* 27, no. 5 (May 1910), pp. 400–14. Written 1908.

CAMFIELD 1979 Camfield, William A. *Francis Picabia, His Art, Life and Times.* Princeton, N.J.: Princeton University Press, 1979.

CARMEAN 1980 Carmean, E. A., Jr. *Picasso: The Family of Saltimbanques.* Washington, D.C.: National Gallery of Art, 1980.

CAVALLO 1966 Cavallo, Luigi, ed., with the collaboration of the Galerie Michaud. *5 Xilographie e 4 puntesecche di Ardengo Soffici con le lettere di Picasso.* Milan: Giorgio Upiglio & C. Edizioni d'Arte Grafica Uno, 1966.

CAVALLO 1986 Cavallo, Luigi, with Valeria Soffici. *Soffici, immagini e documenti (1879–1964).* Florence: Vallecchi Editore, 1986.

CHARLES 1908 Charles, Étienne. "Le Salon des Indépendants—I." *La Liberté,* March 20, 1908, pp. 1–2; and "Le Salon des Indépendants—II." *La Liberté,* March 24, 1908, p. 2.

CHAUMEIL 1967 Chaumeil, Louis. *Van Dongen: L'Homme et l'artiste—La Vie et l'oeuvre.* Geneva: Pierre Cailler, 1967.

CLARK 1982 Clark, Trinkett. "Georges Braque: Chronology and Critical Review." In Isabelle Monod-Fontaine with E. A. Carmean, Jr. *Braque: The Papiers Collés.* Washington, D.C.: National Gallery of Art, 1982.

COOPER 1956 Cooper, Douglas, ed. and trans. *Letters of Juan Gris (1913–1927). Collected by Daniel-Henry Kahnweiler.* London: [privately printed], 1956.

COOPER 1970 Cooper, Douglas. *The Cubist Epoch.* London: Phaidon, in association with the Los Angeles County Museum of Art and The Metropolitan Museum of Art, 1970.

COOPER 1977 Cooper, Douglas, with the collaboration of Margaret Potter. *Juan Gris.* 2 vols. Paris: Berggruen, 1977.

COOPER 1982 Cooper, Douglas. "Braque as Innovator: The First *Papier Collé.*" In Isabelle Monod-Fontaine with E. A. Carmean, Jr. *Braque: The Papiers Collés.* Washington, D.C.: National Gallery of Art, 1982, pp. 17–21.

COOPER 1983 Cooper, Douglas, and Gary Tinterow. *The Essential Cubism, 1907–1920.* London: The Tate Gallery, 1983.

COUSINS/SECKEL 1988 Cousins, Judith, and Hélène Seckel. "Éléments pour une chronologie de l'histoire des Demoiselles d'Avignon." In Seckel, ed., *Les Demoiselles d'Avignon.* vol. 2. Paris: Éditions de la Réunion des Musées Nationaux, 1988.

DABROWSKI 1989 Dabrowski, Magdalena. "The Russian Contribution to Modernism: 'Construction' as Realization of Innovative Aesthetic Concepts of the Russian Avant-Garde." Ph.D. diss., Institute of Fine Arts, New York University, 1989.

DAIX 1977 Daix, Pierre. *La Vie de peintre de Pablo Picasso.* Paris: Éditions du Seuil, 1977.

DAIX 1979 Daix, Pierre, and Joan Rosselet. *Picasso: The Cubist Years, 1907–1916—A Catalogue Raisonné of the Paintings and Related Works.* London: Thames and Hudson, 1979. Translated by Dorothy S. Blair from *Le Cubisme de Picasso: Catalogue raisonné de l'oeuvre, 1907–1916.* Neuchâtel: Éditions Ides & Calendes, 1979.

DAIX 1987 Daix, Pierre. *Picasso créateur.* Paris: Éditions du Seuil, 1987.

DAIX 1988a Daix, Pierre. "Les Trois Périodes de travail de Picasso sur les trois femmes." *La Gazette des Beaux-Arts* 111 (January–February 1988), pp. 141–54.

DAIX 1988b Daix, Pierre. "L'Historique des Demoiselles d'Avignon révisé à l'aide des carnets de Picasso." In Hélène Seckel, ed., *Les Demoiselles d'Avignon.* vol. 2. Paris: Éditions de la Réunion des Musées Nationaux, 1988, pp. 489–545.

D./B. 1966 Daix, Pierre, and Georges Boudaille, with Joan Rosselet. *Picasso: 1900–1906*. Neuchâtel: Éditions Ides & Calendes, 1966.

DELAUNAY PRESS ALBUM Delaunay, Sonia. Album of newspaper clippings, catalogues, and announcements, 1911–14. Cabinet des Estampes, Bibliothèque Nationale, Paris.

DERAIN 1955 Derain, André. *Lettres à Vlaminck*. Paris: Éditions Flammarion, 1955.

DICTIONNAIRE 1968 *Dictionnaire de la chanson française*. Paris: Larousse, 1968, p. 160.

VAN DONGEN 1911 van Dongen, Kees. Preface to *Peintures nouvelles de van Dongen*. Paris: Bernheim-Jeune Cie, 1911.

DOUGLAS 1979 Douglas, Charlotte. "Cubisme français, cubo-futurisme russe." *Cahiers du Musée National d'Art Moderne, Centre Georges Pompidou, 1979* 2 (October–December 1979), pp. 184–93.

D./R. 1959 Dorra, Henri, and John Rewald. *Seurat*. Paris: Les Beaux-Arts, 1959.

ELDERFIELD 1976 Elderfield, John. *The "Wild Beasts": Fauvism and Its Affinities*. New York: The Museum of Modern Art, 1976.

ELDERFIELD 1978 Elderfield, John. *Matisse in the Collection of The Museum of Modern Art*. New York: The Museum of Modern Art, 1978.

FARRELLY SCRAPBOOK Farrelly, Aline. "Modern Art in America 1912–41: With special emphasis on the period 1912–18." A scrapbook of newspaper clippings, catalogues, and announcements; assembled by Aline Farrelly. The Museum of Modern Art, New York; special collections.

FLAM 1973 Flam, Jack D., ed. *Matisse on Art*. New York: Phaidon, 1973.

FLAM 1986 Flam, Jack. *Matisse: The Man and His Art, 1869–1918*. Ithaca, N.Y., and London: Cornell University Press, 1986.

FLANNER 1957 Flanner, Janet. "Master." In Flanner, *Men and Monuments*. New York: Harper & Brothers, 1957. First published as "Master, I," *The New Yorker*, no. 33 (October 6, 1956), pp. 49–89; and "Master, II," *The New Yorker*, no. 34 (October 13, 1956), pp. 50–97.

FLEURET 1928 Fleuret, Fernand. *Charles Vildrac, André Salmon, Othon Friesz*. Paris: Éditions des Chroniques du Jour, les Écrivains Réunis, 1928.

FRIESZ 1929 Friesz, Othon. "Jubilé du fauvisme: Souvenirs d'Othon Friesz." *L'Intransigeant*, June 17, 1929.

FRY 1966a Fry, Edward F. "Cubism 1907–1908: An Early Eyewitness Account." *Art Bulletin* 48, no. 1 (March 1966), pp. 70–73.

FRY 1966b Fry, Edward F. *Cubism*. New York: McGraw-Hill, 1966.

FRY 1988 Fry, Edward F. "Picasso, Cubism, and Reflexivity." *Art Journal* 47, no. 4 (Winter 1988), pp. 296–310.

DES GACHONS 1912 Des Gachons, Jacques. "La Peinture d'après-demain." *Je sais tout*, April 15, 1912, pp. 349–56.

GALLUP 1953 Gallup, Donald, ed. *The Sweet Flowers of Friendship: Letters Written to Gertrude Stein*. New York: Alfred A. Knopf, 1953.

GAMWELL 1980 Gamwell, Lynn. *Cubist Criticism*. Ann Arbor, Mich.: UMI Research Press, 1980. Originally presented as Ph.D. diss., University of California, Los Angeles, 1977.

GARNIER 1953 Garnier, François. *Correspondance de Max Jacob, I: Quimper–Paris, 1876–1921*. Paris: Éditions de Paris, 1953.

GAUTHIER 1957 Gauthier, Maximilien. *Othon Friesz*. Geneva: Pierre Cailler, 1957.

GEELHAAR 1970 Geelhaar, Christian. "Pablo Picassos Stilleben 'Pains et compotier aux fruits sur une table': Metamorphosen einer Bildidee." *Pantheon* 28, no. 2 (1970), pp. 127–40.

GERSH-NEŠIĆ 1989 Gersh-Nešić, Beth. "The Early Criticism (1910–1925) of André Salmon: A Study of His Thoughts on Cubism." Ph.D. diss., The City University of New York–Graduate School and University Center, 1989.

GILOT/LAKE 1964 Gilot, Françoise, and Carlton Lake. *Life with Picasso*. New York: McGraw-Hill, 1964.

GOLDING 1988 Golding, John. *Cubism: A History and an Analysis 1907–1914*. Cambridge, Mass.: The Belknap Press of Harvard University, 1988. 3rd ed. First published, London: Faber & Faber, 1959.

GOODMAN 1989 Goodman, James Neil. Preface to *Cubism: Le Fauconnier, Gleizes, Kupka, Marcoussis, Metzinger, Valmier, Villon.* Essay by Daniel Robbins. New York: James Goodman Gallery, 1989.

HAUSSER 1968 Hausser, Elizabeth. *Paris au jour le jour: Les Evénements vus par la presse 1900–1919.* Paris: Éditions de Minuit, 1968.

HOFFMAN 1909 Hoffman, Eugène. Review of the Indépendants. *Journal des artistes,* April 4, 1909, p. 6050.

HOMER 1977 Homer, William Innes. *Alfred Stieglitz and the Avant-Garde.* Boston: New York Graphic Society, 1977.

HOPE 1949 Hope, Henry R. *Georges Braque.* New York: The Museum of Modern Art, in association with The Cleveland Museum of Art, 1949.

HUBERT 1986 Hubert, Étienne-Alain. "Georges Braque selon Guillaume Apollinaire." In *Mélanges Décaudin: L'Esprit nouveau dans tous ses états, en hommage à Michel Décaudin.* Paris: Librairie Minard, 1986.

HUYGHE 1935 Huyghe, René, ed. *Histoire de l'art contemporain: La Peinture.* Paris: Librairie Félix Alcan, 1935.

IRWIN 1908 Irwin, Inez Hayes Gilmore. Typescript diary of March 27–May 3, 1908. Arthur and Elizabeth Schlesinger Library on the History of Women, Radcliffe College, Cambridge, Mass.

JARDOT 1955 Jardot, Maurice. *Picasso: Peintures, 1900–1955.* Paris: Musée des Arts Décoratifs, 1955.

KAHN 1912 Kahn, Gustave. "Art: Le Salon d'Automne." *Mercure de France* 99, no. 368 (October 16, 1912), pp. 879–84.

KAHNWEILER 1920a Kahnweiler, Daniel-Henry. *Der Weg zum Kubismus.* Munich: Delphin Verlag, 1920. Translated by Henry Aronson as *The Rise of Cubism.* New York: Wittenborn, Schulz, 1949.

KAHNWEILER 1920b Kahnweiler, Daniel-Henry. "Werkstätten." *Die Freude: Blätter einer neuen Gesinnung* (Burg Lauenstein), vol. 1 (1920), pp. 153–54.

KAHNWEILER 1949 Kahnweiler, Daniel-Henry. "Naissance et développement du cubisme." In *Les Maîtres de la peinture française contemporaine,* ed. Maurice Jardot and Kurt Martin. Baden-Baden: Woldemar Klein, 1949. French translation (revised and expanded) of "Ursprung und Entwicklung des Kubismus." In *Die Meister französischer Malerei der Gegenwart,* ed. Maurice Jardot and Kurt Martin. Baden-Baden: Woldemar Klein, 1948.

KAHNWEILER 1952 Kahnweiler, Daniel-Henry. "Huit entretiens avec Picasso." *Le Point,* October 1952, p. 24. From an interview on December 2, 1933.

KAHNWEILER 1953 Kahnweiler, Daniel-Henry. "Picasso et le cubisme." In *Picasso.* Lyon: Musée de Lyon, 1953.

KAHNWEILER 1955 Kahnweiler, Daniel-Henry. "Du temps que les cubistes étaient jeunes." *L'Oeil,* no. 1 (January 15, 1955), pp. 27–31. Interview with Georges Bernier.

KAHNWEILER 1963 Kahnweiler, Daniel-Henry. *Confessions esthétiques.* Paris: Éditions Gallimard, 1963.

KAHNWEILER 1972 Kahnweiler, Daniel-Henry, with Francis Crémieux. *My Galleries and Painters.* New York: The Viking Press, 1972. Translated by Helen Weaver from *Mes Galeries et mes peintres: Entretiens avec Francis Crémieux.* Paris: Éditions Gallimard, 1961.

KAHNWEILER PRESS ALBUMS Three albums of newspaper clippings: I, July 1907–November 1912; II, November 1912–March 1914; III, March 1914–1918. Galerie Louise Leiris, Paris.

KIM 1980 Kim, Youngna. *The Early Works of Georges Braque, Raoul Dufy and Othon Friesz.* Ph.D. diss., Ohio State University, Columbus, 1980.

KLÜVER/MARTIN 1989 Klüver, Billy, and Julie Martin. *Kiki's Paris: Artists and Lovers, 1900–1930.* New York: Harry N. Abrams, 1989.

LAMPUÉ 1912 Lampué, Pierre. "Lettre ouverte à M. Bérard, sous-secrétaire d'état aux beaux-arts." *Mercure de France,* 99, no. 368 (October 16, 1912), pp. 894–96.

LANTIER 1909 Lantier, Claude. "Cercle d'Art Moderne." *La Cloche illustrée* (Le Havre), June 12, 1909.

LASSAIGNE 1973 Lassaigne, Jacques. "Entretien avec Braque." In *Les Cubistes.* Bordeau: Delmas, 1973. From an interview with Braque conducted in 1961.

LAURENS 1964 Laurens, Claude. "Hommage à Georges Braque." *Derrière le miroir,* no. 144–6 (May 1964), p. 66.

LAURENT 1966 Laurent, Robert. "A Personal Statement." Hamilton Easter Field Foundation Collection, Ogunquit, Maine, 1966, n.p.; Hamilton Easter Field papers, Archives of American Art, Smithsonian Institution, Washington, D.C. Microfilm 68.2.

LEAL 1988 Leal, Brigitte. "Carnets." In Hélène Seckel, ed. *Les Demoiselles d'Avignon,* vol. 1. Paris: Éditions de la Réunion des Musées Nationaux, 1988.

LEIGHTEN 1989 Leighten, Patricia. *Re-Ordering the Universe: Picasso and Anarchism, 1897–1914.* Princeton, N.J.: Princeton University Press, 1989.

LEONARD 1970 Leonard, Sandra E. *Henri Rousseau and Max Weber.* New York: Richard L. Feigen & Company, 1970.

LEVEL 1959 Level, André. *Souvenirs d'un collectionneur.* Paris: Alain C. Mazo, 1959.

LEYMARIE 1961 Leymarie, Jean. *Braque.* Translated from the French by James Emmons. Geneva: Éditions d'Art Albert Skira, 1961.

LEYMARIE 1973 Leymarie, Jean. *Georges Braque.* Paris: Éditions de la Réunion des Musées Nationaux, 1973.

LEYMARIE 1977 Leymarie, Jean. *André Derain.* Paris: Éditions de la Réunion des Musées Nationaux, 1977.

LOWE 1983 Lowe, Sue Davidson. *Stieglitz: A Memoir/Biography.* New York: Farrar Straus Giroux, 1983.

MARTIN 1968 Martin, Marianne W. *Futurist Art and Theory, 1909–1915.* Oxford: Clarendon Press, 1968.

MARTIN 1979 Martin, Alvin. "Georges Braque: Formation and Transition, 1900–1909." Ph.D. diss., Harvard University, 1979.

MARTIN 1982 Martin, Alvin. "Georges Braque and the Origins of the Language of Synthetic Cubism." In Isabelle Monod-Fontaine with E. A. Carmean, Jr. *Braque: The Papiers Collés.* Washington, D.C.: National Gallery of Art, 1982.

MARTIN 1986 Martin, Alvin. "The Moment of Change: A Braque Landscape in the Minneapolis Institute of Arts." *Minneapolis Institute of Arts Bulletin,* October 1986, pp. 83–93.

McCULLY 1982 McCully, Marilyn. *A Picasso Anthology: Documents, Criticism, Reminiscences.* Princeton, N.J.: Princeton University Press, 1982. First published, London: The Arts Council of Great Britain, 1981.

MELLOW 1974 Mellow, James R. *Charmed Circle: Gertrude Stein and Company.* New York and Washington, D.C.: Praeger Publishers, 1974.

METZINGER 1910 Metzinger, Jean. "Notes sur la peinture." *Pan,* October–November 1910, pp. 649–52.

M.-F./C. 1982 Monod-Fontaine, Isabelle, with E. A. Carmean, Jr. *Braque: The Papiers Collés.* Washington, D.C.: National Gallery of Art, 1982.

MONOD-FONTAINE 1982 Monod-Fontaine, Isabelle. "Braque: The Slowness of Painting." In Monod-Fontaine with E. A. Carmean, Jr. *Braque: The Papiers Collés.* Washington, D.C.: National Gallery of Art, 1982.

MONOD-FONTAINE 1984a Monod-Fontaine, Isabelle, et al. *Donation Louise et Michel Leiris: Collection Kahnweiler-Leiris.* Paris: Musée National d'Art Moderne, Centre Georges Pompidou, 1984.

MONOD-FONTAINE 1984b Monod-Fontaine, Isabelle. *Daniel-Henry Kahnweiler: Marchand, éditeur, écrivain.* Paris: Musée National d'Art Moderne, Centre Georges Pompidou, 1984.

MORICE 1908 Morice, Charles. "Art moderne. La 24e Exposition des Artistes Indépendants." *Mercure de France,* 72, no. 260 (December 16, 1908), pp. 728–36.

MORICE 1909 Morice, Charles. "La Vingt-cinquième Exposition des Indépendants." *Mercure de France,* 78, no. 284 (April 16, 1909), pp. 725–31.

MYRA 1909 Myra, Andrée. "Art. Salon des Indépendants." *La Critique,* no. 266 (April 1909), p. 26.

OLIVIER 1965 Olivier, Fernande. *Picasso and His Friends.* New York: Appleton-Century-Crofts, 1965. Translated by Jane Miller from *Picasso et ses amis.* Paris: Librairie Stock Delamain et Boutelleau, 1933.

OLIVIER 1988 Olivier, Fernande. *Souvenirs intimes.* Paris: Calman-Levy, 1988. Published posthumously from a manuscript dating from the 1950s.

PARIGORIS 1988 Parigoris, Alexandra. "Les Soirées de Paris: Apollinaire, Picasso et les clichés Kahnweiler." *Revue de l'art,* no. 82 (1988), pp. 61–74.

PAULHAN 1952 Paulhan, Jean. *Braque, le patron.* Paris: Éditions Gallimard, 1952.

PENROSE 1973 Penrose, Roland. *Picasso: His Life and Work.* New York: Harper & Row, 1973. First published London: Victor Gollancz, 1958.

POTTER 1970 Potter, Margaret, ed. *Four Americans in Paris: The Collections of Gertrude Stein and Her Family.* New York: The Museum of Modern Art, 1970.

POUILLON 1982 Pouillon, Nadine, with Isabelle Monod-Fontaine. *Braque: Oeuvres de Georges Braque (1882–1963), Collections du Musée National d'Art Moderne.* Paris: Musée National d'Art Moderne, Centre Georges Pompidou, 1982.

DES PRURAUX 1911 Des Pruraux, Henri. "Intorno al cubismo." *La Voce,* no. 49 (December 7, 1911), pp. 703–04.

PUY 1910 Puy, Michel. *Le Dernier État de la peinture française.* Paris: Le Feu, Union Française d'Édition, 1910. Originally published as "Le Dernier État de la peinture française." *Mercure de France,* July 16, 1910, pp. 243–66.

RAPHAEL 1913 Raphael, Max. *Von Monet zu Picasso.* Munich: Delphin Verlag, 1913.

RAPHAEL 1933 Raphael, Max. *Proudhon, Marx, Picasso: Trois études sur la sociologie de l'art.* Paris: Excelsior, 1933.

RAPHAEL 1986 Raphael, Max. *Raumgestaltungen: Der Beginn der modernen Kunst im Kubismus und im Werk von Georges Braque,* edited by Hans-Jürgen Heinrichs. Frankfurt: Qumran im Campus Verlag, 1986.

REVERDY 1912 Reverdy, Pierre, ed. *La Section d'or* (Paris), October 9, 1912.

RICHARDSON 1959 Richardson, John. *Georges Braque.* London and Harmondsworth: Penguin, 1959.

RICHARDSON 1962 Richardson, John, ed. *Picasso: An American Tribute.* New York: Public Education Association, 1962.

RICHARDSON 1980 Richardson, John. "Your Show of Shows." *New York Review of Books,* no. 28 (1980), pp. 16–24.

ROBBINS 1985 Robbins, Daniel. "Jean Metzinger: At the Center of Cubism." In Joann Moser, ed., *Jean Metzinger in Retrospect.* Iowa City: The University of Iowa Museum of Art, 1985.

ROCHE-PÉZARD 1983 Roche-Pézard, Fanette. *L'Aventure futuriste, 1909–1916.* Rome: École Française de Rome, 1983.

RODRIGUEZ 1984–85 Rodriguez, Jean-François. "Picasso à la Biennale de Venise (1905–1948): Sur Deux Lettres de Picasso à Ardengo Soffici." *Atti dell'Istituto Veneto di Scienze, Lettere e d'Arti* (Venice), 143 (1984–85), pp. 27–63.

ROMILLY 1982 Romilly, Nicole Worms de, and Jean Laude. *Braque: Cubism, 1907–1914.* Paris: Éditions Maeght, 1982. Translated from *Braque, Le Cubisme: Catalogue de l'oeuvre, 1907–1914.* Paris: Éditions Maeght, 1982.

ROSENBLUM 1968 Rosenblum, Robert. *Jean-Auguste-Dominique Ingres.* New York: Harry N. Abrams, 1968.

ROSENBLUM 1973 Rosenblum, Robert. "Picasso and the Typography of Cubism." In John Golding and Roland Penrose, eds., *Picasso in Retrospect, 1881–1973.* New York: Praeger, 1973.

ROSENBLUM 1986 Rosenblum, Robert. "The *Demoiselles* Sketchbook No. 42, 1907." In Arnold Glimcher and Marc Glimcher, eds., *Je suis le cahier: The Sketchbooks of Picasso.* New York: The Pace Gallery, 1986.

ROSKILL 1985 Roskill, Mark. *The Interpretation of Cubism.* Philadelphia: Art Alliance Press, 1985.

RUBIN 1972 Rubin, William. *Picasso in the Collection of The Museum of Modern Art.* New York: The Museum of Modern Art, 1972.

RUBIN 1977 Rubin, William. "Cézannisme and the Beginnings of Cubism." In Rubin, ed. *Cézanne: The Late Work.* New York: The Museum of Modern Art, 1977, pp. 151–202.

RUBIN 1980 Rubin, William, ed. *Pablo Picasso: A Retrospective.* Chronology by Jane Fluegel. New York: The Museum of Modern Art, 1980.

RUBIN 1983 Rubin, William. "From Narrative to 'Iconic' in Picasso: The Buried Allegory in *Bread and Fruitdish on a Table* and the Role of the *Demoiselles d'Avignon*." *Art Bulletin* 65, no. 4 (December 1983), pp. 615–49.

RUBIN 1984 Rubin, William. "Modernist Primitivism: An Introduction," and "Picasso." In Rubin, ed. *"Primitivism" in 20th Century Art: Affinity of the Tribal and the Modern.* New York: The Museum of Modern Art, 1984.

RUDENSTINE 1988 Rudenstine, Angelica. *Modern Painting, Drawing and Sculpture Collected by Emily and Joseph Pulitzer, Jr.* Cambridge, Mass.: Harvard University Art Museums, 1988.

RUSSELL 1959 Russell, John. *Braque.* London: Phaidon, 1959.

SABARTÉS 1954 Sabartés, Jaime. *Picasso: Documents iconographiques.* Geneva: Pierre Cailler, 1954.

SALMON 1909 Salmon, André. "Les Indépendants." *L'Intransigeant,* March 26, 1909, p. 2.

SALMON 1910 Salmon, André. "Le Salon d'Automne," *Paris-Journal,* September 30, 1910, p. 5.

SALMON 1912 Salmon, André. *La Jeune Peinture française.* Paris: Société des Trente, Albert Messein, 1912.

SALMON 1919 Salmon, André. *La Jeune Sculpture française.* Paris: Société des Trente, Albert Messein, 1919.

Salmon 1920 Salmon, André. "Georges Seurat." *The Burlington Magazine,* no. 210 (September 1920), pp. 115–22.

Salmon 1922 Salmon, André. *Propos d'ateliers.* Paris: Éditions G. Crès, 1922.

Salmon 1926 Salmon, André. "Seurat." *L'Art vivant,* no. 37 (July 15, 1926), pp. 525–27.

Salmon 1945 Salmon, André. *Souvenirs sans fin: L'Air de la Butte.* Paris: Les Éditions de la Nouvelle France, 1945.

Salmon 1956 Salmon, André. *Souvenirs sans fin: Deuxième époque (1908–1920).* Paris: Éditions Gallimard, 1956.

Seckel 1977 Seckel, Hélène. "L'Armory Show." In *Paris–New York.* Paris: Musée National d'Art Moderne, Centre Georges Pompidou, 1977.

Seckel 1988 Seckel, Hélène, ed. *Les Demoiselles D'Avignon.* 2 vols. Paris: Éditions de la Réunion des Musées Nationaux, 1988.

Severini 1946 Severini, Gino. *Tutta la vita di un pittore, I.* Rome, Paris, Milan: Garzanti, 1946.

Severini 1983 Severini, Gino. *La vita di un pittore.* Preface by Filiberto Menna. Biographical note by Maurizio Faggiolo dell'Arco. Milan: Giangiacomo Feltrinelli, Editore, 1983. An integrated edition of a work previously published in two parts: I, cited above as Severini 1946; II, *Tutta la vita di un pittore, II.* Florence: Edizioni Vallecchi, 1968.

Soffici 1911 Soffici, Ardengo. "Picasso e Braque." *La Voce* 3, no. 34 (August 24, 1911), pp. 635–37.

Soffici 1913 Soffici, Ardengo. *Cubismo e oltre.* Florence: La Voce, 1913. Republished in larger edition as *Cubismo e Futurismo.* Florence: La Voce, 1914.

Soffici 1920 Soffici, Ardengo, ed. "36 Lettere inedite di G. Apollinaire." *Rete Mediterranea* (Florence), September 1920, pp. 229–319.

Spies 1983 Spies, Werner. *Picasso: Das plastische Werk.* Stuttgart: Verlag Gerd Hatje, 1983.

Steegmuller 1963 Steegmuller, Francis. *Apollinaire, Poet Among the Painters.* New York: Farrar, Straus, & Co., 1963.

De Stefani 1988 De Stefani, Alessandro. "Matisse e il cubismo: Per una nuova datazione del 'Grand Nu' di Braque." *Paragone* 39 (March 1988), pp. 35–61.

Steichen 1963 Steichen, Edward J. *A Life in Photography.* Garden City, N.Y.: Doubleday & Co. in association with The Museum of Modern Art, 1963.

Stein 1922 Stein, Gertrude. *Geography and Plays.* Boston: Four Seas, 1922.

Stein 1934 Stein, Gertrude. *Autobiographie d'Alice Toklas.* Translated into French by Bernard Faÿ. Paris: Éditions Gallimard, 1934.

Stein 1939 Stein, Gertrude. *Picasso.* New York: Charles Scribner's Sons, 1939. First published in French, Paris: Librairie Floury, 1938.

Stein 1950 Stein, Leo. *Journey into the Self, Being the Letters, Papers & Journals of Leo Stein.* Edited by Edmund Fuller. New York: Crown Publishers, 1950.

Stein 1955 Stein, Gertrude. *Painted Lace and Other Pieces (1914–1937).* Introduction by Daniel-Henry Kahnweiler. New Haven: Yale University Press, 1955.

Stein 1961 Stein, Gertrude. *The Autobiography of Alice B. Toklas.* New York: Vintage Books, 1961. First published New York: Harcourt, Brace, 1933.

Tériade 1952 Tériade, E. "Matisse Speaks" (1951). *1952 Art News Annual* 21. Reprinted in Jack D. Flam. *Matisse on Art.* New York: Phaidon, 1973.

Transition 1935 Henri Matisse, Tristan Tzara, Maria Jolas, Georges Braque, Eugene Jolas, and André Salmon. "Testimony Against Gertrude Stein." Supplement to *Transition,* no. 23 (July 1935).

Uhde 1928 Uhde, Wilhelm. *Picasso et la tradition française: Notes sur la peinture actuelle.* Paris: Éditions des Quatre-Chemins, 1928.

Vallier 1954 Vallier, Dora. "Braque, la peinture et nous." *Cahiers d'art* 29, no. 1 (October 1954), pp. 13–24.

Vauxcelles 1908a Vauxcelles, Louis. "Le Salon des Indépendants." *Gil Blas,* March 20, 1908, p. 2.

Vauxcelles 1908b Vauxcelles, Louis. "Exposition Braque. Chez Kahnweiler, 28, rue Vignon." *Gil Blas,* November 14, 1908. Reprinted in Fry 1966b, pp. 50–51.

Vauxcelles 1934 Vauxcelles, Louis. "Les Fauves: L'Atelier de Gustave Moreau." *Expositions de "Beaux-Arts" de La Gazette des Beaux-Arts.* Paris, November–December 1934.

Verdet 1962 Verdet, André. "Avec Georges Braque." *XXe Siècle* (Paris) 24, no. 18 (February 1962), supplement, n.p.

VERDET 1978 Verdet, André. *Entretiens, notes et écrits sur la peinture: Braque, Léger, Matisse, Picasso.* Paris: Éditions Galilée, 1978.

WERTH 1910 Werth, Léon. "Le Mois du peintre: Exposition Picasso (galerie Notre-Dame-des-Champs, mai)." *La Phalange* 4, no. 48 (June 20, 1910), pp. 728–30.

YALE 1950 *Collection of the Société Anonyme, Museum of Modern Art 1920.* New Haven, Conn: Yale University Art Gallery, 1950.

DE ZAYAS 1911 de Zayas, Marius. "Pablo Picasso." *America: Revista mensual illustrada* (New York), May 1911, pp. 363–65. In Spanish. English-language version published as de Zayas, "Pablo Picasso," *Camera Work* 34–35 (April–July 1911), pp. 65–67.

DE ZAYAS 1980 de Zayas, Marius. "How, When, and Why Modern Art Came to New York." Introduction and Notes by Francis Naumann. *Arts Magazine* 54, no. 8 (April 1980), pp. 96–126. From unpublished notes, "L'Art moderne à New York," 2 vols.

ZERVOS 1932 Zervos, Christian. "Georges Braque et le développement du cubisme." *Cahiers d'art* 7, nos. 1–2 (1932), pp. 13–23.

ZERVOS 1932–78 Zervos, Christian. *Pablo Picasso.* 33 vols. Paris: Éditions Cahiers d'Art, 1932–78.

ZILCZER 1975 Zilczer, Judith. *The Aesthetic Struggle in America, 1913–1918: Abstract Art and Theory in the Stieglitz Circle.* Ph.D. diss., University of Delaware, 1975.

ZURCHER 1988 Zurcher, Bernard. *Georges Braque: Life and Work.* New York: Rizzoli International, 1988.

Acknowledgments

The realization of an exhibition of this size and scope requires the assistance, commitment, and collaboration of a great many people. I have been most fortunate in the assistance I have received and in the energy, dedication, and goodwill with which it has been given.

Many museums have been extraordinarily generous, making possible multiple loans. Without the fifteen paintings from the collection of The Hermitage Museum in Leningrad and The Pushkin State Museum of Fine Arts in Moscow, a proper understanding of the early history of Cubism would be impossible. We are extremely grateful to our colleagues in the Soviet Union for making these loans possible. Christian Geelhaar, Director of the Kunstmuseum Basel, and Dieter Koepplin, Curator of its Kupferstichkabinett, have been exceedingly generous in allowing us to borrow a good part of the Kunstmuseum's very important collection of Picasso's and Braque's Cubist works. I am pleased to think that they will be able to enjoy their own version of this exhibition after ours closes. Pierre Georgel and Gérard Regnier of the Musée Picasso, Paris, have also been outstanding in their generosity, and we are very much in their debt. In addition, Mr. Georgel greatly aided our research by allowing us access to Braque's letters to Picasso from the Cubist period in the Picasso Archives, Musée Picasso, Paris. The Musée National d'Art Moderne, Centre Georges Pompidou, Paris, under the leadership of Jean-Hubert Martin, has helped us to realize this project not only through the many works it has graciously lent to this exhibition, but also by participating in an exchange exhibition with The Hermitage Museum in Leningrad which, in turn, made the Hermitage's loans to our show possible. Isabelle Monod-Fontaine, Curator at the Centre Georges Pompidou, has also been especially helpful. Dr. Jiří Kotalík, Director of the National Gallery, Prague, long a gracious lender to this Museum's exhibitions, has been exceptionally kind in lending a number of important works from Prague's superb but little-known Cubist collection, and his support is very much appreciated. We owe thanks as well to Anne d'Harnoncourt, Director of the Philadelphia Museum of Art; Joëlle Pijaudier of the Musée d'Art Moderne, Villeneuve-d'Ascq; Thomas Messer, former Director of the Solomon R. Guggenheim Museum, Thomas Krens, the Guggenheim's current Director, and Diane Waldman, Deputy Director at the Guggenheim; Philip Rylands, Deputy Director of the Peggy Guggenheim Collection, Venice; Sir Alan Bowness, former Director, and Nick Serota, current Director, of The Tate Gallery, London; Dr. Hans Christoph von Tavel, Director, Sandor Kuthy, Deputy Director, and Anne Tremblay, Conservator, of the Kunstmuseum Bern; Susanne Pagé, Director, and Danielle Molinari, Curator, of the Musée d'Art Moderne de la Ville de Paris; Olle Granath, Director of the Moderna Museet, Stockholm; James Wood, Director, and Neal Benezra, Curator, of The Art Institute of Chicago; Philippe de Montebello, Director of The Metropolitan Museum of Art, and William Lieberman, Chairman of Twentieth-Century Art for that museum; Peter Marzio, Director of The Museum of Fine Arts, Houston; J. Carter Brown, Director, and Charles Moffett and Jack Cowart, Curators, of the National Gallery of Art, Washington, D.C. All of these people have been exceptionally supportive of our enterprise. In addition, I owe a special debt of gratitude to Olivier Chevrillon, Director of the Réunion des Musées Nationaux de France, and to his close associate, Irène Bizot, whose help and advice have been extremely important to me.

This undertaking required the assistance of many experts in the field of Cubism, both scholars and dealers. I am, of course, especially indebted to Dominique Bozo, whose intelligence and insight played a role in the initial conceptualization of the endeavor. Pierre Daix has been extremely important to the formation of the project because of his previous research—especially his excellent catalogue raisonné of Picasso's Cubist works—and in his capacity as consultant to the exhibition. Edward Fry, too, has acted as a consultant, and we have greatly depended on his judgment and advice. Maurice Jardot has also been extremely gracious and helpful in matters relating to our research.

Many people were kind enough to respond to urgent letters and telephone calls with information that helped us date or trace works of art. Brigitte Baer's insights into the dating of Picasso's prints were always extremely helpful and given in a spirit of collegial goodwill; I am in her debt. Nicole Worms de Romilly responded with seemingly inexhaustible kindness and patience to our numerous queries regarding works reproduced in her catalogue raisonné of Braque's Cubist years. Mr. and Mrs. Claude Laurens were exceptionally generous in allowing us access to those por-

tions of the correspondence in their archives which were germane to our project. Donna Stein very kindly assisted us in locating Cubist prints in American collections. Toby Schreiber has also been extremely helpful and gracious. In recent years, many important modern works have found their way into Japanese collections. I am immensely grateful to Tamon Miki and Masaharu Ono of The National Museum of Art, Osaka, as well as to Tohru Matsumoto of The National Museum of Modern Art, Tokyo, and Takeo Uchiyama of The National Museum of Art, Kyoto, for their efforts on our behalf in Japan. In addition, I owe thanks to Kazuko Miyamoto, whose Japanese translations and telephone calls helped us to secure important loans.

Of the numerous dealers whose assistance on this project has been invaluable, we owe special thanks to Ernst Beyeler, who sacrificed many hours of his time in assisting us with insurance-estimate problems related to obtaining U.S. government indemnification. In addition, he and his assistant, Claudia Neugebauer, have invariably met our requests for help in contacting owners, or obtaining photographs and insurance values, with good cheer and efficiency. Among the other dealers to whom we are particularly indebted are William Acquavella; Eugene Thaw; Stephen Hahn; Klaus Perls; Eleanore Saidenberg; Heinz Berggruen; Thomas Ammann; David Nahmad and Berta Katz of Davlyn Gallery; Alain Tarica; Tomomi Baumgarten of Galerie Nichido, Tokyo; Angela Rosengart; Jan Krugier, Vivienne Warszawski, and Jean Pettibone of Jan Krugier Gallery, New York; Frank Lloyd and David Somerset of Marlborough Gallery; Desmond Corcoran of Reid and Lefevre Gallery, London; Miyoshi Nakayama of Tokyo Station Gallery; Toshio Tamada of Fuji Television Gallery Co., Ltd.; and Alexandra Schwartz of Pace Master Prints, New York, who provided us with insurance valuations of the prints included in the exhibition. We are also most grateful to Patrick Cooney and Chris Demetruis of the Citibank Art Advisory Service, to David Nash and Michel Strauss of Sotheby's New York and Sotheby's London, and to Christopher Burge of Christie's New York for helping us to contact lenders.

On behalf of the Trustees of The Museum of Modern Art, I wish to express my deep appreciation to all of the lenders whose names appear on page 458. I am keenly aware that for many, it is a great sacrifice to part with these fine works for the four months of the exhibition, and we are most fortunate that, in so many cases, a profound understanding of and sympathy with the scholarly goals of our project prompted such generosity.

Almost all the departments in the Museum have participated in one way or another in the preparation of this publication and exhibition. Among these colleagues, I should first like to express my thanks to Richard E. Oldenburg, Director of The Museum of Modern Art, without whose support this exhibition could not have happened. I am very much in his debt. I am also extremely grateful to Kirk Varnedoe, Director of the Department of Painting and Sculpture, for his unfailing interest in and enthusiasm for this project.

James Snyder, as the Museum's Deputy Director for Planning and Program Support, has been of enormous assistance, advising on insurance-related concerns, facilitating Soviet loans to the exhibition, and overseeing matters related to our physical plant. I am most appreciative of his help. I am grateful as well for the support of Riva Castleman, in her capacity as both Deputy Director for Curatorial Affairs and Director of the Department of Prints and Illustrated Books. She has collaborated generously on this exhibition, as has John Elderfield, Director of the Department of Drawings. Beatrice Kernan, Assistant Curator, and Robert Evren, Curatorial Assistant, both in the Department of Drawings, and Audrey Isselbacher, Associate Curator in the Department of Prints and Illustrated Books, have given their time, and their help is very much appreciated. Magdalena Dabrowski, Associate Curator in the Department of Drawings, was kind enough to share with us some of her research on Vladimir Tatlin. The patience, efficiency, and dedication of Richard Palmer, Coordinator of Exhibitions, has been remarkable in light of the complex problems associated with mounting an exhibition of this kind, and I am very grateful to him and to his staff: Betsy Jablow, who assembled our U.S. government indemnity application, Rosette Bakish, Executive Secretary, and Allison Rachleff, Administrative Assistant. Special thanks are due to the Department of Registration, including Eloise Ricciardelli, Director; Lynne Addison, who worked on the preliminary phases of this project; and Sarah Tappen, Christina Kelly, and Donna Mauro, who have coped admirably with the many challenges posed by the assembly of so many works of art from such a wide variety of locations. The Department of Conservation deserves deep appreciation for the scrupulous care and attention they have given to the loans coming to this exhibition. I am especially grateful to Antoinette King, Director of the Department, to Patricia Houlihan, and to James Coddington, who provided me with information gleaned by examining, under X-ray and ultraviolet light, the Cubist works in the collection of The Museum of Modern Art.

Jerome Neuner, Production Manager, Exhibition Program, has been of invaluable help in devising the installation. Thanks are also due to Karen Meyerhoff and Fred Coxen of that department for their help with installation and framing. I am grateful to Jeanne Collins, Director of Public Information, Jessica Schwartz, Associate Director, and Edna Goldstaub, Press Representative, for their efforts in finding the broadest possible audience for this exhibition. Philip Yenawine, Director of Education, and Emily Kies, Museum Educator, have been extremely helpful in planning and implementing the associated public programs. I also wish to thank Sue B. Dorn, Deputy Director for Development and Public Affairs, who has been very active in soliciting support for this project.

The library staff has been extremely understanding in aiding us in our research, and while Judith Cousins, as author of the Documentary Chronology, thanks them individually for their contributions, I want to express my appreciation as well. Susan Jackson and the members of the

Department of Visitor Services have been extremely resourceful in planning to accommodate the public smoothly at this exhibition. I would also like to express my thanks to Joan Howard, Director of Special Events, and to her staff for their work in organizing the exhibition's opening festivities. Waldo Rasmussen, Director of the International Program, has taken time from his busy schedule to help us secure a loan, and for this I am extremely grateful. Beverly Wolff, Secretary and General Counsel of the Museum, helped with several crucial loan negotiations, and I owe her my thanks as well. I also owe a debt of gratitude to Ethel Shein, Executive Assistant to Richard Oldenburg, whose advice I have often sought. We have all depended on the language skills of both Rose Kolmetz, Research Consultant for the International Program, and Catherine Evans, Assistant Curator in the Department of Photography, and I thank them for their help.

The preparation of this book has been an enormous task, and I am most grateful for the dedication of the Department of Publications. William P. Edwards, formerly Deputy Director for Auxiliary Activities, was kind enough to consult with us, early on, regarding computers. I also appreciate the support of Harriet Bee, Managing Editor in the department. It was my great good fortune as well as my great pleasure to work once again with James Leggio, who edited this very complex and daunting publication with enormous intelligence and skill. He has contributed countless improvements to every aspect of the book, and we are all very much in his debt. I would also like to thank Maura Walsh, who joined in the editing at a crucial point, as well as Amy Ellis and Anna Jardine. Tim McDonough, Production Manager, has once again brought to bear all his accustomed professionalism in the making of the color plates, and has been most diligent in overseeing all phases of the book's production under the pressure of almost impossible deadlines. I owe him, and his assistant, Marisa Hill, my special thanks. I would also like to extend my gratitude and appreciation to Michael Hentges, for working with us on the design of this publication, laying it out with sensitivity, and demonstrating great patience and fortitude, even as he simultaneously carried out his responsibilities as Director of the Museum's Department of Graphics. Thanks are also due to Richard Tooke, Supervisor of Rights and Reproductions; to Mikki Carpenter for making the Museum's photographic archives available to us; and to Kate Keller and Mali Olatunji for producing the photographs we have used of works from the Museum's collection.

Finally, I owe an immense debt to Pepe Karmel, who came on board primarily to help us in regard to his specialty, Picasso's Cubist drawings, but who has worked superbly on almost every aspect of this exhibition, functioning as virtually its associate director. Together, we would never have been able to bring it off, however, without the extraordinary professional collaboration of Lynn Zelevansky, the exhibition's Curatorial Assistant, who, more than any other single person, has borne the burden of the show's organization. *Chapeaux bas!* As she has for many years now, my marvelous secretary, Ruth Priever, has worked better, harder, and more patiently than anyone has a right to expect, all the while graciously bearing the slings and arrows of the show's impatient, indeed exasperated, director. I express my debt to Curator for Research Judith Cousins elsewhere, but that debt is really beyond words. Associate Curator Cora Rosevear and Loan Assistant Alexandra Muzek have pitched in nobly to take care of exchange and replacement loans. Véronique Chagnon-Burke and Laura Carton made helpful contributions as Research Assistants. Jodi Hauptman, also Research Assistant, worked on this exhibition for the better part of a year, displaying infinite patience and extraordinary grace under pressure. Last, but far from least, my thanks to a member of the Department of Painting and Sculpture who, though not officially connected with the exhibition, has generously once again assumed her old role of curatorial "fireman," in order to effect a timely rescue; Carolyn Lanchner provided the kind of invaluable professional knowledge and critical judgment without which this book would never have seen the light of day.

William Rubin

The preparation of the Documentary Chronology in this volume met with nearly insuperable difficulties on account of both its scale and the extreme constraints of time during which it had to be produced. Without the generous courtesy and cooperation of many persons at the Museum and elsewhere, without the special help, the time, and the energy they have contributed, this endeavor would most certainly never have been accomplished. I wish to thank them all.

My principal debt of gratitude is owed to William Rubin, Director Emeritus of the Department of Painting and Sculpture, who conceived this project and whose willingness to give his time, encouragement, and support proved indispensable to its realization.

Foremost among those whose contribution was absolutely essential to this undertaking are Denise and Claude Laurens, who spared no effort in providing documentary materials concerning Georges and Marcelle Braque. They were unfailingly willing to answer endless questions and expended enormous energy (Denise Laurens especially) on my behalf, and they have my most profound appreciation. Maurice Jardot and Quentin Laurens were instrumental in supplying correspondence addressed to Daniel-Henry Kahnweiler, primarily from Braque and Picasso, as well as documentation and photographs from the Galerie Louise Leiris Archives. They devoted many days of their time to assist me with never-failing courtesy, and their help was invaluable. Pierre Georgel of the Musée Picasso, Paris, through extraordinary efforts made available excerpts of Braque's correspondence to Picasso from the Picasso Archives, and was most generous in providing archival photographs and permission to reproduce them. I am deeply grateful to him.

As collaborator on the initial, French-language version of the chronology, Pierre Daix contributed to this work in a fundamental way that continued to be felt through its subsequent evolution. Giving liberally of his time and knowledge of Picasso, he also contributed significantly to the dating of Braque's letters to Kahnweiler. My debt to him is considerable.

Among those who have been most generous in sharing their knowledge and their research with me, I should like to acknowledge especially Edward F. Fry, who provided a wealth of information with respect to the Cubism of Picasso and Braque, generously answered innumerable questions, and made available his photographic archives; in addition, his article "Picasso, Cubism, and Reflexivity," published last year in *Art Journal,* was invaluable to my research. (It is cited, along with the other publications mentioned below, in the notes to the chronology.)

Ulla Dydo, Edward Burns, and Leon Katz, specialists in Gertrude Stein, contributed their expertise to my study of the Gertrude Stein Archives at Yale University. Dr. Dydo checked many facts related to the Stein manuscripts at Yale; most important, she brought to my attention Stein's virtually unknown "portrait" of Braque, written in early 1913 and not published until 1922. Hélène Seckel, Curator at the Musée Picasso, who generously answered questions in reference to Picasso and Hamilton Easter Field, Apollinaire, and Max Jacob, was helpful in every possible way; and Laurence Berthon, Documentaliste at the Musée Picasso, likewise greatly facilitated my research at that institution and offered valuable assistance. Étienne-Alain Hubert, specialist in Pierre Reverdy and the journalism of the period, helped in my study of Apollinaire and Braque and provided useful documentation of the Salon des Indépendants of 1908. Lynn Gamwell, Curator of the University Art Museum, State University of New York–Binghamton, made available with unfailing generosity the documentation she assembled in the preparation of her book *Cubist Criticism.* Patricia Leighten, Associate Professor of Art History at the University of Delaware, provided a wealth of information growing out of her work on the "Revising Cubism" issue of *Art Journal,* for which she served as guest editor. Special thanks are due Doreen Bolger, Associate Curator of American Paintings and Sculpture at The Metropolitan Museum of Art, for making available information she gathered in the course of her research on Hamilton Easter Field, including references to unpublished documents. Beth Gersh-Nešić, who recently completed a doctoral dissertation on André Salmon, freely shared her expertise in his early criticism and provided essential help; I owe her very special thanks. My colleague Magdalena Dabrowski, Associate Curator of Drawings at The Museum of Modern Art, most generously made available her dissertation, including research on Tatlin's visit to Paris. Billy Klüver and Julie Martin were extraordinarily generous with documentation gathered in connection with their book on the history of the artists' community in Montparnasse during 1900–30, in particular with respect to André Salmon, Gino Severini, Georges Braque, and Wilhelm Uhde. Lori Misura helped in resolving many problematic details related to the Stein Archives at Yale. Paul Fees, Curator of the Buffalo Bill Historical Center, generously made available documentary material on William F. Cody. Alexandra Parigoris was especially helpful with information on Apollinaire, Picasso, and *Les Soirées de Paris,* and provided advance proofs of her article on this subject in *Revue de l'art.* Stanley K. Jernow provided key documentation on Gelett Burgess and Inez Haynes Irwin, and their visits to the studios of Braque and Picasso in the spring and early summer of 1908; his help was of immense benefit. Valérie Durey, Documentaliste at the Musée des Beaux-Arts, Lyon, provided valuable information about the exhibition seen there by Braque in July 1914. Monique Nonne, Documentaliste at the Musée d'Orsay, made special efforts to provide documentary material. The advice and counsel of Michèle Richet, Conservateur Émérite of the Musée Picasso, were invaluable to me during extended periods of research in Paris. Jack Flam, who gave time and thought to questions concerning Matisse and Cubism, kindly brought to my attention the little-known volume of interviews by André Verdet. Jean-François Rodriguez was particularly helpful in response to requests for information about Ardengo Soffici. Alvin Martin was especially generous in making available his dissertation on Braque and allowing me to cite from his text.

Particular gratitude is due the following individuals, who

made available archival texts and/or photographs and gave permission for their use: Ludovic de Beaugendre, Service de Documentation Photographique de la Réunion des Musées Nationaux de France; Edward Burns; Catherine Bondy Cozzano; Michel Décaudin; Yves de Fontbrune; Pierrette Gargallo; Patricia King, Director, Arthur and Elizabeth Schlesinger Library on the History of Women in America, Radcliffe College; John Laurent; William McNought, Archives of American Art, Smithsonian Institution; Jean-Pierre Mohen, Conservateur en Chef, Musée des Antiquités Nationales, Saint-Germain-en-Laye; Alicia Rodero Riaza, Museo Arqueológico National, Madrid; Robert H. Smith, Jr., Head of Archives and Special Collections, Wright State University; Valeria Soffici; Dina Verney, and her collaborator Françoise Daderian; Jeanine Warnod; Rodrigo de Zayas; and Sergio Zoppi.

For their valued assistance in a variety of ways, I should like to thank Albert Albano, Todd Alden, Véronique Balu, Paula Baxter, Marie-Laure Besnard Bernadac, Claude Bernès, Gilbert Boudar, LeRoy C. Breunig, Micheline Charton, Donna De Salvo, Dawn Dewey, Alessandro Di Stefano, Jeannette Druy, Susan Earle, Jacques Faujour, Ramon Favella, Lynn Fernandez, John H. Field, Jane Fluegel, Phyllis J. Freeman, Colette Giraudon, Serge Gleboff, Marie-Hélène Gold, Trevor Hadley, Linda Henderson, Michel Hoog, Ron Johnson, Lewis Kachur, Gilbert Krill, Brigitte Leal, Jean Leymarie, Bernard Lirman, Paule Mazouet, Liliane Meffre, Peter Moak, Isabelle Monod-Fontaine, Jane Necol, Philippe Peltier, John Pultz, Jeanne Bouniort-Piens and Bernard Piens, Theodore Reff, Antoinette Rezé, Yves Sangiovanni, Raymond Josué Seckel, Dorothy Smith, Phillipe Solvit, Natasha Staller, Gail Stavitsky, Per Jonas Storsve, Wendy Botting Tagg, Catherine Vare, Thomas M. Whitehead, and Natalia Zitzelsberger.

I was helped by many members of the Museum's staff. To the following colleagues in the Department of Painting and Sculpture, for their many and valued efforts on behalf of this project, I should like to express my deepest gratitude: Kirk Varnedoe, Director, has my warmest thanks for his wholehearted support of this endeavor from its inception. To Carolyn Lanchner, Curator, I owe an incalculable debt, and to Julia McNeil, Secretary, who assisted her with extraordinary resourcefulness. Jodi Hauptman, Research Assistant, contributed significantly, under extreme pressure, to the realization of the project, with the valued advice of Lynn Zelevansky, Curatorial Assistant. Véronique Chagnon-Burke, Research Assistant in the final phase of preparation, provided essential help in writing for permissions.

Mary Beth Smalley, Curatorial Assistant, Ruth Priever, Secretary to the Director Emeritus, and Anne Umland, Assistant to the Director, were each most generous in offering help. Pepe Karmel, who participated as consultant to the exhibition and book, gave valued advice on the dating and sequence of works by Braque and Picasso mentioned in the chronology. Others who contributed much-appreciated assistance are Rona Roob, Museum Archivist; Eloise Ricciardelli, Registration; John Elderfield, Director of the Department of Drawings; Beatrice Kernan, Assistant Curator of Drawings; Riva Castleman, Director of the Department of Prints and Illustrated Books; Catherine Evans, Assistant Curator of Photography; Richard Tooke, Supervisor, Mikki Carpenter, Archivist, Thomas Grischkowsky, Permissions Officer, and Rosa Laster, Assistant Photo Lab Technician, Rights and Reproductions; and Richard Palmer, Coordinator of Exhibitions, Rosette Bakish, Executive Secretary, and Betsy Jablow, Associate Coordinator, Exhibition Program. Clive Phillpot, Director of the Library, and his staff have been especially helpful and attentive, responding to requests for information and assistance with proficiency and exemplary goodwill. I am particularly indebted to Janis Ekdahl, Assistant Director, and Terry Myers, Library Assistant, for their efforts in obtaining research materials and interlibrary loans on my behalf. Special thanks are due also to the other members of the Library staff who have helped me: Chantal Veraart, Executive Secretary; Daniel Starr, Associate Librarian, Cataloguing; Hikmet Dogu, Associate Librarian, Reference; Eumie Imm and Thomas Micchelli, Assistant Librarians, Cataloguing; Daniel Fermon and Tavia Fortt, Library Assistants. James Leggio has edited the manuscript, which presented unusual trials and difficulties, with endless patience, consummate intelligence, and perceptivity; all those who read the chronology are in his debt. Both Tim McDonough, Production Manager, Publications, and Michael Hentges, Director of Graphics, have shown extraordinary sensitivity to the goals of this document in their work on its design and printing. I have been most fortunate in having their help.

Most particularly, I wish to thank Pierre Adler, Sophie Hawkes, and Stephen Saltarelli for their expert translation into English of the initial, French version of the manuscript and of the majority of texts cited in the chronology. It has been a pleasure to work with them.

Finally, I should like to express my gratitude to my husband, Dominick Di Meo, who has continuously sustained me throughout this venture.

Judith Cousins

Lenders to the Exhibition

Stedelijk Museum, Amsterdam
Kunstmuseum Basel
Kunstmuseum Bern
Albright-Knox Art Gallery, Buffalo
Fitzwilliam Museum, Cambridge
The Provost and Fellows of King's College, Cambridge
Fogg Art Museum, Harvard University, Cambridge,
	Massachusetts
The Art Institute of Chicago
Cincinnati Art Museum
The Cleveland Museum of Art
Museum Ludwig, Cologne
Columbus Museum of Art, Ohio
The Detroit Institute of Arts
Kunstsammlung Nordrhein-Westfalen, Düsseldorf
Scottish National Gallery of Modern Art, Edinburgh
Stedelijk van Abbe Museum, Eindhoven
Museum Folkwang, Essen
Kimbell Art Museum, Fort Worth
Sprengel Museum, Hannover
Hood Museum of Art, Dartmouth College, Hanover,
	New Hampshire
The Hiroshima Museum of Art
The Menil Collection, Houston
The Museum of Fine Arts, Houston
The Hermitage Museum, Leningrad
The Tate Gallery, London
Musée des Beaux-Arts de Lyon
The Minneapolis Institute of Arts
The Pushkin State Museum of Fine Arts, Moscow
Yale University Art Gallery, New Haven, Connecticut
Solomon R. Guggenheim Museum, New York
The Metropolitan Museum of Art, New York
The Museum of Modern Art, New York
Allen Memorial Art Museum, Oberlin College,
	Oberlin, Ohio
The National Museum of Art, Osaka
Nasjonalgalleriet, Oslo
Musée d'Art Moderne de la Ville de Paris
Musée National d'Art Moderne, Centre Georges
	Pompidou, Paris
Musée Picasso, Paris
Philadelphia Museum of Art
National Gallery, Prague
Washington University Gallery of Art, St. Louis
Marion Koogler McNay Art Museum, San Antonio
San Francisco Museum of Modern Art
Moderna Museet, Stockholm
Staatsgalerie Stuttgart
Art Gallery of New South Wales, Sydney
Ulmer Museum, Ulm
Peggy Guggenheim Collection, Venice; The Solomon R.
	Guggenheim Foundation, New York

Musée d'Art Moderne, Villeneuve-d'Ascq
Kunstmuseum Winterthur

Mr. and Mrs. William Acquavella
Alsdorf Foundation
Mr. and Mrs. James W. Alsdorf
Dr. Herbert Batliner
Heinz Berggruen
Ernst Beyeler
Foundation E. G. Bührle Collection
Mr. and Mrs. Gustavo Cisneros
The Colin Collection
The Douglas Cooper Collection, Churchglade Ltd.
Estate of John T. Dorrance
Mrs. Robert Eichholz
Aaron Fleischman
Mrs. Victor W. Ganz
The Jacques and Natasha Gelman Collection
Stephen Hahn
Carlos Hank
Mr. and Mrs. Richard C. Hedreen
Mrs. Marcia Riklis Hirschfeld
Carroll and Conrad Janis
Josefowitz Collection
Katz Collection
Michel Leiris
Mr. and Mrs. Raphael Lopez-Cambil
Ludwig Collection
Alex Maguy
Mr. and Mrs. Donald B. Marron
Hope and Abraham Melamed
Mr. and Mrs. Markus Mizné
George L. K. and Suzy F. Morris Trust
Mr. and Mrs. Klaus Perls
Marina Picasso
Collection Rosengart
Maya Ruiz-Picasso
Mr. and Mrs. Daniel Saidenberg
Yves Saint Laurent and Pierre Bergé Collection
Mrs. Bertram Smith
Bernhard Sprengel Foundation
Mr. and Mrs. Eugene V. Thaw
Thyssen-Bornemisza Collection
Claire B. Zeisler
The Richard S. Zeisler Collection
36 anonymous lenders

Thomas Ammann Fine Art, Zurich
Artcurial, Paris
Galerie Beyeler, Basel
Galerie Jan Krugier, Geneva
E. V. Thaw and Co., New York

Trustees of
The Museum of Modern Art

Permission to print excerpts from unpublished letters and papers has been granted by the archives cited in the notes to the Documentary Chronology: Galerie Louise Leiris Archives, Paris; Laurens Archives; Picasso Archives, Musée Picasso, Paris; Arthur and Elizabeth Schlesinger Library of the History of Women in America, Radcliffe College, Cambridge, Massachusetts; Archives of American Art, Smithsonian Institution, Washington, D.C.; Collection of American Literature, Beinecke Rare Book and Manuscript Library, Yale University, New Haven, Connecticut.

Photographs reproduced in this volume have been provided, in the majority of cases, by the owners or custodians of the works, indicated in the captions. Individual works of art appearing here may be additionally protected by copyright in the United States of America or abroad, and may not be reproduced in any form without the permission of the copyright owners.

© Succession Picasso, for each work appearing with the following credit: Musée d'Art Moderne de la Ville de Paris; Musée National d'Art Moderne, Centre National d'Art et de Culture Georges Pompidou, Paris; Musée Picasso, Paris; Mr. and Mrs. Rafael Lopez-Cambil, New York; Marina Picasso, Galerie Jan Krugier, Geneva; Maya Ruiz-Picasso; and those on the following pages: 84, 110 bottom right, 156 bottom right, 162 bottom left, 200 far right, 238 top left, 294 bottom left, 299, 314 bottom right.

S.P.A.D.E.M., Paris, is the exclusive French agent for reproduction rights for Picasso and A.D.A.G.P., Paris, for Braque; A.R.S., New York, is the exclusive United States agent for S.P.A.D.E.M. and A.D.A.G.P.

The following list, keyed to page numbers, applies to photographs for which a separate acknowledgment is due.

Acquavella Gallery, New York: 74 bottom right. © A.D.A.G.P., Paris, and Cosmopress, Geneva: 321 top left. Maurice Aeschimann, Switzerland: 162 top left. Muriel Anssens: 99 top right, 133, 142, 151, 230 right, 246 top left, 306 bottom. C. Bahier/P. Migeat, Paris: 88 bottom right, 280 bottom right. Michael Bodycomb, Houston: 113. Courtesy Camille Bondy: 21 left. Buffalo Bill Historical Center, Cody, Wyoming: 50 top left. Courtesy Edward Burns: 341 bottom. © Cahiers d'Art, Paris: 34, 35, 280 top left, 427. Cavallo, *Soffici, immagini e documenti (1879–1964):* 43 right. © Colorphoto Hans Hinz: 106 top left, 107, 115, 149, 158 bottom right, 211, 236 top left, 239, 271, 275, 307, 329. Colorpro P/L, Sydney: 112.

Bernard Décaudin, courtesy Montfort Collection: 372. Michael Dyer Associates Ltd., London: 114 top left. Allan Finkleman, New York: 215 top. Vladimir Fyman, Prague: 160 top left. Rick Gardner, Houston: 164 top left. Courtesy Pierrette Gargallo: 388. Patrick Goetlen: 290. Carmelo Guadagno, Venice: 317. David Heald: 76, 143, 148, 190, 194, 201, 231, 300 bottom right. Peter Heman: 182 top left, 233. Paul Hester, Houston: 250 bottom right. Jacqueline Hyde, Paris: 169, 257 top right. Imageart, Antibes: 162 bottom left. Bob Kolbrenner, Chicago: 129 top right, 173, 286 bottom right. Jacques Lathior, Oslo: 249. Courtesy John Laurent: 68, 367. Laurens Archives: 17, 18, 31, 37 right, 44, 52, 315, 343, 351, 355, 382, 390, 401, 412, 413, 424, 428, 433. Galerie Louise Leiris Archives, Paris: 376, 392, 398, 405, 406, 410. Tord Lund: 122 top right, 183. André Morain, Paris: 320 top left. Picasso Archives, Musée Picasso, Paris: 23, 36 bottom, 41, 49, 361 top, 363, 368, 369, 373, 385, 389. The Museum of Modern Art, New York: 33 left, 37 right, 50 bottom right, 341 top, 348, 349, 353, 356 bottom, 361 bottom, 364, 366, 371, 380, 383, 387, 416, 423, 425. Edward Owen, Washington, D.C.: 106 bottom right. © Douglas Parker, Los Angeles: 159. Pfister Film, Cleveland: 212 bottom left. Photos NBC, Geneva: 256 bottom right. Milan Posselt, Prague: 163 bottom right. Cliché des Réunion des Musées Nationaux de France, Paris, © Photo R.M.N.–S.P.A.D.E.M.: 20, 42, 43 left, 45, 46, 53, 340, 347, 362, 403, and all works appearing with the credit Musée Picasso, Paris. Rheinisches Bildarchiv, Cologne: 168, 274. Tom Scott, Edinburgh: 196 bottom right. Courtesy Sotheby's, New York: 364. Studio Lourmel, Photo Routhier, Paris: 105. Joseph Szaszfai, New Haven, Connecticut: 260 top right. Michael Tropea, Chicago: 104 top left, 180 top left, 199 bottom right, 261 bottom right. © Malcolm Varon, New York: 78, 86 bottom right, 94, 95, 102, 109 top left, 119, 124, 125, 131 top left, 135, 139, 140 top right, 145, 172 bottom right, 188 top left, 195, 202 top left, 229 bottom, 230 top left, 240 top left, 241 top right, 244 top left, 281 top left, 330 bottom right, 332 top right and bottom. Courtesy Dina Vierny: 365. Roger-Viollet, © Collection Viollet, Paris: 374. Dedra Walls: 170 bottom right, 176 bottom, 208 top right. Courtesy Jeanine Warnod: 375. John Webb: 203. Wright State University, Dayton, Ohio: 33 right, 356 top. Collection of American Literature, Beinecke Rare Book and Manuscript Library, Yale University, New Haven, Connecticut: 37 left, 352, 359, 360, 429, 430. Zayas Archives, Seville: 432. © Dorothy Zeidman: 219.